Psychiatry and Psychology

in the

Visual Arts and Aesthetics

A Bibliography

Psychiatry and Psychology

in the

Visual Arts and Aesthetics

A Bibliography

Compiled and Edited by

Norman Kiell

The University of Wisconsin Press • Madison and Milwaukee, 1965

Published by
THE UNIVERSITY OF WISCONSIN PRESS
Madison and Milwaukee
P.O. Box 1379, Madison, Wisconsin 53701

Printed in the United States of America
by Cushing-Malloy, Inc., Ann Arbor, Michigan

Library of Congress Catalog Card Number 65-18877

Contents

Introduction

From the latter half of the nineteenth century, particularly as seen in the writings of Cesar Lombroso, on to the present day, psychological analysis of artists and their works has been a fairly common undertaking. In the last fifty years, Freud's incidental remarks and occasional essays concerning art or a specific artist have given psychologists a new viewpoint and a more disciplined framework in which art and relevant problems can be examined.

Freud himself admitted that he did not qualify as an expert upon style. Content rather than technique, with interest centered on the unconscious, appealed to him in artistic representation. Freud tended to regard art as in some ways independent of psychoanalysis. He contended that "knowledge gained from . . . analysis does not diminish the enjoyment of the work of art" (An Autobiographical Study). He conceded that psychoanalysis cannot purport to explain the nature of talent or of artistic technique, that "psychoanalysis must lay down its arms before the problem of the poet—that is to say, the biological aspects of innate gifts." And in Civilization and Its Discontents, Freud wrote, "There is no evident use in beauty; the necessity of it for cultural purposes is not apparent, and yet civilization could not do without it. . . .Unfortunately psycho-analysis . . . has less to say about beauty than about most things." Art's usefulness is pointed out in The Future of an Illusion, where Freud stated, "Art has a special usefulness to both society and the individual. It offers substitutive gratifications for the oldest cultural renunciations, and it promotes feelings of identification of which every cultural group has so much need." Art, Freud underlined, is "a great social institution" (Totem and Taboo).

As part of this institution, psychologists, psychoanalysts, philosophers, aestheticians, art critics, and educators have written of their findings in art and their insights in such sufficient quantity to merit a bibliography whereby access to their efforts can be more easily secured.

The table of contents gives evidence of the large part which art interpretation and analysis have played in our lives. Psychometrists have used art for the development of projective methods in obtaining useful data about the personality of individuals. Anthropologists have explored the arts of primitive and pre-historic societies to reconstruct and ponder about cultural values and familial relationships. A synthesis of aesthetics and psychology has long been attempted but has not as yet been satisfactorily achieved. Psychologists are vitally concerned about the usefulness of art for diagnoses and therapy, and psychoanalysts are equally alert to the possibilities of investigating the lives of artists and interpreting them through their creations,

much as they have done with poets and poetry. Art objects made by psychotic patients, as well as the techniques for making these objects, have frequently served not only as sources of inspiration for various artists but also as areas for intense scrutiny by the psychologist.

The choice of listings under "Psychoses and Art" in this bibliography follow the criteria suggested by Anastasi and Foley.[1] Their approach to the art of the psychotic is "concerned neither with aesthetic values nor with diagnostic and therapeutic techniques, but rather regards the products as artistic behavior. This approach may be characterized by its predominant emphasis upon the perceptual, imaginative, and other intellectual as well as emotional functions leading to the production of such art. The abnormality is studied primarily for the light which it may throw upon the basic mechanisms of behavior. The distortions, exaggerations, and retrogressions revealed in insane products are examined for clues to the nature and development of the functions involved."

Other sections of this bibliography do reveal the diagnostic and therapeutic use psychologists have made of art, through figure drawing, finger painting and other projective techniques. Here, too, while the quality of the art work is by no means of primary import, the substance and technique are basic for the clinician's data. Although there are some psychologists who feel that to perceive is not to experience stimuli passively but to a certain extent is to create, the editor has not included any projective tests to which the subject responds only verbally. It is true that some such tests might reveal a creative faculty, but their inclusion here would not serve a useful function. Such tests include the Rosenzweig Picture Frustration Study, the Children's Apperception Test, the Thematic Apperception Test, the Rorschach, the Szondi, and so on. The projective tests which are included give the testee several degrees of freedom to organize a plastic medium in his own way through some visual effort. Since little external aid is provided in these tests, he is required to give expression to the most readily available forces within himself. Thus unconscious revelations of the personality are evinced with which the clinician can make a tentative or supportive diagnosis. The proliferation of this material is evident in the several hundred listings in the bibliography in this area (Sections 7 and 21).

Still other writers point out the psychological significance of the resemblances between the art products of the abnormal and those of primitive, mystic, and modern and fantastic art. In children's art work we are given clues to the inner needs and perspectives of children.

The largest single section in this book falls, as might be expected, in the fields of aesthetics and art criticism. The difficulty in including data in these categories is manifest. As Pratt[2] has indicated, "Aesthetics has no clearly defined boundaries or directions. Any review of the subject will therefore almost certainly be selective, incomplete, and if not wholly one-sided, at least defective in one region or another. . . . The lack of decent

[1] A survey of the literature on artistic behavior in the abnormal. II: Approaches and interrelations. Ann NY Acad Sci 1941, 42:46.
[2] Aesthetics. Ann Rev Psychol 1961, 12:71.

boundaries for aesthetics is in large measure owing to the fact that the subject falls in no man's land. Philosophers, psychologists, historians, critics, and artists wander at odd moments into the field. . . ."

Probably the most recent source for a new interpretation of artistic creativity and for understanding the influence of illness on the artist has been the experimental inducement of temporary psychosis in a subject. Hallucinogens—such as LSD-25 (Lysergic Acid Diethylamide), mescaline, and psilocybin—offer, in the experiments, affective release to the artist-subject. While the schizogenic agent intensifies the inner experience of the individual, it breaks down the synthetic control functions and reduces the creative expression to doodling and fragmentation of lines. And although a mystical hallucinatory state of 'grace' and 'transfiguration' develop under inducement of the drug, there is a grave discrepancy with expressive facility. The three dozen entries listed in the section "Psychopharmacology" are evidence of the growing scope with which this new channel of exploratory research is being pursued.

CRITERIA FOR SELECTION OF MATERIAL

All schools of psychology are represented without discrimination. The quality of a given listing has not been the measure of its acceptance for inclusion, nor is there a guarantee for psychological accuracy. The wide variety of listings will give the reader the opportunity to compare interpretations of the same artist or his work—Vincent van Gogh, for instance—from two or more viewpoints. The very catholicity of approaches, ranging from the eugenical to the parapsychological and on through to the cross-cultural and psychoanalytical, should provide ample material for student and scholar alike.

METHOD OF PROCEDURE

Wherever possible, all editions of a given work are listed, particularly the publication of the same article or book in different languages. The English title is generally given primacy.

Titles of books have been capitalized whereas titles of articles and chapters in books are in small letters. Translations into English of titles for languages less familiar to American readers—such as Japanese, Hebrew, Russian, and Portugese—have usually been provided.

Abbreviations used for the names of journals and some publishers are generally in accord with those found in the World List of Scientific Periodicals, the Index Medicus, Psychological Abstracts, the Union List of Serials, and the publications of the Library of Congress. In some few instances, the compiler devised his own abbreviations. Full titles of the journals are spelled out in a section following this introduction.

Duplicate listings have been avoided as far as possible. Where an item might easily be placed in two or even three categories (such as "The Aesthetics of Primitive African Sculpture"), I have used my prerogative to put it where I felt it fell into the most logical category—in this instance "Sculpture" and not under "Primitive Art" or "Aesthetics."

Bibliographic materials were gathered from a number of sources. I am listing the primary ones here.

Anastasi, A., and J. Foley, Jr. A survey of the literature on artistic behavior in the abnormal. I: Historical and theoretical background. J gen Psychol 1941, 25:111-142. II: Approaches and interrelations. Ann NY Acad Sci 1941, 42:1-112. III: Spontaneous productions. Psychol Monogr 1940, 52:1-71. IV: Experimental investigations. J gen Psychol 1941, 25:187-237.

Baldwin, J.M. Dictionary of Philosophy and Psychology. NY: Macmillan 1905; NY: Smith 1949.

Chandler, A.R., and E.N. Barnhart. A Bibliography of Psychology and Experimental Aesthetics, 1864-1937. Berkeley: Univ California 1938, 190 p. (Mimeographed.)

Graewe, H. Geschichtlicher Überblick über die Psychologie des kindlichen Zeichnens. Arch ges Psychol 1936, 96:103-220.

Grinstein, A. (ed.). The Index of Psychoanalytic Writings. Vols. 1-5. NY: IUP 1950-1959.

Hammond, W.A. A Bibliography of Aesthetics and of the Philosophy of the Fine Arts from 1900 to 1932. NY: Longmans, Green 1934, 205 p.

Hungerland, H. Selective current bibliography for aesthetics and related fields. JAAC 1945-1963, Vols. 4-21.

Menninger, K.A. A Guide to Psychiatric Books. NY: Grune & Stratton 1956, 157 p.

Kanzer, M. Applied psychoanalysis. Ann Survey Psychoanal 1951-1955.

Naville, P. Elements d'une bibliographie critique relative au graphisme enfantin jusqu'en 1949. Enfance 1950, No. 3, 129-222.

Richter, M. Internationale Bibliographie der Farbenlehre und Ihre Grenzgebiete. Nr. 1: Berichtzeit 1940-1949. Göttingen: "Munsterschmidt" Wissenschaftlicher 1952, 244 p.

Rickman, J. Index Psychoanalyticus. London: Woolf 1928.

Young, A.R. Art Bibliography. NY: Columbia University, Teachers College 1947, 92 p. (Mimeographed.)

Applied Science and Technology Index, 1958-1962. NY: Wilson.

Art Index, 1933-1962, Vols. 1-13. NY: Wilson.

Bibliography of Medical Reviews, 1961-1962, Vols. 6-7. Washington, D.C.: U.S. National Library of Medicine.

Cumulative Book Index. Minneapolis, Minn.: Wilson.

Cumulative Index of Hospital Literature, 1945-1963. Chicago: American Hospital Association.

Cumulated Index Medicus, 1960-1963, Vols. 1-4. Chicago: American Medical Association.

Current List of Medical Literature, 1950-1959, Vols. 19-36. Washington, D.C.: U.S. Army Medical Library.

Education Index, 1929-1962, Vols. 1-34. NY: Wilson.

Excerpta Medica. Neurology and Psychiatry, Section VIII, 1954-1961, Vols. 7-14. Amsterdam and NY: Excerpta Medica Foundation.

Industrial Arts Index, 1950-1962. NY: Wilson.

International Index to Periodicals. NY: Wilson.

Library of Congress Catalog. Books: Subjects. 1900-1954; 1955-1959; 1960; 1961; 1962. Ann Arbor, Mich.: Edwards.

Psychological Abstracts, 1927–1963, Vols. 1–37. Lancaster, Pa.: American Psychological Association.
Psychopharmacology Abstracts, 1961–1962, Vols. 1–2. Washington, D.C.: American Psychopharmacology Association.
Quarterly Cumulative Index to Current Medical Literature, 1916–1926, Vols. 1–12. Chicago: American Medical Association.
Quarterly Cumulative Index Medicus, 1927–1956, Vols. 1–60. Chicago: American Medical Association.
Readers Guide to Periodical Literature. NY: Wilson.
Review of Educational Research, 1931–1962, Vols. 1–32. Washington, D.C.: American Educational Research Association.
Sociological Abstracts, 1952–1963, Vols. 1–10. NY.
Zentralblatt für die gesamte Neurologie und Psychiatrie, 1956–1961, Vols. 138–161. Berlin: Springer-Verlag.

CONCLUSION

It is hoped that this bibliography will serve as a useful research instrument. Every effort has been made to include as many items related to the visual arts, aesthetics, and psychology as was humanly possible. In addition to unavoidable errors of omission, errors of commission may also very well have crept into the work. For all errors, I naturally am responsible.

For whatever merit the bibliography has, I should like to share it with the unknown but spontaneously generous librarians of the Medical Library of the University of Copenhagen and the Royal Library of Copenhagen, where most of this work was researched during a sabbatical year. I am also grateful to the Dean of Students, Herbert H. Stroup, and the Dean of Faculty, Walter Mais, both of Brooklyn College of the City University of New York, for their assistance in providing typists for the manuscript.

N.K.

Freeport, New York
January 6, 1964

List of Abbreviations
and Journals

Acad	Academy
Acta neurol psychiat belg	Acta Neurologica et Psychiatrics Belgica
Acta psychiat neurol	Acta Psychiatrica et Neurological Scandinavica (Copenhagen)
Acta psychol	Acta Psychologica (Amsterdam)
Amer	American
Amer Inst Archit J	American Institute of Architects Journal
Amer J ment Deficiency	American Journal of Mental Deficiency
Amer J occup Ther	American Journal of Occupational Therapy
Amer J Psychiat	American Journal of Psychiatry
Amer J Psychother	American Journal of Psychotherapy
Ann	Annals
Année Psychol	L'Année Psychologique
Ann méd-psychol	Annales Médico-psychologiques (Paris)
Arch	Archives; Archivio; Archivos; Archiv
Arch gen Psychiat	Archives of General Psychiatry (Chicago)
Arch ges Psychol	Archiv für die gesamte Psychologie (Leipzig)
Arch ital di psicol	Archivio italiano di psicologia (Turin)
Archit Forum	Architectural Forum
Archit Rec	Architectural Record
Archit Rev	Architectural Review
Arch Neurol Psychiat	Archives of Neurology and Psychiatry (Chicago)
Arch Psicol Neurol Psichiat	Archivio di Psicologia, Neurologia e Psichiatria (Milan)
Arch Psychiat Nerven-krankheiten	Archiv für Psychiatrie und Nervenkrankheiten; vereingt mit Zeitschrift für die gesamte Neurologen
Arch Psychol	Archives de Psychologie (Geneva, Paris)
Brit	British
Bull	Bulletin
Bull Hist Med	Bulletin of the History of Medicine (Baltimore)
Bull Soc clin méd ment	Bulletin de la Société clinique de medécine mentale (Paris)
Char Pers	Character and Personality
Child Develpm	Child Development
Confin Psychiat	Confinia Psychiatria
Criança portug	Criança portugesa
Dis Nerv System	Diseases of the Nervous System (Galveston)
Dissertation Abstr	Dissertation Abstracts
Educ	Education; educational
Educ psychol Measmt	Educational and Psychological Measurement
Egypt J Psychol	Egyptian Journal of Psychology
Elem School J	Elementary School Journal
ETC	ETC: A Review of General Semantics
Évolut Psychiat	Évolution Psychiatrique
Genet psychol Monogr	Genetic Psychology Monographs
Indiv	Individual
Int	International
Int J Psycho-Anal	International Journal of Psycho-Analysis (London)
Int Z indiv-Psychol	Internationale Zeitschrift für Individual-psychologie
Int Z Psychoanal	International Zeitschrift für ärtzliche Psychoanalyse

IPEK	Jahrbuch für prähistorische und ethnographische Kunst (Leipzig)
IUP	International Universities Press (NY)
JAAC	Journal of Aesthetics and Art Criticism
J abnorm soc Psychol	Journal of Abnormal and Social Psychology
J Amer Psychoanal Ass	Journal of the American Psychoanalytic Association
Jap J Psychol	Japanese Journal of Psychology
J appl Psychol	Journal of Applied Psychology
J clin exp Psychopath	Journal of Clinical and Experimental Psychopathology and Quarterly Review of Psychiatry; formed by the union of the Journal of Clinical and Experimental Psychopathology (formerly the Journal of Clinical Psychopathology and Psychotherapy) and the Quarterly Review of Psychiatry and Neurology
J clin Psychol	Journal of Clinical Psychology
J comp Psychol	Journal of Comparative Psychology
J consult Psychol	Journal of Consulting Psychology
J exp Educ	Journal of Experimental Education
J exp Psychol	Journal of Experimental Psychology
J genet Psychol	Journal of Genetic Psychology
J gen Psychol	Journal of General Psychology
J ment Sci	Journal of Mental Science
JNMD	Journal of Nervous and Mental Diseases
J opt Soc Amer	Journal of the Optical Society of America
JPNP	Journal de Psychologie Normale et Pathologique
J proj Tech	Journal of Projective Techniques
J soc Psychol	Journal of Social Psychology
Klin Monatsbl Augenh	Klinische Monatsblätter für Augenheilkunde und für augenärztliche Fortbildung
Lit	Literature
Med	Medical
Ment Hyg	Mental Hygiene (New York)
Minerva Med	Minerva Medica (Turin)
Ned Tijdschr Geneesk	Nederlandsch Tijdschrift voor Geneeskunde
Ned Tijdschr Psychol	Nederlandsch Tijdschrift voor der Psychologie en Haar Gransgebieden
Neue psychol Stud	Neue psychologische Studien (Münich)
Occup Ther Rehab	Occupational Therapy and Rehabilitation
Ops	American Journal of Orthopsychiatry
Ped Sem	Pedagogical Seminary
Philos	Philosophy; philosophical
Philos phenomenol Res	Philosophy and Phenomenological Research
Philos Rev	Philosophical Review (New York)
Pop Sci Mon	Popular Science Monthly
Prax Kinderpsychol Kinderpsychiat	Praxia der Kinderpsychologie und Kinderpsychiatrie
Presse méd	Presse Médicale
Proc	Proceedings
Progr Archit	Progressive Architecture
Psyche	Psyche. Eine Zeitschrift für psychologische und medizinische Menschenkunde (Stuttgart)
Psyché-Paris	Psyché-Paris. Revue internationale des sciences de l'homme et de la psychanalyse
Psychiat Quart	Psychiatric Quarterly
Psychiat Quart Suppl	Psychiatric Quarterly Supplement
Psychoanal	Psychoanalysis; Psychoanalytic
Psychoanal Bewegung	Psychoanalytische Bewegung
Psychol	Psychology; Psychological
Psychol Beiträge	Psychologische Beiträge
Psychol Forsch	Psychologische Forschung. Zeitschrift für allgemeine Psychologie, Ethologie und medizinische Psychologie (Berlin)

Psychol Monogr	Psychological Monographs: General and Applied
Psychol Praxis	Psychologische Praxis (Basel)
Psychosom Med	Psychosomatic Medicine
PUF	Presses Univérsitaires de France
Quart	Quarterly
Rass studi psichiat	Rassegna di Studi Psichiatrici
Res	Research
Rev	Revue; Revista; Review
Rev de Psychol	Revue de psychotherapie et de psychologie appliquée
Rev franç Psychanal	Revue Française de Psychanalyse
Rev psicol (Madrid)	Revista de Psicologia General y Aplicado
Riv	Rivista
Rorschach Res Exch	Rorschach Research Exchange
Sāmiksā	Sāmiksā: Journal of the Indian Psycho-Analytic Society
Schweiz ANP	Schweizer Archiv für Neurologie und Psychiatrie
Schweiz ZPA	Beihefte zur Schweizerischen Zeitschrift für Psychologie und ihre Anwedungen
Sci	Science; Scientific
Sem univ Pédag Univ de Bruxelles	Semaine universitaire de Pédagogie de l'Université Libre de Bruxelles
Soc	Society
Yrb nat Soc Stud Educ	Yearbook of the National Society for the Study of Education
Z	Zeitschrift
Z Aesth	Zeitschrift für Ästhetik und allgemeine Kunstwissenschaft
Z angew Psychol	Zeitschrift für angewand Psychologie
Z diagnost Psychol	Zeitschrift für diagnostische Psychologie und Personlichkeitsforschung
Z exp angew Psychol	Zeitschrift für experimentelle und angewandte Psychologie
Z exp Pädag	Zeitschrift für experimentelle Pädagogik
Z Kinderforsch	Zeitschrift für Kinderforschung
Z Kinderpsychiat	Zeitschrift für Kinderpsychiatrie
ZNP	Zentralblatt für die gesamte Neurologie und Psychiatrie
Z pädag Psychol	Zeitschrift für pädagogische Psychologie
Z Psychoanal Psychother	Zeitschrift für Psychoanalyse und Psychotherapie
Z Psychol	Zeitschrift für Psychologie
Z Psychol Physiol Sinnesorg	Zeitschrift für Psychologie und Physiologie der Sinnesorgane
Z psycho-som Med	Zeitschrift für psycho-somatische Medizin
Z Psychother med Psychol	Zeitschrift für Psychotherapie und medizinische Psychologie

Psychiatry and Psychology

in the

Visual Arts and Aesthetics

A Bibliography

1 Aesthetics and Art Criticism

0001. Abadi, E. Le monde extérieur selon l'intuition artistique et l'observation psychologique. La Psychologie et la Vie (Paris) 1930, 4:175-178.

0002. Abell, W. Myth, mind, and history. JAAC 1945, 4:77-86.

0003. ——. Representation and Form. A Study of Aesthetic Values in Representational Art. NY: Scribner's 1936, 172 p.

0004. ——. Toward a unified field in aesthetics. JAAC 1952, 10:191.

0005. Adams, E.K. The Aesthetic Experience; Its Meaning in a Functional Psychology. Chicago 1907, 114 p; Doctoral dissertation. Univ. Chicago 1904.

0006. Adanczewski, Z. L'art est tempore! Diogène 1961, 36:93-119.

0007. Adcock, C.J. Aesthetics. J gen Psychol 1962, 67:83-87.

0008. Aiken, H.D. The aesthetic relevance of artists' intentions. J Philos 1955, 52: 742-753.

0009. ——. The concept of relevance in aesthetics. JAAC 1947, 6:152-161.

0010. ——. Criteria for an adequate aesthetics. JAAC 1948, 7:141-148.

0011. ——. A pluralistic analysis of aesthetic value. Philos Rev 1950, 59:493-513.

0012. ——. Some notes concerning the aesthetic and the cognitive. JAAC 1955, 13:378-394.

0013. Albenda, P. Esthetics in art education. High Points 1963, 45:43-49.

0014. Albert, E.M., C. Kluckhohn, et al. A Selected Bibliography in Values, Ethics, and Esthetics in the Behavioral Sciences and Philosophy, 1920-1958. Glencoe, Ill.: Free Press 1959, 342 p.

0015. Alberti, L.B. On Painting. New Haven: Yale Univ Pr 1956, 141 p.

0016. Aldrich, V.C. Pictorial meaning, picture thinking, and Wittgenstein's theory of aspects. Mind 1958, 67:70-79.

0017. ——. Picture space. Philos Rev 1958, 67:342-352.

0018. Aler, J.M.M., H. Hungerland, and B.v. Lier. De Functie van de Kunst in onze Tijd. The Hague: Servire 1962, 112 p.

0019. Alexander, C. A result in visual aesthetics. Brit J Psychol 1960, 51:357-371.

0020. Alexander, H.G. Subjectivity in aesthetics. Philos Quart 1955, 5(21):329-341.

0021. Alexander, S. Artistic Creation and Cosmic Creation. London: Milford 1927.

0022. ——. Beauty and Other Forms of Value. NY: Macmillan 1933.

0023. ——. The creative process in the artist's mind. Brit J Psychol 1927, 17:305-321.

0024. Alford, J. The future of aesthetics. Art Bull 1945, 27:209-212.

0025. Alford, R.M. Francisco Goya and the intentions of the artist. JAAC 1960, 18: 482-493.

0026. Alfred, J. Art and reality, 1850-1950. College Art J 1959, 17:228-246.

0027. Allen, A.H.B. A psychological theory of aesthetic value. Brit J Psychol 1937, 28:43-58; 1908, 2:406-463.

0028. Allen, G. Physiological Aesthetics. NY: Appleton 1877, 283 p.

0029. Alvarez Villar, A. Filosofía del arte. Madrid: Morata 1961, 144 p.

0030. Ames, V.M. Aesthetics: the problem of art and beauty. In Winn, R.B. (ed.), American Philosophy. NY: Philosophical Library 1955, 34-48.

0031. ——. Art ahead. JAAC 1945, 3(9-10): 107.

0032. ——. Existentialism and the arts. JAAC 1951, 9:252-256.

0033. ——. Expression and aesthetic expression. JAAC 1947, 6:172-179.

0034. ——. The function and value of aesthetics. JAAC 1941, 1(1): 95-105.

0035. Anderson, H.H. (ed.). Creativity and Its Cultivation. NY: Harper 1959, 293 p.

0036. Anderson, L. Aesthetics and determinism. Amer Magazine of Art 1933, 26: 127-130.

0037. Anderson, W.V. Watercolor in Cézanne's artistic process. Art International 1963, 7(5):23-27.

0038. Andreas-Salomé, L. Collective review on aesthetics and the psychology of the artist. Int. J Psycho-Anal 1921, 2: 94-100; In Bericht über die Fortschritte der Psychoanalyse 1914-1919. Vienna: Internationale Psychoanalitischer Verlag 1921.

0039. Andrews, M.F. (ed.). Creativity and Psychological Health. Syracuse, NY: Syracuse Univ Pr 1961, 148 p.

0040. Anesaki, M. Art, Life, and Nature in Japan. Boston: Marshall Jones 1932, 178 p.

0041. Anon. Man through his art. UNESCO Courier 1962, 15:10-11.

0042. Anon. The relation of aesthetics to psychology. Brit J Psychol 1919, 10:43-50.

0043. Ansari, A. A critique of the traditional approach in psychology to aesthetic experience. Educ & Psychol (Delhi) 1955, 2(2):6-14; Indian J Psychol 1955, 30:35-42.

0044. Antal, F. Florentine Painting and Its Social Background. The Bourgeois Republic before Cosimo de'Medici's Advent to Power. XIV and Early XV Centuries. London: Routledge & Kegan Paul 1948, 388 p.

0045. ———. Remarks on the method of art history. Burlington Magazine 1949, 91: 49-52, 73-75.

0046. Apollonio, M. Ontologia dell'arte. Brescia: Morcelliana 1961, 148 p.

0047. Arnheim, R. Accident and the necessity of art. JAAC 1957, 16:18-31.

0048. ———. The artist conscious and subconscious. Art News 1957, 56(4):31-33.

0049. ———. Gestalt and art. JAAC 1943, 2(8):71-75.

0050. ———. Picasso's Guernica, the Genesis of a Painting. Berkeley: Univ California Pr 1962, 135 p.

0051. ———. The priority of expression. JAAC 1949, 8:106-110.

0052. ———. A review of proportion. JAAC 1955, 14:44-57.

0053. ———. The robin and the saint: on the twofold nature of the artistic image. JAAC 1959, 18:68-79.

0054. Arnold, S. A psychological approach to aesthetics. In Atti del III° congresso internazionale di estetica, 1956. Turin: Ed della Rivista di Estetica 1957, 423-427.

0055. ———. Symbolism in Art. London: Candlelight Pr 1957, 24 p.

0056. Aschenbrenner, K. Aesthetic theory—conflict and conciliation. JAAC 1959, 18: 90-108.

0057. Ashmore, J. The old and the new in non-objective painting. JAAC 1951, 9: 294-300.

0058. ———. Santayana's mistrust of fine art. JAAC 1956, 14:339-347.

0059. ———. Some differences between abstract and non-objective painting. JAAC 1955, 13:486-495.

0060. Ashton, D. The Unknown Shore: A View of Contemporary Art. Boston: Little, Brown 1962, 265 p.

0061. Assunto, R. L'arte e le opere d'arte. Rassegna di Filosofia 1953, 2:252-273.

0062. ———. Filosofia e criticia d'arte. Aut Aut 1955, 25.

0063. ———. Filosofia dell'arte e filosofia della relazione. Aut Aut 1955, 30.

0064. ———. Studi estetici: Forma formante e forma formata. Rassegna di Filosofia 1954, 3:137-161.

0065. Asthana, B.C. Individual differences in aesthetic appreciation. Educ & Psychol (Delhi) 1956, 3:22-26.

0066. Attneave, F. Physical determinants of the judged complexities of shapes. J exp Psychol 1957, 53:221-227.

0067. ———. Stochastic composition processes. JAAC 1959, 17:503-510.

0068. Aznar, J.C. Fenomenologia del arte. I. Los problemas de la crítica. Rev de Psicologia y Pedagogia 1937, 5:201-258.

0069. Babbitt, I. On Being Creative. Boston: Houghton, Mifflin 1932.

0070. Badt, K. John Constable's Clouds. London: Routledge & Kegan Paul 1950, 102 p.

0071. Bailey, H.T. Symbolism for Artists. Worcester, Mass.: Clark Univ Pr 1925.

0072. Baker, G.M. An enterprise in art appreciation with college students. Education 1939, 60:162-165.

0073. Baldwin, J.M. La mémoire affective de l'art. Rev philosophique de la France et de l'étranger 1909, 67:449-460.

0074. Balet, L. Rembrandt and Spinoza. NY: Philosophical Library 1962, 222 p.

0075. Ballard, E.G. Art and Analysis: An Essay Toward a Theory in Aesthetics. The Hague: Nyhoff 1957, 219 p.

0076. ———. In defense of symbolic aesthetics. JAAC 1953, 12:38-43.

0077. Balthalon, E. Récherches experimentales sur la nature du plaisir esthétique Geneva 1910.

0078. Baltrušaitis, J. Aberrations, quatre essais sur la légende des formes. Paris 1957, 136 p.

0079. Banfi, A. Filosofia dell'arte. Rome: Riuniti 1962.

0080. Barkan, M. A Foundation for Art Education. NY: Ronald 1955, 235 p.

0081. ———. Through Art to Creativity. Boston: Allyn & Bacon 1960, 365 p.

0082. Barker, V. From Realism to Reality in Recent American Painting. Lincoln: Univ Nebraska Pr 1959, 93 p.

0083. Barolin, J.C. Inspiration und Genialität. Vienna, Leipzig: Braumüller 1927.

0084. Barr, A.H., Jr. Fantastic Art, Dada, Surrealism. NY: Museum of Modern Art 1936, 248 p.

0085. Barraud, (?). Philosophie de l'art. Connaître 1945, 5:13-16.

0086. Barrett, W. The testimony of modern art. In Irrational Man. A Study in Existentialist Philosophy. Garden City, NY: Doubleday Anchor 1958, 42-68.

0087. Barron, F. Diffusion, integration, and enduring attention in the creative process. In White, R.W. (ed.), The Study of Lives. Essays on Personality in Honor of Henry A. Murray. NY: Atherton 1963, Ch. 10.

0088. ———. The psychology of imagination. Sci Amer 1958, 199:150-160.

0089. Bartlett, E.M. Types of Aesthetic Judgment. London: Allen & Unwin 1937.

0090. Bartling, D. De Struktur van het Kunstwerk. Amsterdam: Veen 1946, 146 p.

0091. Barua, B.M. Ancient Indian theories of art. Indian Soc Oriental Art J 1933, 1 (2):81-84.

0092. Barwell, J.S. The nature of ugliness. Brit J med Psychol 1937, 17:119-127.

0093. Batataglini, G. Il problema dell'arte nel pensiero fenomenologico italiano. Il Verri 1960, 4.

0094. Bates, M. The flight from meaning in painting. Canadian Art 1954, 11(2):59-61.

0095. Battisti, E. Simbolo ed arte figurativa. Riv di Estetica 1962, 7:185-197.

0096. Baudelaire, C. The Mirror of Art. NY: Phaidon 1955, 361 p.

0097. ———. The Painter of Modern Life. NY: Phaidon 1964.

0098. Baudouin, C. Psychoanalysis and Aesthetics. London: Allen & Unwin, 1924, 328 p; NY: Dodd, Mead 1924, 328 p.

0099. Bauer, J.R.H. Research in art appreciation. School & Soc 1932, 36:119-121.

0100. Baur, J.T.H. The machine and the subconscious: Dada in America. Magazine of Art 1951, 44:233-237.

0101. Bayer, R. Traité d'Esthétique. Paris: Colin 1956, 302 p.

0102. Beardsley, M.C. Aesthetics. Problems in the Philosophy of Criticism. NY: Harcourt, Brace 1958, 614 p.

0103. ———. The concept of economy in art. JAAC 1956, 14:370-375.

0104. Beck, M. The cognitive character of aesthetic enjoyment. JAAC 1945, 3(11): 55-61.

0105. Becker, E.M. Whistler and the Aesthetic Movement. Dissertation Abstr 1960, 20:2744.

0106. Bedel, M. The rights of the creative artist. In UNESCO, Freedom and Culture. NY: Columbia Univ Pr 1951, 157-202.

0107. Begg, W.P. The Development of Taste, and Other Studies in Aesthetics. Glasgow 1887.

0108. Bell, C. Art. NY: Putnam 1959, 190 p.; NY: Capricorn 1958, 190 p.

0109. ———. Contemporary art criticism in England. Magazine of Art 1951, 44:179-183.

0110. ———. Doctor Freud on art. Nation & Athenaenum 1924, 35:690-691.

0111. ———. Post-impressionism and aesthetics. Burlington Magazine 1912-13, 22: 226-230.

0112. Bellozzi, F. Socialismo e romanticismo nell'arte moderna. Rome: Sciascia 1959.

0113. Beloff, J. Comments on the Gombrich problem. Brit J Aesthetics 1961, 1(2).

0114. Bengtsson, A. Idea and form. Studies in the history of art. Figura (Uppsala) 1960.

0115. Benscher, I. Bericht über den III Kongress für Aesthetik und allgemeine Kunstwissenschaft in Halle, 7 bis 9. Juni 1927. Arch ges Psychol 1928, 62:241-272.

0116. Benson, M. Du gribouillage au dessin. Techniques de l'Education Artistique. Neuchâtel: Delachaux & Niestlé 1957.

0117. Berefelt, G. The regeneration problem in German neo-classicism and romanticism. JAAC 1960, 18:475-481.

0118. Berenson, B. Aesthetics and History in the Visual Arts. London: Constable 1948; NY: Pantheon 1948, 260 p.

0119. ———. The Arch of Constantine or the Decline of Form. NY: Macmillan 1954, 80 p.

0120. ———. Betrachtungen zur Kunstwissenschaft. Phoebus 1950-51, 3(1):1-11.

0121. ———. Caravaggio. His Incongruity and His Fame. NY: Macmillan 1953, 122 p.

0122. ———. Essays in Perception. NY: Macmillan 1958.

0123. ———. Piero della Francesca. The Ineloquent in Art. NY: Macmillan 1953, 44 p.

0124. ———. Seeing and Knowing. NY: Macmillan 1953, 48 p.

0125. Beres, D. Communication in psychoanalysis and in the creative process: a parallel. J Amer Psychoanal Ass 1957, 5: 408-423.

0126. Berger, J. Toward Reality: Essays in Seeing. NY: Knopf 1962, 233 p.

0127. Bergmann, E. Die Begründung der deutschen Ästhetik durch A.G. Baumgarten und G.F. Meier. Leipzig: Roder & Schunke 1911, 273 p.

0128. Bergström, L. Disguised symbolism in 'Madonna' pictures and still life. Burlington Magazine 1955, 631:303-308.

0129. Berkman, A. Art and Space. NY: Social Sciences Publishers 1949, 175 p.

0130. Berliner, A. Geometrisch-ästhetische Untersuchungen mit Japanern und an japanischen Material. Arch ges Psychol 1924, 49:433-450.

0131. Berndtson, A. Beauty, embodiment, and art. Philos phenomenol Res 1960, 31: 50-61.

0132. ——. Semblance, symbol, and expression in the aesthetics of Suzanne Langer. JAAC 1956, 14:487-502.

0133. Bernheimer, R. The Nature of Representation. NY: New York Univ Pr 1961, 249 p.

0134. Bernheimer, R., R. Carpenter, K. Koffka, and M.C. Nahm. Art; a Bryn Mawr Symposium. Bryn Mawr, Pa.: Bryn Mawr College 1940, 350 p.

0135. Berque, J. Sur l'esthétique musulmane et ses motivations psychologiques et sociales. JPNP 1961, 58:433-444.

0136. Bertrand, A. Esthétique et psychologie. Rev Philosophique de la France et de l'étranger 1907, 63:33-66.

0137. Best, M. Simplified Human Figure. Intuitional Expression. NY: Knopf 1937, 234 p.

0138. Best-Maugard, A. A Method for Creative Design. NY: Knopf 1937.

0139. Beyer, B.I. Baroque representation. JAAC 1954, 12:360-365.

0140. Bialostock, J. (On different attitudes to works of art and the types of satisfaction they give.) Estetyka (Warsaw) 1960, 1.

0141. Biddle, G. The Yes and No of Contemporary Art. Cambridge: Harvard Univ Pr 1957, 188 p.

0142. Biederman, C. Art as the Evolution of Visual Knowledge. Red Wing, Minnesota 1948, 696 p.

0143. Bilsky, M. The significance of locating the art object. Philos phenomenol Res 1953, 13:531-536.

0144. Binyon, L. The Spirit of Man in Asian Art. Cambridge: Harvard Univ Pr 1935, 217 p.

0145. Bird, M.H. A Study in Aesthetics. Cambridge: Harvard Univ Pr 1932, 117 p.

0146. Blachowski, St. Über künstliche Ekstasen und Visionen. Rocznik Psychjatryczny (Warsaw) 1938, 34-35:143-159.

0147. Blake, E.M. A method for the creation of geometric designs. JAAC 1949, 7: 216-234.

0148. Blake, V. Relation in Art. London: Oxford Univ Pr 1925.

0149. Blankner, F. A new method of education for the composer based on a new psychology of the arts. Musicol 1947, 1:399-406.

0150. ——. A psychology of the arts as vibrational design. School Arts 1950, 50 (4):112-115.

0151. Blanshard, F.B. The Retreat from Likeness in the Theory of Painting. NY: Columbia Univ Pr 1949, 178 p.

0152. Blaustein, L. (Imaginative Representations. A Study from the Border Region of Psychology and Aesthetics.) Lwów 1930.

0153. ——. (Schematic and Symbolic Representations. Researches from the Border Region of Psychology and Aesthetics.) Lwów 1931.

0154. Blend, C.D. Early expressions of Malraux's art theory. Romanic Rev 1962, 53:199-213.

0155. Blomberg, E. Ernst Josephsons sjukdomsbild. Ord och Bild (Stockholm) 1963, 1:81-88.

0156. Blomsky, P.P. Schönheit und Unschönheit. Arch ges Psychol 1932, 85:529-558.

0157. Bloom, L. Psychology and esthetics: a methodological Monroe doctrine. J gen Psychol 1961, 65:305-317.

0158. Blunt, A. Artistic Theory in Italy, 1450-1600. Oxford Univ Pr 1956.

0159. Boas, G. In defense of the unintelligible. JAAC 1951, 9:285-293.

0160. ——. The Heaven of Invention. Baltimore: Johns Hopkins Univ Pr 1963.

0161. ——. Il faut être de son temps. JAAC 1941, 1(1):52-65.

0162. ——. A Primer for Critics. Baltimore: Johns Hopkins Univ Pr 1937, 153 p.

0163. ——. The social responsibility of the artist. College Art J 1947, 6:270-276.

0164. ——. Wingless Pegasus. A Handbook of Art Criticism. Baltimore: Johns Hopkins Univ Pr 1950, 244 p.

0165. Boas, G., C.J. Ducasse, K. Gilbert, and S.C. Pepper. Aiken's "Criteria for an adequate aesthetics": a symposium. JAAC 1948, 7:148-158.

0166. Bodenheimer, A.R. Schönheit und Hässlichkeit als Elemente der Physiognomik und der Psychopathologie. Schweiz ZPA 1955, 14:259-277.

0167. Bodensohn, A. Über das Wesen des Aesthetischen. Ein Beitrag zum Wert- und Wertungsproblem in dem Kunsterziehung. Frankfurt: Dipa 1961, 96 p.

0168. Bodkin, M. The relevance of psycho-analysis to art criticism. Brit J Psychol 1924, 15:174-183.

0169. Boeck, W. Rembrandts Vollendung im späten Werk. Universitas (Stuttgart) 1963, 18:123-136.

0170. Borissavliévitch, M. The Golden Number. NY: Philosophical Library, 1958, 91 p.

0171. Bosanquet, B. A History of Aesthetic. London: Allen & Unwin 1892, 502 p.

0172. ———. Three Lectures on Aesthetic. London: Macmillan 1915.

0173. Bossart, W. Authenticity and aesthetic value in the visual arts. Brit J Aesthetics 1961, 1(3).

0174. Bottorf, E.A. An approach to an appreciation of art. Penn State Coll Studies in Educ 1942, No. 24, 7.

0175. Boulay, D. (ed.). Les grands problèmes de l'esthétiques. Paris 1961, 170 p.

0176. Bouquet, H. Les criminels peints par eux-mêmes. Aesculape, April 1912.

0177. Bowers, D.F. The role of subject-matter in art. J Philos 1939, 36:617-630.

0178. Bowie, H.P. On the Laws of Japanese Painting. San Francisco: Elder 1911, 117 p; NY: Dover 1962, 132 p.

0179. Bowman, H.E. Art and reality in Russian "realist" criticism. JAAC 1954, 12:386-392.

0180. Bowman, M.B. William Blake: a study of his doctrine of art. JAAC 1951, 10:53-66.

0181. Bradac, O. Aesthetic trends in Russia and Czechoslovakia. JAAC 1950, 9:97-105.

0182. Brandt, P. Ver y comprender el arte. Barcelona: Labor 1959, 436 p.

0183. Brants, J.P.J. (The human figure in Cyprian art.) Internationale Arch für Ethnographie (Leiden) 1926, 27:77-88.

0184. Braun, O. Studien zum Expressionismus. Z Aesth 1918-19, 13:283-302.

0185. Braun-Vogelstein, J. Geist und Gestalt der abendländischen Kunst. The Hague: Hijhoff 1957, 379 p.

0186. Breithaupt, E.M., Jr. A Study and Specification of Art Appreciation in Terms of the Structure of Visual Perception. Dissertation Abstr 1960, 20:2744-2747.

0187. Brelet, G. Le temps musical. Paris: PUF 1949, 2 vols., 842 p.

0188. Brennan, J.G. The role of emotion in aesthetic experience. Quart J Speech 1954, 40:422-428.

0189. Brimer, M.A. Psychology and aesthetic beauty. J Educ & Psychol (Baroda) 1951, 9:78-87.

0190. Brinckmann, A.E. Plastik und Raum. Münich 1922.

0191. Brion, M. L'art abstrait: son origine, sa nature et sa signification. Diogène 1958, 24:51-75.

0192. Britsch, G. Theorie der bildenden Kunst. Münich: Bruckmann 1930, 152 p; Ratingen: Henn 1952.

0193. Brittain, W.L., and K.R. Beittel. Analyses of levels of creative performances in the visual arts. JAAC 1960, 19:83-90.

0194. Bronowski, J. The creative process. Sci Amer 1958, 199:58-65.

0195. Brown, M.E. Croce's early aesthetics. JAAC 1963, 22:29-41.

0196. Brown, R.F. Impressionist technique: Pissarro's optical mixture. Magazine of Art 1950, 43:12-15.

0197. Bru, C.P. Esthétique de l'abstraction; essai sur le problème actuel de la peinture. Paris: PUF 1955, 331 p.

0198. Brücke, E. Principles scientifiques des beaux-arts. Paris 1878.

0199. Bruen, C. Artistic activity. Psyche (Boston) 1928, 9:75-95.

0200. ———. The artistic process. Psyche (Boston) 1929, 10:41-59.

0201. ———. The present state of aesthetics. Psyche (Boston) 1928, 9:58-75.

0202. Brunet, C. Prolégomènes à une esthétique intégrale. Entre-ambiguité-esthétique. Paris: d'Eseignement Supérieur. 1962, 176 p.

0203. Bryson, L., et al. (eds.). Symbols and Value: an Initial Study. NY: Harper 1954, 827 p.

0204. Bryson, L., M. Mead, R. Arnheim, and M.C. Nahm. The conditions for creativity. In Summerfield, J.D., and L. Thatcher (eds.), The Creative Mind and Method: Exploring the Nature of Creativeness in American Arts, Sciences, and Professions. Austin: Univ Texas Pr 1960, 105-111.

0205. Buchheim, L.G. Der Blaue Reiter und Neue Künstlervereinigung München. Feldafing: Buchheim Verlag 1960, 344 p.

0206. Bühler, K. Die Gestaltwahrmehmungen; experimentelle Untersuchungen zur psychologischen und ästhetischen Analyse der Raum—und Zeitanschauung. Stuttgart: Enke 1913, 297 p.

0207. Buermeyer, L. The Aesthetic Experience. Marion, Pa.: Barnes Foundation Pr 1929.

0208. Bullough, E. Aesthetics: Lectures and Essays. Stanford: Stanford Univ Pr 1957, 158 p; London: Bowes & Bowes 1957, 158 p.

0209. ———. "Psychical distance" as a factor in art and an aesthetic principle. Brit J Psychol 1912-13, 5:87-118; In Aesthetics: Lectures and Essays. Stanford: Stanford

Univ Pr 1957.

0210. ——. Recent work in experimental aesthetics. Brit J educ Psychol 1934, 12: 76-99.

0211. ——. The relation of esthetics to psychology. Brit J Psychol 1919, 10:43-50.

0212. Bullrich, R. (The influence of culture and race on esthetic conception in painting.) Día Médico 1938, 10:1328-1332.

0213. Bully, M.H. Art and Understanding. NY: Scribner's 1937, 292 p.

0214. Bunim, M.S. Space in Mediaeval Painting and the Forerunners of Perspective. NY: Columbia Univ Pr 1940, 261 p.

0215. Burgart, H.J. Art in Higher Education: the Relationship of Art Experience to Personality, General Creativity and Aesthetic Performance. Dissertation Abstr 1962, 22: 2285.

0216. Burger, E. Einführung in die moderne Kunst. Berlin: Neubabelsberg 1915.

0217. Butler, R. Creative Development. Five Lectures to Art Students. London: Routledge & Kegan Paul 1962.

0218. Cabot, J. Accions superficial i profunda de l'art. Criterion 1929, 9:89-91.

0219. ——. La "ciencia general de l'art." Criterion 1928, 8:439-442.

0220. Cagnis di Castellamonte, E. Il sentimento estetico nella psicologia. Turin: Bocca 1909, 36 p.

0221. Cain, T.I. Problems and prospects of civic planning. JAAC 1945, 3(9-10):68.

0222. Cairns, H. (ed.). The Limits of Art. NY: Pantheon 1949, 1473 p.

0223. Calas, N. Surrealist intentions. Transformation 1950, 1:48-52.

0224. ——. What is the real illusion? Art News 1962, 61(4):33-34, 60-61.

0225. Calkin, M.W. An attempted experiment in psychological aesthetics. Psychol Rev 1900, 7:580-591.

0226. Camón Aznar, J. Problemática del arte contemporáneo. Santander: Univ Int "Menéndez Pelayo" 1959, 49 p.

0227. Campbell, J. The cultural setting of Asian art. College Art J 1958, 18:25-35.

0228. Campbell-Fisher, I.G. Aesthetics and the logic of sense. J gen Psychol 1950, 43:245-273.

0229. ——. Factors which work toward unity or coherence in visual design. J exp Psychol 1941, 28:145-162.

0230. ——. Intrinsic expressiveness. J gen Psychol 1951, 45:3-24.

0231. ——. Objective form and its role in aesthetics. In Proceedings of the 6th International Congress of Philosophy 1926. NY: Longmans, Green 1927, 448-455.

0232. ——. Static and dynamic principles of art. J gen Psychol 1951, 45:25-55.

0233. Cardinet, J. Préferences esthétiques et personnalité. Année Psychol 1958, 58: 45-69.

0234. Carlini, A. Problematicità dell'atto estetico fondamentale. Riv di Estetica 1956, 1(1).

0235. Carpenter, R. The Esthetic Basis of Greek Art of the Fifth and Fourth Centuries B.C. Bloomington: Indiana Univ Pr 1959, 177 p.

0236. ——. Modern art and the philosopher. College Art J 1949, 9(2):115-128.

0237. ——. The phenomenon of spirit as a content of visual art. Int philos Quart 1963, 3:94-105.

0238. Carritt, E.F. An Introduction to Aesthetics. NY: Longmans Green 1950, 191 p.

0239. Cary, J. Art and Reality. NY: Harper 1958, 175 p.

0240. Casanovas, M. La moral social y el arte. Nosotros 1928, 22:217-222.

0241. ——. Vanguardismo y arte revolucionario: Confusiones. Amauto 1929, 22: 73-76.

0242. Casas, B.A. Formas de expresión estética del niño. Rev de Educacíon (La Plata) 1949, 90(5):103-110.

0243. Cassirer, E. Philosophie der symbolischen Formen. Berlin: Cassirer 1923-31, 3 vols.

0244. Cassou, J. Philosophie du cubisme. Rev d'Esthétique 1953, 6:386-399.

0245. Cassou, J., E. Langui, and N. Pevsner. Gateway to the Twentieth Century. Art and Culture in a Changing World. NY: McGraw-Hill 1962.

0246. Castaldi, L. (Esthetic ideal in anatomico-artistic canons of the Renaissance.) Scritti biologici (Sienna) 1933, 8:267-294.

0247. Castelfranco, G. Lineamenti di Estetica. Florence: Nuova Italia 1950, 69 p.

0248. Castelli, E. (ed.). Filosofia e Simbolismo. Rome: Organo dell'Instituto di Studi Filosofici 1956, 308 p.

0249. ——. Umanesimo e Simbolismo: Atti del IV Convegno Intérnazionale di Studi Umanistici, Venezia, 19-21 Settembre 1958. Padua: Cedam 1958, 317 p.

0250. Castillo, L. El yo y la creacíon artistica. Rev de Ideas Esteticas (Madrid) 1951.

0251. Centeno, A. (ed.) The Intent of the Artist. Princeton: Princeton Univ Pr 1941.

0252. Cevasco, G.A. J.K. Huysmans and the impressionists. JAAC 1958, 17:201-207.

0253. Chandler, A.R. The aesthetic categories. Monist 1921, 31:409-419.

0254. ——. Beauty and Human Nature. Elements of Psychological Aesthetics. NY: Appleton-Century 1934, 381 p.

0255. ——. A Bibliography of Experimental Aesthetics, 1865-1932. Bureau of Educ Res Mimeographs No. 1. Columbus: Ohio State Univ Studies 1933, 25 p.

0256. ——. Recent experiments on visual aesthetics. Psychol Bull 1928, 25:720-732.

0257. Chandler, A.R., and E.N. Barnhart. A Bibliography of Psychological and Experimental Aesthetics, 1864-1937. Berkeley, Calif.: Univ California Pr 1938, 190 p. (mimeographed.)

0258. —— & ——. A bibliography of psychological and experimental aesthetics, 1864-1937. Man 1943, 43:66.

0259. Chastel, A. Les arts en Europe. La Table Ronde 1963, 181:90-99.

0260. Chaudhury, P.J. Catharsis in the light of Indian aesthetics. JAAC 1956, 15:215-226.

0261. ——. Psychical distance in Indian aesthetics. JAAC 1948, 7:138-140.

0262. ——. Studies in Comparative Aesthetics. Santinitekan, India: Santinitekan Pr 1953, 127 p.

0263. Cheney, S. Expressionism in Art. NY: Boni & Liveright 1934.

0264. Chessick, R.D. The sense of reality, time, and creative inspiration. Amer Imago 1957, 14:317-331.

0265. Chiari, J. Realism and Imagination. NY: Macmillan 1961, 216 p; London: Barrie & Rockliff 1960, 216 p.

0266. Choisy, M. Aesthetics. Monist 1926, 36:405-416.

0267. Christ, Y. L'art de la nouvelle genèse. La Table Ronde 1963, 182:125-129.

0268. Chu, K.T. (Psychology of Literature and Arts.) Shanghai: Kai Ming 1937, 344 p.

0269. Citron, M. Communication between spectator and artist. College Art J 1955, 14(2):147-153.

0270. Clair, M.B. Variation in the perception of aesthetic qualities in paintings. Psychol Monogr 1939, 51, No. 5.

0271. Clark, K. Art and society. Harper's Magazine 1961, 223:74-82.

0272. ——. The Gothic Revival: An Essay in the History of Taste. NY: Holt, Rinehart & Winston 1963, 236 p.

0273. ——. Leonardo da Vinci, an Account of His Development as an Artist. Cambridge: Cambridge Univ Pr 1939, 1952, 204 p.

0274. ——. Looking at Pictures. NY: Holt, Rinehart & Winston 1960, 199 p.

0275. ——. The naked and the nude. Art News 1954, 53(6):18-21, 66-71.

0276. ——. The Nude. A Study in Ideal Form. NY: Pantheon, 1956, 458 p; London: Murray, 1956, 408 p.

0277. ——. El sabio en arte. Rev de Ideas Estéticas 1960, 18(69).

0278. Clarke, B.L. On the difficulty of conveying ideas. Sci Monthly 1928, 27:545-551.

0279. Clements, G. The meaning of art. Arts & Architecture 1944, 61:4.

0280. Clements, R.J. Michelangelo's Theory of Art. NY: New York Univ Pr 1961, 471 p.

0281. Clutton-Brock, A. The primitive tendency in modern art. Burlington Magazine 1911, 19:226-228.

0282. Cobb, J.B. Toward clarity in aesthetics. Philos phenomenol Res 1957, 18:169-189.

0283. Cohn, J. Psychologische oder kritische Begründung der Aesthetik. Arch für systematische Philosophie 1904, 10:131-159.

0284. Collingwood, R.G. Essays in the Philosophy of Art. Bloomington: Indiana Univ Pr 1964.

0285. ——. Principles of Art. Oxford: Oxford Univ Pr 1938, 347 p; Mexico: Fondo de Cultura Económica 1960, 316 p.

0286. Cook, F. Points on art aesthetics. Russell Cotes Museum Bull 1940, 19:2-8.

0287. Coomaraswamy, A.K. Christian and Oriental Philosophy of Art. NY: Dover 1957, 146 p.

0288. ——. Imitation, expression, and participation. JAAC 1945, 3(11-12):62.

0289. ——. The Transformation of Nature in Art. Cambridge: Harvard Univ Pr 1934, 245 p; NY: Dover 1962, 250 p.

0290. Copi, I.M. A note on representation in art. J Philos 1955, 52:346-349.

0291. Cormier, B. L'oeuvre picturale est une expérience. Manifeste (Montreal) 1948.

0292. Cornelius, H. Elementargesetze der bildenden Kunst. Grundlagen einer praktischen Aesthetik. Leipzig-Berlin 1911.

0293. Cornell, K. The Symbolist Movement. New Haven: Yale Univ Pr 1951, 217 p.

0294. Cory, H.E. The significance of artistic form. J Philos 1926, 23:324-328.

0295. Costa, A.M. Il contributo della psicologia "transazionale" all'estetica. In Atti del III° congresso internazionale di estetica, 1956. Turin: Ed della Rivista di Estetica 1957, 465-468.

0296. Coulton, G.G. Art and the Reformation. Cambridge: Cambridge Univ Pr 1953, 622 p.

0297. Cranmer-Byng, L. The Vision of Asia: An Interpretation of Chinese Art and Cul-

ture. NY: Farrar 1933, 306 p.

0298. Cranston, M. The twilight of aesthetics. Apollo 1962, 76:201-203.

0299. Creed, I.P. Iconic signs and expressiveness. JAAC 1945, 3(11):15-21.

0300. Cristol, H. Quelques aperçus sur les conditions psychophysiologiques du déclanchement d'un mouvement artistique. In Atti del III° congresso internazionale di estetica, 1956. Turin: Ed della Rivista di Estetica 1957, 453-455.

0301. Croce, B. Aesthetic. London: Macmillan 1929.

0302. ———. Aesthetic as Science of Expression and General Linguistic. London: Macmillan 1922; NY: Noonday Pr 1922; Bari: Laterza 1909.

0303. ———. Brévaire d'Esthétique. Paris: Payot 1923, 183 p.

0304. ———. The Essence of Aesthetic. London: Heinemann 1921.

0305. ———. Nuovi Saggi di Estetica. Bari: Laterza 1926.

0306. Crockett, C. Art for society's sake. Bucknell Rev 1958, 7:100-106.

0307. ———. The lack of historical perspective in aesthetics. JAAC 1951, 10:160-165.

0308. ———. Psychoanalysis in art criticism. JAAC 1958, 17:34-44.

0309. Crowley, D.J. Aesthetic judgment and cultural relativism. JAAC 1958, 17: 187-193.

0310. Dali, S. Conquest of the Irrational. NY: Levy 1935.

0311. Damon, S.F. William Blake: His Philosophy and Symbols. London 1924.

0312. Davidson, M. Surrealism from 1450 to Dada and Dali. Art News 1936, 35:11-13, 22.

0313. Davis, F.C. Aesthetic proportion. Amer J Psychol 1933, 45:298-302.

0314. Davison, N.J. Galdós' conception of beauty, truth and reality in art. Hispania 1955, 38(1):52-54.

0315. Day, J.P. Artistic verisimilitude. Dialogue (Kingston, Ontario) 1962, 1(3).

0316. Deeb, B. Esthetics: Souriau's theory. Egypt J Psychol 1952-53, 8:249-261.

0317. Dégand, L. Langage et signification de la peinture. Paris: PUF 1956.

0318. De Gennaro, A.A. The drama of the aesthetics of Benedetto Croce. JAAC 1956, 15:117-121.

0319. Delacroix, H.J. L'art de la vie intérieure. Rev de Métaphysique et de Morale 1902, 10:164-183.

0320. ———. Les sentiments esthétiques et l'art. In Dumas, G. (ed.), Nouveau traité de psychologie, Vol. 6, Book 2. Paris: Alcan 1939, 253-316.

0321. Delaunay, R. Du Cubisme à l'art abstrait. Paris: S.E.V.P.E.N. 1958, 415 p.

0322. Dempf, A. Was ist Philosophie Kunst? Wissenschaft u Weltbild 1959, 12:591-600.

0323. DeSelincourt, O. Art and Morality. London: Methuen 1935.

0324. De Solier, R. L'art fantastique. Paris: Pauvert 1961.

0325. Dessoir, M. Aesthetics and the philosophy of art in contemporary Germany. Monist 1926, 36:299-310.

0326. ———. Ästhetik und allgemeine Kunstwissenschaft. Stuttgart: Enke 1923, 443 p.

0327. ———. Anschauung und Beschreibung. Ein Beitrag zur Ästhetik. Arch für systematische Philosophie u Soziologie 1904, 10:20-65.

0328. ———. Art history and systematic theories of art. JAAC 1961, 19:463-469.

0329. ———. Beiträge zur allgemeinen Kunstwissenschaft. Stuttgart: Enke 1929, 230 p.

0330. ———. Über das Beschreiben von Bildern. Z Aesth 1913, 8:440-461.

0331. ———. Beziehungen zur Ästhetik. In Geschichte der neuren deutschen Psychologie. Berlin 1902, 558-606.

0332. ———. The contemplation of works of art. JAAC 1947, 6:108-119.

0333. ———. Systematik und Geschichte der Künste. Z Aesth 1914, 9:1-15.

0334. De Tolnay, C. Michelangelo. Princeton: Princeton Univ Pr 1960, 5 Vols.

0335. Deutsch, F. Body, mind, and art. Daedalus 1960, 89:34-45.

0336. Dewey, J. Aesthetic experience as a primary phase and as an artistic development. JAAC 1950, 9:56-58.

0337. ———. Art and Education. Marion, Pa.: Barnes 1929, 349 p; 1954, 316 p.

0338. ———. Art as Experience. NY: Minton, Balch 1934, 362 p.

0338a. Diano, C. Linee per una fenomenologia dell'arte. Venice: Pozza 1956, 124 p.

0339. Dickie, G. Is psychology relevant to aesthetics? Partisan Rev 1962, 61:285-302.

0340. Dickson, T.E. In Defense of Sensibility or Psychological and Pedagogical Aspects of Aesthetic Appreciation. London: Grant & Murray 1936, 19 p.

0341. Dilthey, W. Die Kunst als erste Darstellung der menschlichgeschichtlichen Welt in ihrer Individuation. In Gesammelte Schriften. Leipzig-Berlin 1914-24, Vol. 5, 275-303 p.

0342. Dix, L. Aesthetic experience and growth in life and education. Teachers Coll Record 1938, 40:206-221.

0343. Dixon, J.W., Jr. Form and Reality:

Art as Communication. Nashville, Tenn.:
Methodist Student Movement 1957.

0344. Dixon, W.M. Civilization and the
arts. Scottish Art Rev 1952, 4(1):17-20.

0345. Dorfles, G. Arte e percezione. Domus
1961, 376:43-44.

0346. ———. Arte e tecnica nella società
moderna. Aut Aut 1951, 1:240.

0347. ———. Communication and symbol in
the work of art. JAAC 1957, 15:289-297.

0348. ———. Un convegno sulle funzioni
della critica, a Francoforte. Domus 1961,
374:35-36.

0349. ———. Discorso Technico delle Arti.
Pisa: Nistri-Lischi 1952, 250 p.

0350. ———. Ultime tendenze dell'arte
d'oggi. Milan: Feltrinelli 1962.

0351. ———. Van Gogh e la "Wavy Line."
Aut Aut 1952, 2:148.

0352. Dorival, B. La peinture abstraite.
Rev de Paris 1958, 84-99.

0353. Dow, H.J. Van Gogh both Prometheus
and Jupiter. JAAC 1964, 22(3):269-288.

0354. Downey, J.E. Creative Imagination.
NY: Harcourt Brace 1928, 230 p.

0355. Dreher, R.E. The psychology of es-
thetics: a challenge. Proc Indiana Acad
Sci 1950, 59:286.

0356. Drost, W. Form als Symbol. Z Aesth
1927, 21:358-371.

0357. Ducasse, C.J. Art, the Critics and
You. Indianapolis: Bobbs-Merrill 1955;
NY: Piest 1945, 170 p.

0358. ———. Art history, criticism and es-
thetics. Creative Art 1931, 9:57-60.

0359. ———. Is art the imaginative expres-
sion of a wish? Philos Rev 1928, 37:360-
372.

0360. ———. The Philosophy of Art. NY: Dial
1930, 314 p.

0361. ———. Some questions in aesthetics.
Monist 1932, 42:42-59.

0362. ———. The sources of the emotional
import of an aesthetic object. Philos phe-
nomenol Res 1960-61, 21:556-557.

0363. ———. What has beauty to do with
art? J Philos 1928, 25:181-186.

0364. Dufrenne, M. Phénoménologie de
l'expérience esthétique. 2 Vols. Paris:
PUF 1953, 692 p.

0365. Duhem, H. Impressions d'art con-
temporain. Paris 1913, 328 p.

0366. Dunlop, R.O. Beauty and ugliness in
art. Artist 1944, 28:74-76.

0367. Duplessis, Y. Le surréalisme. Paris:
PUF 1958, 128 p.

0368. Dwelshauvers, G. Récherches ex-
perimentales sur l'imagination créatrice.
JPNP 1935, 32:435-442.

0369. Easton, R.D. Student questions on

art may develop aesthetic values. NY
State Educ 1954, 41:363-364.

0370. Ecker, D.W. The artistic process as
qualitative problem solving. JAAC 1963,
21:283-290.

0371. Edman, I. Arts and the Man; A Short
Introduction to Aesthetics. NY: Norton
1939, 154 p.

0372. ———. The World, the Arts, and the
Artist. NY: Norton 1928.

0373. Edmonston, P. A Methodology for
Inquiry into One's Own Studio Processes.
Dissertation Abstr 1961, 22:2353.

0374. Ehrenwald, H. Störung der Zeit-
auffassung der räumlichen Orientierung
des Zeichnens und des Rechnens bei einem
Hirnverletzen. ZNP 1931, 132:518-569.

0375. Ehrenzweig, A. The hidden order of
art. Brit J Aesthetics 1961, 1(3).

0376. ———. The modern artist and the crea-
tive accident. Listener 1956, 53-55.

0377. ———. A new psychoanalytical approach
to aesthetics. Brit J Aesthetics 1962, 2:
301-317.

0378. Eickstedt, E.v. Forschungen in Süd-
und Ostasien. Z für Rassenkunde 1938,
8:294-333; 1939, 10:1-67, 120-162; 1940,
11:21-79, 115-153.

0379. Eindhoven, J.E. Creative Processes
in Painting. Master's thesis. Univ. Hawaii
1949.

0380. Ekman, G., and T. Kuennapas. Scales
of aesthetic value. Perceptual & Motor
Skills 1962, 14:19-26.

0381. Ekman, R. (The Fictions of Aesthetic
Life.) Lund: Gleerup 1949, 392 p.

0382. Eliasberg, W.G. Art: immoral or im-
mortal. J Criminal & Law Criminology
1954, 45:274-278.

0383. Eliot, A. Sight and Insight. NY: Dut-
ton 1960, 164 p; NY: Obolensky 1959,
196 p.

0384. Ellis, J.M. Great art: a study in
meaning. Brit J Aesthetics 1963, 3(2).

0385. Elsen, A.E. Lively art from a dying
profession, the role of the modern artist.
JAAC 1960, 18:446-455.

0386. ———. Purposes of Art. NY: Holt, Rine-
hart & Winston 1962, 341 p.

0387. Elton, W. Aesthetics and Language.
NY: Philosophical Library 1954, 186 p.

0388. Embler, W. Symbols in literature and
art. College Art J 1956, 16:47-58.

0389. Encina, J. Crítica de arte, de Baude-
laire a Malraux. Cuadernos Americanos
1957, 4:246-255.

0390. Enggas, R. Aesthetic limitations of
non-objective painting. College Art J
1950, 10:30-35.

0391. Erkes, E. (Chinese art as a social

phenomenon.) Arch für Sozialwissenschaft (Tübingen) 1928, 59:169-174.

0392. Evans, J. Taste and Temperament; a Brief Study of Psychological Types in Their Relation to the Visual Arts. NY: Macmillan 1939, 128 p; London: Cape 1939, 128 p.

0393. Eysenck, H.J. The empirical determination of an aesthetic formula. Psychol Rev 1941, 48:83-92.

0394. ———. Personality factors and preference judgments. Nature (London) 1941, 148:346.

0395. Fairbairn, W.R.D. The ultimate basis of aesthetic experience. Brit J Psychol 1938, 29.

0396. Fallico, A.B.L. Art and Existentialism. Englewood Cliffs, N.J.: Prentice-Hall 1962, 175 p.

0397. Farnsworth, P.R. Psychology of aesthetics. In Harriman, P.L. (ed.), Encyclopedia of Psychology. NY: Philosophical Library 1946, 12-26.

0398. Farré, L. El arte y la crítica: el crítico, el creador y el gozador. Rev de Ideas Estéticas 1953, 11:361-373.

0399. Faulkner, R. Art and its relation to society. In Art in American Life and Education. 40th Yearbook. National Soc Stud Educ. Bloomington, Ill.: Public School Publ Co 1941, 427-441.

0400. ———. Standards of value in art. In Art in American Life and Education. 40th Yearbook. National Soc Stud Educ. Bloomington, Ill.: Public School Publ Co 1941, 401-426.

0401. Faulkner, R., and E. Myers. Art. Rev educ Res 1941, 11:376-386.

0402. Faulkner, R., et al. Art Today: An Introduction to the Fine and Functional Arts. NY: Holt, Rinehart & Winston 1956, 553 p.

0403. Faulkner, R., and E. Ziegfeld. Art Today. Minneapolis: Univ Minnesota Mimeograph Dept 1936.

0404. Fechner, G.T. Über die Ächtheitsfrage der Holbeinischen Madonna. Diskussion und Acten. Leipzig: Breitkopf & Hartel 1871, 167 p.

0405. ———. Zur Deutungsfrage und Geschichte der Holbeinischen Madonna. Leipzig: Weigel 1866, 45 p.

0406. ———. Zur experimentalen Ästhetik. Abhandlungen der sächsischen Gesellschaft der Wissenschaft 1871, 9:556-637.

0407. ———. Die Historischen Quellen und Verhandlungen über die Holbeinische Madonna. Leipzig: Weigel 1866, 74 p.

0408. ———. Vorschule der Ästhetik. 2 Vols. Leipzig 1925, 264 p., 320 p.; Leipzig:

Breitkopf & Härtel 1897-98, 314 p.

0409. Federn, K. Das ästhetische Problem. Hannover: Sponholtz 1928, 142 p.

0410. Fehl, P. The hidden genre: a study of the "Concert Champêtre" in the Louvre. JAAC 1957, 16:153-168.

0411. Feibleman, J.K. Aesthetics, a Study of the Fine Arts in Theory and Practice. NY: Duell, Sloan & Pearce 1949, 463 p.

0412. ———. A behaviourist theory of art. Brit J Aesthetics 1963, 3(1).

0413. ———. The hypothesis of esthetic measure. Philos Sci 1945, 12:194-217.

0414. ———. Logical value of the objects of art. JAAC 1941, 1(2-3):70-85.

0415. ———. An ontology of art. Personalist 1949, 30:129-141.

0416. Feldman, E.B. Dilemma of the artist. Studies Art Educ 1962, 4:4-10.

0417. Fels, F. La psychologie de l'art. L'école de Paris. La Psychologie et la Vie (Paris) 1927, 1(6):16-18.

0418. ———. La psychologie des théories picturales contemporaines. La Psychologie et la Vie (Paris) 1927, 1(4):18-20.

0419. Fen, S.N. A transactional conception of experience as art. J Philos 1948, 45: 712-718.

0420. Ferguson, G. Signs and Symbols in Christian Art. NY: Oxford Univ Pr 1954, 346 p.

0421. Ferlicot, J. Prise de conscience esthétique et modes d'action de l'enseignement de la peinture. Rev d'Esthétique 1961, 14:186-202.

0422. Ferre, (?). Les criminels de l'art et la littérature. Paris: Alcan 1897.

0423. Ferren, J. The problem of creative thinking in painting. In Industrial Research Institute, The Nature of Creative Thinking. NY: New York Univ Pr 1957.

0424. Ferrier, J.L. Klee, un réalism opératoire. Temps Modernes 1963, 200:1201-1203.

0425. ———. Sur la peinture d'Hélène de Beauvoir. Temps Modernes 1963, 201:1504-1512.

0426. Fiedler, C. Über die Beurtheilung von Werken der bildenden Kunst. Leipzig 1876.

0427. ———. On Judging Works of Visual Art. Berkeley: Univ Calif Pr 1957, 76 p.

0428. Fingesten, P. The six-fold law of symbolism. JAAC 1963, 21:387-397.

0429. ———. The theory of evolution in the history of art. College Art J 1954, 13:302-310.

0430. Finkelstein, S. Art and Society. NY: International Publishers 1947, 288 p.

0431. ———. Realism in Art. NY: International Publishers 1954, 190 p.

0432. Fischer, J.L. Art styles as cultural cognitive maps. Amer Anthropologist 1961, 63:79-93.

0433. Fishman, S. The Interpretation of Art: Essays on the Art Criticism of John Ruskin, Walter Pater, Clive Bell, Roger Fry, and Herbert Read. Berkeley: Univ California Pr 1963, 195 p.

0434. Fitzsimmons, J. Space and image in art. Quadrum 1959, 11:69-86.

0435. Fizer, J. The problem of the unconscious in the creative process as treated by Soviet aesthetics. JAAC 1963, 21:399-406.

0436. Flaccus, L.W. The Spirit and Substance of Art. NY: Appleton-Century-Crafts 1941, 593 p.

0437. Fleming, W. Arts and Ideas. NY: Holt 1955, 790 p.

0438. ———. The newer concepts of time and their relation to the temporal arts. JAAC 1945, 4:101-106.

0439. Fleury, (?). Une opinion sur la peinture de H. Smith. Arch Psychol 1908, 7: 205.

0440. Flewelling, R.T. Art and the man. Personalist 1949, 30:117-128.

0441. Focillon, H. The Life of Forms in Art. NY: Wittenborn 1958; New Haven: Yale Univ Pr 1942.

0442. Folejewski, Z. Frustrations of socialist realism. JAAC 1956, 14:485-488.

0443. Formaggio, D. Fenomenologia della tecnica artistica. Milan: Nuvoletti 1953, 416 p.

0444. ———. L'idea di artisticità. Dalla "morte dell'arte" al "ricominciamento" dell'estetica filosofica. Milan: Ceschina 1962, 370 p.

0445. Fosca, F. De la valeur en peinture. JPNP 1926, 23:265-274.

0446. Foss, B.M. Biology and art. Brit J Aesthetics 1962, 2:195-199.

0447. Foss, M. Symbol and Metaphor in Human Experience. Princeton: Princeton Univ Pr 1949, 205 p.

0448. Fraenkel, E. Esthétique industrielle et psychanalyse. Rev d'Esthétique 1951, July-Dec.

0449. Francastel, P. Art et technique aux XIXe et XXe siècles. Paris: Minuit 1956, 299 p.

0450. ———. Aspecta sociaux de la symetrie du XVe au XXe siecle. Temps Modernes 1963, 202:1666-1691.

0451. ———. Destruction d'un espace plastique. JPNP 1951, 44:128-175.

0452. ———. Imagination plastique, vision théâtrale et signification humain. JPNP 1953, 46:157-187.

0453. ———. Technics and aesthetics. JAAC 1953, 11:187-197; Cahiers Internationaux de Sociologie 1948, 5:97-116.

0454. Frank, J. Malraux's metaphysics of art. Sewanee Rev 1962, 70:620-650.

0455. Freedman, L. Looking at Modern Painting. NY: Norton 1961.

0456. Freeman, A.E. The nature of coherence in aesthetics. Monist 1927, 37:256-268.

0457. Friedenwald, J.S. Knowledge of space perception and the portrayal of depth in painting. College Art J 1955, 15:96-112.

0458. Fry, R. Last Lectures. NY: Macmillan 1939.

0459. ———. Transformations; Critical and Speculative Essays on Art. London: Chatto & Windus 1926, 230 p.

0460. ———. Vision and Design. London: Chatto & Windus 1929, 204 p; NY: Meridian 1956, 302 p.

0461. Fulchignoni, E. Contributi ad una estetica psicoanalitica. Psicoanalisi 1946, 2(1):65-74.

0462. Funck-Hallet, C. De la proportion. Paris: Vincent, Fréal 1953, 48 p.

0463. Furst, H. Art and temperament. Apollo 1941, 34:11-14, 40-43, 65-66, 84-86, 115-118, 147-149.

0464. ———. Defence of the philistine. Apollo 1945, 41:22-24.

0465. Furstenberg, J. Les sources de la création artistique. Monaco: du Rocher 1962, 204 p.

0466. Gabelentz, H-C. von der. Bildende Kunst und Weltanschauung. Z für Kunst 1949, 3:61-66.

0467. Gaertner, J.A. Art as the function of an audience. Daedalus 1955, 86(1):80-93.

0468. Galli, E. Intorno all origine dei sentimenti estetici. Riv di Psicologia Normal e Patologia 1928, 24:147-160.

0469. ———. Potenziale psichico e stato estetico. Arch ital di psicol 1939, 17:61-66.

0470. Gallie, W.B. Art as an essentially contested concept. Philos Q 1956, 6:97-114.

0471. Galvano, A. Storicità e significato dell'arte "astratta." Filosofia dell'Arte 1953, 1.

0472. Gandtner, J. Schicksale des Menschenbildes. Berne-München: Francke 1958.

0473. Gardner, H. Understanding the Arts. NY: Harcourt, Brace 1932, 336 p.

0474. Garrison, S.C. Fine arts. Rev educ Res 1934, 4:498-500, 536-539; 1935, 5: 45-47, 104-106.

0475. Garvin, L. Emotivism, expression, and symbolic meaning. J Philos 1958, 55: 111-118.

0476. ———. The paradox of aesthetic mean-
ing. Philos phenomenol Res 1947, 8:99-
106.

0477. ———. The problem of ugliness in art.
Philos Rev 1948, 57:404-409.

0478. Gassner, J., and S. Thomas (eds.).
The Nature of Art. NY: Crown 1964.

0479. Gatz, F.M. The object of aesthetics.
JAAC 1941, 1(1-2):3-26; 1941, 1(4):33-57.

0480. Gaunt, W. The Aesthetic Adventure.
NY: Harcourt, Brace 1945.

0481. Gauss, C.E. The Aesthetic Theories
of French Artists, 1885 to the Present.
Baltimore: Johns Hopkins Univ Pr 1949,
11! p.

0482. ———. The theoretical backgrounds
of surrealism. JAAC 1943, 2(8):37-44.

0483. Gaya Nuño, J.A. Entendimiento del
arte. Madrid: Taurus 1959, 364 p.

0484. Gehlen, A. In die Freiheit verstrickt.
Zur Situation der modernen Kunst. Merkur
1960, 146:301-307.

0485. Geiger, M. Beiträge zur Phänomeno-
logie des aesthetischen Genusses. Jahr-
buch für Philosophie und phänomenolo-
gische Forschung 1922, 1(2):567-684;
Halle 1913, 118 p.

0486. ———. Zugäne zur Aesthetik. Leipzig:
Neue Geist 1928, 158 p.

0487. Gentile, G. La Filosofia dell'Arte.
Milan: Fratelli Treves 1931.

0488. Ghiselin, B. (ed.). The Creative Pro-
cess: A Symposium. NY: New American
Library 1955, 251 p; Berkeley: Univ Cali-
fornia Pr 1952, 259 p.

0489. Ghyka, M.C. Esthétique des pro-
portions dans la nature et dans les arts.
Paris 1927, 452 p.

0490. ———. The Geometry of Art and Life.
NY: Sheed & Ward 1957, 174 p.

0491. Gibson, E.H. Painting and Reality.
NY: Pantheon 1957, 367 p; Paris: Vrin
1958, 368 p.

0492. Giedieon, S. Transparency: primitive
and modern. Art News 1952, 51(4):47-50.

0493. Gilbert, C. Degas and the problem of
verifiable excellence. JAAC 1952, 10:217-
222.

0494. Gilbert, K.E. Aesthetics: recent
trends in. In Encyclopedia of the Arts. NY:
Philosophical Library 1945, 996-999.

0495. ———. Art between the distinct idea
and the obscure soul. JAAC 1947, 6:21-26.

0496. ———. Studies in Recent Aesthetic.
Chapel Hill, N.C.: Univ North Carolina
Pr 1927.

0497. Gilbert, K.E., and H. Kuhn. A History
of Esthetics. Bloomington, Ind.: Indiana
Univ Pr 1953, 613 p; NY: Macmillan 1939,
582 p.

0498. Gill, E. Paintings and criticism.
Archit Rev 1930, 67:111-112.

0499. Gilson, E.H. L'oeuvre d'art et le
jugement critique. In Pareyson, L. (ed.),
Il guidizio estetico. Padua: Edizioni della
Rivista di Estetica 1961, 1-13; 1958, 7-
19.

0500. ———. Painting & Reality. NY: Pan-
theon 1957, 367 p; London: Routledge
1958, 367 p; NY: Meridian; Paris 1958,
370 p.

0501. Giraudi, D. L'enseignement artistique
en France. Rev d'Esthétique 1962, 15:
368-375.

0502. Godfrey, F.M. The rebirth of an aes-
thetic ideal; an essay on three masters
of art appreciation: Pater, Wilde & Fry.
Studio 1948, 135:150-151, 182-185.

0503. Göppert, H. Das Erlebnis des Schöner
im Rahmen der Libidoentwicklung. Psyche
(Heidelberg) 1957, 11:270-274.

0504. Goffin, P. The Realm of Art. London:
Drummond 1946.

0505. Golding, J. Cubism: A History and
Analysis 1907-1914. NY: Wittenborn 1959,
207 p.

0506. Goldman, B. The question of a Judaic
aesthetic in ancient synogogue art. JAAC
1961, 19:295-304.

0507. Goldman, R. Realist iconography: in-
tent and criticism. JAAC 1959, 18:183-
192.

0508. Goldwater, R. Individuality and style,
conflicting points of view. Design Quart
1954, 30:3-8.

0509. Goldwater, R.J. Primitivism in Moderr
Painting. NY: Harper 1938.

0510. Gombrich, E.H. André Malraux and
the crisis of expressionism; Voices of
Silence. Burlington Magazine 1954, 96:
374-378.

0511. ———. Art and imagery in the Romantic
Period. Burlington Magazine, June, 1949.

0512. ———. Blurred images and the unvar-
nished truth. Brit J Aesthetics 1962, 2(2).

0513. ———. Meditations on a hobby horse
or the roots of artistic form. In Whyte,
L.L. (ed.), Aspects of Form. London: Lund
Humphries 1951.

0514. ———. On physiognomic perception.
Daedalus 1960, 89:228-241.

0515. ———. The Story of Art. NY: Phaidon
1950, 462 p.

0516. ———. Tradition and expression in
western still life. Burlington Magazine
1961, 103:174-180.

0517. ———. Visual metaphors of value in
art. In Bryson, L., et al (eds.), Symbols
and Values: An Initial Study. 13th Sym-
posium of the Conference on Science,

Philosophy and Religion. NY: Harper 1954.

0518. Goodenough, E. Jewish Symbols in the Graeco-Roman Period. NY: Pantheon 1955.

0519. Gordon, D.A. Methodology in the study of art evaluation. JAAC 1952, 10: 338-352.

0520. Gordon, K. Imagination: a psychological study. J gen Psychol 1935, 12: 194-207.

0521. Gorelov, A. (Ideas and forms in artistic creations.) Zvezda 1934, 6:133-140.

0522. Gotschalk, D.W. Aesthetic expression. JAAC 1954, 13:80-85.

0523. ——. Art and beauty. Monist 1931, 41:624-632.

0524. ——. Art and the Social Order. Chicago: Univ Chicago Pr 1947, 253 p; NY: Dover 1962, 255 p.

0525. ——. A next step in aesthetics. JAAC 1959, 18:46-54.

0526. Gottlieb, C. Movement in painting. JAAC 1958, 17:22-33.

0527. ——. The role of the window in the art of Matisse. JAAC 1964, 22(4):393-424.

0528. ——. Three new themes in twentieth century art. JAAC 1962, 31:177-188.

0529. Grafly, D. Some aspects of art criticism. Education 1942, 63:253-257.

0530. Graña, C. French Impressionism as an urban art. J Social Issues 1964, 20(1): 37-48.

0531. Grate, P. Art historians and art critics. Burlington Magazine 1959, 101: 277-281.

0532. Gray, C. Cubist Aesthetic Theories. Baltimore: Johns Hopkins Univ Pr 1953, 190 p.

0533. ——. The cubist conceptions of reality. College Art J 1953, 13:19-23.

0534. Greenberg, C. Abstract and representational. Art Digest 1954, 29:6-8.

0535. ——. Art and Culture; Critical Essays. Boston: Beacon 1961, 278 p.

0536. Greene, B. The artist's reluctance to communicate. Art News 1957, 55:44-45.

0537. ——. Doctrine of pure aesthetic: news and comments of a contemporary artist. College Art J 1959-60, 19(2):122-133.

0538. Greene, T.M. The Arts and the Art of Criticism. Princeton: Princeton Univ Pr 1940, 690 p.

0539. ——. Beauty in art and nature. Sewanee Rev 1961, 69:236-268.

0540. Grey, L. Communication and the arts. In Bryson, L. (ed.), The Communication of Ideas. NY: Harper 1949, 119-142.

0541. Grimes, J.W. Values in a work of art. Educ Res Bull, Ohio State Univ 1940, 19:283-292.

0542. Gropius, W. Design topics. Magazine of Art 1947, 40:298-304.

0543. Grossart, F. Zur Psychologie des ästhetischen Verhaltens. Arch ges Psychol 1932, 86:115-133.

0544. Grousset, R. Chinese Art and Culture. NY: Grove 1959, 331 p.

0545. Grudin, L. A Primer of Aesthetics. NY: Covici, Friede, 1930, 247 p.

0546. Guastalla, P. Esthétique. Paris: Vrin 1925, 127 p.

0547. Guerard, A.L. Art for Art's Sake. Boston & NY: Lothrop, Lee & Shepard 1936, 349 p.

0548. Guerry, L. Le thème du "triomphe de la mort" dans la peinture italienne. Paris: Maisonneuve 1950.

0549. Guggenheimer, R. Creative Vision in Artist and Audience. NY: Harper 1950, 173; 1960, 175 p.

0550. ——. Sight and Insight: A Prediction of New Perceptions in Art. NY: Harper 1945, 255 p.

0551. Guilford, J.P. Creativity. Amer Psychologist 1950, 5:444-454.

0552. Guilloux, L. Avantage de l'ignorance. Verve 1952, 7(27-28):135-138.

0553. Guist, G. Über die Auffassung des Raumes, imbesondere des Bildraumes. Z für Augenheilkunde 1922, 47:31-41.

0554. Gundlach, R.H. Psychology and aesthetics. In Marcuse, F.L. (ed.), Areas of Psychology. NY: Harper 1954, 478-524.

0555. Gunthrop, J.M. Aesthetic maturity. Ped Sem & J genet Psychol 1940, 57:207-210.

0556. Gusdorf, G. Le sens de la création artistique. JPNP 1953, 46:385-404.

0557. Guyau, M. Les problèmes de l'esthétique contemporaine. Paris: Alcan 1884, 260 p.

0558. Guzzo, A. L'arte. Turin: Edizioni di "Filosofia" 1962, 205 p.

0559. ——. Varie direzioni della ricerca artistica. Filosofia 1962, 13:35-50.

0560. Haftmann, W. Der Maler Franz Marc und die deutsche Kunst des 20. Jahrhunderts. Universitas (Stuttgart) 1963, 18:25-48.

0561. Hahn, O. Art et technique de Sonderborg. Temps Modernes 1962, 199:1139-1142.

0562. Haight, E.H. Aspects of Symbolism in the Latin Anthology and in Classical and Renaissance Art. NY: Longmans, Green 1952, 69 p.

0563. Haines, T.H., and A.E. Davies. The psychology of aesthetic reaction to rectangular forms. Psychol Rev 1904, 11:249-281.

0564. Haldar, A.K. Symbolism in Indian art and religion. JAAC 1950, 9:124-127.

0565. Hallman, R.J. The art object in Hindu aesthetics. JAAC 1954, 12:493-498.

0566. Hambridge, J. The Elements of Dynamic Symmetry. NY: Brentano 1926, 140 p.

0567. Hamburger, M. Das Form-Problem in der neueren deutschen Ästhetik und Kunsttheorie. Heidelberg 1915, 159 p.

0568. Hamilton, C. Picasso at Antibes. JAAC 1955, 13:478-485.

0569. Hamilton, G.H. Cézanne, Bergson and the image of time. College Art J 1956, 16(1):2-12.

0570. ———. Manet and His Critics. New Haven: Yale Univ Pr 1954, 295 p.

0571. ———. Object and image. Art News 1954, 53(3):18-21, 58-59.

0572. Hamm, V.M. The problem of form in nature and the arts. JAAC 1954, 13:175-184.

0573. Hammond, W.A. A Bibliography of Aesthetics and of the Philosophy of the Fine Arts from 1900 to 1932. NY: Longmans, Green 1934, 205 p.

0574. Harap, L. The Social Roots of the Arts. NY: International Publishers 1949, 192 p.

0575. Hargraves, H.L. The faculty of imagination. Brit J Psychol Monogr Suppl 3, 1927.

0576. Harms, E. Prolegomena of monistic aesthetics. JAAC 1941, 1(2-3):96-104.

0577. ———. Short-term styles in modern art. Studio 1957, 154:132-139.

0578. Harrell, J.G. A note on artistic criticism. J Philos 1950, 48:530-532.

0579. Harris, M.S. The sophistic attitude in art appreciation. Psychol Bull 1933, 30:614.

0580. Harrison, J.E. Ancient Art and Ritual. London: Oxford Univ Pr 1918.

0581. Harrison, M. Popular taste in Britain and America. Apollo 1943, 38:70-71.

0582. Hart, C.H. The place of aesthetics in philosophy. JAAC 1947, 1(6):3-11.

0583. Hart, H.H. The integrative function in creativity. Psychiat Quart 1950, 24:1-16.

0584. Hartlaub, G.F. Kunst und Religion. Berlin: Wolff 1919.

0585. Haskell, F. Patrons and Painters. A Study in the Relations between Italian Art and Society in the Age of Baroque. NY: Knopf 1963.

0586. Hatzfeld, H.A. Literary criticism through art and art criticism through literature. JAAC 1947, 6:1-21.

0587. Hauser, A. The conception of time in modern art and science. Partisan Rev 1956, 23:320-333.

0588. ———. The Philosophy of Art History. NY: Knopf 1959, 427; Munich: Beck 1958, 463; Madrid: Guadarrama 1961, 538 p.

0589. ———. The Social History of Art. Vol. I. From Prehistoric Times to the Middle Ages. Vol. II. Rennaiscence, Mannerism, Barroque. Vol. III. Rococo, Classicism and Romanticism. Vol. IV. Naturalism, Impressionism, The Film Age. London: Routledge & Kegan Paul 1962; NY: Vintage.

0590. ———. Sozialgeschichte der mittelalterlichen Kunst. Hamburg 1957, 253 p.

0591. Hausman, C.R. Art and symbol. Rev Metaphysics 1961, 15:256-270.

0592. ———. Intradiction: an interpretation of aesthetic understanding. JAAC 1964, 22(3):249-261.

0593. ———. Maritain's interpretation of creativity in art. JAAC 1960, 19:215-219.

0594. ———. Mechanism or teleology in the creative process. J Philos 1961, 58:577-584.

0595. Hausman, J.J. A review of research in the graphic and plastic arts. Rev educ Res 1958, 28:169-179.

0596. ———. Towards discipline of research in art education. JAAC 1959, 17:354-361.

0597. Hayakawa, S.I. The revision of vision: a note on the semantics of modern art. ETC 1947, 4:258-267.

0598. Hayes, B.H., Jr. Naked Truth and Personal Vision; A Discussion about the Length of the Artistic Road. Andover, Mass. Addison Gallery 1952, 112 p.

0599. Hayman, D. Art in the life of man. UNESCO Courier 1961, 14:4-23.

0600. Haynes, P.C. Expressive meaning in art. Philos phenomenol Res 1960-61, 21: 543-551.

0601. Heckel, R. Optische Formen und ästhetisches Erleben. In Untersuchungen über das ästhetische Erleben. Heft 1. Göttingen: Vandenhoek & Ruprecht 1927, 104 p.

0602. Heidegger, M. Der Ursprung des Kunstwerkes. Stuttgart: Reclam 1962, 126 p

0603. ———. Der Ursprung des Kunstwerkes. In Holzwege. Frankfurt 1950, 7-28.

0604. Hein, H.S. Theories of Aesthetic Inspiration. Dissertation Abstr 1962, 22: 600-601.

0605. Heller, J. Changes in Art Judgment Resulting from Courses in Art Appreciation. Univ Southern California, Abstracts of dissertations 1948, 107-108.

0606. Heller-Heinzelmann, R. L'immaginazione e la vita estetica. Florence: Pubbl Univ Firenze 1933, 11, 225 p.

0607. Hennig, R. Selbstzeugnisse grosser

Männer über die Art ihres geistigen
Schaffens. Umshau 1910, 14:743–746.

0608. Henning, E.B. Paths of Abstract Art.
Cleveland: Cleveland Museum of Art 1960,
84 p.

0609. ———. Patronage and style in the arts:
a suggestion concerning their relations.
JAAC 1960, 18:464–471.

0610. Henze, D.F. Is the work of art a
construct? A reply to Professor Pepper.
J Philos 1955, 52(16):433–438.

0611. ———. Logic, creativity and art. Aus-
tralasian J Philos 1962, 40:24–34.

0612. ———. The "look" of a work of art.
Philos Quart 1961, 11:360–365.

0613. Hepburn, R.W. Aesthetics and ab-
stract painting: two views. Philosophy
1960, 35:97–113.

0614. Herbert, E.W. The Artist and Social
Reform: France and Belgium, 1885–1898.
New Haven: Yale Univ Pr 1961, 236 p.

0615. Herbert, S. The unconscious root of
aesthetic taste. Int J Psycho-Anal 1922,
3:47–49.

0616. Herman, W.R. Photographic natural-
ism and abstract art. College Art J 1960,
19:231–241.

0617. Herring, F.W. Touch—the neglected
sense. An inquiry into the reasons for our
comparative failure to create and enjoy
tactile art forms. JAAC 1949, 7:199–215.

0618. Hertz, R. Chance and Symbol. A Study
in Aesthetic and Ethical Consistency. Chi-
cago Pr 1948, 198 p.

0619. Hess, T.B. Abstract Painting. Back-
ground and American Phase. NY: Viking
1951, 164 p.

0620. Hesse, O.E. Psychoanalyse und Kunst-
philosophie. Z Aesth 1921, 15:328–336.

0621. Hevner, K. The aesthetic experience:
a psychological description. Psychol Rev
1937, 44:245–263.

0622. ———. Aesthetics. In Guilford, J.P.
(ed.), Fields of Psychology. NY: Van Nos-
trand 1940, 584–614; 1950, 695–728.

0623. Heyl, B.C. "Artistic truth" recon-
sidered. JAAC 1950, 8:251–258.

0624. ———. Meanings of Baroque. JAAC
1961, 19:275–287.

0625. ———. New Bearings in Esthetics and
Art Criticism. New Haven: Yale Univ Pr
1943, 172 p; College Art J 1944, 4:61–63.

0626. ———. "Relativism" and "objectivity"
in Stephen C. Pepper's theory of criticism.
JAAC 1960, 18:378–393.

0627. Hildebrand, A. The Problem of Form
in Painting and Sculpture. NY: Stechert
1907, 1932, 141 p.

0628. ———. Remarks on the problem of form;
condensed. College Art J 1952, 11(4):

251–258.

0629. Hildebrandt, H. Der Expressionismus
in der Malerei. Vortrag. Stuttgart 1919,
27 p.

0630. Hiler, H. Letter to the editor. JAAC
1954, 13:109–110.

0631. ———. The origin and development of
structural design. JAAC 1956, 15:106–116.

0632. ———. Science and art—a comment.
Main Currents in Modern Thought 1959,
15:111.

0633. ———. The search for a method of
graphic.expression. JAAC 1951, 10:10–25.

0634. ———. Why Abstract? Norfolk, Conn.:
New Directions 1945, 100 p.

0635. ———. Why Expressionism? Los An-
geles: McNaughton, Porter 1948, 196 p.

0636. Hipple, W.J., Jr. The aesthetics of
Dugald Stewart: culmination of a tradition.
JAAC 1955, 14:77–96.

0637. Hodin, J.P. Aesthetic judgment and
modern art criticism. In Pareyson, L. (ed.),
Il Guidizio Estetico. Padua: Edizioni della
Rivista di Estetica 1961, 24–34.

0638. ———. Aesthetics and art criticism.
In Il Guidizio Estetico. Padua: Edizioni
della Rivista di Estetica 1958, 20–30.

0639. ———. Art history or the history of
culture: a contemporary German problem.
JAAC 1955, 13:469.

0640. ———. Contemporary art; its defini-
tion and classification. College Art J 1951,
10(4):337–354.

0641. ———. The Dilemma of Being Modern.
London: Routledge & Kegan Paul 1956,
271 p.

0642. ———. Expressionism. Horizon 1949,
19:38–53.

0643. ———. The future of surrealism. JAAC
1956, 14:475–484.

0644. ———. German books on modern art.
Burlington Magazine 1960, 212–214.

0645. ———. Modern art in Germany: a re-
port on current writings. JAAC 1960, 18:
504–510.

0646. ———. The painter's handwriting in
modern French art. Thoughts on the prob-
lem of style in art from Delacroix to Dali.
JAAC 1949, 7:181–199.

0647. ———. Problemen van de moderne es-
thetics. Kroniek van Kunst en Kultur 1956,
8:188–190.

0648. ———. The spirit of modern art. Brit
J Aesthetics 1961, 1(3).

0649. ———. The timeless and the timebound
in art. JAAC 1958, 16:497–502.

0650. Hoekstra, R. Art and truth. Philos phe-
nomenol Res 1945, 5:365–378.

0651. Hoeltje, G. Die abstrakte Kunst als
Symptom. Deutsche Kunst u Dekoration

1930, 66:37-38.

0652. Hoenigswald, R. Wissenschaft und Kunst. Stuttgart: Kohlhammer 1961, 119 p.

0653. Hofer, C. Das Selbstverständliche und das Artistische in der Kunst. Thema 1949, 1:30-32.

0654. Hoffman, R. Conjectures and refutations on the ontological status of the work of art. Mind 1962, 71:512-520.

0655. Hofstadter, A. On the grounds of esthetic judgment. J Philos 1957, 54:679-688.

0656. Hojo, M. (The meaning and the function of art criticism.) Bigaku (Tokyo) 1950, 1(3).

0657. Hollis, C. Art et littérature en Australie. La Table Ronde 1963, 183:100-104.

0658. Honey, W.B. Science and the Creative Arts. London: Faber 1945, 84 p.

0659. Honeyman, T.J. How to look at pictures. Glaszon Art Rev 1946, 1:15-17.

0660. Hopwood, V.G. Dream, magic and poetry. JAAC 1951, 10:152-159.

0661. Hospers, J. The Croce-Collingwood theory of art. Philosophy 1956, 31:291-308.

0662. ———. The ideal aesthetic observer. Brit J Aesthetics 1962, 2(2).

0663. ———. Meaning and Truth in the Arts. Chapel Hill: Univ North Carolina Pr 1946, 252 p.

0664. Hough, E.L. A note on aesthetic theory. Psychiatry 1940, 3:507-508.

0665. Howard, R.F. The commonplace of visual aesthetics. JAAC 1941, 1(2-3):92.

0666. Howell, A.R. The Meaning and Purpose of Art. London: Zwemmer 1945.

0667. Howes, E.P. Esthetics. Psychol Bull 1913, 10:196-201; 1914, 11:256-262.

0668. Hughesdon, P.J. Phenomenal symbolism in art. Mind 1920, 186-206.

0669. Huisman, D. L'Esthétique. Paris: PUF 1954, 126 p.

0670. Huizinga, J. Homo Ludens: A Study of the Play Element in Culture. London: Routledge & Kegan Paul 1949, 220 p; Boston: Beacon Pr 1955, 220 p.

0671. Hulme, T.E. Speculations: Essays on Humanism and the Philosophy of Art. NY: Harcourt Brace 1961, 271 p.

0672. Hungerland, H. The aesthetic judgment. In Pareyson, L. (ed.), Il Guidizio Estetico. Padua: Edizioni della Rivista di Estetica 1961, 35-40; 1958, 31-36.

0673. ———. The aesthetic response reconsidered. JAAC 1957, 16:32-43.

0674. ———. Aesthetics at the Tenth International Congress of Philosophy. JAAC 1949, 7(3):267-271.

0675. ———. An analysis of some determinants

in the perception of works of art. JAAC 1954, 12:450-456.

0676. ———. The basis of the aesthetic response. Amer Psychologist 1953, 10(8):433.

0677. ———. The concept of expressiveness in art history. JAAC 1945, 3(11-12):22-28.

0678. ———. Consistency as a criterion in art criticism. JAAC 1948, 7(2):93-112.

0679. ———. Contemporary American painting. Aesthetics (Bombay) 1953, 6:15-20.

0680. ———. Perception, interpretation and evaluation. JAAC 1952, 10:223-241.

0681. ———. Problems of descriptive analysis in the visual arts. JAAC 1945, 4(1):20-25.

0682. ———. The responsibility of the artist in contemporary society. College Art J 1956, 15(3):216-227.

0683. ———. The social basis of art criticism. Algemeen Nederlands Tijdschrift voor Wijsbegeerte en Psychologie 1949, 41:201-211.

0684. ———. Sugestões para a crítica de arte e outros ensaios. Rio de Janeiro: Ministério da Educação e Cultura 1959, 108 p.

0685. ———. Suggestions for procedure in art criticism. JAAC 1947, 5:189-195.

0686. ———. Two visions of art: art for art and art for man. In The Horizons of Man. Detroit: Wayne State Univ Pr 1963, 47-73.

0687. Hungerland, I.C. The concept of intention in art criticism. J Philos 1955, 52:733-742.

0688. Huxley, A. The new frontiers in beaut Show 1963, 3(12):92-94, 152.

0689. Huyghe, R. L'art est-il un autre langage? La Table Ronde 1960, 53:52-61.

0690. ———. Art and the Spirit of Man. NY: Abrams 1962, 526 p; Paris: Flammarion 1960.

0691. ———. Idea and Form: Studies in the History of Art. Stockholm: Almquist & Wiksell 1960, 296 p.

0692. ———. Ideas and Images in World Art; Dialogue with the Visible. NY: Abrams 1959, 447 p; London: Thames & Hudson 1959, 447 p.

0693. Imaizumi, A. (On criticism of fine art.) Bigaku (Tokyo) 1950, 1(3).

0694. Imura, Y. (Art and truth.) Bigaku (Toky 1963, 14(3).

0695. Ingarden, R. Abstract painting. Estetyka (Warsaw) 1960, 1.

0696. ———. La pittura astratta. Riv di Estetica 1961, 6:165-190.

0697. ———. Studia z Estetyki. 2 Vols. Warsaw: Panstwowe Wydawnietwo Naukowe 1958, 439 p; 478 p.

0698. ———. Untersuchungen zur Ontologie der Kunst. Musikwerk-Bild-Architektur-Film. Tübingen: Niemeyer 1962, 342 p.

0699. Inui, Y. (The problem of space in the painting-perspective in ancient painting.) Bigaku (Tokyo) 1959, 10(1).

0700. Isaacs, W.F. Day dreams and art. Parnassus 1934, 6:28-29.

0701. Isenberg, A. Critical communication. Philos Rev 1949, 58:330-344.

0702. ———. Perception, meaning, and the subject-matter of art. J Philos 1944, 41: 561-575.

0703. Ishikawa, K. (Realism in the problem of artistic expression.) Bigaku (Tokyo) 1955, 6(2):24-35.

0704. Ismail, M.I. (Aesthetic experience in the light of modern psychology.) Egypt J Psychol 1949-50, 5(2):185-190.

0705. Jacobson, L. Art as experience and American visual art today. JAAC 1960, 19: 117-126.

0706. ———. A Critical Investigation of the Broad Conception of Art in American Art Education. Doctoral dissertation. Univ Southern California 1953.

0707. Jaeger, H. Heidegger and the work of art. JAAC 1958, 17:58-71.

0708. Jaensch, E. Das philosophische Wertproblem im besonderen Hinblick auf die deutsche Bewegung und die Kunst. Neue psychol Stud 1934, 12(2):1-22.

0709. ———. Psychologie und Aesthetik. Z Aesth 1925, 19:11-28.

0710. Jamati, G. La conquête de soi: Méditations sur l'art. Paris: Flammarion 1961, 474 p.

0711. Jampolsky, P. La personnalité et les préférences aesthétiques chez l'adulte. Année Psychol 1954, 54:377-395.

0712. Janicik, E.C. Art As Propaganda: An Analysis of Principles Involved, with Emphasis on Iconographic Aspects. Dissertation Abstr 1956, 16:1878-1879.

0713. Janneau, G. L'art cubiste; théories et réalisations. Étude critique. Paris 1929, 111 p.

0714. Jarrett, J.I. The Quest for Beauty. Englewood Cliffs, N.J.: Prentice-Hall, 1957, 318 p.

0715. Jean, M. Concerning the great hot-houses of the city of Paris and the island of hallucinations. In The History of Surrealist Painting. NY: Grove 1960, 39-55; London: Weidenfeld 1960; Paris: Editions du Seuil 1959.

0716. Jenkins, I. Art and the Human Enterprise. Cambridge: Harvard Univ Pr 1958, 318 p.

0717. ———. Art and ontology. Rev Meta-physics 1956, 9:623-637.

0718. ———. The human function of art. Philos Quart 1954, 4:128-146.

0719. ———. Imitation and expression in art. JAAC 1942, 1(5):42-52.

0720. ———. The unity and the varieties of art. JAAC 1954, 13:185-202.

0721. Jessup, B.E. Aesthetic size. JAAC 1950, 9:31-38.

0722. ———. The comparative esthetic judgment. Philos phenomenol Res 1954, 14: 546-552.

0723. ———. Meaning range in the work of art. JAAC 1954, 12:378-385.

0724. ———. Taste and judgment in aesthetic experience. JAAC 1960, 19:53-59.

0725. ———. What is great art? Brit J Aesthetics 1962, 2:26-35.

0726. Johnson, J.R. Art history and the immediate visual experience. JAAC 1961, 19:401-406.

0727. Johnson, M. Art and Scientific Thought: Historical Studies towards a Modern Revision of their Antagonism. NY: Columbia Univ Pr 1949, 200 p.

0728. Jones, A.M. A Comparative Study of the Vehicle-Referent Relationship in the Representation of Two Non-Verbal Media by Groups Differing in Their Habitual Orientation. Dissertation Abstr 1963, 23: 3466.

0729. Jones, D. Epoch and Artist. NY: Hillary 1959, 320 p.

0730. Jordan, E. The Aesthetic Object; An Introduction to the Philosophy of Value. Bloomington, Ind.: Principia Pr 1937.

0731. Joussain, A. L'originalité et l'universalité dans l'art. Rev philosophique de la France et de l'étranger 1915, 79: 231-260.

0732. Kainz, F. Aesthetics the Science. Detroit: Wayne State Univ Pr 1963, 579 p.

0733. ———. Vorlesung über Ästhetik. Vienna: Sexl 1948, 664 p.

0734. Kallen, H.M. Art and Freedom; a Historical and Biographical Interpretation of the Relations between the Ideas of Beauty, Use and Freedom in Western Civilization from the Greeks to the Present Day. NY: Duell, Sloan & Pearce 1942, 2 Vols.

0735. Kaminsky, J. Hegel on Art; An Interpretation of Hegel's Aesthetics. NY: University Publishers 1962, 207 p.

0736. Kandinsky, W. The Art of Spiritual Harmony. London 1914, 112 p; Münich 1912, 125 p.

0737. ———. On the Spiritual in Art. NY: Guggenheim Foundation 1946.

0738. Kane, E.K. Gongorism and the Golden Age: A Study of Exuberance and Unrestraint

in Arts. Chapel Hill: Univ North Carolina
Pr 1928.

0739. Kanzer, M. Contemporary psycho-
analytic view of aesthetics. J Amer Psy-
choanal Ass 1957, 5:515-524.

0740. Kaplan, A. Obscenity as an esthetic
category. In Kramer, R. (ed.), Law and
Contemporary Problems. Durham, N.C.:
Duke Univ Pr 1955, 544-559.

0741. ——. Referential meaning in the arts.
JAAC 1954, 12:457-474.

0742-3. ——. Il significato riferitivonell
arti. Nuova Corrente 1963, 10:7-33.

0744. Kato, M. (An experimental study on
aesthetic proportion in simple forms.)
Japanese J experimental Psychol 1938, 5:
57-61.

0745. Kaufmann, W. Art, tradition and truth.
Partisan Rev 1955, 17:9-28.

0746. Kavolis, V. A role theory of artistic
interest. J soc Psychol 1963, 60:31-37.

0747. Kayser, W. The Grotesque in Art and
Literature. Bloomington: Indiana Univ Pr
1963, 244 p.

0748. Keel, J.S. Sir Herbert Read's theory
of aesthetic education. In Research in Art
Education. 9th Yearbook. Kutztown, Pa.:
National Art Educ Ass 1959, 21-26.

0749. ——. The unfolding of Sir Herbert
Read's philosophy of art education. Art
Educ 1956, 9:3-5, 20.

0750. Kellett, K.R. A Gestalt study of the
function of unity in aesthetic perception.
Psychol Monogr 1939, 51, No. 5, 23-51.

0751. Kennick, W.E. Art and the ineffable.
J Philos 1961, 58:309-320.

0752. Kepes, G. Form and motion. Arts &
Architecture 1948, 65:26-28.

0753. ——. Introduction to the issue "The
visual arts today." Daedalus 1960, 89:1-
268.

0754. ——. The Language of Vision. Chi-
cago: Theobald 1945, 1951, 228 p.

0755. ——. The New Landscape in Art and
Science. Chicago: Theobald 1956, 384 p.

0756. Kermode, F. Tradition and the new
art: talks with Harold Rosenberg and E.H.
Gombrich. Partisan Rev 1964, 31(2):241-
252.

0757. Kessler, C.S. Max Beckmann's "De-
parture". The modern artist as heroic
prophet. JAAC 1955, 14:206-217.

0758. ——. Science and mysticism in Paul
Klee's "Around the Fish." JAAC 1957, 16:
76-83.

0759. Khatchadourian, H. Works of art and
physical reality. Ratio 1960, 2:148-161.

0760. Klee, P. Das bildnerische Denken.
Basle: Schwabe 1960.

0761. ——. Éléments pour une esthétique.

Temps Modernes 1963, 200:1204-1215.

0762. ——. On Modern Art. London: Faber
1948.

0763. Klein, R. Vom Wesen der künstlerisch
Begabung. Deutsche Kunst u Dekoration
1908, 12:288-297.

0764. Klinger, J. Das irrationale Wesen der
Kunst. Gebrauchsgraphik 1933, 10:60-61.

0765. Knapp, R.H. Attitudes toward time
and aesthetic choice. J soc Psychol 1962,
56:79-87.

0766. Knapp, R.H., J. Brimmer, and M. White.
Educational level, class status, and aes-
thetic preference. J soc Psychol 1959, 50:
277-284.

0767. Knepler, H.W. Communication and the
artist. College Art J 1953, 12:328-335.

0768. Knight, E.H. Some aesthetic theories
of I.A. Richards. Mind, n.s. 1927, 36:69-
76.

0769. Knight, H. Aesthetic experience in
pictorial art. Monist 1930, 40:74-83.

0770. Knorr, J.B. An Exhibition of Paintings,
Accompanied by a Journal of the Nature of
the Creative Process and the Act of Paint-
ing. Dissertation Abstr 1957, 17:1055.

0771. Köbner, R., and G. Köbner. Vom Schör
und seiner Wahrheit. Berlin: de Gruyter
1959, 126 p.

0772. König, R. Die naturalistische Aesthet
in Frankreich und ihre Auflösung. Ein Bei-
trag zur systemwissenschaftlichen Betrach
tung der Künstlerästhetik. Leipzig: Noske
1931, 233 p.

0773. Kolaja, J., and R.N. Wilson. The them
of social isolation in American painting
and poetry. JAAC 1954, 13:37-45.

0774. Krauss, R. Über graphischen Ausdruck
Eine experimentelle Untersuchung über da:
Erzeugen und Ausdeuten von gegenstands-
freien Linien. Z angew Psychol Beiheft No.
48, 1930, 141 p.

0775. Kreibig, J.K. Beiträge zur Psychologie
des Kunstschaffens. Z Aesth 1909, 4:532-
558.

0776. Krestovskaia, L.A. Le problème
spirituel de la beauty et de la laideur.
Paris: PUF 1948, 204 p.

0777. Krestovsky, L.A. Le dédoublement
esthétique. Psyché-Paris 1952, 7:37-45.

0778. Kris, E. Die Arbeiten des Gabriel de
Grupello für den Wiener Hof. Jahrbuch
Kunsthistorischen Sammlungen (Vienna)
1934, 8:204-205.

0779. —— (ed.). Goldschmiedarbeiten des
Mittelalters, der Renaissance und des
Barock. Part I. Vienna: Schroll 1932.

0780. ——. Meister und Meisterwerke der
Steinschneidekunst in der italienischen Re
aissance. Vienna: Schroll 1929, 2 Vols, 20C

0781. ———. Mittelalterliche Bildwerke. Vienna: Kunsthistorie Museum 1933, 48 p.

0782. ———. Probleme der Ästhetik. Imago 1941, 26:142-178.

0783. ———. Der Stil "rustique." Jahrbuch Kunsthistorischen Sammlungen (Vienna) 1920, 1.

0784. Kris, E., and A. Kaplan. Aesthetic ambiguity. Philos phenomenol Res 1948, 8(3):415-435; In Psychoanalytic Explorations in Art. NY: IUP 1952, 243-264; London: Allen & Unwin 1953, 243-264.

0785. Kristeller, P.O. The modern system of the arts: a study in the history of aesthetics. J History Ideas 1952, 12:496-527.

0786. Krutch, J.W. Experience and Art. NY: Collier 1962.

0787. Kubler, G.A. The Shape of Time: Remarks on the History of Things. New Haven: Yale Univ Pr 1962, 136 p.

0788. Kuchling, H. Das Abstrakte in der Kunst. Wissenschaft u Weltbild 1959, 12: 448-457.

0789. Kühr, V. Ästhetisches Erleben und künstlerisches Schaffen; psychologisch-ästhetische Untersuchungen. Stuttgart: Enke 1929, 143; Copenhagen: Gyldendalske 1927, 205 p.

0790. Külpe, O. Der Gegenwärtige Stand der experimental Aesthetik. Ber über d II Kong für Exper Psychol, Würzberg 1906; Leipzig 1907, 1-57.

0791. Küppers, L. Kunst und Künstler. Zur Phänomenologie des Schönen. Paderborn: Bonifacius 1949, 150 p.

0792. Kuhn, A. A painter on imagination. Brit J Aesthetics 1961, 1(4).

0793. Kuhn, H. On the indispensability of metaphysical principles in aesthetics. JAAC 1950, 9:128-133.

0794. ———. The system of the arts. JAAC 1941, 1(1):66-79.

0795. Kuhn, M. Creative potential in the visual arts for the American adult. In Research in Art Education. 9th Yearbook. Kutztown, Pa.: National Art Educ Ass 1959, 15-20.

0796. Kuhns, R.F., Jr. Art structures. JAAC 1960, 19:91-97.

0797. Kumm, K. Entwurf einer emporischen Ästhetik der bildenden Kunst. Berlin 1895, 83 p.

0798. Kurz, O., and E. Kris. Die Legende vom Kunstler; ein geschichtlicher Versuch. Vienna: Krystall 1934, 139 p.

0799. Kusunagi, M. (The existential character of art.) Bigaku (Tokyo) 1955, 6(3).

0800. Lafleur, L.J. Biological evidence in aesthetics. Philos Rev 1942, 51:587-595.

0801. LaFollette, S. Art in America. NY: Norton 1929, 361 p.

0802. Lalo, C. L'Art et la Morale. Paris: Alcan 1922, 184 p.

0803. ———. L'art et la vie sociale. Paris 1921, 378 p.

0804. ———. Le conscient et l'inconscient dans l'inspiration. JPNP 1926, 23:11-51.

0805. ———. Esthétique. Paris: Alcan 1925, 107 p.

0806. ———. L'esthétique expérimentale contemporaine. Paris: Alcan 1908, 208 p.

0807. ———. Esthétique psychologique et esthétique sociologique. JPNP 1920, 17: 643-657.

0808. ———. L'idée de progrès dans les sciences et dans les arts. JPNP 1930, 27: 449-484.

0809. ———. Notions d'Esthétique. Paris: Alcan 1925; PUF 1948, 110 p.

0810. ———. La science générale de l'art. JPNP 1928, 25:193-227.

0811. ———. A structural classification of the fine arts. JAAC 1953, 11:307-323; JPNP 1951, 44:9-37.

0812. ———. Valeur esthétique de la symétrie. JPNP 1934, 30:598-634.

0813. Lalo, C., et al. Formes de l'art, formes de l'esprit. Paris: PUF 1951, 400 p.

0814. Lameere, J. L'art ou la recherche du plaisir. Rev de Philos 1961, 86:201-219.

0815. Lancaster, C. Keys to the understanding of Indian and Chinese painting: the "six limbs" of Yasodhara and the "six principles" of Hsieh Ho. JAAC 1952, 11: 95-104.

0816. Lange, K. Sinnesgenuss und Kunstgenuss. Weisbaden: Bergmann 1903, 100 p.

0817. ———. Das Wesen der Kunst. Grundzüge einer illusionistichen Kunstlehre. Berlin 1907, 2 Vols.

0818. ———. Über den Zweck der Kunst. Stuttgart 1912, 49 p.

0819. Langer, S.K. Abstraction in art. JAAC 1964, 22(4):379-392.

0820. ———. Abstraction in science and abstraction in art. In Henle, Paul, et al. (eds.), Structure, Method and Meaning. NY: Liberal Arts 1951.

0821. ———. On artistic sensibility. Daedalus 1960, 89:242-244.

0822. ———. Feeling and Form. A Theory of Art Developed from Philosophy in a New Key. NY: Scribner's 1953, 431 p; London: Routledge & Kegan Paul 1950, 1955, 430p.

0823. ———. The primary illusions and the great orders of art. Hudson Rev 1950, 3: 219.

0824. ———. Problems of Art. NY: Scribner's 1957, 184 p.

0825. ——— (ed.). Reflections on Art. A Source

of Writings by Artists, Critics, and Philosophers. Baltimore: Johns Hopkins Univ Pr 1958, 364 p; London: Oxford Univ Pr 1958.

0826. Langfeld, H.S. The Aesthetic Attitude. NY: Harcourt Brace 1920, 287 p.

0827. ——. Feeling and emotion in art. In Reymert, M.L. (ed.), Feelings and Emotions; The Mooseheart Symposium. NY: McGraw-Hill 1950, 516-520.

0828. ——. The place of aesthetics in social psychology. Brit J Psychol 1936, 27:135-147.

0829. ——. Psychological aesthetics in America today. Proc 10th Int Congress Philos 1948-49, 523-526.

0830. ——. The rôle of feeling and emotion in aesthetics. In Emotions and Feelings: The Wittenberg Symposium. Worcester, Mass.: Clark Univ Pr 1928, 346-355.

0831. Lansner, K. Malraux's aesthetic. Kenyon Rev 1950, 12(2):340-348.

0832. Lapicque, C. Essais sur l'espace, l'art et la destinée. Paris: Grasset 1958.

0833. Laporte, P.M. Cultural evaluation of subjectivism in contemporary painting. College Art J 1951, 10(2):95-109.

0834. ——. Humanism and the contemporary primitive. Gazette Beaux-Arts 1946, 29:47-62.

0835. Lapoujade, R. Le signe et la signification. Méditations 1961, 1:81-96.

0836. Larguier des Bancels, J. Les méthodes de l'esthétique expérimentale. Formes et couleurs. Année Psychol 1900, 6:144-190.

0837. Lasaga, J.I. Outline of a descriptive aesthetics from a structuralist point of view. Psychol Rev 1947, 54:9-23.

0838. Laudois, R. De l'influence des altérations de la vue sur l'oeuvre des artistes. Thèse de med de Paris 1931, 92 p.

0839. Lázár, B. Die Maler des Impressionismus; sechs Vorträge gehalten in der University Extension zu Budapest. Leipzig-Berlin 1913, 64 p..

0840. Leboutillier, C.G. Art as communication. JAAC 1943, 2(8):76-84.

0841. Lee, D. Lineal and nonlineal codifications of reality. ETC 1950, 8:13-26; Psychosom Med 1950, 12:89-97.

0842. Lee, H.B. On the aesthetic states of the mind. Psychiatry 1947, 10:281-306.

0843. ——. The creative imagination. Psychoanal Quart 1949, 18:351-361.

0844. ——. The cultural lag in aesthetics. JAAC 1947, 6:120-138.

0845. ——. Projective features of contemplative artistic experience. Ops 1949, 19:101-111.

0846. ——. Spirituality and beauty in artistic experience. Psychoanal Quart 1948, 17:507-523.

0847. ——. The values of order and vitality in art. In Roheim, G. (ed.), Psychoanalysis and the Social Sciences. Vol. 2. NY: IUP 1950, 231-274.

0848. Lee, H.N. Perception and Aesthetic Value. NY: Prentice-Hall 1938.

0849. Lee, V. [pseudo. of Violet Paget]. The Beautiful. Cambridge: Cambridge Univ Pr 1913, 158 p.

0850. ——. Problèmes et méthodes de l'esthetique empirique. JPNP 1926, 23: 1-10.

0851. Lee, V., and C. Anstruther-Thomson. Beauty and ugliness. Contemporary Rev 1887, 554-569, 669-688.

0852. —— & ——. Beauty and Ugliness, and Other Studies in Psychological Aesthetics. London: Lane 1912, 376 p.

0853. Legowski, L.W. Beiträge zur experimentellen Aesthetik. Arch ges Psychol 1908, 12:236-311.

0854. Lehaby, W.R. Form in Civilization: Collected Paper on Art Labour. London: Oxford Univ Pr 1957, 196 p.

0855. Leon, P. The work of art and the esthetic object. Mind 1931, 40:285-296.

0856. Levey, H.B. (Lee, H.B.) A critique of the theory of sublimation. Psychiatry 1939, 2:239-270.

0857. Levi, A. L'estetica psicologia del Lipps. Riv di Psicologia (applicata) 1909, 239-248.

0858. Levi, A.W. Pierce and painting. Philos phenomenol Res 1962, 23(1).

0859. Levich, M. (ed.). Aesthetics and the Philosophy of Criticism. NY: Random House 1963, 649 p.

0860. Lewis, F.H. The development of artistic appreciation. Psychol Bull 1934, 31:6-14.

0861. Lhamon, W.T. A note on aesthetic criteria in personality evaluation. Psychiat Quart Suppl 1952, 26:237-243.

0862. Lhote, A. La peinture libérée. Paris: Grasset 1956, 248 p.

0863. ——. Traité du Paysage. Paris 1939.

0864. Liebermann, M. Die Phantasie in der Malerei. Berlin 1916.

0865. Lifton, W.M. A Pilot Study of the Relationship of Empathy to Aesthetic Sensitivity. Urbana: Univ Illinois Pr 1956, 49 p.

0866. Lindsay, K.C., and B. Huppé. Meaning and method in Brueghel's painting. JAAC 1956, 14:376-386.

0867. Lipman, M. The aesthetic presence of the body. JAAC 1957, 15:425-434.

0868. ——. The physical thing in aesthetic

experience. JAAC 1956, 15:36-46.

0869. ——. The relation of critical functions and critical decisions to art inquiry. J Philos 1954, 51:653-667.

0870. Lipps, T. Aesthetik. II. Die aesthetische Betrachtung und die bildende Kunst. Leipzig: Voss 1906, 645 p; 1914-1920, 2 Vols.

0871. ——. Aesthetik. I. Grundlegung der Aesthetik: Psychologie des Schönen und der Kunst. Leipzig: Voss 1903, 601 p; 1914-1920, 2 Vols.

0872. ——. Aesthetische Einfühlung. Z Psychol Physiol Sinnesorg 1900, 22:415-450.

0873. ——. Aesthetische Factoren der Raumanschauung. Hamburg & Leipzig 1891.

0874. ——. Von der Form der aesthetischen Apperzeption. In Philosophische Abhandlung, Gendenkschrift für Rudolf Haym. Halle: Neimeyer 1902, 365-406.

0875. ——. Zur Lehre von den Gefühlen, inbesondere den ästhetischen Elementarbefühlen. Z Psychol 1895, 8:321-361.

0876. ——. Psychologie und Ästhetik. Arch ges Psychol 1907, 9:91-116.

0877. Logan, F.M. Fine arts. Rev educ Res 1955, 25:176-187.

0878. Logròscino, G. Teoria dell'arte e della critica. Padua: Cedam 1962, 252 p.

0879. Longman, L.D. The concept of psychical distance. JAAC 1947, 6:31-36.

0880. ——. Contemporary painting. JAAC 1945, 3(9-10):8.

0881. ——. Criteria in criticism of contemporary art. JAAC 1960, 18:285-293.

0882. Loomis, A. The Eye of the Painter and the Elements of Beauty. NY: Viking 1961, 144 p; London: Macmillan 1961, 144 p.

0883. Lowenfeld, V. The meaning of aesthetic growth for art education. JAAC 1955, 14:123-126.

0884. Lowie, R.H. A note on esthetics. Amer Anthropologist 1921, 23:170-174.

0885. Lucas, R.S. Autonomous art and art history. Brit J Aesthetics 1961, 1(2).

0886. Lucques, C. Un Problèm de l'expression. Essai sur les sources de l'inspiration. Paris: PUF 1948.

0887. Lundholm, H. The Aesthetic Sentiment. Cambridge, Mass.: Sci-Art 1941, 223 p.

0888. Lundin, R.W. Aesthetic experience or response? A psychological viewpoint. Psychol Record 1956, 6:28-32.

0889. Lunding, E. Wege zur Kunstinterpretation. Copenhagen: Munksgaard 1953, 93 p.

0890. Luzzatto, G.L. 10 dialoghi su la creazione artistica. Lanciano 1932, 230 p.

0891. MacCallum, H.R. Emotion and pattern in aesthetic experience. Monist 1940, 40:53-73.

0892. McCoubrey, J.W. Studies in French Still-Life Painting, Theory and Criticism: 1660-1860. Dissertation Abstr 1959, 19:1704-1705.

0893. McCurdy, H.G. Aesthetic choice as a personality function. JAAC 1954, 12:373-377.

0894. MacDonald, J.M. The Uses of Symbolism in Greek Art. Doctoral dissertation. Bryn Mawr 1918; Chicago 1922, 56 p.

0895. Mace, C.A. Psychology and aesthetics. Brit J Aesthetics 1962, 2:3-16.

0896. Mach, E. Symmetry. Chicago: Open Court 1895, 313 p.

0897. Mack, M.P. An Exhibition of Paintings and Drawings, Accompanied by an Autobiographical Statement Regarding the Painting Act. Dissertation Abstr 1960, 21:842-843.

0898. McMahon, A.P. Is a work of art a beauty forever? Parnassus 1938, 10:5-7.

0899. ——. Preface to an American Philosophy of Art. Chicago: Univ Chicago Pr 1945, 194 p.

0900. MacMurray, J. Reason and Emotions. NY: Appleton 1937.

0901. ——. Religion, Art and Science. Liverpool: Liverpool Univ Pr 1961, 78 p.

0902. Mainwaring, J. An examination of the value of empirical approach to aesthetics. Brit J Psychol 1941, 32:114-130.

0903. Major, E. Die Quellen des künstlerischen Schaffens. Leipzig: Klinckhardt & Biermann 1913.

0904. Maldonado de Guevara, F. La estética del arte nuevo y un pintor. Rev de Ideas Estéticas 1953, 11:17-31.

0905. Malraux, A. Art, popular art, and the illusion of the folk. Partisan Rev 1951, 18:487-495.

0906. ——. The Metamorphosis of the Gods. London: Secker & Warburg 1960; NY: Garden City; NY: Doubleday 1960; Paris: Gallimard 1957.

0907. ——. The psychology of creation. Magazine of Art 1949, 42:123-127, 148-149.

0908. ——. The Voices of Silence. First published in English as The Psychology of Art, in 3 Vols.: Museum Without Walls; The Creative Act; The Twilight of the Absolute. NY: Doubleday 1953, 1963, 661 p; NY: Pantheon 1949-50; Geneva: Skira 1947-50; London: Zwemmer 1949; Baden-Baden: Klein 1949; Paris: NRF 1951, 657 p.

0909. Marcadé, J. Roma Amor; Essay on

Erotic Elements in Etruscan and Roman Art. Geneva, NY: Nagel 1961, 129 p.

0910. Marchal, G. Contribution à l'étude du sentiment esthétique. Bull Inst National d'Étude du Travail et d'Orientation Professionnelle 1958, 14:82-93; 1959, 15:249-257.

0911. Marcu, J. Objective Fundamentals of Aesthetics: the Aesthetics of Painting. Doctoral dissertation. Columbia Univ 1932.

0912. Marcuse, L. Freud's aesthetic. JAAC 1958, 17:1-21.

0913. Margolis, J. Describing and interpreting works of art. Philos phenomenol Res 1961, 21:537-542.

0914. —— (ed.). Philosophy Looks at the Arts. NY: Scribner's 1962, 235 p.

0915. Maritain, J. Art and Poetry. NY: Philosophical Library 1943, 104 p.

0916. ——. Art and Scholasticism. NY: Scribner's 1930, 232 p.

0917. ——. Creative Intuition in Art and Poetry. NY: Pantheon 1953, 423 p.

0918. ——. The Responsibility of the Artist. NY: Scribner's 1960, 120 p; Paris: Fayard 1961, 128 p.

0919. ——. Things and the creative self. Magazine of Art 1953, 46:51-58.

0920. Marshall, H.R. The relation of aesthetics to psychology and philosophy. Philos Rev 1905, 14:1-20.

0921. Martienssen, H. Aesthetic judgement and the art historian. Brit J Aesthetics 1962, 2:200-206.

0922. Martin, F.D. Unrealized possibility in the aesthetic experience. J Philos 1955, 42(15):393-400.

0923. Martin, F.T. Aspects of value in contemporary painting. College Art J 1953, 12(4):321-328.

0924. Martin, L.J. Über ästhetische Synästhesie. Z Psychol 1910, 53:1-60.

0925. ——. Psychology of aesthetics. Amer J Psychol 1905, 16:35-118.

0926. Marx, K., and F. Engels. Über Kunst und Literatur. Vienna 1948.

0927. Masson-Oursel, P. Art et scolastique. JPNP 1926, 23:77-82.

0928. Matoré, G. Les notions de l'art et d'artist à l'époque romantique. Rev des Sciences Humaines 1951.

0929. Matsumoto, M. The Psychology of Esthetic Appreciation of Pictorial Arts. Tokyo: Sionami Shoten 1926, 378 p.

0930. Matthews, J.H. The case for surrealist painting. JAAC 1962, 31:139-148.

0931. Maumann, G. Geschlecht und Kunst: Prolegomena zu einer physiologischen Aesthetik. Leipzig: Haissel 143 p.

0932. Mayer, A. Der Gefühlausdruck in der bildenden Kunst. Berlin: Casirer 1913, 79 p.

0933. Mayhew, L.B. Critical analysis and judgment in the humanities. JAAC 1954, 13:256-261.

0934. Mazet, H. Pourquoi des artistes. Paris: Belfond 1961, 136 p.

0935. Meier-Graefe, J. Über Impressionismus. Kunst für Alle 1909-10, 25:145-162.

0936. ——. Modern Art; Being a Contribution to a New System of Aesthetics. 2 Vol, NY: 1908; Münich-Leipzig 1907, 210 p.

0937. Meige, H. (The nude in Christian art.) Presse méd 1930, 38:629-631.

0938. Meiss, M. Guilt, penance and religious rapture after the Black Death. Magazine of Art 1951, 44:280-285.

0939. ——. Painting in Florence and Siena after the Black Death. Princeton: Princeton Univ Pr 1951, 194 p.

0940. Menguet, P. L'art comme jeu ou comme science. Rev nouvelle 1961, 34: 302-310.

0941. Meumann, E. Die Grenzen der psycho logischen Ästhetik. In Philosophische Abhandlungen Max Heinge zum 70. Geburt stage gewidmet von Freunden und Schüler Berlin 1906, 146-182.

0942. Meyerson, I. Les métamorphoses de l'espace en peinture. JPNP 1953, 46:405-428.

0943. ——. Peinture et réalité. A propos d'un livre de M. Étienne Gilson. JPNP 1961, 58:331-346.

0944. ——. Sur la spécificité de l'art et des ses objects. JPNP 1956, 53:53-62.

0945. Michelis, P.A. An Aesthetic Approach to Byzantine Art. London: Batsford 1955, 284 p.

0946. ——. Aesthetic distance and the charm of contemporary art. JAAC 1959, 18:1-45.

0947. ——. Aesthetic judgment. Riv di Estetica 1958, 3(3):428-437.

0948. ——. Dialectics in art. In Actes des Entretiens philosophiques d'Athènes, 1955 Athens 1956, 135-142.

0949. ——. Esthetique de l'art byzantin. Paris: Flammarion 1959, 289 p.

0950. Minguet, P. L'oeuvre d'art comme forme symbolique. Rev de Philos 1961, 86:307-318.

0951. Mischel, T. Some questions concerning art and exhibitive judgment. J Philos 1959, 56:233-246.

0952. Mochizuki, T. (The problem of character in art—the human figure.) Bigaku (Tokyo) 1956, 7(2):10-16.

0953. Möbius, P.J. Über Kunst und Künstle

Leipzig 1901, 296 p.

0954. Moholy-Nagy, L. In defense of "abstract" art. JAAC 1945, 4:74-76.

0955. ———. Idea and pure form. Arts & Architecture 1951, 68:24-25.

0956. Molé, W. Prolegomena to the aesthetics of early medieval art. Estetyka (Warsaw) 1961, 2.

0957. Moles, A. Théorie de l'information et perception esthétique. Paris: Flammarion 1958.

0958. Molnar, F. Pour une science de l'art. Réponse à Lapicque. Aujourd'hui 1961, 6:3.

0959. Mondrian, P. Plastic Art and Pure Plastic Art 1937 and Other Essays, 1941-1943. NY: Wittenborn 1945, 63 p.

0960. Monod-Herzen, E. Léonard de Vinci. Le probleme de la sala asse à Milan. Rev d'Esthetique 1962, 15:113-137.

0961. Moore, J.S. The work of art and its material. JAAC 1948, 6:331-338.

0962. Morales, J.M.R., and J.A. Gaya Nuño. Greco-Das Lebenswerk des Malers und sein Weltruhm in unserer zeit. Universitas (Stuttgart) 1963, 18:391-399.

0963. Morawski, S. (Realism as an artistic category.) Estetyka (Warsaw) 1961, 2:17-36.

0964. Morgan, D.N. Criticism cubed: H. Osborne's aesthetics and criticism. Rev Metaphysics 1955, 9:274-284.

0965. ———. Icon, index and symbol in the visual arts. Philos Studies 1955, 6(4): 49-54.

0966. ———. On pictorial "truth." Philos Studies 1953, 4:17-24.

0967. Morris, B. The Aesthetic Process. Evanston, Ill.: Northwestern Univ Pr 1943, 189 p.

0968. ———. The art-process and the aesthetic fact in Whitehead's philosophy. In Schlipp, P.A. (ed.), The Philosophy of Alfred North Whitehead. NY: Tudor 1941, 463-486.

0969. ———. The arts and their cultural matrix. Western Humanities Rev 1950, 4: 121-128.

0970. ———. The arts today. Antioch Rev 1960-61, 20:467-476.

0971. ———. Intention and fulfillment in art. Philos phenomenol Res 1940, 1:127-153.

0972. ———. The legacy of Freud in art criticism. Colorado Quart 1960, 9:165-174.

0973. Morris, C. Science, art, and technology. Kenyon Rev 1939, 1:409-423.

0974. ———. Significance, signification, and painting. In Lepley, R. (ed.), The Language of Value. NY: Columbia Univ Pr 1957, 58-76; Methodos 1953, 5:87-102.

0975. Morris-Jones, H. Art and imagination. Philosophy 1959, 34:204-216.

0976. ———. What is great art? Brit J Aesthetics 1962, 2(1).

0977. Motherwell, R. Beyond the aesthetic. Design 1946, 47:14-15.

0978. Moutsopoulos, E. Vers une phénoménologie de la création. Rev de Philos 1961, 86:263-291.

0979. Mueller, J.H. Theories of esthetic appreciation. In Studies in Appreciation of Art. Eugene, Oregon: Univ Oregon Pr 1934, 4, No. 6, 7-30.

0980. Müller, M. (Decadent art, pathologic art.) Rev de Psihologie teoretică si aplicată (Cluj Universitatea) 1948, 11:117-132.

0981. Müller, W. Genie und Talent; über das Ethos im Kunstwerk. Munich: Reinhardt 1940, 49 p.

0982. Müller-Freienfels, R. Die Entwicklung und Ausbreitung des ästhetischen Lebens durch die Kunst. Arch für systematische Philosophie u Soziologie 1910, 16:521-531.

0983. ———. Zur Theorie der ästhetischen Elementarerscheinungen. Vierteljahrsschrift für wissenschaftliche Philosophie 1908, 32:95-133, 193-236.

0984. Mukerjee, R. The meaning and evolution of art in society. Amer Sociological Rev 1945, 10:496-503.

0985. ———. The Social Function of Art. NY: Philosophical Library 1954, 280 p; Bombay: Hind 1948, 366 p.

0986. Mumford, L. Art and Technics. NY: Columbia Univ Pr 1952, 162; London: Oxford Univ Pr 1952, 162 p; Stuttgart: Kohlhammer 1960, 135 p.

0987. ———. The Brown Decades. A Study of the Arts in America, 1865-1895. NY: Harcourt, Brace 1931, 266 p; NY: Dover 1962, 280 p.

0988. ———. The role of the creative arts in contemporary society. Durham, N.H.: Univ New Hampshire 1958, 23 p.

0989. Mundt, E. Art Form and Civilization. Berkeley: Univ California Pr 1952, 246 p.

0990. Munitz, M.K. Toward a philosophy of art as creation. Amer Scholar 1941, 10(4):472-482.

0991. Munro, T. Aesthetic inquiry: current types of. In Encyclopedia of the Arts. NY: Philosophical Library 1945, 13-14.

0992. ———. Aesthetics and the artist. JAAC 1953, 11:397-412.

0993. ———. Aesthetics: an old subject comes to life. Amer Magazine Art 1931, 23:447-450.

0994. ———. Aesthetics as science: its de-

velopment in America. JAAC 1951, 9:161–207; in Farber, M. (ed.), Philosophic Thought in France and the United States. Buffalo: Univ Buffalo Pr 1950.

0995. ——. The analysis of form in art. In Art in American Life and Education. 40th Yearbook. National Soc Stud Educ. Bloomington, Ill.: Public School Publ Co 1941, 349–368.

0996. ——. Art, aesthetics, and liberal education. JAAC 1944, 3(9):91–106.

0997. ——. Art Education: Its Philosophy and Psychology. Selected Essays. NY: Liberal Arts Pr 1956, 387 p.

0998. ——. Art and scientific technology. Philos phenomenol Res 1959, 19:399–410.

0999. ——. Les arts et leur relations mutuelles. Paris: PUF 1954, 454 p.

1000. ——. The Arts and Their Interrelations. A Survey of the Arts and an Outline of Comparative Aesthetics. NY: Liberal Arts Pr 1949, 559 p.

1001. ——. Creative ability in art, and its educational fostering. In Art in American Life and Education. 40th Yearbook. National Soc Stud Educ. Bloomington, Ill.: Public School Publ Co 1941, 289–322.

1002. ——. Do the arts evolve? Some recent conflicting answers. JAAC 1961, 19:407–417.

1003. ——. Do the arts progress? JAAC 1955, 14:175–190.

1004. ——. Evolution in the Arts: And Other Theories of Culture History. Cleveland: Cleveland Museum of Art 1963, 562 p.

1005. ——. Form in the arts: an outline for descriptive analysis. JAAC 1943, 2(8):5.

1006. ——. Form and value in the arts: a functional approach. JAAC 1955, 13:316–341.

1007. ——. Four hundred arts and types of art: a classified list. JAAC 1957, 16:44–65.

1008. ——. Knowledge and control in the field of aesthetics. JAAC 1941, 1(1):1–12.

1009. ——. The Marxist theory of art history. Socio-economic determinism and the dialectic process. JAAC 1960, 18:430–445.

1010. ——. The Scientific Method in Aesthetics. NY: Norton 1928, 101 p.

1011. ——. The strange neglect of G.L. Raymond; some needed researches in American aesthetics. JAAC 1955, 13:533–537.

1012. ——. Suggestions and symbolism in the arts. JAAC 1956, 15:152–180.

1013. ——. Toward Science in Aesthetics; Selected Essays. NY: Liberal Arts Pr 1956, 371 p.

1014. ——. What is art? Cleveland Museu Bull 1943, 30:126.

1015. Munro, T., et al. The Future of Aesthetics: a Symposium on Possible Ways of Advancing Theoretical Studies of the Arts and Related Types of Experience. Cleveland: Cleveland Museum of Art 1942 111 p.

1016. Murphy, A.E. The Artist as Creator; an Essay of Human Freedom. Baltimore: Johns Hopkins Univ Pr 1956.

1017. Murray, E. Some uses and misuses of the term "aesthetic." Amer J Psychol 1930, 42:640–644.

1018. Myers, B.S. Art and Civilization. NY: McGraw-Hill 1957, 757 p.

1019. ——. The German Expressionists: A Generation in Revolt. NY: Praeger 1957, 401 p; London: Thames & Hudson 1957, 400 p; Cologne 1957, 396 p.

1020. Nachmansohn, M. Zur Erklärung der durch Inspiration entstandenen Bewusstseinserlebnisse. Arch ges Psychol 1917, 26(2,3).

1021. Nahm, M.C. (ed.). Aesthetic Experience and Its Presuppositions. NY: Harper 1946.

1022. ——. Art as one of the bridges of cultural understanding. In Bryson, L., et al. (eds.), Approaches to Group Understanding. NY: Harper 1947, 375–388.

1023. ——. The Artist as Creator; An Essay of Human Freedom. Baltimore: Johns Hopkins Univ Pr 1956, 352 p.

1024. ——. The functions of art and fine art in communication. JAAC 1947, 5:273–280.

1025. ——. The relation of aesthetics to art criticism. J Philos 1961, 58:704–705.

1026. ——. Structure and judgment of art. J Philos 1948, 45:684–695.

1027. Nahm, M.C., et al. Form in art; the function of art. In Art; a Bryn Mawr Symposium. Bryn Mawr, Pa.: Bryn Mawr College 1940, 275–311, 312–350.

1028. Nakian, R., and B.V. Bothmer. Ego and eternity, a dialogue on late Egyptian art. Art News 1960, 59(7):28–30.

1029. Narazaki, M. (On the art of Kiyochika Kobayashi.) Bigaku (Tokyo) 1950, 1(1).

1030. Naville, A. Linéaments de psychologie esthétique. Arch Psychol 1903, 2:89–104.

1031. Negri, N.C. Notes toward a scientific classification of art. Hibbert J 1961, 60:35–43.

1032. Neihardt, C.R. A Painter's Approach to the Role of Theory in the Creative Act of Painting. Dissertation Abstr 1961, 22:2354-2

1033. Neumeyer, A. Arts and social reconstruction. JAAC 1945, 3(9-10):79.

1034. ——. Glanz des Schönen. Gespräche mit Bildern. Heidelberg: Lambert Schneider 1959, 115 p.

1035. ——. Picasso and the road to American art. JAAC 1943, 2(6):24.

1036. Newton, A. Art in relation to truth. Studio 1945, 129:74-77.

1037. Newton, E. Art as communication. Brit J Aesthetics 1961, 1(2).

1038. Newton, N.T. An Approach to Design. Cambridge, Mass.: Addison-Wesley 1951, 144 p.

1039. Nicholas, F.W. Your esthetic I.Q. Carnegie Magazine 1945, 19:109-111.

1040. Nohl, H. Vom Sinn der Kunst. Göttingen: Vandenhöck & Ruprecht 1961, 129 p.

1041. Nordau, M.S. On Art and Artists. London 1907, 351 p.

1042. Northrop, F.S.C. Theory of Beauty. NY: Philosophical Library 1953.

1043. Novotny, F. Adalbert Stifter als Maler. Vienna: Schroll 1947, 119 p.

1044. ——. Das Problem des Menschen Cézanne in Verhältnis zu seiner Kunst. Z Aesth 1932, 26:268-289.

1045. Ogden, C.K., I.A. Richards, and J. Wood. The Foundations of Aesthetics. London: Allen & Unwin 1922, 92 p.

1046. Olguín, M. Marcelino Menéndez Pelayo's theory of art, aesthetics, and criticism. Berkeley: Univ California Pr 1950, 25 p.

1047. ——. The theory of ideal beauty in Arteaga and Wincklemann. JAAC 1949, 8: 12-33.

1048. Ortega, J.Y.C. The Dehumanization of Art and Notes on the Novel. Princeton: Princeton Univ Pr 1948, 103 p; Garden City, NY: Doubleday 1956, 187 p.

1049. Osborne, H. The quality of feeling in art. Brit J Aesthetics 1963, 3(1).

1050. ——. The use of nature in art. Brit J Aesthetics 1962, 2:318-327.

1051. Ossowski, S. (At the Bases of Aesthetics.) Warsaw: Pánstwowe Wydawnictwo 1958, 362 p.

1052. Ozenfant, A. Art. Paris: Budry 1928, 316 p.

1053. ——. Du canon. Cahiers d'Art 1932, 7(8-10):343-351.

1054. ——. Sur les écoles cubistes et postcubistes. JPNP 1926, 23:290-302.

1055. ——. Foundations of Modern Art. NY: Dover 1962, 236 p; NY: Harcourt 1927.

1056. Paalen, W. Form and Sense. NY: Wittenborn 1945.

1057. Paci, E. Angoscia e fenomenologia dell'eros. Aut Aut 1954, 24.

1058. Panofsky, E. Der Begriff des Kunstwollens. Z Aesth 1919-20, 14:321-339.

1059. ——. Codex Huygens and Leonardo Da Vinci's Art Theory. London: Warburg Institute 1940, 138 p.

1060. ——. Galileo as a Critic of the Arts. The Hague 1954.

1061. ——. Ideas. Leipzig-Berlin 1924.

1062. ——. Meaning in the visual arts. Magazine of Art 1951, 44:45-50.

1063. ——. Meaning in the Visual Arts. Papers in and on Art History. NY: Doubleday 1957, 362 p.

1064. ——. Die Perspektive als Symbolische Form. Leipzig: Warburg 1927.

1065. ——. Zum Problem der Beschreibung und Inhaltsdeutung von Werken der bildenden Kunst. Logos 1932, 21:103-119.

1066. ——. Renaissance and Renascences in Western Art. Stockholm: Amquist & Wiksell 1960, 242 p.

1067. ——. Studies in Iconology: Humanistic Themes in the Art of the Renaissance. NY: Harper & Row 1962, 262 p; Oxford: Oxford Univ Pr 1939, 262 p.

1068. ——. Die theoretische Kunstlehre Albrecht Dürers. Doctoral dissertation. Freiburg. Berlin 1914, 61 p.

1069. ——. Three decades of art history in the United States; impressions of a transplanted European. College Art J 1954, 14: 7-27.

1070. ——. Über das Verhältnis der Kunstgeschichte zur Kunsttheorie. Z Aesth 192425, 18:129-161.

1071. Pap, J. Kunst und Illusion. Leipzig 1914, 224 p.

1072. Pappas, G. An Analysis of the Process of Beginning and Developing Works of Art. Dissertation Abstr 1957, 17:2882-2883.

1073. Pareyson, L. Interprétation et jugement. Rev de Philos 1961, 86:222-236.

1074. ——. Personalità e socialità dell'arte. Riv di Estetica 1959, 4:197-219.

1075. Parker, D.H. Aesthetics. In Runes, D. (ed.), Twentieth Century Philosophy. NY: Philosophical Library 1949, 39-50.

1076. ——. The Analysis of Art. New Haven: Yale Univ Pr 1926, 190 p.

1077. ——. The Principles of Aesthetics. NY: Crofts 1920, 1946, 316 p.

1078. ——. Wish fulfillment and intuition in art. In Brightman, E.S. (ed.), Proceedings of the Sixth International Congress of Philosophy, 1926. NY: Longmans, Green 1927, 437-441.

1079. Parkhurst, H.H. Beauty. NY: Harcourt, Brace 1930, 336 p.

1080. Parnes, S.J., and H.F. Harding (eds.). A Source Book for Creative Thinking. NY:

Scribner's 1962, 393 p.

1081. Paschal, L. Esthétique nouvelle
fondée sur la psychologie du génie. Paris
1910, 398 p.

1082. Passeri Pignoni, V. Autorità e libertà
nell'arte contemporanea. Teoresi 1960,
15:222-230.

1083. ———. Solitudine e communicazione
nell'arte contemporanea. Sapienza 1962,
15:63-85.

1084. Passmore, J.A. The dreariness of
aesthetics. Mind 1951, 60:318-335.

1085. ———. Psycho-analysis and aesthetics.
Australian J Psychol Philos 1936, 14:127-
144.

1086. Pater, W.H. The Renaissance; Studies
in Art and Poetry. London: Macmillan 1910,
328 p; NY: Macmillan 1913, 328 p.

1087. Paulsson, G. (Critique and Program.)
Stockholm: Geber 1949, 160 p.

1088. ———. Die soziale Dimension der
Kunst. Bern: Francke 1955.

1089. Payant, F. The social background of
American art. Yrb nat Soc Stud Educ 1941,
40:29-36.

1090. Pearson, R.M. Experiencing Pictures.
NY: Harcourt Brace 1932, 225 p.

1091. Peel, E.A. On identifying aesthetic
types. Brit J Psychol 1945, 35:61-69.

1092. Pelles, G. The image of the artist.
JAAC 1962, 31:119-138.

1093. Pepper, S.C. Aesthetic Quality; A
Contextualistic Theory of Beauty. NY:
Scribner's 1938.

1094. ———. Art and experience. Rev Meta-
physics 1958, 12:294-299.

1095. ———. The Basis of Criticism in the
Arts. Cambridge: Harvard Univ Pr 1945,
177 p.

1096. ———. Is non-objective art superfi-
cial? JAAC 1953, 11:255-261.

1097. ———. Principles of Art Appreciation.
NY: Harcourt Brace 1949, 326 p.

1098. ———. The Work of Art. Bloomington:
Indiana Univ Pr 1955, 183 p.

1099. Pepper, S.C., and K.H. Potter. The
criterion of relevancy in aesthetics: a
discussion. JAAC 1957, 16:202-216.

1100. Pérès, J. Sur le rôle du critérium
historique en matière artistique et sur
l'anachronisme. JPNP 1934, 31:419-428.

1101. Pérez Ballestar, J. Reflexiones acerca
de la función existencial de la obra de
arte. Convivium (Barcelona) 1958, 3(5).

1102. Perls, H. Das Geheimnis der Kunst.
Zürich-Stuttgart: Artemis 1959, 238 p.

1103. Peterson, C. Recent studies in the
field of psychological aesthetics. J Home
Economics 1958, 50:769-771.

1104. Pfister, O. Die Entstehung der künst-

lerischen Inspiration. Imago 1913, 2:481-
512.

1105. ———. Wahrheit und Schönheit in der
Psychanalyse. Zurich: Rascher 1918, 143 p

1106. Philips, G.B. What does art express?
J Philos 1929, 26:459-466.

1107. Philipson, M. (ed.). Aesthetics To-
day. NY: Meridian 1961, 475 p.

1108. ———. Dilthey on art. JAAC 1958, 17:
72-76.

1109. ———. Outline of a Jungian Aesthetics.
Evanston, Ill.: Northwestern Univ Pr 1963,
214 p.

1110. Phillips, D. The Artist Sees Different
NY: Weyhe 1931.

1111. Phillips, L.M. Art and Environment.
NY: Holt 1911.

1112. Picard, C. Sens et portée des arts
alexandrins. JPNP 1951, 44:65-84.

1113. Pickford, R.W. "Aesthetic" and "tech-
nical" factors in artistic appreciation.
Brit J Psychol 1948, 38:135-141.

1114. Picon, G. Le jugement esthétique et
le temps. Rev d'Esthétique 1955, 8:135-
156.

1115-6. Piemontese, F. Arte e filosofia.
Riv di Estetica 1960, 5:331-348.

1117. ———. Problemi di Filosofia dell'Arte.
Turin: Bottega d'Erasmo 1962, 227 p.

1118. Pierce, E. The aesthetics of simple
forms. I. Psychol Rev 1894, 1:483-495.

1119. ———. The aesthetics of simple forms.
II. Functions of the elements. Psychol Rev
1896, 3:270-282.

1120. Pieter, J. (The Criticism of Creative
Works.) Katowice, Poland: Czytelnik 1949,
337 p.

1121. Piguet, J.C. Temps et éternité. Rev
de Philos 1961, 86:247-261.

1122. Pillai, A.S.N. Sthayibhava as aes-
thetic sentiment. J psychol Res (Mysore)
1957, 1(3):23-28.

1123. Pinilla, N. Bibliografía de estética.
Bol Educ fís Santiago de Chile 1939, 6:
854-864.

1124. Pinter, R. Esthetics. Psychol Bull
1920, 17:331-335.

1125. Piper, R. Das Tier in der Kunst. Münic
1921, 302 p.

1126. Piper, R.F. The Hungry Eye; An Intro-
duction to Cosmic Art. Los Angeles: De-
Voiss 1957, 145 p.

1127. Pirenne, M.H. The scientific basis
of Leonardo da Vinci's theory of perspec-
tive. Brit J Philos Sci 1952, 3:169-185.

1128. Piwocki, K. Folk artists and their in-
spiration. Brit J Aesthetics 1963, 3(2).

1129. Placywk, S. Erotik und Schaffen.
Berlin: Marcus & Weber 1934, 225 p.

1130. Plekhanov, G.V. Art and Society. NY:

Critics Group Pr 1937, 93 p.

1131. Pope, A. Art, Artist, and Layman. Cambridge: Harvard Univ Pr 1937, 152 p.

1132. ——. The Language of Drawing and Painting. Cambridge, Mass.: Harvard Univ Pr 1949, 162 p.

1133. ——. A quantitative theory of aesthetic value. In Art Studies; Medieval, Renaissance, and Modern. Cambridge: Harvard Univ Pr 1925, Vol. 3.

1134. Porena, M. Che cos' e' il bello? Schema d'un'estetica psicologica. Milan 1905, 483 p.

1135. Porter, F. Class content in American abstract painting. Art News 1962, 61(2): 27-28, 48-49.

1136. Porter, R.F. Abstract Visual Expression. Senior thesis. Princeton Univ 1958.

1137. Portnoy, J. Is the creative process similar in the arts? JAAC 1960, 19:191-195.

1138. Pottle, T. Emotional tendencies of line; outline. School Arts Magazine 1931, 31:71-72.

1139. Prall, D.W. Aesthetic Analysis. NY: Crowell 1936, 211 p.

1140. ——. Aesthetic Judgment. NY: Crowell 1929, 394 p.

1141. Pratt, C.C. Aesthetics. Annual Rev Psychol 1961, 12:71-92.

1142. Prestipino, G. L'Arte e la Dialettica in Lukàcs e Della Volpe. Messina: D'Anna 1961, 212 p.

1143. Price, K.B. Is a work of art a symbol? J Philos 1953, 50:485-503.

1144. Procopiou, A. (Art and Aesthetics in America.) Athens 1961, 213 p.

1145. Puffer, E. The Psychology of Beauty. NY: Houghton Mifflin 1905.

1146. Querol, M. La creación artistica y lo humano en el arte. Rev de Ideas Estéticas 1960, 18(69).

1147. Quirt, W. Art's theoretical basis. College Art J 1952, 12(1):12-15.

1148. Rader, M.M. The artist as outsider. JAAC 1958, 16:306-318.

1149. —— (ed.). A Modern Book of Esthetics. NY: Holt 1952, 602 p; 1960, 540 p.

1150. Rainey, R.L. Toward a dynamic esthetic. Design 1946, 48:21-22.

1151. Ramos, S. Filosofia de la vida artistics. Buenos Aires: Espasa-Calpe Argentina 1950, 145 p.

1152. Rannells, E.W. Aesthetic expression and learning. JAAC 1947, 5:314-320.

1153. Rashevsky, N. Contribution to the mathematical biophysics of visual perception with special reference to the theory of aesthetic values of geometrical patterns. Psychometrika 1938, 3:253-271.

1154. Rassem, M. Gessellschaft und bildende Kunst. Ein Studie zur Wiederherstellung des Problems. Berlin: De Gruyter 1960, 79 p.

1155. Rawlins, F.I.G. A "directive" philosophy of paintings. Science Progress 1946, 34:721-733.

1156. Rawlins, I. Aesthetics and Gestalt. Edinburgh: Nelson 1953, 227 p.

1157. Raymond, G.R. Art in Theory, an Introduction to the Study of Comparative Aesthetics. NY: Putnam 1894, 1922, 286 p.

1158. ——. The Essentials of Aesthetics in Music, Poetry, Painting, Sculpture, and Architecture. NY: Putnam 1906, 1921, 404 p.

1159. ——. The Genesis of Art Form. NY: Putnam 1892.

1160. ——. Painting, Sculpture, and Architecture as Representative Arts. NY: Putnam 1895.

1161. ——. Proportion and Harmony of Line and Color in Painting. Sculpture, and Architecture. NY: Putnam 1899.

1162. ——. The Representative Significance of Form; An Essay in Comparative Aesthetics. NY: Putnam 1900, 514 p.

1163. Razumnyi, V.A. (Art and aesthetic education.) Kommunist 1957, 2.

1164. Read, H. Aesthetic judgment and the archetype. Riv di Estetica 1958, 3(3).

1165. ——. The Anatomy of Art; an Introduction to the Problems of Art and Aesthetics. NY: Dodd 1932, 224 p.

1166. ——. L'arte e l'evoluzione dell'uomo. Aut Aut 1951, 1:383.

1167. ——. Art Now; an Introduction to the Theory of Modern Painting and Sculpture. NY: Pitman 1948, 144 p; London: Faber & Faber 1933, 144 p.

1168. ——. A Coat of Many Colours. NY: Horizon Pr 1956, 352 p.

1169. ——. The fate of modern painting. Aesthetics (Bombay) 1951, 1(1); Horizon 1947, 16:242-254.

1170. ——. The Forms of Things Unknown: An Essay on the Impact of the Technological Revolution on the Creative Arts. Cleveland: World 1964, 249 p.

1171. ——. Grass Roots of Art. Lectures on the Social Aspects of Art in an Industrial Age. NY: Wittenborn 1955, 160 p; London: Faber & Faber 1955, 160 p.

1172. ——. Icon and Idea. The Function of Art in the Development of Human Consciousness. Cambridge: Harvard Univ Pr 1955, 161 p; London: Faber & Faber 1955.

1173. ——. Meaning of Art. London: Faber & Faber 1956, 262 p; NY: British Book Service 1956, 262 p.

1174. ———. The Modern Movement in Eng-
lish Architecture, Painting and Sculpture.
London: Cassell 1934, 124 p.

1175. ———. The Philosophy of Modern Art.
NY: Horizon 1953, 278 p; NY: Meridian
1955, 319 p.

1176. ———. Psycho-analysis and the prob-
lem of aesthetic value. Int J Psycho-Anal
1951, 32:73-82; In Yearbook of Psycho-
analysis. NY: IUP 1952, 8:344-360.

1177. ———. Realism and abstraction in
modern art. Eidos 1960, 1:26-37.

1178. ———. Recent tendencies in abstract
painting. Canadian Art 1958, 15:192-203,
242-243.

1179. ———. To Hell with Culture: and Other
Essays on Art and Society. London: Rout-
ledge & Kegan Paul 1963; NY: Schocken
1964.

1180. Read, H., and H. Arnason. Dialogue
on modern U.S. painting. Art News 1960,
59(3):32-36.

1181. Read, W.T. Aesthetic emotion. Philos
phenomenol Res 1940, 1:199-207.

1182. Redig de Campos, R. Crise de l'art
contemporain. La Table Ronde 1960, 148:
84-89.

1183. Reid, L.A. A Study in Aesthetics.
London: Macmillan 1931.

1184. ———. Symbolism in modern art. Brit
J Aesthetics 1961, 1(3).

1185. ———. The anatomy of ugliness. Art
& Industry 1945, 38:55-56.

1186. Reik, T. Ästhetik, Literatur, Kunst.
Jahrbuch für Psychoanalytische und Psy-
chopathologische Forschungen 1914, 6:
387-392.

1187. Rhodes, J.M. The Dynamics of Crea-
tivity; An Interpretation of the Literature
on Creativity with a Proposed Procedure
for Objective Research. Dissertation Abstr
1957, 17:96.

1188. Ribot, T.A. An Essay on the Creative
Imagination. Chicago: Open Court 1906,
370 p; London: Kegan Paul 1906; Paris:
Alcan 1921, 304 p.

1189. Richards, I.A., C.K. Ogden, and J.
Wood. The Foundations of Aesthetics.
NY: Lear 1948, 94 p.

1190. Rickman, J. On the nature of ugliness
and the creative impulse. Int J Psycho-
Anal 1940, 21:294-313; in Selected Con-
tributions to Psychoanalysis. NY: Basic
Books 1957, 68-69.

1191. Rieser, M. The aesthetic theory of
social realism. JAAC 1957, 16:237-248.

1192. ———. Metaphoric expression in the
plastic art. JAAC 1958, 17:194-200.

1193. ———. Object and forms of aesthetic
judgment. Riv di Estetica 1958, 3(3).

1194. ———. The semantic theory of art in
America. JAAC 1956, 15:12-26.

1195. ———. Symbolic function of aesthetic
terms. JAAC 1941, 1(4):58-72.

1196. Ringe, D.A. Horatio Greenough, Arch
bald Alison, and the functionalist theory
of art. College Art J 1960, 19(4):314-321.

1197. Ritchie, A.C. Abstract Painting and
Sculpture in America. NY: Museum of Mod
ern Art 1951, 159 p.

1198. Ritchie, B. Formal structure of the
aesthetic object. JAAC 1945, 3(11):5-14.

1199. Ritter, H. (The effect of works of
art on man.) Ärztliche Mitteilungen. Das
Hörrohr 1928, 29:13.

1200. Rodman, S. The Insiders; Rejection
and Rediscovery of Man in the Arts of Our
Time. Baton Rouge: Louisiana State Univ
Pr 1960, 130 p.

1201. Rogers, C.R. Toward a theory of crea-
tivity. ETC 1954, 11:249-260.

1202. Rojas, P. Coatlicue. Ensayo sobre
un ensayo de estética mexicana. Cuaderno
Americanos 1955, 81(3):197-204.

1203. Rolland, C. Contribution de la psy-
chologie expérimentelle à la critique
esthétique. IV Congrès Int de Psychol.
Paris 1901, 374-375.

1204. Romanell, P. Prolegomena to any
naturalistic aesthetics. JAAC 1960, 19:
139-143.

1205. Rombold, G. Nachahmung oder Schöp-
fung? Zur Philosophie der Kunst. Philo-
sophischer Rundschau 1961-62, 9(2-3):
203-208.

1206. Rome, S.C. Some formulae for aes-
thetic analysis. Rev Metaphysics 1954,
8:357-364.

1207. Romm, A. Henry Matisse: A Social
Critique. NY: Lear 1947, 96 p.

1208. Rosenberg, H. Action painting: a
decade of distortion. Art News 1962, 61
(8):42-44, 62-63.

1209. ———. Art books, book art, art. Parti-
san Rev 1960, 137-142.

1210. ———. Critics within the act. Art News
1960, 26-28.

1211. Rosenthal, E. The Changing Concept
of Reality in Art. NY: Wittenborn 1962,
96 p.

1212. Rosten, L. The Story Behind the Paint-
ing. Garden City, NY: Doubleday 1962.

1213. Roth, C. Representation in early Jewis
art. Brit J Aesthetics 1961, 1(3).

1214. Rothschild, E.F. The Meaning of Un-
intelligibility in Modern Art. Chicago:
Univ Chicago Pr 1934, 103 p.

1215. Rothschild, L. Form in flux: western
art. Amer Scholar 1963, 32:588-596.

1216. ———. Style in Art; the Dynamics of

Art as Cultural Expression. NY: Yoseloff 1960, 175 p.

1217. Rowland, B., Jr. The Classical Tradition in Western Art. Cambridge: Harvard Univ Pr 1963.

1218. Rowland, E.H. Aesthetics of Repented Space Forms. Doctoral Dissertation. Radcliffe College 1905; Harvard Psychol Studies 1906, 2:193-268.

1219. ———. The Significance of Art; Studies in Analytical Esthetics. Boston-NY, 1913, 188 p.

1220. Rowley, G. Principles of Chinese Painting. Princeton: Princeton Univ Pr 1947, 111 p.

1221. Rubin, W. Archile Gorky, surrealism and the new American painting. Art International 1963, 7(2):27-38.

1222. Rudner, R. On semiotic aesthetics. JAAC 1951, 10:67-77.

1223. ———. Some problems of non-semiotic aesthetic theories. JAAC 1957, 15:298-310.

1224. Rudolph, G.A. The aesthetic field of I.A. Richards. JAAC 1956, 14:348-358.

1225. Rudrauf, L. L'Annonciation. Étude d'un thème plastique et de ses variations en peinture et en sculpture. Paris: Grou-Radenez 1943, 150 p; résumé in JAAC 1949, 7:325-348 and in Les Cahiers Techniques de l'Art 1947, 1:62-84.

1226. ———. Le Rapas d'Emmaüs: Étude d'un thème plastique et de ses variations en peinture et en sculpture. Paris: Latines 1956, 286 p.

1227. Rugg, H. Self-cultivation and the creative act: issues and criteria. J educ Psychol 1931, 22:241-254.

1228. Ruin, H. La psychologie structurale et l'art moderne. Theorie 1949, 15:253-275.

1229. Runes, D.D., and H.G. Schrickel (eds.). Encyclopedia of the Arts. NY: Philosophical Library 1946, 1064 p.

1230. Rusk, R.D. The conflict of science and art. Sci Monthly 1930, 30:458-464.

1231. Rusk, W.S. Art as memory, activity and goal. J Higher Educ 1945, 16:312-318.

1232. ———. Art in a democratic society. JAAC 1942, 2(1):32-39.

1233. ———. Current literature on aesthetics. Art J 1961, 20(4):218-222.

1234. ———. New dimensions and the arts. Amer Scholar 1944, 13(2):193-200.

1235. ———. New ways of seeing. College Art J 1955, 15(1):38-46.

1236. Russi, A. L'arte e le arti. Saggio di un'estetica della memoria e altri saggi. Pisa: Nistri-Lischi 1960, 220 p.

1237. Rutter, F.V.P. Evolution in Modern Art. NY: Dial 1926.

1238. Ruyer, B. Le silence. Rev de Philos 1961, 86:329-331.

1239. Sachs, C. The Commonwealth of Art: Style in the Fine Arts, Music and the Dance. NY: Norton 1946.

1240. Saisselin, R.G. Malraux: from the hero to the artist. JAAC 1957, 16:256-260.

1241. Sánchez Vásquez, A. Tradicíon y creacíon en la obra de arte. Cuadernos Americanos 1955, 84(6):146-155.

1242. Sander, J. Untersuchungen über die sinnliche Lebhaftigkeit von Vorstellung. Langensalza: Beyer 1927, 140 p.

1243. Santangelo, P.E. Discorso sull'arte. Milan: Santangelo-Viale Brianza 1956, 99 p.

1244. Santayana, G. Reason in art. In The Criterion of Taste. NY: Scribner's 1905.

1245. Sarton, G. Ancient alchemy and abstract art. J History Med & Allied Sci (New Haven) 1954, 9:157-173.

1246. Saulnier, C. Le dilletantisme; essai de psychologie, de morale et d'esthétique. Paris: Vrin 1940, 404 p.

1247. Sauvage-Nolting, W.J.J. De. Lets over de psychologie der schoonheit. Een essay. Ned Tijdschr Psychol 1949, 4:460-481.

1248. Schaper, E. The "history of art" and the "history of taste." Brit J Aesthetics 1963, 3(2).

1249. ———. Philosophical surveys XII: a survey of works on aesthetics, 1945-1953. Philos Quart 1954, 4:356-372.

1250. ———. Significant forms. Brit J. Aesthetics 1961, 1(2).

1251. Schapiro, M. Introduction to Vincent van Gogh. NY: Abrams 1950.

1252. ———. Style. In Kroeber, A.L. (ed.), Anthropology Today. Chicago: Univ Chicago Pr 1953, 287-311.

1253. ———. Taste. Encyclopedia social Sciences 1934, 14:523-525.

1254. Schilling, K. Die Kunst. Bedeutung, Entwicklung, Wesen, Gattungen. Meisenheim-Glan: Hain 1961, 232 p.

1255. Schinneller, J.A. Art: Search and Self-Discovery. Scranton, Pa.: International Textbook 1961, 322 p.

1256. Schmarsow, A. Gemeinschaft der Sinnesgebiete im schöpferischen Akt. Z Aesth 1930, 1:1-14.

1257. ———. Kunstwissenschaft und Völkerpsychologie. Ein Versuch zur Verständigung. Z Aesth 1907, 2:305-339, 469-500.

1258. Schmied-Kowarzik, W. Gestaltpsychologie und Aesthetik. Atti d V Cong Int di filos. Naples 1924, 14 p.

1259. Schmitz, O.A.H. Die Triebfeder des

künstlerischen Schaffens. Österreich
Rundschau 1921, 17, 1-2.

1260. Schneider, E. The Aesthetic Motive.
NY: Macmillan 1939.

1261. Schnier, J. The function and origin
of form. A preliminary communication on
the psychology of aesthetics. JAAC 1957,
16:66-75.

1262. Schön, B. Mittheilungen aus dem
Leben Geistesgestörter. Vienna & Leipzig.
Hartleben 1859, 320 p.

1263. Schoen, M. Aesthetic experience in
the light of current psychology. JAAC 1941,
1:23-33; in Harriman, P.H. (ed.), Twen-
tieth Century Psychology. NY: Philosophi-
cal Library 1945, 457-467.

1264. ———. Art and Beauty. NY: Macmillan
1932, 230 p.

1265. ———. Creative experience in science
and art. JAAC 1941, 1(4):22-32.

1266. ——— (ed.). The Enjoyment of the Arts.
NY: Philosophical Library 1944, 336 p.

1267. ———. The social message of art.
JAAC 1944, 3(9):118-127.

1268. Schönbaumsfeld, E. Bericht über den
IV. internationalen Kongress für Ästhetik,
Athens, 1. bis 6. September 1960. Wiener
Z für Philosophie, Psychologie, Pädagogik
1961, 7(3):145-168.

1269. Schrickel, H.G. Editorial on aes-
thetic inquiry. JAAC 1945, 3(11-12):3.

1269a. ———. A psycho-anthropological
approach to problems in aesthetics. JAAC
1952, 10:315-322.

1270. Schuhl, P.S. Une évolution psycho-
logique vue par Vélasquez. Séances de la
Société Française d'Esthétique. 1961, Nov.
Rev d'Esthétique 1962, 15:376-384.

1271. Schuwer, C. Les deux sens de l'art.
Paris: PUF 1962, 124 p.

1272. Schwartz, A. The esthetics of psycho-
analysis. Amer Imago 1953, 10(4):323-343.

1273. Schwarz, J.E. Subject-Matter, Con-
tent, and the Primacy of Form. Disserta-
tion Abstr 1957, 17(10):2741.

1274. Seaby, A.W. Art in the Life of Man-
kind. NY: Oxford Univ Pr 1928.

1275. Séailles, G. Essai sur le génie dans
l'art. Leipzig: Seemann 1904, 292 p; Paris:
Baillière 1883, 1923, 313 p.

1276. ———. Le genie et l'art, chez Schopen-
hauer. JPNP 1926, 23:83-95.

1277. ———. L'origine et les desinées de
l'art. Paris 1925, 158 p.

1278. Seddon, R. Artist's vision. Studio
1948, 136:161-169; 1949, 137:1-9, 33-42,
65-73.

1279. ———. The critic and the artist. Studio
1945, 129:82-87.

1280. ———. Two modes of perception and

expression performed by artists when
painting. JAAC 1947, 6:27-31.

1281. Sedlmayr, H. Kunst und Wahrheit.
Zur Theorie und Methode der Kunstges-
chichte. Hamburg: Rowohlt 1958, 211 p.

1282. Segal, H. A psycho-analytical ap-
proach to aesthetics. In Klein, M. (ed.),
New Directions in Psycho-analysis. Lon-
don: Tavistock 1955; Int J Psycho-Anal
1952, 33:197-207.

1283. Segal, J. Beiträge zur experimentellen
Ästhetik. Über die Wohlgefälligkeit ein-
facher räumlicher Formen. Eine psycho-
logische-ästhetische Untersuchung.
Zurich 1906, 76 p.

1284. ———. (On the psychological char-
acter of the fundamental aesthetic prob-
lems.) Przegląd Filoz 1911, 4.

1285. ———. Psychologische und normative
Aesthetik. Z Aesth 1907, 2:1-24.

1286. Ségalen, V. Les synesthésies de
l'école symboliste. Mercure de France
1902, 4.

1287. Segy, L. Art appreciation and pro-
jection. ETC 1954, 12:23-32.

1288. Seitz, W. Spirit, time and abstract
expressionism. Magazine of Art 1953, 46:
80-87.

1289. Selig, H. (ed.). Jugendstil. Der Weg
ins 20. Jahrhundert. Münich: Keysersche
1959, 459 p.

1290. Selz, P. The aesthetic theories of
Wassily Kandinsky and their relation-
ship to the origin of non-objective paint-
ing. Art Bull 1957, 39:127-136.

1291. ———. German Expressionist Painting.
Berkeley: Univ California Pr 1957, 379 p.

1292. ———. New Images of Man. NY: Museum
of Modern Art 1959, 159 p.

1293. Servien, P. Art et langage. Rev
d'Esthétique 1955, 8:51-61.

1294. Sesto, I. A la caza de emociones
estéticas en diez países europeos. Monte-
video 1950, 197 p.

1295. Seuphor, M. L'art abstrait, ses
origines, ses premiers maîtres. Paris 1949.

1296. Shahn, B. How an artist looks at
aesthetics. JAAC 1954, 13:46-51.

1297. Sharrer, H. Humanism in art. Reality:
A Journal of Artists' Opinions 1952, 1(1).

1298. Shaw, T.L. Art Reconstructed; a New
Theory of Aesthetics. Boston: Marshal
Jones 1937, 278 p.

1299. Shawcross, J. Associative and aes-
thetic perception. Mind 1910, 63-81.

1300. Shearer, E.A. Dewey's esthetic theory.
II. J Philos 1935, 32:650-664.

1301. Shissler, B. George Lansing Ray-
mond's comparative aesthetics. JAAC 1961,
19:327-337.

1302. Siebeck, H. Das Wesen der ästhe-
tischen Anschauung; Psychologische
Untersuchungen zur Theorie des Schönen
und der Kunst. Berlin: Dümmder 1875,
215 p.

1303. Siemens, H.W. Der Favus auf alten
Gemälden. Hautartz 1953, 4:431-433.

1304. Simoni, J.P. Art Critics and Criti-
cism in Nineteenth Century America.
Dissertation Abstr 1958, 18:1390-1391.

1305. Singer, I. The aesthetics of "art for
art's sake." JAAC 1954, 12:343-359.

1306. Sirén, O. The Chinese on the Art of
Painting. NY: Schocken 1963.

1307. Slate, J., and I.L. Child. The pre-
conceptual eye. Art J 1963, 23:27-32.

1308. Slive, S. Realism and symbolism in
seventeenth-century Dutch painting.
Daedalus 1962, 91:469-500.

1309. Sloane, J.C. French Painting Between
the Past and the Present: Artists, Critics,
and Traditions from 1848 to 1870. Prince-
ton: Princeton Univ Pr 1951, 241 p.

1310. ———. On the resources of non-objec-
tive art. JAAC 1961, 19:419-424.

1311. ———. The tradition of figure painting
and concepts of modern art in France from
1845 to 1870. JAAC 1948, 7:1-29.

1312. Soffici, A. Cubismo e futurismo.
Florence 1914, 78 p.

1313. Sokal, E. Zur neuen psychologischen
Aesthetik. Gegenwart 1902, 61:324-325.

1314. Solomon, A.R. The new art. Art Inter-
national 1963, 7(7):37-41.

1315. Somerville, J. The arts: socialist
realism. In Soviet Philosophy. NY: Philo-
sophical Library 1946, 269 p.

1316. Sorel, G. Contributions psycho-
physiques à l'esthétique. Rev philosophique
de la France et de l'étranger 1890, 29:561-
579.

1317. Sosínska, H. (A contribution to the
psychology of esthetic feeling.) Kwartal-
nik Psychologiczny 1935, 7:489-503.

1318. Souriau, E. Art et philosophie. Rev
philosophique de la France et de l'étranger
1954, 144:1-21.

1319. ———. L'avenir de l'esthétique. Paris:
Alcan 1929, 403 p.

1320. ———. La correspondance des arts,
éléments, d'esthétique comparée. Paris:
Flammarion 1947, 280 p.

1321. ———. A general methodology for the
scientific study of aesthetic appreciation.
JAAC 1955, 14:1-18.

1322. ———. L'insertion temporelle de
l'oeuvre d'art. JPNP 1951, 44:38-62.

1323. ———. La part de la contemplation.
Rev de Philos 1961, 86:179-200.

1324. ———. Time in the plastic Arts. JAAC

1949, 7:294-307.

1325. Souriau, P. L'esthétique de la lumière.
Paris 1913, 439 p.

1326. ———. L'imagination de l'artiste.
Paris 1901, 288 p.

1327. ———. La suggestion dans l'art. Paris:
Alcan 1893.

1328. Sparshott, F.E. The Structure of Aes-
thetics. Toronto: Univ Toronto Pr 1963,
471 p.

1329. Spitzer, H. Psychologie, Aesthetik,
und Kunstwissenschaft. Deutsche Literatur-
zeitung 1909, 29(25,26,27).

1330. Stace, W.T. The Meaning of Beauty,
a Theory of Aesthetics. London: Richards
& Toulmin 1929.

1331. Stärcke, A. (The Road Back. No. 1:
Psychoanalysis and Aesthetics.) Baarn:
Hollandia 1922, 75 p.

1332. Stechow, W. Subject matter and form.
Parnassus 1941, 31:104-106.

1333. Steenberg, E. A study of aesthetics.
Theoria 1957, 23:180-192.

1334. Stefanini, L. Trattato di estetica, I:
L'arte nella sua autonomia e nel suo pro-
cesso. Brescia: Morcelliana 1960, 255 p.

1335. Stein, L. A.B.C. of Aesthetics. NY:
Boni & Liveright 1927.

1336. Steinberg, L. The eye is a part of the
mind. Partisan Rev 1953, 20:194-212.

1337. Stéphan, L. Phénoménologie du mouve-
ment pictural pur chez Léger et Pignon.
Rev d'Esthétique 1957, 10:392-406.

1338. Stephenson, R. Space, time and mon-
tage. Brit J Aesthetics 1962, 2(3).

1339. Sterzinger, O. Zur Prüfung und Unter-
suchung der künstlerischen Veranlagung.
Psychotechnische Z 1931, 6.

1340. ———. Das Steigerungsphänomen beim
künstlerischen Schaffen. Z Aesth 1917, 12.

1341. Stevenson, C.L. On the "analysis" of
a work of art. Philos Rev 1958, 67:33-51.

1342. ———. Interpretation and evaluation
in aesthetics. In Black, M. (ed.), Philo-
sophical Analysis. Ithaca: Cornell Univ
Pr 1950, 341-383.

1343. ———. Symbolism and the representa-
tive arts. In Henle, P. (ed.), Language,
Thought, and Culture. Ann Arbor, Mich.:
Univ Michigan Pr 1958, 226-257.

1344. Stites, R.S. The Arts and Man. NY:
McGraw-Hill 1940, 872 p.

1345. ———. The symbolic value of art struc-
ture. JAAC 1941, 1(1):13.

1346. Stoddard, G.D. (ed.). Art As the Meas-
ure of Man. NY: Museum Modern Art 1964,
64 p.

1347. Stömme, A. Die Struktur in der Lebens-
form der Kunst. Norske Videnskaps-Akademis
acta (Oslo), Ser II 1954, 2:12.

1348. Stokes, A.D. Inside Out: an Essay in the Psychology and Aesthetic Appeal of Space. London: Faber & Faber 1947, 72 p.

1349. Stolnitz, J. Aesthetics and the Philosophy of Art Criticism. Boston: Houghton Mifflin 1960, 510 p.

1350. ———. On artistic familiarity and aesthetic value. J Philos 1956, 53:261-276.

1351. ———. On the formal structure of esthetic theory. Philos phenomenol Res 1952, 12:346-364.

1352. ———. Some questions concerning aesthetic perception. Philos phenomenol Res 1961-62, 22:69-87.

1353. ———. On ugliness in art. Philos phenomenol Res 1950, 11:1-24.

1354. Suzuki, M. (Problems of exoticism and the style of art.) Bigaku (Tokyo) 1952, 3(3).

1355. Sweeney, J.J. New directions in painting. JAAC 1960, 18:368-377.

1356. Sypher, W. Rococo to Cubism in Art and Literature. NY: Random House 1960, 353 p.

1357. ——— (ed.). Art History. An Anthology of Modern Criticism. NY: Vintage 1963, 428 p.

1358. Szathmary, A. Symbolic and aesthetic expression in painting. JAAC 1954, 13:86-96.

1359. Tagliabue, G.M. Il Concetto Dello Stile. Saggio di Una Fenomenologia dell' Arte. Milan: Bocca 1951, 504 p.

1360. Tanida, E. (How design has come into existence.) Bigaku (Tokyo) 1955, 6(2):13-23.

1361. Tannahill, S., and T.K. Kurzband. Art. Rev educ Res 1934, 4:171-175, 230-232.

1362. Tapie, M. Observations. NY: Wittenborn 1956.

1363. Tatarkiewicz, W. Abstract art and philosophy. Brit J Aesthetics 1962, 2:227-238.

1364. ———. New art and philosophy. Estetyka (Warsaw) 1960, 1.

1365. ———. The philosophies and classical art. JAAC 1963, 22:3-8.

1366. Tatsumuya, K. (The perception of art, in time and space.) Bigaku (Tokyo) 1952, 2(4).

1367. Tatton, D.W. Esthetic Preference Change and the Personality of the Student. Dissertation Abstr 1959, 20:1289.

1368. Taylor, B.F. Form and Feeling in Painting. NY: Pageant 1959, 92 p.

1369. Taylor, H. Art and the Intellect. Moral Values and the Experience of Art. NY: Museum Modern Art 1960, 62 p.

1370. Taylor, I.A. The nature of the creative process. Amer Inst Archit J 1960, 34: 48-53.

1371. Taylor, K.E. An Analysis of Painting in the Light of Aesthetic Theory. Master's thesis. Univ Washington 1931.

1372. Ten Doesschate, G. Was Cézanne a forerunner of Luneberg? Ophthalmologica 1959, 138:456-458.

1373. Testa, A. Il carattere di realtà immediata nell' expressione artistica. Imola: Imolese 1933, 19 p.

1374. Teyssèdre, B. La réflexion sur l'art et le devenir de la raison. Rev de Philos 1961, 86:293-306.

1375. Theodor, K. Kunst als Anschauungssynthese. Baden-Baden: Heitz 1962, 129 p.

1376. Thibaudet, A. Jugement et gout. JPNP 1926, 23:52-67.

1377. Thompson, L. Logico-aesthetic integration in Hopi culture. Amer Anthropologist 1945, 47:540-553.

1378. Thompson, S.S. Existence, essence, and the work of art. Int philos Quart 1963, 3:517-536.

1379. Thomson, H.T. Art and the Unconscious; A Psychological Approach to a Problem of Philosophy. London: Kegan Paul 1925, 241 p.

1380. Thorburn, J.M. Mysticism and art. Monist 1920, 30:599-617.

1381. Thouless, R.H. A racial difference in perception. J soc Psychol 1933, 4:330-339.

1382. Thurston, C. The "principles" of art. JAAC 1945, 4:96-100.

1383. ———. The Structure of Art. Chicago: Univ Chicago Pr 1940.

1384. Tietze, H. Zur Psychologie und Ästhetik der Kunstfalschung. Z Aesth 1933, 27:209-240.

1385. Tokunaga, I. Some suggestions about the nude. Bigaku (Tokyo) 1951, 1(4).

1386. Tolstoy, L.N. What Is Art? NY: Liberal Arts Pr 1960, 213 p.

1387. Tomas, V. Creativity in art. Philos Rev 1958, 67:1-15.

1388. ———. Ducasse on art and its appreciation. Philos phenomenol Res 1952, 13: 73-74.

1389. ———. Has Professor Greene proved that art is a cognitive process? J Philos 1940, 37:459-469.

1390. ———. Dr. Munro, scientific aesthetics and creative art. Philos phenomenol Res 1959, 19.

1391. ———. A note on creation in art. J Philos 1962, 59:464-468.

1392. ———. Mr. Stolnitz questions concerning aesthetic vision: a reply. Philos

phenomenol Res 1961-62, 22:88-91.

1393. Torossian, A. A Guide to Aesthetics. Palo Alto, Calif.: Stanford Univ Pr 1937.

1394. Tracy, H.L. An intellectual factor in aesthetic pleasure. Philos Rev 1941, 50:498-508.

1395. Tripathi, D. The 32 sciences and the 64 arts. Indian Soc Oriental Art J 1943, 11:40-64.

1396. Tsuzumi, T. (The Essence of the aesthetic object.) Bigaku (Tokyo) 1955, 6(2):1-12.

1397. Tuttle, J.R. Freedom in art. JAAC 1943, 2(8):45-53.

1398. Tyler, K. Modern methods in teaching art; psychological aesthetics, stimuli. Design 1937, 39:7-9.

1399. Unesco. The Artist in Modern Society. NY: Columbia Univ Pr 1954, 128 p.

1400. Ungaretti, G. L'artista nella società moderna. Aut Aut 1952, 2.

1401. University of California. Art and Artist. Berkeley: Univ California Pr 1956, 240 p.

1402. Ushenko, A.P. Beauty in art. Monist 1932, 42:627-629.

1403. ———. Dynamics of Art. Bloomington: Indiana Univ Pr 1953, 257 p.

1404. ———. Pictorial movement. Brit J Aesthetics 1961, 1(2).

1405. Utitz, E. Aesthetik. Berlin 1923, 204 p.

1406. ———. Ästhetik und allgemeine Kunstwissenschaft. Jahrbuch für Philosophie und phänomenologische Forschung 1913, 1:322-364.

1407. ———. Ästhetik und Philosophie der Kunst. Jahrbuch für Philosophie und phänomenologische Forschung 1927, 3: 306-332.

1408. ———. Ausserästhetische Faktoren im Kunstgenuss. Z Aesth 1912, 7:619-651.

1409. ———. Die Funktiousfreuden im ästhetischen Verhalten. Halle 1911, 152 p.

1410. ———. Die Grundlagen der jüngsten Kunstbewegung. Ein Vortrag. Stuttgart: Enke 1913, 27 p.

1411. ———. Grundlegung der allgemeinen Kunstwissenschaft. Stuttgart: Enke 1920, 2 Vols.

1412. ———. Der Künstler. Stuttgart: Enke 1925, 68 p.

1413. ———. A note on "Aesthetics and the artist." JAAC 1954, 12:393-395.

1414. ———. Vom Schaffen des Künstlers. Z Aesth 1915, 10(4), Oct.

1415. ———. Zum Schaffen des Künstlers. Z Aesth 1924, 18:59-70.

1416. ———. Die Überwindung des Expressionismus. Charakterologische Studien zur Kultur der gegenwart. Stuttgart: Enke 1927, 190 p.

1417. Valentine, C.W. An Introduction to the Experimental Psychology of Beauty. London: Methuen 1962, 438 p; NY: Dodge 1913, 94 p; 1926, 340 p; London: Jack 1913.

1418. Vallis, V. Artist and environment: an Australian study. Brit J Aesthetics 1962, 2(4).

1419. Valverde, J.M. La aventura del espacio en la pintura contemporánea española. Rev de Ideas Estéticas 1960, 18(69).

1420. Van der Kroon, A. (From automatism to art.) Ned Tijdschr Geneesk 1933, 77: 5278-5288.

1421. Van der Leeuw, (?). Das Heilige und das Schöne. Z für Religionspsychologie 1929, 2:101-140.

1422. Vantongerloo, G. Paintings, Sculptures, Reflections. NY: Wittenborn 1948, 48 p.

1423. Varendonck, J. (On aesthetic symbolism. A psychoanalytic study.) Antwerp: De Ned Boekhandel 1923.

1424. ———. A contribution to the study of artistic preference. Int J Psycho-Anal 1922, 3:409-429.

1425. ———. (Unconscious symbolism in the field of aesthetics.) Ned Tijdschr Geneesk 1923, 67:1601.

1426. Various. Art and criticism, 1918-1939. Times Lit Suppl, Aug 10, 1946, 373-374.

1427. Various. Art and reality: a symposium. College Art J 1943, 11:115-127.

1428. Various. Atti del III° congresso internazionale di estetica (Venezia, 3-5 Settembre 1956). Turin: Ed della Rivista di Estetica 1957, 718 p.

1429. Various. Mélanges Georges Jamati. Création et vie intérieure: recherches sur les sciences et les arts. Paris: Centre National de la Recherche Scientifique 1956, 333 p.

1430. Various. Vergleichende Untersuchungen zur Psychologie, Typologie, und Pädagogik des ästhetischen Erlebens. Göttingen: Bandenhoeck & Ruprecht 1928.

1431. Various. Visages et perspectives de l'art moderne (peinture, musique, poésie). Paris: Éd du Centre National de la Recherche Scientifique 1955.

1432. Vax, L. Le fantastique, la raison et l'art. Rev de Philos 1961, 86:319-328.

1433. Veal, H. Perceptual impressionism. Artist 1957, 54:2-4, 38-40, 54-56.

1434. Veinstein, A. Charles Lalo lectures: from superstition to science in aesthetics. JAAC 1949, 7:355-364.

1435. Venturi, L. Aesthetic idea of impres-

sionism. JAAC 1941, 1(1):34-45.

1436. ———. Art Criticism Now. Baltimore: Johns Hopkins Univ Pr 1941.

1437. ———. Art and taste. Art Bull 1944, 26:271-273.

1438. ———. Painting & Painters. NY: Scribner's 1945, 250 p.

1439. ———. Le rôle de la critique contemporaine dans la création artistique. L'Amour de l'Art 1938, 19:305-306.

1440. Verkauf, W. (ed.). Dada: Monograph of a Movement. NY: Wittenborn 1957, 188 p.

1441. Verworn, M. Ideoplastische Kunst. Jena 1914.

1442. Vivas, E. Artistic Transaction and Essays on Theory of Literature. Columbus: Ohio State Univ Pr 1963.

1443. ———. Creation and Discovery; Essays in Criticism and Aesthetics. NY: Noonday Pr 1955, 306 p.

1444. ———. The esthetic judgment. J Philos 1936, 33:57-69.

1445. Vivas, E., and M. Krieger (eds.). The Problems of Aesthetics; A Book of Readings. NY: Rinehart 1953, 639 p.

1446. Vleuten, F. Van. Visionäre Mystik und visionäre Kunst. Die Nation 1907, 24: 363.

1447. Volek, J. (Aesthetics as science and artistic programme.) Estetyka (Warsaw) 1961, 2:63-75.

1448. Volkett, J. Die Bedeutung der niederen Empfindungen für die ästhetische Einfühlung. Z angew Psychol 1903, 32:1-37.

1449. ———. Kunst und Volkerziehung; Betrachtungen über Kulturfragen der Gegenwart. München 1911, 184 p.

1450. ———. Zur Psychologie des ästhetischen Geniessens. Z Aesth 1924-25, 18:1-16.

1451. ———. Psychologische analyse der Aesthetik. Z Psychol 1901, 25:1-49.

1452. ———. Die psychologischen Quellen des ästhetischen Eindruckes. Z für Philosophie und philosophische Kritik 1900, 117:161-189.

1453. ———. System der Aesthetik. München: Beck 1925-27.

1454. Von Allesch, G.J. Über das Verhältnis der Aesthetik zur Psychologie. Z Psychol 1910, 54:401-536.

1455. Wacker, J. Intention in art criticism. J Philos 1961, 58:706.

1456. ———. Particular works of art. Mind 1960, 59:223-233.

1457. Waelder, R. Psychoanalytic Contributions to Aesthetics. NY: IUP 1964.

1458. Wagner, G. The organized heresy: abstract art in the United States. Modern Age 1960, 4(3):260-268.

1459. ———. Parade of Pleasure: A Study of Popular Iconography in the U.S. NY: Library Publ 1955, 192 p.

1460. Wahl, J. Correspondence complète de Vincent Van Gogh. Rev Métaphysique et de Morale 1963, 1:100-142.

1461. ———. Note sur la realité. Verve 1952, 7(27-28):105-106.

1462. Wahl, M. Le mouvement dans la peinture. Paris: PUF 1955, 179 p.

1463. Waldberg, P. Surrealism. NY: Skira 1962, 150 p.

1464. Walden, H. Einblick in Kunst. Expressionismus, Futurismus, Kubismus. Berlin 1917, 175 p.

1465. Waldmann, E. Die Kunst des Realismus und des Impressionismus im 19. Jahrhundert. Berlin 1927, 652 p.

1466. ———. Moskauer ästhetik. Kunst u Künstler 1932, 31:182-186.

1467. Waley, A. The Chinese philosophy of art. Burlington Magazine 1920, 37:309-310; 1921, 38:32, 111-112, 244-247; 1922, 39: 10-11, 84-89, 128-131, 235-236, 292-298.

1468. ———. An Introduction to the Study of Chinese Painting. NY: Grove 1958, 262 p; London 1923.

1469. Wall, E.A. Aesthetic Sense and Education. Doctoral dissertation. New York Univ 1931, 415 p.

1470. Wallach, M.A. Art, science and representation: toward an experimental psychology of aesthetics. JAAC 1959, 18:159-173.

1471. ———. Two correlates of symbolic sexual arousal: level of anxiety and liking for esthetic material. J abnorm soc Psychol 1960, 61:396-401.

1472. Wallaschek, R. Psychologie und Pathologie der Vorstellung. Ein Beitrag zur Grundlegung der Aesthetik. Leipzig: Barth 1905, 323 p.

1473. ———. Psychologische Aesthetik. Vienna: Rikola 1930, 799 p.

1474. Wallis, M. (Juvenile and senile self-portraits.) Wiedza i Zycie 1949, 17:863-874.

1475. ———. The origin and foundations of non-objective painting. JAAC 1960, 19: 61-71; Estetyka (Warsaw) 1960, 1.

1476. ———. (The social background of the self-portrait.) Wiedza i Zycie 1949, 17: 532-553.

1477. ———. (The world of art and the world of signs.) Estetyka (Warsaw) 1961, 2:37-52.

1478. Walsh, D. The cognitive content of art. Philos Rev 1943, 52:433-451.

1479. Ward, W.E. The lotus symbol: its meaning in Buddhist art and philosophy. JAAC 1952, 11:135-146.

1480. Warner, E. Art: An Experience. NY: Harper & Row 1963, 225 p.

1481. Watson, B.A. Art and communication. Sociology & social Res 1958, 43:28-33.

1482. Watson, B. Kunst, Künstler, und soziale Kontrolle. Cologne: Westdeutschei Verlag 1961, 107 p.

1483. Weber, C.O. The aesthetics of rectangles and theories of affection. J appl Psychol 1931, 15:310-318.

1484. ———. Theories of affection and aesthetics of visual form. Psychol Rev 1927, 34:206-219.

1485. Weber, J.P. Vision infantile et peinture. Rev d'Esthétique 1957, 10:370-391.

1486. Weismann, D.L. On the function of the creative process in art criticism. College Art J 1949, 9:12-18.

1487. Weiss, J. A psychological theory of formal beauty. Psychoanal Quart 1947, 16:391-400.

1488. Weiss, P. Art, substances, and reality. Rev Metaphysics 1961, 14:685-694.

1489. ———. Organic form: scientific and aesthetic aspects. Daedalus 1960, 89: 177-190.

1490. ———. The World of Art. Carbondale: Southern Illinois Univ Pr 1961, 193 p.

1491. Weissman, P. The psychology of the critic and psychological criticism. J Amer Psychoanal Ass 1962, 10:745-761.

1492. Weisstein, A. Iconography of Chagall. Kenyon Rev 1954, 16:38-48.

1493. Weitz, M. Does art tell the truth? Philos phenomenol Res 1943, 3:338-348.

1494. ———. The logic of art. Philos phenomenol Res 1945, 5:378-388.

1495. ——— (ed.). Problems in Aesthetics. NY: Macmillan 1959, 697 p.

1496. ———. The role of theory in aesthetics. JAAC 1956, 15:27-35.

1497. ———. Symbolism and art. Rev Metaphysics 1954, 7:466-481.

1498. Werner, A. Impressionismus und Expressionismus. Leipzig-Frankfurt 1917, 58 p.

1499. Wernick, G. Zur psychologie des ästhetischen Genusses. Leipzig 1903, 148 p.

1500. Westheim, P. The art of Tamayo. A study in esthetics. Arts de Mexico 1956, 4(12):5-20.

1501. ———. Vom unbewusst schaffenden Künstler. Deutsche Kunst und Dekoration 1909, 24:118-119.

1502. Whelan, C. The arts contribute to adjustment. Design 1941, 43:19.

1503. White, J. The Birth and Rebirth of Pictorial Space. Boston: Boston Book & Art Shop 1962; London: Faber & Faber 1957, 288 p.

1504. Whitmore, C.E. The psychological approach to esthetics. Amer J Psychol 1927, 38:21-38.

1505. Whittick, A. Aesthetics and abstract painting, two views. Philosophy 1961, 36: 217-219.

1506. Whyte, L.L. (ed.). Aspects of Form. A Symposium on Form in Nature and Art. London: Lund Humphries 1951; NY: Pelligrini & Cudahy 1951, 249 p.

1507. Wickiser, R.L. Fine arts. Rev educ Res 1952, 22:141-160.

1508. Wiegand, C. The meaning of Mondrian. JAAC 1942, 2(8):62.

1509. Wiese, L.v. Ideenkunst und Sinnekunst. Z Aesth 1938, 32:97-109.

1510. Wilenski, R.H. Modern French Painters. London: Faber & Faber 1944, 424 p.

1511. ———. The Modern Movement in Art. NY: Stokes 1935, 240 p; London 1927, 237 p.

1512. ———. Something to be said for aesthetic art. Studio 1960, 159:191-195.

1513. Wiley, L.W. Some factors of pleasantness in visual design. Psychol Bull 1940, 37:568.

1514. Williams, F. Cézanne and French phenomenology. JAAC 1954, 12:481.

1515. Williams, W.M. A Theoretical Construct for the Analysis of the Painter's Task. Dissertation Abstr 1962, 22:3598-3599.

1516. Wilson, C. Form—the spirit of man. Royal Architectural Institute Canada J 1952, 29:185-188.

1517. Wilson, F.A. Approaches to contemporary art. Apollo 1958, 67:135-137, 234-236; 68:84-86, 217-219.

1518. ———. Art into Life; An Interpretation of Contemporary Trends in Painting. London: Centaur 1958, 230 p; NY: Citadel 1958, 230 p.

1519. ———. Art as Understanding. London: Routledge & Kegan Paul 1963, 200 p.

1520. Wind, E. Art and Anarchy. NY: Knopf 1964, 194 p.

1521. Winn, R.B. The beauty of nature and art. JAAC 1942, 1(5):3-13.

1522. ———. The language of art. JAAC 1945, 3(11):49-54.

1523. Winterstein, A.R.F. Das Erlebnis der Schönheit und das künstlerische Ichideal. Psychoanal Bewegung 1931, 3:112-120.

1524. ———. Zum Thema: Künstlerisches Schaffen und Kunstgenuss. Z Psychoanal

38

AESTHETICS AND ART CRITICISM

Psychother 1911, 2:291.

1525. Wischnitzer-Bernstein, (?). Studies in Jewish art. Jewish Quart Rev 1945, 36: 47-59.

1526. Witasek, S. Zur psychologischen Analyse der aesthetischen Einfühlung. Z Psychol 1901, 25:1-49.

1527. Wölfflin, H. The Art of the Italian Renaissance. NY 1913, 436 p.

1528. ——. Über den Begriff des Malerischen. Logos 1913, 4:1-7.

1529. ——. Gedanken zur Kunstgeschichte. Basel 1941.

1530. ——. Die klassische Kunst. Basel: Schwabe 1948, 299 p.

1531. ——. Die Kunst Albrecht Dürers. Münich 1905, 316 p.

1532. ——. Principles of Art History. The Problem of the Development of Style in Later Art. NY: Dover 1956, 237 p; London 1932, 237 p.

1533. Wolff, R.J. About creativity and artists. College Art J 1957, 16:322-325.

1534. Wollheim, R. Art and illusion. Brit J Aesthetics 1963, 3(1).

1535. Woodward, J.M. Perseus. Cambridge: Cambridge Univ Pr 1937.

1536. Worringer, W. Abstraction and Empathy: A Contribution to the Psychology of Style. NY: IUP 1953, 144 p; Münich, n.d.

1537. ——. Art questions of the day. Criterion 1927, 6:101-117.

1538. ——. Lächelt die Mona Lisa wirklich? Thema 1949, 2:25-49.

1539. ——. Von Transzendenz und Immanenz in der Kunst. Z Aesth 1908, 3:592-598.

1540. Wright, W.H. The Creative Will; Studies in the Philosophy and Syntax of Aesthetics. NY: Lane 1916.

1541. ——. Modern Painting. NY: Dodd Mead 1927.

1542. Wulf, M. (About the nature of art.) Ofakim (Israel) 1947, 4:2-9.

1543. ——. (Studying the psychology of artistic shapings.) Ofakim (Israel) 1956, 10:309-352.

1544. Wunderlich, H. Psychology of the aesthetic object. Amer Psychologist 1949, 4:265.

1545. Wyss, D. Der Surrealismus. Eine Einführung und Deutung surrealistischer Literatur und Malerei. Heidelberg: Schneider 1950, 88 p.

1546. Yasser, J. The variation form and synthesis of arts. JAAC 1956, 14:318-323.

1547. Yee, C. The philosophical basis of Chinese painting. In Northrop, F.S.C. (ed.), Ideological Differences and World Order. New Haven: Yale Univ Pr 1949, 35-68.

1547a. Yoshioka, K. (Art and reality.) Bigaku (Tokyo) 1963, 14(1).

1548. ——. (On the artistic expression.) Bigaku (Tokyo) 1952, 3(3).

1549. ——. (The universality of art.) Bigaku (Tokyo) 1958, 9(2).

1550. Yourievitch, S. L'art et la vision. Bull de l'Institut géneral psychologique (Paris) 1933, 32:26-40.

1551. Zahorska, S. Zur Umivertung des Impressionismus. Z Aesth 1929, 23:258-268.

1552. Zaidenberg, A. (ed.). The Art of the Artist. NY: Crown 1951, 176 p.

1553. Zajac, J.L. (Space in paintings.) Estetyka (Warsaw) 1962, 3:103-130.

1554. Zambrano, M. L'amour et la mort dans les dessins de Picasso. Cahiers d'Art 1951 26:29-56.

1555. Zeishold, H. Technical Studies in the Field of Fine Arts. Cambridge: Fogg Art Museum, Harvard Univ 1934.

1556. Zervos, C. Un demi-siècle d'art en France; notes sur le renouvellement esthétique de notre époque. Cahiers d'Art 1955, 30:7-13.

1557. Ziegenluss, W. Die phänomenologische Ästhetik. Berlin: Collignon 1928, 161 p.

1558. Ziehen, T. Vorlesungen über Aesthetik. Halle 1923, 1925.

1559. Ziff, P. On what a painting represents. J Philos 1960, 57:647-654.

1560. Zimmer, H. Myths and Symbols in Indian Art and Civilization. NY: Pantheon 1946, 248 p.

1561. Zonneveld, P. Het symbool. Tijdschrift voor Filosofie 1962, 24:3-51.

1562. Zucker, P. Styles in Painting. A Comparative Study. NY: Viking 1950, 338 p.

1563. Zupnick, I.L. The "aesthetics" of the early mannerists. Art Bull 1953, 35:302-306.

1564. ——. Concept of space and spatial organization in art. JAAC 1959, 18:215-217.

1565. ——. The iconology of style (or Wölfflin reconsidered). JAAC 1961, 19: 264-273.

1566. ——. Modern thought and modern art. College Art J 1954, 13(3):185-194; 13(4): 316-317; 14(1):54-55.

1567. ——. The "paratactic" image in Egyptian art. Art J 1963, 22:96-98.

1568. ——. The social conflict of the impressionists. College Art J 1960, 19:146-153.

1569. Zutt, J. Der Aesthetische Erlebnisbereich und seine krankhaften Abwandlungen. Nervenartz 1952, 163-169.

1570. Zwolínska, K. Contemporary rationalistic painting. Estetyka (Warsaw) 1960, 1.

2 Architecture

1571. Abe, K. (The problem of space in architecture.) Bìgaku (Tokyo) 1951, 3(2).
1572. ——. (Space in modern architecture.) Bigaku (Tokyo) 1956, 7(1).
1573. Adler, A. House-building and architecture. In Art and Artist. Creative Urge and Personality Development. NY: Knopf 1932, 161–206.
1574. Adler, L. Theorie der Baukunst als reine und angewandte Wissenschaft. Z Aesth 1926, 20:275–287.
1575. Alex, W. Japanese Architecture. NY: Braziller 1963, 128 p.
1576. Alford, J. Creativity and intelligibility in Le Corbusier's chapel at Ronchamp. JAAC 1958, 16:293–305.
1577. ——. Modern architecture and the symbolism of creative process. College Art J 1955, 14(2):102–123.
1578. Allsopp, B. Art and the Nature of Architecture. London: Pitman 1952, 124 p.
1579. Andersen, S.P. American Ikon: Response to the Skyscraper, 1875–1934. Dissertation Abstr 1960, 21:841.
1580. Andrews, W. Architecture, Ambition and Americans. NY: Harper 1955, 315 p.
1581. ——. Image of the architect. Amer Scholar 1960, 29:244.
1582. Anon. Administration and receiving buildings, State Hospital, Hastings, Minn. Archit Rec 1952, 111:194–199.
1583. Anon. Alaska designs for a complex community. Archit Rec 1963, 11:174–177.
1584. Anon. Architects hear psychiatrists' frustrations over design of nation's mental hospitals. Magazine of Building 1952, 96:59.
1585. Anon. Award citation; psychiatric hospital and neuropsychiatric institute for state of Tennessee, Memphis. Prog Archit 1959, 40:136–137.
1586. Anon. Aydelott design wins federal competition: psychiatric hospital for federal prisoners. Prog Archit 1962, 43:76.
1587. Anon. Baldpate, Inc., sanitarium, Georgetown, Mass. Archit Rec 1941, 90:54–55.

1588. Anon. California hospital for mental defectives. Archit Rec 1956, 120(5):220–225.
1589. Anon. Chestnut Lodge Therapy Building. Archit Forum 1955, 103(3):132–135.
1590. Anon. Children's hospital with psychiatric unit at the Medical center of University of Michigan. Prog Archit 1954, 35:12.
1591. Anon. Clinic and training center for a university. Archit Rec 1956, 120(5):212–215.
1592. Anon. Cottage plan for a state school-hospital. Archit Rec 1963, 11:178–181.
1593. Anon. A county hospital programmed for service. Archit Rec 1963, 11:168–169.
1594. Anon. Custodial mental unit with a cheerful air, geriatrics building, Middletown, N.Y., State homeopathic hospital. Archit Forum 1955, 103:138–139.
1595. Anon. Drab world; New York State Hospitals. Archit Forum 1944, 80:132.
1596. Anon. Esthetics; the new technology has freed architecture from dishonest symbolism. Archit Forum 1948, 89:142–147.
1597. Anon. General hospital with unique psychiatric unit; Methodist hospital of southern California, Arcadia. Archit Rec 1957, 122:202–207.
1598. Anon. Health buildings; intensive-care children's wing for Eastern Pennsylvania psychiatric institute. Archit Forum 1957, 107–128.
1599. Anon. Institute for psychosomatic and psychiatric research and training, Michael Reese Hospital, Chicago. Archit Rec 1951, 110:172–179.
1600. Anon. Interim report on 3500-bed hospital; Northville state hospital, Northville, Michigan. Archit Rec 1954, 116:207–212.
1601. Anon. Juvenile unit for a state mental hospital. Archit Rec 1956, 120(5):216–219.
1602. Anon. Menninger builds for service. Archit Rec 1963, 11:170–173.
1603. Anon. Mental health pavilion for general hospital. Archit Rec 1956, 120(5):226–227.

1604. Anon. Mental hospital, Jerusalem. Progr Archit 1949, 30:55-58.

1605. Anon. Mental hospital; recreation & occupational therapy wing for Philadelphia psychiatric hospital. Archit Forum 1951, 95:198-200.

1606. Anon. New hospital planned for modern intensive treatment program; South Florida state mental hospital. Archit Rec 1955, 118:219-226.

1607. Anon. Normal building for restoring mental patients to normal life, Rockville, Md. Archit Forum 1955, 103:133-135.

1608. Anon. Philadelphia, new hospital type substitutes glass for bars. Archit Forum 1953, 98:118-121.

1609. Anon. Philadelphia psychiatric hospital, Thalheimer and Weitz, architects; views and floor plans. Archit Rec 1941, 90:87-89.

1610. Anon. Planning the mental hospital. Archit Rec 1947, 101:106-113.

1611. Anon. Privacy for students in psychiatric nursing. Central Oklahoma state hospital, Norman. Archit Rec 1954, 115: 181-185.

1612. Anon. Private mental sanitorium group; problem, critique, awards, map. Beaux Arts Institute Design Bull 1948, 24:27-30.

1613. Anon. Projected mental hospital shows new trends. Archit Rec 1956, 120(5):206-211.

1614. Anon. Psychiatric clinic for a general hospital. Archit Rec 1963, 11:182-184.

1615. Anon. Psychiatric clinic at University of California hospital. Architecture & Engineering 1940, 140:50.

1616. Anon. Psychiatric group clinic, Seattle. Progr Archit 1958, 39:136-139.

1617. Anon. Psychiatric hospitals; with time-saver standards. Archit Rec 1938, 84:105-110.

1618. Anon. Psychiatric rehabilitation center for a general hospital, Whitney Warren prize; problem, critique, awards. Beaux Arts Institute Design Bull 1954, 30:23-29.

1619. Anon. Psychopathic and cancer hospital, San Francisco. Architecture & Engineering 1935, 121:45.

1620. Anon. Rx for a mental clinic. (Houston State Psychiatric Center). Archit Forum 1962, 117(2):124-125.

1621. Anon. Six clinics. Archit Forum 1964, 120(2):90-97.

1622. Anon. State hospital, Little Rock. Progr Archit 1951, 32:66.

1623. Anon. Therapy center for a private institution. Archit Rec 1963, 11:166-167.

1624. Anon. U.S. picks architect by competition: psychiatric hospital complex for federal prisoners. Archit Rec 1962, 131: 14-15.

1625. Anon. Young architect: B. Ameill proposes village for mentally ill. Progr. Archit 1959, 40:81.

1626. Appel,·K.E. Humanization of the mental hospital. Archit Rec 1953, 114(5):185-187.

1627. Argan, G.C. Architettura e ideologia. Zodiac 1957, 1:47-52.

1628. Baker, A. Planungsgrundsätze bei psychiatrischen kliniken. Baukunst u Werkform 1961, 14:596.

1628a. Baker, A., L. Davies, and P. Sivadon. Psychiatric Services and Architecture, Public Health Paper No. 1. Geneva: World Health Organization 1959.

1629. Bandmann, G. Mittelalterliche Architektur als Bedeutungsträger. Berlin: Mann 1951, 275 p.

1630. Barata, M. Réflexions sur l'architecture moderne au Brésil. Rev d'Esthétique 1962, 15:320-325.

1631. Barnes, E.A., and B.M. Young. Children and Architecture; a Unit of Work. NY: Teachers College 1932, 353 p.

1632. Barsacq, A. Architecture et dramaturgie. Paris: Flammarion 1950.

1633. Bateson, M.M. Architecture among the American Indians. Master's thesis. Univ Chicago 1925.

1634. Bayer, R. L'émotion tragique; sa nature et ses consequences pour l'architecture scénique. In Actas del Primer Congresso Nacional de Filosofia, at Mendoza 1949, March-April. National Univ of Cuyo 1951, 3:1432-1435.

1635. Behrendt, W.C. City planning. Yrb nat Soc Stud Educ 1941, 40:37-48.

1636. Belgioioso, B.L. Per una metodologia dell'analisi architettonica. Casabella 1957, 216 p.

1637. Belluschi, P. Architecture and society. Archit Rec 1951, 109:116-118; Amer Inst Archit J 1951, 15:85-88.

1638. ———. The meaning of regionalism in architecture. Archit Rec 1955, 118:131-139.

1639. Benevolo, L. Storia dell'architettura moderna. Bari: Laterza 1960.

1640. Bick, M.E. Planning the psychiatric physical plant. Amer J occup Ther 1954, 8:84-86.

1641. Bittermann, E. Art in Modern Architecture. NY: Reinhold 1952, 178 p.

1642. Blain, D. Psychiatric facilities of the future. Archit Rec 1956, 120(5):205.

1643. Blegen, C.W. (ed.). Studies in the Arts and Architecture. Philadelphia: Univ

Pennsylvania Pr 1942.

1644. Bonelli, R. Estetica contemporanea e critica dell'architettura. Zodiac (Milan) 1959, 4:22-29, 193, 203.

1645. ———. L'estetica moderna a la critica dell'architettura. Zodiac (Milan) 1959, 4.

1646. Borissavliévitch, M. Les théories de l'architecture. Paris: Payot 1926.

1647. ———. Traité d'esthétique scientifique de l'architecture. Paris 1954, 308 p.

1648. Bornat, C. The role of the architect in mental health. Royal Soc Health J 1964, 84:14-17.

1649. Bourgeois, V. De l'architecture au temps d'Erasme à l'humanisme social de notre architecture. Brussels: l'Enseyne du chat qui pêche 1949, 117 p.

1650. Boyd, A. Chinese Architecture and Town Planning, 1500 B.C.—A.D. 1911. Chicago: Univ Chicago Pr 1962, 166 p.

1651. Braddell, D. How to Look at Buildings. London: Methuen 1945.

1652. Brenner, A. Builders, artists, social planners. Saturday Rev 1951, 34:41-42.

1653. Brown, F.E. Roman Architecture. NY: Braziller 1962.

1654. Brownell, B., and F.L. Wright. Architecture and Modern Life. NY: Harper 1938, 357.

1655. Brukalska, B. (Social Principles of City Planning.) Warsaw: Trzaska, Evert & Michalski 1949, 203 p.

1656. Burchard, J.E. Alienated affection in the arts. Daedalus 1960, 89:52-61.

1657. ———. The dilemma of architecture. Archit Rec 1955, 117:193-198.

1658. ———. Shape of an architecture. Archit Rec 1957, 121:183-189.

1659. ———. The urban aesthetic. Ann Amer Acad Political & Social Sci 1957, 314:112-122.

1660. ——— (ed.). Views on art and architecture. A conversation (with Pietro Belluschi, Harry Bertoia, Reg. Butler, Eduardo Chillida, Jimmy Ernst, Walter Gropius, Le Corbusier, Richard Lippold, Walter Netsch, Irene Rice Pereira, and José Luis Sert). Daedalus 1960, 89:62-73.

1661. Burchard, J.E., and A. Bush-Brown. The Architecture of America, a Social and Cultural History. Boston: Little, Brown 1961, 595 p.

1662. Burgess, C.S. Progress in architecture. Royal Architectural Institute Canada J 1954, 31:278-280.

1663. ———. The role of architecture. Royal Architectural Institute Canada J 1953, 30: 313-315.

1664. Bush-Brown, A. The architectural polemic. JAAC 1959, 18:143-158.

1665. ———. This new shell game; function, structure, symbolism, or art? Archit Rec 1957, 121:185-189.

1666. Bush-Brown, A., and I. Halasz. Toward a basis for criticism. Archit Rec 1959, 126: 138-194.

1667. Calogero, G., et al. Estetica e architettura. Architettura 1961, 7:336-337.

1668. Caniff, C.E. Architectural barriers— a personal problem. Rehabilitation Lit 1962, 23:13-14.

1669. Carlson, D.B. Town and gown. Archit Forum 1963, 118(3):92-95.

1670. Carritt, E.F. The aesthetic experience of architecture. Brit J Aesthetics 1963, 3(1).

1671. Chandler, A.R. Architecture. In Beauty and Human Nature. Elements of Psychological Aesthetics. NY: Appleton-Century 1934, 119-135.

1672. Chang, A.I.T. The Existence of Intangible Content in Architectonic Form Based upon the Practicality of Laotzu's Philosophy. Princeton: Princeton Univ Pr 1956, 72 p.

1673. Chermayeff, S., and C. Alexander. Community and Privacy: Toward a New Architecture. Garden City, NY: Doubleday 1963, 236 p.

1674. Choay, F. Chronologie sommaire de la période 1850-1960. Principaux édifices élèves et publications le plus importantes. Rev d'Esthétique 1962, 15:351-367.

1675. Churchill, H.S. The City Is the People. NY: Reynal & Hitchcock 1945, 186 p.

1676. Clark, K. Humanism and architecture. Archit Rev 1951, 109:65-69.

1677. Colbert, C.R., et al. Social dimensions of design. Amer Inst Archit J 1962, 38:27-41.

1678. Colquohoun, A. The modern movement in architecture. Brit J Aesthetics 1962, 2: 59-65.

1679. Combet, G. Introduction à l'architecture fonctionelle. Rev d'Esthétique 1958, 11(3):7-34.

1680. Condit, C.W. Modern architecture: a new technical-esthetic synthesis. JAAC 1947, 6:45-60.

1681. Conrads, U., and H.G. Sperlich. The Architecture of Fantasy. NY: Praeger 1962, 187 p.

1682. Cram, R.A. Architecture in Its Relation to Civilization. Boston 1918, 30 p.

1683. Creighton, T.H. (ed.). Building for Modern Man: A Symposium. Princeton: Princeton Univ Pr 1949, 219 p.

1684. ———. New sensualism. Progr Archit 1959, 40:141-147, 180-187.

1685. Crompton, W.E.V. Excursion in aesthetics. Royal Institute Brit Architects J

1931, 106:76-77.

1686. Cronin, J.W. Coordinated hospital system for nervous and mental patients. Archit Rec 1953, 114(5):183-184.

1687. Cronin, J.W., and W. R. Taylor. Environment for mental therapy. Archit Rec 1956, 120(5):201.

1688. Crozet, R. Architecture et décor. Rev d'Esthétique 1958, 11(1):75-85.

1689. Cumming, J., and E. Cumming. Ego and Milieu: Theory and Practice of Environmental Therapy. NY: Atherton 1962, 292 p.

1690. Davies, J.H.V. The state of architectural criticism. Nine 1950, 3:11-19.

1691. De Tolnay, G. Michelangelo. IV: The Tomb of Julius II. Princeton: Princeton Univ Pr 1954, 200 p.

1692. Dewey, J. The meaning of architecture. Archit Rev 1935, 78:119.

1693. Djelepy, P.N. L'architecture et l'enfant. Enfance 1952, 5:138-153.

1694. Donner, P.F.R. Criticism: architecture for art's sake. Archit Rev 1941, 90: 124-126.

1695. Dorflès. G. Architecture et sémantique. Rev d'Esthétique 1962, 15:254-263.

1696. Dracoulidès, N.N. Impressions psychanalytiques de la villa d'Este. Psyché-Paris 1950, 5:867-879.

1697. Drexler, A. Japanese Architecture. NY: Museum Modern Art 1954, 288 p.

1698. Duhl, L.J. Urban design and mental health. Amer Inst Archit J 1961, 35:48-50.

1699. Early, J. Romantic Thought and Architecture in the United States. Doctoral dissertation. Harvard Univ 1953.

1700. Edman, I. Architecture and other forms of artistic expression. Amer Inst Archit J 1948, 10:154-160.

1701. Egbert, D. The idea of organic expression and American architecture. In Persons, S. (ed.), Evolutionary Thought in America. New Haven: Yale Univ Pr 1950, p. 336 ff.

1702. Escherich, M. Die Architekturmalerei in der mittelalterlichen Kunst. Z Aesth 1917, 12:425-438.

1703. Fasola, G.N. Social factors in architecture. JAAC 1950, 8:259-265.

1704. Felix, R.H. The community mental health center, a new concept. Archit Rec 1963, 11:162-164.

1705. Fitch, J.M. American Building. The Forces that Shape It. Boston: Houghton Mifflin 1948, 382 p.

1706. Frey, A. In Search of Living Architecture. NY: Architectural Book Publ 1939.

1707. ———. Some thoughts on esthetic research. Amer Inst Archit J 1958, 30:40-41.

1708. Friedman, J.J. Psychology of the audience in relation to the architecture of the theater. Psychoanal Quart 1953, 22:561-57

1709. Froment, P. Évolution de l'architectur et de l'équipement des centres psychiatriq L'Architecture d'Aujourd' hui 1959, 30:22-2

1710. Funk, J.B. Maryland builds mental hospitals. Archit Rec 1950, 108(4):154-156

1711. Galeffi, R. A propósito do ensino da estética nas escolas de belas artes e nas faculdades de arguitetura no Brasil. Rev Brasileira de Filosofia 1963, 13:229-260.

1712. Garma, A. Algunas significados de la ornementacion y la genesis del arte plastico. Rev de Psicoanálisis (Buenos Aires) 1953, 10:399-421

1713. ———. The Indo-American winged or feathered serpent, the step coil and the Greek meander: the unconscious meaning of serpentine ornamentation. Amer Imago 1954, 11:113-145.

1714. ———. Serpentine ornamentation and a regression. Amer Imago 1955, 12:293-297.

1715. Giedion, S. Architecture, You and Me: the Diary of a Development. Cambridge: Harvard Univ Pr 1958, 221 p.

1716. ———. The Beginnings of Architecture. Vol II of the Eternal Present. NY: Pantheon 1

1717. ———. Space, Time and Architecture. The Growth of a New Tradition. Cambridge: Harvard Univ Pr 1941, 601 p.

1718. Gilbert, K. Aesthetic Studies: Architecture and Poetry. Durham, N.C.: Duke Univ 1952, 145 p.

1719. ———. Clean and organic: a study in architectural semantics. Soc Architectural Historians J 1951, 10:3.

1720. Gillet, G., and J. Gillet. L'architecture européene. La Table Ronde 1963, 181: 100-108.

1721. Ginsburg, A.M. (Proportions and equilibrium of mass in architecture.) Psikhotek i psikhofiziol truda 1931, 1:46-55.

1722. Gloag, J. Victorian Taste. Some Social Aspects of Architecture and Industrial Design, from 1820-1900. NY: Macmillan 1962, 175 p.

1723. Globus, G.G., and J. Gilbert. A metapsychological approach to the architecture of Frank Lloyd Wright. Psychoanal Rev 1964, 51(4):117-129.

1724. Goldfinger, E. The sensation of space Archit Rev 1941, 90:129-131.

1725. Goodman, P. Architecture—the social art. Amer Inst Archit J 1954, 21:11-15.

1726. Goodman, P., and P. Goodman. Jews in modern architecture. Commentary 1957, 24:28-35.

1727. Goshen, C.E. (ed.). Psychiatric Architecture; a Review of Contemporary Develop

ments in the Architecture of Mental Hospitals, Schools for the Mentally Retarded, and Related Facilities. NY: American Psychiatric Ass 1959, 1961, 156 p.

1728. Gottlieb, B.J. (Greek gods of medicine and their temples. II. Epidaurus: impressions of a study trip to Hellas.) Folia Clinica Internacional (Barcelona) 1961, 11:420-422.

1729. Govinda, L.A. Solar and lunar symbolism in the development of Stupa architecture. Marg (Bombay) 1950, 4:9-20.

1730. Granpré Molière, M.J. De eeuwige architectuur, I de hedendaags arch. in het licht der geschiedenis. Amsterdam: Argus 1958, 94 p.

1731. Greeley, W.R. The Essence of Architecture. NY 1927, 119 p.

1732. Grey, E. The creative process and modern architecture. Pencil Points 1934, 15:497-498.

1733. Gromort, G. Initiation à l'architecture. Paris: Cucher 1938.

1734. Gropius, W. Esthetics. Archit Forum, Nov. 1948.

1735. ——. The Scope of Total Architecture. NY: Harper 1955, 185 p.

1736. Gutkind, E.A. Architettura e società. Milan: Communità 1959, 154 p.

1737. ——. The Twilight of Cities. NY: Free Pr 1963, 201 p.

1738. Gutman, B. Revue de la littérature consacrée aux problèmes de l'urbanisme aus U.S.A. Rev d'Esthétique 1962, 15: 343-350.

1739. Guttersen, A.G. Design of intensive treatment buildings. Archit Rec 1953, 114 (5):189-203.

1740. ——. Programming mental health facilities. Archit Rec 1963, 11:165.

1741. ——. Psychiatric service in the general hospital. Archit Rec 1953, 114(5): 204-212.

1741a. ——. Trends in the design and construction of hospital facilities in Holland. Mental Hospitals 1956, 7:27-32.

1742. Gutton, A. Conversation sur l'architecture, Vol. I. Paris: Fréal 1952.

1743. Hamilton, S.W., and M.E. Corcoran. Planning a mental hospital of 1500 beds. Dis Nerv System 1950, 11.

1744. Hamlin, T.F. The Enjoyment of Architecture. NY: Scribner's 1921.

1745. ——. Form and Function of 20th Century Architecture. NY: Columbia Univ Pr 1952, 4 Vols.

1746. ——. Public architecture. Yrb nat Soc Stud Educ 1941, 40:49-56.

1747. Hammond, P. Liturgy and Architecture. London: Barrie & Rockliff 1960, 191 p.

1748. Harkness, A. The architect in a changing world. Amer Inst Archit J 1946, 5:215-217.

1749. Haun, P. A program for a psychiatric hospital. Archit Rec 1950, 108(4):136-141.

1750. ——. Psychiatric facilities for the general hospital. Archit Rec 1949, 105: 128-129.

1751. ——. Psychiatric Sections in General Hospitals. NY: Archit Rec Publ 1950, 80 p.

1752. Heilbronn, M. Über eine architektonische Gesetzlichkeit. Z Aesth 1924-25, 18:162-194.

1753. Hesselgren, S. Arkitekturens uttrycksmedel; en arkitekturteoretisk studie med tillämpning av experimentalpsykologi och semantik. Stockholm: Almqvist & Wiskell 1954, 369 p.

1754. Hiler, H. Color in architecture. California Arts and Architecture, Sept. 1943, pp. 11, 18, 46.

1755. Hitchcock, H.R. (ed.). American Architectural Books; A List of Books, Portfolios, and Pamphlets on Architecture and Related Subjects Published in America before 1895. Minneapolis: Univ Minnesota Pr 1946, 130 p; London: Oxford Univ Pr 1946, 130 p.

1755a. ——. The Architecture of H.H. Richardson and His Times. NY: Museum of Modern Art 1936, 311 p; Hamden, Conn.: Archon 1961, 343 p.

1756. Hoeber, F. Das Kulturproblem der moderner Baukunst. Z Aesth 1918-19, 13: 1-26.

1757. Howe, G. Functional aesthetics and the social ideal. Pencil Points 1932, 13: 215-218, 505-507, 625-626.

1758. Hudnut, J. Architecture and the individual. Archit Rec 1958, 124:165-170.

1759. ——. Architecture and the Spirit of Man. Cambridge: Harvard Univ Pr 1949, 301 p.

1760. ——. Engineer's aesthetics. Archit Rec 1956, 119:139-146.

1761. Hummel, S. Die Lamapagode als psychologisches Diagramm. Psyche (Stuttgart) 1952, 5:628-635.

1762. Jacobs, J. The Death and Life of Great American Cities. NY: Random 1961, 458 p.

1763. Jeannert-Gris, C.E. (Le Corbusier). Architecture d'époque machiniste. JPNP 1926, 23:325-350.

1764. ——. Toward a New Architecture. NY: Payson & Clarke 1927.

1765. Johnson, D.L. Form and architecture. Progr Archit 1961, 42:168-170.

1766. Johnson, J.R. Art history and the immediate visual experience. JAAC 1961, 19:401-406.

1767. Johnson, P.C. Mies Van Der Rohe. NY: Museum Modern Art 1954, 216 p.

1768. Jones, B. Prolegomena to a study of the aesthetic effect of cities. JAAC 1960, 18:419-429.

1769. Jones, J.C., and D.G. Thornley (eds.). Conference on Design Methods: Papers Presented at the Conference on Systematic and Intuitive Methods in Engineering, Industrial Design, Architecture and Communications, London, September 1962. NY: Macmillan 1963, 222 p.

1770. Kaufmann, E. Architecture in the Age of Reason. Baroque and Post-Baroque in England-Italy-France. Cambridge: Harvard Univ Pr 1955, 293 p.

1771. ———. L'architecture du siècle des lumières (1715-1810). Paris: Julliard 1963.

1772. Kennedy, R.W. Philosophy—variable or constant. Amer Inst Archit J 1954, 22: 243-245.

1773. Kepes, G. Notes on expression and communication in the city-scape. Daedalus 1961, 90:147-165.

1774. ———. Visual form, structural form. Art & Architecture 1950, 67:28-29.

1775. Kingsbury, S. Reflections on where we are now. Amer Inst Archit J 1954, 22: 37-40.

1776. Kobatake, M. (Audiorium and stage-space in theatre research.) Bigaku (Tokyo) 1963, 13(4).

1777. König, G.K. Caratteri distributivi come Istituto di Storia linguistica architettonica. Florence: Coppini 1959.

1778. Kubler, G. Mexican Architecture of the Sixteenth Century. 2 Vols. New Haven: Yale Univ Pr 1948, 573 p, 468 p.

1779. Kuhn, J. Mythologische Motive in romanischen Kirchen. Schaffhausen: Columban 1949, 48 p.

1780. Kuhnen, H. Psychoanalyse und Baukunst. Imago 1924, 10:374-388.

1781. Lancaster, C. Architectural Follies in America. Or Hammer, Saw-Tooth and Nail. Rutland, Vt.: Tuttle 1960, 243 p.

1782. ———. Metaphysical beliefs and architectural principles. A study in contrasts between those of the West and Far East. JAAC 1956, 14:287-303.

1783. Lancaster, O. Pillar to Post. London: Murray 1938.

1784. Lapidus, M. The quest for emotion in architecture. Amer Inst Archit J 1961, 36:55-58.

1785. Laporte, P.M. Conceptual problems of architecture. College Art J 1949, 8(4): 247-255.

1786. Léger, F. La couleur dans l'architecture. In Meyerson, I. (ed.), Problèmes de la couleur. Paris: S.E.V.P.E.N. 1957.

1787. Le Guillant, L., and E. Monnerat. Remarques sur les établissements pour enfants inadaptés. L'Architecture d'Aujourd hui 1949, 20:89-91.

1788. Lehaby, W.R. Architecture, Nature and Magic. London: Duckworth 1956, 155 p

1789. Lehman, H.C. The creative years: oil paintings, etchings and architectural works. Psychol Rev 1942, 49:19-42.

1790. Le Ricolais, R. Ver l'âge des structures tendues. Rev d'Esthétique 1962, 15: 334-342.

1791. Lerner, M. Building, design, and the arts. In America As a Civilization. NY: Simon & Schuster 1957, 857-868.

1792. Letwin, W. Architecture in American society. J Architectural Educ 1958, 13(2): 18.

1793. Lewis, S.T. The New York Theatre; Its Background and Architectural Development: 1750-1853. Dissertation Abstr 1959, 20:261-263.

1794. Lindo, R. Arquitectura y música. Rev de Ideas Esteticas (Madrid) 1951.

1795. Löwitsch, F. Raumempfinden und moderne Baukunst. Imago 1928, 14:293-321.

1796. Loos, A. Architettura. Casabella 1959 233:35-38.

1797. Lukashok, A.K., and K. Lynch. Some childhood memories of the city. Amer Institute Planners J 22(3):142-162.

1798. Lurçat, A. Formes, compositions et lois d'harmonie. Élements d'une science de l'esthétique architecturale. Paris 1955-57, 5 vols.

1799. ———. L'organisation de l'espace urbain. In Lalo, C., et al. (eds.), Formes de l'art, formes de l'esprit. Paris: PUF 1951, 197-224.

1800. Lynch, K. The Image of the City. Cambridge: Technology Pr & Harvard Univ Pr 1960, 194 p.

1801. MacKinnon, D.W. Creativity and images of the self. In White, R.W. (ed.), The Study of Lives. Essays on Personality in Honor of Henry A. Murray. NY: Atherton 1963, Ch. 11.

1802. ———. The nature and nurture of creative talent. Amer Psychologist 1962, 17(7) 484-495.

1803. ———. The personality correlates of creativity: a study of American architects. In Nielsen, G.S. (ed.), Proceedings of the XIV International Congress of applied Psychology, Copenhagen 1961. Vol. 2. Copenhagen: Munksgaard 1962, 11-39.

1804. McQuinness, W.J. Mental hospital h odor-reducing system. Progr Archit 1959, 4

1805. Madge, C. Sociology and architecture. Archit Rec 1956, 119:184-189.

1806. Marriott, C. The necessity of follies. Archit Rev 1950, 107:218-220.

1807. Martin, K. Psychology and the architect. Arts & Architecture 1955, 72:12-13.

1808. ———. Social psychology and architecture. Arts & Architecture 1955, 72:21.

1809. Martin, P.S. The Kiva, a Survival of an Ancient House Type. Doctoral dissertation. Univ Chicago 1929.

1810. Mead, M. An anthropologist looks at architecture. Amer Inst Archit J 1958, 30: 73-79.

1811. Meeks, C.L.V. The Railroad Station. New Haven: Yale Univ Pr 1956, 203 p.

1812. Meerloo, J.A.M. The monument as a delusional token. Amer Imago 1954, 11: 363-374.

1813. Mendelsohn, E. Three Lectures on Architecture. Berkeley: Univ California Pr 1944.

1814. Michelis, P.A. Aesthetic distance and the charm of contemporary art. JAAC 1959, 18:1-45.

1815. ———. (The aesthetics of American architecture.) Technical Chronicle (Athens) 1954.

1816. ———. (The Aesthetics of Ferro-Concrete Architecture.) Athens: Ekdoseis tou Ethnikou Metsoviou Polytechneiou 1955, 196 p.

1817. ———. (Architecture As an Art: An Applied Aesthetics.) Athens: Hellados 1951, 364 p.

1818. ———Contemplation et expérience esthétique: à propos du fonctionnalisme en architecture. Rev d'Esthétique 1962, 15: 227-244.

1819. ———. Esthétique de l'architecture du beton armé. Paris: Dunod 1963, 221 p.

1820. ———. Refinements in architecture. JAAC 1955, 14:10-43.

1821. ———. Space-time and contemporary architecture. JAAC 1949, 8:71-86.

1822. Middleton, G.A. The Evolution of Architectural Ornament. London 1913, 117 p.

1823. Mikhailov, B.P. Les proportion dans le création architecturale. Rev d'Esthétique 1962, 15:292-319.

1824. Miller, A. Wandel im psychiatrischen krankenhaus. Baukunst u Werkform 1961, 14:504-505.

1825. Millon, H.A. The architectural theory of Francesco di Giorgio. Art Bull 1958, 40(3):257.

1826. Mock, E.B. The Architecture of Bridges. NY: Museum Modern Art 1954, 128 p.

1827. Moholy-Nagy, S. Architecture and the moon age. Archit Forum 1963, 118(2):90-92.

1828. Moore, C.W. Water and Architecture. Dissertation Abstr 1959, 19:2906.

1829. Morris, J. Cities. NY: Harcourt, Brace & World 1964, 375 p.

1830. Mueller, G.E. Philosophy and architecture. Amer Inst Archit J 1960, 34:38-43.

1831. Muller, H. The Uses of the Past. NY: Oxford Univ Pr 1952, 394 p.

1832. Mumford, L. Architecture. Chicago: American Library Ass 1926; NY: Dodd 1917.

1833. ———. The case against modern architecture. Archit Rec 1962, 131:155-162.

1834. ———. City Development. Studies in Disintegration and Renewal. NY: Harcourt, Brace 1945, 248 p.

1835. ———. The City in History; Its Origins, Its Transformations, and Its Prospects. NY: Harcourt Brace 1961, 784 p.

1836. ———. The Culture of Cities. NY: Harcourt Brace 1938, 586 p; London: Secker & Warburg 1938, 1940, 542 p.

1837. ———. Form in modern architecture. Architecture 1929, 60:125-128, 313-316; 1930, 61:151-153; 1930, 62:1-4, 315-318.

1838. ———. Function and expression in architecture. Archit Rec 1951, 110:106-112.

1839. ———. Monumentalism, symbolism and style. Magazine of Art 1949, 42:203-207, 227-228, 258-263; Archit Rev 1949, 105: 173-180.

1840. ———. Prospettiva dell'architetto. Architettura 1962, 7:838-839.

1841. ——— (ed.). The Roots of Contemporary American Architecture: 37 Essays Dating from the Mid-19th Century to the Present. NY: Reinhold 1952, 454 p; Grove 1959, 454 p.

1842. ———. The South in Architecture. NY: Harcourt, Brace 1941, 147 p.

1843. ———. Sticks and Stones; A Study of American Architecture and Civilization. NY: Boni & Liveright 1924, 247 p; NY: Horton 1933; NY: Dover 1955, 238 p.

1844. ———. Technics and Civilization. NY: Harcourt Brace 1934, 595 p; London: Routledge 1934.

1845. Nervi, P.L. L'influence du béton armé et des progrès techniques et scientifiques sur l'architecture présente et future. Exposé 1961, 2:9-10.

1846. Neutra, R. Arqitetura social: architecture of social concern. Sao Paulo, Brazil 1948, 220 p.

1847. ———. The domestic setting today. Yrb nat Soc Stud Educ 1941, 40:57-63.

1848. ———. The sound and smell of architecture. Progr Archit 1949, 30:65-66.

1849. ———. Survival through Design. Oxford: Oxford Univ Pr 1954, 384 p.

1850. ———. World and Dwelling. NY: Universe 1962, 159 p.

1851. Noel, M.S. Fundamentos para una estética nacional; contribucion a la historia de la arquitectura hispano-americana. Buenos Aires 1926, 238 p.

1852. Norberg-Schulz, C. Intentions in Architecture. Oslo: Norwegian Universities Pr 1963, 242 p.

1853. Nowicki, M. Origins and trends in modern architecture. Magazine of Art, Nov. 1951, p. 273 ff.

1854. Ogden, R.M. The tectonic arts. In The Psychology of Art. NY: Scribner's 1938, 235-256.

1855. Otto, F. Construction légère et architecture. Rev d'Esthétique 1962, 15:326-333.

1855a. Oudine, J. New trends in psychiatric architecture. Mental Hospitals 1958, 9: 31-35.

1856. Ozarin, L.D. New horizons in psychiatry. Archit Rec 1956, 120(5):202-204.

1857. Panofsky, E. Gothic Architecture and Scholasticism. Latrobe, Pa.: Archabbey Pr 1951, 156 p.

1858. Papadaki, S. (ed.). Le Corbusier: Architect, Painter, Writer. With Essays by Joseph Hudnut, S. Giedion, Fernand Leger, J.L. Sert, James Thrall Soby. NY: Macmillan 1948, 152 p.

1858a. Penney, M.F. (ed.). Bibliography on Architecture of Mental Health Facilities. Bethesda, Md.: U.S. Dept. of Health, Education, & Welfare 1964, 17 p.

1859. Pevsner, N. Mannerism and architecture. Archit Rev 1944, 96:184.

1860. ———. An Outline of European Architecture. London: Pelican 1949; Baltimore: Penguin 1964, 496 p.

1861. ———. Pioneers of Modern Design from William Morris to Walter Gropius. NY: Museum Modern Art 1954, 152 p.

1862. Pierce, J.S. Visual and auditory space in baroque Rome. JAAC 1959, 18:55-67.

1863. Pilcher, L.F. Institutions for the mentally afflicted; typical building program for an institution treating 3,500 patients. Archit Rec 1932, 71:130-137.

1864. Ponti, G. Out of a philosophy of architecture. Archit Rec 1956, 120:155-164.

1865. Pudor, H. Von den ästhetischen Formen der Raumanschauung. Ein Beitrag zur Psychologie der Architektur. Z für Philosophie und philosophische Kritik 1906, 128:154-167.

1866. Raskin, E. Behind today's walls. Archit Forum 1958, 108:155-156.

1867. Rasmussen, S.E. Experiencing Architecture. NY: Technology Pr of M.I.T. & Wiley 1959, 251 p.

1868. Read, H. The architect as universal man. Arts & Architecture 1956, 73:32-33; Archit Rec 1956, 119:166-168.

1869. Reed, H.H., Jr. The Golden City—A Pictorial Argument in the Raging Controversy over "Classical" vs. "Modern" Fashion in Architecture and other American Arts. NY: Doubleday 1959, 160 p.

1870. Rogers, E.N. Esperienza dell'architettura. Turin: Einaudi 1959, 320 p.

1871. ———. Situazione dell'architettura italiana. Aut Aut 1951, 1:452.

1872. Rosenfield, I. Philadelphia psychiatric hospital. Progr Archit 1946, 27:81-88.

1873. Rudolph, P. The changing philosophy of architecture. Amer Inst Archit J 1954, 22:65-70.

1874. Rusk, W.S. Do art forms combine or confuse? Design 1936, 38:6-8.

1875. Rutter, F. The Poetry of Architecture. London: Hodder & Stoughton; NY: Doran 1924.

1876. Saarinen, A.B. (ed.). Eero Saarinen on His Work. New Haven: Yale Univ Pr 1962, 108 p.

1877. Salvadori, M.G., and E. Raskin. The psychology of shells. Archit Forum 1958, 109:112-113.

1878. Sander, F. Gestalt Psychologie und Kunsttheorie. Ein Beitrag zur Psychologie der Architektur. Neue psychol Stud 1931, 8:311-334.

1879. Sartoris, A. Perspectivas acerca de la integracíon de las artes en la arquitectura. Rev de Ideas Estéticas 1958, 16(64).

1880. Scarborough, C. Industrial psychology in the training of architects. Royal Institute Brit Architects J 1935, 42:1134-1135.

1881. Scherer, L.G. Philosophy of modern architecture. Architecture 1930, 15:634.

1882. Schneider, W. Babylon Is Everywhere: the City as Man's Fate. NY: McGraw-Hill 1963, 400 p.

1883. Schnier, J. The cornerstone ceremony. Psychoanal Rev 1947, 34:357-369.

1884. Scholfield, P.H. The Theory of Proportion in Architecture. Cambridge: Cambridge Univ Pr 1958, 156 p.

1885. Schumacher, F. Zeitfragen der Architektur. Jena 1929, 159 p.

1886. Scott, G. The Architecture of Humanism, A Study in the History of Taste. NY: Doubleday 1954, 197 p; London: Constable 1924, 272 p.

1887. Scully, V. The Earth, the Temple, and the Gods. Greek Sacred Architecture. New Haven: Yale Univ Pr 1962, 257 p.

1888. ———. L'ironie en architecture. Rev
d'Esthétique 1962, 15:245-253.
1889. ———. Modern Architecture. NY:
Braziller 1962.
1890. Seipp, H.F.D. Wahres und Unwahres
in Architektur und Plastik; bau- und bild-
nerkunst—ästhetische Betrachtungen.
Strassburg 1929, 91 p.
1891. Shaw, A. Do we really want beauty
and order? Amer Inst Archit J 1949, 11:
249-256.
1892. Siegel, C. Structure and Form in
Modern Architecture. NY: Reinhold 1962,
308 p.
1892a. Smith, C. Architectural research
and the construction of mental hospitals.
Mental Hospitals 1958, 9:39-45.
1893. Smith, E.B. Architectural Symbolism
of Imperial Rome and the Middle Ages.
Princeton, N.J.: Princeton Univ Pr 1956,
219 p.
1894. ———. The Dome: A Study in the His-
tory of Ideas. Princeton: Princeton Univ
Pr 1950, 164 p.
1895. Smith, M.G. Architects and ids; ex-
cerpt from address. Archit Forum 1961,
115:183.
1896. Sommer, R., and G.W. Gillilana. Per-
sonal space. Design for friendship: re-
search in a large mental hospital. Amer
Inst Archit J 1962, 38:81-86.
1897. Spiegel, E. The English Farm House:
A Study of Architectural Theory and De-
sign. Dissertation Abstr 1960, 21:843-844.
1898. Stechow, W. Problems of structure
in some relations between the visual arts
and music. JAAC 1953, 11:324-333.
1899. Stein, T.A. A report of progress in
the elimination of architectural barriers.
Rehabilitation Lit 1964, 25:15-16.
1900. Sternberger, D. Gedanken über die
zeitgenössische Baukunst. Z Aesth 1929,
23:268-275.
1901. Stokes, A.D. The impact of architec-
ture. Brit J Aesthetics 1961, 1(4).
1902. Strzygowski, J. Die bildende Kunst
der Gegenwart. Leipzig 1907, 279 p;
Vienna 1923, 390 p.
1903. Sullivan, L.H. Kindergarten Chats on
Architecture, Education and Democracy.
Lawrence, Kans.: Scarab Fraternity Pr
1934, 256 p; NY: Wittenborn, Schultz 1947,
252 p.
1904. Summerson, J. The case for a theory
of modern architecture. Royal Institute Brit
Architects J 1957, 64:307-313.
1905. ———. Heavenly Mansions and Other
Essays on Architecture. NY: Scribner's
1948, 253 p; NY: Norton 1963, 253 p.
1906. Taut, B. The nature and aims of

architecture. Creative Art 1929, 4:169-
174.
1907. Thiersch, A. Die Proportionen in der
Architektur. In Handbuch der Architektur.
Darmstadt: Bergsträsser 1893, Part 4,
Section 1.
1908. Turnor, R. Nineteenth Century Archi-
tecture in Britain. London: Batsford 1950,
118 p.
1909. U.S. Dept. of Health, Education, &
Welfare. Design of Facilities for Mental
Health and Psychiatric Services—A Se-
lected Bibliography. Washington, D.C.:
Public Health Services Publ. No. 930-6-
5, 1963.
1909a. Urbain, P. Un principle d'évolution
dans l'architecture. JPNP 1926, 23:306-
324.
1910. Various. Building Types Study No.
166—Mental hospitals. Ten new mental
facilities. Archit Rec 1950, 108(4):123-157.
1911. Various. Mental hospitals; building
types study. Archit Rec 1953, 114(5):181-
212.
1912. Various. Mental hospitals; building
types study No. 240. Archit Rec 1956,
120(5):201-232.
1913. Vetter, H. Architecture's prehistoric
heritage: hunter, herder, farmer and artisan.
Archit Rec 1955, 118:194-198.
1914. Violich, E. The esthetics of city and
region. Arts & Architecture 1945, 62:25, 46,
50, 52.
1915. Walker, R. The changing philosophy
of architecture. Amer Inst Archit J 1954,
22:75-82.
1916. ———. The esthetics of architecture.
Amer Inst Archit J 1945, 4:103-109.
1917. Weigert, H. Die neue Baukunst als
Zeitspiegel. Preussische Jahrbücher 1932,
228:219-230.
1918. Wethey, H.E. Colonial Architecture
and Sculpture in Peru. Cambridge: Harvard
Univ Pr 1949, 330 p.
1919. White, W.M. Living environments
that move. Interior Design 1961, 32:160-
161.
1920. Winfield, D. An essay in the criticism
of architecture. JAAC 1955, 13:370-377.
1921. Wingo, L., Jr. (ed.). Cities and Space.
Baltimore: Johns Hopkins Univ Pr 1963,
272 p.
1922. Wittkower, R. Architectural principles
in the age of humanism. London: Studies
Warburg Inst 1949, 19.
1923. ———. Principles of Palladio's archi-
tecture. Warburg & Courtauld Institutes J
1944, 7:102-122; 1945, 8:68-106.
1924. Wölfflin, H. Prolegomena zu einer
Architektur Ästhetik. In Kleine Schriften.

Basel: Schwabe 1946.

1925. ———. Prolegomena zu einer Psychologie der Architektur. Doctoral dissertation. Univ Munich 1886, 50 p.

1926. Worringer, W. Egyptian Art. London 1928, 95 p.

1927. Wright, F.L. Architecture. Man in Possession of His Earth. Garden City, NY: Doubleday 1962.

1928. ———. Selected Writings on Architecture 1894-1900. NY: Duell, Sloan & Pearce 1941.

1929. ———. When Democracy Builds. Chicago: Univ Chicago Pr 1945.

1930. Wu, N.I. Chinese and Indian Architecture. NY: Braziller 1963, 121 p.

1931. Zévi, B. Architectura in nuce. Venice-Rome: Instituto per la Collaborazione

culturale 1960, 247 p.

1932. ———. L'architecture dans le monde actuel. Rev d'Esthétique 1962, 15:264-277.

1933. ———. Architecture as Space. How to Look at Architecture. NY: Horizon 1957, 288 p.

1934. ———. Architettura e societa. De Homine 1963, 5-6.

1935. ———. Storia dell'architettura modern Milan: Einaudi 1950.

1936. Zórawski, J. Consistency and freed in architecture. Estetyka (Warsaw) 1960,

1937. Zucker, P. The aesthetics of space in architecture, sculpture, and city planning. JAAC 1945, 4:12-19.

1938. ———. The role of architecture in future civilization. JAAC 1945, 3:30-38.

3 Art Therapy

1939. Alschuler, R.M. One year's experience with group psychotherapy. Ment Hyg 1940, 24:190–196.

1940. Anon. Amateur standing: back-to-health art. Art News 1955, 54:10.

1941. Anon. Art therapy; Hyman Segal's work in Cornwall. Artist 1953, 44:132–133.

1942. Anon. Therapeutic art; mural painting for hospital walls. Art Digest 1932, 6:11.

1943. Anon. Victoria (B.C.) experiment in art therapy. Canadian Hospital 1952, 29:88.

1944. Anon. The way to mental health. Times (London) Educ Suppl 1960, July 22, 2357:116.

1945. Appel, K.E. Drawings by children as aids to personality studies. Ops 1931, 1:129–144.

1946. Axline, V. Play Therapy; the Inner Dynamics of Childhood. Boston: Houghton Mifflin 1947, 379 p.

1947. Azima, H., F. Cramer-Azima, and E.D. Wittkower. Analytic group art therapy. Int J group Psychotherapy 1957, 7:243–260.

1948. Baruch, D.W., and H. Miller. Use of spontaneous drawings in group therapy. Amer J Psychother 1951, 5:45–58.

1949. Beals, R.G. Measurable factors in psychiatric occupational therapy. Amer J occup Ther 1949, 6:297–301.

1950. Bellak, L. Artistic production and response. In Schizophrenia: A Review of the Syndrome. NY: Logos 1958, 262–264, 388–394, 668, 749, 751, 752.

1951. Bender, L. Art and therapy in the mental disturbances of children. JNMD 1937, 86:249–263.

1952. ——, (ed.). Child Psychiatric Techniques; Diagnostic and Therapeutic Approach to Normal and Abnormal Development through Patterned, Expressive and Group Behavior. Springfield, Ill.: Thomas 1952; Oxford: Blackwell 1952; Toronto: Ryerson 1952, 335 p.

1953. ——. Group activities on a children's ward as methods of psychotherapy. Amer J Psychiat 1937, 93:1151–1170.

1954. Bender, L., and J.A. Montague. Psychotherapy through art in a Negro child. College Art J 1947, 7:12–16.

1955. Bender, L., and A.G. Woltmann. The use of plastic material as a psychiatric approach to emotional problems in children. Ops 1937, 7:283–300; In Child Psychiatric Techniques. Springfield, Ill.: Thomas 1952, 238–257.

1956. Berg, C.S. The lion and the rainbow; painting as a release for tensions. School Arts 1959, 59:15–17.

1957. Bergeron, M., and R. Volmat. Techniques et modalités de la therapeutique par l'art à l'hôspital psychiatrique. Ann méd-psychol 1952, 110:701–704.

1958. —— & ——. De la thérapeutique collective par l'art dans les maladies mentales. Encéphale 1952, 41:143–211.

1959. Bhatt, L.J. Diagnostic and therapeutic value of arts. J Educ & Psychol (Baroda) 1955, 13:132–138.

1960. Bieber, I., and J.K. Herkimer. Art in psychotherapy. Amer J Psychiat 1948, 104:627–631.

1961. Bishop, J.A. Art for our sake. Amer J Nursing 1953, 53:1205.

1962. Bloom, L. Aspects of the use of art in the treatment of maladjusted children. Ment Hyg 1957, 41:378–385.

1963. Bobon, J., G. Maccagani, and M.L. Vaessen. Plastical activity of mental patients in semeiology and psychotherapy. Confin Psychiat 1963, 6:4–14.

1964. Brick, M. Mental hygiene value of children's art work. Ops 1944, 14:136–147.

1965. Burlingame, C.C. The use of art in psychotherapy. In The Arts in Therapy. Bull Museum Modern Art 1943, 19(3):17–19.

1966. Burton Arje, F. The fine arts as an adjunct to rehabilitation. J Rehabilitation 1960, 26:28–29.

1967. Cerny, J., et al. (Creative sheetmetal,

50 ART THERAPY

metal and wire products and their use in
the treatment of mental disorders in chil-
dren.) Ceskoslovenska Psychiatrie 1963,
59:234-240.
1968. César, O. L'art chez les aliénés
dans l'hospital de Juquéri. Ann méd-
psychol 1952, 110:725-726.
1969. ———. Higiene mental e arte. Im-
prensa Médica. Revista brasileira de medi-
cina e sciencias affines (Rio de Janeiro)
1947, 22:80-87.
1970. Champernowne, H.I. Art in occupa-
tional therapy as an inner remedial pro-
cess in psychoneurotic and mental dis-
orders. Brit J physical Medicine 1952,
15:281-290.
1971. Cook, C. The role of the art educa-
tor in modern therapy. Art Digest 1953,
27:21.
1972. Cook, W.S. Student project brightens
mental hospital ward. Hospitals 1961, 35:
47.
1973. Curran, F.J. Art techniques for use
in mental hospitals and correctional in-
stitutions. Ment Hyg 1939, 23:371-378.
1794. ———. Organization of a ward for
adolescents in Bellevue Psychiatric Hos-
pital. Amer J Psychiat 1939, 95:1365-1388.
1975. ———. Value of art in the psychiatric
hospital. Dis Nerv System 1940, 1:336-
337.
1976. D'Amico, V. Art therapy in education.
In The Arts in Therapy. Bull Museum Mod-
ern Art 1943, 10(3):9-10.
1977. Dax, E.C. The creative activities in
mental hospital treatment. Med J Australia
1955, 1:57-64.
1978. ———. Experimental Studies in Psy-
chiatric Art. Philadelphia: Lippincott 1953,
100 p; London: Faber & Faber 1953, 100 p.
1979. Despert, J.L. Emotional Problems in
Children. Utica, NY: State Hospital Pr
1938, 128 p.
1980. ———. Technical approaches used in
the study and treatment of emotional prob-
lems in children. Psychiat Quart 1936,
10:619-638; 1937, 11:111-130, 267-295,
491-506, 677-693; 1938, 12:176-194.
1981. Dolto-Marrette, F. Rapport sur l'in-
terprétation psychanalytique des dessins
au cours des traitements psychothérapiques.
Psyché-Paris 1948, 3:324-346.
1982. Doorbar, R.R. Projective art at Menlo
Park. Welfare Reporter 1951, 6(11):3-4, 9.
1983. Dühsler, E. Die verschiedenen Ge-
sichtspunkte bei der Betrachtung von
Kinderziechnungen. Prax Kinderpsychol
Kinderpsychiat 1955, 4:56-60.
1984. Edelston, H. The analysis and treat-
ment of a case of neurotic conduct dis-

order in a young child illustrating the
value and use of drawing in child guidanc
technique. J ment Sci 1939, 85:522-547.
1985. English, W.H. Treatment of behavior
disorders in children. Psychiat Quart 1936
10:45-71.
1986. Enke, H., and D. Ohlmeier. Über
die Bedeutung spontaner Bildnereien in
der Psychotherapie. Z psycho-som Med
1962, 8(1):45-48.
1987. Erickson, M.H., and L.S. Kubie. The
use of automatic drawing in the interpre-
tation and relief of a state of acute ob-
sessional depression. Psychoanal Quart
1938, 7:443-466.
1988. Feather, D.B. An exploratory study
in the use of figure drawings in a group
situation. J soc Psychol 1953, 37:163-170
1989. Ferdière, G. (Reflections on art ther-
apy.) Ann méd-psychol 1961, 119:947-951
1990. Fontes, V. (Drawings and writing in
psychiatric diagnosis.) Clinica, Higene
e Hidrologia (Lisbon) May 1938.
1991. Foster, M. The mental health of the
artist as an educator in the community.
Mental Hygiene (London) 1956, 40:96-106
1992. Freeman, M. Drawing as a psycho-
therapeutic intermedium. Proc Amer Ass
mental Deficiency 1936, 41:182-187.
1993. Freeman, R.V., and I. Friedman. Art
therapy in mental illness. School Arts
1955, 54:17-20.
1994. ——— & ———. Art therapy for psy-
chiatric patients. Mental Hospitals 1955,
6:15.
1995. ——— & ———. Art therapy in a total
treatment plan. JNMD 1956, 124:421-425.
1996. Friedman, I. Art in a neuropsychiatri
centre. Canadian Hospital 1949, 26:68.
1997. ———. Art and therapy. Psychoanal
Rev 1952, 39:354-361.
1998. ———. Art in therapy; an outline of
suggested procedures. Amer J occup Ther
1953, 7:169-170.
1999. ———. Art therapy as an aid to reinte-
grative processes. Amer J occup Ther 1952
6:64-65.
2000. Garfinkle, L. Art teaching in Bellevu
Psychiatric Hospital. Psychologists Leagu
J 1939, 3:37-38.
2001. Gitelson, M. Clinical experience
with play therapy. Ops 1938, 8:466-478.
2002. Gondor, E.I. Art and Play Therapy.
Garden City, NY: Doubleday 1954, 61 p.
2003. Gordon, B. The value of art in thera-
peutic treatment. Hospital Management
1937, 43:13.
2004. Gordon, J. Art helps free a troubled
mind. School Arts 1959, 58:13-14.
2005. Grant, N. Art and the Delinquent;

How to Stimulate Social Adjustment
through Guided Self-Expression. NY: Ex-
position Pr 1958, 36 p.

2006. Greenliegh, L. Timelessness and
restitution in relation to creativity and
the aging process. J Amer Geriatrics
Society 1960, 8:353-358.

2007. Grosschopff, E.v. Heiling durch
Kunst. Psychiatrisch-neurologische
Wochenschrift (Halle) 1934, No. 5.

2008. Gutman, B. An Investigation of the
Applicability of the Human Figure Draw-
ing in Predicting Improvement in Therapy.
Dissertation Abstr 1952, 12:722.

2009. Harms, E. The arts as applied psy-
chotherapy. Occup Ther Rehab 1944, 23:
51-61.

2010. ———. Arts as applied to psychother-
apy. Design 1945, 46:4-8.

2011. ———. Awakening into consciousness
of subconscious collective symbolism as
therapeutic procedure. J Child Psychol
1948, 1:208-238.

2012. ———. The psychotherapeutical im-
portance of the arts. Occup Ther Rehab
1939, 18:235-239.

2013. Hartley, R.E., and E.I. Gondor. The
use of art in therapy. In Brower, D., and
L.E. Abt (eds.), Progress in Clinical Psy-
chology, Vol. II. NY: Grune & Stratton
1956, 202-211.

2014. Hasselmann-Kahlert, M. The diag-
nostic and therapeutic value of spontane-
ous painting in childhood. Monatsschrift
für Kinderheilkunde 1953, 101:188-189.

2015. Haswell, E.B. Art treatment of mental
illness. Hygeia 1944, 22:898.

2016. Hauser, A. The drawing as a help in
child psychotherapy. Amer J indiv Psychol
1956, 12:53-58.

2017. Haward, L.R.C. Art therapy in general
practice. Practitioner 1958, 180:1-8.

2018. Heyer, G.R. Bildnereien aus dem
Unbewussten. In Speer, E. (ed.), Lindauer
Psychotherapiewoche. Stuttgart: Hippo-
krates 1951, 26-33.

2019. ———. Klinische Analyses von Hand-
zeichnungen Analsierter. In Leitsätze der
Vorträge und Referate des IV Allgemeinen
ärztlichen Kongresses für Psychotherapie
in Bad Nauheim von 12-14 April, 1929.
Allgemeine ärtzliche Z für Psychotherapie
und psychische Hygiene (Leipzig) 1929,
2:137-138.

2020. ———. The Organism of the Mind: an
Introduction to Analytical Psychotherapy.
London: Kegan Paul, Trench, Trubner 1933,
271 p.

2021. Hicks, D.G. Creative arts in the psy-
chiatric treatment program. Med technical

Bull 1957, 8:189-196.

2022. Hill, A. Art Versus Illness: a Story
of Art Therapy. London: Allen & Unwin
1948, 106 p.

2023. Hoffman, J., and M. McDonald. The
use of artistic expression as an integral
part of the psychotherapeutic process.
Amer J Psychother 1955, 9:269-282.

2024. Hulse, W.C. Symbolic painting in
psychotherapy. Amer J Psychother 1949,
3:559-584.

2025. Huntoon, M. Art for therapy's sake.
Mental Hospitals 1959, 10:20.

2026. ———. The creative arts as therapy.
Bull Menninger Clinic 1949, 13:198-203.

2027. Hyde, R.W., and C.R. Atwell. Evaluat-
ing the effectiveness of a psychiatric
occupational therapy program. Amer J occup
Ther 1948, 2:332-349.

2028. Kennedy-Jackson, I. The use of clay
in occupational therapy. Canadian J oc-
cupational Therapy 1956, 23:103-105.

2029. Jacobs, H. Western Psychotherapy
and Hindu Sâdhanâ. NY: IUP 1961, 232 p.

2030. Jelliffe, S.E. Modern art and mass
psychotherapy. Boston med surgical J
1918, 179:609-613.

2031. Juliusburger, O. Das Leiden und die
Kunst—ein Weg seelischer Behandlung.
Z Psychother med Psychol 1952, 2:107-
110.

2032. Kalina, E. Tratamiento psicoanalito
de un adolescente a travès del dibujo.
Acta Psiquiátrica y Psicológica Argentina
1962, 8(3):218-226.

2033. Kankeleit, O. Die schöpferische Macht
des Unbewussten, ihre Auswirkungen in
der Kunst und in der modernen Psycho-
therapie. Berlin: de Gruyter 1933.

2034. Karland, S.E., and P.N. Patti. Art pro-
ductions indicating aggression toward one's
mother. Psychiat Quart Suppl 1948, 22:47-
51.

2035. Kerschbaumer, L. Art and mental health.
Avocations 1939, 4:165-166.

2036. Kielholz, A. Kind, Kunst und Analyse.
Z Psychoanal Psychother 1950, 1:121-132.

2037. Kolle, K. Bildnerei in der Psycho-
therapie. In Speer, E. (ed.), Die Vorträge
der 2. Lindauer Psychotherapiewoche 1951.
Stuttgart: Hippocrates 1952, 87-98.

2038. Kos, M., I Munari, and W. Spiel. A
propos d'un cas de vol chez l'enfant.
Rassegna di Psicologia Generale e Clinica
1956, 1(1):16-36.

2039. Kramer, E. Art Therapy in a Children's
Community; A Study of the Function of Art
Therapy in the Treatment Program of
Wiltwyck School for Boys. Springfield, Ill.:
Thomas 1958, 238 p.

2040. ———. Art therapy at Wiltwyck school. School Arts 1959, 58:5-8.

2041. Kwiatkowska, Y. Family art therapy: experiments with a new technique. Bull Art Therapy 1962, 1:3-15.

2042. Lachtin, M. Psychotherapeutische Wirkung von Kunsthandarbeit auf die Nervenkranken. Fortschritte der Sexualwissenschaft und Psychoanalyse (Leipzig-Vienna) 1928, 3:154-164.

2043. Laforgue, R. Die Rolle von Auge und Ohr in der Psychotherapie. Z psycho-som Med 1959, 5:167-171.

2044. Langfeldt, G. (Art in hospitals; the effect on mental patients.) Tidsskrift for den Norske Laegeforening 1951, 71:145-146.

2045. LeBarre, H., and M. Monod. (Drawings in evaluating psychism of children during sanitarium care.) Pédiatrie 1954, 9:300-303.

2046. LeGallais, P. (Art and psychopaths; the therapeutic role of art in the history of psychiatry.) Rev Brasileira de saúde mental 1955, 1:121-138.

2047. Lhermitte, J. Art et folie; à propos de l'exposition des oeuvres exécutées par les maladies mentaux à Sainte-Anne. Presse méd 1946, 54:193.

2048. Liss, E. Creative therapy. The arts in therapy. Bull Museum Modern Art 1943, 10(3):13-15.

2049. ———. The graphic arts. Ops 1938, 8:95-99.

2050. ———. Play techniques in child analysis. Ops 1936, 6:17-22.

2051. Lowenfeld, V. Creative and Mental Growth. NY: Macmillan 1957, 541 p.

2052. Lyddiatt, E.M. The way to mental health. Times (London) Educ Suppl 1960, July 22, 2357:117.

2053. McDougall, J.B. Art in therapeutics. Brit J physical Medicine 1943, 6:172-175.

2054. McIntosh, J.R. An inquiry into the use of children's drawings as a means of psychoanalysis. Brit J educ Psychol 1939, 9:102-103.

2055. MacKenzie, W.P. Art as occupational therapy. Occup Ther Rehab 1931, 10:307-315.

2056. Malcolmsen, D. Paint your bogey man. Coronet 1938, 4:98-103.

2057. Marinow, A. Painting in the treatment of a schizophrenic patient. Bull Art Therapy 1962, 1:24-25.

2058. Meares, A. The Door of Serenity: a Study in the Therapeutic Use of Symbolic Painting. Springfield, Ill.: Thomas 1958, 119 p; London: Faber & Faber 1958, 119 p.

2059. ———. Hypnography (hypnotic painting)—technic in in hypnoanalysis. J ment Sci 1954, 100:965-974.

2060. ———. Hypnography; a Study in the Therapeutic Use of Hypnotic Painting. Springfield, Ill.: Thomas 1957, 271 p; Oxford: Blackwell 1958, 271 p.

2061. ———. Shapes of Sanity: a Study in the Therapeutic Use of Modeling in the Waking and Hypnotic State. Springfield, Ill.: Thomas 1960, 480 p.

2062. Meinertz, J. Bild und Bild-Erfassen. Ein Kernproblem der psychotherapie. Z Psychother med Psychol 1941, 6:130-155.

2063. Milner, M.G. The communication of primary sensual experience. (The yell of joy.) Int J Psycho-Anal 1956, 37:278-281.

2064. Mohr, P. Das künstlerische schaffen Geisteskranker und seine Bezeugen zum Verlauf des Krankheit. Schweiz ANP 1940, 45:427-446.

2065. Mosse, E.P. Painting-analysis in the treatment of neuroses. Psychoanal Rev 1940, 27:68-82.

2066. Naumburg, M. Art as symbolic speech. JAAC 1955, 13:435-450; In Anshen, R.N. (ed.), In the Beginning Was the Word: An Enquiry into the Meaning and Function of Language. NY: Harper 1956.

2067. ———. Art therapy: its scope and function. In Hammer, E.F. (ed.), The Clinical Application of Projective Drawings. Springfield, Ill.: Thomas 1958, 511-517.

2068. ———. Art therapy with a seventeen year old schizophrenic girl. In Hammer, E.F. (ed.), The Clinical Application of Projective Drawings. Springfield, Ill.: Thomas 1958, 518-561.

2069. ———. Psychoneurotic Art: Its Function in Psychotherapy. NY: Grune & Stratton 1953, 148 p.

2070. ———. Schizophrenic Art: Its Meaning in Psychotherapy. NY: Grune & Stratton 1950, 247 p.

2071. ———. Spontaneous art in diagnosis and therapy. In Brower, D., and L.E. Abt (eds.), Progress in Clinical Psychology, Vol. I. NY: Grune & Stratton 1952, 290-311.

2072. ———. Studies of Free Art Expression of Behavior Problem Children and Adolescents as a Means of Diagnosis and Therapy. Nervous & Mental Disease Monograph Series 1947, No. 71; NY: Coolidge Foundation 1947, 225 p.

2073. ———. A study of the art expression of a behavior problem boy as an aid in diagnosis and therapy. Nervous Child 1944, 3:277-319.

2074. Naumburg, M., and J. Caldwell. The use of spontaneous art in analytically oriented group therapy of obese women. Ac

Psychotherapeutica, Psychosomatica et Orthopaedagogica (Basel) 1959, 7:254-287.

2075. Niswander, P.D., and R.W. Hyde. The value of crafts in psychiatric occupational therapy. Amer J occup Ther 1954, 8:104-106.

2076. Overend, N. Art therapy in sanatorium and home. Brit J physical Medicine 1950, 13:117.

2077. Pasto, T.A. Art therapy and art instruction. Confin Psychiat 1962, 5:243-250.

2078. ———. Meaning in art therapy. Bull Art Therapy 1962, 2:73-76.

2079. Paternostro, J. Pintura e recuperaçao mental. Psyke-Brasil 1947, 3.

2080. Pessin, J., and I. Freidman. The value of art in the treatment of the mentally ill. Occup Ther Rehab 1949, 28:1-20.

2081. Petrie, M. Art and Regeneration. London: Elek 1946, 142 p.

2082. Pickford, R.W. New projection material for child therapy. Quart Bull Brit psychol Society 1950, 1:358-363.

2083. Polsby, E. Brief experience with art therapy in Israel. Bull Art Therapy 1962, 1:19-23.

2084. Potts, L.R. Two picture series showing emotional changes during art therapy. Int J group Psychotherapy 1958, 8:383-394.

2085. ———. The use of art in group psychotherapy. Int J group Psychotherapy 1956, 6:115-135.

2086. Prados, M. The use of pictorial images in group therapy. Amer J Psychother 1951, 5:196-214.

2087. Prodan, S. Therapeutic collage. Amer J Nursing 1959, 59:1288-1289.

2088. Rambert, M.L. The use of drawings as a method of child psychoanalysis. In Children in Conflict. NY: IUP 1949, 173-190.

2089. Reca de Acosta, T., and N.M. Tavella. Utilización del dibujo en la clínica psicológica-psiquiatrica infantil. Arch argentinos de pediatrie (Buenos Aires) 1945, 24:404-419.

2090. Rechenberger, H.G., and C. Rechenberger. (Experiments with design as an aid in the psychotherapy of children and adolescents.) Medico Boehringer 1962, 6:170-180.

2091. Reese, H.H. Pictorial creations of psychiatric patients—a means of diagnosis and therapy. Wisconsin Med J 1954, 53:397-400.

2092. Reitman, F. Art expression and the psychotic patient. Occup Ther Rehab 1947, 26:413-431.

2093. Reznikoff, M., and L. Mundy. Changes in human figure drawings associated with therapy: a case study. Amer J Psychother 1956, 10:542-549.

2094. Roberts, M.E. Cultural education in hospital; therapy by books and the arts. Gesundheit (Zurich) 1952, 32:122-124.

2095. Rocha, Z. (Drawings in diagnosis and therapy of children's emotional disturbances.) Neurobiologia (Brazil) 1955, 18:101-113.

2096. Rogerson, C.H. Play Therapy in Childhood. London: Oxford Univ Pr 1939, 64 p.

2097. Rossman, I., and M. Clarke. Recreational and work therapy on a home care program. J Chronic Diseases 1961, 14:643-654.

2098. Sainsbury, M.J., and J.S. Price. Art and psychotherapy. Med J Australia 1962, 49:196-198.

2099. Sanders, B. Art as therapy. In The Arts in Therapy. Bull Museum Modern Art 1943, 10(3):21.

2100. Sandison, R.A. Art in mental hospitals. Hospital (London) 1949, 45:17-20; Australian Hospital 1949, 16:10.

2101. Schaefer-Simmern, H., and S.B. Sarason. Therapeutic implications of artistic ability—a case study. Amer J ment Deficiency 1944, 49:185-196.

2102. Schilder, P.F. Theoretical aspects of the art work in Bellevue Hospital. Direction 1939, 2:2-3.

2103. Schnier, J. Dynamics of art expression. College Art J 1951, 10(4):377-384.

2104. Schultze, M. Emotional release, social adjustment through art. School Arts 1962, 62:5-8.

2105. Schultze, M. Über Zeichnen und Malen als experimentell-psychologische Hilfe in der Psychotherapie. ZNP 1938, 87:704.

2106. Schwerdtner, H. (Art as a form of psychotherapy.) Schweizerische medizinische Wochenschrift 1926, 56:345-346.

2107. Searle, W.F. Art classes with mental patient. Ment Hyg 1943, 27:63-69.

2108. Sechehaye, M.A. La realisation symbolique: nouvelle méthode de psychothérapie appliquée à un cas de schizophrénie. Suppl Rev Suisse de Psychologie et de Psychologie Appliquée 1947, 12.

2109. Segal, A. Art as a Test of Normality and Its Application for Therapeutical Purposes. London: Arthur Segal's Painting School 1939, 18 p.

2110. Smith, H. Art therapy. Menninger Quart 1950, 4(4):15-18.

2111. Smith, P.A., et al. Psychological

attributes of occupational therapy crafts. Amer J occup Ther 1959, 13:16.

2112. Spitz, R. Review of Naumburg's "Psychoneurotic Art." Psychoanal Quart 1953, 23:279-282.

2113. Stern, E. Drawings as a diagnostic and therapeutic method in child psychiatry. In Heymann, K., Kind und Kunst. Psychol Praxis 1951, No. 10.

2114. Stern, H. Dessins et jeux libre en psychothérapie. Psyché-Paris 1948, 3: 360-372.

2115. Stern, M.M. Free painting as an auxiliary technique in psychoanalyses. In Bychowski, G., and J. Despert (eds.), Specialized Techniques in Psychotherapy. NY: Basic Books 1952, 65-83; NY: Grove, n.d., 65-83.

2116. Strong, R. Techniques and instruments of mental hygiene diagnosis and therapy. Rev educ Res 1940, 10:450-459.

2117. Taggart, D.L. Educational activities in mental hospitals. II. What shall be taught—designed occupational therapy for the psychiatric team. Amer J Psychiat 1953, 110:171-174.

2118. Taylor, P. Art as psychotherapy. Amer J Psychiat 1950, 106:599-605.

2119. Teirich, H.R. Group psychotherapy represented in patient's drawing. Medizinische 1955, 432-435.

2120. Trabucchi, C., and M. Marini. (The organization of a painting studio in a psychiatric hospital.) Arch Psicol Neurol Psichiat 1961, 22:509-521.

2121. Tullis, L. Christmas decorating promotes rehabilitation. Mental Hospitals 1959, 10:38.

2122. Ulman, E. Art therapy at an outpatient clinic. Psychiatry 1953, 16:55-64.

2123. Ulman, E., and H.I. Champernowne. Psychotherapy and the arts at the Withymead Center. Bull Art Therapy 1963, 2:91-119.

2124. Ulman, E., et al. Art therapy: problems of definition. Bull Art Therapy 1961, 1:10-29.

2125. Van der Horst-Oosterhuis, C.J. (Drawing and creative symbolization as therapeutic method.) Ned Tijdschr Geneesk 1955, 99:2637-2641.

2126. ——. Thérapie figurative. Évolut Psychiat 1959, 4:585-593.

2127. ——. Der therapeutische Kontakt in der Psychotherapie. Z Kinderpsychiat 1955, 22:73-80.

2128. ——. Thought painting: a key to therapy of emotionally disturbed children. J social Therapy 1957, 3:2-8.

2129. ——. "Der Unbekannte": eine zentrale magische Figur. Z Psychother med Psychol 1959, 9:1-8.

2130. ——. Visual depiction therapy in mentally disordered patients. Acta Psychotherapeutica, Psychosomatica et Orthopaedagogica (Basel) 1958, 6:205-220.

2131. VanderVeer, A.H. Occupational therapy in a children's hospital; a psychiatric view. Amer J occup Ther 1949, 3:189-195.

2132. Vernon, R.F. Silk screen painting offers ideal work for therapeutic rehabilitation. Hospital Management 1951, 71:128-1

2133. Vinchon, J. L'apport du dessin en psychothérapie. Histoire de la Médecine (Paris) 1955, 5:89-97.

2134. ——. Essais s'autotherapie par l'art. La Vie Médicale. Numero Spécial. Art et psychopathologie. Dec. 1956, 24-26.

2135. ——. La magie du dessin: Du griffonage automatique au dessin thérapeutiqu Bruges: Desclée de Brouwer 1959, 182 p.

2136. ——. La valeur du mandala en psych thérapie. Aesculape 1950, 31:169-177.

2137. VonEnke, H., and D. Ohlmeier. Über die Bedeutung spontaner Bildnereien in der Psychotherapie. Z Psycho-som Med 1962, 8:45-48.

2138. Walker. S. Paintings for patients. Hospitals (London) 1952, 26:72.

2139. Waterboer, H. Grundsätzliches zum heilpädagigischen Zeichenunterricht. Blätter für Heilerziehung 1928, 6.

2140. Williamson, F.E. Art therapy as crea tive activity for aging patients. Mental Hospitals 1959, 10:18-19.

2141. ——. Art therapy for geriatric mental patients. Geriatrics 1959, 14:752-755.

2142. Winkler, W. Aktivierung der Gestaltungskräfte durch tiefenpsychologische Verfahren. Vortäge 3. Lindauer Psychotherapiewoche 1952, 184-190.

2143. Zachry, C.B. The role of art in perso ality development. Ment Hyg 1933, 17:51-

2144. ——. The rôle of mental hygiene in the arts. Art Educ Today 1937, 31-36.

2145. Zierer, E. Bipolarity in diagnosis through art. Amer J Psychother 1950, 4: 488-499.

2146. ——. Dynamics and diagnostic value of creative therapy. The body-space test. Acta Medica Orientalia; The Israel Med J 1950, 9:35-43.

2147. ——. Dynamic and diagnostic value of creative therapy. Element-integration. Acta Medica Orientalia; The Israel Med J 1951, 10:41-48.

2148. ——. The total personality in creative therapy. Amer Imago 1952, 9(1):197-2

2149. Zierer, E., and E. Zierer. Structure ar therapeutic utilization of creative activity Amer J Psychother 1956, 10:481-519.

4 Caricature and Cartoon

2150. Abelson, R.P., and J. Levine. A factor analytic study of cartoon humor among psychiatric patients. J Personality 1958, 26:451-466.

2151. Adam, (?). The physician in caricature. Z für ärztliche Fortbildung (Jena) 1938, 35:28-30.

2152. Annis, A.D. The relative effectiveness of cartoons and editorials as propaganda. Psychol Bull 1939, 36:638.

2153. Anon. Famous faces by Oscar Berger. Amer Artist 1963, 27:45-49, 65-67.

2154. Anon. My Son the Teenager. A Cartoon Satire. NY: Belmont 1963, n.p.

2155. Anon. Vingt-quatre caricatures médicales de Daumier. Aesculape 1929, 19:161-184.

2156. Armstrong, L., and W. Darrow, Jr. A Child's Guide to Freud. NY: Simon & Schuster 1963.

2157. Ashbee, C.R. Caricature. London: Chapman & Hall 1928.

2158. Baumgarten, F. (Political caricature drawing of children as a mass psychologic phenomenon.) Z Kinderpsychiat 1948, 15:92-100.

2159. Baumgarten-Tramer, F. L'enfant caricaturiste politique. Horyzonty 1948, No. 1-2.

2160. Bishop, W.J. Medical caricature. Med & Biological Illustrations 1956, 6:9-16.

2161. Blum, A. La caricature révolutionnaire. Paris: Jouve 1916.

2162. ——. L'estampe satirique en France pendant les guerres de religion. Paris: Giard et Briet 1916.

2163. Boubier, A.M. Les jeux de l'enfant pendant la classe. Arch Psychol 1901, 1.

2164. Brodbeck, A.S., and D.M. White. How to read L'il Abner intelligently. In Rosenberg, B. (ed.), Mass Culture: The Popular Arts in America. Glencoe, Ill.: Free Pr 1957, Ch. 10; In Haimowitz, M.L., and N.R. Haimowitz (eds.), Human Development. Selected Readings. NY: Crowell 1960, 754-760.

2165. Collier, M.J. Popular cartoons and prevailing anxieties. Amer Imago 1960, 17(3):255-269.

2166. Dangers, R. (Wilhelm Busch as caricaturist of physicians and surgeons.) Münchener medizinische Wochenschrift 1937, 84:1420-1421.

2167. Davis, R. Caricature of to-day. Studio 1938, Special Autumn No.

2168. Denney, J.T. Fractured Freud. Englewood Cliffs, N.J.: Prentice-Hall 1959.

2169. Dorbec, P. La peinture française sans le Second Empire jugée par le factum, le chanson, et la caricature. Gazette des Baux-Arts 1918, 14:409-427.

2170. Drake, T.G.H. Medical caricatures of Thomas Rowlandson. Bull Hist Med 1942, 12:323-335.

2171. Feiffer, J. Sick, Sick, Sick. NY: McGraw-Hill 1952; NY: New American Library 1960, n.p.

2172. Felon, A. La caricature en Angleterre. Paris 1902, 282 p.

2173. Fuchs, E. Die Frau in der Karikatur. Munich: Lange 1906.

2174. ——. Die Karikatur des Europäischen Volker vom Altertum zur Neuzeit. Berlin: Hoffman 1901.

2175. ——. Die Jüden in der Karikatur. Munich: Lange 1921.

2176. ——. Der Weltkrieg in der Karikatur. Munich: Lange 1916.

2177. George, D.M. English Political Caricature: A Study of Opinion and Propaganda. 2 Vols. Oxford: Oxford Univ Pr 1960, 237 p, 275 p.

2178. Gombrich, E.H. Cartoon and Progress. London: Contact 1947.

2179. Gombrich, E.H., and E. Kris. Caricature. London: King Penguin 1940.

2180. —— & ——. Principles of caricature. Brit J med Psychol 1938, 17; in Kris, E., Psychoanalytic Explorations in Art. NY: IUP 1952, 189-203; London: Allen & Unwin 1953, 189-203.

2181. Gori, G. Il grottesco nell'arte e nella letteratura, comico, tragico, lurico. Rome 1926, 175 p.

2182. Graham, J. I'm Driving my Analyst Crazy. NY: Citadel 1959.

2183. Guilford, J.P., N.W. Kettner, and P.R. Christensen. A factor-analytic study across the domains of reasoning, creativity, and evaluation: II. Administration of tests and analysis of results. Rep psychol Lab, No. 16. Los Angeles: Univ Southern California 1956.

2184. ———, ——— & ———. A factor-analytic study across the domains of reasoning, creativity, and evaluation: I. Hypotheses and descriptions of tests. Rep psychol Lab, No. 11. Los Angeles: Univ Southern California 1954.

2185. Haggard, E.A., and H. Sargent. Use of comic strip characters in diagnosis and therapy. Psychol Bull 1941, 38:714.

2186. Jones, H.W. Medical caricatures. Bull Med Library Ass 1943, 31:108-118.

2187. Kettner, N.W., J.P. Guilford, and P.R. Christensen. A factor-analytic study across the domains of reasoning, creativity, and evaluation. Psychol Monogr 1959, 73:1-31.

2188. Kris, E. The psychology of caricature. Imago 1934, 20:450-466; In Psychoanalytic Explorations in Art. NY: IUP 1952,173-188; London: Allen & Unwin 1953,173-188.

2189. La Barre, W. The apperception of attitudes: responses to "The Lonely Ones" of William Steig. Amer Imago 1949, 6:3-43.

2190. Leake, C.D. Medical caricature in the United States. Bull Soc Med History 1928, 4:1-29.

2191. Le Fann, W.R. A Holbein cartoon discovered. Brit Med J 1963, 323:117.

2192. Léger, C. Courbet selon les caricatures et les images. Paris 1920.

2193. Levine, J. Responses to humor. Sci Amer 1956, 194(2):31-35.

2194. Lopez-Rey, J. Goya's Caprichos. Beauty, Reason and Caricature. 2 Vols. Princeton: Princeton Univ Pr 1953, 224 p, 265 p.

2195. Lynch, B. A History of Caricature. London: Faber & Gwyer 1936.

2196. McGuire, D., and C.S. Moss. An indirect validation study of the Draw-A-Person Test through the cartoons of William Steig. J proj Tech 1962, 26(1):89-95.

2197. Machover, K. The body image in art communication as seen in William Steig's drawings. J proj Tech 1955, 19:453-460.

2198. Miller, H. As others see us or doctors in caricature. Med Art Sci 1948, 2: 28-40.

2199. Mitchell, A.G. Medical caricature. Proc California Acad Med 1939-40,23-24.

2200. Moellenhoff, F. Remarks on the popularity of Mickey Mouse. Amer Imago 1940,1.

2201. More, D.M., and A.F. Roberts. Societal variations in humor response to cartoons. J soc Psychol 1957, 45:233-243.

2202. Munro, L. Analysis of a cartoon in a case of hypochondriasis. Int J Psycho-Anal 1948, 29:53-57.

2203. Murray, P. The Leonardo cartoon. Brit J Aesthetics 1962, 2(3).

2204. Myers, L. Psychiatric Glossary: A Cartoon View of the World of Psychiatry. NY: Dutton 1962, 94 p.

2205. Nathan, H., J. Hirsch, and N. Bingol. The physician in the caricature. Postgraduate Med J 1961, 29:214-218.

2206. Redlich, F.C. The psychiatrist in caricature; an analysis of unconscious attitudes toward psychiatry. Ops 1950, 20:560-571.

2207. Redlich, F.C., J. Bingham, and J. Levi The Inside Story. Psychiatry and Everyday Life. NY: Random House 1953; NY: Vintage 1963, 240 p.

2208. Rosen, V.H. Variants of comic caricature and their relationship to obsessive-compulsive phenomena. J Amer Psychoanal Ass 1963, 11:704-724.

2209. Sachs, F. (Caricatures in medicine.) Deutsche medizinische Wochenschrift (Stuttgart) 1928, 54:1007-1010.

2210. Schapiro, M. Courbet and popular imagery. Warburg and Courtauld Institute J 1941, 4:164-191.

2211. Shaffer, L.F. Children's Interpretation of Cartoons. Teachers College Contributions to Education, No. 429. NY: Bureau of Publications, Teachers College 1930, 73

2212. Shapiro, E., B. Biber, and P. Minuchin The Cartoon Situation Test: a semi-structured technique for assessing aspects of personality pertinent to the teaching process. J proj Tech 1957, 21:172-184.

2213. Starer, E. Reaction of psychiatric patients to cartoons and verbal jokes. J gen Psychol 1961, 65:301-304.

2214. Strother, G.B., M.M. Barnett, and P.C. Apostolakos. The use of cartoons as a projective device. J clin Psychol 1954, 10:38-43.

2215. Székély-Kovács, O., and R. Berény. Caricatures of 88 Pioneers in Psychoanal Drawn from Life at the Eighth International Psychoanalytic Congress. NY: Basic Book 1954, 96 p.

2216. Thompson, St. C. Medical celebrities of the Victorian age, as depicted in the cartoons of "Vanity Fair." Med Press 1939, 201:84-96.

2217. Wagner, M. Psychiatrist at the drawing board. Today's Health 1963, 41(8):15 17, 58-60, 63.

5　Children and Art

2218. Albert W.　Das Kind als Gestalter. Nürnberg: Korn 1925.

2219. Alexander, C.　The origin of creative power in children. Brit J Aesthetics 1962, 2:207-226.

2220. Alschuler, R.M., and L. Weiss Hattwick. Paintings and Personality; A Study of Young Children. Chicago: Univ Chicago Pr 1947, 2 Vols.

2221. —— & ——.　Understanding children through their paintings. Understanding the Child 1947, 16:98-101.

2222. Amaldi, P.　(Anthropometric observations on a nursling, with references to figures by Andrea Della Robbia.) Scritti biologici (Sienna) 1931, 6:91-118.

2223. Ament, W.　Entwicklung von Sprechen und Denken beim Kinde. Leipzig 1899.

2224. Anastasi, A., and J.P. Foley, Jr.　An analysis of spontaneous drawings by children in different cultures. J appl Psychol 1936, 20:689-726.

2225. —— & ——.　A study of animal drawings by Indian children of the North American Coast. J soc Psychol 1938, 9:363-374.

2226. Anderson, J.E.　Personality organization in children. Amer Psychologist 1948, 3:409-416.

2227. Andrews, M.F.　The quest for self-actualization. Art Educ 1962, 15:6-9.

2228. Anon.　Child psychology. Design 1934, 36:32.

2229. Anon.　Eine ausstellung aus jugendlichen kriegszeichnungen. Z pädag Psychol 1916, 17:388.

2230. Anon.　Japan's young dreams, children's drawings show how occupation has changed their aspirations. Life 1954, 36:89-93.

2231. Anthony, E.　We build a personality. School Arts 1941, 40:183-186.

2232. Anthony, T.W.　Does Specific Art Talent Manifest Itself in Childhood. Master's thesis. Univ California 1926.

2233. Appel, K.E.　Drawings by children as aids to personality studies. Ops 1931, 1:129-144.

2234. Arend, R.　(Drawing Disturbances—Dispinxias—and Child Drawing.) Warsaw: Państwówe Zakiady Wydawmctiv Lebarskich 1950, 146 p.

2235. Arisman, K.J.　Expressive arts in school instruction. Rev educ Res 1943, 13:190-198.

2236. Ausubel, D.P., F. DeWit, B. Golden, and S.H. Schpoont.　Prestige suggestion in children's art preferences. J genet Psychol 1956, 89:85-93.

2237. Ayer, F.C.　The present status of instruction in drawing with respect to scientific investigation. Yrbk nat Soc Stud Educ 1919, 18:96-110.

2238. Aznive, G.N.　The Function of Art in Secondary Schools. Master's thesis. Boston Univ 1932.

2239. Bakusinskii, (?).　(On the representation of space by children.) Novawa (Moscow) 1925.

2240. Ballard, P.B.　What children like to draw. J Experimental Pedagogy & Training College Record (London) 1913, 2:127-129.

2241. ——.　What London children like to draw. J Experimental Pedagogy & Training College Record (London) 1912, 1:186-197.

2242. Banchieri, F.　Giudizi di grandezza, giudizi di distanza e comparazione di forme nei bambini dai tre ai quattro anni. Contributi psicologici del Laboratorio di psicologia sperimentale della R. Università di Roma 1912-13, 2(6).

2243. Barbey, L.　Le sens esthétique des images chez l'enfant. Nouvelle Rev Pédagogique 1949, 4:450-454.

2244. Barkan, M.　The research committee and the nature of research in art education. Art Educ 1957, 10:10-12.

2245. Barkan, M., and J. Hausman.　Two pilot studies with the purpose of clarifying hypotheses for research into creative behavior. In Research in Art Education. 7th Yearbook. Kutztown, Pa.: National Art Educ Ass 1956, 126-141.

2246. Barnes, E.　The art of little children. Ped Sem 1895, 5.

2247. ———. Notes on children's drawings. Ped Sem 1891, 1:445-447.

2248. ———. Studies on children's drawings. Studies in Educ 1896-1897, I, 1902.

2249. ———. A study of children's drawings. Ped Sem 1892, 2:451-463.

2250. Barnhart, E.N. Developmental stages in compositional construction in children's drawings. J exp Educ 1942, 11:156-184.

2251. ———. Stages in construction of children's drawing as revealed through a recording device. Psychol Bull 1940, 37: 581.

2252. Barry, H. Relationships between child training and the pictorial art. J abnorm soc Psychol 1957, 54:380-383.

2253. Baruch, D.W., and H. Miller. Developmental needs and conflict revealed in children's art. Ops 1952, 22:186-203.

2254. Baumgarten, F. Die Hauszeichnungen von Kindern als Nachwirkung des Massenzerstörungen im Kriege. Z Kinderpsychiat 1949, 16:74-83.

2255. ———. Supranormales Zeichnen eines Kindes. Z Kinderpsychiat 1936, 2:182-189.

2256. ———. Wunderkinder. Psychologischen Untersuchungen VIII. Leipzig: Barth 1930, 184 p.

2257. ———. Zeichnungen der Schweitzer Jugend. Z pädag Psychol 1927, 28:7-8.

2258. Baumgarten, F., and M. Tramer. Kinderzeichnungen in vergleichend psychologischer Beleuchtung. Bern: Franke 1952, 64 p; Z Kinderpsychiat 1943, 9:161-220.

2259. Beach, V., and M. Bressler. Organizing a painting set-up for young children. J exp Educ 1944, 13:77-80.

2260. ——— & ———. Phases in the development of children's painting. J exp Educ 1944, 13:1-4.

2261. Bechterew, W. Recherchés objectives sur l'évolution du dessin chez l'enfant. JPNP 1911, 8:385-405.

2262. Beck, O.W. Self-Development in Drawing as Interpreted by the Genius of Romano Dozzi and Other Children. NY: Putnam 1928.

2263. Beckham, A.S. A study of the social background and art aptitude of superior Negro children. J appl Psychol 1942, 26: 777-784.

2264. Belart, W. Die sinnespsychologischen Grundlagen seiten- und hohenverkehrter Kinderzeichnungen. Z Kinderpsychiat 1943, 10:8-13.

2265. Belinfante, A. Het Kinderteekenen en het volle leven. Zeit 1920.

2266. Bell, J.E. Perceptual development and the drawings of children. Ops 1952, 22:386-393.

2267. Belot, G. Dessins d'enfants. Bulletin de la Société d'étude la Psychologie de l'enfant 1901, 1:50-59.

2268. Belvès, P. Le portrait d'après nature Enfance 1950, 3:117-127.

2269. Bencini, P. I disegni dei Fanciulli. Riv Pedagogica 1908, 1:665-690.

2270. Bender, L. Gestalt principles in the sidewalk drawings and games of children. J genet Psychol 1932, 41:192-210.

2271. Bender, L., and J. Rapoport. Animal drawings of children. Ops 1944, 14:521-527.

2272. Bender, L., and P. Schilder. Graphic art as special ability in children with reading disability. J clin exp Psychopath 1951, 12:147-156; Med Woman's J 1951, 58:11-18.

2273. ——— & ———. Principles of form in the play of children. J gen Psychol 1936, 49:254-261.

2274. Bender, L., and W.Q. Wolfson. The nautical theme in art and fantasy of children. Ops 1943, 13:462-468.

2275. Benne, K. Art education as the development of human resources. In Art Education Today, 1948. NY: Teachers College 1948, 1-8.

2276. Bergemann-Könitzer, M. Entwicklungsaufbau Plastischer Gestaltung. Z für Jugendkunde 1935, 5:42-50.

2277. ———. Das plastische Gestalten des Kleinkindes. Z angew Psychol 1928, 31: 202-258.

2278. Berkowitz, P., and E. Rothman. Art work for the emotionally disturbed pupil. Clearing House 1951, 26:232-234.

2279. Berliner, A. Aesthetic judgments of school children. J appl Psychol 1918, 2: 229-242.

2280. Bernson, M. Du Gribouillis au dessin Neuchâtel, Switzerland: Delachaux et Niestle 1957, 86 p.

2281. Besnard, A. Dessins d'enfants. Bull soc l'étude psychol de l'enfant 1902, 2: 162-169.

2282. ———. Dessins d'enfants. Rev Universelle 1901, 1:817-823.

2283. Bettelheim, B. Joey: a "mechanical boy." Sci Amer 1959, March, 2-10.

2284. ———. What students think about art. In Dunkel, H.B. (ed.), General Education in the Humanities. Washington: American Council on Education 1947, 177-234.

2285. Bettica-Giovannini, R. Interpretazion psicologica medica del disegni infantili. Rass studi psichiat 1952, 41:430-437.

2286. Betzler, E. Creative youth. In Heyma K., Kind und Kunst. Psychol Praxis 1951, N

2287. Beyrl, F. Über die Grössenauffassung bei Kindern. Z Psychol 1926, 344.

2288. Bhatt, M. Art and the socially maladjusted. School Arts 1955, 54:23-25.

2289. Biber, B. Children's Drawings: from Lines to Pictures. NY: Bureau educ Experiments 1934.

2290. Biehler, R.F. An Analysis of Free Painting Procedures As Used with Preschool Children. Dissertation Abstr 1953, 13:1254.

2291. Billing, M.L. A report of a case of inverted writing and drawing. Child Develpm 1936, 6:161-163.

2292. Binet, A. Interprétation des dessins. Rev philosophique de la France et de l'étranger 1890, 30.

2293. Black, I.S. Art and the troubled child. Art in America 1960, 48(2):70-71.

2294. ———. Children's art a century ago. Art in America 1960, 48(1):98-99.

2295. Blumenfeld, V. Untersuchungen über Formvisualitat. Z Psychol 1923, 91:1, 236.

2296. Boas, B. (ed.). Art Education Today. NY: Bureau of Publications. Teachers College 1941.

2297. Bogardus, F.S. An individual study of drawings made by first grade pupils. Trans Illinois Soc Child-Study 1896.

2298. Bond, G.H. A Study in Comparison of the Art Abilities of Children of Various Nationalities. Doctoral dissertation. Univ Southern California 1930.

2299. Bonte, T. Die eidetische Anlage und ihre Bedeutung für Erziehung and Unterricht. Leipzig 1934.

2300. Boubier, A.M. Les jeux de l'enfant pendant la classe. Arch Psychol 1902, 1: 44-68.

2301. Bouman, H. Das biogenetische Grundgesetz und die Psychologie der primitiven bildenen Kunst. Z angew Psychol 1919, 14: 129-145.

2302. Bourgeois, S. Modern art and the psychology of adolescence. Worcester Museum Bull 1932, 23:81-85.

2303. Boussion-Leroy, A. Dessins en transparence et niveau de développement. Enfance 1950, 3:93-104.

2304. Boutonier, J. Les dessins des enfants. Paris: Scarabée 1953, 125 p.

2305. Bowditch, H.P. Notes on children's drawings. Ped Sem 1891, 1:445.

2306. Bradier-Stadtman, L. Die psychologische Beurteilung freier Kinderzeichnungen. Erziehung u Bildung, Beilage d Preuss, Lehrerzeitung 1933, No. 8.

2307. Bragman, L.J. Thumbsucking and other auto-erotic tendencies in children, as portrayed in art. JNMD 1931, 74:708-709.

2308. Brandell, G. Das Interresse der Schulkinder an den Unterrichtsfächern. Z angew Psychol 1915, 10:146-151.

2309. Braunschvig, M. L'art et l'enfant. Essai sur l'education esthétique. Paris 1907, 400 p.

2310. Breest, F. Ein kleiner Künstler. Kind u Kunst 1905, 1:333.

2311. Bried, C. Le dessin de l'enfant. Premières représentation humaines. Enfance 1950, 3:77-91.

2312. Brooks, F.D. The relative accuracy of ratings assigned with and without use of drawing scales. School & Sci 1928, 27: 518-520.

2313. Brown, D.D. Notes on children's drawings. Univ California Studies 1897, 2(1).

2314. Brütsch, G. Theorie der bildenden Kunst. 1931.

2315. Buchanan, S. The psychology of human art. Proc 3rd bienn Meeting soc Res Child Developm 1939, 6-7.

2316. Buchner, M. Gegenbewegung der linken Hand und Symmetrie. Beiträge Kinderforschung und Heilerziehung. Heft 115. Langensalza: Meyer 1914.

2317. Bühler, K. Abriss der geistigen Entwicklung des Kindes. Leipzig: Quelle & Meyer 1928, Ch 5.

2318. ———. Kunst und Jugend. Z Aesth 1926, 20:288-306.

2319. Bühler, K., and H. Hetzer. Die symbolische Darstellung in früher Kindheit. Vienna 1926.

2320. Burk, F. The genetic vs. the logical order in drawing. Ped Sem 1902, 9:296-323.

2321. Burkhardt, A. Zeichnerische Erganzungsversuche mit 4- bis 14 jähringen Kindern. Glauchau, Chemnitz: Pickenhahn 1936, 39 p.

2322. Burkhardt, H. Veränderungen der Raumlage in Kinderzeichnungen. Z pädag Psychol 1925, 26:352-371.

2323. ———. Über Verlagerung raumlicher Gestalten. Neue psychol Stud 1933, 7(3), 158 p.

2324. Burkhart, R.C. An Analysis of Individuality of Art Expression at the Senior High School Level. Dissertation Abstr 1957, 17:2873-2874. In Research in Art Education. 9th Yearbook. Kutztown, Pa.: National Art Educ Ass 1959, 90-97.

2325. Burks, B.S., D.W. Jense, and L.M. Terman. Genetic Studies of Genius. III. The Promise of Youth. Palo Alto: Stanford Univ Pr 1930, 508 p.

2326. Burns, R. Some correlations of design with personality. In Research in Art Education. 9th Yearbook. Washington,

D.C.: National Art Educ Ass 1959, 125-130.

2327. Burton, A., and R. Tueller. Successive reproductions of visually perceived forms. J genet Psychol 1941, 58:71-82.

2328. Buseman, K.U.A. Über das Zeichnen nach Vorlage. Z Kinderforsch 1915, 20:518-530.

2329. Busemann, A. Jugend im Selbstbildnis. Ein Beitrag zur Psychologie geistigen Werkschaffens im Jugendalter. Z Kinderforsch 1935, 44-63.

2330. ——. Die zeichnerische Reaktion des Kleinkindes auf Reizfiguren. Schweiz ZPA 1950, 9:392-407.

2331. Busse, K.H. Vergleichende Entwicklungspsychologie der primitiven Kunst bei den Naturvölkern, den Kindern und in der Urzeit. Kongres Ästhet in allg Kunstwissenschaft 1914, 232.

2332. Buswell, G.T. Learning to look at pictures. Progressive Educ 1936, 13:422-426.

2333. Cain, J., and J. Gomila. Le dessin de la famille chez l'enfant. Ann méd-psychol 1953, 4:501-506.

2334. Cameron, N. Individual and social factors in the development of graphic symbolization. J Psychol 1938, 5:165-184.

2335. Cane, F. The gifted child in art. J Educational Sociology 1936, 10:67-73.

2336. Capdeville, L. (The importance of spontaneous drawing in neuro-psychiatry of children.) Rev Chilena de Neuro-psichiatria 1950, 3:171-184.

2337. Cappe, J. Les manifestations artistisques chez l'enfant. Nouvelle Rev Pédagogique 1947, 3:89-93.

2338. Carlson, R.B. Art education and character integration. Religious Educ 1920, 25:51-54.

2339. Carter, B. Artistic development and auditory sensitivity: an initial study. Art Educ Bull, Eastern Arts Ass 1957, 14:28-29.

2340. Carter, M.R., and W.H. Fox. Art in the elementary schools of Indiana. Bull School Educ Indiana Univ 1950, 26(2):83 p.

2341. Chapin, B.M. Rural children, too, need the best. Childhood Educ 1950, 20:206-208.

2342. Christoffel, B. Bildnereien normaler und abnormaler Knaben. Schweiz ANP 1924, 14:118-119.

2343. Claparède, E. Plan d'expérience collective sur le dessin des enfants. Arch Psychol 1907, 6:276-278.

2344. Clark, A.B. The child's attitude toward perspective problems. In Barnes, E. (ed.), Stanford Univ Studies in Educ 1897, 1:283-294.

2345. Clark, J.S. Some observations on children's drawings. Educ Rev 1897, 13:76-82.

2346. Claus, A. Psychologische Betrachtungen zur Methodik des Zeichenunterrichts. Z pädag Psychol 1901, 3:456-473.

2347. Clot, R.J. L'éducation artistique. Paris: PUF 1958, 118 p.

2348. Cockrell, D.L. Design in the paintings of young children. School Arts 1930, 30:33-39, 112-119.

2349. Cohn, R. Role of "body image concept" in pattern of ipsilateral clinical extinction. Arch Neurol Psychiat 1953, 70:503-509.

2350. Cole, N. Dig deep for beauty. Childhood Educ 1949, 25:302-304.

2351. Commonwealth of Virginia. Art and the child. Bulletin, Vol. 30, No. 7. Richmond: State Board of Education 1948, 106 p.

2352. Cook, C. Art for today's child. School Arts 1956, 56:11-14.

2353. Cooke, E. Art teaching and child nature. Lond J Educ 1885.

2354. Cordeau, R. Le nombre d'or dans le dessin enfantin. Enfance 1953, 6:147-151.

2355. ——. Psychologie du dessin enfantin. Enfance 1949, 1:54-59.

2356. Cornelius, J. Pedagogia dell'Arte. Rome: Paravin 1924, 115 p.

2357. Cotte, S. Le bonbomme "aux mains carpées"; dessins d'enfants délinquants. Z Kinderpsychiat 1946, 13:156-164.

2358. Cousinet, R. Le dessin dans l'éducation nouvelle. École nouvelle française (Paris) 1947-48, 3-4:57-60.

2359. Cox, C.M., et al. Early Mental Traits of 200 Geniuses. Palo Alto: Stanford Univ Pr 1926, 842 p.

2360. Craddick, R.A. Size of Easter egg drawings before and after Easter. Perception & Motor Skills 1962, 15:591-593.

2361. ——. Size of Halloween witch drawings prior to, on, and after Halloween. Perceptual & Motor Skills 1963, 16:235-238.

2362. ——. Size of Santa Claus drawings as a function of the time before and after Christmas. J psychol Studies 1961, 12:121-125.

2363. Cramaussel, E. Experiences au jardin d'enfant. JPNP 1927, 24:701.

2364. ——. Ce que voient des yeux d'enfant. JPNP 1924, 21:161-169.

2365. Cranston, J.P. The nature and development of aesthetic appreciation in children. Quart Bull Brit psychol Soc 1952, 3:21-23.

2366. Crawford, C.C. An experiment with three ways of teaching water-color paint-

ing. Elem School J 1935, 36:40-43.

2367. Curran, F.J., and P. Schilder. A constructive approach to the problems of childhood and adolescence. J Crimonology & Psychopathology 1940-41, 2:125-152, 305-320.

2368. —— & ——. Problemas de la infancia y adolescencia. Index; revista iberoamericana de analisis bibliograficos de neurologia y psiquiatria 1940, 2:135-145.

2369. Cushman, L.S. The art impulse; its form and relation to mental development. National Educ Ass 1908, 515.

2370. Czurles, S.A. The Emergence of Art Abilities in the First Three Years of Life. Master's thesis. Syracuse Univ 1938.

2371. Daiber, W. Das Eigengestalten des Kindes im Zeichenunterricht einer Volkschulklasse. Düsseldorf 1932.

2372. Dalla Volta, A. Rappresentazione dell'indistinto a sviluppo del bambino. Minerva Pediatrica; Revista di Pediatria, Peodopsichiatria e Puericultura (Turin) 1951, 3:44-79.

2373. ——. La rappresentazione grafica di alcuni aspetti del mondo esterno come test del grado di sviluppo mentale del bambino. Arch Psicol Neurol Psichiat 1951, 12:325-332.

2374. Dallinger, K. Über den Zusammenhang zwischen der Entwicklung des Ichbewusstseins und den kindlichen Zeichnens. In Tumitz, O. (ed.), Jugenkundliche Arbeiten, Vol. II. Langensalza: Beyer & Mann 1928, 119 p.

2375. D'Amico, V.E. Art and individual development in the secondary-school level. In Art in American Life and Education. 40th Yearbook. National Soc Study Educ. Bloomington, Ill.: Public School Publ Co 1941, 541-544.

2376. Daniels, P.C. Discrimination of compositional balance at the pre-school level. Psychol Monogr 1933, 45(1):1-11.

2377. Datta, A. Drawings of children. Indian J Psychol 1935, 10:179-182.

2378. Davis, R. The fitness of names to drawings. A cross-cultural study in Tanganyika. Brit J Psychol 1961, 52:259-268.

2379. DeAssis Pacheco, O. (The "little worlds" and free drawing of children with behavior deviations.) Criança portug 1951-52, 11:333-356.

2380. ——. (The symbolism of movement in children.) Criança portug 1952, 11:129-139.

2381. DeBaracchini, N.Y. El dibujo como importante factor en la formación del concepto de lo bello en el niño. Rev de Educacíon (La Plata) 1946, 88(4):23-29.

2382. Debesse, M. La creativité de l'enfant et la creation artistique. Gawein 1960, 8:194-200.

2383. DeCarli Valerio, J. Considerazioni su uno studio analitico e comparativo dell'evoluzione grafico-figurativa in tre sorelle seguite con il method biografico. Rev de Psicologia Sociale 1960, 7:161-176.

2384. Declich, M. Quelques considérations sur le diable chez les enfants. Hygiene Mentale 1962, 51(5):229-235.

2385. Decroly, O. Le développement et l'aptitude graphique. J de Neurologie et Psychiatria 1912, 17:441.

2386. ——. Le psychologie du dessin. J de Neurologie et Psychiatria 1912, 17: 421-424, 441-453.

2387. ——. Quelques faces du développement de l'aptitude graphique. La psychologie du dessin. In Études de Psychogenèse. Brussels 1932.

2388. Decroley, O., and (?) Wauther. Contribution à l'étude des enfants bien doues. Année Psychol 1930.

2389. DeFrancesco, I.L. Communication through the arts: the visual arts. Childhood Educ 1951, 27:264-266.

2390. Degallier, A. Note psychologique sur les Negres Pahouins. Arch Psychol 1905, 4:362-368.

2391. Dehning, G. Bilderunterricht: Versuche mit Kindern und mit Erwachsenen über die Erziehung des aesthetischen Urteils. Leipzig: Quelle & Meyer 1912, 108 p.

2392. DeLannoy, J-D. Perception de la forme en elle-même. JPNP 1962, 59(1-2):59-74.

2393. Denner, A. Dessin et rationalisation chez l'enfant. Enfance 1953, 4:291-328; 1954, 41-70.

2394. Dennis, W. Values expressed in children's drawings. In Dennis, W. (ed.), Readings in Child Psychology. Englewood Cliffs, N.J.: Prentice Hall 1951, 1963, 265-271.

2395. DeSanctis, S. La cierca psicologica nella grafica dei bambini, I desegni dei bambani. Rome: Dante Alleghieri 1901.

2396. Dessoir, M. Ästhetik und allgemeine Kunstwissenschaft. Stuttgart 1906.

2397. Deutsch, F. The art of interviewing and abstract art. Amer Imago 1952, 9:3-19.

2398. ——. Mind, body and art. II. Studies of the pictographic reflections of the body image on the drawings of children. Acta Psychotherapeutica, Psychosomatica et Orthopaedagogica (Basel) 1963, 11:181-192.

2399. Dide, M., and M. Guilhem. Explora-

tion psychologique infantile par l'expression graphique du mouvement. Mémoires de l'Academie de Science (Toulouse) 1929, 7:247-259.

2400. Diekmeier, L. Famous paintings of sick children. Kinderärztliche Praxis (Leipzig) 1954, 22:86-97.

2401. Dietrich, G.L., and C.W. Hunnicitt. Art content preferred by primary-grade children. Elem School J 1948, 48:557-559.

2402. DiVesta, F.J. Effects of mediated generalization on the development of children's preferences for figures. Child Develpm 1962, 33:209-220.

2403. Dix, K.W. Körperliche und geistige Entwicklung eines Kindes. Heft 2: Die Sinne. Leipzig 1912, 174 p.

2404. Djukić, S. (Evolution of certain parts of human body and face in children's drawings.) Savremena Škola 1953, 8:450-458.

2405. Döhlemann, K. Prähistorische Kunst und Kinderzeichnungen. Beiträge zur Anthropologie und Urgeschichte 1908, 51 ff.

2406. Döring, M. Ein Versuch zur Erforschung elementarer aesthetischer Gefühle bei 7-9 jährigen Kindern. Z exp Pädag 1906, 3:65-74.

2407. Doms, F.P. Les échelles Gaublomme. Le graphisme et l'expression graphique. Sem univ Pégad Univ de Bruxelles 1935, 1:171-182.

2408. Doucette, A.H. Research in art education. Eastern Arts Ass Bull 1938, 29: 7-12; 1939, 30:18-22.

2409. Dow, M. An observational study in a playground situation of differences in artistic personality at the child level. Proc Iowa Acad Sci 1933, 40:197.

2410. ———. Playground behavior differentiating artistic from non-artistic children. Psychol Monogr 1933, 45, No. 1, 82-94.

2411. Dracoulidès, N.N. Interprétation psychanalytique du dessin des enfants. Psyché-Paris 1950, 5.

2412. Dubin, E.R. Effect of training on the tempo of development of graphic representation in pre-school children. J exp Educ 1946, 15:166-173.

2413. Dück, J. Über das zeichnerische und künstlerische Interesse der Schüler. Z pädag Psychol 1912, 13:172-177.

2414. Dühsler, E. Die verschiedenen Gesichtspunkte bei der Betrachtung von Kinderzeichnungen. Prax Kinderpsychol Kinderpsychiat 1955, 4:56-60.

2415. Dumont, L. L'émotion esthétique chez l'enfant. Bull de l'Institut général Psychologique (Paris) 1927, 27:62-76.

2416. Dunn, M.B. Global Evaluation of Children's Drawings of "Person" and "Self." Dissertation Abstr 1955, 15:1254-1255.

2417. Dunnett, R. Art and Child Personality Based on Experience with the Boys of Whiteacre Camp School, 1940-45. London, Methuen 1948, 72 p.

2418. Eickhoff, L.F.W. Dreams in sand. J ment Sci 1952, 98:235-243.

2419. Eiderton, E. On the association of drawing with other capacities in school children. Biometrika 1909-10, 222.

2420. Eisner, E.W. Evaluating children's art. School Arts 1963, 63(1):20-22.

2421. Eissner, K. Über Kinderzeichnen. Aufgaben für Zeichnen und Werktätigkeit. I. Teil. Dresden-Vienna 1907.

2422. Elderton, E. On the association of drawing with other capacities in school children. Biometrika 1909-10, 222-226.

2423. Eliasberg, W. Ausdruck oder Bewegung im künstlerischen Schaffen? Z Kinderpsychiat 1935, 2:83-86.

2424. Elkisch, P. The emotional significance of children's art work. Childhood Educ 1941 23:236-241.

2425. ———. Significant relationships between the human figure and the machine in the drawings of boys. Ops 1952, 22:79-85.

2426. Ellsworth, F.F. Elements of form in the free paintings of twenty nursery school children. J gen Psychol 1939, 20:487-501.

2427. Elsen, A. Die Kinderzeichnung. Augsburg 1929.

2428. Eng, H. Ästhetische Gefühle. In Experimentelle Untersuchungen über das Gefühlsleben des Kindes im Vergleich mit dem des Erwachsen. Leipzig: Barth 1922, 107-112.

2429. ———. Kunstpädgagik. Kristiania: Aschehong 1918.

2430. ———. The Psychology of Child and Youth Drawing from the Ninth to the Twenty fourth year. NY: Humanities Pr 1957, 205 p

2431. ———. The Psychology of Children's Drawings: From the First Stroke to the Color Drawing. NY: Harcourt Brace 1931, 223 p; London: Kegan Paul, Trench, Trubner 1931, 393 p; Z angew Psychol, Beiheft No. 39, 1927, 198 p.

2432. ———. Weshalb zeichnet das Kind und dichtet der Jugendliche? Jahrbuch der Erziehungswissenschaft und Jugendkunde (Berlin) 1927, 3:201.

2433. England, A.O. Cultural milieu and parental identification. Nervous Child 1947 6:301-305.

2434. ———. Non-structured approach to the study of children's fears. J clin Psychol 1946, 2:364-368.

2435. ——. A psychological study of children's drawings; comparison of public school, retarded, institutionalized and delinquent children's drawings. Ops 1943, 13:525-531.

2436. Fallaize, E.N. Children's drawings and primitive art. J Educ (London) 1933, 65:142-143.

2437. Fanta, O. Der Schriftausdruck der asozialen und antisozialen Jugendlichen. Graphologia 1938, 1:50-66.

2438. Farnsworth, P.R. Ratings in music, art, and abnormality in the first four grades. J Psychol 1938, 6:89-94.

2439. Farwell, L. Reactions of kindergarten, first, and second-grade children to constructive play materials. Genet psychol Monogr 1930, 8:431.

2440. Faulkner, R. A survey of recent research in art and art education. Yrbk nat Soc Stud Educ 1941, 40:369-377.

2441. ——. Toward a philosophy of research in art education. In Record of the Conventions at St. Louis & Milwaukee, 1940. Bull. Vol. 6. Washington, D.C.: National Educ Ass 1940, 23-29.

2442. Fay, H.M. Une méthode pour le dépistage des arriérés dans les grandes collectivités d'enfants d'âge scolaire. Bull la Ligue d'Hygiène Mentale 1923, July-Oct.

2443. Feld, O. Das Kind als Künstler. Z pädag Psychol 1932, 3:1901.

2444. Ferretti, G. Il disegno dei fanciulli e l'origine musicale dell'espressione figurativa. Riv Psicoanal 1927, 33:49-67.

2445. Findley, M. Design in the art training of young children. Child Life (London) 1907.

2446. Fischer, H. Die Konstitution des Kindes und ihre Spiegelung in kindlichen Malereien. Psychologische Rundschau 1957, 8:120-135.

2447. ——. Die Wechselbeziehungen zwischen Konstitution und Kinderzeichnung. Prax Kinderpsychol Kinderpsychiat 1954, 1:302-305.

2448. Flakowski, H. Entwicklungsbedingte Stilformen von Kinderaufsatz und Kinderzeichnung. Psychol Beiträge 1957, 3:446-467.

2449. Flemming, E.G. Personality and artistic talent. J educ Sociology 1934, 8:27-33.

2450. Florina, A. Research into the drawings of preschool children. New Era 1928, 9:37-38.

2451. Foley, J.P., and A. Anastasi. The work of the Children's Federal Art Gallery. School & Soc 1938, 48:859-861.

2452. Fomenko, K.E. (The perception of pictures of spatial and perspective relations in the preschool age.) In Psikhologitchni doslidzennia. Naookovi Zapiski. Kharkov: Derj Ped Inst 1939, 101-199.

2453. Fontes, V. (The body schema and children's drawings.) Criança portug 1944, 3:213-246.

2454. ——. (The supernatural in children's drawings.) Criança portug 1946-47, 6:71-100.

2455. Fordham, M.S.C. The Life of Childhood. London: Kegan Paul, Trench, Trubner 1944.

2456. ——. Some observations on the self in childhood. Brit J med Psychol 1951, 24:89-96.

2457. Foster, N. Children and creative activities. Bull Inst Child Studies (Toronto) 1954, 16(4):10-13.

2458. Franck, P. Das schaffende Kind. Berlin: Stollberg 1928.

2459. Frank, L.K. The developmental role of the arts in education. In Art Education Today, 1948. NY: Teachers College 1948, 23-26.

2460. French, J.E. Children's preferences for abstract designs of varied structural organization. Elem School J 1956, 56:202-209.

2461. ——. Children's Preferences for Pictures of Varied Complexity of Pictorial Pattern. Doctoral dissertation, Univ California 1951.

2462. ——. Children's preferences for pictures of varied complexity of pictorial pattern. Elem School J 1952, 53:90-95.

2463. Freud, A. Technique of child analysis. Nervous & Mental Diseases Monograph Series 1928, No. 48, 59 p.

2464. Freyberger, R.M. Differences in the Creative Drawings of Children of Varying Ethnic and Socio-Economic Backgrounds in Pennsylvania Based on Samplings of Grades One through Six. Dissertation Abstr, Pennsylvania State Coll 1951, 14:265-270; In Research in Art Education. 7th Yearbook. Kutztown, Pa.: National Art Educ Ass 1956, 115-125.

2465. Frumkin, R.M. Art, education, and real knowledge. Jewish Teacher 1954, 22:13-14.

2466. Fuchs, H. Das Bilderbuch im Kindergarten. Zugleich ein Beitrag zum Entwicklung zeichnerischer Urformen beim Kleinkinde. Z für psychoanalytischen Pädagogie 1931, 5:145-151.

2467. Fusswerk, J., and S. Horinson. La personalité et le dessin du "Moi." En-

fance 1949, 3:222-229.

2468. Gaitskell, C., and M. Gaitskell. Art Education during Adolescence. NY: Harcourt Brace 1954, 116 p.

2469. Galkina, O.J. La perception de la forme pour les enfants dans l'apprentissage de l'écriture et du dessin en lre classe. In Problèmes de psychologie de l'enfant et de psychologie générale. Moscow: Acad des Sciences pédag 1954.

2470. Gallagher, M. Children's spontaneous drawings. Northwestern Monthly 1897, 8:130-134.

2471. Galli, E. Osservazioni sulla reproduzione di profile. Arch ital di psicol 1934, 12:165.

2472. Gantschewa, A. Kinderplastic. Munich: Beck 1930.

2473. Garrison, S.C. Fine arts. Rev educ Res 1935, 5:45-47.

2474. Garton, M.D. Social and emotional growth through creative painting. Amer Childhood 1953, 38:18-21.

2475. Gasorek, K. A Study of the Consistency and Reliability of Certain of the Formal and Structural Characteristics of Children's Drawings. Dissertation Abstr 1952, 12:34-35.

2476. Gattegno, C. Psychologie du dessin enfantin. Enfance 1948, 1:407-411.

2477. Gaupp, R. Psychologie des Kindes. Leipzig 1928, 131-145.

2478. Geck, F.J. The effectiveness of adding kinesthetic to visual and auditory perception in the teaching of drawing. J educ Res 1947, 41:97-101.

2479. Gelb, A., K. Goldstein, and (?) Maki. Psychologische Analysen hirnpathologischer Fälle. XII. Natürliche Bewegungstendenzen der rechten und der linken Hand und ihr Einfluss auf das Zeichnen und den Erkennungsvorgang. Psychol Forsch 1928, 10:1.

2480. Gerald, H.J.P. Inverted positions in children's drawings. Report of two cases. JNMD 1928, 68:449-455.

2481. Gerstman, M.K. Child art and personal perception. School Arts 1957, 56: 21-22.

2482. ——. Guidance in the art class. School Arts 1949, 48:337-338.

2483. Gesell, A., and L.B. Ames. The development of directionality in drawing. J genet Psychol 1946, 68:45-61.

2484. Ghent, L. Form and its orientation: a child's-eye view. Amer J Psychol 1961, 76:177-190.

2485. Ghesquiere-Diericks, B. Comment dessinent les enfants: évolution du dessin selon l'âge. Enfance 1961, 2:179-183.

2486. Giddings, F. Creative abilities of children. Childhood Educ 1934, 10:251-253.

2487. Götze, C. Das Kind als Künstler. Zur Reform des Zeichenunterrichts. Hamburg 1898.

2488. Goode, J. Painting and the unstable child. J Educ (London) 1955, 87:491-493.

2489. Goodenough, F.L. Child development-IX. Drawing. In Encyclopedia of Educational Research. NY: Macmillan 1941, 157-160.

2490. ——. Children's drawings. In Murchison, C. (ed.), Handbook of Child Psychology. Worcester, Mass.: Clark Univ Pr 1931, 480-514.

2491. ——. Studies in the psychology of children's drawings. Psychol Bull 1928, 25:272-283.

2492. Goodenough, F.L., and D.S. Harris. Studies in the psychology of children's drawings: II. 1928-1949. Psychol Bull 1950, 47:369-433.

2493. Goosen, C.J. A doctor looks at child art. Central Africa J Med 1963, 9:144-148.

2494. Gottschaldt, K., and E. Schneider. Beitrag zur Phänomenologie der Persona. II. Z Psychol 1962, 162:1-25.

2495. Graberg, F. Kraftsteigern des Zeichne Z exp Pädag 1909, 8:104-113.

2496. ——. Eine Stufenfolge von Masszeichen. Z exp Pädag 1907, 4:175-188.

2497. ——. Die visuell-motorischen Zeichnenvorgänge. Z ecp Pädag 1908, 7:68-92.

2498. ——. Zeichnen, Sprechen, Rechnen. Z exp Pädag 1909, 9:149-168.

2499. Gräser, L. Familie in Tieren. Die Familiensituation im Spiegel der Kinderzeichnung. Münich-Basel: Reinhard 1957, 119 p.

2500. Graewe, H. Die Entwicklung des kindlichen Zeichnens. Erziehung und Bildung. Beilage z Preuss, Lehrerzeitung 1933, Apr. 29.

2501. ——. Geschichtlicher Überblick über die Psychologie des kindlichen zeichnens. Arch ges Psychol 1936, 96:103-220.

2502. ——. Das kindliche Zeichnen, ein Spiel. Kleine Kinder 1934, Jan.

2503. ——. Die Tendenz zur Pregnanz im kindlichen Seelenleben und ihre Erforschun (Zum Verstehen kindlicher Zeichungen). Pädag Warte 1935, Nov 1.

2504. ——. Das Tierzeichnen der Kinder. Z pädag Psychol 1935, 251-256, 291-300.

2505. ——. Untersuchung der Entwicklung des Zeichnens nach allen seinen Komponenten bei Kindern im Alter von 3 bis 14 Jahren und Vergleich dieser Komponenten untereinander unter spezieller Berücksich-

tigung des Phantasiezeichnens, insbe-
sondere auch von Hergangen ("Erzählungs-
bilden"). Halle: Schroedel 1932, 180 p.

2506. Graham, F.K., P.W. Berman, and C.B.
Emhart. Development in preschool chil-
dren of the ability to copy forms. Child
Develpm 1961, 31:339-359.

2507. Grant, N., Jr. Arts and the Delin-
quent. NY: Exposition 1958, 36 p.

2508. Green, G.H. A child's first attempt
to interpret drawings. J genet Psychol
1928, 35:473-474.

2509. Gridley, P.F. Graphic representation
of a man by four-year-old children in
nine prescribed drawing situations. Genet
psychol Monogr 1938, 20:183-350.

2510. Griffiths, R. A Study of Imagination
in Early Childhood and Its Function in
Mental Development. London: Kegan Paul,
Trench, Trubner 1945, 367 p.

2511. Grippen, V.B. A study of creative
artistic imagination in children by the
constant contact procedure. Psychol
Monogr 1933, 45, No. 1, 63-81.

2512. Grözinger, W. Scribbling, Drawing,
Painting; the Early Forms of the Child's
Pictorial Creativeness. NY: Praeger 1955,
142 p.

2513. Grosser, H., and W. Stern. Das freie
Zeichnen und Formen des Kindes. Leipzig
1913.

2514. Groth, G. Beziehungen zwischen
intellektueller und künstlerischtech-
nischer Begabung an einem Mädchen-
lyceum. Z pädag Psychol 1932, 33:197.

2515. Grzegorzewska, M. Enquête sur les
gouts esthétiques de jeunesse scolaire.
JPNP 1915, 12:511-524.

2516. ———. Essai sur le développment du
sentiment esthétique. Bull de l'Institut
géneral psychologique (Paris) 1916, 16:
117-251; Paris: PUF 1916, 134 p.

2517. ———. La mémoire esthétique du pay-
sage chez l'enfant. Rev Bleue 1918, 6:
181-185.

2518. ———. Le portrait et son appréciation
au point de vue esthétique par la jeunesse.
JPNP 1915, 12:391-422.

2519. Guillaume, P. La compréhension des
dessins. JPNP 1953, 46:278-298.

2520. Guillaumin, J. Quelques faits et
quelques réflexions à propos de l'orienta-
tion des profils humains dans les dessins
d'enfante. Enfance 1961, No. 1, 57-74.

2521. Guillaumin, J., J. Blanc, M. Breuil,
and M. Voelckel. Une méthode pour.
l'étude longitudinale de la personnalité
de l'enfant telle qu'elle s'exprime dans
le dessin et le comportement. Enfance
1959, No. 5, 495-508.

2522. Guillet, C. Retentiveness in child
and adult. Amer J Psychol 1909, 20.

2523. Gunn, R.L. Effectiveness of Art
Teachers in Meeting the Needs of Adoles-
cents. Dissertation Abstr 1956, 16:95-96.

2524. Gurewicz, S. Beurteilung freier
Schüleraufsätze und Schülerzeichnungen
auf Grund der Adlerischen Individual-
psychologie. Zürich: Rascher 1948, 235 p.

2525. Guyer, W. Kind und Künstler.
Schweizerische pädagogische Z 1922, 32:
161-168.

2526. Haddon, A.C. Drawings by natives
of British New Guinea. Man 1904, 4:33-36.

2527. Haggerty, M.E. Enrichment of the
Common Life. Minneapolis: Univ Minne-
sota Pr 1938, 36 p.

2528. Hallowell, A.I. The child, the savage,
and human experience. Child Res Clinic,
Proc 6th Inst Except Child 1939, 8:34.

2529. Hammarstrand, A., and C. Hassler-
Göransson. Skolbarn i närbild. Stockholm
1954.

2530. Hammer, E.F. Creativity: an Explora-
tory Investigation of the Personalities of
Gifted Adolescent Artists. NY: Random
1961, 150 p.

2531. ———. An exploratory investigation
of the personalities of creative adoles-
cent art students. Studies in Art Educ
1960, 1:42-68.

2532. Hanfmann, E. (Some experiments on
spacial positions as a factor in children's
perception and reproduction of simple
figures.) Psychol Forsch 1933, 16:319.

2533. Hansen, W. Das bilderische Gestalten
des Kindes. Vierteljahrsschrift für wissen-
schaftliche Pädagogik 1933, 9:155.

2534. Harms, E. Child art as aid in diag-
nosis of juvenile neuroses. Ops 1941, 11:
191-209; Z Kinderpsychiat 1940, 6:129-
143.

2535. ———. Child art reveals mental ills.
Design 1945, 46:16-17.

2536. Harris, D.B. Review of "Painting and
Personality" by Rose H. Alschuler and
LaBerta W. Hattwick. Ment Hyg 1948, 32:
653-659.

2537. Hartentstein, E. Aktuelle Kulturin-
halte im Spiegel der Kinderzeichnung.
Z für Jugendkunde 1934, 4:106-120.

2538. Hartlaub, G.F. Der Genius im Kinde;
ein Versuch über die zeichnerische Anlage
des Kindes. Breslau: Hirt 1930, 229 p.

2539. Hartley, R.E., et al. The use of graphic
materials. In Understanding Children's
Play. London: Routledge & Kegan Paul
1952, 218-269.

2540. Hartlieb, K. Die Erkenntnisgrund-
lagen der Bildsprache. Die Entwicklung

der kindlichen Bildsprache, ihre künstlerische Grundlage und ihre pädagogische Bedeutung. Esslingen 1933.

2541. Hartman, G., and A. Shumaker (eds.). Creative Expression. The Development of Children in Arts, Music, Literature, and Dramatics. NY: Day 1932, 350 p.

2542. Hasserodt, O. Bilderunterricht; Einführung in das Künstlerische Bildverständnis. Z pädag Psychol 1913, 14:210-222, 276-290.

2543. Hastie, R., and S.G. Wold. Art education. Rev educ Res 1961, 31:217-223.

2544. Hatano, I. (The children's drawing of dreams.) Jap J Psychol 1932, 7:67-102.

2545. ——. (The development of a child during the course of a year, seen through his drawings.) Kyôiku Shinri Kenkyû 1935, 10:475-504.

2546. ——. (The picture stories and suggestions to the education of drawing.) Trans Inst Child Study (Japanese) 1934, 16:811-830.

2547. Hattwick, L.W., and M.K. Sanders. Age differences in behavior at the nursery school level. Child Develpm 1938, 9:27-47.

2548. Hausman, J.J. Children's art work and their socio-metric status. In Research in Art Education. 5th Yearbook. Kutztown, Pa.: National Art Educ Ass 1954, 131-151.

2549. —— (ed.). Research in Art Education. 9th Yearbook. Kutztown, Pa.: National Art Educ Ass 1959, 177 p.

2550. Haward, L.R.C. Extra-cultural differences in drawings of the human figure by African children. Ethnos 1956, 3-4: 220-230.

2551. Heberholz, D.W. An experimental study to determine the effect of modeling on the drawing of the human figure by second grade children. In Research in Art Education. 9th Yearbook. Kutztown, Pa.: National Art Educ Ass 1959, 65-69.

2552. Heckhausen-Holstein, (?). Zeichnerische Gestaltung und Schulreife. Münster: Psychologisches Institut 1957.

2553. Henkes, R. Art expressions and adolescence. School Arts 1958, 57:21-23.

2554. ——. Value of contour drawing in teaching adolescents. Bull Art Therapy 1963, 2:122-126.

2555. Henry, E.M. Evaluation of children's growth through art experiences. Art Educ 1953, 6:1-23.

2556. Henry, W.E. Drawing and painting. In Fostering Mental Health in Our Schools. 1950 Yearbook. Association for Supervision and Curriculum Development. Washington, D.C.: National Educ Ass 1950, 254-256.

2557. Herrick, M.A. Children's drawings. Ped Sem 1893, 3:338-339.

2558. Herwagen, K. Der Siebenjährige. Versinnungsunterricht. Z angew Psychol 1920.

2559. Hetzer, H. Kind und Schaffen, Experimente über konstruktive Betätigungen im Kleinkindalter. Quellen und Studien zur Jugendkunde 1931, 7:108.

2560. ——. Die symbolischer Darstellung in der frühen Kindheit. Wiener Arbeiten zur pädagogischen Psychologie 1926, 3: 1-92.

2561. Heymann, K., et al. Kind und Kunst. Psychol Praxis 1951, No. 10, 127 p.

2562. Hicks, M.D. Art in early education. Kindergarten Magazine 1894, 6:590-605.

2563. Hildreth, G. A Child Mind in Evolution: a Study of Developmental Sequence in Drawing. NY: King's Crown Pr 1941, 163 p.

2564. ——. Developmental sequence in name writing. Child Develpm 1936, 7:291-303.

2565. ——. War theme in children's drawings. Childhood Educ 1943, 20:121, 124-127.

2566. Hirota, M. Characteristics of children's paintings and an attempt at rating them. Jap J Psychol 1959, 29:363-375.

2567. Hochberg, J., and V. Brooks. Pictorial recognition as an unlearned ability: a study of one child's performance. Amer J Psychol 1962, 75:624-628.

2568. Hoesch-Ernst, L. Beitrag zur Psychologie der Schulkinder beim Betrachtung von Bildern. Deutsche Psychologie (Halle) 1916, 1:233-280; 1919, 2:172-183, 224-244, 324-356; 1920, 3:149-176.

2569. Hofmann, H. Children's drawings as an indication of readiness for first grade. In Inter-Institutional Seminar in Child Development, Collected Papers 1957. Ann Arbor, Mich.: Author 1957, 33-47.

2570. Holland, J.D. Children's Responses to Objects in Daily Living, a Developmental Analysis. Ann Arbor: Univ Microfilms 1956, Publ No. 14849.

2571. Hollingworth, L.S. Gifted Children. NY: Macmillan 1926, 209-210.

2572. ——. Special Talents and Defects; Their Significance for Education. NY: Macmillan 1923, Ch 7.

2573. Holzmeister, C. Die Weckung des Kunstsinnes in der österreichischen Jugend. Schriften die pädagogische Institut der Stadt Wien 1935, 5, 12 p.

2574. Homma, T. (The law of Prägnanz in the process of drawing figures.) Jap J Psychol 1937, 12:112-153.

2575. Horison, S. Éléments vécus dans quelques dessins d'enfants et d'adolescents. Enfance 1950, 3:105-115.

2576. Hornig, R. Zeichen und Schreibphänomene bei Elementarschülern. Z angew Psychol 1910, 4:541-545.

2577. Huang, I. (The Psychology of Children's Drawings.) Shanghai: Commercial Pr 1938.

2578. Hubbard, M.W. Understanding through art. Childhood Educ 1949, 25:305-307.

2579. Hug-Hellmuth, H. Aus dem Seelenleben des Kindes. Leipzig, 151-163.

2580. Hughes, M.M., and L. Stockdale. The young child and graphic expression. Childhood Educ 1940, 16:307-314.

2581. Hurlock, E.B. Drawing. In Child Development. NY: McGraw-Hill 1956, 331-335.

2582. ———. The spontaneous drawings of adolescents. J genet Psychol 1943, 63:141-156.

2583. Hurlock, E.B., and J.L. Thomson. Children's drawings: an experimental study of perception. Child Develpm 1934, 5:127-138.

2584. Huth, A. Formauffassung und Schreibversuch im Kindergarten. Z pädag Psychol 1914, 15:566.

2585. ———. Neigung und Eignung. Z für Jugendkunde 1934, 4:198-206.

2586. Ignatiev, E.I. Perception et reproduction des couleurs au cours de l'apprentissage du dessin chez des enfants d'âge scolaire. Voprosy Psikhologii 1957, 1:45-53.

2587. ———. (Psychology of Children's Drawings.) Moscow: State Pedagogical Publishing House of the RSFSR Ministry of Education 1961, 222 p.

2588. Iinuma, R., and K. Watanabe. (Observations on moving objects drawn by children. Orientation and motion of railway trains.) Jap J Psychol 1937, 12:393-408.

2589. Indrikson, M.J. Understanding the child through art. School Arts 1945, 44:295.

2590. Isaacs, S. Intellectual Growth in Young Children. NY: Harcourt, Brace 1930, 370 p.

2591. Jacobi, J. Ich und Selbst in der Kinderzeichnung. Schweiz ZPA 1953, 12:51-62.

2592. Jacobs, E. Contributions a l'étude psychologique de l'enfant: le langage graphique de Rouma. Rev de Psychol 1913, 6:363.

2593. Jacques, A. Le dessin, moyen d'expression de l'énfant. École nouvelle française (Paris) 1947-48, 3:60-86.

2594. Jaensch, E.R., and W. Jaensch. Über die Verbreitung der eidetischen Anlage im Jugendalter. Z Psychol 1921, 87:91.

2595. Jakab, I. Expression graphique et définition verbale des idées abstraites chez les enfants. Ann méd-psychol 1959, 117:213-228.

2596. Jasper, C.C. The sensitivity of children of pre-school age to rhythm in graphic form. Psychol Monogr 1933, 45:12-25.

2597. Jensen, B.T. Left-right orientation in profile drawing. Amer J Psychol 1952, 65:80-83.

2598. ———. Reading habits and left-right orientation in profile drawings by Japanese children. Amer J Psychol 1952, 65:306-307.

2599. Jessen, P. Die Erziehung zur bildenden Kunst. Z pädag Psychol 1902, 4:1-10.

2600. Joesten, E. Eidetische Anlage und bildnerisches Schaffen. Arch ges Psychol 1929, 71:493-539.

2601. Johnson, B. Variations in emotional responses of children. Child Develpm 1936, 7:85-94.

2602. Johnson, R.E. Fine arts as a means of personality integration. School Rev 1948, 56:223-228.

2603. Johnson, S.R., and E. E. Gloye. A critical analyses of psychological treatment of children's drawings and paintings. JAAC 1958, 17:242-250.

2604. Joseph, A., R.B. Spicer, and J. Chesky. The Desert People. Chicago: Univ Chicago Pr 1949.

2605. Joteyko, J. Comment on retient les chiffres, les syllabe, les mots, les images. Rev de Psychol 1911, 4:1.

2606. Joteyko, J., and V. Kipiani. Rôle du sens musculaire et de la vision dans l'écriture. Rev de Psychol 1911, 4:357.

2607. ——— & ———. Rôle du sens musculaire dans le dessin. Rev de Psychol 1911, 4:362.

2608. Julian, O. Untersuchung über räumliche Prufaufgaben. Psychotechnische Z 1928, 3:117.

2609. Junger, O. Was Kinder zu ihrem Vergnügen zeichnen und der Zeichenunterricht. Kiel 1907.

2610. Just-Kéry, H. (Stages of development in written and drawn representations of children.) Magyar Pszichologicae Szemle 1960, 17:155-163.

2611. Kagan, P.W. From Adventure to Experience Through Art. San Francisco: Chandler 1959.

2612. Kainz, F. Gestaltgesetzlichkeit und Ornamentenstehung. Z angew Psychol 1927, 28:267.

2613. Kamal, S. Analysis of Children's

Drawings. Proc 6th Pakistan Sci Conf (Karachi) 1954, Pt III, 267.

2614. Karmi, H. (Children's drawings and their life's background.) Urim (Israel) 1954–55, 12:363–365.

2615. Karrenberg, C. Der Mensch als Zeichenobjekt. Leipzig 1910.

2616. Kasza, W.J. The Effects of Praise and Criticism on the Creative Drawings of Fifth Grade Children. Dissertation Abstr 1962, 22:3924.

2617. Katô, M. (A genetic study of children's drawings of man.) Japanese J experimental Psychol 1936, 3:175–185.

2618. ———. Eine genetische Untersuchung über Gestaltauffassung und Wiedergabe von Gitterquadrat. Japanese J experimental Psychol 1934, 1:49–66.

2619. Katz, D. Ein Beitrag zur Kenntnis der Kinderzeichnungen. Z Psychol 1906, 41: 251–256.

2620. ———. Studien zur Kinderpsychologie. Wissenschaftliche Beiträge zur Pädagogik und Psychologie Heft 4. Leipzig 1913.

2621. Katz, E. Children's Preferences for Traditional and Modern Paintings. NY: Teachers College 1944, 101 p.

2622. Katz, R. Ein Beitrag zur Persönlichkeitsund Milieudiagnose des Kindes. In Eckman, G., et al. (eds.), Essays in Psychology... David Katz. Uppsala: Almqvist & Wiksells, 1951, 161–179.

2623. Katzaroff, D. Qu'est-ce que les enfants dessinent? Arch Psychol 1910, 9: 125.

2624. Kawaguchi, I. (A study of the children's group-work in painting: with emphasis on the developmental stage of cooperativeness and its relation with group atmosphere.) Japanese J educ Psychol 1956, 3:214–220.

2625. Kellogg, R. What Children Scribble and Why. Palo Alto, Calif.: National Pr 1959, 131 p.

2626. Kerr, M. Children's drawings of houses. Brit J med Psychol 1936, 16:206–218.

2627. Kerr, R.N. Art and the young child. School Arts 1936, 36:5–8.

2628. Kerschensteiner, G. Die Entwicklung der zeichnerischen Begabung. Munich: Gerber 1905.

2629. Kielholz, A. Child, art and analysis. Int J Psycho-Anal 1949, 30:206–207.

2630. ———. Kinderkunst. Z Kinderpsychiat 1949, 16:1–17.

2631. Kienle, G. Zur künstlerischen und gruppenpädagogischen Behandlung der Pubertätskrisen. Z Psychother med Psychol 1960, 10:70–77.

2632. Kienzle, R. Das bildhafte Gestalten als Ausdruck der Personlichkeit. Esslingen: Langguth 1932.

2633. ———. The development of drawing ability in the growing child. In Heymann, K., Kind und Kunst. Psychol Praxis 1951, No. 10.

2634. Kik, C. Kriegszeichnungen der Knab und Mädchen. Z angew Psychol 1915.

2635. ———. Die Übernormale Zeichenbegabung bei Kindern. Z angew Psychol 1909, 2:92–149.

2636. Kimmins, C.W. The Sense of Visual Humor in Children. London: Report Britis Association for the Advancement of Scien 1922, 394 p.

2637. Kirek, (?). Die Bedeutung der sensoriellen Veranlagungen für die Bildung von Objektvorstellungen, inbesondere be Eidetikern. Z für die behandlung Schachsinniger u Epileptischer 1926, 46:121.

2638. Klauser, W. Die Entwicklung der Raumauffassung beim Kinde. Eine Untersuch an Hand von Kinderzeichnungen. Doctoral dissertation. Zurich 1916.

2639. Klein, M. Infantile anxiety situatior reflected in a work of art and in the crea tive impulse. Int J Psycho-Anal 1929, 10: 436–443; In Contributions to Psychoanalysis. London: Hogarth 1946, 227–235; Int Z Psychoanal 1931, 17:497–506.

2640. ———. Narrative of a Child Analysis. London: Hogarth & Institute of Psycho-Analysis 1960, 496 p.

2641. ———. The Psychoanalysis of Children. London: Hogarth 1937, 393 p.

2642. Knehr, E. Kindliche Bildbeurteilunge als Hilfsmittel bei der Psychodiagnose. Z diagnost Psychol 1955, 3:34–46.

2643. Kobayashi, S. (A study on a variation of facsimiles drawn by children.) Jap J Psychol 1937, 12:375–392.

2644. Köhler, W. Sammlungen freier Kinderzeichnungen. Z angew Psychol 1908, 472.

2645. Könen, H. Physioplastiek bij kinder Doctoral dissertation. Amsterdam (Zeist) 1921.

2646. Körperth-Tippel, A. Kind und Bild. Vienna: Deutscher Verlag für Jugend und Volk, 1935, 126 p.

2647. Koga, Y., and Y. Naka. (Studies on the ability to draw.) Kyôiki Shinri Kenkyû 1939, 14:509–519, 581–590, 749–761.

2648. Kollmeyer, L.A. The Relationship between Children's Drawings and Reading Achievement, Personal-Social Adjustment and Intelligence. Dissertation Abstr 1958 19:2269.

2649. Kornmann, E. Anfänge neuer Jugend-

kunst. Urkunden deutscher Volkskunst 3. Augsburg 1927.

2650. ——. Über die Gesetzmässigkeiten und den Wert der Kinderzeichnung. Ratingen: Henn 1949, 1953, 24 p.

2651. ——. Talent und Lehre. Ratingen: Henn 1951.

2652. Koster, H. Über das Verhältnis der intellektuellen Begabung zu musikalischen, zeichnerischen und technischen Begabung. Z pädag Psychol 1930, 30:399.

2653. Krauland-Steinbereithner, F., and E. Neugebauer. (The value of children's drawings in psychiatry.) Wiener Z für Nervenheilkunde und der Grenzgebiete 1953, 8:101-108.

2654. Krause, W. Experimentelle Unter-suchungen über die Vererbung der zeich-nerischen Begabung. Z Psychol 1932, 126:86.

2655. Krauttner, O. Die Entwicklung der plastischen Gestalten beim vorschulp-flichtigen Kinde. Ein Beitrag zur Psycho-genese der Gestaltung. Z angew Psychol 1930, Beihefte No. 50, 100 p.

2656. Krebs, E. (Children and landscape.) Z pädag Psychol 1936, 37:108-115.

2657. Kretschmann, O. Beiträge zur Frage nach der Vererbung der zeichnerischen Anlagen. Arch ges Psychol 1941, 108:267-316.

2658. Kretzschmar, J. Die freie Kinderziech-nung in der wissenschaftlichen Forschung. Z pädag Psychol 1912, 13:380-396.

2659. ——. Kinderkunst und Urzeitkunst. Z pädag Psychol 1910, 11:354-366.

2660. ——. Die Kinderkunst bei den Völkern höheran und niederer Kultur; ein Beitrag zur vergleichenden Pädagogik. Arch für Pädagogie 1912, 1:39-61.

2661. ——. Sammlungen freier Kinderzeich-nungen. Z angew Psychol 1910, 3:459.

2662. ——. Die Sammlung von Kinderzeich-nungen im Königl. Sächs. Institut für Kultur- und Universalgeschichte bei der Universität Leipzig. Z pädag Psychol 1912, 13:417.

2663. Krieger, K.L. Wer kann zeichnern? Zweibrücken 1921.

2664. Krötzsch, W. Rhythmus und Vorstel-lung in der freien Kinderzeichnung. Leip-zig: Hasse 1917.

2665. Kroh, O. Die Psychologie des Grund-schulkindes in ihrer Beziehung zur kind-lichen Gesamtentwicklung. Langensalza: Meyer 1931.

2666. ——. Subjective Anschauungsbilder bei Jugendlichen. Göttingen 1922.

2667. Krüber, W. Über das Aufzeichnen von Formen aus dem Gedächtnis. Z angew Psychol 1938, 54:273-327.

2668. Krüger, F., and H. Wolkelt (eds.). Das bildnerisch gestaltende Kind. Neue psychol Stud 1933, 8.

2669. Kubo, Y. (Appreciation of Japanese pictures by school children.) Japanese J applied Psychol 1936, 4:218-220.

2670. ——. (Children's appreciation of Japanese pictures.) Trans Inst Child Stud (Japanese) 1937, 17:1-38.

2671. Kunitz, A. Are talented children good athletes? High Points 1941, 23:55-59.

2672. Kuric, J. (Dominant factors in the perception and evaluation of art paintings by adolescent youth.) Psychologický Cǎsopis 1953, 1:101-121.

2673. Kurzband, T.K. Self-awareness through art in the junior high core curriculum. Res Bull, Eastern Arts Ass 1953, 4:4-6.

2674. Labunskaya, (?). Infantile drawing. School Arts 1934, 33:368-371.

2675. Lamprecht, K. Aufforderung zum Sam-meln von Kinderzeichnungen. Kind u Kunst 1905, 1:359.

2676. ——. Les dessins d'enfants comme source historique. Acad Royal de Belgique 1906, 9-10:457.

2677. ——. Einführung in die Ausstellung von Parallelen Entwicklungen in der bild-enden Kunst. Kongr f Aesth u allg Kunst-wiss (Stuttgart) 1914, 75.

2678. ——. De l'étude comparée des des-sins d'enfants. Rev de Synthèse historique 1905, 11:54.

2679. Lange, B. Zur Psychologie des heutigen Zeichnunterrichts. Deutsche höhere Schule 1935, 16:573.

2680. ——. The teaching of drawing in schools as a preparation of attitudes to-ward life. Int J Individual Psychol 1935, 1:67-72.

2681. Lange, K. Die künstlerische Entwick-lung der deutschen Jugend. Darmstadt 1893.

2682. ——. Kunst und Spiel in ihrer erzie-herischen Bedeutung. Kind u Kunst 1904, 1:1.

2683. Langevin, V., and J. Lombard. Esthé-tique du dessin d'enfant. Rev d'Esthétique 1958, 11(1):3-39.

2684. —— & ——. Peintures et dessins collectifs des enfants. Paris: Scarabée 1950.

2685. Lansing, K.M. The Effect of Class Size and Room Size upon the Creative Drawings of Fifth Grade Children. Doc-toral dissertation. Pennsylvania State Univ 1956; In Research in Art Education. 9th Yearbook. Kutztown, Pa.: National Art Educ Ass 1959, 70-74.

2686. Lantz, B. Children's spontaneous

classroom paintings as a key to emotional disturbances. Amer Psychologist 1950, 5: 467.

2687. Lark-Horovitz, B. On art appreciation of children: IV. Comparative study of white and Negro children, 13 to 15 years old. J educ Res 1939, 30:258-285.

2688. ———. On art appreciation of children: II. Portrait preference study. J educ Res 1938, 31:572-598.

2689. ———. On art appreciation in children: I. Preference of picture subjects in general. J educ Res 1937, 31:118-137.

2690. ———. On art appreciation of children: III. Textile pattern preference study. J educ Res 1939, 33:7-35.

2691. ———. Comparison of subjective and objective judgments of children's drawings. J exp Educ 1942, 10:153-163.

2692. ———. On learning abilities of children as recorded in a drawing experiment: II. Aesthetic and representational qualities. J exp Educ 1941, 9:345-360.

2693. ———. On learning abilities of children as recorded in a drawing experiment: I. Subject matter. J exp Educ 1941, 9:332-345.

2694. Lark-Horovitz, B., and J. Norton. Children's art abilities: developmental trends of art characteristics. Child Develpm 1959, 30:433-452.

2695. ——— & ———. Children's art abilities: the interrelations and factorial structure of ten characteristics. Child Develpm 1960, 31:453-462.

2696. Lascaris, P.A. L'education esthétique de l'enfant. Paris 1928, 508 p.

2697. Lassen, H. Raumauffassung und Raumdarstellung in Kinderzeichnungen. Arch ges Psychol 1943, 112:153-195.

2698. Lay, W.A. Die plastische Kunst des Kindes. Z exp Pädag 1906, 3:31.

2699. Leatherman, L.R. Children's Drawings, the Effect of Color and Neutral Tones upon the Variety and Number of Interests. Master's thesis. Northwestern Univ 1931.

2700. Leggitt, D. A comparison of abilities in cursive and manuscript writing and in creative art. School Rev 1941, 49:48-56.

2701. Legrün, A. Wie und was "schreiben" Kindergartenzöglunge? Z pädag Psychol 1932, 33:322.

2702. Lehman, H.C. Environmental influence upon drawing "just for fun." School Arts Magazine 1927, 27:3-6.

2703. Lehman, H.C., and P.A. Witty. Play interests as evidence of sex differences in aesthetic appreciation. Amer J Psychol 1928, 40:449-457.

2704. Leicht, H. Kunstgeschichte der Velt.

Zurich: Füssli 1945.

2705. Leighton, D., and C. Kluckhohn. Children of the People. Cambridge: Harvard Univ Pr 1947.

2706. Leland, J.W. Relax, and release the child's art. School Arts 1962, 61:7-8.

2707. Lembke, W. Über Zeichnungen von "frechen" und "schüchternen" Schulkindern. Z pädag Psychol 1930, 31:459-463.

2708. Leon, E.F. Children in ancient art. Art & Archaeology 1932, 33:140-145.

2709. Lerner, E., L.B. Murphy, et al. Meth for the study of personality in young chil dren. Monogr Soc Res Child Develpm 194 6, No. 4. Washington, D.C.: National Research Council.

2710. Leroy, A. Dessins en transparence et niveau de développement. Enfance 195 3:276-287.

2711. ———. Représentation de la perspective dan les dessins d'enfants. Enfance 1951, 4:286-307.

2712. Levinstein, S. Kinderzeichnungen b zum 14 Lebensjahre. Mit Parallelen aus der Urgeschichte, Kulturgeschichte und Völkerkunde. Leipzig: Voigtländer 1905, 169 p.

2713. ———. Untersuchungen über das Zeic der Kinder bis zum 14 Lebesjahr. Mit kul turhistorischen und ethnologischen Paral lelen. Doctoral dissertation. Leipzig 190

2714. Levy, M. Art and adolescence. J Ed (London) 1956, 88:16.

2715. Lewis, H.F. Development Stages in Children's Representation and Appreciation of Spatial Relations in Graphic Art. Doctoral dissertation. Univ California 1959, 86 p.

2716. Lewis, H.P. Spatial representation drawing as a correlate of development ar a basis for picture preference. J genet Psychol 1963, 102(1):95-107.

2717. Lewis, N.D.C., and B.L. Pacella. M ern Trends in Child Psychiatry. NY: IUP 1946, 341 p.

2718. Lézine, L. L'enfant et la guerre; dé pouillement d'une enquête. Enfance 1948 1:142-158.

2719. Lichtwark, A. Übungen in der Betrac tung von Kunstwerken nach Versuchen mi einer Schulklasse. Dresden: Kühtmann 19 143 p.

2720. Leibeck-Kirschner, L. Kinderziech nungen und ihre psychoanalytische Auswertbarkeit. Berlin allg ärztl Kongres für Psychother 1931, 246-250, 251-260.

2721. Liese, E. Die freihandzeichnen bei kindlicher Selbständigkeit und unter Berucksichtung des kindlichen Vermögens. Langensalza: Beltz 1931, 96 p.

2722. Lindstrom, M. Children's Art. Berkeley: Univ California Pr 1957, 230 p; 1960, 95 p.

2723. Littré, F. Le dessin enfantin. Paris: Grasset, Maintenant.

2724. Lobsien, M. Kinderzeichnung und Kunstkanon. Z pädag Psychol 1905, 7:393-404.

2725. Loch, M. Über Eidetik und Kinderzeichnung. Ochsenfurt am Main 1931.

2726. Lombardo-Radice, G. Il disegno infantile. L'educazione nazionale 1925, Feb.

2727. Lombroso, P. Das Leben der Kinder. Leipzig 1909, Ch. V.

2728. Lorent, H. Sur une Methode Synthetique de dessin après nature. Rev de Psychol 1911, 4:345-357.

2729. Lowenfeld, V. Creative growth in child art. Design 1954, 56:12-13.

2730. ———. The meaning of aesthetic growth for art education. JAAC 1955, 14: 123-126.

2731. ———. The meaning of creative activity in elementary education as a means of self-expression and self-adjustment. Design 1945, 46:14-15.

2732. ———. Your Child and Art; a Guide for Parents. NY: Macmillan 1954, 186 p.

2733. Luchins, A.S. Social influences on perception of complex drawings. J soc Psychol 1945, 21:257-273.

2734. Lucio, W.H., and C.D. Mead. An investigation of children's preferences for modern pictures. Elem School J 1939, 39: 678-689.

2735. Lukens, H. Drawing in the early years. Proc National Educ Ass 1900, 945.

2736. ———. A study of children's drawings in the early years. Ped Sem 1896, 4:79-110.

2737. Luquet, G.H. Les bonshommes têtards dans le dessin enfantin. JPNP 1920, 17: 684-710.

2738. ———. Les dessins d'un enfant. Étude psychologique. Paris: Alcan 1913, 262 p.

2739. ———. Le dessin enfantin. Paris: Alcan 1927, 260 p.

2740. ———. L'étude statistique des dessins d'enfants. JPNP 1924, 21:738-756.

2741. ———. L'évolution du dessin enfantin. Bull Soc Binet 1929, 29:145-163.

2742. ———. La mêthode dans l'étude des dessins d'enfants. JPNP 1922, 19:193-221.

2743. ———. La méthode dans l'étude des dessins d'enfants. Genèse de l'art figuré. II. Les origines de l'art figuré paléolithique. JPNP 1922, 19:795-831.

2744. ———. La méthode dans l'étude des dessins d'enfants. Genèse de l'art figuré. I. La phase préliminaire du dessin enfantin. JPNP 1922, 19:695-719.

2745. ———. La narration graphique chez l'enfant. JPNP 1924, 21:183-218.

2746. ———. Le premier âge du dessin enfantin. Arch Psychol 1912, 12:14.

2747. Lurcat, L. Étude des facteurs kinesthésiques dans les premiers tracés enfantins. Psychologie Française 1962, 7(4):301-311.

2748. Lyle, J., and R. Shaw. Encouraging fantasy expression in children. Bull Menninger Clinic 1937, 1:78.

2749. McCabe, S.F. Die Entwicklung der Child Guidance-Bewegung in Grossbritannien. Praxis Kinderpsychol Kinderpsychiat 1953, 2(5-6):140-142.

2750. McCarty, S.A. (ed.). Children's Drawings. A Study of Interests and Abilities. Baltimore: Williams & Wilkins 1924, 164 p.

2751. McDermott, L. Favorite drawings of Indian children. Northwestern Monthly 1897, 8:134-137.

2752. MacDonald, H.R. Character development through the arts. In Proceedings of the Second Conference. Langhorne, Pa.: Child Research Clinic, Woods School 1936, 52-58.

2753. McFee, J.K. A study of perception-delineation: its implications for art education. In Research in Art Education. 9th Yearbook. Washington, D.C.: National Art Educ Ass 1959, 98-104.

2754. Macgowan, C. Art education. In Encyclopedia of the Arts. NY: Philosophical Library 1945, 68-69.

2755. MacGregor, G. Warriors without Weapons. Chicago: Univ Chicago Pr 1946.

2756. McIntosh, J.R. An inquiry into the use of children's drawings as a means of psychoanalysis. Brit J educ Psychol 1939, 9:102-103.

2757. McIntosh, J.R., and R.W. Pickford. Some clinical and artistic aspects of a child's drawings. Brit J med Psychol 1943, 19:342-362.

2758. McLeish, J. Sex differences in children's art judgment: a preliminary survey. Leeds Institute Educ Res Studies 1951, No. 3, 70-83.

2759. McVitty, L. An Experimental Study on Various Methods in Art Motivations at the Fifth Grade Level. Doctoral dissertation. Pennsylvania State Univ 1954; In Research in Art Education. 7th Yearbook. National Art Educ Ass 1956.

2760. Märtin, H. Die Motivwahl und ihr Wandel in der freien Zeichnung des Grundschulkindes. Z pädag Psychol 1939, 40: 231-241.

2761. ——. Die "Phonetik" der Kinder-
zeichnung. Z Psychol 1939, 146:281-306.

2762. ——. Die plastische Darstellung der
Menschengestalt beim jüngeren Schul-
kinde. Z pädag Psychol 1932, 33:257.

2763. ——. Stile und Stilwandlungsgesetze
der Kinderzeichnung, nachgewiesen an
den Menschenzeichnungen der Volks-
schulkinder. Vierteljahrsschrift für Jugend-
kunde 1932, 2:211-226.

2764. Maitland, L. Notes on Eskimo draw-
ings. Northwestern Monthly 1899, 9:443-
450.

2765. ——. What children draw to please
themselves. Inland Educ 1895, 1:87.

2766. Malato, M.T., and S. Platania. La
transapenza nel disegno infantile e i suci
rapporti col livello intellettuale. Lavoro
di Neuropsichiatrie 1951, 9:429-440.

2767. Malrieu, P. Observations sur quel-
ques dessins libres chez l'enfant. JPNP
1950, 43:239-244.

2768. Malter, M.S. Children's preferences
for illustrative materials. J educ Res 1948,
41:378-385.

2769. Manas, L. Spontaneous drawing as
a visual diagnostic aid. Amer J Optometry
1960, 37:186-200.

2770. Manson, J.B. The drawings of Pamela
Bianca. Int Studio 1919, 68:119-125.

2771. Marcucci, H. Fanciulli che diseg-
nano. Rassegna dell'istruzione artistica
1932, 3:171-180.

2772. Marinho, H. A Linguagem na Idade
Pré-escolar. Rio de Janeiro: Instituto
Nacional de Estudos Pedagógicos 1955.

2773. ——. Logica e desheno. Rev de Edu-
cacao Publica, D.F. 1947, 5(19).

2774. ——. Die Ursprünge des Denkens in
der frühen Kindheit. Psychol Beiträge 1960,
5:141-153.

2775. Marino, D. (Infantile drawings and
sexuality.) Bol Inst Int Amer de Proteccion
a la Infancia, Montevideo 1956, 30:10-18.

2776. Marsh, E. Paul Klee and the art of
children. College Art J 1957, 16:132-145.

2777. Marshall, S. An Experiment in Edu-
cation. NY: Cambridge Univ Pr 1963,
222 p.

2778. Maspero, F. (ed.). Les enfants
d'algérie. Recits et dessins. Paris 1962,
186 p.

2779. Matějček, Z. (The possibilities of
using the drawing expression of the child
in psychological practice.) Ceskoslovenka
Psychologie 1957, 1:53-60.

2780. Mathias, M.C. Encouraging the art
expression of young children. Childhood
Educ 1939, 15:293.

2781. Mattil, E.L. Children and the arts.
Childhood Educ 1964, 40:286-291.

2782. ——. A study to determine the rela-
tionship between the adjustment of junior
high school children and their creative
products. Res Bull, Eastern Arts Ass 1953,
4:8-10.

2783. ——. A Study to Determine the Rela-
tionship between the Creative Products
of Children, Age 11 to 14, and Their Ad-
justment. Doctoral dissertation. Pennsyl-
vanis State Univ 1953.

2784. Maugé, G. Représentations du mouve-
ment et schématisation. JPNP 1955, 52:
243-252.

2785. Mazzini, G. (Thumbsucking and other
psychoanalytic data in old paintings and
sculptures of children.) Rass studi psichis
1927, 16:468-473.

2786. Meier, N.C. Appreciational arts—art.
In Implications of Research for the Class-
room Teacher. Washington, D.C.: National
Educ Ass 1939, 249-253.

2787. Meinhof, W. Die Bildgestaltung des
Kindes. Leipzig-Berlin: Teubner 1930, 74 p.

2788. Meiss, G. Sinn und Wert der Kinder-
kunst. Breslau: Görlich 1931, 114 p.

2789. Mellinger, B.E. Children's interests
in pictures. Teachers College Contribution
to Educ 1932, No. 516, 52 p.

2790. Meloun, J. Schriften und Zeichnungen
von Kindern. Charakter 1:77.

2791. Mendelowitz, D.M. Children Are
Artists: an Introduction to Children's Art
for Teachers and Parents. Palo Alto, Calif.:
Stanford Univ Pr 1963, 158 p.

2792. Merry, R.C. Art talent and racial back
ground. J educ Res 1938, 32:17-22.

2793. Metraux, R. Children's drawings:
satellites and space. J Social Issues 1961,
17(2):36-42.

2794. Metz, P. Die eidetische Anlage der
Jugendlichen in ihrer Beziehung zur künst-
lerischen Gestaltung. Langensalza: Beyer
1930, 116 p.

2795. Meumann, E. Ein Programm zur psy-
chologischen Untersuchung des Zeichnens.
Z pädag Psychol 1912, 13:353-380.

2796. ——. Vorlesungen zur Einführung in
die experimentelle Pädagogik. Leipzig:
Engelmann 1907, 1914, 800 p.

2797. Meyer, B. Kind und Kunst. Z Kinder-
forsch 1910, 15:129.

2798. Meyer, P. Über die Reproduktion
eingerprägter Figuren und ihrer räumlichen
Stellungen bei Kindern und Erwachsenen.
J Psychol 1913, 64:34.

2799. ——. Weitere Versuch über die Repro-
duktion räumlicher Lagen früher wahr-
genommener Figuren. Z Psychol 1919,
82:1.

2800. Meyers, H. Experimentelle Unter-
suchung zur Entwicklung der zeichne-
rischen Gestaltung bei Sechs- und Sieben-
jährigen am Beispiel der Darstellung des
menschlichen Koppes. Doctoral disserta-
tion. Mainz 1950.

2801. ———. Fröhliche Kinderkunst. Munich:
Kaiser 1953.

2802. ———. Die Welt der kindlichen Bild-
nerei. Witten: Lutherverlag 1957.

2803. Meyerson, I., and P. Quercy. L'orien-
tation des signes graphiques chez l'en-
fant. JPNP 1920, 17:462.

2804. Michael, J. The effect of award,
adult standard, and peer standard upon
the creativeness in art of high school
pupils. In Research in Art Education. 9th
Yearbook. Kutztown, Pa.: National Art
Educ Ass 1959, 98-104.

2805. Michaux, L., M. Saulnier, and S. Horin-
son. La concept de la route à travers la
dessin du village chez les instables. Arch
françaises de Pédiatrie 1954, 11:644-648.

2806. Miller, A.L. A project in art appre-
ciation. School Rev 1931, 39:300-306.

2807. Miller, W.A. The picture choices of
primary-grade children. Elem School J
1936, 37:273-282.

2808. ———. What children see in pictures.
Elem School J 1938, 39:280-289.

2809. Milner, D.E. Child art. Med J South-
West (Bristol) 1957, 72:125-128.

2810. Minkowska, F. Les dessins des en-
fants. L'âge Nouveau 1950, 46:20.

2811. ———. Méthode du dessin en tant qu'
expression du monde des formes chez les
enfants caractériels et sa portée pratique.
Congr Besançon 1950.

2812. ———. De Van Gogh et Seurat aux
dessins d'enfants. Paris: Presses du Temps
Présent 1949.

2813. Minkowska, F., and Y. Bert. Dessins
de jeunes enfants: source d'activité
artistique, stimulation pédagogique,
dépistage des particularités caractérielles.
Congr Besançon 1950.

2814. Minkowska, F., and (?) Foirer. Des-
sins d'adolescents: enseignement du
dessin et problèmes pédagogiques, pic-
turaux et psychopathologiques. Congr
Besançon 1950.

2815. Minkowski, E. Les dessins d'en-
fants dans l'oeuvre de F. Minkowska. Ann
méd-psychol 1952, 110:711-714.

2816. Mitchell, C.W. A Study of Relation-
ships between Attitudes about Art Ex-
perience and Behavior in Art Activity. Doc-
toral dissertation. Ohio State Univ 1957,
245 p.

2817. ———. A study of relationships be-
tween attitudes about art experience and
behavior in art activities. In Research in
Art Education. 9th Yearbook. Washington,
D.C.: National Art Educ Ass 1959, 105-111.

2818. Mitchell, E.L. Art. Rev educ Res 1937,
7:128-130.

2819. Mitchell, J.B. Art as the revelation
of the world and the self. In Ziegfeld, E.
(ed.), Art and Human Values. 3rd Yearbook.
Kutztown, Pa.: National Art Educ Ass 1953,
27-42.

2820. Morgenstern, F.B. The Effect of an
Experimental Situation Involving Failure
and Disparagement on Certain Features
of Children's Figure Drawings. Disserta-
tion Abstr 1960, 20:3403-3404.

2821. Morgenstern, S. L'importance du des-
sin dans l'étude psychanalytique de l'esprit.
Congr Psychiat Infant (Paris) 1937.

2822. ———. Psychanalyse infantile. Sym-
bolisme et valeur clinique des créations
imaginatives chez l'enfant. Avec soixante-
dix-sept reproductions de dessins. Paris:
Denoël 1937.

2823. ———. Le symbolisme et la valeur
psychoanalytique des dessins infantiles.
Rev franç Psychanal 1939, 11:39-48.

2824. Morgenthaler, W. Zur Psychologie
des Zeichens. Rev Suisse de Psychologie
et de Psychologie Appliquée 1942, 112:
102.

2825. Morino Abbele, F. Il disegno infan-
tile come manifestazione di problemi
della personalità. Bollettino di Psicologia
Applicata 1960, No. 37-39, 71-121.

2826. Moroni, F. Art in a rural Italian school.
School Arts 1955, 54:25-28.

2827. Morrison, J.G. Children's Preferences
for Pictures, Commonly Used in Art Appre-
ciation Courses. Chicago: Univ Chicago
Pr 1935, mimeographed 55 p; Cambridge:
Cambridge Univ Pr 1935.

2828. Mott, S.M. The development of con-
cepts. J genet Psychol 1936, 48:199-214.

2829. ———. The development of concepts:
a study of children's drawings. Child
Develpm 1936, 7:144-148.

2830. Mould, L. The value of art in under-
standing children. Understanding the Child
1950, 19:120-122.

2831. Mühle, G. Entwicklungspsychologie
des zeichnerischen Gestaltens. Munich:
Barth 1955, 165 p.

2832. Müller, F. Aesthetisches und aus-
seraesthetisches Urteilung des Kindes
bei der Betrachtung von Bildwerken. Doc-
toral dissertation. Univ Halle 1911; Leip-
zig: Quelle & Meyer 1912, 94 p.

2833. Mundell, L.R. The effect of lectures
on art principles upon art production at

the fifth and sixth grade levels. Psychol Monogr 1930, 51, No. 5, 127-139.

2834. Munro, T. Adolescence and art education. In Rusk (ed.), Methods of Teaching the Fine Arts. Chapel Hill: Univ North Carolina Pr 1935; Worcester Museum Bull 1932, 23:61-80.

2835. ——. Art Education, Its Philosophy and Psychology. NY: Liberal Arts 1956, 387 p.

2836. ——. Creative ability in art and its educational fostering. Yrb nat Soc Stud Educ 1941, 40:289-322.

2837. ——. Introduction. In Art in American Life and Education. National Soc Study Educ. 40th Yearbook. Bloomington, Ill.: Public School Publ Co 1941, 3-25.

2838. Munro, T., B. Lark-Horovitz, and E.N. Barnhart. Children's art abilities: studies in the Cleveland Museum of Art. J exp Psychol 1942, 11:97-155.

2839. Munro, T., R.N. Faulkner, H. Hungerland, and J.B. Smith. School instruction in art. Rev educ Res 1946, 16:161-181.

2840. Mursell, J.L. How children learn aesthetic responses. In 49th Yrb National Soc Stud Educ 1951, Part 1, 183-191.

2841. Mursell, J.L., L. Grey, L.B. Pitts, and A. Young. The measurement of understanding in the fine arts. In 45th Yrb National Soc Stud Educ 1946, 201-212.

2842. Muth, G.F. Über Alters-, Geschechts-, und Individual-unterschiede in der Zierkunst des Kindes. III. Teil der Omamentations-versuche mit Kindern. Z angew Psychol 1914, 8:507-548.

2843. ——. Über Ornamentationsversuche mit Kindern im Alter von 6 bis 9 Jahren. Z angew Psychol 1912, 6:21-50.

2844. ——. Über Ornamentationsversuche mit Kindern im Alter von 6 bix 10 Jahren. Entwicklungsparallelen von drei Kindern. Z angew Psychol 1913, 7:223-271.

2845. ——. Zierversuche mit Kindern. IV. Über eine sehr merkwürdige Linie in den zierkunstlerischen Arbeiten des Kindes. Z angew Psychol 1920, 17:259-269.

2846. Naber, L. Relation of child art to primitive art. Proc nat Educ Ass 1937, 75:208-209.

2847. Naguib, A. (Modern art education.) Egypt J Psychol 1952, 7:405-408.

2848. Nagy, L. Fejezetek a Gyermekrajzok lélektanából. Budapest 1905.

2849. Nakae, J. (Children's ways of representing a solid body.) Kyôiku Shinri Kenkyû 1939, 14:105-117.

2850. National Education Association, National Art Education Association. Art and Human Values. Washington, D.C.:

National Educ Ass 1953.

2851. National Society for the Study of Education. Art in American Life and Education 40th Year Book. Bloomington, Ill.: Public School Publ Co 1941.

2852. Natorp, F. Ein Versuch zur Deutung von Kinderzeichnungen. Werdende Zeitalter 1930, 7:347-349.

2853. Naumburg, M. Children's art expressions and war. Nervous Child 1943, 2:360-373.

2854. ——. The drawing of an adolescent girl suffering from conversion hysteria with amnesia. Psychiat Quart 1944, 18:197-224.

2855. ——. Fantasy and reality in the art expression of behavior problem children. In Lewis, N.D.C., and B.L. Pacella (eds.), Modern Trends in Child Psychiatry. NY: IUP 1945, 193-218.

2856. ——. The psychodynamics of the art expression of a boy patient with tic syndrome. Nervous Child 1945, 4:374-409.

2857. ——. A study of the art work of a behavior problem boy as it relates to ego development and sexual enlightenment. Psychiat Quart 1946, 20:74-112.

2858. ——. A study of the psychodynamics of the art work of a nine-year-old behavior problem boy. JNMD 1945, 101:28-64.

2859. Naville, P. Éléments d'une bibliographie critique relative au graphisme enfantin jusqu'en 1949. Enfance 1950, 3:130-222.

2860. ——. Notes sur les origines de la fonction graphique. De la tache au trait. Enfance 1950, 3:189-203.

2861. Naville, P., R. Zazzo, P.G. Weil, et al. Le dessin chez l'enfant. Paris: PUF 1951.

2862. Neubauer, V.E. Zur Entwicklung der dekorativen Zeichnung. Z angew Psychol 1931, 39:273-325.

2863. ——. Über die Entwicklung der technischen Begabung bei Kindern. Z angew Psychol 1927, 29:289-336.

2864. Neuhaus, W. Der Aufbau der geistig Welt des Kindes. Basel & Münich: Reinhardt 1963, 246 p.

2865. Newcomb, A.P., Jr. Possible influences of Masculine-Feminine Stereotypes on the Ratings of Children's Drawings. Dissertation Abstr 1962, 23:2033-2034.

2866. Nugent, F. Experiments in superiorit for young artists. California J Secondary Educ 1948, 23:286-289.

2867. Oberlin, D.S. Children who draw. Delaware State med J 1938, 10.

2868. Obonai, T., and K. Sumi. (A study of picture association in children.) Jap J

Psychol 1939, 14:389-395.

2869. Okerbloom, E.C. Hoyt Sherman's experimental work in the field of visual form. College Art J 1944, 3:143-147.

2870. Oldham, H.W. Child Expression in Form and Color. London: Lane 1940.

2871. Olney, E.E., and H.M. Cushing. A brief report of the responses of preschool children to commercially available pictorial materials. Child Develpm 1935, 6: 52-55.

2872. Orzehowski, J. A pilot study involving art education for emotionally disturbed youth. In Research in Art Education. 9th Yearbook. Kutztown, Pa.: National Art Educ Ass 1959, 168-173.

2873. O'Shea, M.V. Children's expression through drawing. Proc National Educ Ass 1894, 1015.

2874. ———. Some aspects of drawing. Educ Rev 1897, 14:263-284.

2875. Østlyngen, E. (On the direction of drawings.) Studia Psychologia et Paedagogica (Lund) 1948, 2:206-210.

2876. Oyama, S., and M. Kido. (An experimental study on plastic molding by children.) Jap J Psychol 1939, 14:327-338.

2877. Paget, G. Some drawings of men and women made by children of certain non-European races. J Royal Anthropological Institute 1932, 62:127-144.

2878. Pal, S.K. Developing artistic abilities in children. Shiksha 1958, 8(2):113-117.

2879. Palazzo, A. Il movimento nelle prime esperienze grafiche del fanciullo. Riv di Psicologia Normale e Patologie 1950, 46:215-232.

2880. Papavassiliou, J.T. Les dessins d'enfants considerés à la lumière de la psychologie comparée. Z Kinderpsychiat 1951, 18:65-87.

2881. Pappenheim, K. Bemerkungen über Kinderzeichnungen. Z pädag Psychol 1899, 1:57-73.

2882. ———. Das Tierzeichnen der Kinder. Kindergarten 1900, 41:180-182, 247-252.

2883. Parischa, P. Children's fantasies as expressed in their spontaneous drawings. Indian J Psychol 1947, 22:91-97.

2884. Parnitzke, E. Räumliche Klarheit in der Kinderzeichnung. Neue Deutsche Schule 1932, 6:455.

2885. Partridge, L. Children's drawings of men and women. In Barnes, E. (ed.), Studies in Education. Vol. 2. Palo Alto, Calif.: Stanford Univ Pr 1902, 163-179.

2886. Paset, G. Some drawings of men and women made by children of certain non-European races. J Royal Anthropological Institute 1932, 62:127-144.

2887. Passy, J. Notes sur les dessins d'enfants. Rev philosophique de la France et de l'étranger 1891, 32:614-621.

2888. Patel, A.S. Distortion in perception and reproduction of figures as a function of mental set exercised by language labels. Indian J Psychol 1961, 36:119-125.

2889. Paulsson, G. The creative element in art. An investigation of the postulates of individual style. Scandinavian Scientific Rev (Kristiana) 1923, 2:11-173.

2890. Pearson, G.H.J. Inverted position in children's drawings. Report of 4 cases. JNMD 1928, 68:449-455.

2891. Peck, L. An experiment with drawing in relation to the prediction of school success. J appl Psychol 1936, 20:16-43.

2892. Pelikan, A.G. The Art of the Child. NY: Bruce 1931, 123 p.

2893. Pérez, B. L'art et la poésie chez l'enfant. Paris 1888, Ch. VI.

2894. Peter, R. Beiträge zur Analyse der zeichnerischen Begabung. Z pädag Psychol 1914, 15:96-104.

2895. Pfister, O. Analysis of artistic expression. In The Psychoanalytic Method. NY: Moffat Yard 1917.

2896. ———. Die Entstehung der künstlerischen Inspiration. Imago 1913, 2:481-512.

2897. Pfleiderer, W. Die Geburt des Bildes. Ursprung, Entwicklung und künstlerische Bedeutung der Kinderzeichnung. Stuttgart 1930.

2898. Piaget, J. Art education and child psychology. In Various, Education and Art. NY: UNESCO 1955, 22-23.

2899. Piaget, J., and B. Inhelder. La représentation de l'espace chez l'enfant. Paris: PUF 1948.

2900. Piotrowska, I., and M. Sobeski. The primitive: an analysis of the first stage of development in figurative arts. JAAC 1941, 1(4):12-22.

2901. Popplestone, J.A. Male Human Figure Drawing in Normal and Emotionally Disturbed Children. Dissertation Abstr 1958, 19:573-574.

2902. Porot, M. Le dessin de la famille. Exploration par le dessin de la situation affective de l'enfant dans sa famille. Pédiatrie 1952, 41:359-381.

2903. ———. L'utilisation du dessin pour l'exploration du psychisme inconscient de l'enfant. Algérie Médicale 1948, 51: 284-288.

2904. Portalupi, F. Il bambino lattante nella pittura. Minerva Nipiologica (Torino) 1952, 2:68-83.

2905. ———. (The child in paintings.) Minerva

76 CHILDREN AND ART

Med 1952, 43:918-940.

2906. Portocarrero de Linares, G.V. El desarrollo del dibujo imitativo en la población femenina de Lima. Bol Inst Psicopedagogico Nacional (Lima) 1948, 7(2):47-148.

2907. Potpeschnigg, L. Aus der Kindheit bildender Kunst. Heft 2. Leipzig-Berlin 1912.

2908. Potter, H. Psychotherapy in children. Psychiat Quart 1935, 9:335-348.

2909. Prantle, R. Kinderpsychologie. Paderborn 1927.

2910. Probst, E. A pair of eidetic twins. In Heymann, K., Kind und Kunst. Psychol Praxis 1951, No. 10.

2911. Probst, M. Les dessin des enfants Kabyles. Arch Psychol 1907, 6:131-140.

2912. Prudhommeau, M. Dessin et écriture chez l'enfant. Enfance 1948, 1:117-125.

2913. ——. Les premières étapes du graphisme. Dessin et écriture chez l' enfant. Enfance 1948, 2:117-125.

2914. Raab, L.M. The effect of lectures on art principles upon art production at the fifth and sixth grade levels. Univ Iowa Stud Aims Progr Res 1941, No. 69, 217-222.

2915. Raalte, V. van. (Children's drawings in their relationship to psychopathology.) Psychiatrische en neurologische bladen (Amsterdam) 1912, 5-6.

2916. Rabau, G. Le sens de la symétrie chez les enfants. Enfance 1952, 1:33-47.

2917. Rabello, S. Caractericas do desenho infantil. Contribucão para o estudo psychologico da criança brasileira. Boletim Diretoria Technica de Educación (Pernambuco) 1932, 2:15-78.

2918. ——. (Color and form perception in children of three to eleven years.) Boletim Diretoria Technica de Educación (Pernambuco) 1933, 3:16-45.

2919. Rauschning, D. Die geistige Welt des Sechsjährigen im Kindergarten. Z angew Psychol 1935, 48:3.

2920. Read, H. Peintures d'enfants anglais. Préface à une Exposition du "British Council." Perpignan: Union Nat des Intellectuels 1945.

2921. ——. The Significance of Children's Art. Art as Symbolic Language. Vancouver: Univ Brit Columbia 1957, 53 p.

2922. Reca, T., and A. Speier. La representación del síntoma en los trastornos psicosomaticos: Observaciones sobre la representación del asma. Acta Psiquiatrica y Psicologica Argentina 1963, 9:216-222.

2923. Reed, C. Early Adolescent Art Education. Peoria, Ill.: Bennett 1957, 205 p.

2924. Restorff, H.v. Beobachtungen über Nachahmungs- und Darstellungsfähigkeit jüngerer Kinder. Z Kinderforsch 1931, 38: 411-451.

2925. Rey, A. Le freinage volontaire du mouvement graphique chez l'enfant. Cahie Pédag Orient Profess 1954, 13:60-71.

2926. Ricci, C. L'arte dei bambini. Bologna 1887; Leipzig: Voigtländer 1906; Ped Sem 1894, 3:302-307.

2927. Rice, C. Excellence of production and types of movements in drawing. Child Develpm 1930, 1:1-14.

2928. ——. The orientation of plane figures as a factor in their perception by children. Child Develpm 1930, 1:111-143.

2929. Richardson, M.E. Art and the Child. London: Univ London Pr 1954, 88 p.

2930. Richter, J., and H. Wamser. Experimentalle Untersuchung der beim Nachzeichnen von Strecken und Winkeln entstehenden Grössenfehler. Z Psychol 1904, 35:321.

2931. Rimerman, Y. (The significance of color in children's paintings.) Urim (Israel) 1960-61, 18:598-602; 1961-62, 19:84-86.

2932. Rimoli, A. (The psychology of children's drawings.) Cong paulist de psicol neurol psiquiat endocrinol indent med leg e criminol, atas (1938), 1941, 91-112.

2933. Ringwall, E.A. Some Picture Story Characteristics As Measures of Personalit Traits of Children. Microfilm Abstr 1951, 11:752-753.

2934. Rioux, G. Dessin et structure mentale: contribution à l'étude psycho-social des milieux nord-africains. Paris: PUF 1953, 416 p.

2935. Robertson, S.M. Rosegarden and Labyrinth: A Study in Art Education. London: Routledge & Kegan Paul 1963, 230 p.

2936. Robinault, I.P. Preschool Children's Accomplishments in Tactual and Visual Form Perception. Dissertation Abstr 1958, 19:3219.

2937. Rodgers, F. Variation in the aesthetic environment of artistic and non-artistic children. Psychol Monogr 1933, 45, No. 1, 95-107.

2938. Rosello, P., and F. Piazza. Note sur les types de description d'images chez l'enfant. Arch Psychol 1922, 18:208.

2939. Rostohar, M. L'évolution de la représentation visuelle à partir de l'impression initiale. Année Psychol 1930, 31:130.

2940. ——. Über Kinderzeichnungen. Ein Beitrag zur Entwicklung der Kindervorstellungen. Bericht über 10 Kongres für exper Psychol (Jena) 1928, 154.

2941. ——. (Studies in Developmental

Psychology.) Brno: Opera Facult Philosoph Universit Masarykian. Brunensis, Cisto 25, 1928, 1-118.

2942. Rothe, R. Kindertümliches Zeichnen. Vienna, Leipzig 1929.

2943. Rothman, E., and P. Berkowitz. Art and mental health. Grade Teacher 1952, 69:16-17.

2944. Rotten, E. Die Entfaltung der schöpferischen Kräfte im Kinde. Gotha 1926.

2945. ———. Die kindliche Kunst. Werdende Zeitalter 1930, 9:347-349.

2946. Rouma, G. Dessins d'indiens quitchouas et aymaras. La graphisme et l'expression graphique. Sem univ Pédag Univ de Bruxelles 1935, 1:133-147.

2947. ———. Le langage graphique de l'enfant. Brussels: Misch & Thron 1912, 304 p; 1913, 283 p; Paris: Alcan 1913.

2948. Ruesch, J., and J.E. Finesinger. The relation of the Rorschach color response to the use of color in drawings. Psychosom Med 1941, 3:370-388.

2949. Rüssel, A. Über Formauffassung zwei- bis fünfjähriger Kinder. Neue psychol Stud 1931, 7(1).

2950. Rugg, H., and A. Shumaker. The psychology of the creative act. In The Child-Centered School. NY: World 1928, 276-286.

2951. Russell, I.M. Relationships between certain aspects of creative expression and reading development. In Research in Art Education. 7th Yearbook. Kutztown, Pa.: National Art Educ Ass 1956, 103-114.

2952. Russell, R.W. The spontaneous and instructed drawings of Zuni children. J comp Psychol 1943, 35:11-15.

2953. Ruttmann, W.J. Die Ergebnisse der bisherigen Untersuchungen zur Psychologie des Zeichnens. Leipzig: Wunderlich 1911.

2954. ———. Das Erlebnis des Symbols im Jugendalter. Z pädag Psychol 1934, 35:24.

2955. ———. Zur Psychologie des Zeichnens. Z pädag Psychol 1912, 13:434; 1914, 15:430.

2956. ———. Vergleichende Psychologie der Kinderzeichnungen. Z pädag Psychol 1916, 17:336-337.

2957. Sakulina, N.P. (The development of artistic abilities.) Izv Akad Pedag Nauk RSFSR 1959, 100.

2958. ———. (The drawings of pre-school children for literary works.) Doshkolnoie Vospitanie 1947, 3:9-18.

2959. Salber, W. Formen zeichnerischer Entwicklung. Z diagnost Psychol 1958, 6:48-64.

2960. Salomon, C. Charlotte: a Diary in Pictures. Biographical note by Emil Straus.

NY: Harcourt, Brace & World 1963.

2961. Sanders, B. Art as an approach to children's emotional problems. In Art Education Today: 1938. NY: Teachers College 1938.

2962. Sargent, W. Problems in the experimental pedagogy of drawing. J educ Psychol 1912, 3:264-276.

2963. Saunders, A.W. The stability of artistic aptitude at the childhood level. Psychol Monogr 1936, 48, No. 213, 126-153.

2964. Scapinakis, N. Children's drawings. Clínica Contemporánea 1956, 10:46-52.

2965. Schachter, M. (Mirror writing and inverted drawings by children.) Acta Paedopsychiatrica (Basel) 1963, 30:226-231.

2966. Schaefer-Simmern, H. The Unfolding of Artistic Activity: Its Basis, Processes, and Implications. Berkeley: Univ California Pr 1948, 201 p.

2967. Scharfe, R. Kurze Anweisung zum Verwendung den freien Kinderzeichnung bei Untersuchung von Schulneulingen. Pädagogisch-psychologische Arbeiten (Leipzig) 1922, 12:55.

2968. Scheer, G. Ausdrucksfactoren in der zeichnerischen Entwicklung des Pubertätsalters (nach 225 Knabenzeichnungen). Arch ges Psychol 1934, 92:1-34.

2969. Schendel, L.S. Art and the adolescent. Master's thesis. Univ California 1926.

2970. Schereschewsky, B. Versuche über die Entwicklung des Bildverständnisses beim Kind. Z Kinderforsch 1929, 35:455-493.

2971. Schiebe, G. Erlebnismotorik und ziechnerischer (physiognomischer) Ausdruck bei Kindern und Jugendlichen (Zur Psychogenese der Ausdrucke-gestaltung). Z Kinderforsch 1934, 43:49-76.

2972. Schilder, P. The art of children and the problems of modern art. In Bender, L. (ed.), Child Psychiatric Techniques. Springfield, Ill.: Thomas 1952, 303-312.

2973. ———. L'enfant et le symbole. Scientia (Milan) 1938, 64:21-26.

2974. ———. Theories of art and its relation to the psychology and psychopathology of children. In Bender, L. (ed.), Child Psychiatric Techniques. Springfield, Ill.: Thomas 1952, 104-118.

2975. Schinke, W. Dein Kind zeichnet. Kleine Kinder 1931, 94.

2976. Schmalenbach, W. Kind und Kitsch. Werk 1951, 38:80-84.

2977. Schmidl-Waehner, T. Formal criteria for the analysis of children's drawings. Ops 1942, 2:95-104.

2978. Schmidt, F. (Descriptions of pictures

with pupils of real-gymnasia.) Gyermek (Hungary) 1933, 25:158-171.

2979. ——. Über spontane aesthetische Empfänglichkeit beim Schulkinde. Z exp Pädag 1908, 7:119.

2980. Schmidt, K.D. Ästhetik und ästhetische Erziehung in der Schule. Pädagogische Rundschau 1949, 3:68-70.

2981. Schneider, E. Kinderzeichnungen und Körperschema. Schweiz ZPA 1948, 7:165-171.

2982. Schnell, G. The Waldorfschul pedagogy in relation to the waning and reestablishment of the pictorially creative forces. In Heymann, K., Kind und Kunst. Psychol Praxis 1951, No. 10.

2983. Scholtz, D.A. Die Grundsatze der Gestaltwahrnehmung in der Haptik. Acta psychol 1958, 13(3):299-333.

2984. Schorn, M. Untersuchungen über die Handgeschlichlichkeit (mit Beiträgen zur Psychologie der menschlichen Persönlichkeit). Z Psychol 1929, 112:325.

2985. Schrenck, J. Über das Verständnis für bildische Darstellung bei Schulkindern. Wissenschaftliche Beiträge zur Pädagogik und Psychologie, Heft 5, Leipzig 1914.

2986. Schreuder, A.J. Über Kinderzeichnungen. Die Kindefehler. Z Kinderforsch 1902, 7:216-229.

2987. Schringer, W. Die Entwicklung der Diagnostik der Kinderzeichnung im Überblick. Diagnostica 1960, 6:18-30.

2988. Schubert, A. Drawings of Orotchen children and young people. J genet Psychol 1940, 37:232-244.

2989. Schulze, R. Der Mimik der Kinder beim künstlerischen Geniessen. Leipzig: Voigtländer 1906.

2990. Schumann, F. Beiträge zur Analyse der Gesichtswahrnehmungen. Z Psychol 1900, 24:1.

2991. Schuyten, M.C. Note pédagogique sur le dessin des enfants. Arch Psychol 1907, 6:389-391.

2992. ——. De oorspronkelijke "Ventjes" der Antwerpsche Schoolkinderen. Paedologisch Jaarboek 1904, 5:1-87.

2993. ——. (The study of original childsketches as a basis of child analysis.) Paedologisch Jaarboek 1901, 2:113-126.

2994. Schwartz, O. Das freie Zeichnen in der Hilfschule. Die Hilfschule 1931, 24:227.

2995. Schwarz, I. Der Einfluss verschiedener Bildvorlagen auf die gestaltung Sechsjähriger. Psychol Beiträge 1960, 5:248-272.

2996. Schwarz, L. Quelques remarques sur l'attitude des enfants de la campagne

devant des oeuvres d'art. Enfance 1953, 6:249-261.

2997. Scorse, S.W. Pediatrics and painting. Clinical Pediatrics (Phila) 1963, 2:345-348.

2998. Scripture, E., and C. Lyman. Drawing a straight line: a study in experimental didactics. Studies Yale Psychol Laboratory 1892-93, 1:92.

2999. Scupin, E., and G. Scupin. Bubi's erste Kindheit. Leipzig 1907.

3000. —— & ——. Bubi im vierten bis sechsten Lebensjahre. Leipzig 1910.

3001. Seeman, E. Development of the pictorial aptitude in children. Char Pers 1934, 2:209-221.

3002. Seeman, E., and R. Saudek. The self-expression of identical twins in handwriting and drawing. Char Pers 1932, 1:91-128.

3003. Segirs, J.E. Récherches sur la perception visuelle chez les enfants agés de 3 à 12 ans et leur application à l'education. I. Perceptions simples. JPNP 1926, 23:608-636, 723-753.

3004. Sell, R. Saving children from their pasts with the paint brush. St. Louis Post Dispatch Sunday Magazine Section 1938, April 17, p 1.

3005. Shabalin, S.N. (The objective-gnostic moments in the perception of form in pre-school children.) Sci Mem pedag Inst Herzen 1939, 18:59-106.

3006. Shaw, R.F., and J. Lyle. Encouraging fantasy expression in children. Bull Menninger Clinic 1937, 1:78-86.

3007. Shinn, M.W. Studies of children's drawings. Univ California Studies 1897, 2.

3008. Sigg-Boeddinghaus, M. Zeichnen und Malen und ihre Bedeutung für die seelische Entwicklung des Kindes. Psychologische Rundschau 1929, 1:222-229; 1930, 2:324-330.

3009. Sikorsky, J.A. Die Seele des Kindes. Leipzig 1902, 59-61.

3010. Silverstein, A.B., and H.A. Robinson. The representation of physique in children's figure drawings. J consult Psychol 1961, 25:146-148.

3011. Simonio, (?). Zeichnerische Leistunge eines psychopathen. Z Kinderforsch 1926, 32:18-22.

3012. Simpson, B.R. Creative activity in children. J educ Psychol 1943, 34:431-439.

3013. Siverer, M.G. The psychology of expression. Design 1940, 42:5-8; 1941, 42:6-9.

3014. Slettehaugh, T.C. Children's Respons to Three-Dimensional Abstract Ceramic

Forms, a Developmental Analysis. Ann Arbor: Univ Microfilms 1957, Publ No. 19345.

3015. Slochower, M.Z. Experiments on dimensional and figural processes in the clay and pencil reproductions of line figures by young children: I. Dimension. J genet Psychol 1946, 69:57-75.

3016. Sommrova, O. (The importance of drawing in determining the mental state in children in relation to their physical state.) Ceskoslovenska Pediatrie 1963, 18:234-240.

3017. Sonntag, F. Kinderzeichnungen. Baden: Klein 1955.

3018. Sorge, S. Neue Versuche über die Wiedergabe abstraktes optischer Gebilde. Arch ges Psychol 1940, 106:1-89.

3019. Spiegel, L.A. The child's concept of beauty: a study in concept formation. J gen Psychol 1950, 77:11-23.

3020. Spielrein, S. Kinderzeichnungen bei offenen und geschlossenen Augen. Untersuchungen über die unterschwelligen kinästhetischen Vorstellung. Imago 1931, 17:359-391; Z für psychoanalytischer Pädagogie 1931, 5:446-459.

3021. Spoerl, D.T. A note on the Anastasi-Foley cultural interpretation of children's drawings. J soc Psychol 1941, 13:187-192.

3022. Springer, N.N. A study of the drawings of maladjusted and adjusted children. J genet Psychol 1941, 58:131-138.

3023. Sprung, S.R. The Effect of Direction and Nondirection of Children's Drawings. Dissertation Abstr 1953, 13:725.

3024. Ssakylina, N.P. (The role of observation in the evolution of children's drawings.) Doshkolnoje Vospitanie 1944, No. 1, 32-36.

3025. Steiger, R. Von künstlerischen gestalten bei der Behandlung kindlicher Neurosen. Praxis Kinderpsychol Kinderpsychiat 1953, 2:193-194.

3026. Stern, A. Notes sur la peinture d'enfants. Psyché-Paris 1952, 7:472-474.

3027. Stern, C., and W. Stern. Die zeichnerische Entwicklung eines Knaben vom 4 bis zum 7 Jahre. Z angew Psychol 1910, 3:1-31.

3028. Stern, W. Die Entwicklung der Raumwahrnehmung beim Kinde. Bericht über d 3. Kongres für exper Psychol (Leipzig) 1900, 239.

3029. ———. Die Entwicklung der Raumwahrnehmung in der ersten Kindheit. Z angew Psychol 1909, 2:412.

3030. ———. Psychology of Early Childhood up to the Sixth Year of Age. NY: Holt 1930, Ch 26; Leipzig 1914, 1927, Ch 20.

3031. ———. Spezielle Beschreibung der Austellung, freier Kinderzeichnungen aus Breslau. Langensalza 1907, 411-417.

3032. ———. Überverlagerte Raumformen. Z angew Psychol 1909, 2:498.

3033. Stern, W., W. Köhler, and M. Verworn. Sammlungen, freier Kinderzeichnungen. Z angew Psychol 1908, 1:179-187, 472-476.

3034. Stolz, A., and H.T. Manuel. The art ability of Mexican children. School & Soc 1931, 34:379-380.

3035. Stone, P.M. A Study of Objectively Scored Drawings of Human Figures in Relation to the Emotional Adjustment of Sixth Grade Pupils. Dissertation Abstr 1953, 13:1265.

3036. Stückrath, F. Das geometrische Erleben des Kindes in seinem Werkschaffen. Eine bildungspsychologische Studie. Hamburg: Broschek 1930, 88 p.

3037. Subes, J. L'appréciation esthétique d'oeuvres d'enfants par les enfants. Enfance 1958, No. 2, 115-130.

3038. ———. La sensibilité de l'enfant a l'art pictural. Enfance 1955, 8:345-368.

3039. ———. Sensibilité esthétique enfantine et influence de milieu. Enfance 1957, 1:43-65.

3040. Subes, J., and J. Auzet. Une tentative d'étude objective du sens esthétique chez l'enfant. Enfance 1950, 3:160-167.

3041. Sully, J. Studies of Childhood. London 1895; Paris: Alcan 1898; NY: Appleton 1908.

3042. Takeda, T. (Children's drawings.) Jap J Psychol 1934, 9:217-226.

3043. Takemasa, T. (Copy drawing in kindergarten children.) Kyôiku Shinri Kenkyû 1939, 14:1-12.

3044. Takemasa, T., and G. Kato. (On the development of the process of clay work in primary-school children.) Kyôiku Shinri Kenkyû 1939, 14:341-355.

3045. Taylor, H.M. Children's Interests as Revealed by Their Drawings in Three Grades. Master's thesis. George Peabody College for Teachers 1932, 60 p.

3046. Taylor, W.S. A note on cultural determination of free drawings. Char Pers 1944, 13:30-36.

3047. Thöne, F. "Die Düsseldorfer Austellung": Das schöpferische Kind im Herbst 1924. Z pädag Psychol 1925, 26.

3048. Thomas, R.M. Effects of Frustration on Children's Paintings. Dissertation Abstr Stanford Univ 1950-51, 26:43-45; Child Develpm 1951, 22:123-132.

3049. Thompson, L., and A. Joseph. The Hopi Way. Chicago: Univ Chicago Pr 1944, 151 p.

3050. Tisserand-Perrier, M., and A.M. Blaizot. Le dessin, mode d'investigation de la personnalité chez les jumeaux identiques. Acta Geneticae Medicae et Gemollologiae (Rome) 1955, 4:261-274.

3051. Todd, J.M. Drawing in the Elementary School. Chicago: Univ Chicago Pr 1931, 65 p.

3052. ———. Preferences of children for modern and older paintings. Elem School J 1943, 44:223-231.

3053. Tombu, M.L. Aptitudes pour le dessin. Rev de Psychol 1911, 4:211.

3054. Tomlinson, R.R. Children As Artists. London: King Penguin 1944.

3055. ———. Picture Making by Children. London: Studio 1934.

3056. Torrance, E.P. Guiding Creative Talent. Englewood Cliffs, N.J.: Prentice-Hall 1962, 278 p.

3057. Torren, J. van der. Über Auffassungs- und Unterscheidungsvermogen für optische Bilder bei Kindern. Z angew Psychol 1908, 1:189.

3058. Traill, M.J., and H. Harap. Art preferences in junior high school; a guide to art objectives. J exp Psychol 1934, 2:355-365.

3059. Tramer, M. Zeichnen als künstlerische Ausdrucksform und als planmäszige, organisatorisch-architektonische Betätigung eines Kindes. Z Kinderpsychiat 1946, 13: 141-156.

3060. Traube, T. La valeur diagnostique des dessins des enfants difficile. Arch Psychol 1937, 26:285-309.

3061. Tröndle-Engel, A., and O. Tröndle-Engel. Vom kindlichen Zeichnen. Z kinderpsychiat 1937, 4:84-86.

3062. Trümper-Bödemann, (?). Die freie Kinderzeichnung; ihre Auswertung und ihre Auswirkung in der Praxis. Z für die Behandlung Schwachsinniger u Epileptischer 1926, 46:97-105.

3063. Tumlirz, O. Einführung in die Jugendkunde mit besonderer Berücksichtigung der experimentell-pädagogischen Forschungen. Leipzig 1920.

3064. Uhlin, D.M. The relationship of adolescent physical development to art expression. Studies Art Educ 1962, 3:64-68.

3065. Ushizima, Y. (On the development of children's drawings.) Trans Inst Child Study (Hiroshima) 1932, 14.

3066. Van der Horst, L. Affect, expression, and symbolic function in the drawing of children. In Reymert, M.L. (ed.), Feelings and Emotions; The Mooseheart Symposium. NY: McGraw-Hill 1950, 384-417.

3067. Van der Horst-Oosterhuis, C.J. Over het 'van binnen uit' tekenen en schilderen. Ned Tijdschr Psychol 1956, 11:261-270.

3068. Van der Molen, F.J. Kinderzeichnung Kinderstudie 1916, 1:1.

3069. Van de Wal, (?). De perspectief in het naif teekenen. Scool en leven 2-3.

3070. Van Gennep, A. Dessin d'enfant et dessin préhistorique. Arch Psychol 1911, 10:327-337.

3071. Van Krevelen, D.A., and J.G. Martens-Wartena. Die Zeichnung des Kindes als Ausdrucksmittel. Schweiz ZPA 1955, 14: 106-123.

3072. Various. Art education for secondary schools. A selected bibliography. Art Educ 1959, 12(8):6-9.

3073. Vasilieva, E.I. (Thematic drawing on assignment in the middle group.) Doshkol'noe Vospitanie 1950, II (Feb.), 18-26.

3074. Verworn, M. Kinderkunst und Urgeschichte. Sitzungsberichte d anthropol Vereins zu Göttingen, Braunschweig 1908, 6.

3075. ———. Sammlungen freier Kinderzeichnungen. Z angew Psychol 1909, 2:180.

3076. Viola, W. Child Art. Peoria, Ill.: Bennett 1949, 206 p; London: Univ London Pr 1944, 206 p.

3077. ———. Child Art and Franz Cizek. NY: Reynal & Hitchcock 1936, 111 p.

3078. Visual Arts in General Education: Report of Committee on Function of Art in General Education, Progressive Education Association Commission on the Secondary School Curriculum. NY: Appleton 1940, 166 p.

3079. Vogelsang, H. Aus der Ideenwelt jugendlicher Rechtsbrecher. Z für Jugendkunde 1934, 4:120-125.

3080. Volkelt, H. Das bildnerisch gestaltende Kind. Z pädag Psychol 1929, 30:43.

3081. ———. Fortschritt der experimentelle Psychologie. Bericht über den 9. Kongres für exper Psychol, Jena, 1926, 80.

3082. ———. Neue Untersuchungen über die kindliche Auffassung und Wiedergabe von Formen. Bericht über den 4. Kongres für Heilpädagog. Berlin 1929, 15.

3083. ———. Primitive Komplexqualitäten in Kinderzeichnungen. Bericht über den 8. Kongres für exper Psychol, Jena 1924, 204-208.

3084. ———. Zur Psychologie der Kinderkunst. Kinderkunst, Sonderheft von Schauen und Schaffen 1930, 56, Heft 4.

3085. ———. Versuche über Raumdarstellung der Schulkinst. Bericht über den 12. Kongres d. Deutschen Gesselschaft f Psychol Jena 1932, 435.

3086. Vuoristo, G. (Painting as an aid to diagnosis in child psychiatry.) Duodecim 1950, 66(5):414-423.

3087. Vydra, J. Stammesunterschiede in der Begabund des Kindes für bildende Kunst. 4 Versammlung für Kinderforschungen, Bratislava 1932, 311-314.

3088. Waehner, T.S. Formal criteria for the analysis of children's drawings. Ops 1942, 12:95-103.

3089. Wagner, P.A. Das freie Zeichnen von Volksschulkindern. Z angew Psychol 1914, 8:1-70.

3090. Walchak, F.A. Art helps pupil adjustment. School Arts 1954, 53:24-26.

3091. Wall, J. The Base Line in Children's Drawings of Self and Its Relationship to Aspects of Overt Behavior. Dissertation Abstr 1959, 20:591.

3092. Wallon, H. Préambule, in Le dessin chez enfant. Paris: PUF 1951, v-viii; Enfance 1950, 3:V-VIII.

3093. Wallon, H., E. Evart-Chmielniski, and R. Sauterey. Le sens de la verticale chez l'enfant. JPNP 1959, 56, 161-186.

3094. Wallon, H., and L. Lurçat. Le dessin du personnage par l'enfant: ses étapes et ses mutations. Enfance 1958, No. 3, 177-211.

3095. ――― & ―――. L'espace graphique de l'enfant. JPNP 1959, 56:427-453.

3096. ――― & ―――. Graphisme et modèle dans les dessins de l'enfant. JPNP 1957, 54:257-278.

3097. Webb, J. Art helps to prevent delinquency. School Arts 1945, 44:244-245.

3098. Wehrli, G.A. Die inneren Körperorgane in den Kinderzeichnungen mit einigen ethnographischen Parallelen. Zurich: Mitteilungen d. Geograph-Ethnographischen G'schaft, 1918-19.

3099. Weidmann, J. The child and the developments of arts. In Heymann, K., Kind und Kunst. Psychol Praxis 1951, No. 10.

3100. Weil, P.G. Caractéristiques du développement du dessin par groupes d'âge, selon divers auteurs. Enfance 1950, 3:221-226.

3101. Weinert, F. Der Einfluss der Übung auf das aufgabenbezogene Verhalten bei zehnjährigen Kindern. Z exp angew Psychol 1959, 6:212-247.

3102. Weisberg, P.S., and K.J. Springer. Environmental factors in creative function: a study of gifted children. Arch gen Psychiat 1961, 5:554-564.

3103. Weldele, M.K. Art in the Life of the Public School Pupil. Master's thesis. Terre Haute: Indiana State Teachers College 1933.

3104. Welling, J.B. Children make art. Childhood Educ 1949, 25:299-301.

3105. Weston, M.D. Mother and Son Descriptions of Mothers and Sons in a Picture Story Test. Dissertation Abstr 1956, 16:1288-1289.

3106. White, R., and B. Johnson. Children's choices in modern art. Child Develpm 1930, 1:347-349.

3107. Whitford, W.G. An Introduction to Art Education. NY: Appleton 1929, 1937, 391 p.

3108. ―――. Selected references on elementary-school instruction: art. Elem School J 1938, 39:219-220; 1939, 40:219-221; 1940, 41:217-219; 1941, 42:220-222; 1942, 43:179-180.

3109. ―――. Selected references on secondary-school instruction: art. School Rev 1939, 47:222-224; 1940, 48:221-224; 1941, 49:223-225; 1942, 50:225-228.

3110. Whitford, W.G., N.C. Meier, and J.E. Moore. Art. Rev educ Res 1937, 7:464-466.

3111. Whorley, K.S. An experimental investigation of the sensitivity of children to compositional unity. Psychol Monogr 1933, 45, No. 1, 26-45.

3112. Wiggin, R. Developmental Stages of Drawing Expression. College Park, Md.: Wiggin 1948 (mimeographed).

3113. Wilding, J.H. Art Education in High School as It Affects Home and Family Living. Dissertation Abstr 1960, 21:165.

3114. Williams, J.N. Interpretation of drawings made by maladjusted children. Virginia med Monogr 1940, 67:533-538.

3115. Willing, J.B. Children make art. Childhood Educ 1949, 25:299-301.

3116. Wilson, L.A. Child guidance through art. Design 1946, 47:19.

3117. Wilson, M. Everyone can draw. Bull Inst Child Study (Toronto) 1956, 18(2):9-12.

3118. Winslow, L.L. Some characteristics of pupils' reported talent in art. Baltimore Bull Educ 1935, 13:50-54.

3119. ―――. Stages of growth and development in art. Educ Administration Supervision 1952, 38:18-24.

3120. Wintsch, J. Le dessin comme témoin du développement mental. Z Kinderpsychiat 1935, 2:69-83.

3121. Wischer, P. Zur Auswahl und Prüfung der zeichnerisch Begabten. Z pädag Psychol 1919, 20:219-230.

3122. Wolfenstein, M. French children's paintings. In Mead, M., and M. Wolfenstein (eds.), Childhood in Contemporary Cultures. Chicago: Univ Chicago Pr 1963, Ch 5.

3123. Wolff, H. Die Kinderzeichnung nach Inhalt, Form und Farbe. Weimar 1929.

3124. Wolff, W. Diagrams of the Unconscious. NY: Grune & Stratton 1948.

3125. ———. The Personality of the Pre-School Child; the Child's Search for His Self. NY: Grune & Stratton 1946, 341 p.

3126. Wommelsdorf, O. Die Ausstellung deutscher Kinderzeichnungen auf dem Weltkongress in Helsingör. Werdende Zeitalter 1929, 8:673.

3127. Woody, C. Arithmetic, language, fine arts, physical and health education, and industrial arts. Rev educ Res 1931, 1:261–275.

3128. Wulff, O. Die Kunst des Kindes, der Entwicklungsgang seiner zeichnerischen und bildnerischen Gestaltung. Stuttgart: Enke 1927, 408 p.

3129. Wundt, W. Die Zeichnungen des Kindes under die zeichnende Kunst der Naturvölker. In Festschrift Johannes Volkelt zum 70. Geburtstag. München 1918,

3130. Zachry, C.B. The role of art in personality development. Ment Hyg 1933, 17:51–58.

3131. Zagala, B., and S. Szuman. (We are Painting: An Album of Child Art.) Warsaw: Nasza Księgarnia 1961, 27 p.

3132. Zambaldi, I. La scuola attiva e il metodo d'insegnamento. Il disegno. Riv pedagogica 1935, 27, 64 p.

3133. Zavalloni, R., and N. Giordani. Ricerca sulla sensibilità estetica nell'età evolutiva. Problemi della Pedagogia. Rivista Bimenstrale (Rome) 1958, 6:904–919.

3134. Zawacki, A.J. Synthetic and Analytic Tendencies in the Art Expressions of Third Graders. Ann Arbor: Univ Microfilms 1956, Publ No. 16737.

3135. Zecca, G. Il comportamento grafico del bambino nelle prime rappresentazioni degli indistinti naturali. Arch Psicol Neur Psichiat 1956, 17:737–753.

3136. Zesbaugh, H.A. An analysis of the graphic representation of the human figur by school children. Elem School J 1926, 26:759–770.

3137. ———. Children's Drawings of the Human Figure. Chicago: Univ Chicago Pr 1934, 75 p.

3138. Ziegfeld, E. Art education. Rev educ Res 1949, 19:158–171.

3139. ——— (ed.). Art and Human Values. 3rd Yearbook. Kutztown, Pa.: National Art Educ Ass 1953, 122 p.

3140. ———. Education and Art: A UNESCO Symposium. NY: Columbia Univ Pr 1953, 129 p.

3141. Ziehen, T. Die Prüfung der Phantasietätigkeit bei Kranken Gesunden. J fü Psychologie und Neurologie 1938, 37:422

3142. ———. Das Seelenleben der Jugendlichen. Langensalza 1931.

3143. Zilahi-Beke, A. Zusammenhange zwischen Kunst- und Charakterentwicklung. Int Z indiv-Psychol 1931, 9:51–60.

3144. Zilgitt, H.H. Relationships in child development. Design 1935, 37:26–27.

3145. Zimmer, R. Developmental stages. In Heymann, K., Kind und Kunst. Psychol Praxis 1951, No. 10.

3146. Zimmerman, E. Ausstellung für Kinderkunst in Dresden. Kind u Kunst 1905, 1:355.

3147. Zinn, M.C. A Study of Originality in Children's Drawings. Master's thesis. Pennsylvania State College 1932, 84 p.

3148. Zuk, G.H. Size: its significance in the copied drawings of children. J clin Psychol 1960, 16:38–42.

6 Color

3149. Aars, C. Der aesthetische Farben-
sinn bei Kindern. Z pädag Psychol 1899,
1:173-179.
3150. Abraham, E. Mittelung: Zeichnung
und Farbe als seelischer Ausdruck. Psyche
1950, 4:237-240.
3151. Adam, G.K. An experimental study of
memory, color and related phenomena.
Amer J Psychol 1923, 34:359-407.
3152. Aires, F. (A psychologic study of
color perception.) Arquivos brasileiros
de oftalmologia (São Paulo) 1940, 3:276-
280.
3153. Albers, J. The Interaction of Color.
New Haven: Yale Univ Pr 1963.
3154. Aldrich, V.C. Colors as universals.
Philos Rev 1952, 61:377-381.
3155. Allen, E.C., and J.P. Guilford. Fac-
tors determining the affective values of
color combinations. Amer J Psychol 1936,
48:643-648.
3156. Allen, F. Color, from substance to
sensation. Sci Monthly 1937, 44:57-61.
3157. Allen, G. The Color Sense—Its
Origin and Development. London: Kegan
Paul, Trench & Trubner 1892.
3158. Altea, E. Factors determining reac-
tion to color and form; relation to develop-
ment of perceptive structures. Lavoro di
Nevropsichiatrie 1953, 12:260-266.
3159. Ameseder, R. Über die Absolute Auf-
fälligkeit der Farben. In Meinong, A.,
Untersuchungen zur Gegenstandstheorie
und Psychologie. Leipzig 1904.
3160. Anon. L'attrait des couleurs chez les
enfants. Arch Orient prof Dép Nord 1938,
1, 16 p.
3161. Anon. Psychological painted school
improves pupils' performance. Architecture
& Engineering 1957, 209:7.
3162. Anschütz, G. Kurze Einführung in die
Farbe-Ton-Forschung. Leipzig 1927, 31 p.
3163. Arlitt, A.H., and S.H. Buckner. A study
of color preferences in white and negro
three-year olds. Proc 35th Ann Meeting
Amer Psychol Ass 1926, 23:190-191; Psy-
chol Bull 1927, 24:190-191.
3164. Ascoli, G. Comment l'enfant sait
classer les objets. Enfance 1950, 3:411-
433.
3165. Atwell, S. Color vision in relation
to artistic ability. J Psychol 1939, 8:53-
56.
3166. Avera, L.F. Color—what it is and
how do we see it. Amer J Optometry 1939,
16:14-21.
3167. Babska, Z. (Development of the Con-
notative Function of the Color and Shape
of Objects in Early Childhood.) Warsaw:
Warsaw Univ Pr 1961, 219 p.
3168. Baker, E.S. Experiments on the aes-
thetic of sight and color: on combina-
tions of two colours. Univ Toronto Stud,
Psychol Series 1900, 1:201-209.
3169. ——. Experiments on the aesthetic
of light and colour. Spectrally pure colours
in binary combinations. Univ Toronto Stud,
Psychol Series 1902, 2:25-43.
3170. Balaraman, S. Color vision research
and the trichromatic theory; a historical
review. Psychol Bull 1962, 59:434-438.
3171. Baldwin, K.W. The therapeutic value
of light and color. Atlantic med J 1927,
30:431-432.
3172. Baley, S., and T. Witwicki. (Color,
form and size perception in the pre-school
child.) Psychologia Wychowawcza 1948,
13(3-4):1-23.
3173. Banerji, S., and S.C. Mitra. Studies
in aesthetic perception. Indian J Psychol
1942, 17:94-98.
3174. Baranova, F., et al. (The question of
representation of colors in illustrations.)
Psikhologie 1932, 4:56-63.
3175. Barber, F.L. Combinations of colours
with tints and with shades. Univ Toronto
Studies, Psychol Series 1905, 11:1-20;
1907, 167-184, 245-290.
3176. Bardin, K.V. (Age peculiarities of the
memory for colors in school children.)
Doklady Akademiia Pedagogscheskikh
Nauk RSFSR 1958, No. 3, 67-72.
3177. Baron, A. A Comparative Study of
Color Vision and Color Matching as Re-

lated to Chronological Age, Mental Age, and Intelligence Quotient of Children. Master's thesis. New York Univ 1931.

3178. Barrett, D.M., and E.B. Eaton. Preference for color or tint and some related personality data. J Personality 1947, 15: 222-232.

3179. Bartleson, C.J. Memory colors of familiar objects. J opt Soc Amer 1960, 50: 53-77.

3180. Bartlett, H.H. Color nomenclature in Battak and Malay. Michigan Acad Sci Arts Letters 1928, 10:1-52.

3181. Basu, M.N. Possibility of a racial significance of colour preference. Eastern Anthropologist 1949, 2(3):160-161.

3182. Battke, H. Über Farbe und Raum in der Malerei. Kunstwerk 1949, 3:33-45.

3183. Beaglehole, E. Tongan color vision. Man 1939, 39:170-172.

3184. Beck, H.S. The relationship of colors to various concepts. J educ Res 1960, 53: 194-196.

3185. Belaiew-Exemplarsky, S. Über die sogennanten "hevortretenden" Farben. Z Psychol 1925, 96:400-429.

3186. Benedict, A.A., and A.R. Lauer. Apparatus for the quantitative measurements of color vision. J comp Psychol 1935, 20: 107-112.

3187. Berchen, E.v.D. Untersuchungen zur Geschichte der Farbengebung in der venezianischen Malerei. Parchim 1914.

3188. Berg, J., and C.J. Polyot. The influence of color on reactions to incomplete figures. J consult Psychol 1956, 20:9-15.

3189. Berge, C. Le symbolisme des couleurs. Psyché-Paris 1949, 4:529-534, 658-662, 757-777.

3190. Bezold, W. Die Farbenlehre im Hinblick auf Kunst und Kunstgewerk. Braunschweig: Vieweg 1921.

3191. Biema, C. Farben und Formen als lebendige Kräfte. Jena 1930, 213 p.

3192. Binet, A. La perception des couleurs et des nombres chez les enfants. Rev philosophique de la France et de l'étranger 1890, 30:68-81.

3193. Birren, F. A chart to illustrate the fundamental discrepancies of color study in physics, art and psychology. Psychol Rev 1930, 37:271-273.

3194. ———. Character Analysis through Color. Westport, Conn.: Crimson Pr 1940.

3195. ———. Color Dimensions. Westport, Conn.: Crimson Pr 1934.

3196. ———. Color Psychology and Color Therapy; a Factual Study of the Influence of Color on Human Life. NY: McGraw-Hill 1950, 284 p; New Hyde Park, NY: University Books 1961.

3197. ———. Color and psychotherapy. Tran Amer Acad Opthalmology 1946, 51:106-10 Modern Hospital (Chicago) 1946, 67:57-58.

3198. ———. Color: A Survey in Words and Pictures, from Ancient Mysticism to Modern Science. New Hyde Park, NY: University Books 1963, 224 p.

3199. ———. Color in Your World. NY: Colli 1962, 121 p.

3200. ———. The effect of color in the huma organism. Amer J occup Ther 1959, 13:125 129, 133.

3201. ———. The emotional significance of color preference. Amer J occup Ther 1952, 6:61-63.

3202. ———. Functional Color. NY: Crimson Pr 1937.

3203. ———. Monument to Color. London: McFarlane, Ward, McFarlane 1938.

3204. ———. New Horizons in Color. NY: Reinhold 1955, 200 p; London, Chapman 1955, 200 p.

3205. ———. The psychologic value of color Modern Hospital (Chicago) 1928, 31:85-88.

3206. ———. The Story of Color. Westport, Conn.: Crimson Pr 1942, 338 p.

3207. ———. Your Color and Your Self; the Significance of Color Preference in the Study of Human Personality. Sandusky, Ohio: Prang 1952, 124 p.

3208. Bischler, W. Le rôle des zones érogènes dans la genèse du talent artistique Rev franç Psychanal 1933, 3:475-482.

3209. Bixby, F. A phenomenological study of luster. J gen Psychol 1928, 1:136-174.

3210. Bjerstedt, A. Color arrangement and color association. Nordisk Psykologi 1959 11:96-106.

3211. ———. Warm-cool color preferences as potential personality indicators: preliminary note. Perceptual & Motor Skills 1960, 10:31-34.

3212. Blanchard, (?). (Association of color with certain figures and words.) Bull de l'Academie de Médicin (Paris) 1916, 76: 615.

3213. Block, D.S., and W.E. Caldwell. Rela tionships between color and affect in paranoid schizophrenics. J gen Psychol 1959, 61:231-235.

3214. Bocci, G. The importance of color in illumination; a psychologic study of preference with respect to color. Rass studi psichiat 1954, 43:1-25.

3215. Boice, M.L., M.A. Tinker, and D.G. Paterson. Color vision and age. Amer J Psychol 1948, 61:520-526.

3216. Bokslag, J.G.H. (Age and sex in the Lüscher test and the influence of the examiner.) Ned Tijdschr Psychol 1954, 9: 497-516.

3217. Boll, M., and J. Dourgnon. Le secret des couleurs. Paris: PUF 1946, 1949, 128 p.

3218. Bolles, R.C., I.M. Hulicka, and B. Hanly. Colour judgment as a function of stimulus conditions and memory colour. Canadian J Psychol 1959, 13:175-185.

3219. Bopst, H. Color and Personality. NY: Vantage 1962, 99 p.

3220. Bordier, A. L'esthétique scientifique. La lumière et les couleurs. Ann de l'Univ Grenoble 1902, 14:198-226.

3221. Bourdon, B. Couleur et profondeur. JPNP 1935, 32:673-686.

3222. Bowles, J.W., Jr., N.H. Pronko, G.W. Allen, and F.W. Snyder. Another experiment in the pursuit of "color blindness." J Psychol 1949, 28:265-271.

3223. Bradford, E.J.G. A note on the relation and esthetic value of perceptive types in color appreciation. Amer J Psychol 1913, 24:545-554.

3224. Brandt, F. Formkolorisme. Bidrag til kromatismeines faenomenologi. Copenhagen 1958.

3225. Braunshausen, N. La couleur et la forme. Le graphisme et l'expression graphique. Sem univ Pédag Univ de Bruxelles 1935, 1:83-110.

3226. Brennan, J.G., R.W. Burnham, and S.M. Newhall. Color terms and definition. Psychol Bull 1949, 46:207-230.

3227. Brian, C.R., and F.L. Goodenough. The relative potency of color and form perceptions at various ages. J exp Psychol 1929, 12:197-213.

3228. Brown, W.R.J. Color discrimination of twelve observers. J opt Soc Amer 1957, 47:137-143.

3229. Brücke, E. Die Physiologie der Farben für die Zwecke der Kunstgewerk. Leipzig 1866.

3230. Bruner, J.S., L. Postman, and J. Rodrigues. Expectation and the perception of color. Amer J Psychol 1951, 64:216-227.

3231. Buckle, D. The psychologic aspects of color perception. Trans Opthalmology Soc Australia (1941), 1942, 3:113-117.

3232. Bühler, K. Die Erscheinumgsweisen der Farben. In Handbuch der Psychologie. Jena: Fischer 1922, 211 p.

3233. Bullough, E. On the apparent heaviness of colors. Brit J Psychol 1907, 2:111-152.

3234. ———. The perceptive problem in the aesthetic appreciation of simple colour-combinations. Brit J Psychol 1909-10, 3: 406-447.

3235. ———. The perceptive problem in the esthetic appreciation of single colors. Brit J Psychol 1906-08, 2:406-463.

3236. Burnham, R.W., R.M. Hanes, and C.J. Bartleson. Color: A Guide to Basic Facts and Concepts. NY: Wiley 1963, 249 p.

3237. Calinich, M. Versuch einer Analyse des Stimmungswertes der Farbenerlebnisse. Arch ges Psychol 1910, 11:242-311.

3238. Campailla, G. Sulla polarizzazione percettiva verso il colore rispetto alla forma in ammalati di mente. Arch Psicol Neurol Psichiat 1943, 4:1-13.

3239. Campbell, I.G. A study of the fitness of color combinations in duple and triple rhythm to line designs. J exp Psychol 1942, 30:311-325.

3240. Carta, M. (Descriptive capacity and imagination of children's response in oral and written comment on form and color; preliminary report.) Riv de patologia nervosa e mentale (Florence) 1953, 74:218-221.

3241. Cerbus, G., et al. Personality variables and response to color. Psychol Bull 1963, 60:566-575.

3242. Chandler, A.R. The pleasantness of color and the expressiveness of color. In Beauty and Human Nature. Elements of Psychological Aesthetics. NY: Appleton-Century 1934, 66-118.

3243. Chapanis, A. Relationships between age, visual acuity and color vision. Human Biology 1950, 22:1-33.

3244. Chase, W.P. Color vision in infants. J exp Psychol 1937, 20:203-222.

3245. Chauchard, P. Problèmes de la couleur. Paris: S.E.V.P.E.N. 1957, 372 p.

3246. Chevreul, M.E. The Laws of Contrast of Colour, and Their Application to the Arts. London: Routledge 1857, 243 p.

3247. Chou, S.K. Some comments on color preference of Chinese students. J soc Psychol 1936, 7:119-121.

3248. Chou, S.K., and H.P. Chen. General versus specific color preferences of Chinese students. J soc Psychol 1935, 6:290-314.

3249. ——— & ———. (A survey of color preferences of Chinese students.) Education & Vocation (Series No. 157) 1934, 437-447.

3250. Chown, S.A. Combinations of colours and uncoloured light. Univ Toronto Stud, Psychol Series 1904, 2:1-15; 1907, 3:1-20, 85-102.

3251. Christoffel, H. Affektivität und Farben, speziell Angst- und Hellundkelerscheinungen. ZNP 1923, 82:46-52.

3252. ———. Farbensymbolik. Imago 1926, 12:305-320.

3253. Cima, V., and M. Meucci. Color vision in schizophrenia. Riv Oto-Neuro-Oftalmologica (Bologna) 1953, 28:241-250.

3254. Clifford, L.T., and A.D. Calvin. Effect of age on the discriminative learning of color and brightness by children. Amer J Psychol 1958, 71:766-767.

3255. Cohen, J. Color vision and factor analysis. Psychol Rev 1949, 56:224-233.

3256. ———. Experimentelle Untersuchungen über die Gefühlsbetonung der Farben, Helligkeiten und ihre Combinationen. Philosophische Studien (Leipzig) 1894, 10:562-602.

3257. ———. Gefühlston und Sättigung der Farben. Philosophische Studien (Leipzig) 1900, 15:279-286.

3258. Committee on Colorimetry of the Optical Society of America. The Science of Color. NY 1953, 385 p.

3259. Conesny, H.L. A Comparative Study of Two Methods of Developing Color Appreciation in the Junior High School. Master's thesis. Univ Denver 1929.

3260. Conrad-Martins, H. Farben. In Festschrift für Edmund Husserl Zum 70. Geburtstag. Halle 1929.

3261. Conroy, E. The Symbolism of Light and Color. Philadelphia: McKay 1928, 66 p.

3262. Cook, W.M. The Ability of Children in Color Discrimination. Baltimore: Johns Hopkins Univ Pr 1932, 19 p; Child Develpm 1931, 2:303-320; Doctoral dissertation. Johns Hopkins Univ 1931.

3263. Corbett, H.V. Hue discrimination in normal and abnormal colour vision. J Physiology 1937, 88:176-190.

3264. Corcoran, A.L. Children's responses to color stimuli. In Research in Art Education. 7th Yearbook. Kutztown, Pa.: National Art Educ Ass 1956, 84-95.

3265. ———. Color usage in nursery school painting. Child Develpm 1954, 25(2):107-113.

3266. ———. The Variability of Children's Responses to Color Stimuli. Dissertation Abstr, Pennsylvania State Univ 1953, 1954, 16:223-230.

3267. Cutler, C.G., and S.C. Pepper. Modern Color. Cambridge: Harvard Univ Pr 1923, 163 p.

3268. Das Gupta, P.C., and M.N. Basu. Possibility of a racial significance of color preference. Indian J Psychol 1936, 11:201-204.

3269. Dashiell, J.F. Children's sense of harmonies in colors and tones. J exp Psychol 1917, 2:466-475.

3270. Davison, H.J. The effect of color on mental and physical well-being, a study in psychological reaction. Modern Hospital (Chicago) 1918, 10:277.

3271. Del Solar, L. (Colors and libido). Rev de Médica latino-americano (Buenos Aires) 1937, 22:693-697.

3272. Déribéré, M. Psychologie des couleurs: le rouge. Travaux de Peinture 1948, 3.

3273. ———. Quelques aspects psychologiques de la couleur. Chimie des Peintures 1946, Oct., 1946, Jan.-May.

3274. ———. Symbolisme et psychologie de la couleur. Travaux de Peinture 1948, 3.

3275. Descoudres, A. Couleur, forme ou nombre? Arch Psychol 1914, 14:305-341.

3276. ———. Couleur, position ou nombre? Recherches experimentales sur la choix suivant l'âge, le sexe et l'intelligence. Arch Psychol 1916, 16:37-69.

3277. Deutsch, F. Psycho-physical reactions of the vascular system to influence of light and to impressions gained through light. Folia clinica Orientalia 1937, 1:3-4.

3278. De Zeeuw, J. (Color Preference in Psychodiagnostics.) The Hague: Staatsdrukkerij 1957, 56 p.

3279. Dieter, W. (Subjective color sensations in congenital disturbances of color perception.) Z Psychol Physiol Sinnesorg 1927, 58:73-79.

3280. Dimmick, F.L., and M.R. Hubbard. The spectral components of psychologically unique red. Amer J Psychol 1939, 52:348-353.

3281. Dörner, M. Materials of the Artist and Their Use in Painting. NY: Harcourt Brace 1934, 432 p; Berlin 1928.

3282. Dogliani, P., and G. Senini. (Principles and problems of the clinical psychology of color. Brief historical-analytic considerations on chromatic-biotypologic doctrines.) Rass studi psichiat 1962, 51:105-116.

3283. ——— & ———. (Principles and problems of the clinical psychology of color. Definition of the concept of color.) Rass studi psichiat 1962, 51:97-104.

3284. ——— & ———. (Principles and problems of the clinical psychology of color: introductory premise. Historical outline of the theories concerning the nature of light and color.) Rass studi psichiat 1961 50:657-674.

3285. ——— & ———. (Principles and problems of the clinical psychology of color. The historical theories on the physio-psychological nature of color vision.) Rass studi psichiat 1961, 50:675-688.

3286. Doherty, L.T. The Teaching and

Appreciation of Color. Master's thesis. Boston College 1931.

3287. Dorcus, R.M. Color preference and color association. Ped Sem 1926, 33:399-434.

3288. Drechsler, R.J. Affect-simulating effects of color. J abnorm soc Psychol 1960, 61:323-328.

3289. DuBois, P.H. The sex difference on the color-naming test. Amer J Psychol 1939, 52:380-382.

3290. Dumas, H. La physique des couleurs et la peinture. Paris: PUF 1930, 171 p.

3291. Dunlap, K. Color. Amer Mercury 1930, 21:333-336.

3292. ——. Color theory and realism. Psychol Rev 1915, 22:99-103.

3293. ——. Defective vision and its remedy. J comp Psychol 1945, 38:69-85.

3294. ——. Mental maladjustment and color vision. Science 1943, 98:470-472.

3295. Dvořák, J., and A. France. (Color sensitivity in psychotic patients.) Časopis lékaru českých (Prague) 1950, 89:773-776.

3296. Ehler, H. Weitere Untersuchungen zum Weber-Fechnerschen Gesetz bei Darbietung zweier farbiger Lichtreize. Dissertation. Univ Halle-Wittenberg 1941; Arch ges Psychol 1941, 108:211-266.

3297. Ehrler, F. Über das Farbengedächtnis und seine Beziehungen zur Atelier- und Freilichtmalerei. Neue psychol Stud 1926, 2:213-308.

3298. Eicher, J.B., P.M. Decker, and M.L. Shipley. An operational definition of color preference. J Psychol 1964, 57:195-199.

3299. Ekhaus, D. (Color in children's painting.) Hahinukh (Israel) 1958-59, 31:183-188.

3300. Elliott, E.C. Some recent conceptions of color theory. JAAC 1960, 18:494-503.

3301. ——. On the understanding of color in painting. JAAC 1958, 16:453-470.

3302. Ellis, H. The psychology of red. Pop Sci Mon 1900, 57:365-375, 517-526.

3303. ——. The psychology of yellow. Pop Sci Mon 1906, 68:456-463.

3304. Emery, M. Color in occupational therapy. Occup Ther Rehab 1929, 8:421-434.

3305. ——. An experiment in the color preference of psychiatric patients. NY Times, April 11, 1936, p 17.

3306. Engel, P. Über die teilinhaltliche Beachtung von Farbe und Form. Untersuchung an 800 Schulkindern. Z pädag Psychol 1935, 36:202-214, 241-251.

3307. Engelking, E. (The influence of psychologic factors on color thresholds in trichromatism.) Berichte über die Versammlungen der deutschen opthalmologischen gesellschaft (Münich) 1929, 47:139-145.

3308. Engels, G.W. A Study in the Psychology of Color Preferences. Doctoral dissertation. New York Univ 1932.

3309. England, A.O. Color preference and employment in children's drawings. J Child Psychiatry 1952, 2:343-349.

3310. Erhard, H. (The biologic aspect of changes in color and pigmentation.) Handbuch der normalen u pathologischen Physiologie (Berlin) 1929, 13:193-263.

3311. Erickson, M.H., and E.M. Erickson. Hypnotic induction of hallucinatory color vision followed by pseudonegative afterimages. J exp Psychol 1938, 22:581-588.

3312. Esser, A.A.M. (The significance of excessively long eyebrows in ancient oriental paintings and statues.) Klin Monatsbl Augenh 1941, 106:486-489.

3313. Evans, R.M. An Introduction to Color. NY: Wiley 1948, London: Chapman 1948.

3314. Evarts, A.B. Color symbolism. Psychoanal Rev 1919, 6:124-157.

3315. Exner, F. Zur Charakteristik der schönen und hässlichen Farben. Akad der Wissenschaften in Wien. Sitzungsberichte, matnaturwiss. Klasse 1902, Bd 3, Abt II A, 901-922.

3316. Eysenck, H.J. A critical and experimental study of color preferences. Amer J psychol 1941, 54:385-394.

3317. ——. Experimental and Statistical Investigation of Some Factors Influencing Aesthetic Judgments. Doctoral dissertation. Univ. of London 1940.

3318. ——. The general factor in aesthetic judgments. Brit J Psychol 1940, 31:94-102.

3319. ——. Psychological aspects of colour measurements. Nature 1941, 147:682-683.

3320. Farnsworth, P.R., and T.L. Chichizola. Color preferences in terms of sigma units. Amer J Psychol 1931, 43:631.

3321. Farnum, R.B. Results of a questionnaire on color in art education. J opt Soc Amer 1942, 32:720-726.

3322. Faulkner, R., and E. Meyers. The arts of color and form. In Fryer, D.H., and E.R. Henry (eds.), Handbook of Applied Psychology. NY: Rinehart 1950.

3323. Favre, L. (The music of colors and the motion picture.) Bull de l'Institut géneral psychologique (Paris) 1927, 27:77-111.

3324. Feige-Seiffert, H. Farbkenntnis und Farbverwendung des ersten Grundschuljahres. Z pädag Psychol 1939, 40:150-155.

3325. ——. Farbkenntnis und Farbver-
wendung bei Kindern des ersten Grund-
schuljahres. Z pädag Psychol 1939, 40:
189-197.

3326. Féré, C. Sensation et Mouvement.
Paris 1900, 176 p.

3327. Fernberger, S.W. A note on the affec-
tive value of colors. Amer J Psychol 1914,
25:448-449.

3328. Fishman, E.E. Two Studies on the
Affectivity of Colors. Master's thesis.
Clark Univ thesis abstracts 1931, Vol 3.

3329. Flach, W. Farbe und Form. Analyt-
ische Untersuchungen zum Geltungspro-
blem der Malerei. Z für philosophische
Forschung 1961, 15:497-518.

3330. Fleischer, E. Farbensehen. Plfügers
Arch für die gesamte Physiologie 1943,
246:803-819.

3331. Forbes, M.L.H. A differential based
on the Dearborn color-form test. J genet
Psychol 1936, 49:470-471.

3332. Fortier, R.H. The response to color
and ego functions. Psychol Bull 1953, 50:
41-63.

3333. ——. A Study of the Relation of the
Response to Color and Some Personality
Functions. I. The Response to Color and
Ego Functions: an Effect-Color Theory.
II. An Analysis of Groups of Dream Series
Differing in the Frequency of Dreams in
Color. III. Some Rorschach Variables As-
sociated with the Frequency of Dreams in
Color. Doctoral dissertation. Western Re-
serve Univ 1952.

3334. Francastel, P. La couleur dans la
peinture contemporaine. In Meyerson, I.
(ed.), Problèmes de la couleur. Paris:
S.E.V.P.E.N. 1957.

3335. Francès, R. Les modification percep-
tive en fonction du sens objectal des
contenus. JPNP 1961, 58:65-96.

3336. Frankl, G.J.R. How Cézanne saw and
used colour. Listener 1951, 46:1182.

3337. Franklin, C.L. Colour and Colour
Theories. NY: Harcourt, Brace 1929, 287 p.

3338. ——. L'état actuel du problème de
la nature des sensations de couleurs.
Année Psychol 1924, 25:1-17.

3339. Franz, W. Zur Theorie des Farben-
sehens. Plfügers Arch für die gesamte
Physiologie 1941, 246:112-128; Natur-
wissenschaften 1942, 29:766.

3340. Freeman, E. An anomaly of foveal
color perception. Amer J Psychol 1929, 41:
643-645.

3341. Freund, H. Das Phänomen der her-
vortretenden Farben unter typologischen
Gesichtspunkt. Z Psychol 1942, 152:258-
292.

3342. Fricke, K. Versuch einer Farben-
symbolik. Photographische Rundschau
1941, 78:236-237.

3343. Fry, G.A. New observations related
to the problem of color contrast. J exp
Psychol 1934, 17:798-804.

3344. Fuchs, W. On transparency. The in-
fluence of form on the assimilation of
colors. In Ellis, W.D. (ed.), A Source Book
of Gestalt Psychology. NY: 1939, 89-103.

3345. Furrer, W. Die Farbe in der Person-
lichkeitsdiagnostik Lehrbbuch des Lüscher
Tests. Bern: Huber 1954, 232 p.

3346. Gale, A.V.N. Children's Preferences
for Colors, Color Combinations, and Color
Arrangements. Chicago: Univ Chicago Pr
1933, 60 p.

3347. Galifret, Y. (ed.). Mechanisms of
Colour Discrimination. NY: Pergamon 1960
296 p.

3348. ——. Les psychophysiques de la
saturation chromatique. Année Psychol
1959, 59:35-46.

3349. Garth, T.R. A color preference scale
for one thousand white children. J exp
Psychol 1924, 7:233-241.

3350. ——. Color preferences of 559 full-
blooded Indians. J exp Psychol 1922, 5:
392-418.

3351. Garth, T.R., and I.R. Collado. Color
preferences of Filipino children. J comp
Psychol 1929, 9:397-404.

3352. Garth, T.R., K. Ikeda, and R.M. Lang-
don. Color preferences of Japanese chil-
dren. J soc Psychol 1931, 2:397-402.

3353. Garth, T.R., M.R. Moses, and C.N.
Anthony. Color preference of East Indian
Amer J Psychol 1938, 51:709-713.

3354. Garth, T.R., and E.P. Porter. The colc
preferences of 1,032 young children. Amer
J Psychol 1934, 46:448-451.

3355. Gatti, F. (The perception of tridimen
sional consecutive figures in antagonistic
colors.) Arch ital di psicol 1929, 7:138-
152.

3356. Geddes, W.R. The colour sense of
Fijian natives. Brit J Psychol 1946, 37:30-
36.

3357. Geissler, L.R. The affective tone of
color combinations. In Studies in Psychol
Titchner Commemorative Volume. Worceste
Mass.: Clark Univ Pr 1917, 150-174.

3358. Gelb, A. (Psychopathology of color
perception.) Z Psychol 1933, 129:271-281

3359. Gellhorn, E., and G. Fabian. (Change
in color perception.) Pflügers Arch für die
gesamte Physiologie 1926, 214:274-294.

3360. Gesche, I. The color preferences of
1,152 Mexican children. J comp Psychol
1927, 7:297-311.

3361. Gilbert, J.G. Age changes in color matching. J Gerontology 1957, 12:210-215.

3362. Gloye, E.E. Why are there primary colors? JAAC 1957, 16:128-131.

3363. Göthlin, G.F. The Fundamental Colour Sensations in Man's Colour Sense. Stockholm: Almqvist & Wiksells 1943.

3364. ———. Inhibitory processes underlying color vision; bearing on 3-component theories. Amer J Psychol 1943, 56:537-550.

3365. Goldiamond, I., and L.F. Malpass. Locus of hypnotically induced changes in color vision responses. J opt Soc Amer 1961, 51:1117-1121.

3366. Goldstein, K. Some experimental observations concerning the influence of colors on the function of the organism. Occup Ther Rehab 1942, 21:147-151.

3367. Goldstein, K., and O. Rosenthal. Zum Problem der Wirkung der Farben auf den Organismus. Schweiz ANP 1930, 26:3-26.

3368. Gordon, K. The aesthetics of simple color arrangements. Psychol Rev 1912, 19:352-363.

3369. ———. A study of imagined color blends. J gen Psychol 1934, 10:432-439.

3370. Gorriti, F. Color from the point of view of mental hygiene. Semana médico (Buenos Aires) 1934, 1:252-253.

3371. Gramm, H., and W. Ries. Farbpsychologische Altersstudien im Lichte der Statistik. Z für Alterforschung (Dresden) 1960, 14:112-126.

3372. Granger, G.W. Aesthetic measure applied to color harmony: an experimental test. J gen Psychol 1955, 52:205-212.

3373. ———. Area balance in color harmony; an experimental study. Science 1953, 117:59-61.

3374. ———. An experimental study of colour harmony. J gen Psychol 1955, 52:21-35.

3375. ———. An experimental study of colour preferences. J gen Psychol 1955, 52:3-20.

3376. ———. The prediction of preference for color combinations. J gen Psychol 1955, 52:213-222.

3377. Graves, M. The Art of Color and Design. NY: McGraw-Hill 1941.

3378. Gregoire, (?). La valeur du coloriage des croquis en pédagogie catechistique. Montreal: Inst Pedagogique Saint-Georges 1950, 80 p.

3379. Grünberg, V. Über die scheinbare Verschiebung zwischen zwei verschiedenfarbigen Flächen in durchfallendem Lichte. Z Psychol 1906, 42:10-21.

3380. Grunewald, K., and K. Haptén. Gestaltpsychology as clue to the possible source of error in the examination of color sense. Acta Opthalmologica (Copenhagen) 1954, 32:425-429.

3381. Guilford, J.P. The affective value of color as a function of hue, tint, and chroma. J exp Psychol 1934, 17:342-370.

3382. ———. The prediction of affective values. Amer J Psychol 1913, 43:469-478.

3383. ———. A study of psychodynamics. Psychometrika 1939, 4:1-23.

3384. ———. There is system in color preferences. J opt Soc Amer 1940, 30:455-459.

3385. Guilford, J.P., and P. Smith. A system of color preferences. Amer J Psychol 1959, 72:487-502.

3386. Guillot, M. Sur certaines possibilités psychophysiologiques et physiques d'un technique nouvelle de division des couleurs en peinture. JPNP 1961, 58:11-32.

3387. ———. L'harmonie physique, chemique et esthétique des couleurs en peinture. Les Lettres françaises 1959, No. 774, 8.

3388. ———. Sur les propriétes optiques des pigments utilisés en peinture et de leur mélanges. Peintures, pigments, vernis 1954, 30:714-722.

3389. Gupta, P.C.D., and M.N. Basu. Determination of the relative feeling-tone of colour impressions of the Koms of Manipur. Indian J Psychol 1935, 10:81-86.

3390. Haack, T. (Color perception: contrast and transformation.) Z Psychol Physiol Sinnesorg 1929, 112:93-138.

3391. Haas, W.A. Investigation of the stability of color preferences. J consult Psychol 1963, 27:537-539.

3392. Habasque, G. Le contraste simultané des couleurs et son emploi en peinture depuis un siecle. In Myerson, I. (ed.), Problèmes de la couleur. Paris: S.E.V.P.E.N. 1957.

3393. Hamwi, V., and C. Landis. Memory for color. J Psychol 1955, 39:183-194.

3394. Hardy, L.H., G. Rand, and M.C. Rittler. The incidence of defective color vision among psychotic patients. Arch Opthalmology (Chicago) 1948, 40:121-133; J gen Psychol 1948, 39:229-242.

3395. Harris, V.A. Development of the Structural Use of Color in Painting. Master's thesis. Univ Chicago 1927.

3396. Haward, L.R.C. Colour associations as a contributing factor to neurotic colour shock. Brit J med Psychol 1955, 28:183-187.

3397. Hefter, E. Farbenbeliebtheit bei Geisteskranken. Eine Experiment. Reintek: Jürgens 1935, 58 p.

3398. Helm, C.E., and L.R. Tucker. Individual differences in the structure of color-perception. Amer J Psychol 1962, 75:437-444.

3399. Helmholtz, H.v. Erweiterte Anwendung des Fechner'schen Gestezes im Farbensystem. Z Psychol 1891, 2:1-30.

3400. Hevner, K. Experimental studies of the affective value of colors and lines. J appl Psychol 1935, 19:385-398.

3401. Heymann, K. Psychose und Farbenblindheit. Monatschrift für Psychiatrie und Neurologie (Basel) 1940, 102:235-247.

3402. Hildreth, G.H. Color and picture choices of young children. J genet Psychol 1936, 49:427-435.

3403. Hiler, H. Color Harmony and Pigments. NY: Favor, Ruhl 1942, 61 p.

3404. ———. Some associative aspects of color. JAAC 1946, 4(4):203-217.

3405. Hiltmann, H., and R. Heiss. Der psychologisch-diagnostische Wert von Farbreaktionen. Schweiz ZPA 1950, 9:441-462.

3406. Hirohashi, B. Some experiments on the beauty of color. Jap J Psychol 1926, 1:406-432.

3407. Hirst, R.J. The Problems of Perception. London: Allen & Unwin 1959.

3408. Hörnfeldt, R. En experimentell studie rörande färg- och forminställningen. Studia Psychologica et Paedagogica (Lund) 1948, 2:64-100.

3409. Hofmann, H. The color problem in pure painting—its creative origin. In Wight, F.S. (ed.), Hans Hofmann. Berkeley: Univ California Pr 1957, 51-56; Arts & Architecture 1956, 73(2):14-18.

3410. Hofstätter, P.R., and H. Lübbert. Eindrucksqualitäten von Farben. Z diagnost Psychol 1958, 6:211-227.

3411. Holden, W.A., and K.K. Bosse. The order of development of color perception and of color preference in the child. Arch Ophthalmology (Chicago) 1900, 29:261-276.

3412. Honkavaara, S. The color and form reaction as a basis of interpersonal relationships. J Psychol 1958, 46:33-38.

3413. Houstoun, R.A. Light and Colour. NY 1923, 179 p.

3414. Huang, I. Abstraction of form and color in children as a function of the stimulus objects. J genet Psychol 1945, 66:59-62.

3415. Hug-Hellmuth, H.v. Über Farbenhören. Imago 1912, 1(3).

3416. Hunt, R.H. Color tests not reliable as a mental test. US Naval med Bull 1924, 21:74-76.

3417. Hunt, W., and J. Flannery. Variability in the affective judgment. Amer J Psychol 1938, 51:507-513.

3418. Hurlock, E.B. Color preferences of white and negro children. J comp Psychol 1927, 7:389-404.

3419. Imada, M. Color preferences of school children. Jap J Psychol 1926, 1:1-21, 373-393.

3420. ———. (Preference of color combinations.) Rep 6th Congr Jap Psychol Ass 1938, 62-68.

3421. Itten, J. The Art of Color; The Subjective Experience and Objective Rationale of Color. NY: Reinhold 1961, 155 p.

3422. Jacobs, M. The Art of Color. Garden City, NY: Doubleday 1923, 90 p.

3423. ———. The Study of Color. London: Heinemann 1927, 235 p.

3424. Jacobson, E. Basic Color. An Interpretation of the Ostwald Color System. Chicago: Theobald 1948, 207 p.

3425. Jaensch, E.R. Farbensystem und Aufbau der psychophysischen Person. I, II, III Z Psychol 1934, 132:193-201, 202-210, 211-238.

3426. ———. (Functional and total considerations of color perception.) Z Psychol 1932, 129:158-175.

3427. ———. Gefühl und Empfindung (Untersuchung ihres Verhältnesses am Beispiel des Farbensinnes). Bericht 15 Kongres dtsch Ges Psychol (Jena) 1936, 65-70.

3428. ———. Über Grundfragen der Farbenpsychologie. Leipzig 1930, 470 p.

3429. Janz, K. (A comparison of varying degrees of brightness.) Psychol Forsch 1927, 9:354-388.

3430. Jastrov, S. The popular aesthetics of color. Pop Sci Mon 1897, 50:361-368.

3431. Johns, E.H., and F.C. Sumner. Relation of the brightness differences of colors to their apparent distances. Amer J Psychol 1948, 26:25-29.

3432. Kagan, J., and J. Lemken. Form, color and size in children's conceptual behavior Child Develpm 1961, 32:25-28.

3433. Kanicheva, R.A. (The influence of color in size perception.) Trud Inst Mozga Bekht 1939, 9:61-75.

3434. Kansaku, J. (The analytical study of affective values of color-combinations; a study of color pairs.) Jap J Psychol 1963, 34(1).

3435. Kaplan, H.M., and R.J. Lynch. Color blindness in the psychoses. Amer J Psychiat 1945, 101:675-676.

3436. Kardos, L. (Color perception problems.) Arch ges Psychol 1930, 78:185-215.

3437. Karwoski, T. Variations toward purple in the visual after-image. Amer J Psychol 1929, 41:625-636.

3438. Katz, D. Der Aufbau der Farbwelt. Leipzig 1930, 484 p.

3439. ———. Die Erscheinungsweisen der Farben und ihre Beeinflussung durch die individuelle Erfahrung. Z Psychol 1911, 7:425.

3440. ———. Psychologisches zur Frage der Farbengebung. Bericht I Kongres für Aesthetik u allg Kunstwiss. Stuttgart 1915, 314-321.

3441. ———. Sammelreferat über Arbeiten aus dem Gebiet der Farbenwahrnehmung. Psychol Forsch 1928, 11:133-156; 1929, 12:260-278.

3442. ———. The World of Color. London: Kegan Paul, Trench, Trubner 1935.

3443. Katz, S.E. Color preference in the insane. J abnorm soc Psychol 1931, 26: 203-211.

3444. Katz, S.E., and F.S. Breed. The color preference of children. J appl Psychol 1922, 6:225-266.

3445. Katzenstein-Sutro, E. Symbolwerk der Farbe im psychischen Geschehen. Schweiz ZPA 1951, 10:1-26.

3446. Keehn, J.D. The color-form responses of normal, psychotic and neurotic patients. J abnorm soc Psychol 1954, 49:533-537.

3447. ———. A factorial study of tests of color-form attitudes. J Personality 1955, 23:295-307.

3448. ———. "The response to color and ego functions": a critique in the light of recent experimental evidence. Psychol Bull 1954, 51:65-67.

3449. Keehn, J.D., and A. Sabbagh. Color-form response as function of mental disorder (in schizophrenia, epileptic and defective patients). J ment Sci 1956, 102: 319-323.

3450. Keller, H.G., and J.R. Macleod. Application of physiology of color vision in modern art. Ann Report Smithsonian Museum 1913, 723-739; Pop Sci Mon 1913, Nov., 450-465.

3451. Kellershohn, C. L'adaptation colorée. In Myerson, I. (ed.), Problèmes de la couleur. Paris: S.E.V.P.E.N. 1957.

3452. Kerr, A.H. Color Preferences of Socially Unaccepted Six- and Seven-Year-Old Boys. Master's thesis. Univ Tennessee 1950.

3453. Khozak, L.E. (An attempt to change the verbal reactions of children by an experimental organization of their actions.) Na Putyakh k Izuch vysshykh Form Neirodin Reb 1934. 405-414.

3454. Kido, M. Feeling manifestations in colours and tones. Jap J Psychol 1926, 1: 433-452.

3455. Kiesow, F. Del color bruno. (Nota preliminare.) Arch ital di psicol 1929, 7:153-160.

3456. Kimura, T. Apparent warmth and heaviness of colours. Jap J Psychol 1950, 20(2):33-36.

3457. Kirschmann, A. Über das Kolorit. Z Aesth 1907, 2:25-45.

3458. ———. Die psychologisch-esthetische Bedeutung der Helligkeits- und Farbenkontraste. Wundt Philos Studien 1892, 7: 362-393.

3459. Klar, H. (Color psychology and medicine.) Medico Boehringer (Europa) 1963, 1:29-32; 1963, 2:43-47.

3460. Koblo, M. World of Color. An Introduction to the Theory and Use of Color in Art. NY: McGraw-Hill 1963, 240 p.

3461. Koch, B.C. The apparent weight of colors. NY: Methodist Book 1928, 27 p; Columbus: Ohio State Univ Studies in Psychol, No. 9, 1928, 27 p.

3462. Koch, W. Psychologische Farbenlehre; die sinnlich-sittliche Wirkung der Farben. Halle: Marhold 1931, 325 p.

3463. König, J. Die Bezeichnung der Farbe. Umfang, Konsequenz, und Übereinstimmung der Farbenenung, philologisch-historisch betrachtet sowie experimentell-psychologisch untersucht. Arch ges Psychol 1927, 60:129-204.

3464. Koffka, K. On problems of color perception. Acta psychol (Hague) 1935, 1: 129-134.

3465. Koffka, K., and M.R. Harrower. Color and organization, Part II. Beiträge zur Psychologie der Gestalt XXII. Psychol Forsch 1931, 15:194-274.

3466. Kompaneisky, B.N. (The change of color perceived at a distance.) Trud Inst Mozga Bekht 1939, 9:15-59.

3467. ———. (The change of color perception of black and white background at a small visual angle.) Bakht Inst Brain Res 20th Anniversary 1938, 57-61.

3468. ———. (New principles in the science of color; the problem of perception of color of objects.) Acta Argentina de Fisiologia y Fisiopatologia (Cordoba) 1952, 2: 233-316.

3469. Kouwer, B.J. Colors and Their Character; a Psychological Study. The Hague: Nijhoff 1949, 191 p.

3470. Kovsharova, V. (A study in experimentally influencing the verbal choice reactions of children.) Na Putyakh k Izuch vysskykh Form Neirodin Reb 1934, 415-435.

3471. Kravkov, S.W. (Apparent difference between successive contrast colors and complementary colors.) JPNP 1929, 38: 282-291.

3472. ———. (The direction of color transformation.) Psychol Forsch 1928, 10:20-31.

3473. ———. (The influence of odors upon color vision.) Acta Ophthalmologica (Copenhagen) 1939, 17:426-442.

3474. Kugelmass, S., and E. Douchin. (Colors and emotional situations.) Megamot (Israel) 1959-60, 10:271-281.

3475. Kuttner, R. Primitive color perception. Perceptual & Motor Skills 1960, 11: 220.

3476. Ladd-Franklin, C. Colour and Colour Theories. NY: Harcourt, Brace 1929, 287 p.

3477. ———. The nature of colour sensations. Psyche (London) 1927, 9:8-20.

3478. Lang, M. Character Analysis through Color. Westport, Conn.: Crimson Pr 1940, 80 p.

3479. Lapicque, C. La couleur dans l'espace. JPNP 1951, 44:106-127.

3480. Larguier, B. Les méthodes de l'esthétique experimentelle: formes et couleurs. Année Psychol 1900, 6:144-190.

3481. Latif, K.Z. Colour, line and space; integrative dynamic in the study of young children. Egypt J Psychol 1949-50, 5(2): 161-184.

3482. Lee, S.E. Notes on the philosophy of color. New Philos 1949, 362-368.

3483. Leelaratne, S.S. Colour preference as an index of abnormal personality. Educ & Psychol (Delhi) 1954, 1(3):50-55.

3484. Le Grand, Y. Anatomie, physiologie et vision colorée. JPNP 1957, 54:394-402.

3485. ———. Coleur et perception. JPNP 1961, 58:257-269.

3486. Lewis, E.H. Color Theory. NY: Favor, Ruhl 1931.

3487. Liebmann, S. Über das Verhalten farbiger Formen bei Helligkeitsgleichheit von Figur und Grund. Psychol Forsch 1927, 9: 300-353.

3488. Lightfoot, C. Contextual influence upon the perception of color. Amer J Psychol 1962, 75:503-504.

3489. Ligon, E.M. A genetic study of color naming and word reading. Amer J Psychol 1932, 44:103-122.

3490. Lillie, W. A note on the nature of color associations. Mind 1926, 35:535-536.

3491. Lindberg, B.J. Experimental Studies of Colour and Non-Colour Attitudes in School Children and Especially with Regards to Its Condition in Different Types According to the Individual Psychology of Sjöbring and the Anthropometric Index of Stömgren with Two Psychological Tests. Copenhagen: Munksgaard 1938, 170 p.

3492. Lo, C.F. The affective values of color combinations. Amer J Psychol 1936, 48:617-624.

3493. Lowy, M. (Psychologic comments on Goethe's theory of colors.) Medizinische Klinik 1933, 29:1113-1116.

3494. Luckiesh, M. Color and Colors. NY: Chapman 1939.

3495. ———. Color and Its Applications. NY: Van Nostrand, 263 p.

3496. ———. The Language of Color. NY: Dodd, Mead 1918, 282 p.

3497. ———. Light and Shade. NY: Van Nostrand. 1916.

3498. ———. A note on color preferences. Amer J Psychol 1916, 27:251-256.

3499. Lüscher, M. Psychologie der Farbe. Basel 1949.

3500. Lukins, N.M., and I.C. Sherman. The effect of color on the output of work of psychotic patients in occupational therapy. Occup Ther Rehab 1941, 20:121-125.

3501. McCormick, E.J., R.E. Blanchard, and G.G. Karas. The effect of hue, brightness and saturation on color preference considering various contexts. Proc Indiana Acad Sci 1957, 67:297.

3502. McGregor, D. Sensitivity of the eye to the saturation of colors. J exp Psychol 1936, 19:525-546.

3503. Maclean, W.P. A Comparison of the Effectiveness of Colored and Uncolored Pictures. Master's thesis. Univ Chicago 1930.

3504. Maerz, A., and M.R. Paul. A Dictionar of Color. NY: McGraw-Hill 1950, 208 p.

3505. Marois, P. Des Gouts et des Couleurs Paris: Michel 1949.

3506. Marri, G. Des goûts et des couleurs; essai historique sur la couleur dans la peinture française. Paris 1915, 110 p.

3507. Marshall, M.L. A Comparison of Schizophrenics, Children, and Normal Adults in Their Use of Color. Dissertation Abstr 1954, 14:2128-2129.

3508. Marston, W.M. Primary colours and primary emotions. Psyche (Boston) 1927, 30:4-33.

3509. Martin, A. Die Gefühlsbetonung von Varben und Farbenkombinationen. Z Kinderforsch 1921, 26:128-156.

3510. Mason, W. Father Castel and his color clavecin. JAAC 1958, 17:103-116.

3511. Matsuoka, T. (Studies on the development-order of affection and emotion by Color Symbolism Test and Word Association Test.) Japanese J educ Psychol 1960, 7: 227-235.

3512. Matthaei, R. (Experimental studies on attributes of color; the measurement of clarity.) Z Psychol Physiol Sinnesorg 1928, 59:257-311.

3513. ———. (Experimental studies on the

clarity of colors and color harmony.) Z
Psychol Physiol Sinnesorg 1928, 59:312–
355.

3514. Mazumdar, A.K., and T.K. Chatterjee.
Duration of attention and colour pref-
erence. Psychol Stud (Mysore) 1962, 7(2):
11–15.

3515. Meier, B. The child's sense of color.
Psychol Bull 1927, 24:517–518.

3516. Meier, N.C. Emotions versus meas-
urement in teaching color. J opt Soc Amer
1942, 32:699–702.

3517. Melhuish, F.E. A Study of Children's
Choices of Color Combinations as Con-
ditioned by Age. Master's thesis. Pennsyl-
vania State College 1932.

3518. Mendelsohn, H., and I. Crespi. The
effect of artistic pressure and institutional
structure on preference in a choice situa-
tion. J soc Psychol 1952, 36:109–123.

3519. Mercer, F.M. Color preferences of
1,006 Negroes. J comp Psychol 1925, 5:
109–146.

3520. Mercer, H.G. Color Preferences of
Mixed Blood Indians. Doctoral disserta-
tion. Univ Texas 1922.

3521. Metcalf, J.T. Pleasantness of bright-
ness combinations. Amer J Psychol 1927,
38:607–623.

3522. Meyerson, I. (ed.). Problèmes de la
couleur. Exposés et discussions du col-
loque du Centre de Recherches de Psycho-
logie comparative tenu à Paris les 18, 19
et 20 Mai 1954. Paris: S.E.V.P.E.N. 1957,
372 p.

3523. Michaels, G.M. Color preferences
according to age. Amer J Psychol 1924,
35:79–87.

3524. Miles, W.R. Color blindness in
11,000 museum visitors. Yale J Biological
Med 1943, 16:59–76.

3525. Miller, T.K. Color is good medicine
for mental patients. Modern Hospital
(Chicago) 1951, 77:81–82.

3526. Minor, A. Über die Gefälligkeit der
Sättigungsstufen der Farben. Z Psychol
1909, 50:433–444.

3527. Mintz, A. ("Black-white" problem.)
Psychol Forsch 1930, 13:128–134.

3528. Mitra, S.C., and A. Datta. The in-
fluence of color on the estimation of area.
Indian J Psychol 1939, 14:91–94.

3529. Mizuguchi, F., and S. Acki. (Color
preferences of adults.) Jap J Psychol 1926,
1:22–33, 394–405.

3530. Mogensen, M.F., and H.B. English.
The apparent warmth of colors. Amer J
Psychol 1926, 37:427–428.

3531. Monroe, M. The apparent weight of
color and correlated phenomena. Amer J

Psychol 1925, 36:192–206.

3532. Moon, P., and D.E. Spencer. Aes-
thetic measure applied to color harmony.
J opt Soc Amer 1944, 34:234–242.

3533. Morón Rubio, J.M. (A contribution to
experimental psychology of color percep-
tion.) Rev español de Oto-Neuro-Oftal-
mologia y Neurocirugia (Valencia) 1949,
8:439–488.

3534. Mosse, E.P. Color therapy. Occup
Ther Rehab 1942, 21:33–40.

3535. Müller-Freienfels, R. Zur Theorie der
Gefühlstöne der Farbenempfindungen. Z
Psychol 1907, 46:241–274.

3536. Muller, G.E. Über die Farbenemp-
findungen. Psychophysische Untersuchun-
gen. 2 Vols. Leipzig 1930, 434 p, 214 p.

3537. ——. (The psychophysics of color
sensation.) Z Psychol Physiol Sinnesorg
1931, 62:53–109.

3538. Murray, D.C., and H.L. Deabler.
Colors and mood-tones. J appl Psychol
1957, 41:279–283.

3539. Murray, E. Color problems: the di-
vergent outlook of physicist and psycholo-
gist. Amer J Psychol 1930, 42:117–127.

3540. ——. Mass-testing of color vision;
a simplified and accelerated technique.
Amer J Psychol 1948, 61:370–385.

3541. Naumann, F. Form und Farbe. Berlin
1909, 220 p.

3542. Nickerson, D. Color measurements
in psychological terms. J opt Soc Amer
1931, 21:643–650.

3543. Nickerson, D., and S.M. Newhall.
Psychologic color solid. J opt Soc Amer
1943, 33:419–422, 579–614.

3544. Norman, R.D., and W.A. Scott. Color
and affect: a review and semantic evalua-
tion. J gen Psychol 1952, 46:185–225.

3545. Obonai, T., and T. Matsuoka. The
color symbolism personality test. J gen
Psychol 1956, 55:229–239.

3546. Obuchowska, I., and K. Obuchowski.
(Experimental studies on the effect of the
color composition of walls in psychiatric
hospitals.) Neurologia, Neurochirurgia i
Psychiatria Polska (Warszawa) 1962, 12:
255–263.

3547. Oeser, O.A. Some experiments on the
abstraction of form and colour. Part I.
Tachistoscopic experiments. Brit J Psychol
1932, 22:200–215.

3548. Oesterreich, T.K. (The psychophysi-
ology of green color.) Z Psychol Physiol
Sinnesorg 1928, 59:356–380.

3549. Ogden, R.M. Color. In The Psychology
of Art. NY: Scribner's 1938, 155–169.

3550. Oldfield, R.C. Physical and psycho-phy-
sical aspects of colour. Nature 1949, 163:430–431.

3551. Ostwald, W. Colour Science, Part I, Colour Theory and Colour Standardization. London: Winsor & Newton 1931.

3552. ———. Colour Science, Part II, Colour Measurement and Colour Harmony. London: Winsor & Newton 1933.

3553. ———. The development of color theory since Newton. In Zeishold, H. (ed.), Technical Studies in the Field of Fine Arts. Cambridge: Fogg Art Museum, Harvard Univ 1934.

3554. ———. Einführung in die Farbenlehre. Leipzig 1919, 174 p.

3555. ———. Er und Ich. Leipzig: Martins 1936.

3556. ———. Die Farbfibel. Leipzig: Unesma 1916.

3557. ———. Der Farbkörper. Grossbothen: Unesma 1919.

3558. ———. Die Harmonie der Farben. Leipzig: Unesma 1918, 48 p.

3559. ———. Die Harmothek. Grossbothen: Unesma 1926.

3560. ———. Lebenslinien. Berlin: Klasing 1927.

3561. Oyama, T., and R. Akatsuka. (The effect of hue and brightness on the size-illusion of concentric circles: a further study.) Japanese psychol Res 1962, 4(3).

3562. Oyama, T., T. Tanaka, and J. Haga. (Color affection and color symbolism in Japanese and American students.) Jap J Psychol 1963, 34(3).

3563. Oyama, T., et al. (Affective dimensions of colors.) Japanese psychol Res 1962, 4(2).

3564. Paneth, L. (An interpretation of form and color as path into the subconscious.) Nervenarzt 1929, 2:326-337.

3565. Parsons, J.H. An Introduction to the Study of Color Vision. Cambridge, England: Cambridge Univ Pr 1915, 1924, 308 p.

3566. Pasto, T.A., and P. Kivisto. Group differences in color choice and rejection. J clin Psychol 1956, 12:379-381.

3567. Pepper, S.C. Changes in appreciation for color combinations. Psychol Rev 1919, 26:389-396.

3568. Peters, H.N. Influence of set upon affective values of colors. J exp Psychol 1943, 33:285-298.

3569. Philip, B.R. Effect of length of series upon generalization and central tendency in the discrimination of a series of stimuli. Canadian J Psychol 1952, 6:173-178.

3570. Pialat, E. Recherches sur la fonction mnémonique de la forme et de la couleur dans les images colorées. JPNP 1929, 26: 101-121.

3571. Pickford, R.W. Individual differences in colour vision and their measurement. J Psychol 1949, 27:153-202.

3572. ———. Sex differences in color perception. Nature 1947, 159:606-607.

3573. ———. Total color blindness of hysterical origin. Nature 1944, 153:256.

3574. ———. Total color blindness of hysteric origin. Brit J med Psychol 1949, 22:122-128

3575. Pierce, D.H., and J.D. Weinland. The effect of color on workmen. Personality J 1934, 13:34-38.

3576. Píeron, H. Délire ou charlatanisme de la couleur. Bull de l'Institut National d'Étude du Travail et d'Orientation Professionelle 1959, 15:108.

3577. ———. Quelques observations sur la récréation post-adaptive de la sensibilité aux couleurs. Année Psychol 1943, 41(2): 148-167.

3578. Plehn, A. Farbensymmetrie und Farbenwechsel. Strassburg: Heitz 1912.

3579. Podestà, H. (Mode of vision and the painting of colorblind painters; recollections of the painter Wiehelm von Kügelgen.) Klin Monatsbl Augenh 1949, 114:401-412.

3580. Ponzo, M. Forme et effets polychromatique. In Miscellanea psychologica Albert Michotte. Paris: Libraire Philosophiq 1947, 123-129.

3581. Popplestone, J.A. Scoring colored responses in paintings. J clin Psychol 1955, 11:191-193.

3582. Poulson, M.W., and B. Nielson. Certain color preferences of college students. Trans Utah Acad Sci 1933, 10:87-88.

3583. Powelson, I., and M.F. Washburn. The effect of verbal suggestion on judgments of the affective value of colors. Amer J Psychol 1913, 24:267-269.

3584. Prescott, B.D. The psychologic analysis of light and color. Occup Ther Rehab 1942, 21:135-146.

3585. Pressey, S.L. The influence of color upon mental and motor efficiency. Amer J Psychol 1921, 32:326-357.

3586. Puhl, E. (Color perception: individual differences in their relation to total personality.) Z für Sinnesphysiologie (Leipzig) 1932, 63:1-37.

3587. Rabate, H. Peintures pour artistes. In Meyerson, I. (ed.), Problèmes de la couleur Paris: S.E.V.P.E.N. 1957.

3588. Rakshit, D.P. Color preferences of extroverted and introverted individuals. Indian J Psychol 1946, 21:89-92.

3589. Reed, J.D. A note on reaction time as a test of color discrimination. J exp Psycho 1949, 39:118-121.

3590. Reeder, J.E., Jr. Psychogenic color field (in psychoneurotic diagnosis). Amer

J Ophthalmology 1944, 27:358-361.

3591. Reutersvärd, O. The "Violettomania" of the impressionists. JAAC 1950, 9(2): 106-110.

3592. Révész, G. Colour mixture and sound mixture. Acta Psychol 1949, 6:3-26.

3593. Rhodes, H. Psychology and Tradition of Color. London: Daniel 1924, 128 p.

3594. Richard, F. Trichromatic theory of colors. Arch Psychol 1948, 32:177-208.

3595. Richardson, L.F. Quantitative mental estimates of light and colour. Brit J Psychol 1929, 20:27-37.

3596. Richter, M. Internationale Bibliographie der Farbenlehre und Ihre Grenzgebiete. Nr. 1: Berichtszeit 1940-1949. Göttingen: "Munsterschmidt" Wissenschaftlicher 1952, 244 p.

3597. Rickers-Ovsiankina, M.A., et al. Factors affecting the psychodiagnostic significance of color perception. J proj Tech 1963, 27:461-466.

3598. Riffenburgh, G.H. Responses to color combinations as indices to personality traits. J gen Psychol 1959, 61:317-322.

3599. Risler, J. L'influence psychologique de la lumière. Cour médicale 1927, 77: 40-42.

3600. Ritter, E. Die teilinhatliche Beachtung von Form und Farbe bei Jugendlichen in ihrer Beziehung zur striktur-psychologischen Typenlehre. Z Psychol 1930, 117:307-338.

3601. Robertson, J.P.S. The use of colour in the paintings of psychotics. J ment Sci 1952, 98:174-184.

3602. Rodríques, J. Las preferencias de color en los niños en edad escolar. Rev psicol (Madrid) 1950, 5:59-67.

3603. Rodriquez Bou, I., and D. Cruz Lopez. Preferences in colors and illustrations of elementary school children of Puerto Rico. J educ Psychol 1953, 44:490-496.

3604. Rönsch, W. Einfache Raumformen unter dem Einfluss verschiedener Farbgebung. Ein Beitrag zur Psychologie farbiger Raumgestaltung. Doctoral dissertation. Univ Leipzig 1940; Arch ges Psychol 1940, 107:241-292.

3605. Rohde, K.H. (Color perception: a study from the point of view of function and of the character type of the subject.) Z für Sinnesphysiologie (Leipzig) 1932, 63:93-124.

3606. Rood, R. Color and Light in Painting. NY: Columbia Univ Pr 1941, 299 p.

3607. Rosenblich, J.F. Imitative color choices in kindergarten children. Child Develpm 1961, 32:211-223.

3608. Rossigneux, C. Essai sur l'audition colorée et sa valeur esthétique. JPNP 1905, 2:193-215.

3609. Roth, N. The significance of color in dreams. Dis Nerv System 1961, 22:278-281.

3610. Rudisill, M. Children's preferences for color versus other qualities in illustrations. Elem School J 1952, 52:444-451.

3611. Ruesch, J., and J.E. Finesinger. The relation of Rorschach color response to use of color in drawings. Psychosom Med 1941, 3:370-388.

3612. Sachs, E. Beitrag zum Studium der Vererbung von Störungen des Farbensinnes. Klin Monatsbl Augenh 1928, 81:231-233.

3613. St. George, M.W. Color preferences of college students with reference to chromatic pull, learning, and association. Amer J Psychol 1938, 51:714-716.

3614. Sanders, C.L. Color preferences for natural objects. Illuminating Engineering 1959, 54:452-456.

3615. Sargent, W. The Enjoyment and Use of Color. NY: Scribner's 1923.

3616. Sasame, A., and M. Kido. (On the threshold of color expression.) Jap J Psychol 1936, 11:194-206.

3617. Schaie, K.W. A Q-sort study of color-mood association. J proj Tech 1961, 25: 341-346.

3618. Schilder, P.F. Yellow and blue. Psychoanal Rev 1930, 17:123-125.

3619. Schliephacke, B.P. Farbe und Heilweise. Gettenbach: Lebensweiser 1931, 28 p.

3620. Schmeckebier, L. Die Erscheinungsweisen kleinflächiger Farben. Arch ges Psychol 1932, 85:1-40.

3621. ———. The psychology of color. Amer Mercury 1932, 26:196-198.

3622. Schoch-Bodmer, H. Zur Problemanalyse von Kinderzeichnungen mit Lüschertest-Farben. Psychologische Berater gesunde practische Lebensgestalt 1952, 4:503-508.

3623. Scholl, R. (Ocular perception of form, color and size in preschool age.) Z Psychol Physiol Sinnesorg 1928, 109:1-39.

3624. Schroeder, C. (Color psychology and the course of labor.) Zentralblatt für Gynäkologie 1952, 74:59-62.

3625. Schubert, G. (The perception of primary colors as complementary.) Arch ges Psychol 1928, 220:82-100.

3626. Schulte, R.W. Über die Wohlgefälligkeit von Farben und Dreifachfarbenverbindungen. Z angew Psychol 1924, 24:42-50.

3627. Schumann, H.J. von. (Colored light treatment as an aid in psychotherapy.) Medizinische Monatsschrift (Stuttgart) 1961, 15:662-665.

3628. Schuyten, M.C. Über den Farbensinn

bei Schulkindern. Z exp Pädag 1906, 3: 102-103.

3629. Schwartz, A.M. The Effects of Conditioning upon Children's Color Choices and Color Usage. Dissertation Abstr 1960, 21:128-129.

3630. Shen, N.C. The color preferences of 1,368 Chinese students, with special reference to the most preferred color. J soc Psychol 1937, 8:185-204.

3631. ———. A note on the color preferences of Chinese students. J soc Psychol 1936, 7:68-81.

3632. Sheppard, D., and E.V. Sheppard. Colour associations. Psychol Newsletter 1954, 5(3):77-95.

3633. Sherman, H.L., and R.L. Mooney. The problem of color in teaching drawing. College Art J 1946, 6:106-114.

3634. Shikiba, T. (Color preferences of deranged persons and delinquent boys.) Jap J Psychol 1927, 2:677-700.

3635. Simmons, H.C. A Study of Light As a Medium of Creative Expression in the Visual and Practical Arts. Dissertation Abstr 1956, 16:1125.

3636. Slade, T.K. An enquiry into the nature of color associations. Mind 1925, 34:455-470.

3637. Sloan, L.L. Vision: value, chroma, and hue. Psychol Bull 1927, 24:100-114.

3638. Smith, H.C. Age differences in color discrimination. J gen Psychol 1943, 29:191-226.

3639. Smith, R.S. An Investigation of the Relationship between Physiological and Cognitive Measures of the Affective Response to Color. Dissertation Abstr 1958, 19:873.

3640. Smith, T. The quantitative estimation of the sensation of colour. Brit J Psychol 1930, 20:362-364.

3641. Snowden, E.N. The Kemp Prossor colour scheme; a report of its effect on nervous patients. Lancet 1919, 1:522.

3642. Spence, W., and J.P. Guilford. The affective value of combinations of colors. Amer J Psychol 1933, 45:495-501.

3643. Squires, M.A., and T. Bernard. Colour-vision and colour discrimination amongst the Bechuana. Trans Royal Society South Africa 1942, 29(2):29-34.

3644. Squires, P.C. The influence of hue on apparent visual movement. Amer J Psychol 1931, 43:49-64.

3645. Staples, R. Color vision and color preference in infancy and childhood. Psychol Bull 1931, 28:297-308.

3646. ———. Responses of infants to color. J exp Psychol 1932, 15:119-141.

3647. Staples, R., and W.E. Walton. A study of pleasurable experience as a factor in color preference. J genet Psychol 1933, 43:217-223.

3648. Stefanescu-Goanga, F. Experimentelle Untersuchungen zur Gefühlsbetonung der Farben. Psychologische Studien 1911, 7: 284-335.

3649. Steinke, L. (Studies in color psychology in congenital disorders of color perception by use of the Luescher test.) Confin Psychiat 1960, 3:97-116.

3650. Stengel, E. Syndrome of visual alexia with color agnosia. J ment Sci 1948, 94: 46-58.

3651. Stewart, K.R. Color blindness and tone deafness restored to health during psychotherapeutic treatment using dream analysis. JNMD 1941, 93:716-718.

3652. Stiles, W.S., et al. Psychophysical problems. In Galifret, Y. (ed.), Mechanisms of Colour Discrimination. NY: Pergamon 1960.

3653. Stokes, A.D. Colour and Form. London: Faber & Faber 1950, 135 p.

3654. Stokvis, B. A simple hypnotizing techr with the aid of color-contrast action. Amer J Psychiat 1952, 109:380-381.

3655. Storath, H. Die Bedeutung der Farbe und ihre Anwedung im Lüscher-Test. Psychologie Berater gesunde practische Lebens gestalt 1952, 4:358-365.

3656. Stover, D.A. Color Theories and a Need of Standardization of the Teaching of Color as Related to Art Education in Pennsyvania. Master's thesis. Penn State College 1929.

3657. Stratton, G.M. The color red, and the anger of cattle. Psychol Rev 1923, 30:321-3.

3658. Strebel, J. (Art and eye; four phases in the development of the painting technique of a color blind artist.) Klin Monatsb Augenh 1938, 100:593-597.

3659. ———. (Light, colors and color sense of the human eye; 4 phase development of a red-green blind painter; Goethe's color doctrine.) Praxis 1950, 39:555-562.

3660. Streimer, I. Age and Sex as Factors in Ability of Adults to Discriminate Saturation Differences in the Colors Cyan and Yellow. Dissertation Abstr 1960, 20:3863.

3661. Subes, J. Des goûts des enfants pour les couleurs. Enfance 1959, No. 2, 117-142

3662. Sutermeister, H. Über Farbentherapie Moderne biologischpsychologische Problem Grenzgebiete der Medizin 1949, 2:233-240.

3663. Synolds, D.L., and N.H. Pronko. An exploratory study of color discrimination of children. Trans Kansas Acad Sci 1949, 52: 105-109; J genet Psychol 1949, 74:17-21.

3664. Tachibana, K. Color preferences of the aged. Jap J Psychol 1929, 4:65-78.

3665. Tagliaventi, I. Introduzione allo studio dei colori. Bologna: Patron 1956.

3666. Tatibana, Y. (Color feeling of the Japanese. (II). The expressive emotional effects of colors.) Tohoku psychologica Folia (Japan) 1938, 6:35-80.

3667. ———. (Color feelings of the Japanese. I. The inherent emotional effects of colors.) Tohoku psychologica Folia (Japan) 1937, 5:21-46.

3668. Taylor, F.A. Colour Technology. NY: Oxford Univ Pr 1962, 140 p.

3669. Taylor, G.H. Color sense and the emotion of sex. Opthalmology 1916, 12: 688.

3670. ———. The psychology of color. Med J Australia 1924, 1:313.

3671. Taylor, J.S. A Simple Explanation of the Ostwald Colour System. London: Winsor & Newton 1935.

3672. Teevan, R.C., and R.C. Birney (eds.). Color Vision. Princeton, N.J.: Van Nostrand 1961.

3673. Telford, C.W. Differences in response to colors and to their names; some racial comparisons. J genet Psychol 1930, 37: 151-159.

3674. Tennant, J. The psychological factor in colour contrast. Brit J Psychol 1929, 20: 1-26.

3675. Thomachewski, E. Die Farbe in der experimentellen Charakterforschung. Z für Jugendkunde 1935, 5:50-53.

3676. Thomas, G.J. A comparative study of four tests. Amer J Psychol 1943, 56:583-591.

3677. Thorpe, J.G. Differential effects of colour on chronic schizophrenics. J ment Sci 1961, 107:845-846.

3678. Tinker, M.A. The effect of color in visual apprehension and perception. Genet psychol Monogr 11, 61-136.

3679. ———. Effect of stimulus-texture upon apparent warmth and affective value of colors. Amer J Psychol 1938, 51:532-535.

3680. Tobie, H. Die Entwicklung der teilinhaltlichen Beachtung von Farbe und Form in vorschulpflichtigen Kindesalter. Beihefte Z angew Psychol 1927, No. 38, 103 p.

3681. Tomoda, Z. (The effective value of colour combinations.) Jap J Psychol 1921, 32:145; 1934 N.S., 9:489-509.

3682. Trenga, V. (Color and colors; comparisons and metaphors originating from names of colors in medical, popular and scientific language.) Praticien du Nord de l'Afrique 1937, 10:25-36.

3683. Trojan, F. Zur Psychologie der Farben bei Goethe. Z Aesth 1930, 24:232-238.

3684. Tudor-Hart, B. Studies in transparency, form and colour; the influence of form on the perception of colour. Psychol Forsch 1928, 10:255-273.

3685. Utitz, E. Grundlage der aesthetischen Farbenlehre. Stuttgart: Enke 1908, 156 p.

3686. ———. Kritische Vorbemerkungen zu einer ästhetischen Farbenlehre. Z Aesth 1908, 3:337-360.

3687. Valentine, C.W. The colour perception and colour preferences of an infant in its fourth and eighth months. Brit J Psychol 1914, 6:363-386.

3688. Van Eeckhoutte, R. Contribution a l'étude affective de l'enfant au moyen des "responses-couleurs." Rev Belge de Psychologie Pédagogie 1950, 12:105-126.

3689. Van Valkenburg, C.T. Zur Pathologie mnestischer Störungen allegemeiner und besonderer Natur (Farbensinn) nach Hirntrauma. Schweiz ANP 1929, 23:266-283.

3690. Villalobos Domínguez, C. Los colores que veían los griegos. Nosotros 1930, 24: 222-230.

3691. Von Allesch, G.J. Die aesthetische Erscheinungsweise der Farben. Psychol Forsch 1925, 6:1-91, 215-281; Berlin: Springer 1925, 157 p.

3692. Wallis, W.A. The influence of color on apparent size. J gen Psychol 1935, 13: 193-199.

3693. Walton, W.E. The sensitivity of children and adults to color harmony. Psychol Monogr 1933, 45, No. 1, 51-62.

3694. Walton, W.E., R.B. Guildord, and J.P. Guilford. Color preferences of 1,297 university students. Amer J Psychol 1933, 45: 322-328.

3695. Walton, W.E., and B.M. Morrison. A preliminary study of the affective value of colored lights. J appl Psychol 1931, 15: 294-303.

3696. Ward, J. Colour Harmony and Contrast. London 1903, 140 p.

3697. Warner, S.J. The color preferences of psychiatric groups. Psychol Monogr 1949, 63, No. 6, Whole No. 301, 25 p.

3698. Washburn, M.F. Effect of verbal suggestion on the affective values of colors. Psychol Bull 1913, 10:375-376.

3699. ———. A note on the affective value of colors. Amer J Psychol 1911, 22:114-115.

3700. Washburn, M.F., M.M. Bacon, and E.A. Roud. A study of affective contrast. Amer J Psychol 1914, 25:290-293.

3701. Washburn, M.F., D. Clark, and M.S. Goodsell. The effect of area on the pleasantness of colors. Amer J Psychol 1911, 22: 578-579.

3702. Washburn, M.F., and D. Crawford. Fluctuations in the affective value of colors during fixation for one minute. Amer J Psychol 1911, 22:579–582.

3703. Washburn, M.F., and S.L. Grose. Voluntary control of likes and dislikes: the effect of an attempt voluntarily to change the affective value of colors. Amer J Psychol 1921, 32:284–289.

3704. Washburn, M.F., and J. Regensburg. The relation of the pleasantness of color combinations to that of the colors seen singly. Amer J Psychol 1921, 32:145–146.

3705. Washburn, M.F., M.T. MacDonald, and D. Van Alstyne. Voluntarily controlled likes and dislikes of color combinations. Amer J Psychol 1922, 33:426–428.

3706. Washburn, M.F., K.G. McLean, and A. Dodge. The effect of area on the pleasantness and unpleasantness of colors. Amer J Psychol 1934, 46:638–640.

3707. Washburn, M.F., E.L. Norris, and A.G. Twiss. An effect of fatigue on judgments of the affective value of colors. Amer J Psychol 1911, 22:112–114.

3708. Washburn, M.F., and I. Powelson. The effect of verbal suggestion on the judgments of affective value of colors. Amer J Psychol 1913, 24:267–269.

3709. Washburn, M.F., H. Robbins, and D. Smith. Influence of fatigue on affective sensations to color. Amer J Psychol 1915, 26:291–292.

3710. Webber, V.J. Children's ability to perceive change of color in painting. Elem School J 1948, 48:494–497.

3711. Weber, H. Über die psychophysischen Grundlagen der Ton- und der Farbenharmonie. Forschungen und Fortschritte: Korrespondenzblatt der deutschen Wissenschaft und Technik 1939, 15:248–250.

3712. Weidlich, K. Farben und Farbenempfindung. Stettin: Saran 1930, 31 p.

3713. Wellek, A. (Color harmony and color organ; a history of its development in the 18th century.) Arch ges Psychol 1935, 94: 347–375.

3714. Wells, N.A. A description of the affective character of the colors of the spectrum. Psychol Bull 1910, 7:181–195.

3715. Wilcox, W.W., and B.M. Morrison. Psychological investigation of the relation of illumination to esthetics. Psychol Monogr 1933, 44:282–300.

3716. Williams, E.J. A technique for testing color harmony sensitivity in young children. Psychol Monogr 1933, 45(1):46–50.

3717. Wilson, H. Relation of color to the emotions. Arena 1898, 19:810–827.

3718. Winch, W.H. Colour preferences of school children. Brit J Psychol 1909, 3: 42–65.

3719. Winick, C. Taboo and disapproved colors and symbols in various foreign countries. J soc Psychol 1963, 59(2):361–368.

3720. Woods, W.A. Some determinants of attitudes toward colors in combinations. Perceptual & Motor Skills 1956, 6:187–193.

3721. Woodworth, R.S. The puzzle of color vocabularies. Psychol Bull 1910, 7:325–334.

3722. Wright, B. The influence of hue, lightness, and saturation on apparent warmth and weight. Amer J Psychol 1962, 75:232–241.

3723. Wright, B., and B. Gardner. Effect of color on black and white pictures. Perceptual & Motor Skills 1960, 11:301–304.

3724. Wright, B., and L. Rainwater. The meaning of color. J gen Psychol 1962, 67: 89–99.

3725. Wright, W.D. Color. Science Progress 1946, 34:681–695.

3726. ———. The Measurement of Colour. London: Hilger 1944.

3727. Wright, W.D., and F.H.G. Pitt. Hue discrimination in normal colour vision. Proc Physical Soc London 1934, 46:459–473.

3728. Yokoyama, M. Affective tendency as conditioned by color and form. Amer J Psychol 1921, 32:81–107.

3729. ———. The affective value of single colours. Mita Rev 1926, 343:35–40.

3730. Zeishold, H. Philosophy of the Ostwald color system. J opt Soc Amer 1944, 34(7).

7 Finger Painting

3731. Alper, T.G., H.T. Blane, and B.K. Abrams. Reactions to finger painting as a function of social class. In Dennis, W. (ed.), Readings in Child Psychology. Englewood Cliffs, N.J.: Prentice Hall 1951, 1963, 438–452.

3732. Amberson, R. Finger-painting—a new art of self-expression. Forecast 1936, 51: 84–87.

3733. Andrews, K. Rubbing their troubles away. Rockefeller Center Weekly 1936, 6:15.

3734. Anon. Finger painting designs. School Arts 1938, 37:172–173.

3735. Anon. Finger-painting. Fortune 1935, 11:52.

3736. Anon. Finger painting—white on black. School Arts 1939, 38:166.

3737. Anon. Finger paints. Time Magazine 1933, 21:25.

3738. Anon. Fingertip painters: Chinese fingertip painting. Newsweek 1939, 13:20–21.

3739. Anon. Spectrum and children: painting helps show what they see in colors. Newsweek 1938, 11:25.

3740. Anon. Ten thousand fingers. Time Magazine 1938, 31:39.

3741. Ansilion, M. Teaching art in the grade school. Catholic School J 1939, 39: 236–237.

3742. Arlow, J.A., and A. Kadis. Finger-painting in psychotherapy with children. Ops 1946, 16:134–146.

3743. Azeneda, M. More about finger-painting. School Arts 1937, 37:21.

3744. Bishop, A.S. Finger-painting. Amer Child 1940, 35:22.

3745. ———. Finger-painting. Design 1936, 38:37.

3746. ———. Finger-painting. Instructor 1937, 46:33.

3747. ———. Finger-painting for small people. School Arts 1935, 34:496–498.

3748. Blum, L.H. A technique for recording painting behavior. J genet Psychol 1950, 76:191–194.

3749. Blum, L.H., and A. Dragostiz. Finger-painting: the developmental aspect. Child Develpm 1947, 18:88–105.

3750. Braun, J. Finger-painting in high schools. Texas Outlook 1939, 23:18.

3751. Cairns, J.H. Finger-painting at Perkins Institution. Teachers Forum (Blind) 1935, 8:6–7.

3752. Campbell, G.M., and L. Gold. Finger-painting as an aid in personality evaluation of 44 adult hospitalized mentally ill patients. Psychiat Quart Suppl 1952, 26: 59–69.

3753. Chang, Y.B. Finger-painting at the Guy Mayer Gallery. Art News 1939, 37:16.

3754. Clark, V.E. Fingerpainting as a Means of Appraising Personality. Ohio State Univ Abstracts of Doctoral Dissertations 1946–47, 53:17–22.

3755. Condon, A. Finger-painting is fun to do. Instructor 1943, 52:28.

3756. Curry, M. Tales told in finger paint. School Arts 1937, 37:88–90.

3757. Daivley, A. A Negro child in therapy. Social Case Work Child 1939, 3:185–200.

3758. Dörken, H., Jr. The reliability and validity of spontaneous finger paintings. J proj Tech 1954, 18:169–182.

3759. Drewry, P.H. Finger-painting. Monthly Bull NY State Ass occup Therapists 1936, 7:8–11.

3760. Dühsler, E. Erfahrungen mit Finger-malerei. Prax Kinderpsychol Kinderpsychiat 1952, 1:115–116.

3761. Dunser, A. Finger painting has many values. School Arts 1955, 55:17–18.

3762. Durrell, J. Finger-painting is fun. Osteo Magazine 1940, 27:6–7.

3763. Elste, E.A. Sibling Relationships Observed during Simultaneous Finger Painting Activities. Master's thesis. Clark Univ Abstracts of Dissertations 1947, 19:82–84.

3764. Eyreaud, L.C. Finger-painting. Graduate Teacher 1936, 53:29.

3765. Faulkner, R. Finger-painting in college. Design 1938, 40:5–6.

3766. Feamster, J.H., Jr. Preferences and

Dislikes of Neuropsychiatric Patients and Normals for the Finger Paintings of Other Neuropsychiatric Patients. Dissertation Abstr 1960, 20:3829-3830.

3767. Fleming, J. Observations on the use of finger painting in the treatment of adult patients with personality disorders. Char Pers 1940, 8:301-310.

3768. Franklin, W.R. Rhythm painting. Rouser 1936, 17:21.

3769. Grubert, L. Young America paints: values inherent in the art medium of finger-paint and frescole. Design 1936, 38:40-41.

3770. Hartley, R.E., et al. The finger-paint experience. In Understanding Children's Play. London: Routledge & Kegan Paul 1952, 270-297.

3771. Jacoby, J. Five-year-olds enjoy finger paint. Childhood Educ 1949, 25:315-316.

3772. James, M.L. Releasing curative values in the unconscious through the finger tips. Occup Ther Rehab 1939, 18:253-260.

3773. Jean, D. Fingers come first. School Arts 1937, 37:56.

3774. Jennings, D.S. Their fingers say more than their words. Saturday Evening Post 1945, 218:26-27, 76, 78.

3775. Kadis, A.L. Finger-painting as a projective technique. In Abt, L.E., and L. Bellak (eds.), Projective Psychology. NY: Knopf 1950, 403-431.

3776. Lehmann, H.E., and H. Dörken, Jr. Ratings of fingerpaintings in filmstrip: clinical evaluation of fingerpainting in psychiatry. 1952. (mimeographed.)

3777. Lehmann, H.E., and F. Fraser. Clinical Evaluation of Fingerpainting in Psychiatry. National Film Board of Canada 1952, 35 mm filmstrip.

3778. Lehmann, H.E., and F.A. Risques. The use of fingerpaintings in the clinical evaluation of psychotic conditions: a quantitative and qualitative approach. J ment Sci 1953, 99:763-777.

3779. Levy, J. The use of art techniques in treatment of children's behavior problems. Amer J ment Deficiency 1934, 39:258-260.

3780. Llorens, L.A., and S.P. Bernstein. Fingerpainting with an obsessive-compulsive organically-damaged child. Amer J occup Ther 1963, 17:120-121.

3781. Llorens, L.A., and G.G. Young. Fingerpainting for the hostile child. Amer J occup Ther 1960, 14:306-307.

3782. Long, J.A., and N.P. Dellis. Relationships between fingerpaintings and overt behavior of schizophrenics. J proj Tech 1961, 25:193-198.

3783. Louise, Sister M. Finger painting enriches learning. Nursing Outlook 1962 10:520-522.

3784. Lowe, E.B. Creative expression with finger-paint. School Arts 1941, 40:255-257, 359.

3785. Lyle, J., and R.F. Shaw. Encouraging fantasy expression in children. Bull Menninger Clinic 1937, 1:78-86.

3786. Marshall, E.M. Finger-painting: a new medium of expression. School Arts 1938, 10:65.

3787. Martinelli, R. Experimental finger-painting. School Arts 1942, 41:358.

3788. Mathes, V.T. Finger-painting with crayon. Design 1934, 36:26-28.

3789. Morrison, H.F., and T. Corrigan. Finger painting and movement therapy in a mental hospital in Holland. Nursing Mirr (London) 1957, 106:xiii, N 29.

3790. Mosse, E.P. Painting-analysis in the treatment of neurosis. Psychoanal Rev 1940, 27:65-82.

3791. Napoli, P.J. Finger-painting. In Anderson, H.H., and G.L. Anderson (eds.), An Introduction to Projective Techniques. NY: Prentice-Hall 1951, 386-415.

3792. ———. Fingerpainting: a bibliography. School Arts 1947, 46:208-210.

3793. ———. Finger-painting and personality diagnosis. Genet Psychol Monogr 1946, 34:129-230.

3794. ———. Finger Painting and Personality Diagnosis. Doctoral dissertation. Microfilm Abstracts 1946, 7:39-42.

3795. ———. A finger-painting record form. J Psychol 1948, 26:36-43.

3796. ———. The interpretative aspects of finger-painting. J Psychol 1947, 23:93-132.

3797. Napoli, P.J., and B.E. Gold. Finger painting in an occupational therapy program. Amer J occup Ther 1947, 1:358-361.

3798. Napoli, P.J., and W.W. Harris. Finger painting for the blind. J Psychol 1948, 25:185-196.

3799. Neuschutz, L.M. Paint it with your fingers. Volta 1939, 61:167.

3800. Obrook, I. The curative value of finger-painting. Health Digest 1936, 3:35.

3801. ———. The therapeutic value of finger painting. Crippled Child 1936, 13:172.

3802. Pasewark, R.A. The Use of Finger Paintings in Differentiating Epileptics and Paranoid Schizophrenics: an Evaluation of the Identification Hypotheses Underlying the Szondi Test. Dissertation Abstr 1957, 17:1814.

3803. Patey, H.C. A psychologist looks at finger painting. In Shaw, R.F. (ed.), Finger Painting. Boston: Little, Brown 1934, Ch.

3804. Phillips, E., and E. Stromberg. A comparative study of finger-painting performance in detention home and high school pupils. J Psychol 1948, 26:507-515.

3805. Pringle, G. Finger-painting. Canadian Home J 1940, 37:94.

3806. Rehnstrand, J. Finger-painting, a new way to teach color. School Arts 1938, 37:254-255.

3807. ———. Finger-painting and physical geography. School Arts 1936, 35:369-371.

3808. Riesbal, V.R. Modern mud pies. Amer Child 1939, 24:40-41.

3809. Rosenberg, S.R. Finger-painting. Graduate Teacher 1943, 60:32-33.

3810. Rosenzweig, L., and L. Durbin. Fingerpainting as an investigative approach to therapeutic techniques. Occup Ther Rehab 1945, 24:1-12.

3811. Schofield, W. A laboratory exercise on projective interpretation. J gen Psychol 1952, 46:19-28.

3812. Shaw, R.F. Finger Painting. Boston: Little, Brown 1934, 232 p.

3813. Spring, W.J. Words and masses: a pictorial contribution to the psychology of stammering. Psychoanal Quart 1935, 4:244-258.

3814. Staples, R., and H. Conley. The use of color in the finger painting of young children. Child Develpm 1949, 20:201-212.

3815. Telfer, G.G. Finger-painting. Leisure 1934, 1:9-11.

3816. ———. Fingers were made before brushes. Horn Book 1934, 10:313-315.

3817. Thack, S.D. Finger-Painting As a Hobby. NY: Harper 1937.

3818. Vogel, R., C. Hanke, H. Miller, and J. Smith. Finger-painting techniques at Ypsilanti State Hospital. Amer J occup Ther 1950, 4:100-101.

3819. Wahl, G.G. Finger-painting as a medium of expression. Instructor 1942, 51:35.

3820. Watson, E.W. Finger-painting for art students. Scholastic 1936, 27:24-25.

3821. Weber, F.W. Finger-painting. School Arts 1934, 33:581-584.

3822. Weisleder, T.E. Establishing rapport through finger painting. Elem School J 1947, 48:82-87.

3823. Wickes, F.G. The Inner World of Childhood. NY: Appleton-Century 1935.

3824. Wilds, S. Tell-tale finger-paint. National 1935, 10-11:65-66.

3825. Wille, W.S. New method in using finger paintings. Psychiat Quart Suppl 1952, 26:1-7.

3826. Wrangham, A. How modern children play. Queen 1938, 183:36-37.

3827. Yates, E. What is finger-painting? Monitor Magazine 1935, 8-9.

3828. Zulliger, H. Über Fingerfarben bei der Kleinkindererziehung und in der Erziehungshilfe. Schweizerische Z für Psychologie und ihre Anwendungen 1954, 12:275-282.

3829. Anand, M.R. Chinese posters and woodcuts. Aesthetics (Bombay) 1953, 6: 35–38.

3830. Andrews, J.D. The reward of cruelty; William Hogarth and his engravings. St. Bartholomew's Hospital J 1944, 48:104–107.

3831. Anon. Les hommes à long cou. Aesculape 1929, 19:84–86.

3832. Born, W. Der Traum in der Graphik des Odilon Redon. Die graphischen Künste (Vienna) 1929, 4.

3833. Büch, E. Albrecht Dürers "Melancholia" und die Pest. Medizinische Welt (Stuttgart) 1933, 7:69–72.

3834. Cleaver, J. A History of Graphic Art. NY:Philosophical Library 1963, 282 p.

3835. Farleigh, J. Reflections on wood-engraving. London Studio 1934, 108:21–27.

3836. Francis, H.S. The graphic arts in America. Yrb nat Soc Stud Educ 1941, 40: 196–205.

3837. ——. Woodcut initials of the "Fabrica." Bull Med Library Ass 1943, 31:228–239.

3838. Frye, N. Poetry and design in William Blake. JAAC 1951, 10:35–42.

3839. Getlein, F., and F. Getlein. The Bite of the Print. Satire and Irony in Woodcuts, Engravings, Etching and Lithographs. NY: Potter 1963.

3840. Grange, K.M. An eighteenth-century view of infantile sexuality in an engraving by William Hogarth. JNMD 1963, 137:417–419.

3841. Gwyn, N.B. An interpretation of the Hogarth print, "The Aims of the Company of Undertakers." Bull Hist Med 1940, 8: 115–127.

3842. Heyer, G.R. Ein Bild aus dem unbewussten Seelenleben: die subtile Melancholie. Z Psychother med Psychol 1934, 7:142–145.

3843. ——. Dürers Melancholia und ihre Symbolik. Eranos Jahrbuch 1934, 231–261.

3844. Illingworth, R.S. Satire on the professions in misericords (medieval wood-carvings). Clinical Pediatrics (Phila) 1963, 2:99–102.

3845. Ivins, W.M., Jr. Prints and Visual Communication. Cambridge: Harvard Univ Pr 1953, 190 p.

3846. ——. On the Rationalization of Sight NY: Metropolitan Museum of Art 1938, 52

3847. Jelenski, K.A. Under the skin. In The Selective Eye, an Anthology of the Best from L'Oeil, the European Art Magazine. NY: Reynal 1956–57, 90–95.

3848. Kirste, H. Albrecht Dürers Melencoli I, gesehen mit dem Auge des Arztes. Medizinische 1954, 15:516–518.

3849. Kohen, M. Zur Deutung eines sumerischen Siegelzlinders. Int Z Psychoanal 1939, 24:434–445.

3850. Kurth, J. Geschichte des Japanischen Holzschnitts. Leipzig 1925–29, 3 Vols.

3851. Lehman, H.C. The creative years: oil paintings, etchings, and architectural wor Psychol Rev 1942, 49:19–42.

3852. Liss, E. The graphic arts. Ops 1938, 8:95–99.

3853. Lopez-Rey, J. A Cycle of Goya's Drawings. The Expression of Truth and Liberty. NY: Macmillan 1956, 159 p.

3854. Martin, A. (Description of a woodcut from the 16th century by an imitator of Dürer, depicting care of the Christ child in the nursery.) Münchener Medizinische Wochenschrift 1931, 78:2200–2201.

3855. Milner, M.G. (Joanna Field). Psychoanalysis and art. In Sutherland, J.D. (ed.), Psychoanalysis and Contemporary Thought. NY: Grove 1959, 77–101; NY: Evergreen 1959, 77–101; London: Hogarth 1958.

3856. Nishimura, K. (On Dürer's "Melancolia #1.") Bigaku (Tokyo) 1954, 5(3).

3857. Ong, W.J. From allegory to diagram in the Renaissance mind: a study in the significance of the allegorical tableau. JAAC 1959, 17:423–440.

3858. ——. System, space and intellect in Renaissance symbolism. Bibliothèque d' Humanisme et Renaissance (Geneva) 1956, 18:222–239.

3859. Panofsky, E., and F. Saxl. Dürers "Melencolia I." Eine quellen- und typengeschichtliche Untersuchung. Leipzig-Berlin: Teubner 1923.

3860. Rosenfeld, E.M. Dream and vision; some remarks on Freud's Egyptian bird dream. Int J Psycho-Anal 1956, 37:97-105.

3861. Shahn, B. Love and Joy about Letters. NY: Grossman 1963.

3862. Stechow, W. Justice Holmes' notes on Albert Durer. JAAC 1949, 8:119-124.

3863. Strassmann, P. (Fetishism; Max Klinger's etchings: "The Glove," Opus 6.) Archiv für Frauenkunde u Konstitutionsforschung 1928, 14:165-179.

3864. Vallery-Radot, P. (A profoundly human art: suffering in rags in the engravings of Jacques Callot—1593-1635.) Presse méd 1960, 68:894-895.

3865. Volkmann, L. Eine Melancolia des Vasari. Z für Bildende Kunst 1929, 63:119-126.

3866. Wankmüller-Freyh, R. Zu Dürers Kupferstich "Melencolia I." Confin Psychiat 1960, 3:158-169.

3867. Wight, F.S. The revulsions of Goya: subconscious communications in the etchings. JAAC 1946, 5:1-28.

3868. Wölfflin, H. Zur Interpretation von Dürers "Melancholie." In Gedanken zur Kunstgeschichte. Gedrucktes und Ungedrucktes. Basel: Schwabe 1947, 96-105.

9 Mentally Retarded and Art

3869. Abel, T.M. Resistances and difficulties in psychotherapy of mental retardates. J clin Psychol 1953, 9:107-109.
3870. Abel, T.M., and J.B. Sill. The perceiving and thinking of normal and subnormal adolescents and children on a simple drawing task. J genet Psychol 1939, 54:391-402.
3871. Bender, L. Art and therapy in the mental disturbances of children. JNMD 1937, 86:249-263.
3872. ———. Gestalt function in mental defect. J Psycho-Asthenics 1935, 38:88-106.
3873. ———. Principles of Gestalt in copied form in mentally defective and schizophrenic persons. Arch Neurol Psychiat 1932, 27:661-686.
3874. Bender, L., and P. Schilder. The art of high grade mental defective children depicting their struggle with emotional disorganization and their primitive perceptual experiences. In Bender, L. (ed.), Child Psychiatric Techniques. Springfield, Ill.: Thomas 1952, 146-164.
3875. Berger, A., and M. Bliss. Colored drawings by mentally defective children of three etiologic groups. Training School Bull 1954, 50:191-198.
3876. Berrien, F.K. A study of the drawings of abnormal children. J educ Psychol 1935, 26:143-150.
3877. Birch, J.W. The Goodenough drawing test and older mentally retarded children. J ment Deficiency 1949, 54:218-224.
3878. Christoffel, B., and E. Grossmann. Über die expressionistische Komponente in Bildereien geistig minderwertiger Knaben. ZNP 1923, 87:372-376.
3879. Crawford, J.W. Art for the mentally retarded: directed or creative? Bull Art Therapy 1962, 2:67-72.
3880. ———. The Effect of Art Experiences on the Self-Concept of Institutionalized Adolescent Female Retardates. Dissertation Abstr 1962, 22:3919.
3881. Dallenbach, K.M. Effect of practice upon visual apprehension in the feeble-minded. J educ Psychol 1919, 10:61-82.
3882. De Martino, M.F. Human figure drawings by mentally retarded males. J clin Psychol 1954, 10:241-244.
3883. Díaz Arnal, I. El psiquismo del deficiente a traves del dibujo. Rev Psicol (Madrid) 1950, 5:735-743.
3884. Earl, C.J.C. The human figure drawings of adult defectives. J ment Sci 1933, 79:305-328.
3885. ———. The human figure drawings of feeble minded adults. J Psycho-Asthenics 1933, 38:107-120.
3886. Ellis, N.R., C.D. Barnett, and M.W. Pryer. Performance of mental defectives on the mirror drawing task. Perceptual & Motor Skills 1957, 7:271-274.
3887. England, A.O. A psychological study of children's drawings: comparison of public school, retarded, institutionalized, and delinquent children's drawings. Ops 1943, 13:525-530.
3888. Estes, S.G. Judging personality from expressive behavior. J abnorm soc Psycho 1938, 33:217-236.
3889. Fischer, G.M. Sexual identification in mentally subnormal females. Amer J men Deficiency 1961, 66:266-269.
3890. Fontaine, J.H. Art for the mentally retarded. Amer Teachers Magazine 1962, 47:7-8.
3891. Fontes, V. (Drawing and modeling of abnormal children.) Criança portug 1943, 2:127-136.
3892. Freeman, M. Drawing as a psychotherapeutic intermedium. J Psycho-Asthen 1936, 41:182-187.
3893. Gondor, E.I. Art and play therapy with retarded children. In Art and Play Therapy. Garden City, NY: Doubleday 1954, 27-31.
3894. Goodwin, A. The teaching of art to children of limited intelligence: a few hin to teachers. Mental Welfare (London) 192 9:81-85.
3895. Goslin, J. Students bring art to retarded adults. School Arts 1959, 68:17-18.

3896. Günzburg, H.C. Maladjustment as expressed in drawings by subnormal children. Amer J ment Deficiency 1952, 57: 9-23.

3897. ———. Projection in drawings. A case study. Brit J med Psychol 1955, 28:72-81.

3898. ———. The significance of various aspects in drawings by educationally subnormal children. J ment Sci 1950, 96:951-975.

3899. Heller, A.D. A study in finger and palm prints of imbeciles and idiots. Med Press 1955, 234:588-593.

3900. Hermelin, B., and N. O'Connor. Shape perception and reproduction in normal children and mongol and non-mongol imbeciles. J ment deficiency Res 1961, 5:67-71.

3901. Hoffer, H., and J. Launay. La peinture à grande échelle. Son rôle dans la rééducation des enfants déficients psychiques. Ann méd-psychol 1952, 110:698-701.

3902. Hollingworth, L.S. Psychology of Subnormal Children. NY: Macmillan 1920, 183-184.

3903. Israelite, J. A comparison of the difficulty of items for intellectually gifted children and mental defectives on the Goodenough drawing test. Ops 1936, 6: 494-503.

3904. Johnson, D.F. Art education for the educable mentally retarded child. Amer J ment Deficiency 1957, 62:442-450.

3905. Kerchensteiner, D.G. Die Entwickelung der zeichnerischen Begabung. Munsch: Gerber 1905, 508 p.

3906. Lawlor, G.W. Developmental Age in Feeble-Minded Boys. Master's thesis. Columbia Univ 1930.

3907. Levy, J. The use of art techniques in the treatment of children's behavior problems. Amer J ment Deficiency 1934, 39: 258-260.

3908. Lowenfeld, V. Self-adjustment through creativity. Amer J ment Deficiency 1941, 45:366-373.

3909. McElwee, E.W. Profile drawings of normal and subnormal children. J appl Psychol 1934, 18:599-603.

3910. ———. The reliability of the Goodenough intelligence test used with subnormal children fourteen years of age. J appl Psychol 1934, 18:599-603; 1932, 16: 217-218.

3911. Mein, R. Use of the Peabody Picture Vocabulary Test with severely subnormal patients. Amer J ment Deficiency 1962, 67: 269-273.

3912. Mullen, F.A. Une méthode inductive pour la determination des aspects signifi-

catifs des réponses d'enfants déficients mentaux au T.A.T. et au Michigan Picture Test. Rev de Psychologie Appliquée 1961, 11:279-291.

3913. Patterson, R.M., and M. Leightner. Comparative study of spontaneous paintings of normal and mentally deficient children of same mental age. Amer J ment Deficiency 1944, 48:345-353.

3914. Pollock, M.S. Releasing the true intellectual capacities of a young aphasic child through the unfettering of emotional bonds. Amer J ment Deficiency 1959, 63: 954-966.

3915. Popplestone, J.A. The validity of projective interpretations of art products of mentally retarded individuals. Amer J ment Deficiency 1954, 59:263-265.

3916. Prudhommeau, M. Les enfants déficients intellectuels. Paris: PUF 1956, 305 p.

3917. Richie, J., et al. Performance of retardates on the Memory-for-Designs test. J clin Psychol 1964, 20:108-110.

3918. Rohrs, F.W., and M.R. Haworth. The 1960 Stanford-Benet, WISC, and Goodenough Tests with mentally retarded children. Amer J ment Deficiency 1962, 66:853-859.

3919. Rorschach, H. Analytische Bemerkungen über das Gamälde eines Schizophrenen. Z Psychoanal Psychother 1913, 3:270-272.

3920. Rosenblum, S., and R.J. Callahan. The performance of high grade retarded, emotionally disturbed children on the children's manifest anxiety scale and the children's anxiety pictures. J clin Psychol 1958, 14: 272-274.

3921. Ruhräh, J. Mental deterioration—a painting of a child by Vallecas. Amer J Diseases Children 1932, 43:1220.

3922. ———. Pediatrics in art: cretin or mongol, or both together. Amer J Diseases Children 1935, 49:477-478.

3923. Schaeffer-Simmern, H., and S.B. Sarason. Therapeutic implications of artistic activity; a case study. Amer J ment Deficiency 1944, 49:185-196.

3924. Schenk, V.W.D. (Drawings of untrained and untalented adults.) Psychiatrische en neurologische bladen (Amsterdam) 1939, 43: 591-612.

3925. Semmel, M.I. Art education for the mentally retarded. School Arts 1961, 60: 17-20.

3926. Silverstein, A.B., and P.J. Mohan. Performance of mentally retarded adults on the color form sorting test. Amer J ment Deficiency 1962, 67:458-462.

3927. Slupinski, L. Drawing an obtuse angle. Research Rev (Durham) 1955, No. 6, 54-59.

3928. Sollier, P. Psychologie de l'idiot et

de l'imbécille. Paris: Alcan 1891, 276 p.

3929. Spoerl, D.T. The drawing ability of mentally retarded children. J genet Psychol 1940, 57:259-277.

3930. ———. Personality and drawing in retarded children. Char Pers 1940, 8:227-239.

3931. Stern, M.E., and (?) Maire. (The unusual artistic aptitude of an imbecile; a case.) Arch de médecine des enfants (Paris) 1937, 40:458-460.

3932. Stotijn-Egge, S. (Investigation of the Drawing Ability of Low-Grade Oligophrenics.) Leiden: "Liutor et Emergo" 1952, 174 p.

3933. Traube, T. La valeur diagnostique des dessins des enfants difficile. Arch Psychol 1937, 26:285-309.

3934. Trumper-Bödemann, (?). Die freie Kinderzeichnung, ihre Auswertung und ihre Auswirking in der Praxis. Z für die Behandlung Schwachsinniger u Epileptischer 1926, 46:97-123.

3935. Tumpeer, I.H. The ease of erring in the diagnosis of mongolism from premedical portraits; painting by Jordaens about 1635 definitely diagnosed by Siegert in 1910; portrait by Reynolds in 1773 suspected by author in 1924. Bull Soc Med History Chicago 1937, 5:88-104.

3936. Vaughn, C.L., and E.S. Hoose. Special abilities in a mentally deficient boy. Proc Amer Ass ment Deficiencies 1936, 41:197-207.

3937. Vedder, R. (The Copying of Simple Geometric Figures by Feebleminded and Young Children.) Amsterdam: Noord-Hollandsche Uitgevers Maatschappi 1939.

3938. Wawrzazsek, F., O.G. Johnson, and J.L. Sciera. A comparison of H.T.P. responses of handicapped and non-handicapped children. J clin Psychol 1958, 14: 160-162.

3939. White-Baskin, J. Retarded children need art. School Arts 1955, 54:13-15.

3940. Wiggin, R.G. Art activities for mentally handicapped children. Art Educ 1961, 3(1):88-102.

3941. ———. Art for the retarded. Audio-Visual Instruction 1959, 4:50-52.

3942. Yepsen, L.N. The reliability of the Goodenough drawing test with feebleminded subjects. J educ Psychol 1929, 20: 448-451.

3943. Ziehen, T. Geisteskrankheiten des Kindesalters. Sammlung von Abhandlungen aus dem Gebiet der pädagogischen Psychologie und Physiologie 1904, 1:1-94.

3944. Zuk, G.H. Children's spontaneous object elaborations on a visual-motor test. J clin Psychol 1960, 16:280-283.

3945. ———. The mind as an optical system: a study of perceptual reproduction in the normal and mentally retarded. J genet Psychol 1959, 94:113-130.

10 Personality Studies
of Artists

ERNST BARLACH (1870-1938)
3946. Werner, A. Ernst Barlach. Kenyon Rev 1962, 24:627-661.

MARIE BASHKIRTSEFF (1860-1884)
3947. Bernabei, M. Marie Baskirtsewa. L'eroina dell'io. Milan: Dante Alighieri 1932, 130 p.
3948. Blind, M. A Study of Marie Bashkirtseff. London: 1892.
3949. Christensen, E.O. Infantile sources of artistic interest in the neurosis of Marie Bashkirtseff. Psychoanal Rev 1943, 30:277-312.
3950. Hermann-Cziner, A. Die Grundlagen der zeichnerischen Begabung bei Marie Bashkirtseff. Imago 1924, 10:434-438.

GIOVANNI BELLINI (1430-1516)
3951. Goitein, L. Footnote to an allegory of Bellini. Psychoanal Rev 1934, 21:361-371.

WILLIAM BLAKE (1757-1827)
3952. Benoit, F. Master of art. Blake, the visionary. Ann psychical Sci 1908, 7.
3953. Bronowski, J. A Man Without a Mask. London: Secker & Warburg 1947.
3954. Frye, N. Fearful Symmetry: a Study of William Blake. Boston: Beacon 1962.
3955. Gybal, A. William Blake, poète et peintre de l'iréel. Psyché-Paris 1947, 2: 612-614.
3956. Martin, M.E. A Klippel-Feil syndrome in the artistic works of William Blake. Bull Hist Med 1954, 28:270-271.
3957. Norman, H.J. William Blake. J ment Sci 1915, 61:198.
3958. Witcutt, W.P. Blake, a Psychological Study. London: Hollis & Carter 1947, 127 p.

ARNOLD BÖCKLIN (1827-1901)
3959. Loewenfeld, L. Über die geniale Geistestätigkeit mit besonderer Berücksichtigung des Genies für bildende Kunst. Wiesbaden: Bergmann 1903.

HIERONYMUS BOSCH (1450-1516)
3960. Fraengel, W. Hieronymus Bosch: der Tisch der Weisheit, bisher "Die Sieben Todsünden" genannt. Psyché-Stuttgart 1951, 5:355-384.
3961. Hollmann, E. Eine Deutung der Bildes "Das Steinschneiden" von Hieronymus Bosch. Psyché-Stuttgart 1951, 5:385-390.

FRANCOIS BOUÇHER (1703-1770)
3962. Ninck, J. (Two successful artists.) Tijdschrift voor wetenschappelijke graphologie 1933, 5:119-126.

GEORGES BRACQUE (1882——)
3963. Bazin, G. Sur l'espace en peinture: la vision de Bracque. JPNP 1952, 45:439-448.

WILHELM BUSCH (1832-1908)
3964. Cornioley, H. Sexualsymbolik in der "Frommen Helene" von Wilhelm Busch. Psychoanal Bewegung 1929, 1:154-160.
3965. Paasch, R. (Wilhelm Busch and his relation to medicine.) Z für ärtzliche Fortbildung (Jena) 1932, 29:221-224.

BENVENUTO CELLINI (1500-1571)
3966. Cabanès, A. Les hallucinations des personnages célèbres. Chronica Médica 1900, 7:472-474.
3967. ——. Les maladies de Benvenuto Cellini. Chronica Médica 1900, 7:718.
3968. Cellerino, A. (Benvenuto Cellini in the guise of patient.) Minerva Med (Torino) 1960, 51:1567-1570.
3969. Courbon, P. Le déséquilibré mentale chez Benvenuto Cellini. France Médicale (Paris) 1906, 53:465.
3970. ——. Étude psychiatrique sur Benvenuto Cellini. Thèse Méd. Lyon 1906; Paris: Malvine 1906, 94 p.
3971. Eng, E. Cellini's two childhood memories. Amer Imago 1956, 13:189-203.
3972. Hermann, I. Benvenuto Cellinis dichterische Periode. Imago 1924, 10:418-423.

BENVENUTO CELLINI (cont.)
3973. Lange, J. Kriminologische Unter-
 suchungen an Genialen. Monatschrift für
 Kriminalpsychologie 1936, 27:16-25.
3974. Plank, R. On "Seeing the Salaman-
 der." In Eissler, R., et al. (eds.), The
 Psychoanalytic Study of the Child, Vol.
 12. NY: IUP 1957, 379-398.
3975. Price, G.E. A sixteenth century para-
 noiac (Benvenuto Cellini); his story and
 his autobiography. NY Med J 1914,99:727.
3976. Querenghi, F. La psiche di Benvenuto
 Cellini. Medicina Nuova (Rome) 1919,10:7-8.
3977. Roncoroni, L. Benvenuto Cellini.
 Contributo allo studio della parafrenia.
 Arch di psichiatrie, antropologia criminale,
 etc. (Torino) 1905, 26:271.
3978. Rosenbloom, J. Statements of medi-
 cal interest from the life of Benvenuto
 Cellini. Ann med History (New York) 1919,
 2:348.
3979. Sachs, H. Benvenuto Cellini. Int Z
 Psychoanal 1913, 1:518.
3980. Stekel, W. Ein Traumbild des Ben-
 venuto Cellini. Z Psychoanal Psychother
 1914, 4:322-323.
3981. Varenne, G. Les trois "visions" de
 Benvenuto Cellini. Arch Internationales
 de Neurologie (Paris) 1913, 35:11.
3982. Vossler, K. Benvenuto Cellinis Stil
 in seiner Vita; Versuch einer psycho-
 logischen Stilbetrachtung. Beiträge zur
 Romanischen Philologie. Halle: Niemeyer
 1899.

PAUL CÉZANNE (1839-1906)
3983. Weiss, J. Cézanne's technique and
 scoptophilia. Psychoanal Quart 1953, 22:
 413-418.

MARC CHAGALL (1887——)
3984. Alain, J. L'oeuvre de Chagall est
 l'expression universelle du rêve. Arts
 (Paris), June 26-July 2, 1957.
3985. Demisch, H. Kuh-Motive bei Marc
 Chagall. Alte u Neue Kunst (Zürich) 1959,
 No. 2/3.
3986. Fels, F. Chagall entre le rêve et le
 réel. Les Nouvelles Littéraires (Paris)
 1959, June 18.
3987. Germain, B. En marge du réel: Marc
 Chagall. L'Amour de l'Art (Paris) 1934, 15:
 321-324.
3988. Lehel, F. Notre art dément. 4 études
 sur l'art pathologique. Paris: Jonquières
 1926.
3989. Popov, N. Marc Chagall—Unter-
 suchung des künstlerischen Schaffens von
 Standpunkt der psychophysicischen Konsti-
 tution. Zhurnal Nevropotologii i Psikhiatrii

MARC CHAGALL (cont.)
 (Moscow) 1929, 22(3-4):499-510.
3990. Schneider, D.E. A psychoanalytic
 approach to the paintings of Marc Chagal.
 College Art J 1946, 6(2):115-124.
3991. Werner, A. Marc Chagall, conqueror
 of dreams. The Progressive (Madison,
 Wisc.) 1958, Jan.

GUSTAVE COURBET (1819-1877)
3992. Hirsch, W. Genie und Entartung. Ber
 lin: Coblentz 1894.

RICHARD DADD (?-?)
3993. Binyon, L. A note on Richard Dadd.
 Magazine of Art 1937, 30:106-107.

SALVADOR DALI (1904——)
3994. Pasto, T.A. (A psychoanalytic ex-
 planation of the personality of Salvador
 Dali.) Semaine des Hospitaux: Informatio
 1962, 46:12-13.

HONORÉ DAUMIER (1808-1879)
3995. Rocchietta, S. (Honoré Daumier,
 painter, caricaturist, sculptor.) Minerva
 Med 1961, 52:1983-1985.

LEONARDO DA VINCI (1452-1519)
3996. Bergler, E. Differential diagnosis be
 tween spurious homosexuality and perver-
 sion homosexuality. Psychiat Quart 1947,
 21:399-409.
3997. ——. On a five-layer structure in su
 limation. Psychoanal Quart 1954, 14:76-9
3998. Bonvicini, G. Die Dokumente der
 Linkshändigkeit des Leonardo da Vinci.
 Wiener medizinische Wochenschrift 1937
 1:286-287, 341-343, 365-367, 426-427,
 454-455, 505-507, 533-535.
3999. Cabanès, A. Comment écrivait Léona
 de Vinci. Chronica Médica 1909,16:382-3
4000. Carpenter, E. Das Mittelgeschlecht.
 Munich 114 p.
4001. Christensen, E.O. Freud on Leonardo
 da Vinci. Psychoanal Rev 1944,31:153-16
4002. Clark, K. Leonardo da Vinci. An Ac-
 count of His Development As an Artist. N
 Macmillan 1939, 209 p.
4003. Clark, L.P. A psychological study of
 art vs. science as illustrated in Leonardo
 da Vinci. Arch Psychoanal (Stamford, Con
 1927, 1:531-565.
4004. Craven, T. Leonardo da Vinci. In
 Campbell, O., J. Van Gundy, and C. Shrod
 (eds.), Patterns for Living. NY: Macmillar
 1940.
4005. Dalma, G. Leonardo precurso della
 psicofisiologia e psicologia dinamica
 moderna. Nevrasse 1956, 6:231-253.

LEONARDO DA VINCI (cont.)

4006. Diamant-Berger, L. The life and work of Leonardo da Vinci, with special reference to his interest in anatomy. Bull méd (Paris) 1940, 54:161-171.

4007. Eissler, K.R. Leonardo Da Vinci. Psychoanalytic Notes on the Enigma. London: Hogarth 1962, 375 p; NY: IUP 1961, 375 p.

4008. Evlachov, A. Léonard de Vinci était-il un épileto de? Arch Generale di Neurologie, Psichiatrie e Psicoanalisi 1937, 18:343-357.

4009. Fraiberg, L. Freud's writing in art. Int J Psycho-Anal 1956, 37:82-96; Lit & Psychol 1956, 6:116-130.

4010. Freud, S. Eine Kindheitserinnerung des Leonardo da Vinci. Vienna-Leipzig: Deuticke 1910, 1919, 1923, 71 p; Gesammelte Schriften 9:371-454; Gesammelte Werken 1943, 8:128-211.

4011. ——. Leonardo. Moscow 1912, 119 p.

4012. ——. Leonardo da Vinci and a memory of his childhood. In Strachey, J. (ed), Standard Edition of the Complete Psychological Works of Sigmund Freud. London: Hogarth, Vol. 11.

4013. ——. Leonardo da Vinci: a Psychosexual Study of Infantile Reminiscence. NY: Moffat Yard 1922, 130 p; London: Kegan Paul 1922, 130 p; NY: Dodd Mead 1932, 138 p; NY: Random House 1947, 121 p.

4014. ——. Uma Recordação De Infancia De Leonard Da Vinci. Obras Completas (Lisbon) 11:7-81.

4015. ——. Un Mecuerdo infantil de Leonardo de Vinci. Obras Completas (Madrid) 8:241-333; Obras Completas (Buenos Aires) 1948, 2:365-401.

4016. ——. Un souvenir d'enfance de Léonard de Vinci. In Les Documents Bleu, No. 32. Paris: Gallimard 1927.

4017. ——. Vzpomínka Z Détství Leonarda da Vinci. Prague: Orbis 1933, 135 p.

4018. Frey, L. Der Eros und die Kunst. Leipzig, 142 p.

4019. Fritsch, V. (Sigmund Freud and Leonard da Vinci.) Voinstvuyuschii materialist (Moscow) 1925 1925, 3:160-168.

4020. Fumagalli, G. Eros di Leonardo. Milan: Garzanti 1952.

4021. Hárnik, J. Ägyptologisches zu Leonardos Geierphantasie. Int Z Psychoanal 1920, 6:362-363.

4022. Keele, K.D. The genesis of Mona Lisa. J History Med & Allied Sci (New Haven) 1959, 14:135-159.

4023. Marzi, A. Psicoanalisi di Leonardo. Il Mondo 1945, 1(5):9-11.

4024. Pfister, O. Kryptolalie, Kryptographie und unbewusstes Vexierbild bei Normalen. Jahrbuch für Psychoanalytische und Psychopathologische Forschungen 1913, 5: 146.

4025. Schapiro, M. Leonardo and Freud: an art-historical study. J History Ideas 1956, 17:147-178.

4026. ——. Two slips of Leonardo and a slip of Freud. Psychoanal Rev 1955-56, 4(2):3-8.

4027. Schultze, H. Noch einmal: Leonardo da Vinci nach dem Roman von Mereschkowski. Z Psychoanal Psychother 1913, 3:631-632.

4028. Seidlitz, W. von. Leonardo da Vinci, der Wedepunkt der Renaissance. Vienna 1928.

4029. Stites, R. A criticism of Freud's Leonardo. College Art J 1948, 7:257-267; 1949, 8:40.

4030. Walsh, M.N. Notes on the neurosis of Leonardo da Vinci. Psychoanal Quart 1961, 30:232-241.

4031. Wittels, F. Mona Lisa and feminine beauty; a study of bisexuality. Int J Psycho-Anal 1934, 15:25-40; Imago 1934, 20:316-329.

4032. ——. Vorläufige Mitteilung: Mona Lisa und Weibliche Schönheit. Int Z Psychoanal 1933, 19:622.

4033. Wohl, R.R., and H. Trosman. A retrospect of Freud's Leonardo, an assessment of a psychoanalytic classic. Psychiatry 1955, 18:27-40.

4034. Zierer, E., and E. Zierer. Leonardo da Vinci's artistic productivity and creative sterility. Amer Imago 1957, 14:345-369.

OPICINUS DE CANISTRIS (1296-c. 1350)

4035. Kris, E. A psychotic artist of the middle ages. In Psychoanalytic Explorations in Art. NY: IUP 1952, 118-27; London: Allen & Unwin 1953, 118-127.

FERDINAND VICTOR EUGÈNE DELACROIX (1798-1863)

4036. Lalo, C. Eugène Delacroix. Esquisse d'un type psychoesthétique. JPNP 1940-41, 37-38:161-184.

4037. Schneider, D.E. The Journal of Eugene Delacroix. In The Psychoanalyst and the Artist. NY: IUP 1950, 167-190.

4038. Stanka, H. Torquato Tasso, Eugène Delacroix, Johann Wolfgang von Goethe; psychiatric study. JNMD 1943, 98:387-389.

HENRY EDMOND DELACROIX (1856-1910)

4039. Lalo, C. La psychologie de l'art de Henri Delacroix. JPNP 1927, 24:150-165.

ANDREA DEL SARTO (1486-1531)
4040. Christensen, E.O. Basic determinants
in the art of Andrea del Sarto: a reinter-
pretation. Psychoanal Rev 1942, 29:253-
269.
4041. Ferenczi, S. The sons of tailors.
Int J Psycho-Anal 1923, 9:67-68.
4042. Jones, E. Andrea del Sartos Kunst
und der Einfluss seiner Gattin. Imago
1913, 2:468-480.
4043. ——. The influence of Andrea del
Sarto's wife on his art. In Essays in Ap-
plied Psycho-Analysis. London: Baillière,
Tindall, Cox 1923, 227-244; 1951, 1:22-
38.
4044. Van der Chijs, A. Infantilismus in
der Malerei. Imago 1923, 9:463-474; Ned
Tijdschr Geneesk 1923, 107.

CHARLES DEMUTH (1883-1935)
4045. Farnham, E.E. Charles Demuth: His
Life, Psychology and Works. Dissertation
Abstr 1960, 20:4069.

"MONSU DESIDERIO" (17th Cent.)
4046. Sluys, F. "Monsu Desiderio," peintre
de l'iréel. La Vie Médicale, Numéro Spé-
cial. Art et psychopathologie. Dec. 1956,
53-64.

LOPE DE VEGA (1562-1635)
4047. Geers, G.J. Lope de Vega. Sijn geest
en sijn werk. Vrije Bladen 1935, 7:8.
4048. Pfandl, L. Das Liebesleben des Lope
de Vega. Versuch einer neuen Deutung.
Neophilologus 1935, 20.

ALBRECHT DÜRER (1471-1528)
4049. Brandt, P. Albrecht Dürer. Umschau
1928, 32:271-277.
4050. Panofsky, E. Albrecht Dürer. Prince-
ton: Princeton Univ Pr 1948, 2 Vols.
4051. Van Uytvanck, P. Albrecht Dürer,
voorloper van de moderne constitutieleer.
Belgisch Tydschrift voor Geneeskunde
(Louvain) 1953, 9:1005-1015.
4052. Winterstein, A.R.F. Dürers Melan-
cholia im Lichte der Psychoanalyse. Imago
1929, 15:145-199; Vienna: Internationaler
Psychoanalytischer Verlag 1929.
4053. Wölfflin, H. Die Kunst Albrecht Dürers.
Munich: Bruckmann 1926.

FEUERBACH FAMILY (Anselm Feuerbach: 1829-
1880; Hans Thoma Feuerbach: ?-?; Karl
Wilhelm Feuerbach: 1800-1834)
4054. Cantor, M. Karl Wilhelm Feuerbach.
Heidelberg: Winter 1910.
4055. Eulenberg, H. Die Familie Feuerbach.
Stuttgart: Engelhorn 1924.

FEUERBACH FAMILY (cont.)
4056. Spoerri, Th. Genie und Krankheit.
Eine psychopathologische Untersuchung
der Familie Feuerbach. Basel & NY: Karg
1952.
4057. ——. Maler Anselm Feuerbach, 182⟨
1880. Schweiz ZPA 1952, 11:46-68.
4058. Strohmayer, W. Hans Thoma und An-
selm Feuerbach. Ein Beitrag zu der Lehre
Kretschmers von den Temperamenten. ZN⟩
1922, 76:417-425.

NAUM GABO (1890——)
4059. Gabo, N. Of Divers Arts. The A.W.
Mellon Lectures in the Fine Arts, 1959.
NY: Pantheon 1962, 205 p.

ANTONI GAUDI Y CORNET (1852-1926)
4060. Bückmann, I. Antoni Gaudi. Ein Path
graphischer Versuch, zugleich ein Beitra⟨
zur Genese des Genieruhms. ZNP 1932,
139:133-157.

EUGÈNE HENRI PAUL GAUGUIN (1848-1903)
[For additional items, see listings under
Van Gogh.]
4061. Dovski, L. van. Genie und Eros. Ber
Delphi 1947.
4062. Rothschild, R.D. A Study in the Prob
lems of Self-Portraiture. The Self-Portrai⟩
of Paul Gauguin. Dissertation Abstr 1961
22:532.

THÉODORE GERICAULT (1791-1824)
4063. Vallery-Radot, P. (Gericault, a pain⟩
of suffering and insanity.) Día Medico
Suppl 1960, Suppl I-II; Presses méd 1959
67:2321-2322.

AKE GÖRANSSON (?-?)
4064. Hedenberg, S. Ake Göransson; a
prominent painter of Gothenburg; the rela
tionship of schizophrenia and art. Acta
Medica Scandinavica Suppl 1950, 246:71-

ARSHILE GORKY (1904-1948)
4065. Osborn, M. (The mystery of Arshile
Gorky: a personal account.) Art News 196
61(10):42-43, 58-61.

FRANCISCO JOSE DE GOYA Y LUCIENTES
(1746-1828)
4066. Abeatici, S. La malattia nella vita
e nell'opera di Goya. Minerva Chirurgica
(Torino) 1953, 8:393-394.
4067. Cawthorne, T. Goya's illness. Proc
Royal Society Med 1962, 55:213-217.
4068. LeGuen, C. À propos de Goya: Sur
l'art et l'aliénation. Évolut Psychiat 1961
26:33-67.

FRANCISCO JOSE DE GOYA Y LUCIENTES (cont.)

4069. Reitman, F. Goya: a medical study. Char Pers 1939, 8:1–17.

4070. Seguín, C.A. El sueño de la razón produce monstruos; luz y sombras de Goya. Rev de Neuro-psiquiatría (Lima) 1950, 13:275–291.

4071. Wight, F.S. The revulsions of Goya: subconscious communications in the etchings. JAAC 1946, 5:1–28.

EL GRECO (DOMENIKOS THEOTOKOPOULOS) (1548?–1614? or 1625?)

4072. Mauro, E. Anatomy and anguish in painting of El Greco. Medicina-cirugia-pharmacia (Rio de Janeiro) 1941, 86–98.

4073. Pestel, M. Essai d'une psychologie du Greco. Presse méd 1953, 61:1777–1780.

4074. Verd, Y.B. Le Gréco. Remarques sur la peinture et la folie. Thèse Méd. Bordeaux 1934; J. Biere 108 p.

N. GRIGORESCU (?–?)

4075. Rusu, L. (Psychological interpretation of N. Grigorescu.) Rev Filosofia (Bucharest) 1933, 18:142–151.

JUAN GRIS (1887–1927)

4076. Debrunner, H. Die Bildsymbolik bei Juan Gris. Schweiz ZPA 1948, 7:172–175.

MATTHIAS GRÜNEWALD (1500–1530)

4077. Hünicken, R. Der historische Matthias Grünewald. Forschungen und Fortschritte: Korrespondenzblatt der deutschen Wissenschaft und Technik 1937, 13:374–375.

FRANZ HALS (1580?–1666)

4078. Regnault, F. (Portrait of facial paralysis by Franz Hals; his drunkeness due to poverty in old age.) Bull de la Societe française d'histoire de la médicin 1929, 23:28–31.

LAFCADIO HEARN (1850–1904)

4079. Gould, G.M. Lafcadio Hearn. A study of his personality and art. Fortnightly Rev 1906, 80:685–695, 881–892.

CARL FREDERICK HILL (1849–1911)

4080. Volmat, R. Carl Frederick Hill, peintre schizophrene. Confin Psychiat 1959, 2:172–190.

FERDINAND HODLER (1853–1918)

4081. Behn-Eschenburg, H. Ferdinand Hodlers Parallelismus. Psychoanal Bewegung 1931, 3:329–340.

ERNST JOSEPHSON (1852–1906)

4082. Evensen, H. Psychiatrie und schaffende Kunst. Acta psychiat neurol 1936, 11:455–457.

4083. Forster, E. Über Josephsons Bilder während der Krankheit. Z für bildende Kunst 1910, 175.

4084. Hartlaub, G.F. Ernst Josephson, eine schöpferische psychose. Kunstwerk 1960, 14:3–14.

4085. Mesterton, I. Vägen till försoning; en studie i Ernst Josephsons religiösa fantaswärld. Gothenborg, Sweden: Elanders 1956, 168 p.

4086. Millner, S.L. Ernst Josephson. NY: Machmadian 1948, 57 p.

PAUL KLEE (1879–1940)

4087. Rohe, J. Symbolsprache bei Klee und Chagall. Magnum (Frankfurt) 1956, No. 11.

OSKAR KOKOSCHKA (1886——)

4088. Anon. Oskar Kokoschka: psychological portraitist. Time 1958, 71:62–63.

4089. Hodin, J.P. Style and personality: a graphological portrait of Oscar Kokoschka. JAAC 1948, 6:209–225.

ALFRED KUBIN (1877–?)

4090. Bachler, K. Alfred Kubin und die Flucht ins Traumreich. Ein Beitrag zur Deutung des künsterlischen Schaffens. Psychoanal Bewegung 1933, 5:53–69.

4091. ——. Männer, Mächte und Dämonen. Psychologische Berater gesunde practische Lebengestalt 1952, 4:290–294.

4092. Winkler, W. Das Oneiroid. Zur Psychose Alfred Kubins. Arch für Psychiatrie u Nervenkrankheiten 1948, 181:136–167.

CLAUDE LORRAIN [CLAUDE GELLÉE] (1600–1682)

4093. Jentsch, E. Die Schreckneurose Claude Lorrains. Psychiatrisch-neurologische Wochenschrift (Halle) 1925, 17:227.

FRANZ MARC (1880–1916)

4094. Hárnik, J. Von einem Bilde des Franz Marc. Beitrag zur Psychologie der modernen Kunst. Imago 1931, 17:518–525.

HENRI MATISSE (1869–1954)

4095. Schnier, J. Matisse from a psychoanalytic point of view. College Art J 1953, 12:110–117.

FRANZ XAVER MESSERSCHMIDT (1736–1784)

4096. Kris, E. Art and regression. Trans. NY Acad Sci 1944, 6:236–250.

FRANZ XAVER MESSERSCHMIDT (cont.)
4097. ———. Die Charakterkopfe des F.X. Messerschmitt, Versuch einer historischen und psychologischen Deutung. Jahrbuch Kunsthistorischen Sammlungen 1932, 6: 169-228; In Psychoanalytic Explorations in Art. NY: IUP 1952, 128-150; London: Allen & Unwin 1953, 128-150.
4098. ———. Un esculator aliendo. Las cabezas de caracter de Franz Xaver Messerschmidt. Rev de psicoanálisis (Buenos Aires) 1945, 3:100-133.
4099. ———. Ein geisteskranker Bildhauer. Imago 1933, 19:384-411.
4100. Turcek, M., and M. Malikova. (Xaver Messerschmidt—a contribution to the evaluation of pathological elements of his creat .s.) Bratislavske Lekarske Listy 1962, 42:289-299.

MICHELANGELO BUONARROTTI (1475-1564)
4101. Angelucci, A. (Sublimation in the art of Michelangelo, Wagner, Berlioz; psychoanalysis of the evolution of works of art.) Arch di ottalmologia (Naples) 1928, 35:385, 433, 481, 529.
4102. Langeard, P. (Intersexuality of Michelangelo and that depicted in his works.) Progrès médicale suppl (Paris) 1936, 73-79.
4103. Mandolini, H. Temperament, Konstitution und künstlerisches Genie. Rev de Criminologia Psiquiatria y Medicina legal 1934, 21:34-40.
4104. Praetorius, N. Michelangelos Urningtum. Jahrbuch für sexuelle Zwischenstuffen 1900, 2:254.
4105. Sterba, E., and R. Sterba. The anxieties of Michelangelo Buonarotti. Int J Psycho-Anal 1956, 37:325-329.

JOHN EVERETT MILLAIS (1829-1896)
4106. Bergler, E. John Ruskin's marital secret and J.E. Millais' painting "The Order of Release." Amer Imago 1948, 5: 182-201.

JOHN MIRO (1893———)
4107. Riesman, E.T. Childhood memory in the painting of Joan Miro. ETC 1949, 6: 160-168.

AMEDEO MODIGLIANI (1884-1920)
4108. Werner, A. The inward life of Modigliani. Arts 1961, 35:36-41.

KARL MÜLLER (1797-1840?)
4109. Schmidt, E. Zeichnungen des stellmachers Karl Müller. Kunst u Künstler 1931, 29:382-384.

EDVARD MUNCH (1863-1944)
4110. Huggler, M. Die Überwindung der Lebenangst im Werk von Edvard Munch. Confin Psychiat 1958, 1:3-16.
4111. Steinberg, S., and J. Weiss. The art of Edvard Munch and its function in his mental life. Psychoanal Quart 1954, 23: 409-423.
4112. Stenersen, R. Edvard Munch: Close-Up of a Genius. Oslo: Gyldendal 1946.

NONDA (?-?)
4113. Dracoulidès, N.N. Répercussions du sevrage précoce sur les tableaux d'un peintre moderne. Observations psychoanalytiques. Acta Psychotherapeutica, Psychosomatica et Orthopaedagogica (Basel) 1953, 1:23-33.

PABLO PICASSO (1881———)
4114. Düss, L. À propos de Picasso. Suiss contemporaine 1946.
4115. Gombrich, E.H. Psycho-analysis and the history of art. Int J Psycho-Anal 1954 35:401-411.
4116. Jung, C.G. Picasso. In Wirklichkeit der Seele. Zurich: Rascher 1947, 170-179 Neue Zurich Zeitung 1932, 153 (Nov. 13):
4117. Kahn, E. Two geniuses. Confin Psychiat 1960, 3:62-64.
4118. Rosenthal, M.J. Relationships betwe form and feeling in the art of Picasso. Ar Imago 1951, 8:371-391.
4119. Schneider, D.E. The painting of Pab Picasso. A psychoanalytic study. Colleg Art J 1947-48, 7:81-95.
4120. Wight, F.S. Picasso and the unconscious. Psychoanal Quart 1944, 13:208-216.
4121. Zervos, C. Picasso étudié par le D. Jung; avec un extrait du texte. Cahiers d'Art 1932, 7(8-10):352-354.

RAPHAEL SANTI (1483-1520)
4122. Woltmann, L. Der psychische Typu Raffaels. Politisch-anthropologische Re 1904, 3:171-176.

ODILON REDON (1840-1916)
4123. Roumeguere, P. Le mystère Odilon Redon. La Vie Médicale. Numéro Spécia Art et psychopathologie. Dec. 1956, 64-77.

FRANÇOIS AUGUSTE RENÉ RODIN (1840-19)
4124. Sigogneau, A. Le tourment de Rodi Paris 1933, 242 p.

BRUNO SCHULZ (?-?)
4125. Wegrocki, H.J. Masochistic motiv

BRUNO SCHULZ (cont.)
in the graphic art of Bruno Schulz. Psycho-
anal Rev 1946, 33:154-164.

GIOVANNI SEGANTINI (1858-1899)
4126. Abraham, K. Giovanni Segantini: a
psychoanalytic essay. Psychoanal Quart
1937, 6:453-512; Vienna: Deuticke 1925,
70 p; Sammlungen zur angewandten Seelen-
kunde 1911, 11:1-65; In Clinical Papers
and Essays on Psycho-Analysis. London:
Hogarth Pr 1955, 210-261; NY: Basic
Books 1955, 210-261.

SHOEMAKER FAMILY (Andrew Shoemaker:
1860-?; Gottlieb Shoemaker: 1850-?)
4127. Shoemaker, R. Student pedigree-
studies. 51. Artistic ability in the Shoe-
maker family. Eugenical News 1937, 22:
107-108.

GIOVANNI BAZZI SODOMA (1478-1549)
4128. Kupffer, E.v. Giovan Antonio-il
Sodoma, der Maler der Schönheit. Jahr-
buch für sexuelle Zwischenstuffen 1908,
9:71-168.

CHAIM SOUTINE (1894-1944)
4129. Ragon, M. My years with Soutine.
As told by "Mademoiselle Garde" to
Michel Ragon. In The Selective Eye, an
Anthology of the Best from l'Oeil, the
European Art Magazine. NY: Reynal 1956-
57, 142-147.

KARL STAUFFER-BERN (1857-1891)
4130. Binswanger, R. Karl Stauffer-Bern,
eine psychiatrische Studie. Deutsch Rev,
eine monatsschrift (Berlin) 1892.

TISCHBEIN FAMILY (?-?)
4131. Link, M. Die Malerfamilie Tischbein.
Arch für Rassenwissen u Gesellschaft-
biologie 1933, 27:185-186.

HENRI DE TOULOUSE-LAUTREC (1864-1901)
4132. Loeb, L. Psychopathology and Tou-
louse-Lautrec. Amer Imago 1959, 16:213-
234.
4133. Vles, S.J. (Henri de Toulouse-Lautrec;
a psychoanalytic evaluation of the artist
and his work.) Psychologische Achter-
gronden 1954, 23-24:3-60.

MAURICE-QUENTIN DE LA TOUR (1704-1788)
4134. Ronot, H. La démence sénile de Mau-
rice-Quentin de la Tour. Paris: Véga 1932.

JOSEPH MALLORD WILLIAM TURNER (1775-1851)
4135. Stokes, A. Painting and the Inner

JOSEPH MALLORD WILLIAM TURNER (cont.)
World. London: Tavistock 1963, 85 p.

HUGO VAN DER GOES (1440?-1482)
4136. Dupré, E., and (?) Devaux. Le mélan-
colie du peintre Hugo Van der Goes. En-
céphale 1910, 5:167.
4137. McCloy, W.A. The Ofhuys Chronicle
and Hugo Van Der Goes. Dissertation Abstr
1959, 19:1704.

VINCENT VAN GOGH (1853-1890)
4138. Aigrisse, G. L'évolution du symbole
chez Van Gogh. Psyché-Paris 1954, 9:310-
318.
4139. Alves Garcia, J. (Sickness and work
of two great impressionists.) J Brasileiro
de Psiquiatria 1954, 3:183-198.
4140. Arndt, J. Die Krankheit Vincent van
Goghs nach seinen Briefen an seinen Bruder
Theo van Gogh. Dissertation Med. Leipzig
1945.
4141. Beer, J. Du démon de Van Gogh. Arts
(Paris) 1947, Jan. 31, p. 8.
4142. ——. Essai sur les rapports de l'art
et de la folie chez Vincent Van Gogh.
Médecin Alsace Lorrain 1935, 40:322-369.
4143. ——. La maladie de Van Gogh. Gazette
Beaux Arts 1936, Jan.
4144. ——. Van Gogh. Psyché-Paris 1946,
1:5.
4145. ——. Van Gogh, diagnosis of the
tragedy. Art News Annual 1949, 19:83-86.
4146. Bernat, E. La maladie mentale de
Van Gogh. Thèse Méd. Montpellier 1950,
38 p.
4147. Bett, W.R. Vincent Van Gogh, artist
and addict. Brit J Addiction 1953, 51.
4148. Beuckel, J. de. Un portrait de Vincent
Van Gogh. Liège: Editions du Balancier
1938.
4149. Blum, H.P. Van Gogh's chairs. Amer
Imago 1956, 13:307-318; Rev franç Psy-
chanal 1958, 22:83-93.
4150. Catesson, J. Considérations sur la
folie de Van Gogh. Thèse Méd. Paris 1943.
4151. Cochrane, A. Van Gogh's madness.
Art Digest 1936, 10:15.
4152. Cogniot, G. Vincent Van Gogh. Paris:
Ollendorf 1923.
4153. Coppola, C. La malattia mentale di
Vincenzo Van Gogh. Ospedale Psichiatrico
(Naples) 1950, 18:213-238.
4154. Dahlgren, K.G. Van Gogh als psy-
chiatrisches Problem. Confin Psychiat
1959, 2:190-204.
4155. Delanglade, F. L'aliénation creatice
chez van Gogh. Quadrige 1946, 48-51.
4156. Desruelles, M., and G. Fellion.
L'alcoolisme de Vincent Van Gogh. Congrès

VINCENT VAN GOGH (cont.)
Alién neurol, Clermont-Ferrand 1949, 211-
214.
4157. —— & ——. Les causes du suicide
de Vincent Van Gogh. Congrès Alién
neurol, Clermont-Ferrand 1949, 215-220.
4158. Doiteau, V. A quel mal succomba
Théodore Van Gogh? Aesculape 1940,
May 15.
4159. Doiteau, V., and E. Leroy. La folie
de Van Gogh. Paris: Editions Aesculapes
1928.
4160. —— & ——. Van Gogh et le portrait
du Dr. Rey. Aesculape 1939, Feb. & March.
4161. —— & ——. Vincent van Gogh et le
drame de l'oreille coupée. Aesculape
1936.
4162. —— & ——. Vincent van Goghs
Leidensweg. Freiburg 1930.
4163. Dwyer, J.H., and N.L. Dwyer. Vincent
Van Gogh: a study of the relationship
between some childhood disturbances and
his drive to paint. Psychiatric Communica-
tions 1963, 6:1-8.
4164. Evensen, H. Die Geisteskrankheit
Vincent van Goghs. Allgemeine Z für Psy-
chiatrie (Berlin) 1926, 84:133-153.
4165. Ferdière, G. Art et Épilepsie. Progrès
médicale (Paris) 1946, 74:88-91.
4166. Gastaut, H. La maladie de Vincent
van Gogh envisagée à la luminière des
conceptions nouvelles sur l'épilepsie
psychomotrice. Ann méd-psychol 1956,
114:196-238.
4167. Graetz, H.R. The Symbolic Language
of Vincent Van Gogh. NY: McGraw-Hill
1963, 315 p.
4168. Hariga, J. À propos de la psychologie
de Van Gogh. Acta neurol psychiat belg
1959, 59:215-227.
4169. Hedenberg, S. Van Gogh. Om hans
sjukdom och konst. Svenska Läkartidn
1938, 35:510-524.
4170. Hemphill, R.E. The illness of Vincent
Van Gogh. Proc Royal Soc Med 1961, 54:
1083-1088.
4171. Hoffmann, A. Vincent van Gogh. Eine
charakterologische Studie mit besonderer
Berücksichtigung der Wandlung seiner
Persönlichkeit. Doctoral dissertation.
Leipzig 1943.
4172. Hungerland, H. Psychological ex-
planations of style in art. JAAC 1946, 4:
160-166.
4173. Jaspers, K. Strindberg und van Gogh;
Versuch einer pathographischen Analyse
unter vergleichender Heranziehung von
Swedenborg und Hölderlin. Leipzig-Bern:
Bircher 1922, 131 p; Berlin: Springer 1926,
151 p; Paris: Édit de Minuit 1953, 276 p.

VINCENT VAN GOGH (cont.)
4174. Johnson, H.E. No madman. Art Diges
1934, 8:11.
4175. Kraus, G. Vincent Van Gogh en de
Psychiatrie. Psychiatrische en neurologis
bladen (Amsterdam) 1941, 15:985-1034.
4176. Leroy, E. La provence et van Gogh.
Rev de Pays d'Oc 1932, June.
4177. ——. Le séjour de van Gogh à l'asy
de Saint Rémy de Provence. Aesculape
1926, p. 37.
4178. Lubin, A.J. Vincent van Gogh's ear.
Psychoanal Quart 1961, 30:351-384.
4179. Mauron, C. Notes sur la structure
de l'inconscient chez Van Gogh. Psyché-
Paris 1953, 8:24-31, 124-143, 203-209.
4180. Meerloo, J.A.M. De diagnostische
strijd over Vincent van Gogh. Psychiatris
en neurologische bladen (Amsterdam) 193
508.
4181. Meige, H. La folie du peintre Van
Gogh. Presse méd 1929, Feb.
4182. Minkowska, F. Van Gogh. Les rela-
tions entre sa vie, sa maladie et son
oeuvre. Évolut Psychiat 1933, 3:53-76;
Ned Tijdschr Psychol 1935, 3:155-178.
4183. ——. De van Gogh et Seurat aux
dessins d'enfant. Paris: Presses du temps
présent 1949, 152 p.
4184. Minkowski, E. Problèmes patho-
graphiques. (À propos de la traduction
français du "Strindberg et Van Gogh" de
K. Jaspers.) Rev d'Esthétique 1954, 7:
257-276.
4185. Perruchot, H. La vie de Van Gogh.
Paris: Hachette 1955.
4186. Perry, I.H. Vincent Van Gogh's illne
A case record. Bull Hist Med 1947, 21:
146-172.
4187. Piérard, L. La vie tragique de Vincer
van Gogh. Paris 1924; Brussels 1939;
Paris: Correa 1946.
4188. Prinzhorn, H. Genius and Madness.
Parnassus 1930.
4189. Riese, W. Persönlichkeitsentwicklur
und künstlerische Gestaltung. Gedanken
und Betrachtungen nach einer van Gogh
Ausstellung. Psychologie und Medizin
(Stuttgart) 1928-29, 3:64-69.
4190. ——. Über den Stilwandel bei Van
Gogh. ZNP 1925, 98:1-16.
4191. ——. Vincent Van Gogh in der Krank
heit; ein Beitrag zum Problem der Bezie-
hung zwischen Kunstwerk und Krankheit.
Munich: Bergmann 1926, 38 p.
4192. Rose, M., and J. Mannheim. Vincent
van Gogh im Spiegel seiner Handschrift.
Basel 1938.
4193. Schapiro, M. On a painting of van
Gogh. Perspectives 1952, 1:141-153.

VINCENT VAN GOGH (cont.)

4194. ———. Vincent Van Gogh. In Library of Great Painters. NY 1950.

4195. Schneider, D.E. The psychic victory of talent. A psychoanalytic evaluation of van Gogh. College Art J 1949, 9:325-337; In The Psychoanalyst and the Artist. NY: Farrar, Straus 1950, Ch. 9; NY: New American Library 1963, Ch. 9.

4196. Schnier, J. The blazing sun. A psychoanalytic approach to Van Gogh. Amer Imago 1950, 7:143-162.

4197. Shikiba, R. (Vincent van Gogh. His Life and Psychosis.) Tokyo 1932.

4198. Steiner, U. Van Gogh—ein Epileptiker? Zugleich ein Beitrag zur schizophrenen Symptomatik bei organischen Dämmerzustanden. Psychiatrie, Neurologie und medizinische Psychologie (Leipzig) 1959, 11:170-179.

4199. Thurler, J. À propos de Vincent Van Gogh. Thèse Méd. Geneva 1925.

4200. Tralbaut, M. Vincent Van Gogh pendant sa période anversoise. Amsterdam: Strengholt 1948.

4201. Wahl, J. Le correspondance complete de Vincent Van Gogh. Rev de Metaphysique et de Morale 1963, 1:100-142.

4202. Westerman-Holstijn, A.J. The psychological development of Vincent Van Gogh. Amer Imago 1951, 8:239-273; J ment Sci 1957, 103:1-17; Imago 1924, 10:389-417; Ned Tijdschr Geneesk 1924, 1366.

DIEGO RODRIGUEZ DE SILVA Y VALASQUEZ (1599-1660)

4203. Gybal, A. Velasquez, le Chateaubriand de la peinture. Psyché-Paris 1947, 2:93-97.

4204. Jamot, P. Shakespeare et Velasquez. Gazette des Beaux-Arts 1934, 11:122-123.

DANIEL URRABIETA VIERGE (1851-1904)

4205. Bonvicini, G. Die Aphasie des Malers Vierge. Wiener medizinische Wochenschrift 1926, 76:88-91.

ADOLPH VON MENZEL (1915-1930)

4206. Kusenberg, K. Drei Zwerge und die Kunst. Neue Zeitung 1952, Dec. 10.

STEFAN ZEROMSKI (1864-1925)

4207. Baley, S. (The creative personality of Zeromski.) Warsaw: Nasza Ksiegarnia 1936, 228 p.

Each of the entries below contains psychological studies of several artists and therefore could not be included above. Wherever possible, the artist under discussion is included in brackets after the title.]

4208. Arréat, L. Psychologie du peintre. [Blake, Da Vinci, Delacroix, E., Géricault.] Paris: Alcan 1892.

4209. Audry, J. La folie dans l'art. [Blake, Boch, Breughel the Elder, Goya, El Greco, Guirand, Jongkind, Méryon, Toulouse-Lautrec, Van Gogh.] Lyon Médical 1924, 134:631-634.

4210. Braun, A. Krankheit und Tod im Schicksal bedeutender Menschen. [Beardsley, Cellini, Dürer, Holbein, del Sarto, Stauffer-Bern, Thorwaldsen, Van Gogh, de Vega.] Stuttgart: Enke 1940.

4211. Cabanès, A. Les indiscrétions de l'histoire. Paris: Michel 1924, 6 Vols.

4212. Hyslop, T.B. The Borderland. [Blake, Turner.] London: Allan 1924, 310 p.

4213. ———. The Great Abnormals. London: Allan 1925, 289 p.

4214. Lange-Eichbaum, W. Genie, Irrsinn und Ruhm. Munich: Reinhardt 1928, 498 p; 1956, 4th ed., 628 p.

4215. ———. The Problem of Genius. NY: Macmillan 1932, 187 p.

4216. Mandolini, H. Patología del sentimiento estético. [Chagall, Gauguin, Georg, Rousseau, Soutine, Van Gogh.] Arch argentinos de Psicologia normal y patologica 1933-34, 1:61-64.

4217. Marone, S. Homosexuality and art. [Da Vinci, Michelangelo, Raphael.] Int J Sexology 1954, 7:175-190.

4218. Meerloo, J.A.M. Three artists: an essay on creative urge and artistic perturbation. [Da Vinci, Rembrandt, Van Gogh.] Amer Imago 1953, 10:247-263.

4219. Moll, A. Berühmte Homosexuelle. [Da Vinci, Michelangelo, Sodoma.] Wiesbaden: Bergmann 1910.

4220. Scheffel, K. Lebensbild des Talents. [Cezanne, Gauguin, Van Gogh.] Berlin: Nauck 1948.

4221. Schneider, D.E. The Psychoanalyst and the Artist. [Chagall, Da Vinci, Delacroix, E., Picasso, Van Gogh.] NY: Farrar, Straus 1950, 306 p; NY: New American Library 1963, 236 p.

4222. Slive, S. Realism and symbolism in seventeenth-century Dutch painting. [Bosschaert, Hals, Rembrandt, Van Hoogstraten, Van Musscher.] Daedalus 1962, 91:469-500.

4223. Springer, B. Die genialen Syphilitiker. [Cellini, El Greco, Gauguin, Makart, Manet, Rethel, Van Gogh.] Berlin: Nikolassee 1926.

4224. Stadelmann, H. Die Stellung der
Psychopathologie zur Kunst. Ein Versuch.
Mit acht Bildbeilagen (nach Werken von
Goya, Blake, Rops, Beardsley, Munch,
Behmer, Doms, Kubin.) Munich: Piper
1908, 51 p.
4225. Stokes, A. Art and Science; a Study
of Alberti, Piero della Francesca and
Giorgione. London: Faber & Faber 1949, 76
4226. Winkler, W. Psychologie der modern
Kunst. [Kandinsky, Kubin, Munch.] Tubin-
gen: Alma Mater 1949, 303 p.
4227. Winslow, F. Mad artists. [Barry,
Blake, Cellini, Haydon, Landscer, Mor-
land, Raphael, Turner.] J psychol Medicin
& mental Pathology 1880, 6:33-75.

11 Photography

4228. Anderson, P.L. The Fine Art of Photography. Philadelphia: Lippincott 1919, 314 p.

4229. Anon. Rehabilitation through photography. Hospitals 1959, 33:56-59.

4230. Bailey, H.T. Photography and Fine Art. Worcester, Mass.: Dans 1922.

4231. Bateson, G., and M. Mead. Balinese Character, A Photographic Analysis. NY: New York Academy of Sciences 1942, 277 p.

4232. Baudelaire, C. The modern public and photography. In The Mirror of Art. London: Phaidon 1955; Paris 1859.

4233. Berrer, F. Expressive potentialities of photography. Graphes 1963, 19:288-297.

4234. Besson, G. Pictorial photography—a series of interviews. Camera Work 1908, 24:13-23.

4235. Boni, A. (ed.). A Guide to the Literature of Photography and Related Subjects. NY: Morgan & Lester 1943, 94 p.

4236. ———. Photographic Literature: An International Bibliographic Guide to General and Specialized Literature on Photographic Processes; Techniques; Theory; Chemistry; Physics; Apparatus; Materials and Applications; Industry; History; Biography; Aesthetics. NY: Morgan & Morgan 1963, 335 p.

4237. Bourgeois, P. (ed.). Esthétique de la Photographie. Paris: Photo-Club de Paris 1900, 100 p.

4238. Brandt, H.F. The attention value of color evaluated by means of ocular photography. Proc Iowa Acad Sci 1943, 50: 295-298.

4239. ———. Ocular photography as a scientific approach to the study of art. Proc Iowa Acad Sci 1942, 49:395-404.

4240. Caffin, C.H. Photography as a Fine Art. NY: Doubleday, Page 1901, 191 p.

4241. Campbell, D.T., and L.S. Burwen. Trait judgments from photographs as a projective device. J clin Psychol 1956, 12:215-221.

4242. Capell, M.D. Transference in the Ratings of Photographs by Normals and Neurotics. Dissertation Abstr 1957, 17: 1809-1810.

4243. Clark, K. The relations of photography and painting. Aperture 1955, 3(1):4-14.

4244. Corpron, C.M. Light as a creative medium. Art Educ 1962, 15:4-7.

4245. Das, S.L. Selection of situations for a personality test based on movie pictures. J Psychol Res (Madras) 1963, 7:10-15.

4246. Draguns, J.G., and G. Multari. Recognition of perceptually ambiguous stimuli in grade school children. Child Develpm 1961, 32:541-550.

4247. Ensign, R.P. The art of photography. Yrb nat Soc Stud Educ 1941, 40:187-189.

4248. Evans, R.M. Eye, Film, and Camera in Color Photography. NY: Wiley 1959, 410 p.

4249. ———. Visual processes and color photography. J opt Soc Amer 1943, 33:579-614.

4250. Feininger, A. The Anatomy of Nature. NY: Crown 1956, 168 p.

4251. ———. The Creative Photographer. Englewood Cliffs, N.J.: Prentice-Hall 1955, 329 p.

4252. Fox, H.M. Body image of a photographer. J Amer psychoanal Ass 1957, 5: 93-107.

4253. Fox, M.S. Photography as a popular art. Yrb nat Soc Stud Educ 1941, 40:190-194.

4254. Freitag, R. The subconscious of the camera. Aperture 1957, 5(1):5-6; Photo Magazine 1955.

4255. Freund, G. La photographie en France au dix-neuvième siècle; essai de sociologie et d'esthétique. Paris: Monnier 1936.

4256. Gemelli, A. Les causes psychologique de l'interêt des projections cinématographiques. JPNP 1928, 25:596-606.

4257. Gernsheim, H. Creative Photography. Aesthetic Trends 1839-1960. Boston: Boston Book 1962, 258 p.

4258. Gregory, M. Ansel Adams: the philosophy of light. Aperture 1964, 11(2):49-51.

4259. Grimes, J.W., and E. Bordin. A note on the interchangeability of art originals and colored photographic reproductions.

J educ Psychol 1940, 31:376-382.

4260. Halsman, P. Psychological portraiture. In Morgan, W. (ed.), The Encyclopedia of Photography. NY: Greystone 1963, 1964.

4261. Hattersley, R. Notions on the criticisms of visual photography. Aperture 1962, 10(3):91-114.

4262. Haworth, M.R. Les récherches filmologiques et les situations de test projectif appliquées aux enfants. Rev Int de Filmologie 1956, 7:177-192.

4263. Jones, L.A. Psychophysics and photography. J opt Soc Amer 1944, 34:66-88.

4264. Katz, D. Durchshnittsbild und Typologie. In Studien zur Experimentellen Psychologie. Basel: Schwabe 1953, 11-37.

4265. ——. Le portrait composite et la typologie. Rev Int de Filmologie 1951, 2.

4266. Ketzner, E. Optische Gestaltauffassung bei stehenden Bild und Entwicklung im Film. Arch ges Psychol 1936, 95:63-98.

4267. Lange, K. Bewegungsphotographie und Kunst. Z Aesth 1920-21, 15:88-103.

4268. Lévy-Schoen, A. Une mimique percue comme critere de choix: son emergence dans l'évolution génétique de divers comportements de choix. Psychologie Française 1961, 6:32-46.

4269. Lewin, B.D. Balinese character, a photographic analysis. (Review.) In Eissler, R.S., et al. (eds.), The Psychoanalytic Study of the Child, Vol. 1. NY: IUP 1945, 379-387.

4270. Maslow, A.H., and N.L. Mintz. Effects of esthetic surroundings: I. Initial effects of three esthetic conditions upon perceiving "energy" and "well-being" in faces. J Psychol 1956, 41:247-254.

4271. Meer, B., and A.H. Amon. Photo preference test (PPT) as a measure of mental status for hospitalized psychiatric patients. J consult Psychol 1963, 27(4):283-293.

4272. Metsky, M. The Effects of Photographic Clarity on the Choice of Szondi Pictures. Dissertation Abstr 1953, 13:723-724.

4273. Moholy-Nagy, L. Malerei, Photographie, Film. Munich: Langen 1925.

4274. ——. Vision in Motion. Chicago: Theobald.

4275. Morgan, B. Esthetics of photography. In Morgan, W. (ed.), The Encyclopedia of Photography. NY: Greystone 1963, 1964, 1528-1549.

4276. Morgan, W. (ed.). The Encyclopedia of Photography. NY: Greystone 1963, 1964, 20 Vols, 4,000 p.

4277. Muybridge, E. Animals in Motion. NY: Dover 1963, 440 p.

4278. ——. The Human Figure in Motion. NY: Dover 1963, 390 p.

4279. Newhall, N. Ansel Adams: A Biography. 1. The Eloquent Light. San Francisco: Sierra Club 1963, 166 p.

4280. —— (ed.). The Daybooks of Edward Weston. NY: Wittenborn 1962, 214 p.

4281. Norman, D. Alfred Stieglitz—seer. Aperture 1956, 3(4):3-24.

4282. Omwake, K.T. The value of photogra and handwriting in estimating intelligenc Public Personnel Studies 1925, 3:2-15.

4283. Pattie, F.A., Jr. Photographs in complementary colors for the demonstration of negative after-images. Amer J Psychol 1928, 40:496-497.

4284. Ruesch, J., and W. Kees. Nonverbal Communication; Notes on the Visual Perception of Human Relations. Berkeley: Univ California Pr 1956, 205 p.

4285. Sanders, H. (ed.). Photo Maxima 1959. NY: Triton 1958, 38 p.

4286. Scharf, A. Painting, photography, an the image of movement. Burlington Magazine 1962, 104:186-195.

4287. Siegel, A. Anonymous art and choice the photographer's world. Aperture 1964, 11(2):56-59.

4288. Soby, J.T. Four photographers. In Modern Art and the New Past. Norman: Univ Oklahoma Pr 1957, 158-177.

4289. Steichen, E. On photography. Daeda 1960, 89:136-137.

4290. Sulzberger, C.F. Unconscious motivations of the amateur photographer. Psychoanal Rev 1955, 3(3):18-24.

4291. Warren, D. Photography as an art. Aperture 1952, 1(3):25-30.

4292. Warstat, W. Allgemeine Ästhetik de photographischen Kunst auf psychologisc Grundlage. In Enzyklopädie der Photograp Vol. 65. Halle: Knapp 1909, 98 p.

4293. Wayne, I. American and Soviet them and values: a content analysis of picture in popular magazines. Public Opinion Qu 1956, 20:314-320.

4294. Webb, W.B., and C.E. Izard. Reliability of responses to pictures of peers. J proj Tech 1956, 20:344-346.

4295. White, M. Amateur photocriticism. Aperture 1964, 11(2):62-72.

4296. ——. Criticism. Aperture 1952, 2(2): 27-33.

4297. ——. Lyrical and accurate. A new definition of the characteristics of pure photography. Image 1956, 5:172-181.

4298. ——. Varieties of responses to phot graphs. Aperture 1962, 10(3):116-128.

4299. Winick, C. Art work versus photography: an experimental study. J appl Psychol 1959, 43:180-182.

12 Physically Handicapped and Art

4300. Ahern, P.L. Art in special education at Tucson. School Arts 1961, 60:9-12.

4301. Aldama-Truchuelo, J. (Goya's disease —deafness—in his painting.) Anales de la Casa de salud Valdecilla 1945, 8:95-105.

4302. Almansur Haddad, J. (Art and disease of the cripple—Francisco Antonio Lisboa.) Medicina-cirugia-pharmacia (Rio de Janeiro) 1945, 166-174.

4303. Anon. Around the art clubs: St. James's art society promotes the interest of the deaf. Artist 1953, 46:60-61.

4304. Avalon, J. (Pictures illustrating the parable of the blind.) Aesculape 1937, 27:136-143.

4305. Bartlett, J. Museums and the blind. Museum J 1955, 54:283-287.

4306. Beegs, T.M. Art by the handicapped. J Rehabilitation 1954, 20:20-21.

4307. Berkman, A. Art by the physically handicapped. Art News 1959, 58:65.

4308. Bettica-Giovannini, R., and A. Caldarella. (Ettore Costa, a blind man who painted.) Rassegna di Clinica. Terapia e Scienze Affini (Rome) 1961, 60:356-361.

4309. Brown, C. My Left Foot. NY: Simon & Schuster 1955, 178 p.

4310. Burde, A. Die Plastik der Blinden. Z angew Psychol 1911, 4:106-128.

4311. Caldwell, E.M. Some aspects of teaching brain-injured children. Physiotherapy 1963, 49:149-152.

4312. Centers, L., and R. Centers. A comparison of the body images of amputee and non-amputee children as revealed in figure drawings. J proj Tech 1963, 27:158-165.

4313. Claude, H., and P. Masquin. L'évolution du dessin chez un paralytique général avant et après malaria-thérapie. Ann méd-psychol 1934, 92:356-374.

4314. Clawson, A. Relationship of psychological tests to cerebral disorders in children: a pilot study. Psychol Reports 1962, 10:187-190.

4315. Cook, F. Art without sight. School Arts 1943, 43:40-45.

4316. Degos, R., R. Touraine, M. Haag, and L. Hauser. (Value of free pictorial expression in patients hospitalized for dermatoses. Preliminary note concerning 3 cases of pruritus and 3 of psoriasis.) Bull de la Societe Française de Dermatologie et de Syphilographie 1962, 69:870-873.

4317. Epstein, S. Art, history and the crutch. Ann med History (New York) 1937, 9:304-313.

4318. Feilchenfeld, W. The expression of blindness in nature and art. Trans Int Ophthalmology Congress (1937), 1940, 5:179-224.

4319. Fieandt, K.v. Form perception and modelling of patients without sight. Confin Psychiat 1959, 2:205-213.

4320. Fleurent, H. (Diseases and deformities in mediaeval paintings and statues. Colmar Museum.) Aesculape 1929, 19:1-32.

4321. Garelli, M., J. Meyer, and P. Rossi. Du réel a l'imaginaire. Enfance 1961, No. 4/5, 361-401.

4322. Ginestous, E. (The blind in various religions, art and literature.) J de médecine de Bordeaux et du Sud-Ouest 1938, 114:625; 138, 115:55.

4323. Gladke, E. Über Zeichnungen von Paralytiken. Doctoral dissertation. Univ Bern 1938, 119 p.

4324. Gough, H. Characteristics of Creative Drawings of Stutterers. Dissertation Abstr 1955, 51-80.

4325. Greef, R. (Representation of blind patients on old Peruvian clay vessels.) Klin Monatsbl Augenh 1932, 89:663.

4326. ——. (Reproduction of the blind in old Egyptian art.) Klin Monatsbl Augenh 1933, 90:82-85.

4327. Handley-Read, C. Children's painting and epilepsy. London Studio 1944, 27:152-157.

4328. Heider, F., and G. Heider. Color sorting behavior. In Studies in the Psychology of the Deaf. No. I. Psychol Monogr 1940, 52, No. 1.

120 PHYSICALLY HANDICAPPED AND ART

4329. Holden, R.H. Changes in body image of physically handicapped children due to summer camp experience. Merrill-Palmer Quart 1962, 8:19-26.

4330. ———. Changes in Body Imagery of Physically Handicapped Children Due to Summer Camp Experience. Dissertation Abstr 1961, 21(10):3165.

4331. Ichok, G. Crippled artists. Presse méd 1932, 40:1329-1330.

4332. Jakab, I. Representation consciente et unconsciente de soi-même dans les figures humaine dessinées. Confin Psychiat 1962, 5:112-129.

4333. Jenson, P.M. Art helps the deaf to speak. School Arts 1959, 58:9-10.

4334. Johnson, O.G., and F. Wawrzaszek. Psychologists' judgments of physically handicapped from H-T-P drawings. J consult Psychol 1961, 25:284-287.

4335. Katz, D. Über Zeichnungen von Blinden. In Studien zur experimentellen Psychologie. Basel: Schwabe 1953, 75-115.

4336. Kitinoja, P. Creative art and the deaf child. Amer Ann Deaf 1953, 98:312-317, 320-322.

4337. Lampard, M.T. The art work of deaf children. Amer Ann Deaf 1960, 105:419-423.

4338. Lindner, R. Moralpsychologische Auswertung freier Kinderzeichnungen von taubstummen Schülern. Z pädag Psychol 1914, 15:160-177.

4339. ———. Wiederholung eines Zeichenversuches Kerschensteiners in der Taubstummenschule. Z pädag Psychol 1912, 13:419-421.

4340. Lowenfeld, V. The blind make us see. Magazine of Art 1943, 36:208-211.

4341. ———. A commentary. In Research in Art Education. 9th Yearbook. Kutztown, Pa.: National Art Educ Ass 1959, 174-177.

4342. ———. The Nature of Creative Activity; Experimental and Comparative Studies of Visual and Non-Visual Sources of Drawing, Painting, and Sculpture by Means of Artistic Products of Weak Sighted and Blind Subjects and of the Art of Different Epochs and Cultures. NY: Harcourt, Brace 1939, 272 p; London: Routledge 1939, 272 p.

4343. ———. Psycho-aesthetic implications of the art of the blind. JAAC 1951, 10:1-9.

4344. McDermott, W.H. Art therapy for the severely handicapped. Amer J ment Deficiency 1954, 59:231-234.

4345. Matsubara, T. (On understanding of color-words of the blind.) J Psychol Blind 1957, 3:25-31.

4346. Matz, W. Zeichen- und Modellierversuch an Volkschülern, Taubstumme und Blinden. Z angew Psychol 1915, 10:62-135.

4347. Meier, N.C. Art ability without instruction or environmental background: case study of Loran Lockhart. In Studies in the Psychology of Art. Psychol Monogr 1936, 48, No. 1, 155-163.

4348. Mendenhall, G.S. The influence of the arts on the lives of handicapped children. J Expectional Child 1940, 7:11-19, 33-34.

4349. Münz, L., and V. Lowenfeld. Plastis Arbeiten Blinder. Berlin: Brünn 1934.

4350. Nagai, M. (Gestalt-perception of th blind through tactual movement.) J Psych Blind 1957, 3:10-19.

4351. Neilsen, H.H. Human figure drawing by normal and physically handicapped ch dren: Draw-a-Person test. Scandinavian J Psychol 1961, 2:129-138.

4352. Peterson, E.G., and J.M. Williams. Intelligence of deaf children as measured by drawings. Amer Ann Deaf 1930, 75:273-280.

4353. Pintner, R. Artistic appreciation amo deaf children. Amer Ann Deaf 1941, 86:21-224.

4354. Prater, G.F. A Comparison of the He and Body Size in the Drawing of the Huma Figure by Hemiplegic and Non-hemiplegic Persons. Master's thesis. Univ Kentucky 1950.

4355. Putney, W.W. Characteristics of Creative Drawings of Stutterers. Doctoral dissertation. Pennsylvania State Univ 19

4356. ———. Creative drawings of stutterer In Research in Art Education. 9th Yearboo Kutztown, Pa.: National Art Educ Ass 195 161-167.

4357. Révész, G. Die Formenwelt die Tast sinnes. II. Formästhetik und Plastik der Blinden. The Hague: Nijhoff 1938, 293 p.

4358. ———. Künstlerische Begabung bei Blinden, Tauben und Geistesgestörten. Proc Int orthoped, Congres II (Amsterdam) 1949, 134-144.

4359. ———. Psychology and Art of the Blin NY: Longmans, Green 1950, 338 p.

4360. Rich, F.M. School art for the blind. School Arts 1936, 35:520-524.

4361. Riklan, M., T.P. Zahn, and L. Diller. Human figure drawings before and after chemosurgery of the basal ganglia in parkinsonism. JNMD 1962, 135:500-506.

4362. Sachs, L.J. On changes in identification from machine to cripple. In Eissler R.S., et al. (eds.), The Psychoanalytic Stu of the Child, Vol. 12. NY: IUP 1957, 356-3

4363. Scheerer, T.D. Art and the cerebral palsied. School Arts 1962, 62:15-17.

4364. Schumann, H-J. Träume der Blinden vom Standpunkt der Phänomenologie, Tiefenpsychologie, Mythologie und Kunst. Basel: Karger 1959, 152 p.

4365. Shirley, M., and F.L. Goodenough. A survey of intelligence of deaf children in Minnesota schools. Amer Ann Deaf 1932, 77:238-247.

4366. Silverstein, A.B., and H.A. Robinson. The representation of orthopedic disability in children's figure drawings. J consult Psychol 1956, 20:331-341.

4367. Soret, K. Ästhetik bei Blinden. Blindenfreund 1897.

4368. Spoerl, D.T. A comparative study of the intelligence of a group of deaf and hearing children. J genet Psychol 1940, 57:259-277.

4369. Springer, N.N. A comparative study of the intelligence of a group of deaf and hearing children. Amer Ann Deaf 1938, 38:138-152.

4370. Taillefer, O., and J. François. (Drawing and language of the deaf child.) Rev de Laryngologie, Otologie, Rhinologie (Bordeaux) 1962, 83:729-772.

4371. Taylor, E.M. Psychological Appraisal of Children with Cerebral Defects. Cambridge: Harvard Unit Pr 1959, 499 p.

4372. Thiel, G. Eine Untersuchung von Kinderzeichnungen taubstummer Schüler. Z Kinderforsch 1927, 33:138-176.

4373. Villey, P. Des réprésentations synthétiques des aveugles. JPNP 1930, 27: 391-411.

4374. Wawrzaszek, F., O.G. Johnson, and J.L. Sciera. A comparison of H-T-P responses of handicapped and non-handicapped children. J clin Psychol 1958, 14:160-162.

4375. Wille, W.S. Figure drawings in amputees. Psychiat Quart Suppl 1954, 28: 192-198.

4376. Wolf, N. Über bildnerische Ausdrucksweisen Sprachgehemmter. Prax Kinderpsychol Kinderpsychiat 1957, 6:89-95, 120-126.

4377. Woods, W.A. The role of language handicap in the development of artistic interest. J consult Psychol 1948, 12:240-245.

13 Primitive and Pre-Historic Art

4378. Adam, L. Primitive Art. London: Pelican 1949, 271 p.

4379. Anon. Contrast in drawings made by an Australian aborigine before and after initiation. Records South Australian Museum (Adelaide) 1938, 6.

4380. Anon. Mundlose Figuren aus der jüngeren Steinzeit. Umschau 1928, 32:69.

4381. Anthony, R. À propos de la figure masculine aurignacienne décrite et interprétée par H. Breuil. Bull et mémoires de la Soc d'Anthropol (Paris) 1927, 7:37-41.

4382. Archey, G. Evolution of certain Maori carving patterns. J Polynesian Soc 1933, 42:171-190; 1936, 45:49-62.

4383. Arriens, C. (Art in the Atlas mountains.) Der Erdball (Berlin) 1930, 4:16-22.

4384. Baldwin, J.M. The springs of art. Philos Rev 1909, 18:281.

4385. Bandi, H.G., et al. The Art of the Stone Age; Forty Thousand Years of Rock Art. NY: Crown 1961, 249 p.

4386. Barry, H., III. Relationships between child training and the pictorial arts. J abnorm soc Psychol 1957, 54:380-383.

4387. Bataille, G. L'art primitif. Documents 1930, 7:389-397.

4388. Bayer, R. Art primitif et art classique. In Mélanges Georges Jamati. Paris: Centre National de la Récherche Scientifique 1956.

4389. Bégouen, H. L'art préhistorique est d'origine magique. Publicaçoes de Sala Francêsa de Faculdade de Letras da Universidade de Coimbra 1927.

4390. ———. Les bases magique de l'art préhistorique. Scientia (Milan) 1939, 62:202-216.

4391. ———. The magic origin of a prehistoric art. Antiquity 1929, 3:5-19.

4392. ———. La magie aux temps préhistorique. Memoires de l'Académie des Sciences et Belle-Lettres de Toulouse 1924, 2:417-432.

4393. ———. À propos des Vénus paléolithiques. Lettre ouverte à M.G.H. Luquet. JPNP 1934, 31:792-797.

4394. Bégouen, H., and L. Bégouen. (Representations of animals found in the cave of Three Brothers at Montesquieu-Avantes Ariège.) Rev de Anthropologie (Paris) 1928, 38:359-364.

4395. Beier, U. The attitude of the educated African to his traditional art. Phylo 1957, 18:162-165.

4396. Bird, J.B., et al. Technique and Personality in Primitive Art. NY: University Publ 1962.

4397. Bleek, D.F. Rock Paintings in South Africa. London: Methuen 1930, 28 p.

4398. Boas, F. Decorative art of the Indian of the North Pacific. Amer Museum of Natural History, Bulletin 9, 1897, 123-17

4399. ———. The decorative art of the North American Indians. Pop Sci Mon 1903, Oct

4400. ———. Primitive Art. Cambridge: Harvard Univ Pr 1928, 378 p; Irvington-on-Hudson: Capitol 1951, 376 p; NY: Dover 1955, 376 p; NY: Smith 1962, 372 p.

4401. Bodrogi, T. Art in North-East New Guinea. London: Heinman 1962.

4402. Bouman, K.H. Das biogenetische Grundgesetz und die Psychologie der primitiven bildenen Kunst. Z angew Psych 1919, 14:129-145.

4403. Breuil, H. Four Hundred Centuries of Cave Art. Mointignac, Dordogne: Centre d'Études et de Documentation Préhistoriqu 1952, 413 p.

4404. ———. Observations sur les masques paléolithiques. Rev archéologique 1914, 2:300-301.

4405. ———. Oeuvres d'art paléolithiques inédites du Périgord et art oriental d'Espagne. Rev de Anthropologie (Paris) 1927, 37:101-108.

4406. ———. Les origines de l'art. JPNP 1925, 22:289-296.

4407. ———. Les origines de l'art décoratif. JPNP 1926, 23:364-375.

4408. ———. À propos des masques quaternaires. L'Anthropologie 1914, 25:420-422.

4409. ———. Les roches peintes de Zarza-

junto-Alange (Badajoz). IPEK 1929, 5:14-30.

4410. Brinton, D.G. Left-handedness in North American aboriginal art. Publ Amer Statis Ass 1895, 4:175-181; Amer Anthropologist 1896, 2:175-181.

4411. Brodsky, I. Congenital abnormalities, teratology and embryology; some evidence of primitive man's knowledge as expressed in the art and lore of Oceania. Med J Australia 1943, 1:417-420, 454.

4412. Brown, G.B. The art of the Cave Dweller. A Study of the Earliest Artistic Activities of Man. London: Coleman 1928, 280 p.

4413. ———. The origin and early history of the arts in relation to aesthetic theory in general. Burlington Magazine 1922, 41: 91-95, 134-137.

4414. Bunzel, R.L. The Pueblo Potter. A Study of Creative Imagination in Primitive Art. NY: Columbia Univ Pr 1929, 134 p.

4415. Burkitt, M.C. Bushman art in South Africa. IPEK 1929, 5:89-95.

4416. ———. South Africa's Past in Stone and Paint. Cambridge: Cambridge Univ Pr 1928.

4417. Busse, K.H. Die Ausstellung zur vergleichenden Entwicklungsgeschichte der primitiven Kunst bei den Naturvölkern, den Kindern und in der Urzeit. Kongres Ästh u allg Kunstwissenschaft 1914, 79.

4418. Caldwell, M.G., and H. Sheldon. The culture of the Baya tribe of West Africa. Sci Monthly 1930, 30:320-325.

4419. Capart, J. Les débuts de l'art en Egypt. Brussels: Vromart 1904.

4420. Capitan, L. Les manifestations et magiques sur les parois de la grotte de Montespan. Rev de Anthropologie 1923, 33:545-550.

4421. Carcamo, C.E. Quetzalcoatl; le dieu-serpent à plumes de la religion Maya-Aztéque. Rev franç Psychanal 1948, 12: 101-124.

4422. Carter, D. Symbol of the Beast; the Animal Style Art of Eurasia. NY: Ronald 1957, 204 p.

4423. Casteret, N. (Remarkable products of prehistoric art.) Umschau 1928, 32: 265-267.

4424. Chipp, H.B. Formal and symbolic factors in the art styles of primitive cultures. JAAC 1960, 19:153-166.

4425. Christensen, E.O. Primitive Art. NY: Viking 1955, 384 p; NY: Crown 1961.

4426. Clouzot, H., and A. Level. L'art fétichiste africain. Rev de l'Art Ancien et Moderne 1931, 60:3-14.

4427. Cook, A.B. Les galets peints du Mas d'Azil. L'Anthropologie 1903, 14.

4428. Cordwell, J.M. Some Aesthetic Aspects of Yoruba and Benin Cultures. Doctoral dissertation. Northwestern Univ 1952.

4429. Danzel, T.W. Psychologie altmexikanischer Kunst. IPEK 1925, 124-135.

4430. Darlington, H.S. The primitive manufacture of clay pots; an exposition of the psychology of pot-making. Psychoanal Rev 1937, 24:392-402.

4431. Davey, W.R.P. Semitic Phallicism. Doctoral dissertation. Columbia Univ 1908.

4432. Degallier, A. Note psychologique sur les Négres Pahouins. Arch Psychol 1905, 4:362-368.

4433. Dennert, E. Das geistige Erwacher das Urmenschen. Eine vergleichend-experimentelle Untersuchung über die Entstehung von Technik und Kunst. Weimar 1929, 487 p.

4434. Déonna, W. L'esprit classique et l'esprit primitif dans l'art antique. JPNP 1937, 34:49-112.

4435. ———. Essai sur le genèse des monstres dans l'art. Rev des Études Grecque 1915, 28:322.

4436. ———. À propos d'un bas-relief de Laussel. Rev archéologique 1913, 2:112-114.

4437. ———. Questions de méthode archéologique. Art et réalité. Rev archéologique 1914, 2:231-265.

4438. DePina, L. Fingerprints in primitive art. Estudos morfologia 1947, 236-240.

4439. Dieseldorff, E.P. Kunst und Religion der Mayavölker. Hamburg: Friederichsen 1933, 48 p.

4440. Disselhoff, H.D., and S. Linné. The Art of Ancient America; Civilization of Central and South America. NY: Crown 1961, 274 p.

4441. Douglas, F.H., and R. d'Harnoncourt. Indian Art of the United States. NY: Museum Modern Art 1954, 224 p.

4442. D'Ucel, J. Berber Art. Norman: Univ Oklahoma Pr 1932, 227 p.

4443. Durand, P., L. Lavauden, and H. Breuil. (A painting in a Saharan grotto.) L'Anthropologie 1926, 36:409-427.

4444. Echanove, T., and A. Carlos. El sentido mistico de las artes plásticos Mayas. Rev Int de Sociologie (Paris) 1956, 14:43-54.

4445. Escomel, E. (Primitive science and art in Peru.) Anales de la Facultad de médicina de Lima 1920, 3:187.

4446. Fagg, W. The art of Ife. Magazine of Art 1950, 43:129-133; Image (London) 1949.

4447. ———. L'art nigèrien avant Jésus-

Christ. In L'art nègre. Paris 1951.

4448. ——. De l'art des Yoruba. In L'art
nègre. Paris 1951.

4449. ——. On the nature of African art.
Memoirs & Proc Manchester Lit & Philos
Soc 1953.

4450. ——. The study of African art. Allen
Memorial Art Museum Bull (Oberlin, Ohio)
1955-56, 13(2).

4451. ——. The Webster Plass Collection
of African Art. London 1953.

4452. Fernández, J. Coatlicue: Estética
del Arte Indígena Antiguo. Mexico, D.F.:
Centro de Estudios Filosoficos 1954,
285 p.

4453. Firth, R.W. Art and Life in New
Guinea. London & NY: Studio 1936, 136 p.

4454. Fontana, B.L., et al. Papago Indian
Pottery. Seattle: Univ Washington Pr 1963,
163 p.

4455. Fraser, D.F. The discovery of primi-
tive art. In Arts Yearbook 1957, 119-133.

4456. ——. Primitive Art. Garden City, NY:
Doubleday 1962, 320 p; London: Thames
& Hudson 1962, 320 p.

4457. Freud, S. Totem and Taboo. Resem-
blances between the Psychic Lives of
Savages and Neurotics. NY: New Republic
1927, 281 p; Paris: Payot 1932, 221 p;
London: Routledge 1960, 172 p.

4458. Funke, M.R. Die psychologischen
Grundelmente in der Kunst. Monatshefte
für Kunstwissenschaft 1915, 8:84-96.

4459. Gaillard, C., J. Pissot, and C. Cote.
(A preshistoric cave of La Genière.) Rev
de Anthropologie 1927, 37:1-47.

4460. Ganay, S. de. Aspects de mythologie
et de symbolique bambara. JPNP 1949, 42:
181-201.

4461. Garfield, V. (ed.). The Tsimshian:
Their Arts and Music. NY: Augustin 1951,
290 p.

4462. Gennep, A.v. Dessins d'enfant et
dessin préhistorique. Arch Psychol 1911,
10:327.

4463. Germann, P., and E. Franke. Zeich-
nungen von Kindern und Jugendlichen aus
dem Wildlande von Nord-Liberia. Eth-
nologische Studien 1929, 75-96.

4464. Giedion, S. The Beginnings of Art.
Vol. I of The Eternal Present. NY: Bollingen
1962.

4465. ——. The roots of symbolic expres-
sion. Daedalus 1960, 89:24-33.

4466. Goff, B.L. Symbols of Prehistoric
Mesopotamia. New Haven: Yale Univ Pr
1963, 276 p.

4467. Goldschmidt, W., and R.B. Edgerton.
A picture technique for the study of
values. Amer Anthropologist 1961, 63:26-47.

4468. Goldsmith, E.E. Ancient Pagan Sym-
bols. NY: Putnam 1929, 220 p.

4469. ——. Life Symbols; a Brief Study
into the Origin and Significance of Certai
Symbols which Have Been Found in All
Civilisations, Such As the Cross, the
Circle, the Serpent, the Triangle, the Tree
of Life, the Swastika, and Other Solar Em
blems, Showing the Unity and Simplicity
of Thought Underlying Their Use As Reli-
gious Symbols. NY: Putnam 1928, 411 p.

4470. ——. Sacred Symbols in Art. NY:
Putnam 1928, 296 p.

4471. Gordon, G. The Serpent Motive in
the Ancient Art of Central America and
Mexico. Doctoral dissertation. Columbia
Univ 1903; Transactions Dept Archeology
Univ Museum of Pennsylvania 1905, 1(3):
131-163.

4472. Grosse, E. The Beginnings of Art. NY
Appleton 1915, 1928.

4473. Haddon, K. Artists in String. NY: Dut
ton 1930, 174 p.

4474. Hänel, H. Zur Psychologie der primi-
tiven Kunst. Gesellschaft für Natur und
Heilkunde, Dresden 1912.

4475. Harley, G.W. Masks as agents of
social control. Papers of the Peabody
Museum. Cambridge, Mass., 1950.

4476. Harrison, J.E. Ancient Art and Ritual.
London 1913.

4477. Heilbronner, P. Some remarks on the
treatment of sexes in paleolithic art. Int
J Psycho-Anal 1938, 19:439-447.

4478. Heizer, R.F., and M.A. Baumhoff. Pre
historic Rock Art of Nevada and Eastern
California. Berkeley: Univ California Pr
1962, 412 p.

4479. Herskovits, M.J. Afro-American art.
In Wilder, E. (ed.), Studies in Latin Ameri
can Art. Proceedings of Conference on
Latin American Art, May 28-31, 1945.
Washington, D.C.: Amer Council of Learne
Societies 1949, 58-64.

4480. ——. Afro-American art. In Encyclo-
pedia of World Art, Vol. I. NY: McGraw-
Hill 1959, 150-158.

4481. ——. The art of the Congo. Oppor-
tunity 1927, 5(5):135-136.

4482. ——. Backgrounds of African Art.
Cooke-Daniels Lectures, Jan-Feb 1945.
Denver: Denver Art Museum 1946.

4483. ——. Dahomey, an Ancient West
African Kingdom. NY: Augustin 1938, 2
Vols., 402 p, 405 p.

4484. ——. The nature of primitive art. The
Arts 1928, 14(1):47-50.

4485. ——. Negro art: African and America
Social Forces 1926, 5:291-298.

4486. ——. Symbolism in Dahomean art.

Man 1941, 41:117.

4487. Herskovits, M.J., and F.S. Herskovits. Bush-Negro art. The Arts 1930, 17(1):25-27, 48-49.

4488. Herskovits, M.J., R. Redfield, and G.F. Eckholm. Aspects of Primitive Art. NY: Museum of Primitive Art 1959.

4489. Herve, G. Des pierres-figures au point de vue ethnographique. Rev de d'École d'Anthropol 1909, 19:77.

4490. Hirn, Y. The Origin of Art, a Psychological and Sociological Inquiry. NY: Macmillan 1900, 341 p.

4491. Hoebel, E.A. Art. In Man in the Primitive World. NY: McGraw-Hill 1958, Ch. 15.

4492. Hoffmann, (?). The Graphic Art of the Eskimos. Report of the U.S. National Museum 1895.

4493. Hornblower, G.D. The origin of pictorial art. Man 1951, 51:2-3.

4494. Inverarity, R.B. Art of the Northwest Coast Indians. Berkeley: Univ California Pr 1950, 243 p.

4495. Jones, E. A psychoanalytic note on paleolithic art. Int J Psycho-Anal 1938, 19:448-450; In Essays in Applied Psycho-Analysis 1951, 2:174-177.

4496. Jung, E. Götter, Heilige und Unholde. Archäologische Beiträge zur deutschen Glaubens- und Rechtsgeschichte. Mannus-Z für Vorgeschichte 1928, 20:118-161.

4497. Kainz, F. Gestaltgesetzlichkeit und Ornamententstehung. Z angew Psychol 1927, 28:267-327.

4498. Kelemen, P. Baroque and Rococo in Latin America. NY: Macmillan 1951, 302 p.

4499. ———. Medieval American Art. NY: Macmillan 1943, 2 Vols.

4500. Kempf, E.J. The probable origin of man's belief in sympathetic magic and taboo. Med J & Record 1931, 133(1).

4501. Kimura, S. (About the view of art in primitive art.) Bigaku (Tokyo) 1956, 7(1): 38-44.

4502. Klaatsch, H. Die anfange von Kunst und Religion in der Urmenschheit. Leipzig: Unesma 1913.

4503. Knight, R.P. An Inquiry into the Worship of Priapus. London 1865.

4504. Kooijman, S. The Art of Lake Sentani. NY: Museum of Primitive Art 1959, 64 p.

4505. Kroeber, A.L. Decorative symbolism of the Arapaho. Amer Anthropologist 1901, 3.

4506. ———. Primitive art. In Encyclopaedia of the Social Sciences. Vol. 2. NY: Macmillan 1935, p. 226 ff.

4507. Krutch, J.W. Infatuation with the primitive. Saturday Rev 1962, 45:14-16.

4508. Kühn, H. Alter und Bedeutung der nordafrikanischen Felzeichnung. IPEK 1927, 3:13.

4509. ———. Die Bedeutung der prähistorischen und ethnographischen Kunst für die Kunstgeschichte. IPEK 1925, 1:3.

4510. ———. (East Spanish North African and Franco-Cantabrian schools of paleolithic art.) Z für Ethnologie (Berlin) 1926, 58:349-367.

4511. ———. Iberische Steinskulpturen. IPEK 1929, 5:74-78.

4512. ———. Die Kunst der Primitiven. Munich 1923, 246 p.

4513. ———. Die Malereien der Valltorta-schlucht. IPEK 1926, 2:33.

4514. ———. Symbol in prähistorischer Bedeutung. Z Aesth 1927, 233-239.

4515. Kunike, H. Maori art. Der Erdball (Berlin) 1928, 2:271-274.

4516. Lethbridge, T.C. Gogmagog: The Buried Gods. London: Routledge 1957, 181 p.

4517. Leuzinger, E. Africa; the Art of the Negro Peoples. NY: Crown 1960, 247 p; London: Methuen 1960, 272 p.

4518. Linton, R. Primitive art. Kenyon Rev 1941, 3:34-51; In Elisofon, E., and W. Fagg, The Sculpture of Africa. NY: Praeger 1958, 9-16.

4519. ———. Primitive art. Amer Magazine of Art 1933, Jan., 17-24.

4520. Linton, R., and P.S. Wingert. Arts of the South Seas. NY: Doubleday 1958, 200 p.

4521. Lips, J.E. The Savage Hits Back. New Haven: Yale University Pr 1937, 254 p.

4522. Lombroso, C. Genie und Irrsinn. Leipzig: Reclam 1887, 434 p.

4523. ———. Grafologia. Milan: Hoepli 1895, 245 p.

4524. Lothrop, S.K., et al. Essays in Pre-Columbian Art and Archaeology. Cambridge: Harvard Univ Pr 1961, 507 p.

4525. Lowie, R.H. Crow Indian art. Anthropological Papers, American Museum of Natural History 1922, 21, Part 4.

4526. Luquet, G.H. L'art néo-calédonien. Paris: Institut d'Ethnologie 1926.

4527. ———. L'art primitif. Paris: Doin 1930, 267 p.

4528. ———. The Art and Religion of Fossil Man. New Haven: Yale University Pr 1930, 213 p; London: Oxford University Pr 1930; Paris: Masson 1926.

4529. ———. Les débuts de l'art. Rev du Mois 1920, 326.

4530. ———. Décor de ceintures boliviennes. IPEK 1930, 6:93-108.

4531. ———. Deux problèmes psychologique de l'art primitif. JPNP 1933, 30:514-542.

4532. ———. Le magie dans l'art paléolithique. JPNP 1931, 28:390-421.

4533. ———. Le motif du cavalier dans l'art primitif. JPNP 1925, 22:446-456.

4534. ———. La narration graphique dans l'art primitif. JPNP 1926, 23:376-403.

4535. ———. Le problème des origines de l'art et l'art paléolithique. Rev philosophique de la France et de l'étranger 1913, 75:471-485.

4536. ———. Le réalisme dans l'art paléolithique. L'Anthropologie 1923, 33:17-48.

4537. ———. Le réalisme intellectuel dans l'art primitif. I. Figuration de l'invisible. JPNP 1927, 24:765-797.

4538. ———. Le réalisme intellectuel dans l'art primitif. II. Le rendu de visible. JPNP 1927, 24:888-927.

4539. ———. Sur les caractères des figures humaines dans l'art paléolithique. L'Anthropologie 1910, 21:409-423.

4540. ———. Les Vénus paléolithiques. JPNP 1934, 31:429-460.

4541. Maass, A. Die primitive Kunst der Mentawai-Insulaner. Z für Ethnologie (Berlin) 1906, 38:433.

4542. McCarthy, F.D. Australian Aboriginal Decorative Art. Sydney: Australian Museum 1938, 1948.

4543. McElroy, W.A. Aesthetic ranking tests with Arnhem Land aborigines. Bull Brit psychol Soc 1955, 26:44.

4544. Maringer, J., and H.G. Bandi. Art in the Ice Age. London: Allen & Unwin 1953, 167 p.

4545. Marro, G. Arte primitiva e arte paranoica. Giornale R. Accadamia di Medicina di Torino 1915, 78:268-269.

4546. ———. La nuova scoperta di incisioni preistorische in Val Camonica. Atti della Reale Accademia Scienzia di Torino 1931, 66:3-43.

4547. Masson, L. (Human representation in paleolithic art.) Aesculape 1927, 17: 25-29.

4548. Matyas, C.J. Magic, esthetics and primitive art; art of the Asmat. Science Digest 1962, 52:48-54.

4549. Mead, M. Work, leisure and creativity. Daedalus 1960, 89:13-23.

4550. Mendes Correa, A.A. (New documents on prehistoric art in Portugal.) Rev de Anthropologie (Paris) 1928, 38:169-176.

4551. Metais, E. Quelques symboles de l'art primitif. Étude d'une hache ostensoir néo-Calédonienne. Cahiers Internationaux de Sociologie 1952, 13:78-93.

4552. Mills, G. Navaho Art and Culture: a Study of the Relations among Cultural Premises, Art Styles and Art Values. Doctoral dissertation. Harvard University 1953; Colorado Springs: Taylor Museum 1959, 273 p.

4553. Miranda, M. El sentimiento religios en el arte prehistorico. La Plata 1930, 36

4554. Morlet, A. (Mouthless figures in pre historic ikons.) Aesculape 1927, 17:7-10.

4555. Morley, S.G. The Ancient Maya. Palo Alto, Calif.: Stanford Univ Pr 1956, 494 p.

4556. Mountford, C.P. (ed.). Art, Myth and Symbolism. American-Australian Scientific Expedition to Arnhem Land. I. Melbourne: Melbourne Univ Pr 1956, 513 p; Cambridg Cambridge Univ Pr 1957.

4557. Muensterberger, W. Roots of primitive art. In Wilbur, G.B., and W. Muenste berger (eds.), Psychoanalysis and Culture NY: IUP 1951, 371-389.

4558. Munro, T. Art and medicine in ancie and primitive cultures. Bull Med Library Ass 1944, 32:304-317.

4559. Murphy, J. Gesture, magic and primi tive art. Man 1940, 40:119-121.

4560. Nadel, S.F. Experiments on culture psychology. In Africa. London 1937, Vol. 1

4561. Nettleship, A. Plastic representation of disease made by early man. Bull Hist Med 1954, 28:259-269.

4562. Nierhaus, R. Das Problem psychologischer Deutung vorgeschichtlicher Kun Kunst Prähist Z 1937, 26:1-23.

4563. Obermaier, H., and H. Kühn. Bushma Art; Rock Paintings of South-West Africa, Based on the Photographic Material Collected by Reinhart Maack. NY 1930, 69 p; Berlin: Brandus 1930, 63 p.

4564. Oliva, J.L. The cult of maternity in primitive peoples; introduction of Marian iconography of maternity. Rev española de obstetricia y ginecologia (Valencia) 1946, 4:46-50.

4565. Onimaru, Y. (The artistic character of paleolithic art—concerning Worringer's thesis.) Bigaku (Tokyo) 1963, 14(1).

4566. Paalen, W. Totem art. Dyn (n.d.) 4/ 5:7-30.

4567. Pardal, R. (Pathology in ancient Peru vian ceramics.) Prensa Médica Argentina 1935, 22:2495-2502.

4568. Peyrony, D. (A mural painting in the cavern at Rocamadour.) L'Anthropologie 1926, 36:401-407.

4569. Piotrowska, I., and M. Sobeski. The primitive. JAAC 1941, 1:12-21.

4570. Ponceton, F., and A. Portier. Les arts sauvages. Paris 1930, 2 Vols.

4571. Raphael, M. Prehistoric Pottery and Civilization in Egypt. NY: Pantheon 1947, 160 p.

4572. Rattray, R.S., G.T. Bennett, V. Blake, H.D. Buxton, R.R. Marett, and C.G. Seligman. Religion and Art in Ashanti. Oxford: Clarendon 1927, 414 p.

4573. Raymond, P. La question des pierres-figures. Rev préhistorique 1909, 4:33.

4574. Read, H. Art and the evolution of consciousness. JAAC 1954, 13:143-155.

4575. ———. Australia: Aboriginal Painting, Arnhem Land. Paris 1954.

4576. ———. The origins of form in art. Eranos Jahrbuch 1960, 29:183-206.

4577. Redfield, R., M.J. Herskovitz, and G.F. Ekholm. Aspects of Primitive Art. NY: Museum of Primitive Arts 1959, 100 p.

4578. Reik, T. Eine bildiche Darstellung des Inzestkomplexes bei den Wilden. Int Z Psychoanal 1915, 3:181.

4579. Reinach, S. L'art et la magie, à propos des peintures et des gravures de l'âge du Renne. L'Anthropologie 1903, 4:257-266.

4580. Rodriguez Lafora, G. Estudio psicologico del cubism y expressionismo. Arch de neurobiologia, psicologia, etc. (Madrid) 1922, 3:119-155.

4581. Róheim, G. The concentric circle and fertility rites. In The Eternal Ones of the Dream. NY: IUP 1945.

4582. ———. Stone-shrines and tomb. Ethnological remarks on totemism and cultured stages in Australia. Author's abstract, with discussion by S. Ferenczi, et al. Int J Psycho-Anal 1922, 3:121-127; Int Z Psychoanal 1921, 7:522-525.

4583. Rose, F. Paintings of the Groote Eylandt aborigines. Oceania (Sydney) 1943, 8.

4584. Rosen, F. Über den Naturalismus der paläolithischen Tierbilden. Z angew Psychol 1911, 4:556-562.

4585. Rouma, G. Dessins d'indiens quitchouas et aymaras. Le graphisme et l'expression graphique. Sem univ Pédag Univ de Bruxelles 1935, 1:133-147.

4586. Rout, E.A. Maori Symbolism. NY-London 1926.

4587. Rowe, J.H. Chavin Art: An Inquiry into Its Forms. NY: Museum of Primitive Art 1962, 23 p.

4588. Rowe, W.P. The origin of prehistoric art. Man 1930, 30:6-9.

4589. Salaman, R.N. Deformities and mutilations of the face as depicted in Chimu pottery of Peru. Royal Anthropological Institute Great Britain & Ireland J 1939, 69:109-122.

4590. Schlosser, K. Der Signalismus in der Kunst der Naturvölker biologisch-psychologisch Gesetzlichkeiten in den Abweichungen von der Norm des Vorbildes. Kiel: Mühlau 1952, 52 p.

4591. Schmidt, E. Time Relations of Pre-Historic Pottery Types in Southern Arizona. Doctoral dissertation. Columbia Univ 1929.

4592. Schroeter, K.J.A. Anfänge der Kunst im Tierreich und bei Zwergvölkern. Leipzig 1914, 275 p.

4593. Schuwer, C. Sur la signification de l'art primitif. JPNP 1931, 28:120-162.

4594. Segy, L. African phallic symbolism. Rev de Psychologie des Peuples 1954, Dec.

4595. ———. African snake symbolism. Arch für Völkerkunde 1954, 9.

4596. ———. Divers aspects de l'étude de l'art africain. Rev de Psychologie des Peuples 1954, 9:176-194.

4597. Seton, J.M. American Indian Arts, a Way of Life. NY: Ronald 1962.

4598. Skinner, H.D. The origin and relationship of Maori material culture and decorative art. J Polynesian Soc 1924, 33:229-243.

4599. Smith, M.W. (ed.). The Artist in Tribal Society. NY: Free Pr 1962, 150; London: Routledge 1961, 150 p.

4600. Spearing, H.G. The Childhood of Art. London: Benn 1930, 2 Vols; NY: Putnam 1913.

4601. Stevens, G.A. Educational significance of indigenous African art. In Sadler, M. (ed.), Arts and Crafts of West Africa. London: Oxford Univ Pr 1935.

4602. Stolpe, H. (Collected Essays in Ornamental Art.) Stockholm: Aftonbladets 1927, 128 p.

4603. Sydow, E. von. Ancient and modern art in Benin City. Africa 1938, 11.

4604. ———. Handbuch der afrikanischen Plastik. Berlin 1930, Vol. I.

4605. ———. Die Kunst der Naturvölker. Afrika, Ozeanien, Indonesien. Berlin: Cassirer 1932, 215 p.

4606. ———. Die Kunst der Naturvölker und der Vorzeit. Berlin 1923, 568 p.

4607. ———. Kunst und Religion der Naturvölker. Oldenburg 1926.

4608. ———. Primitive Kunst und Psychoanalyse; eine Studie über die sexuelle Grundlage der bildenden Künste der Naturvölker. Vienna: Internationaler Psychoanalytischer Verlag 1927, 182 p.

4609. ———. Primitive Kunst und Sexualität. Almanach 1928, 104-116.

4610. ———. Die Wiedererweckung der primitiven Kunst. Almanach 1927, 183-189.

4611. Teupser, W. Kind, Kunst und Künstler. Kinderkunst, Sonderheft V, Schauen u Schaffen 1930, 56, Heft 4.

4612. Thomson, D.F. Two painted skulls from Arnhem Land, with notes on the totemic significance of the designs. Man 1939, No. 1.

4613. Trevor-Jones, R. Prehistoric man and his arts. Central Africa J Med 1961, 7:57-62.

4614. Underwood, L. Masks of West Africa. London: Tiranti 1948, 49 p; Hollywood, Fla.: Transatlantic 1948, 49 p.

4615. Vätter, E. Religiöse Plastik der Naturvölker. Frankfurt 1926.

4616. Vaillant, G.C. Indian Arts in North America. NY: Harper 1939, 63 p.

4617. Van Scheltema, F.A. Altnordische Kunstgewerbe und altnordische Kulturforschung. IPEK 1929. 5:6-12.

4618. Verworn, M. Die Anfänge der Kunst. Jena 1920.

4619. ———. Archäolithische und paläolithische Reisestudien in Frankreich und Portugal. Z für Ethnologie (Berlin) 1906, 38:611.

4620. ———. Zur Psychologie der primitiven Kunst. Naturwissenschaftliche Wochenschrift 1907, 22:721-728.

4621. ———. Zur Psychologie der primitiven Kunst. Ed. 2. Jena: Fischer 1917, 48 p.

4622. ———. Das Zeichnen der Naturvölker. Z angew Psychol 1912, 6:299.

4623. Wallace, A.F.C. A possible technique for recognizing psychological characteristics of the ancient Maya from an analysis of their art. Amer Imago 1950, 7:239-253.

4624. Waterman, T.T. Some conundrums in northwest coast art. Amer Anthropologist 1923, 25:435-451.

4625. Wehrli, G.A. Krankheitsdarstellungen in den Winterzeichnungen der Dakota Indianer mit einiger Parallelen aus europäischen Kinderzeichnunge. Zurich: Jahrbuch Geograph-Ethnographischen G'schaft 1917-18.

4626. Weltfish, G. Origins of Art. Indianapolis: Bobbs-Merril 1953, 300 p.

4627. Weule, K. Ostafrikanische Eingeborenen-Zeichnungen. IPEK 1926, 2:87-12

4628. Wingert, P.S. An Outline Guide to the Art of the South Pacific. NY: Columbia Univ Pr 1946, 61 p.

4629. ———. Primitive Art: Its Traditions and Styles. NY: Oxford Univ Pr 1962, 421 p.

4630. Wolfe, A.W. Art and the supernatural in the Ubangi district. Man 1955, article 75.

4631. Wood, M.G. Some use of primitive art in the teaching of young children. Teachers College Record 1923, 24:49-59.

4632. Wyman, L.C. Navaho Sandpainting, the Huckel Collection. Colorado Springs: Taylor Museum 1960, 88 p.

4633. Zizichvili, V. La pintura de los iconos y la ideología cristiana de los tiempos primitivos. Rev de Ideas Estéticas (Madrid 1951.

14 Psychoanalysis, Psychiatry and Art

4634. Abaunza, A. (Psychoanalysis and art.) Arch de medicina, cirugia y especialidades (Madrid) 1930, 33:97–116.

4635. Abell, W.H. The Collective Dream in Art. A Psycho-Historical Theory of Culture Based on Relations Between the Arts, Psychology, and Social Sciences. Cambridge: Harvard Univ Pr 1957, 377 p; Toronto: Saunders 1957; London: Oxford Univ Pr 1957, 378 p.

4636. Abraham, K. Review of Pfister's "Der psychologische und biologische Untergrund des Expressionismus." Imago 1921, 7:204–205.

4637. Ahlenstiel, H., and R. Kaufman. Über die Mandalaform des "lines aren Yantra." Schweiz ZPA 1952, 9:188–197.

4637a. Ajuriaguerra, J. de, and M. de M'Uzan. Psychiatrie et création artistique. Critique 1954, 10:951–965.

4638. Alajouanine, T. Aphasia and artistic realization. Brain 1948, 71:229–241.

4639. ———. La realisation artistique et l'aspasie. Médicine en France (Bombay) 1954, 55:3–13.

4640. Alexander, F. Le psychanalyse devant l'art contemporain. Encephale 1955, 44:26–45.

4641. ———. The psychoanalyst looks at art. In Lindner, R. (ed.), Explorations in Psychoanalysis. NY: Messner 1953, 138–154; In Phillips, W. (ed.), Art and Psychoanalysis. NY: Criterion 1957; In The Western Mind in Transition. NY: Random House 1960.

4642. Angyal, L. (Regressive disturbance of drawing ability due to cerebral vascular spasm; symptomatology of parietal regression.) Arch für Psychiatrie und Nervenkrankheiten 1942, 115:372–391.

4643. Angyal, L., and B. Lorand. Beiträge zu den Zeichenstörungen autopagnostisch-aphatischer Kranken. Arch für Psychiatrie und Nervenkrankheiten 1938, 108:493–516.

4644. Anon. Dreams on canvas. M.D. Medical Newsmagazine 1963, 7(12):152–155.

4645. Anon. Psychiatry and art. Netherne Hospital Exhibition. Brit Med J 1949, 46:228.

4646. Arnheim, R. Artistic symbols—Freudian and otherwise. JAAC 1953, 12:93–97.

4647. Ashley, W.R., and M. Basset. The effect of leucotomy on creative ability. J ment Sci 1949, 95:418–430.

4648. Balint, M. Notes on the dissolution of object-representation in modern art. JAAC 1952, 10:323–327.

4649. Banziger, H. Sinnbild und urbild in der psycho-analyse. Schweizerische Monatscheft "D" 1951, Oct., 41–46.

4650. Barreiros, E. Santos. A patologica neuro-psico-fisiológica e as aberraçoes plásticas. Broteria 1958, 66:424–434.

4651. Baudouin, C. L'inconscient dans la contemplation esthétique. Arch Psychol 1928, 21:55–75.

4652. ———. Psychanalyse de l'art. Paris: Alcan 1929, 274 p; London: Allen and Unwin 1924, 328 p.

4653. ———. La psychanalyse de l'art, prémisses d'une esthétique nouvelle. Rev de Genève 1926.

4654. ———. Psychoanalysis and art. Psyche 1924, 4:196–203.

4655. Bender, L. Disturbances in visual-motor Gestalt function in organic brain disease associated with sensory aphasia. Arch Neurol Psychiat 1933, 30:514–537.

4656. Bender, L., and W.R. Keeler. Body image of schizophrenic children following electroshock therapy. Ops 1952, 22:335–355.

4657. Beres, D. The contribution of psychoanalysis to the biography of the artist: a commentary on methodology. Int J Psycho-Anal 1959, 40:26–37.

4658. Bergler, E. Did Freud really advocate a "hands-off" policy toward artistic creativity. Amer Imago 1949, 6:205–210.

4659. Bettelheim, B. Art: a personal vision. In Stoddard, G.D. (ed.), Art As the Measure of Man. NY: Museum Modern Art 1964, 41–64.

4660. Bischler, W. Le rôle des zones érogènes

dans la genèse du talent artistique. Rev franç Psychanal 1933, 6:475–482.

4661. Bize, P.R. Le biotype artiste. Arch Internationales Neurologie 1946, 64–65: 178–181.

4662. Boerstein, W.S. Drawings as objective criteria for neurotic conflict and their change during psychoanalysis. JNMD 1949, 11:67–77; Arch Neurol Psychiat 1950, 64:479–487.

4663. Bohming, W. Der schaffende Kunstler und sein Werk. Arch für Psychiatrie und Nervenkrankheiten 1924, 71:709–734.

4664. Boon, A.A., and P. Feitscher. (Drawings of a patient with total aphasia.) ZNP 1938, 163:103–122.

4665. Borel, A. La pensée magique dans l'art. Rev franç Psychanal 1934, 7:66–83.

4666. Born, W. The dream and art. Ciba Symposia 1948, 10:940–951.

4667. ——. Unconscious processes in artistic creation. J clin exp Psychopath 1945, 7:253–272.

4668. Bauer, H., and R. Wittkower. Die Zeichnungen des Gianlorenzo Bernini. Berlin: Keller 1931.

4669. Brodbeck, A.J. Religion and art as socializing agencies: a note on the revision of Marxist and Freudian theories. Psychol Reports 1957, 3:161–165.

4670. Brown, J.W. Psycho-analysis and design in the plastic arts. Int J Psycho-Anal 1929, 10:5–28.

4671. Brown, N.O. Art and Eros. In Life Against Death. The Psychoanalytical Meaning of History. NY: Random House 1959, 55–67.

4672. Bruen, C. Artistic activity. Psyche 1928, 9:75–95.

4673. ——. The artistic process. Psyche 1930, 10:41–59.

4674. Burchard, E.M.L. Psychoanalysis, cultural history and art. Psychoanal & psychoanal Rev 1958–59, 45(4):99–104.

4675. Bychowski, G. Art, magic, and the creative ego. Psychoanalysis 1957, 4–5: 125–135.

4676. ——. Autismus und Regression in modernen Kunst bestrebugen. Allgemeine Zeitschrift für Psychiatrie 1922, 78:102–121.

4677. ——. From catharsis to work of art: the making of an artist. In Wilbur, G.B., and W. Muensterberger (eds.), Psychoanalysis and Culture. NY: IUP 1951, 390–409.

4678. ——. Metapsychology of artistic creation. Psychoanal Quart 1951, 20:592–602.

4679. ——. The rebirth of a woman: psycho-

analytic study of artistic expression and sublimation. Psychoanal Rev 1947, 34: 32–57; Imprensa Médica. Revista brasileira de medicina e sciencias affines (Rio de Janeiro) 1950, 25:86–88.

4679a. Cagli, C. Avventura della pittura moderna. I Problemi di Ulisse 1959, 6(33): 9–11.

4680. Caja, C. (Psychoanalysis of contemporary art.) L'illustrazione medica italiana (Genoa) 1932, 14:103–106.

4681. Capone, G. (Dynamics of the unconscious in art.) Arch di Patologia e Clinica Medica (Bologna) 1961, 38:79–130.

4682. Caudwell, C. Illusion and Reality. London: Macmillan 1937, 351 p.

4683. César, O. Durval Marcondes: Sobre dois casos de estereotipa grafica com simbolismo sexual. Memorias do Hospital Juquéri (São Paulo) 1926, 3:161.

4684. Choisy, M. Peut-on psychanalyser un artiste? Psyché-Paris 1951, 6:194–205.

4685. ——. Le problème de la création. Psyché-Paris 1952, 7:705–729.

4686. ——. Propos sur les 7 arts. Psyché-Paris 1947, 2:774–784.

4687. Clark, L.P. Studies on some aspects of art of the Renaissance. Arch Psychoanal (Stamford, Conn.) 1927, 1:767–832.

4688. Clark, L.P., and H.R. Gross. A psychohistorical study of sex balance in Greek art. Med J & Record 1924, 119:154–157, 205–208, 258–259.

4689. Clark, V. Art, psychiatry, war. Design 1943, 44:12–13.

4690. Colquhoun, N.C., and H. Palmer. Pictorial art viewed from the standpoint of mental organization as revealed by the excitatory abreactions of psychiatry. J ment Sci 1953, 99:136–143.

4691. Colucci, C. Appunti di un neurologo sulla considetta arte moderna. Cimento 1931, 85:1–10.

4691a. Conrad, K. Das Vierte Zeitalter und die moderne Kunst. In Ehrhardt, H., et al., Psychiatrie und Gesellschaft. Bern: Huber 1958, 102–113.

4692. ——. Der Zweite Sündenfall (Psychiatrische Betrachtungen zur modernen Kunst). Ann Univ Saraviensis Medizin 1953, 1:3–20.

4693. Conty, J.M. Artistes, économie et culpabilité. Psyché-Paris 1948, 3:506–513.

4694. Dali, S. Why they attack the Mona Lisa. Art News 1963, 62(1):36, 63–64.

4695. Dalla Volta, A. Forma e significato nel processo di inversione de rapporte di figura e spondo. Arch Psicol Neurol Psichia 1949, 10:19–69.

4696. Da Silva, A., and (?) Sousa. (Certain

psychoanalytical aspects of vision and aesthetic deformation in the eyes of artists.) Boletim do Sociedad Portuguesa Oftalmologia 1946-47, 5:301-303.

4697. Da Silveira, N. (Effects of leucotomy on creative activity.) Medicina-cirugia-pharmacia (Rio de Janeiro) 1955, 38-54.

4698. Dax, E.C. Experimental Studies in Psychiatric Art. London: Faber & Faber 1953, 100 p; Philadelphia: Lippincott 1954, 100 p.

4699. ——. (Therapeutic effects of lobotomies: Creative activity in painting in relation to the operation of leucotomy.) Compte rendu du Congrès internat Psychiat. Paris: Hermann 1952, 4:337-343; J Brasileiro de Psiquiatria 1951, 1:310-318.

4700. Debrunner, H. Mandalasymbolik und asymmetrische Ausdrucksformen in der Phantasiezeichnung. Schweiz ZPA 1950, 9:426-441.

4700a. Debuyst, C. Notes sur l'art et la vie affective. In Autour de l'oeuvre du Dr. E. de Greef. II. L'homme devant l'humain. Louvain & Paris: Nauwelaerts 1956, 155-186.

4701. Delay, J. Névrose et création. Comptes rendus Congrès psychiat neurol langue française 1954. Rev des deux mondes 1955, 1:28-45.

4702. Delay, J., R. Volmat, P. Pichot, and R. Robert. Névrose narcissique et production artistique. Anxiété, peinture et sexualité. Encéphale 1959, 48:457-480.

4703. Denber, H.C.B., P. Rajotte, and C.J. Wiart. Peinture et effets secondaires des neuroleptiques majeurs. Ann méd-psychol 1962, 1:11-30.

4704. Desoille, R. Le rêve éveille dirige et la création artistique. Paris: Arts et Lettres 1948, No. 11.

4705. Deutsch, F. The art of interviewing and abstract art. Amer Imago 1952, 9:3-19.

4706. Di Cori, F. Unconscious motivation as a source of creative expression. Dis Nerv System 1960, 21:119-123.

4707. Digby, G.F.W. Meaning and Symbol in Three Modern Artists. Edvard Munch, Henry Moore, Paul Nash. London: Faber & Faber 1955, 204 p.

4708. ——. Symbol and Image in William Blake. Oxford: Oxford Univ Pr 1957, 143 p.

4709. Dimitroff, M. (Psychoanalytic interpretation of artistic creativity.) Godishek Sofiishkija universitet 1933, 13 p.

4710. Dolto-Marette, F. Psychanalyse et pédiatre: Le complex de castration. Paris: Legrand 1940, 274 p.

4711. Dracoulidès, N.N. Interpretation psychanalytique d'un néographisme integré a un néomorphisme. Acta neurol psychiat belg 1962, 62:250-263.

4712. ——. Mobiles psychologiques de l'art moderne. Conf Soc hellenique des Gens de Lettres, Athens 1950, May 11.

4713. ——. Psychalayse de l'Artiste et de Son Oeuvre. Geneva: Collection Action et Pensée, Aux Editions du Mont-Blanc 1952, 232 p.

4713a. ——. (Psychoanalytic Interpretation of Fine Arts.) Athens: Argo 1947.

4714. ——. Regards psychanalytiques sur l'art moderne et la philosophie existentialiste. Bull de l'APB 1951, No. 13, 19.

4715. ——. Repercussions de sevrage précoce sur les tableaux d'un peintre moderne. Acta Psychotherapeutica, Psychosomatica et Orthopaedagogica (Basel) 1953, 1:23-33.

4716. Duboisgachet, P. Reflexions d'un lecteur sur l'art et la psychanalyse. Psyché-Paris 1949, 4:222-224.

4717. Ehrenzweig, A. The creative surrender. Amer Imago 1957, 14(3):193-210.

4718. ——. The mastering of creative anxiety. In Art and Artist. Berkeley: Univ California Pr 1956.

4719. ——. The modern artist and the creative accident. Listener 1956, Jan. 12.

4720. ——. The Psychoanalysis of Artistic Vision and Hearing; an Introduction to a Theory of Unconscious Perception. NY: Julian 1953, 272 p; London: Routledge & Kegan Paul, 1953, 272 p; In Sypher, W. (ed.), Art History. An Anthology of Modern Criticism. NY: Vintage 1963, 312-334.

4721. ——. Unconscious form creation in art. Brit J med Psychol 1948, 21:185-214; 22:88-109.

4722. ——. Unconscious mental imagery in art and science. Nature (London) 1962, 194:1008-1012.

4723. Engerth, G. Zeichenstörungen bei Patienten mit Autopagnosie. ZNP 1933, 143:381-402.

4724. Engerth, G., and H. Urban. Zur Kenntnis der gestörten künstlerischen Leistung bei sensorischer Aphasie. ANP 1933, 145:753-789.

4725. Engleman, A. A case of transexion upon viewing a painting. Amer Imago 1952, 9:239-249.

4726. Esser, A. Ein eigenartiges "künstleriches" Erzeugnis eines Postenzephalitikers. Nervenarzt 1932, 5:289-302.

4727. Evans, J.T. Case report of an amateur artist; psychopathological report. JNMD 1955, 121:480-485.

4728. Evenson, H. Psychiatrie und schaffende Kunst. Acta Psychiat neurol (Copenhagen) 1936, 11:455-457.

4729. Ewald, G. Abstracte Malerei. Ge-
danken eines Psychiaters. Psychologische
Rundschau 1950, 1:133-140.
4730. Ey, H. La psychiatrie devant le sur-
réalisme. Évolut Psychiat 1948, 3:3-52.
4731. Ferdière, G. (Study of design in an
aphasic patient; a question whether it
permits speaking of "intellectual realism"
or of constructive hypopraxia.) Ann méd-
psychol 1939, 97:265-278.
4731a. Fielding, L.S. Review of Schnier's
Psychoanalysis of the Artist. Psychoanal
Quart 1956, 25:458-459.
4732. Fizer, J. Projection and identification
in the artistic perception. Amer Imago 1955,
12(3):299-306.
4733. Fleiss, A.N. Abstraction in art and
psychiatry. New York J Med 1962, 62:
2864-2866.
4734. Forel, J. Aloyse ou la peinture magique
d'une schizophrène. Lausanne: Jaunin 1953.
4735. Foxe, A.N. The symbolism of the sym-
bol. Psychoanal Rev 1947, 34:169-172.
4736. Fraenkel, E. Quelques remarques
relatives à la psychanalyse de l'art. In
Atti del III° congresso internazionale di
estetica, 1956. Turin: Ed della Rivista di
Estetica 1957, 469-471.
4737. Fraiberg, L. Freud's writings on art.
Int J Psycho-Anal 1956, 37:82-96; Lit &
Psychol 1956, 6:116-130.
4738. ——. New news of art and the crea-
tive process in psychoanalytic ego psy-
chology. Lit & Psychol 1962, 11:45-55.
4739. Frankfort, H. Archetype in analytical
psychology and the history of religion.
Warburg & Courtauld Institutes J 1958, 21:
166-178.
4740. Franz, M-L. von. Peter Birkhäuser:
a modern artist who strikes a new path.
Contributions to Jungian Thought, Spring
1964.
4741. Freed, H., and J.T. Pastor. Evaluation
of "draw-a-person" test (modified) in
thalamothomy with particular reference to
the body-image. JNMD 1951, 114:106-120.
4742. Freedman, B. The psychiatry of
ultraism. Amer J Psychiat 1932, 12:347-354.
4743. Freud, S. On Creativity and the Un-
conscious. Papers on the Psychology of
Art, Literature, Love, Religion. NY: Harper
Torchbooks 1958, 310 p.
4744. ——. Letter to André Breton, Dec. 8,
1937. Transformation 1950, 1:49.
4745. ——. Medusa's head. Imago 1940,
25:105-106; Collected Papers 1925, 1959,
5:105-106; Int J Psycho-Anal 1941, 22:69-
70; Gesammelte Werken 1946, 17:47-48.
4746. Frois-Wittman, J. Art, Inconscient et
Réalité. Deuxième Congrès Internationale

d'Esthétique et de la Science de l'art.
Paris: Alcan 1937.
4747. ——. Moderne Kunst und Lustprinz
Versuch einer psychoanalytischen Recht-
fertigung im Expressionismus und Sur-
realismus. Psychoanal Bewegung 1930,
3:211-246, 313.
4748. ——. Preliminary psychoanalytic c
siderations of modern art. Arch Psychoan
(Stamford, Conn.) 1927, 1:891-941; Rev
franç Psychanal 1929, 3:355-394.
4749. Fry, R. The artist and psychoanalys
In Scott, F.W., and J.A. Zeitlin (eds.), Es
says Formal and Informal. NY: Smith 193
536-559; In Burgum, E.B. (ed.), The New
Criticism. NY: Prentice-Hall 1930, 193-
217; London: Hogarth 1924, 20 p.
4750. ——. The arts of painting and scul
In Rose, W. (ed.), An Outline of Modern
Knowledge. NY: Putnam 1931, 909-969.
4751. ——. Psychoanalysis and Art. NY:
1947.
4752. Garma, A. Vicisitudes de los simbc
Rev di psicoanálisis (Buenos Aires) 194
4:611-613.
4753. Gerster, Karl W. Alpträume eines K
lers. II. Allg ärztl Kongres für Psychothe
Bad Nauheim, Sitzg. 1927, 4:28-30.
4754. Geyer, H.C. The mystique of light.
Amer Imago 1953, 10:207-228.
4755. Gianascol, A.J. Psychiatric potenti
ities in art. JNMD 1954, 120:238-244.
4756. Goitein, L. Art and the Unconsciou
NY: United Book 1948, n.p.; Reviewed in
Psychoanal Quart 1949, 18:397-398.
4757. Gold, M. Freud's views on art. Psy
choanal & psychoanal Rev 1961, 48(2):
111-115.
4758. Gombrich, E.H. Psychoanalysis and
art. In Nelson, B.N. (ed.), Freud and the
Twentieth Century. NY: Meridian 1957.
4759. González, Mas R. Ideas neuropsi-
quiátricas en el arte del antiguo Egipto.
Medicina 1953, 21:239-243.
4760. Gordon, A. Psychology and modern
art. Ann méd-psychol 1926, 2:219-229;
Med J & Record 1927, 125:406-408.
4761. Greenacre, P. Woman as artist. Psy
choanal Quart 1960, 29:208-227.
4762. Grinstein, A. A psychoanalytic stud
of Schwind's "The Dream of a Prisoner."
Amer Imago 1951, 8:65-91.
4763. Groddeck, G.W. Der Mensch als Sy
bol; Unmassgebliche Meinungen über
Sprache und Kunst. Vienna: Internationa
Psychoanalytischer Verlag 1933, 162 p.
4764. ——. Unconscious symbolism in la
guage and art. In Exploring the Unconsc
NY: Funk & Wagnalls 1960, 125-131.
4765. ——. The World of Man; As Reflec

in Art, in Words and in Disease. London: Daniel 1934; NY: Funk & Wagnalls 1951, 271 p.

4766. Grotjahn, M. About the representation of death in the art of antiquity and in the unconscious expression of modern men. In Wilbur, G.B., and W. Muensterberger (eds.), Psychoanalysis and Culture. NY: IUP 1951, 410-424.

4767. ——. Symbolism in the drawing of a transvestite. Sāmiksā 1947, 1:241-244.

4768. ——. Transvestite fantasy expressed in drawing. Psychoanal Quart 1948, 17: 340-345.

4769. Gutheil, E. The Language of the Dream. NY: Macmillan 1939, 286 p.

4770. Gyárfás, K. Disturbances of drawing in hypoglycemia. Confinia Neurologica 1939, 2:148-160.

4771. Hacker, F.J. On artistic production. In Lindner, R. (ed.), Explorations in Psychoanalysis. NY: Julian 1953, 128-138.

4772. Haldar, R. Art and the unconscious. Indian J Psychol 1935, 10:191-195.

4773. Hardi, I. (Psychological observations on handwriting and drawing following electroshock therapy.) Arch für Psychiatrie Nervenkrankheiten 1962, 203:610-631.

4774. Harnik, J. Zur Psychologie des Künstlers. Z Psychoanal Psychother 1912, 2:417.

4775. Harré, R. Art and psychology. Ratio 1959, 70-79.

4776. Hartmann, H., E. Kris, and R.M. Loewenstein. Some psychoanalytic comments on culture and personality. In Wilbur, G.B., and W. Muensterberger (eds.), Psychoanalysis and Culture. NY: IUP 1951.

4777. Hauser, A. The psychological approach: psychoanalysis and art. In The Philosophy of Art History. NY: Knopf 1959, 43-116; Munich: Beck 1958; Madrid: Guadarrama 1961; NY: Meridian 1963, 41-116.

4778. Head, H. Aphasia and Kindred Disorders of Speech. Cambridge, England: Univ Cambridge Pr 1926, Ch. 7.

4779. Hecaen, H., J. De Ajuriaguerra, and J. Massonet. Les troubles visuo-constructifs par lésion pariéto-occipitale droits; rôle des perturbations vestibulaires. Encéphale 1951, 40:122-179.

4780. Heinitz, (?). Eine psychoanalytische Betrachtung der Kunst und Natur. Literarische Gesellschaft zu Halberstadt 1916.

4781. Helmholtz, H.F.L. Optisches und Malerei. In Vorträge und Reden, 4th ed. Braunschweig: Vieweg 1896.

4782. Hendin, H. Psychoanalysis, modern art and the modern world. Psychiat Quart 1958, 32:522-531.

4783. Herbert, S. The Unconscious in Life and Art; Essays of a Psychoanalyst. London: Allen & Unwin 1932, 252 p.

4784. Hermann, I. Beiträge zur Psychogenese der zeichnerischen Begabung. Imago 1922, 8:54-66.

4785. ——. Gustave Fechner: Die Begabungs Grundlagen. Imago 1925, 11:409.

4786. ——. Organ Libido und Begabung. Z für Psychoanalyse (Tokyo) 1923, 9.

4787. ——. Die Regression zum zeichnerischen ausdruck bei Goethe. Imago 1924, 10:424-430.

4788. Hesse, H. Psychoanalyse und Künstler. Almanach 1926, 34-38.

4789. Hetherington, R. The effects of electro-convulsive therapy on the drawings of depressed patients. J ment Sci 1952, 98: 450-453.

4790. Hitschmann, E. Hebbel kennt auch die Rolle des Unbewussten im Künstler. Z Psychoanal Psychother 1911, 1:273.

4791. ——. Sexualsymbolik in Bildern. Int Z Psychoanal 1913, 1:518.

4792. Hodin, J.P. The future of surrealism. JAAC 1956, 14:475-486.

4793. Homberger, E. Configurations in play. Psychiat Quart 1937, 6:139-214.

4794. Huckel, H. Vicarious creativity. Psychoanalysis 1953, 2(2):44-55.

4795. Hulbeck, C.R. The creative personality. Psychoanalysis 1945, 5:49-58.

4796. ——. Psychoanalytic notes on modern art. Amer J Psychoanal 1960, 20:164-173.

4797. ——. Psychoanalytic thoughts on creativity. Amer J Psychoanal 1953, 13:84-86.

4798. Hutchinson, E.D. The period of frustration in creative endeavor. Psychiatry 1950, 3:353.

4799. Hutton, E., and H. Bassett. Effect of leucotomy on creative personality. J ment Sci 1948, 44:332-350.

4800. Jacobi, J. Erfassung und Deutung der "Bilder aus dem Unbewussten." Schweiz ZPA 1950, 9:407-426.

4801. ——. Pictures from the unconscious. J proj Tech 1955, 19:264-270.

4802. Jakab, I. Die Wirkung des Elektroschocks und der Leukotomie auf die bildnerischen Darstellungen Schizophrener (Cas 3). Medizinische Bild 1960, 3:129.

4803. Jakovsky, A. (Religions and other leisures.) La Vie Médicale 1963, 44:58-60.

4804. Janis, H. Paintings as a key to psychoanalysis. Arts & Architecture 1946, 63: 38-40.

4805. Jolowicz, E. Expressionismus und Psychiatrie. Kunstblatt 1920.

4806. Jones, E. Artistic form and the unconscious. Mind 1935, 44:211-215, 496-498.

4807. ——. Psychoanalysis and the artist.
Psyche 1928, 8:73–88.

4808. ——. Theory of symbolism. In Papers
on Psychoanalysis. NY: Wood 1923, Ch.
8.

4809. Juliusberger, O. Das Leiden und die
Kunst. Ein Weg seelischer Behandlung. Z
Psychother med Psychol 1952, 2:107–110.

4810. Jung, C.G. Aion: Untersuchungen zur
Symbolgeschichte. Zurich: Rascher 1951,
561 p.

4811. ——. Archetypes of the collective
unconscious. In The Integration of Per-
sonality. NY: Farrar & Rinehart 1939, Ch.
3.

4812. ——. Collected Papers on Analytical
Psychology. London: Baillière, Tindall &
Cox 1920, 492 p; NY: Moffat Yard, 1916,
1917, 492 p.

4813. ——. Das erotische Element in Kunst
und Dichtung. Z für Sexualwissenschaft
und Sexualpolitik 1924, 11:277–288, 297–
301.

4814. ——. Über Mandalasymbolik. In
Gestaltungen des Unbewussten. Zurich:
Rascher 1950.

4815. Kanzer, Mark. Applied psychoanalysis.
I. Arts and aesthetics. In Frosch, J. (ed.),
Annual Survey of Psychoanalysis 1951, 2:
438–475; 1952, 3:511–546.

4816. ——. Applied psychoanalysis. III.
Literature, arts, and aesthetics. In Frosch,
J. (ed.), Annual Survey of Psychoanalysis
1953, 4:355–389; 1954, 5:457–473; 1955,
6:444–465.

4817. Karland, S., and P. Patti. Art produc-
tions indicating aggression towards one's
mother. Psychiat Quart Suppl 1948, 21:47–
51.

4818. Klein, R., and J.J. Stack. Visual ag-
nosia and alterating dominance: analysis
of a case. J ment Sci 1953, 99:749–762.

4819. Kloos, G. Zur psychiatrischen Kritik
schopferischer Leistungen. ZNP 1931, 137:
362–372.

4820. Kris, E. Approaches to art. In Lorand,
S. (ed.), Psychoanalysis Today. NY: IUP
1944, 354–370.

4821. ——. On inspiration. Preliminary
notes on emotional conditions in creative
states. Int J Psycho-Anal 1939, 20:377–
389; In Psychoanalytic Explorations in Art.
NY: IUP 1952, 291–302; London: Allen &
Unwin 1953, 291–302.

4822. ——. Psychoanalysis and the study
of creative imagination. Bull NY Acad Med
1953, 29(4).

4823. ——. Psychoanalytic Explorations in
Art. NY: IUP 1952, 358 p; London: Allen &
Unwin 1953, 358 p.

4824. Kubie, L.S. Neurotic Distortion of
the Creative Process. Lawrence: Univ Kan
Pr 1958, 151 p.

4825. Kučera, O. (The nature, the mechanis
and the function of creative art.) Sbornik
Psychoanalytickýih Prací 1947, 2:101–157

4826. ——, et al. (Psychopathologic Mani
festations in Children of Mild Encephalo-
pathies.) Prague: State Health Publ Co
1961, 260 p.

4827. Lagerborg, R.H.H. (On Psychoanalys
and What It Wishes to Expose on Art and
Artists.) Stockholm: Bonnier 1918, 41 p.

4828. Lalo, C. L'expression de la vie dans
l'art. Paris: Alcan 1933, 263.

4829. Landquist, J. Das künstlerische Sym
bol. Imago 1920, 6:297–322.

4830. Lee, H.B. Review of Kris' "Psycho-
analytic Explorations in Art." Psychoanal
Quart 1953, 22:280–284.

4831. Lenz, H. Richtungsänderung der Kuns
lerischen Leistung bei Hirnsrammerkranku
ZNP 1940, 170:98–107.

4832. Leon, P. Artistic form and the uncon-
scious. Mind 1935, 44:347–349.

4833. Levey, H.B. (Lee, H.B.). A theory con
cerning free creation in the inventive arts
I. Aesthetic theory. II. Philosophical and
other speculative explanations of art crea
tion. III. Theories of art creation as trans
formed sexual instinct energy. IV. Theory
of artistic sublimation advanced by con-
tinental psychoanalysis (Role of Sublima-
tion). V. The defense theory of art creatio
as advanced by British psychoanalysis.
VI. Other concepts of art creation as a re-
action to anxiety. VII. Description of the
free artist as a character type and in term
of his unconscious mental processes. Psy
chiatry 1940, 3:229–293.

4834. Levi, P.G. (Points on the problem of
"style change.") Sistema Nervoso (Milan)
1959, 11:390–392.

4835. Levi Bianchini, M. Contributi alla
storia simbolistica sessuale nell'arte ero
Arch Generale di Neurologie, Psichiatrie e
Psicoanalisi 1930, 11:263–266.

4836. ——. La psicoanalisi della fontasia
creatrice e il pensiero autistico nell'arte
e nelle psicosi. Arch Generale di Neurolo
Psichiatrie e Psicoanalisi 1922, 3:19–39,
73–76.

4837. Lewin, R. Traum und Kunst. März 191
Apr 18.

4838. Lewis, N.D.C. The practical value o
graphic art in personality studies. (1. An
introductory presentation of the possibil-
ities.) Psychoanal Rev 1925, 12:316–322.

4839. Lhote, A. The unconscious in art.
Transition 1937, 26:82–96.

4840. Löwenfeld, L. Hypnose und Kunst. Ein Vortrag. Wiesbaden: Bergmann 1904, 24 p.

4841. Lorand, S. (ed.). Psychoanalysis Today. NY: IUP 1944, 404 p.

4842. Loras, O. (The phenomenological dialectic of artistic creation. The mode of existence of painting.) Confin Psychiat 1963, 6:88-101.

4843. Lovell, H.T. Psycho-analysis and art. Art in Australia 1923, 3d Series, No. 5.

4844. Lowenfeld, H. Psychic trauma and productive experience in the artist. Psychoanal Quart 1941, 10:116-130.

4845. Lundholm, H. A comparative study of creative imagination in normal people and in mentally diseased. Amer J Psychiat 1924, 3:739-756.

4846. Lussheimer, P. The growth of artistic creativity through the psychoanalytic process. Amer J Psychoanal 1963, 23:185-194.

4847. Luzes, P. (The unconscious in artistic creativity.) Jornal do médico (Portugal) 1962, 48:751-758.

4848. Machado Gomes, E. Psychiatry and painting. Habitat: Rev das Artes no Brasil 1953, 9-10.

4849. Marchand, L., J. Fortineau, and P. Petit. Hallucinations visuelles projetées et dessinées, symptomes pré et post-paraoxystiques épileptiques. Ann méd-psychol 1936, 94:205-210.

4850. Marcinowski, J. Die Entsehung der künstlerischen Inspiration. Imago 1913, 2.

4851. ——. Gezeichnete Träume. Z Psychoanal Psychother 1911-12, 2:490-518.

4852. Marie, A. Art et fantasie. L'art 1931, 2.

4853. Marin, J. Ensayos freudianos (de la medicina, de la historia y del arte). Santiago, Chile: Zig-zag 1938, 267 p.

4854. Marone, S. Homosexuality and art. Int J Sexology 1954, 7:175-190.

4855. Mauron, C. L'art et la psychanalyse. Psyché-Paris 1952, 7:24-36.

4856. Mayer, F. Das Formale in der Psychoanalyse. Z Psychother med Psychol 1930, 3:132-141.

4857. Metzinger, J. Critique d'art et psychanalyse. Psyché-Paris 1953, 8:64-66.

4858. Milner, M. Aspects of symbolism in comprehension of the not-self. Int J Psycho-Anal 1952, 33:181-195.

4859. Milner, M.B. (pseud. of Joanna Field). On Not Being Able to Paint. NY: IUP 1958, 184 p; London: Heinemann 1957, 173 p.

4860. Minkowski, E., J. Fusswerk, and M. Drefus. Étude du monde des formes. Dessins chez les jumeaux. Ann méd-psychol 1952, 110:715-718.

4861. Morgenstern, S. Un cas de mutism psychogène. Rev franç Psychanal 1927, 1: 492-504.

4862. Morgenthaler, W. Zur Psychologie des Zeichnens. Schweiz ZPA 1942, 1:102-108.

4863. Mosse, E.P. Psychological mechanisms in art production. Psychoanal Rev 1951, 38: 66-74.

4864. Mottram, V.H. Psycho-analysis in life and art. University Magazine (Canada) 1915; abstract in Int J Psycho-Anal 1922, 3:359-360.

4865. Muller, A. L'art et la psychanalyse. Rev franç Psychanal 1953, 17:297-319.

4866. Munro, T. The bearings of psychoanalysis on theories of art history. Freud and Jung. In Evolution in the Arts. Cleveland: Cleveland Museum of Art 1963, 209-212.

4867. Murphey, B.J. A psychiatrist looks at art. School Arts 1944, 43:336-338.

4868. Nemitz, F. Kunst und psychoanalyse. Deutsche Kunst u Dekoration 1932, 70:44-45.

4869. Neumann, E. Art and the Creative Unconscious. London: Routledge & Kegan Paul 1959, 232 p; NY: Pantheon 1959, 205 p; Zurich: Rascher 1949, 546 p.

4870. Neumann, J. Expressionismus als Lebenstil. Z angew Psychol 1952, 43:414-460.

4871. Neves-Manta, I. de L. Arte de vanguarda e a compreensão psicanalitica. Imprensa Médica. Revista brasileira de medicina e sciencas affines (Rio de Janeiro) 1942, 18:25-27.

4872. Orenstein, L.L., and P. Schilder. Psychological considerations of the insulin treatment in schizophrenia. JNMD 1938, 88:397-413, 644-660.

4873. Paneth, L. Form und Farbe in der Psychanalyse. Ein neuer Weg zum Unbewussten. Nervenartz 1929, 2:326-337.

4874. Papenheim, E. Review of Wyss' Der Surrealismus. Psychoanal Quart 1953, 22: 101-105.

4875. Pasto, T.A., and P. Kivisto. Art and the clinical psychologist. JAAC 1953, 12: 76-82.

4876. Pedersen, S. Eidetics, obsession and modern art. Amer Imago 1954, 11:341-362.

4877. Pederson-Krag, G. Report on panel: psychoanalysis of the creative imagination. Bull Amer Psychoanal Ass 1948, 4:39-44.

4878. Peón del Valle, J. El pensamiento mágico en el pinturas del México antiguo. Rev Méxicana de Psiquiatria y Neurologia 1940, 6:9-14.

4879. Peters, R.J. Immortality and the artist. Psychoanalysis 1961-62, 48(4):126-137.

4880. Pfister, O. Expressionism in Art: Its Psychological and Biological Basis. NY: Dutton 1923, 272 p; Bern: Bircher 1920, 1930, 185 p; London: Kegan Paul, Trench, Trubner 1922, 272 p.

4881. ———. Kryptolalie, Kryptographie und unbewusstes Vexierbild bei Normalen. Jahrbuch für Psychoanalytische und Psychopathologische Forschungen 1913, 5.

4882. ———. Psychoanalyse und bildende Kunst. In Federn, P., and H. Meng (eds.), Das psychoanalytische Volksbuch. Stuttgart: Hippocrates 1926, 468-479; 1928, 2:208-221; Bern: Huber 1939, 606-617.

4883. Phillips, W. (ed.). Art and Psychoanalysis. NY: Criterion 1957, 552 p.

4884. Pickford, R.W. Some interpretations of a painting called "Abstraction." Brit J med Psychol 1939, 18:219-249.

4885. Piñera Llera, H. Algunas interpretaciones psicoanaliticas del arte. Rev Cubana de Filosofia 1955, 3(12):5-12.

4886. Pozzo, C.U. del. Lombroso und die Kunst. Rev de Psiquiatría y Criminalia (Buenos Aires) 1938, 3:537-550.

4887. Rank, O. Art and Artist; Creative Urge and Personality. NY: Knopf 1932, 431 p; NY: Tudor 1932; Leipzig: Internationaler Psychoanalitische Verlag 1925; Vienna: Heller 1907, 1918, 1925.

4888. ———. Der Fisch als Sexualsymbol in modernen Bildwerken. Imago 1914, 3:193-196.

4889. ———. Der Künstler, und andere Beiträge zur Psychoanalyse des dichterischen Schaffens. Leipzig: Internationaler Psychoanalytischer Verlag 1925, 209 p.

4890. ———. Der Künstler; Ansätze zu einer Sexualpsychologie. Vienna: Heller 1907, 56 p; 1918, 85 p.

4891. Reitler, R. Eine anatomisch-künstlerische Fehlleistung Leonardos da Vinci. Int Z Psychoanal 1916-1917, 4:205-207.

4892. Reitman, F. The creative spell of schizophrenics after leucotomy. J ment Sci 1947, 93:55-61.

4893. ———. Dynamics of creative activity. J ment Sci 1948, 94:314-320.

4894. Robertiello, R.C. The artist's block. Psychiat Quart 1963, 37:462-465.

4895. Rosen, V.H. The relevance of "style" to certain aspects of defence and the synthetic function of the ego. Int J Psycho-Anal 1961, 42:447-457.

4896. Rosenthal, M.J. Relationships between form and feeling in the art of Picasso. Amer Imago 1951, 8:371-391.

4897. Rosenzweig, E.M. Surrealism as symptom. Amer Imago 1941, 2:286-295.

4898. Sachs, H. Aesthetics and the psychology of the artist. Int J Psycho-Anal 1921, 2:94-100; In Bericht über die Fortschritte der Psychoanalyse 1914-1919. Vienna: Internationaler Psychoanalytische Verlag 1921, 234-243.

4899. ———. The Creative Unconscious: Stu in the Psychoanalysis of Art. Cambridge, Mass.: Sci-Art 1942, 240 p; 1951, 358 p.

4900. ———. Kunst und Persönlichkeit. Imag 1929, 15:1-14; Almanach 1930, 61-76.

4901. Saiko, G. Possibility of symbolism i modern painting; on the pictures of Jean Viollier. Creative Art 1931, 9:467-474.

4902. Sakurabayashi, H. (An introduction to the unified theory of art psychology— comparing Gestalt school with psychoanalysis.) Bigaku (Tokyo) 1959, 10(1).

4903. Saussure, R. de. Fragments d'analys d'un pervers sexual. Rev franç Psychanal 1929, 314:631-689.

4904. Schenk, V.W.D. (Drawings of patient with aphasia.) Ned Tijdschr Geneesk 193 83:747-756.

4905. Schilder, P.F. The Image and Appearance of the Human Body; Studies in the Constructive Energies of the Psyche. NY: IUP 1950, 353 p; London: Kegan Paul, Tre Trubner 1953, 353 p.

4906. ———. Das Körperbild und die Sozialpsychologie. Imago 1933, 19:367-376.

4907. Schilder, P.F., and H. Hartmann. Körperinneres und Körperschema. ZNP 192 109:666-675.

4908. Schilder, P.F., and E.L. Levine. Abstract art as an expression of human prob lems. JNMD 1942, 95:1-10.

4909. Schnier, J. Art symbolism and the un conscious. JAAC 1953, 12:67-75.

4910. ———. Free association and ego function in creativity: a study of content and form in art. Amer Imago 1960, 17(1):60-90

4911. ———. The function and origin of form JAAC 1957, 16:66-75.

4912. ———. Morphology of a symbol: the octopus. Amer Imago 1956, 13:3-31.

4913. ———. Psycho-analysis of the artist. Sāmiksā 1954, 8:174-190.

4914. ———. Restitution aspects of the crea tive process. Amer Imago 1957, 14:211-22

4915. ———. The symbolic bird in Medieval Renaissance art. Amer Imago 1952, 9:89-1

4916. ———. The symbol of the ship in art, and dreams. Psychoanal Rev 1951, 38:53-

4917. Segni, F. di. Hacia la pintura; psicoanálisis aplicado al arte. Buenos Aires Ediciones del Movemiento NOA 1960, 119

4918. Servadio, E. (ed.). Due studi sul Su realismo. Rome: Luce e Ombra 1931.

4919. ———. Psychoanalyse de l'art hyper-

moderne. Psyché-Paris 1947, 2:1501-1506.

4920. ———. Il surrealismo: storia, dotrina, valutazione psicoanalitica. Psicoanalise 1946, 2:77-84.

4921. Sharpe, E.F. Certain aspects of sublimation and delusion. Int J Psycho-Anal 1930, 11:12-23.

4922. ———. Similar and divergent unconscious determinants underlying sublimations of pure art and pure science. Int J Psycho-Anal 1935, 16:186-202; In Brierly, M. (ed.), Collected Papers on Psycho-Analysis. London: Hogarth 1950, 137-154.

4923. Shiller, F. (Marxism, psychoanalysis and art.) Vestnik Kommunisticheskoi Akademii 1926, 18:244-257.

4924. Silva, H. A funçao do inconsciente nas artes plásticas. Rio de Janeiro: Sociedade dos Artistas Nacionais 1951, 232 p.

4925. Soueif, M.I. La psychanalyse et l'artiste. Egypt J Psychol 1946, 2:282-302.

4926. Spitz, R.A. Vagadu. Une analyse dans la miroir de l'intuition de l'artiste. Commentaire psychanalytique. Rev franç Psychanal 1934, 7:550-579; Paris: Denoël et Steele 1934, 21 p.

4927. Stainbrook, E., and H. Lowenbach. Drawings of psychotic individuals after electrically induced convulsions. JNMD 1944, 99:382-388.

4928. Stekel, W. Poetry and neurosis. Contributions to the psychology of the artist and of artistic creative ability. Psychoanal Rev 1923, 10:73-96, 190-208, 316-328, 457-466; 1924, 11:48-60; Wiesbaden: Bergmann 1909, 73 p.

4929. Sterba, R. Zur Analyse der Gotik. Imago 1924, 10:361-373.

4930. ———. The problem of art in Freud's writing. Psychoanal Quart 1940, 9:256-268; Psychoanal Bewegung 1929, 1:197-206.

4931. Stern, M.M. Trauma, projective technique, and analytic profile. Psychoanal Quart 1953, 22:221-252.

4932. Stocker, A. Essai psychoanalytique sur la cruche cassée de Greuze. Encéphale 1921, 16:78-84.

4933. Stokes, A. Concerning art and metapsychology. Int J Psycho-Anal 1945, 26: 177-179.

4934. ———. Form in art. In Klein, M. (ed.), New Directions in Psycho-Analysis. London: Tavistock 1955.

4935. ———. Form in art: a psychoanalytic interpretation. JAAC 1959, 18:193-203.

4936. ———. Greek Culture and the Ego; A Psycho-Analytic Survey of an Aspect of Greek Civilization and of Art. London: Tavistock 1958, 101 p.

4937. ———. Michelangelo: A Study in the Nature of Art. London: Tavistock 1955, 153 p.

4938. ———. Three Essays on the Painting of Our Time. London: Tavistock 1961, 65 p.

4939. Sydow, E. von. Kunstwissenschaft und Psychoanalyse. In Prinzhorn, H., Auswirkungen der Psychoanalyse in Wissenschaft und Leben. Leipzig: Der Neue Geist 1928, 153-171.

4940. Tarachow, S. Remarks concerning certain examples of late medieval ecclesiastic art. J clin exp Psychopath 1948, 9:233-248.

4941. Teillard-Mendelssohn, A. Le rêve du train qui part. Interprétation d'un dessin de rêve. Psyché-Paris 1947, 2:82-86.

4942. Trapp, C.E., and M.C. Trapp. Psychiatry in art. Ann med History (New York) 1936, 8: 511-517.

4943. Tremmel, E. Nach Analogie der aktivanalytischen Traumdeutung analysierte Handzeichnungen. Bericht VI allg ärztl Kongres Psychotherap 1931, 187-196.

4944. Trilling, L. Art and neuroses. In The Liberal Imagination. Essays on Literature and Society. NY: Viking 1950, 160-180; Garden City, NY: Doubleday Anchor 1953, 159-178.

4945. ———. Freud and art. Kenyon Rev 1940.

4946. Umberto del Pozzo, C. (Lombroso and art.) Rev de Psiquiatría y Criminalia (Buenos Aires) 1938, 3:537-550.

4947. Van den Haag, E. Creativity, health and art. Amer J Psychoanal 1963, 23:144-156.

4948. Van der Chijs, A. (A contribution to the knowledge of the siginface of incest and infantilism in the art of painting.) Ned Tijdsch Geneesk 1922, 1460.

4949. ———. Infantilismus in der Malerei. Imago 1923, 9:463-475.

4950. Varela Aldemira, L. (On Art and Psychoanalysis. Three Lectures Held at the Society of Liberal Arts.) Lisbon: Impresso na Sociedade Industrial de Tipografia 1935, 115 p.

4951. Various. Bericht über die Fortschritte der Psychoanalyse 1914-1919. Vienna: Internationaler Psychoanalytischer Verlag 1921.

4952. Vinchon, J. L'art dans le psychiatrie. Progrès médicale (Paris) 1956, 84:179-184.

4953. ———. Le catalogue de "l'Enfer" de la Bibliothèque Nationale. Rev Psychiat 1913, 17:155-158.

4954. Vinchon, J., and A. Gilles. Les visions du délire de rêve dans l'art japonais. France Médicale 1921, Jan-Oct.

4955. Vinkin, P.J. Some observations on the symbolism of the broken pot in art and

literature. Amer Imago 1958, 15:149-174.

4956. Vitale, L. Manifestazioni del sub-
conticiente el genesi del l'arte. Rassegna
di Clinica, Terapia e Scienze Affini (Rome)
1952, 51:209-250.

4957. Volmat, R. La creation artistique et
la lobotomie. La Vie Médicale. Numéro
Spécial. Art et psychologie. Dec. 1956,
46-50.

4958. ———. Les psychiatres, l'art et la
critique. La Table Ronde 1956, No. 108.

4959. Weindler, F. (Report on three men-
tal epidemics—demoniac possession,
dancing mania and flagellation—during
the Middle Ages in Germany and their
representation in art.) Psychiatrisch-
neurologische Wochenschrift (Halle)
1939, 41:425-430.

4960. Wenkart, A. Modern art and human
development. Amer J Psychoanal 1960,
20:174-179.

4961. Weygandt, W. La psicopatologia
nell'arte. Ferrara: Industrie Grafiche
Italiane 1923, 51 p.

4962. Whitehead, G. Psycho-Analysis and
Art. London: Bale & Donelsom 1930,
146 p.

4963. Wickes, F.G. The Inner World of
Man; with Psychological Drawings and
Paintings. NY: Farrar & Rinehart 1938,
313 p.

4964. Wilhelm, R., and C.G. Jung. The
Secret of the Golden Flower, a Chinese
Book of Life. London: Kegan Paul 1931,
151 p; Munich: Ullmann 1929, 161 p.

4965. Winkler, W. Traumsymbolik und
moderne Malerei. In Speer, E. (ed.),
Lindauer Psychotherapiewoche 1950. Stutt-
gart: Hippocrates 1951, 99-120.

4966. Winterstein, A.R.F. Motorischen
Erleben im schöpferischen Vorgang. Psy-
choanal Bewegung 1929, 1:299-318.

4967. Wittels, F. Art. In Freud and His Time
The Influence of the Master Psychologist
on the Emotional Problems in Our Lives.
NY: Liveright 1931, 398-421.

4968. ———. A contribution to a symposium
on religious art and literature. J Hillside
Hospital 1952, 1:3-6.

4969. Worringer, W. Abstraction and Em-
pathy. NY: IUP 1962.

4970. Wyss, D. Der Surrealismus. Eine
Einführung und Deutung Surrealistischer
Literatur und Malerei. Heidelberg: Lambert
Schneider 1950, 88 p.

4971. Yates, A.J. Rotation of drawings by
brain-damaged patients. J abnorm soc
Psychol 1956, 53:178-181.

15 Psychology and Art

4972. Abel, T.M. Free designs of limited scope as a personality index. Char Pers 1938, 7:50–62.

4973. Abercrombie, L. Communication versus expression in art. Brit J Psychol 1923–24, 14:68–77.

4974. Agrawal, P. Art symbolism. Indian J Psychol 1949, 24:120–127.

4975. Aiken, I. Psychological aspects of surrealism. J clin Psychopath 1945, 7:35–42.

4976. Alexander, B. Zur Psychologie der Kunst. Diskussion: Bericht über den III Int Kongress für Philos 1909, 578–580.

4977. Alexander, C. The longevity of scientists. J soc Psychol 1954, 39:299–302.

4978. Alexander, M. Homosexuality and the arts. Int J Sexology 1954, 8:26–27.

4979. Algrisse, G. L'évolution du symbole chez Van Gogh. Psyché-Paris 1954, 9: 310–318.

4980. Almansur Haddad, J. Art and the senses. Medicina-cirugia-pharmacia (Rio de Janeiro) 1941, 134–138.

4981. Ammons, R.B., P. Ulrich, and C.H. Ammons. Voluntary control of perception of depth in a two-dimensional drawing. Proc Montana Acad Sci 1960, 19:160–168.

4982. Anastasi, A., and J.P. Foley. The study of "populistic painters" as an approach to the psychology of art. J soc Psychol 1940, 11:353–368.

4983. Andersen, I., and R. Munroe. Personality factors involved in student concentration on creative painting and commercial art. Rorschach Res Exch 1948, 12: 141–154.

4984. Anon. Psychology and art. Milwaukee Inst Bull 1931, 4:10.

4985. Arnheim, R. Agenda for the psychology of art. JAAC 1952, 10:310–314.

4986. ——. Art and Visual Perception—A Psychology of the Creative Eye. Berkeley: Univ California Pr 1954, 1958, 408 p; London: Faber & Faber 1956, 408 p.

4987. ——. Artist conscious and unconscious. Art News 1957, 56:31–33.

4988. ——. A complexity scale of movement. JAAC 1954, 13:104–108.

4989. ——. The creative process. Psychol Beiträge 1961, 6:374–382.

4990. ——. Emotion and feeling in psychology and art. Confin Psychiat 1956, 1:69–88.

4991. ——. Gestalt psychology and artistic form. In Whyte, L.L. (ed.), Aspects of Form. London: Lund Humphries 1951, 196–208; NY: Pelligrini & Cudahy 1951, 196–208.

4992. ——. Perceptual abstraction and art. Psychol Rev 1947, 54:66–82.

4993. ——. Perceptual analysis of a symbol of interaction. Confin Psychiat 1960, 3:193–216; JAAC 1961, 19:389–399.

4994. ——. The psychologist who came to dinner. College Art J 1954, 13:107–112.

4995. ——. A psychologist's view of general education for the artist. College Art J 1949, 8:268–271.

4996. Arréat, L. Art et psychologie individuelle. Paris: Alcan 1906, 158 p.

4997. ——. Mémoire et imagination (peintres, musiciens, poètes et orateurs.) Paris: Alcan 1904, 168 p.

4998. ——. Psychologie du peintre. Paris: Alcan 1892, 267 p.

4999. Arundel, R.M. Everybody's Pixillated: a Book of Doodles. Boston: Little, Brown 1937, 108 p.

5000. Aster, E.V. Kunstlerische und wissenschaftliche Psychologie. Wiener Blätter 1915, 10:1234–1259.

5001. Attneave, F. Some informational aspects of visual perception. Psychol Rev 1954, 61:183–193.

5002. Attneave, F., and M.D. Arnoult. The quantitative study of shape and pattern perception. Psychol Bull 1956, 53:452–471.

5003. Auerbach, J.G. Psychological observations on "doodling" in neurotics. JNMD 1950, 11:304–332.

5004. Ayer, F.C. The Psychology of Drawing. Baltimore: Warwick & York 1916, 186 p.

5005. Azizi Piruz. La puissance créatrice de la maladie. Thèse Méd. Paris 1935, 1–88.

5006. Bachelard, G. La poétique de
l'espace. Paris: PUF 1957, 214 p.

5007. Bahle, J. Das Teil-Ganze-Problem
im künstlerischen Schaffensprozess. Arch
ges Psychol 1937, 99:209-212.

5008. Bahnsen, P. Eine Untersuchung über
Symmetrie und Asymmetrie bei visuellen
Wahrnehmungen. Z Psychol 1928, 108:129-
154.

5009. Baldwin, J.M. La mémoire affective
en l'art. Rev philosophique de la France
et de l'étranger 1909, 67:449-460.

5010. Balint, M. Notes on the dissolution
of object-representation in modern art.
JAAC 1952, 10:323-327.

5011. Baranova, F., et al. (The question of
the representation in pictures of the space
and size of objects.) Psikhologie 1932,
No. 4, 23-53.

5012. Barbieri, A. Gli studi psycho-fisici
ed i prodotti dell'arte. Florence: Sieber
1904, 203 p.

5013. Barkla, D., and F.J. Langdon. The
part played by shadows in drawing. Occu-
pational Psychol 1959, 33:46-53.

5014. Barron, F. Creative vision and expres-
sion in writing and painting. In Conference
on the Creative Person. Berkeley: Univ
California, Institute of Personality Assess-
ment & Research 1961, Ch. 2.

5015. Bartlett, F.C. The function of images.
Brit J Psychol 1921, 11:320-337.

5016. Baruzi, J. La psychologie de l'art par
Henri Delacroix. Rev de Métaphysique et
de Morale 1929, 36:553-575.

5017. Bauermeister, H. Die Begabungsfrage
in der bildenden Kunst. Int Z indiv-Psychol
1929, 7:108-111.

5018. Baumstein-Heissler, N. À propos du
dessin: quelques opinions et travaux de
psychologues soviétiques. Enfance 1955,
8:377-399.

5019. Bazin, G. Sur l'espace en peinture:
la vision de Bracque. JPNP 1952, 45:439-
448.

5020. Bazin, H. In passing. Arts & Archi-
tecture 1960, 77:9.

5021. Bazzicalupo, C. (Types of constituion
in relation to art and sciences.) Gazz in-
ternaz med-chirugia (Naples) 1932, 40:
240-244.

5022. Becker, F. Tactual Learning and
Transfer of Geometric Forms. Master's
thesis. Clark Univ Thesis Abstracts 1931,
Vol. III.

5023. Beldoch, M. The Ability to Identify
Expressions of Feelings in Vocal, Graphic,
and Musical Communication. Dissertation
Abstr 1961, 22(4):1246.

5024. Belvés, P. Le portrait d'après nature.

Enfance 1950, 3:299-309.

5025. Berger, F. Sinn und Sinnlichkeit als
Grundproblem bildenen Ausdrucks. Z Psych
1931, 124:5-26.

5026. Berger, G. The psychology of painter.
(abstract). JAAC 1954, 13:125.

5027. Bernberg, R.E. Prestige suggestion in
art as communication. J soc Psychol 1953,
38:23-30.

5028. Binet, A. Le mystère de la peinture.
Année Psychol 1909, 15:300-315.

5029. ———. La psychologie artistique de
Tade Styka. Année Psychol 1909, 15:316-
356.

5030. Binet, A., and A. Binet. Rembrandt
d'apres un nouveau mode de critique d'art.
Année Psychol 1910, 16:31-50.

5031. Blackowski, S. Psychology and physi
ology applied to paintings. Kosmos 1937,
12:245-253.

5032. Blankner, F. Psychology of the arts
as vibrational design. School Arts 1950,
50:112-115.

5033. Blunck, E. Psychologische Beiträge
zur Frage der Behandlung des Raumes in
der ägyptischen Flachkunst und Plastik.
Arch ges Psychol 1924, 47:301-362.

5034. Bobon, J., and P. Roumeguère. Du
geste et du dessin magiques au néographi
conjuratoire. Acta Medica Belgica 1957,
815-829.

5035. Börner, W. Die Kunstlerpsychologie
im Altertum. Z Aesth 1912, 7:82-103.

5036. Boisbaudran, L. de. The Training of
the Memory in Art and the Education of the
Artist. London: Macmillan 1914, 183 p;
Paris: Laurens 1879, 1922, 177 p.

5037. Booth, G. Art and Rorschach. Benning
ton College Alumnae Quart 1956, 7:3-12.

5038. Bord, B., and J. Avalon. (Psychologic
and medical interest of Thomas Rowland-
son's work.) Aesculape 1931, 21:202, 257.

5039. Bordin, E.S. Psychology of the artist.
In Encyclopedia of the Arts. NY: Philo-
sophical Library 1945, 71-72.

5040. Borg, W.R. Personality characteristic
of a group of college art students. J educ
Psychol 1952, 43:149-156.

5041. Bouleau, C. The Painter's Secret
Geometry. NY: Harcourt, Brace & World 19

5042. Boyd, M. Evocative drawing and pai
ing. School Arts 1962, 61:23-26.

5043. Brengelmann, J.C. Grösse und Verän-
derung der Grösse von Reproduktionen als
Mass des Bewegungsausdrucks. Z diagnos
Psychol 1955, 3:23-33.

5044. Bricon, E. Psychologie d'art: Les
Maîtres de la fin du XIX siècle. Paris:
Wourrit 1900.

5045. Brighouse, G. The effects of protract

observation of a painting. Psychol Bull
1939, 36:552.

5046. Broad, C.D. Emotion and sentiment.
JAAC 1954, 13:203-214.

5047. Broeckx, J.L. Enkele beschouwingen
over de psychologische grondslagen van
de hedendaagse kunst. Dialog 1961-62,
2:162-170.

5048. Brown, E.A., and L.P. Goitein. The
significance of body image for personality
assay. JNMD 1943, 97:401-408.

5049. Bullough, E. Mind and medium in art.
Brit J Psychol 1920-21, 11:26-46.

5050. Burk, F. The genetic versus the logi-
cal order in drawing. Ped Sem 1902, 9:
296-323.

5051. Burkhardt, H. Über Verlagerung räum-
licher Gestalten. Neue psychol Stud 1933,
7:158.

5052. Burns, R. Some correlations of design
with personality. In Research in Art Edu-
cation. 9th Yearbook. Kutztown, Pa.: Na-
tional Art Educ Ass 1959, 125-130.

5053. Buschor, E. Technisches Sehen; Fest-
rede gehalten in der öffentlichen Sitzung
der Bayerischen Akademie der Wissen-
schaften in München am 28 Oktober 1949.
München: Beck 1952, 34 p.

5054. Buswell, G.T. How People Look at
Pictures. A Study of the Psychology of Per-
ception in Art. Chicago: Univ Chicago Pr
1935, 198 p.

5055. Cain, T. Psychology of drawing and
painting. In Encyclopedia of the Arts. NY:
Philosophical Library 1945, 817-820.

5056. Calas, N. Iconolatry and iconoclasm.
College Art J 1949, 9(2):129-141.

5057. Cameron, N. Functional immaturity
in the symbolization of scientifically
trained adults. J Psychol 1938, 6:161-175.

5058. ———. Individual and social factors
in the development of graphic symboliza-
tion. J Psychol 1937, 5:161-184.

5059. Campbell, D.M. The Figure-Field
Relationship in My Painting. Dissertation
Abstr 1962, 22:3597-3598.

5060. Campbell-Fisher, I.G. An experiment
on the expressiveness of shell and textile
montages. J exp Psychol 1950, 40:523-526.

5061. Carington, W. Experiments on the
paranormal cognition of drawings. IV. Proc
Soc psychical Res (London) 1944, 47:155-
228.

5062. Carington, W., and R. Heywood. Some
positive results from a group of small ex-
periments. Proc Soc psychical Res (London)
1944, 47:229-236.

5063. Carmichael, L., H.P. Hogan, and A.A.
Walter. An experimental study of the ef-
fect of language on the reproduction of

visually perceived form. J exp Psychol 1932,
15:73-86.

5064. Cassou, J. La nostalgia du metiér.
JPNP 1951, 44:185-194.

5065. Champigneulle, B. L'inquiétude dans
l'art aujourd'hui. L'Amour de l'Art 1937,
18:17-22, 51-56, 77-82, 296-300.

5066. Charlson, P. "Distortion." Art J 1963-
64, 23(2):127-129.

5067. Charouni, J.I.A. (The psychology of
artistic expression: an introspective study.)
Egypt J Psychol 1947, 2:487-499.

5068. Christensen, E.O. Psychology of art.
Univ North Dakota Bull 1925, 3; 1926, 4.

5069. ———. Unconscious motivation in
Gothic art. J clin exp Psychopath 1945,
6:581-599.

5070. Clark, K. The blot and the diagram.
Art News 1962, 61(8):28-31, 70-75.

5071. Comalli, P.E. Studies in physiognomic
perception: VI. Differential effects of direc-
tional dynamics of pictured objects on real
and apparent motion in artists and chemists.
J Psychol 1960, 49:99-109.

5072. Comalli, P.E., H. Werner, and S. Wap-
ner. Studies in physiognomic perception:
III. Effect of directional dynamics and
meaning-induced sets on autokinetic mo-
tions. J Psychol 1957, 43:289-299.

5073. Cook, M. A preliminary study of the
relationship of differential treatment of
male and female headsize in figure draw-
ing to the degree of attribution of the so-
cial function of the female. Psychol News-
letter 1951, 34:1-5.

5074. Cooper, C.W. The Arts and Humanity;
A Psychological Introduction to the Fine
Arts. NY: Philosophical Library 1952, 334 p.

5075. Cooper, L.P. Analysing art. Design
1939, 40:12-14.

5076. Cory, C.E. Drawing—a subconscious
phenomenon. J abnormal Psychol 1920, 14:
369.

5077. Costa, A. Alcune osservazioni sul
paesaggio nell'arte cinese in rapporto con
lo sviluppo psicologico del popolo cinese.
Arch ital di psicol 1932, 10:167-182.

5078. ———. Remarks on the psychology of
art. Acta psychol 1958, 14:1-11.

5079. Dannenberg, O. Auslese und Berufs-
beratung der künstlerisch Begabten. Prak-
tische Psychologie (Leipzig) 1920, 1:150.

5080. Danz, L. A Psychologist Looks at Art.
NY: Longmans, Green 1937, 245 p.

5081. David-Schwarz, H. Die Kunst als
seelische Kraftquelle für die Frau. Psy-
chologische Rundschau 1931, 3:52-53.

5082. Davidson, A.J. Cultural Differences
in Personality Structure as Expressed in
Drawings of the Human Figure. Disserta-

tion Abstr 1954, 14:394.

5083. Davis, R. The fitness of names to drawings: a cross-cultural study in Tanganyika. Brit J Psychol 1961, 52:259-268.

5084. Davis, R.G. Art and anxiety. Partisan Rev 1945.

5085. Dawson, A.M. von B. Proficiency Levels Attainable in the Study of Art by Aging Persons and the Concomitant Changes in Activities and Interests. Dissertation Abstr 1962, 23:149.

5086. DeBuck, A. Un chapître de psychologie égyptienne. Chronique d'Égypte 1946, 21:17-24.

5087. Deckert, H. Zum Begriff des Porträts. Marburger Jahrbuch für Kunstwissenschaft 1929, 5:261-282.

5088. Deeb, B. (Art: its nature and its cognitive implications.) Egypt J Psychol 1953, 8:361-382.

5089. DeFursac, R., and E. Minkowski. Contribution à l'étude de la pensée et l'attitude d'artistes. Encéphale 1923, 18: 217-228.

5090. Degand, L. De la figuration et de l'abstraction en peinture. JPNP 1949, 42: 129-142.

5091. ———. Langage et signification de la peinture en figuration et en abstraction. Boulogne-sur-Seine: Éditions de l'Architecture d'aujourd'hui 1956, 141 p.

5092. DeGroot, A.D. (The term "I do not know what" in art.) Ned Tijdschr Psychol 1951, 6:235-263.

5093. Deignan, F.J. Note on the values of art students. Psychol Reports 1958, 4:566.

5094. Delacroix, H. Psychologie de l'art. Essai sur l'activité artistique. Paris: Alcan 1927, 483 p.

5095. DelGreco, F. Pazzi e delinquenti nelle opere d'arte. Boll Manicomio Prov Ferrara 1898, 26:8-15.

5096. Del-Negro, W. Die Wandlungen der psychologischen Grundansicht und ihre Spiegelung in Gesellschaftsaufbau und Kunstentwicklung. Ned Tidschr Psychol 1935, 3:89-106.

5097. Dennis, W. Handwriting conventions as determinants of human figure drawings. J consult Psychol 1958, 22:293-295.

5098. Dennis, W., and E. Raskin. Further evidence concerning the effects of handwriting habits upon the location of drawings. J consult Psychol 1960, 24:548-549.

5099. Déonna, W. De la planète Mars en terre sainte. Art et subconscient: un médium peintre: Hélène Smith. Paris: Boccard 1932, 410 p.

5100. Deri, M. Kunstpsychologische Untersuchungen. Z Aesth 1912, 7:1-67, 194-265.

5101. ———. Die Malerei im 19 Jahrhundert entwicklungsgeschichtliche Darstellung auf psychologischer Grundlage. Berlin: Cassirer 1919, 2 Vols.

5102. ———. Versuch einer psychologischen Kunstlehre. Stuttgart: Enke 1912, 138 p.

5103. DeSantis, M. (The importance of artist's knowing anatomy and constitution types.) Rev sanitaria siciliana (Palermo) 1937, 25:339-353.

5104. Dickson, T.E. The criterion of accuracy in representational art. Brit J educ Psychol 1934, 4:170-182.

5105. ———. Relation of recent aesthetic an psychological research to art education. J Educ (London) 1941, 73:240.

5106. Dima, A. Realitatile sociale ale arte. Archiva pentru Sti Reforma soc 1936, 14: 760-782.

5107. Doesschate, G. ten. Imaginary space in painting. Ophthalmologica 1951, 122: 46-50.

5108. Doms, F.P. Les échelles Gaublomme Le graphisme et l'expression graphique. Sem univ Pédag Univ de Bruxelles 1935, 1:171-182.

5109. ———. Le graphisme et l'expression graphique. Sem univ Pédag Univ de Bruxelles 1935, 1:209-224.

5110. Donald, A. Psychologie des Kunstsammelns. Bibliothek für Kunst No. 9. Berlin: Schmidt 1911, 156 p.

5111. Dorcus, R.M. Experimental study of forms of expression. Char Pers 1933, 2: 168-176.

5112. Dorfles, G. Arte e psicologia. Aut Au 1952, 2:433.

5113. Dougherty, M.F. A Study of the Influence of a Creative Arts Laboratory on Selected Personality Characteristics of College Students. Dissertation Abstr 1960 20:3183-3184.

5114. Dreher, E. Die Kunst in ihrer Beziehung zur Psychologie. Berlin 1875.

5115. Drepperd, C.W. The Woodworth principle of psychological analysis applied to art by the American people. Art in America 1945, 33:133-138.

5116. Drevdahl, J.E., and R.B. Cattell. Personality and creativity in artists and writers. J clin Psychol 1958, 14:107-111.

5117. Dublineau, J., and J-P. Soboul. Dessi et sens spatial: le goût du dessin chez les gauchers. Ann méd-psychol 1953, 111 76-80.

5118. Dunkel, H.B. General Education in the Humanities. Washington, D.C.: American Council on Education 1947, 321 p.

5119. Egerland, J. Wesen und Pflege des Vorstellungszeichnens nach der Britschen

Kunsttheorie. Doctoral dissertation. Munich 1932.

5120. Ehrenzweig, A. Art and Artists. Berkeley: Univ California Pr 1956.

5121. Eiduson, B.T. Artist and nonartist: a comparative study. J Personality 1958, 26:13-28.

5122. Eindhoven, J.E., and W.E. Vinacke. Creative processes in painting. J gen Psychol 1952, 47:139-164.

5123. Eisen, G.A. Inhalation in art and the action of the emotional centers in the human figure. Art Digest 1935, 9:31.

5124. Eisenberg, H.F. Psychological aspects of teaching art. High Points 1947, 29:52-55.

5125. Elzenberg, H. La personnalité créatrice de l'artiste. Proc 10th Int Congress of Philosophy 1948-49, 520-522.

5126. Espla, O. Vues sur l'art. JPNP 1947, 40:403-424.

5127. Estes, S.G. Judging personality from expressive behavior. J abnorm soc Psychol 1938, 33:217-236.

5128. Fairbairn, W.R.D. Prolegomena to a psychology of art. Brit J Psychol 1938, 28:288-303.

5129. Farner, G.A. Das Erfassen der Weiblichkeit. Eine experimentelle psychologische Untersuchung auf Grund von Bildbetrachtungen. Zurich: Univ Zurich 1927, 111 p.

5130. Faulkner, R. Educational research and effective art teaching. J exp Educ 1940, 9:9-22.

5131. ———. Evaluation in art. J educ Res 1942, 35:544-554.

5132. ———. Evaluation in a general art course. J educ Psychol 1940, 31:481-506.

5133. Feibleman, J.K. The psychology of art appreciation. J gen Psychol 1946, 35: 43-57.

5134. ———. The psychology of the artist. J Psychol 1945, 19:165-189.

5135. Fiedler, W.E. Die Seelensprache... in Traum-, Kunst- und Alltagsleben. Leipzig: Mutze 1912.

5136. Fisher, C. (Apropos of the Poetzl phenomenon. The subliminal effects of visual stimulation on dreams, images and hallucinations.) Évolut Psychiat 1959, 4: 541-566.

5137. Fisher, S. Body reactivity gradient and figure drawing variables. J consult Psychol 1959, 23:54-59.

5138. Fisichelli, V.R., and L. Welch. The ability of college art majors to recombine ideas in creative thinking. J appl Psychol 1947, 31:278-282.

5139. Flemming, E.F. Personality and artistic talent. J educ Sociol 1934, 8:27-33.

5140. Flory, C.D. The effect of art training on mirror drawing. J exp Psychol 1936, 19:99-105.

5141. Fraenkel, E. De l'expression à l'essence. Rev de Philos 1963, 153:67-74.

5142. Francastel, P. Art et psychologie; explorations et théories de ce demi-siècle. JPNP 1954, 47-51, 188-208.

5143. Frank, L.K. The integrative role of the arts in personality. Eastern Arts Ass Yrbk 1950.

5144. Frankl, V.E. Kunst und Geisteskrankheit. Universitas 1958, Heft 3.

5145. Freimark, R. Why a painter has to paint. School Arts 1962, 62:19-21.

5146. Friedlander, M.I. An art expert's observations on personality. Char Pers 1932, 1:75-78.

5147. Funke, M.R. Psychologische Grundelemente in der Kunst. Monatshefte für Kunstwissenschaft 1915, 8:84-96.

5148. Gaffron, M. Right and left in pictures. Art Quart 1950, 13(4):312-331.

5149. Galli, E. La coscienza nella formazione dell'opera d'arte. Riv di Psicologia Normale e Patologia 1932, 27:107-114, 185-193, 275-284.

5150. Gantert, F. (Graphic expression of constitutional types.) Z menschl Vererbungs Konstitutionslehre 1955, 33:221-264.

5151. Gatti, E. Le valutazioni scholastiche nell'ambito dell'orientamento professionale. Insegnamento del disegno a mano libera e professionale. Riv di Psicologia Normale e Patologie 1942, 38:43-76.

5152. Gaülke, J. Zur Psychologie der Kunst. Die Gegenwart 1916, 45:492-495.

5153. George, W. Maître de l'énergie intérieure: Géricault et La Fresnaye. L'Amour de l'Art 1935, 16:349-355.

5154. Gibbs, C.B., M. Farr, and G.G. Baines. Psychology and design: a symposium. Bull Brit psychol Soc 1956, 30:39-42.

5155. Gibson, J.J. Perception as a function of stimulation. In Koch, S. (ed.), Psychology: A Study of a Science. NY: McGraw-Hill 1959, 456-502.

5156. ———. Perception of visual surfaces. Amer J Psychol 1950, 63:367-384.

5157. ———. The Perception of the Visual World. Boston: Houghton Mifflin 1950, 235 p.

5158. ———. Pictures, perspective and perception. Daedalus 1960, 89:216-227.

5159. ———. The reproduction of visually perceived forms. J exp Psychol 1929, 12: 1-39.

5160. ———. A theory of pictorial perception. Audio-Visual Comm Rev 1954, 1:3-23.

5161. ——. What is form? Psychol Rev 1951, 58:403-412.

5162. Giese, F. Psychologie der Arbeitshand. Berlin: Urban & Schwarzenberg 1928, 320 p.

5163. Giraud, A. L'automatisme dans l'art. Paris: Rivière 1938, 128 p.

5164. Goja, H. Zeichenversuche mit Menschenaffen. Z für Tierpsychologie 1959, 16:370-373.

5165. Golann, S.E. Psychological study of creativity. Psychol Bull 1963, 60:548-565.

5166. Goldman, I.J. The Willingness of Music and Visual Art Students to Admit to Socially Undesirable and Psychopathological Characteristics. Dissertation Abstr 1962, 23(2):732.

5167. Gombrich, E.H. Art and Illusion. A Study in the Psychology of Pictorial Representation. London: Phaidon 1960, 355 p; NY: Pantheon 1960, 466 p.

5168. ——. On physiognomic perception. Daedalus 1960, 89:228-242.

5169. Gonzales, X. Mental process in painting. College Art J 1952, 12(1):16-17.

5170. Gordon, D.A. Experimental psychology and modern painting. JAAC 1951, 9:227-243.

5171. ——. Individual differences in the evaluation of art and the nature of art standards. J educ Res 1956, 50:17-30.

5172. Gottlieb, C. Modern art and death. In Feifel, H. (ed.), The Meaning of Death. NY: McGraw-Hill 1959, 157-188.

5173. Granit, A.R. A study of the perception of form. Brit J Psychol 1921, 12:233-247.

5174. Grassberger, R. Der Einfluss der Ermüdung auf die Produktion in Kunst und Wissenschaft. Leipzig, Vienna: Deuticke 1912.

5175. Graumann, C.F. Grundlagen einer Phänomenologie und Psychologie der Perspekivität. Berlin: De Gruyter 1960, 144 p.

5176. Grautoff, (?). Formzertrümmerung und Formaufbau in der bildenden Kunst. Berlin 1919.

5177. Gregor, H.L. Clarification of an Artistic Position with Reference to Gestalt Perceptual Principles. Dissertation Abstr 1960, 21:842.

5178. Grünberg, H. Els pintors i la grafologia. Rev di Psicologia y Pedagogia 1936, 4:261-265.

5179. Guilford, J.P. Creative abilities in the arts. Psychol Rev 1957, 64:110-118.

5180. Guillaume, P. Psychologie de la forme. Paris: Flammarion 1937.

5181. Gutierrez, N.C. Hacía una concepcion biológica del arte. Amauta 1929, 22:17-31.

5182. Haack, T. Das Rechts-Links-Problem und die Bewegungsrichtungen der bildende Kunst. Z angew Psychol 1938, 54:32-39.

5183. Häberlin, P. Symbol in der Psycholog und Symbol in der Kunst. Bern: Benteli 191 32 p.

5184. Haecker, V., and T. Ziehen. Beitrag zur Lehre von der Vererbung und Analyse der zeichnerischen und mathematische Bec bung, inbesondere mit Bezug auf die Korrelation zur musikalischen Begabung (Schluss). Z Psychol 1931, 121.

5185. Hare, D. Spaces of the mind. Magazine of Art 1950, 43:48-53.

5186. Harms, E. The psychology of formal expression. J genet Psychol 1946, 69:97-120.

5187. ——. Struktur-psychologische Analys von Kunstwerken. In II Congres int Esthét Sci Art 1937. Paris: Alcan 1938, 1-4.

5188. Harré, R. Art and psychology. Ratio 1959, 2:70-79.

5189. Hartlaub, G.F., and F. Weissenfeld. Gestalt und Gestaltung; das Kunstwerk al Selbstdarstellung des Künstlers. Krefeld 1958.

5190. Hausman, J.J. Toward a discipline of research in art education. JAAC 1959, 17: 354-361.

5191. Heaton, M.L. The inheritance óf artis tic traits. Eugenical News 1932, 16:211-213.

5192. Henkes, R. Art and the professional guidance counselor. School Arts 1961, 60: 7-8.

5193. ——. Painting toward intuition. Scho Arts 1963, 62:11-13.

5194. Henry, W.E. Exploring Your Personali Chicago: Science Res Ass 1952, 49 p.

5195. Hildreth, G. The simplification tendency in reproducing designs. J genet Psy 1944, 64:329-333.

5196. Hill, A. L'art contra la maladie. Pari Vigot 1947, 128 p.

5197. Hippius, M.T. Graphischer Ausdruck von Gefühlen. Z angew Psychol 1936, 51: 257.

5198. Hirn, Y. The Origins of Art—A Psychological and Sociological Inquiry. London 1900.

5199. ——. The psychological and sociological study of art. Mind (N.S.) 1900, 9: 512-522.

5200. Hirt, E. Bemerkungen zur Psychologi der Kunst und des künstlerischen Schaffer Annalen der Naturphilosophie 1903, 2:34-44.

5201. Hocke, G.R. Die Welt als Labyrinth. Manier and Manie in der europaïschen Kunst. Hamburg 1957, 252 p.

5202. Holland, J.L. A Study of Measured Personality Variables and Their Behavioral Correlates As Seen in Oil Paintings. Dissertation Abstr 1952, 12:380-381.

5203. Holloway, O.E. Perspective in the arts of space and time. Egypt J Psychol 1946, 2:22-38.

5204. Holtgrewe, A. Die Bedeutung "wahrer" und "nichtwahrer" Kunst für unser Leben. Int Z indiv-Psychol 1932, 10:439-446.

5205. Homma, T. (The law of Prägnanz in the process of drawing figures.) Jap J Psychol 1937, 12:112-153.

5206. Honkavaara, S. The color and form reaction as a basis of interpersonal relationships. J Psychol 1958, 46:33-38.

5207. ———. On the Psychology of Artistic Enjoyment. Helsinki: Suomalainen Tiedeakatemia 1949, 161 p.

5208. ———. The psychology of expression. Brit J Psychol Monogr Suppl 1961, 96 p.

5209. Hoop, J.H. van der. Over psychologische benadering van kunst. Psychiatrische en neurologische bladen (Amsterdam) 1941, 2.

5210. Howard, R. The artist's vision. Parnassus 1941, 13:169-173.

5211. Hudson, W. Pictorial depth perception in sub-cultural groups in Africa. J soc Psychol 1960, 52:183-208.

5212. Humphrey, B.M. The relation of ESP to mode of drawing. J Parapsychology 1949, 13:31-47.

5213. ———. Success in ESP as related to form response drawings: I. Clairvoyance experiments. J Parapsychology 1946, 10:78-106.

5214. Hungerland, H. Self-discovery through painting and drawing. Progressive Educ 1937, 14:260-267.

5215. Hutchinson, W.O., W.G. Whittaker, and R.W. Pickford. Symposium on the psychology of music and painting. Brit J Psychol 1942, 33(1).

5216. Huyghe, R. Vers une psychologie de l'art. Rev des Arts 1951, 1:131-142, 229-242.

5217. Ignatiev, E.I. (Problems in the psychological analysis of the process of drawing.) Izvestiia Akademii Pedgagogischeskikn Nauk RSFSR 1950, No. 25, 71-116.

5218. Ignatiev, E.I., V.I. Kireenko, and S.G. Kaplanova (eds.). (Psychology of Drawing and Painting. Problems of the Psychological Study of the Forming of the Image.) Moscow: Akad Pedag Nauk RSFSR 1954, 224 p.

5219. Irwin, F.W., and E. Newland. A genetic study of the naming of visual figures.

J Psychol 1940, 9:3-16.

5220. Isaacs, A.F. Sources of motivation in creatively gifted adults. Gifted Child Quart 1961, 5:63-64.

5221. Israeli, N. Creative art: a self-observation study. J gen Psychol 1962, 66:33-45.

5222. ———. Creative processes in painting. J gen Psychol 1962, 67:251-263.

5223. ———. Social interaction in creation and criticism in the fine arts. J soc Psychol 1952, 35:73-89.

5224. Itagaki, T. (The personality of an artist and the social structure.) Bigaku (Tokyo) 1959, 10(1).

5225. ———. (Personality and type.) Bigaku (Tokyo) 1952, 2(3).

5226. Jacobi, J. Complex, Archetype, Symbol. London: Routledge & Kegan Paul 1959, 230 p.

5227. Jacquot, J. (ed.). Visages et perspectives de l'art moderne: Peinture, poésie, musique. Paris: Centre National de la Recherche Scientific 1956, 209 p.

5228. Jaensch, E.R. Studien zur psychologischen Aesthetik und Kunstpsychologie mit pädagogischen Anwendungen. Langensalza: F. Mann's Pädag Magazin 1933, 14.

5229. Jahoda, G. Sex differences in preferences for shapes: a cross-cultural replication. Brit J Psychol 1956, 47:126-132.

5230. Jensen, B.T. Left-right orientation in profile drawing. Amer J Psychol 1952, 65:80-83.

5231. Joesten, E. Eidetische Anlage und bildnerisches Schaffen. Arch ges Psychol 1929, 71:493-539.

5232. Johnson, R.E. Fine arts as a means of personality integration. School Rev 1948, 56:223-228.

5233. Jones, T.D. An instrument for the study of composition and design. Amer J Psychol 1944, 57:87-92.

5234. Jonesco, V. La personnalité du génie artiste. Paris 1930, 310 p.

5235. Joteyko, J., and V. Kipiani. Rôle du sens musculaire dans le dessin. Rev de Psychol 1911, 4:362.

5236. Juda, A. Über das Vorkommen von gleichen und ähnlichen Begabungsanlagen in den Familien von hochbegabten Künstlern und etwaige Korrelationen zu anderen hervorstechenden Begabungen. Allgemeine Z für Psychiatrie (Berlin) 1940, 116:20.

5237. Judd, C.H. The psychology of the fine arts. Elem School J 1925, 25:414-423.

5238. Kaden, W.E., S. Wapner, and H. Werner. Studies in physiognomic perception: II. Effect of directional dynamics of pictured objects and of words on the position of

apparent horizon. J Psychol 1955, 39:61-
70.

5239. Kahn, R. Inheritance of ability in
drawing. Eugenical News 1931, 16:42.

5240. Kainz, F. Ein Beitrag zur Werk- und
Leistungspsychologie des höheren Gefühls-
lebens. Z Psychol 1934, 132:18-82.

5241. ——. Gestaltgesetzlichkeit und Orna-
mententwicklung. Z angew Psychol 1927,
28:267-327.

5242. ——. Das Steigerungsphänomen als
künstlerisches Gestaltungsprinzip. Leip-
zig: Barth 1924; Z angew Psychol 1924,
33.

5243. Kankeleit, O. Das Unbewusste als
Keimstätte des Schopferischen: Selbst-
zeugnisse von Gelehrten, Dichtern und
Künstlern. Münich: Reinhardt 1957, 192 p.

5244. Kaplan, L.P. Versuch einer Psycho-
logie der Kunst. Baden-Baden: Merlin
1930, 247 p.

5245. Karrenberg, C. Der Mensch als
Zeichenobjekt. Leipzig 1910.

5246. Katz, D. Experimentelle Psychologie
und Gemäldekunst. Bericht über den V
Kongress für exper Psychol. Leipzig:
Barth 1912, 165-169.

5247. ——. Studien zur experimentellen
Psychologie. Basel: Schwabe 1953, 130 p.

5248. Keitel, F. Zur Methodik der psycho-
logischen Untersuchung des Ornamen-
tierens. Z pädag Psychol 1912, 13:394-
396.

5249. Kellerer, C. Weltmacht Kitsch. Ist
Kitsch lebensnötwending? Mit 12 Zeich-
nungen von Hans Beck. Stuttgart: Europa
1957, 99 p.

5250. Kenczler, H. Über die Psychologie
des künstlerischen Schaffens. Arbeiten
aus dem Gebiete der moderne Philosophie
1910, 324-341.

5251. Kennedy, A. The mood-projections of
Walt Ruhman. J ment Sci 1960, 106:827-
830.

5252. Kerschensteiner, G. Über die Ent-
wicklung der zeichnerischen Begabung.
Münich: Gerber 1905.

5253. Kido, M. (Analysis of religious con-
sciousness as manifested in the art of
the Madonna.) Jap J Psychol 1924, 4, No. 1.

5254. Kiener, H. Die Geheimnisse der In-
spiration. Die Kunst 1934, 69:134-138.

5255. Kienzle, R. Das bildhafte Gestalten
als Ausdruck der Persönlichkeit. Esslingen:
Burgbücherei 1932, 180 p.

5256. Kireenko, V.I. (The Psychology of
Abilities for Artistic Creativity.) Moscow:
RSFSR Acad Pedag Sciences 1959, 304 p.

5257. Klages, L. Ausdrucksbewegung und
Gestaltungskraft; Grundlegung der Wissen-

schaft von Ausdruck. Leipzig: Barth 1923,
205 p; 1950.

5258. Klein-Diepold, R. Zur Psychologie
des künstlerischen Schaffens. Rheinlands
1918, 18:33-39.

5259. Klinger, M. Malerei und Zeichnung.
1907.

5260. Köhler, W. La psicologia della forma.
Milan: Feltrinelli 1962.

5261. Koffka, K. Problems in the psycholog
of art. Bryn Mawr Notes Monogr 1940, 9:
180-273.

5262. Kopfermann, H. Psychologische Unte
suchungen über die Wirkung zweidimen-
sionaler Darstellungen körperlicher Ge-
bilde. Psychol Forsch 1930, 13:292-364.

5263. Krause, W. Experimentelle Unter-
suchungen über die Vererbung der zeich-
nerischen Begabung. I. Z Psychol 1932,
126:86-145.

5264. Krauss, R. Über graphischen Ausdruc
Eine experimentelle Untersuchung über da
Erzeugen und Ausdeuten von gegenstands
freien Linien. Z angew Psychol 1930, Bei-
heft 48, 141 p.

5265. Kreibig, J.K. Beiträge zur Psychologi
des Kunstschaffens. Z Aesth 1909, 4:523-
558.

5266. Kroeber, A.L. Configurations of Cul-
ture Growth. Berkeley: Univ California Pr
1944, 882 p.

5267. Kröber, W. Über das Aufzeichnen vo
Formen aus dem Gedächtnis. Z angew Psy
chol 1938, 54:273-327.

5268. Külpe, O. The conception and classi
fication of art from a psychological stand
point. Univ Toronto Studies in Psychol 19
2(1):1-26.

5269. Kynast, K. Allgemeine Aesthetik mit
einer werttheoretischen und psychologisc
Voruntersuchung und einer Analyse des
kunstlerischen Schaffens. Leipzig: Bohlis
Volger 1910, 122 p.

5270. Lacoste, D.F. Peinture spirite. Paris
Méd 1933, April.

5271. Lafora, G.R. A psychological study
of cubism and expressionism. In Don Juar
and Other Psychological Studies. London:
Butterworth 1930, Ch. 5; Madrid: Bibliot
Nueva 1927; Arch de Neurobiologia (Madr
1922, 3:119-155.

5272. Laforgue, R. Erlebnis, Struktur und
Bildgestaltung. Praxis der Psychotherapie
1960, 5:260-265.

5273. Laignel-Lavastine, M. (Hermaphrodi
in art and literature.) Progrès médicale (P
1920, 35:399.

5274. Lalo, C. Étude critique: la "Psycholo
de l'art" de H. Delacroix. JPNP 1927, 24:
169-183.

5275. ——. Sur la psychologie comparée de l'artiste, de l'amateur et du public. JPNP 1927, 24:323-340.

5276. ——. La vision deformante du Gréco; Essai d'esthétique appliquée. JPNP 1932, 29:590-646.

5277. Lange, B. Zur Psychologie des Zeichenunterrichte. Int Z indiv-Psychol 1933, 11:295-301.

5278. Langeard, P. L'intersexualité dans l'art. Psychologie intersexuelle. Montpellier: Thèse de Méd 1936, No. 9.

5279. Langfeld, H.S. Conflict and adjustment in art. In Campbell, C.M., et al. (eds.), Problems of Personality. NY: Harcourt, Brace 1925, 373-383.

5280. Langford, R.C. Ocular behavior and the principle of pictorial balance. Psychol Bull 1933, 30:679.

5281. Langsner, J. The perplexed eye. Arts & Architecture 1948, 65:24.

5282. Lark-Horovitz, B., and F.H. Keith. The rôle of the psychologist in the art museum. J consult Psychol 1942, 6:82-84.

5283. Lawlor, M. Cultural influences on preference for designs. J abnorm soc Psychol 1955, 61:690-692.

5284. ——. An investigation concerned with changes of preference which are observed after group discussion. J soc Psychol 1955, 42:323-332.

5285. Lee, V. Psychologie d'un écrivain sur l'art. Rev philosophique de la France et de l'étranger 1903, 56:225-254.

5286. Lehman, H.C. Art and psychology. Canadian Art 1948, 6(1):16-18.

5287. ——. The creative years: oil paintings, etchings and architectural works. Psychol Rev 1942, 49:19-42.

5288. ——. Some examples of creative achievement during later maturity and old age. J abnorm soc Psychol 1949, 30:49-79.

5289. Lerolle, G. Personality and originality in art. Carnegie Magazine 1935, 9:173-177.

5290. Levy, F.N. Vocational guidance in the design arts. Education 1932, 52:390-395.

5291. Lewandowski. H. Das Sexualproblem in der modernen Literatur und Kunst... seit 1800. Dresden: Arets 1927.

5292. Lewis, N.D.C. The practical value of graphic art in personality studies. Psychoanal Rev 1925, 12:316-322.

5293. Lhermitte, J. (New psychophysiologic studies of painting; body image in pictorial space.) Presse méd 1955, 63:1856-1861.

5294. Lhote, A. L'inconscient dans l'art. Gazette des Beaux-Arts 1936, 16:113-123.

5295. Licurzi, A. Artistas delincuentes y delincuentes artistas. Rev de Psiquiatría y Criminalia (Buenos Aires) 1941, 6:455-468.

5296. Liebold, W. Elementare gestaltpsychologische Fragen der Ornamentik. Giessen Dissertation 1931; Weida: Thomas & Hubert 1934, 49 p.

5297. Lindemann, E. Experimentalle Untersuchungen über das Entstehen und Vergehen von Gestalten. Beiträge zur Psychol d Gestalt, VII. Psychol Forsch 1922, 2:5.

5298. Löwenfeld, L. Über die geniale Geisteshätigkeit mit besonderer Berücksichtigung des Genies für bildende Kunst. Wiesbaden: Bergmann 1903, 104 p.

5299. Loewenstein, R. Artistic creation and reverie. Formes 1930, 10:22-24.

5300. Lombroso, C. The Man of Genius. London: Scott 1895, 370 p.

5301. Lomer, G. Vom Doppelgeschlecht der künstlerischen Menschen. Gegenwart 1913(?), 51:2.

5302. Loomer, G.C. A study of certain effects on three types of learning experiences in art as revealed in the drawings of participants. J exp Psychol 1953, 22:65-102.

5303. Lorand, R.L. Family Drawings and Adjustment. Dissertation Abstr 1957, 17:1596.

5304. Lowenfeld, V. Current research on creativity. J Nat Educ Ass 1958, 47:538-540.

5305. Lowenfeld, V., and K. Beitell. Interdisciplinary criteria of creativity in the arts and sciences: a progress report. In Research in Art Education. National Art Educ Ass. 9th Yearbook. Kutztown, Pa.: National Art Educ Ass 1959.

5306. Luchins, A.S. Social influences on perception of complex drawings. J soc Psychol 1945, 21:257-273.

5307. Lukacs, P. Aspectos sociológicos y psicológicos de la pintura (el drama del pintor). Sanitago de Cuba 1953, 22 p.

5308. McCloy, W. Creative imagination in children and adults. Psychol Monogr 1939, 51, No. 5, 88-102.

5309. ——. Passive creative imagination. Psychol Monogr 1939, 51, No. 5, 103-107.

5310. McCloy, W., and N.C. Meier. Recreative imagination. Psychol Monogr 1939, 51, No. 5, 108-116.

5311. McCurdy, H.G. An interpretation and its analysis. Char Pers 1943, 11:312-317.

5312. McDermott, J.F., and K.B. Taft. Sex in the Arts. NY: Harper 1932, 346 p.

5313. McDougall, R. The colored words of art. Psychol Rev 1913, 20:505-516.

5314. McElroy, W.A. A sex difference in preference for shapes. Brit J Psychol 1954, 45:209-216.

5315. McFee, J.K. Visual Arts: Psychological Implications of Individual Differences in the "Perception-Delineation" Process. Dissertation Abstr 1957, 17:2502.

5316. ———. A study of "perception-delineation": its implication for art education. In Research in Art Education. 9th Yearbook. Kutztown, Pa.: National Art Educ Ass 1959. 9-14.

5317. MacKinnon, D.W. The nature and nurture of creative talent. Amer Psychologist 1962, 17:485-495.

5318. Malraux, A. Psychologie der Kunst. Literar Rev 1949, 117-122.

5319. Mandolini, H. (The problem of artistic creation.) Rev de Crimonologia, Psiquiatria y Medicina legal 1931, 18:434-438.

5320. ———. (Sexual conflicts in artistic genius.) Rev de Crimonologia, Psiquiatria y Medicina legal 1927, 14:471-481.

5321. Manzella, D. Effect of hypnotically induced change in the self-image on drawing ability. Studies Art Educ 1963, 4:59-67.

5322. March, C. Evolution and psychology in art. Mind 1896, 5:441-463.

5323. Marriott, C., A.B. Walkley, H.J. Watt, E. Bullough, and C.W. Valentine. Mind and medium in art. Brit J Psychol 1920, 11:1-56.

5324. Marti Ibañez, F. Experiment in correlation; the psychological impact of atomic science on modern art. Arts & Architecture 1953, 70(1):16-17; 70(2):18-19; 70(3):22-23.

5325. ———. The psychological impact of atomic science on modern art; an experiment in correlation. J clin exp Psychopath 1952, 13:40-67.

5326. Martin, A.W., and A.J. Weir. A comparative study of drawings made by various clinical groups. J ment Sci 1951, 97:532-544.

5327. Marzynski, G. Zwei Darstellungsprobleme der bildenden Kunst; psychologische Untersuchungen. Z Aesth 1920, 15:353-373.

5328. Mason, W.A. The psychology of object drawing. Education (Boston) 1894.

5329. Matsumoto, M. (Psychological aspects of the progress of formative art.) Jap J Psychol 1926, 1:1-22.

5330. ———. (A Psychological Interpretation of Modern Japanese Paintings.) Tokyo: Hokubunkan 1915, 608 p; 1928.

5331. ———. (Psychological motives of the most recent movement in French painting.) Report III Congress Jap Psychol Ass 1931.

5332. ———. (Psychological studies of technical methods of Chinese pictorial arts.) Geibun 1910. 1(3):1-19.

5333. Mead, M. The role of the arts in a culture. Eastern Arts Ass Yrbk 1950.

5334. Meier, N.C. Art ability without instruction or environmental background: case study of Loran Lockhart. Psychol Monogr 1936, 48:155-163.

5335. ———. Art in Human Affairs; An Introduction to the Psychology of Art. NY: McGraw-Hill 1942, 222 p.

5336. ———. The interlinkage of hereditary elements (ancestral occupations) with present artistic aptitude. Psychol Bull 1939, 36:623.

5337. ———. Introduction to studies in the psychology of art. Psychol Monogr 1933, 45, No. 1, v-viii.

5338. ———. The perception of abstractions in graphic form. Psychol Bull 1937, 34:75

5339. ———. Recent research in the psychology of art. Yrb nat Soc Stud Educ 1941, 40 379-400.

5340. ———. Reconstructive imagination. Psychol Monogr 1939, No. 5, 117-126.

5341. ——— (ed.). Studies in the Psychology of Art. Vol. I. Univ Iowa Studies in Psychology 1933, 175 p; Psychol Monogr 193 Nos. 200, 213, 45:1, 48:1.

5342. ——— (ed.). Studies in the Psychology of Art. Vol. II. Univ Iowa Studies in Psychology, No. 19. Psychol Monogr 1936, 48, No. 1, 176 p.

5343. Meyerson, I. Remarques sur l'objet. JPNP 1961, 58:1-10.

5344. Mitchell, C.W. A Study of Relationships between Attitudes about Art Experience and Behavior in Art Activity. Doctoral dissertation. Ohio State Univ 1957; In Research in Art Education. 9th Yearbook. Kutztown, Pa.: National Art Educ Ass 195 105-111.

5345. Möbius, P.J. Über Kunst und Künstle Leipzig: Barth 1901.

5346. ———. Über die Vererbung kunstleris Talente. Leipzig: Barth 1901.

5347. Mohr, F. Psychophysische Behandlungsmethoden. Leipzig: Hirzel 1925, 49

5348. Moldovan, K. The fascination of the pathological for the artist. Ciba Symposi 1961, 9:81-86.

5349. Molnar, E. Die Einstellung der Persönlichkeit und die Kunstbetrachtung. Arch ges Psychol 1933, 87:231-286.

5350. Monrad, N.J. Über den psychologisc Ursprung der Poesie und Kunst. Archiv für systematische Philosophie und Soziologi 1895, 1:347-362.

5351. Montale, E. La solitudine dell'artis Rome: Associazione italinana per la libe della cultura 1952, 24 p.

5352. Moore, J.E. The effect of art trainin

on mirror drawing. J exp Psychol 1927, 21:570-578.

5353. ——. Psychology and methods in the high school and college: art. Rev educ Res 1938, 8:7-10.

5354. Moore, J.S. Art as revelation. Design 1945, 47:3.

5355. Morgan, D.N. Creativity today. A constructive analytic review of certain philosophical and psychological work. JAAC 1953, 12:1-23.

5356. ——. Psychology and art today: a summary and critique. JAAC 1950, 9:81-96.

5357. Morsh, J.E., and H.D. Abbott. An investigation of after-images. J comp Psychol 1945, 38:47-63.

5358. Mosse, E.P. Psychological mechanisms in art production. Psychol Rev 1951, 38:66-74.

5359. Mould, L. Art teachers and psychology. School Arts 1954, 53:5-8.

5360. Mühle, G. Entwicklungspsychologie des zeichnerischen Gestaltens. Munich: Barth 1955, 165 p.

5361. Müller-Freienfels, R. Affekte und Triebe im künstlerischen Geniessen. Arch ges Psychol 1910, 18:249-264.

5362. ——. Die assoziativen Faktoren im aesthetischen Geniessen. Z Psychol 1909, 54:71-118.

5363. ——. Individuelle Verschiedenheiten des Affektlebens und ihre Wirkung im religiösen künstlerischen und philosophischen Leben. Z angew Psychol 1914, 9:1-2.

5364. ——. Individuelle Verschiedenheiten in der Kunst. Z Psychol 1908, 50:1-61.

5365. ——. Das künstlerische Geniessen und seine Mannigfaltigkeit. III. Die sichtbaren Künste. Z angew P ychol 1911, 4:65-105.

5366. ——. Künstlertum und Kunstpublikum. Kölner Z für Soziol u Sozialpsychol 1931.

5367. ——. Zur Psychologie der Erregungs- und Rauschzustände. Z Psychol 1910, 57:161-194.

5368. ——. Psychologie der Kunst; eine Darstellung der Grundzüge. 3 Vols.: I. Die Psychologie des Kunstgeniessens und des Kunstschaffens. II. Die Formen des Kunstwerks und die Psychologie der Wertung. III. Die Psychologie der eingelnen Künste. Leipzig: Teubner 1912-1933; München: Reinhardt 1933.

5369. ——. Psychologie der Künste. I. In Koffka, G. (ed.), Handbuch der vergleichenden Psychologie. München: Reinhardt 1922, 248 p.

5370. ——. Psychologie und Sociologie der modernen Kunst. Halle: Marhold 1926,

56 p; Deutsch Psychologie (Halle) 1926, 4:379-429.

5371. ——. On visual representation: the meaning of pictures and symbols. JAAC 1948, 7(2):112-121.

5372. Munro, T. The arts as psychological technics. In Evolution in the Arts. Cleveland: Cleveland Museum of Art 1963, 368-419.

5373. ——. Methods in the psychology of art. JAAC 1948, 6:225-235.

5373a. ——. Methods in the psychology of art, as set forth in recent German writings. In Department of Art Education Bulletin. Washington, D.C.: National Educ Ass 1941.

5373b. ——. Origini e storia della psicologia dell'arte. Enciclopedia Universale dell'Arte. Venice-Rome 1963.

5374. ——. The psychological approach to art and art education. In Art in American Life and Education. 40th Yearbook. National Soc Stud Educ. Bloomington, Ill.: Public School Pub 1941, 249-288.

5375. ——. A psychological approach to college art instruction. Parnassus 1933, 5:27-30; Art News 1934, 32:20; In Rusk (ed.), Methods in Teaching the Fine Arts. Chapel Hill, N.C.: Univ North Carolina Pr 1935.

5375a. ——. The psychological basis of symbolism in the arts. In Castelli, E. (ed.), Archivio di Filosofia 1956, 176-192.

5376. ——. Psychological limits to the complexity of works of art. In Evolution in the Arts. Cleveland: Cleveland Museum of Art 1963, 326-328.

5377. ——. Psychological and sociological approaches to art history. In Evolution in the Arts. Cleveland: Cleveland Museum of Art 1963, 115-117.

5378. ——. The psychology of art: past, present, future. JAAC 1963, 21:263-282; Teachers College Record 1963, 64:303-313; De Homine (Rome) 1963, 5/6:55-78.

5378a. ——. Types of form as related to the psychology of attention. In Atti del III Congresso internazionale di estetica, Venice 1956. Torino 1957, 303-309.

5379. Munson, G. Psychology underlying the art activity program. Design 1936, 38:3-4.

5380. Munsterberg, E., and P.H. Mussen. The personality structure of art students. J Personality 1953, 21:457-466.

5381. Munsterberg, H. Psychology and art. Atlantic Mon 1898, 81:632-644.

5382. Murray, H.A. Personality and creative imagination. English Inst Ann 1942, 139-162.

5383. Mursell, J.L. The application of psy-

chology to the arts. Teachers College
Record 1936, 37:290-299.

5384. Nakashima, T. Time-relations of
affective processes. Psychol Rev 1909,
16:303-339.

5385. Naumburg, M. Art as symbolic speech.
JAAC 1955, 13:435-450.

5386. ———. Expanding non-verbal aspects
of art education on the university level.
JAAC 1961, 19:439-451.

5387. Nedeljković, D. (Ethnopsychological
elements of local accent in the art of
Southern Siberia.) Contr Phil Ethnopsychol
(Skoplje) 1931, No. 3.

5388. Nelson, H. The creative years. Amer
J Psychol 1928, 40:303-311.

5389. Nemitz, F. Persönlichkeit und rich-
tung. Deutsch Kunst u Dekoration 1930,
66:144-145.

5390. Netschajeff, A. Inspiration. Arch ges
Psychol 1929, 68:165-240.

5391. Oczeret, H. Zur Psychologie moderner
Kunst. Die Tat 1928, 11.

5392. Oelrich, W. Über die Wirksamkeit
künstlerischer Gestaltungsprinzipe auf
den psychologischen Prozess. Z angew
Psychol 1938, 79:91-118.

5393. Ogden, R.M. Naïve geometry in the
psychology of art. Amer J Psychol 1937,
49:198-216.

5394. ———. The pictorial representation
of distance. Psychol Bull 1908, 5:109-
113.

5395. ———. The Psychology of Art. NY:
Scribner's 1938, 291 p.

5396. O'Neill, F.R. The Relation of Art to
Life; A Sketch of an Art Philosophy. Psyche
Monogr No. 10. London: Routledge 1938,
232 p.

5397. ———. Social Value of Art. A Psycho-
logical and Linguistic Approach to an
Understanding of Art Activity. Psyche
Monogr No. 12. London: Routledge 1939,
232 p.

5398. Orschansky, J.G. (Artistic production
and psychological analysis.) Wiestnik
Wospitania (Moscow) 1915, 5.

5399. Østlyngen, E. (Problems with unequal
distribution of right- and left-turned draw-
ings.) In Nordisk Psyckologmøte i Oslo
1947: Fordhandlinger. Oslo: Gyldendal
1948, 101.

5400. Pal, S.K. Psychology of art. Shiksa
1955, 7(4):120-122.

5401. Panneborg, H.J., and W.A. Panneborg.
Die Psychologie der Künstler. Beitrag zur
Psychologie des Bildhauers. Z angew
Psychol 1921, 16:25-39.

5402. ——— & ———. Die Psychologie der
Künstler. Vergleichung des Malers und
Komponisten. Z angew Psychol 1918, 13:
161-178.

5403. ——— & ———. Die Psychologie des
Zeichners und Malers. Z angew Psychol
1917, 12:230-275.

5404. Parandowski, J. (The physiology of
creativeness.) Problemy (Poland) 1949,
4:722-725.

5405. Parlog, C. (The Psychology of Draw-
ing.) Cluj, Rumania: Inst de Psihol Univ
Cluj 1932.

5406. Pasto, T.A., and P. Kivisto. Art and
the clinical psychologist. JAAC 1953,12:
76-82.

5407. Patrick, C. Creative thinking. In P.l
Harriman (ed.), Encyclopedia of Psycholc
NY 1946, 110-113.

5408. ———. Creative thought in artists. J
Psychol 1937, 4:35-37.

5409. Paulsson, G. Die soziale Dimensior
der Kunst. Bern: Francke 1955, 59 p.

5410. Pedersen, S. Eidetics, obsessions
and modern art. Amer Imago 1954, 11:341
362.

5411. Peel, E.A. Psychology and the teach
ing of art. Brit J educ Psychol 1955, 24:
143-153.

5412. Pende, N. L'arte nostra e la psicolc
della nostra stirpe. Ann Ravagini 1938,
18(1).

5413. Perkins, F.T. Symmetry in visual re-
call. Amer J Psychol 1932, 44:473-490.

5414. Pétin, M. La psychologie appliquée
au domaine des beaux-arts. Année Psych
1954, 54:157-164.

5415. Petkoff, W. Über die Auffassung und
Wiedergabe geometrischer Formen bei no
malen und abnormalen Menschen. Beih 9.
Jrb Hamburg Wissenschaft Anstalten, Bd.
31. Hamburg 1914, 31:89.

5416. Phillips, D. Personality in art. Amer
Magazine Art 1935, 28:78-84 , 148-155,
214-221.

5417. Philpot, G. The making of a picture.
Apollo 1933, 17:286-287.

5418. Pickford, R.W. The psychology of
cultural change in painting. Brit J Psycho
Monogr Suppl 1943, No. 26, 62 p.

5419. ———. Social psychology and some
problems of artistic culture. Brit J Psychc
1940, 30:197-210.

5420. Pierce, J.R. Symbols, Signals and
Noise. London: Hutchinson 1962, 305 p.

5421. Plaut, E., and C.W. Crannell. The
ability of clinical psychologists to dis-
criminate between drawings by deteriorat
schizophrenics and drawings by normal
subjects. Psychol Reports 1955, 1:153-15

5422. Plaut, P. Prinzipien und Methoden
der Kunstpsychologie. In Abderhalden (ed

Handbuch der biologischen Arbeits-
methoden. Berlin & Vienna: Urband &
Schwartzenberg 1928, 745-966.

5423. ———. Die Psychologie der produktiven
Persönlichkeit. Stuttgart: Enke 1930, 324
p.

5424. Poffenberger, A.T., and B.E. Barrows.
The feeling values of lines. J appl Psychol
1924, 8:187-205.

5425. Popenoe, P. The inheritance of artis-
tic talents. J Heredity 1929, 30, No. 9.

5426. Portnoy, J. A psychological theory
of artistic creation. Amer Psychologist
1949, 4:266; College Art J 1950, 10:23-29.

5427. ———. A Psychology of Art Creation.
Doctoral dissertation. Univ Pennsylvania
1942, 116 p.

5428. Pradines, M. Du role informateur de
l'art en matière psychologique. JPNP 1952,
45:129-136.

5429. ———. Psychogenesis of art. In Traité
de psychologie générale. II: Le génie
humain, ses oeuvres. Paris: PUF 1946,
477 p.

5430. Prandtl, A. Über die Auffassung geo-
metrischer Elemente in Bildern, Kunstge-
schichte und Aesthetik. Fortschritte der
Psychol und ihre Anwendung (Leipzig)
1914, 2:255-301.

5430a. Pratt, C.C. The perception of art.
JAAC 1964, 23(1):57-62.

5431. Prinzhorn, H., A. Kronfeld, and (?)
Gesemann. Der künstlerische Gestalt-
vorgang in psychologischer Beleuchtung.
Z Aesth 1925, 19:154-180.

5432. Puffer, E.D. Studies in symmetry.
Psychol Rev & Monographs 1903, 4(1):
467-539.

5433. R.L. Études techniques sur l'art de
la peinture. Année Psychol 1912, 18:208-
232.

5434. Rathe, K. Die Ausdrucksfunktion ex-
trem verkurzter Figuren. London: Warburg
Institute 1938, 73 p.

5435. Rathenau, W. Physiologie des Kunst-
empfindes. In Impressionen. Leipzig: Hir-
zel 1902, 223-255.

5436. Rau, C. Psychological notes on the
theory of art as play. JAAC 1950, 8:229-
238.

5437. Read, H. Art and the development of
personality. Brit J med Psychol 1952, 25:
114-121.

5438. ———. Art and Society. London: Faber
& Faber 1956, 152 p.

5439. ———. Education through Art. NY:
Pantheon 1945, 1949, 1958, 328 p.

5440. ———. The psychopathology of reac-
tion in the arts. Art & Architecture 1956,
73(9):16-17; Aut Aut 1956, 31.

5441. Réau, L. L'influence de la forme sur
l'iconographie dans l'art médiéval. JPNP
1951, 44:85-105.

5442. Reed, P.B. An artist diagnoses sex
offenders. J Social Hygiene 1952.

5443. Rees, H.E. A Psychology of Artistic
Creation as Evidenced in Autobiographical
Statements of Artists. NY: Bureau of Pub-
lications, Teachers College, Columbia Univ
1942, 209 p.

5444. Rees, M., and M. Goldman. Some re-
lationships between creativity and per-
sonality. J gen Psychol 1961, 65:145-161.

5445. Regler, O. Frühformen des aesthe-
tischen Verhaltens, am Ausfüllen ungrenzter
Flächen untersucht. Leipzig: Noske 1934,
52 p; Doctoral dissertation. Univ Leipzig
1933.

5446. Reiwald, P. Psychologie des Künstlers.
Nationalzeitung (Basel) 1946, Nov. 10.

5447. Révész, G. Die menschliche Hand.
Eine psychologische Studie. Basel: Karger
1944, 122 p.

5448. ———. Die Psychologie der schöpfer-
ischen Arbeit. Universitas (Stuttgart) 1949,
4:1179-1186.

5449. ———. Talent und Genie. Grundzüge
einer Begabungspsychologie. Bern: Francke
1952, 388 p.

5450. Révész-Alexander, M. (Portrait and
self-portrait as human documents.) Ned
Tijdschr Psychol 1954, 9:372-384.

5451. Rey, A. Les conditions sensori-motrices
du dessin. Schweiz ZPA 1950, 9:381-392.

5452. Reymert, M.L. (ed.). International Sym-
posium on Feelings and Emotions. Witten-
berg College 1927. Worcester, Mass.: Clark
Univ Pr 1928, 454 p.

5453. Richter, G.M. Conscious and subcon-
scious elements in the creation of works
of art. Art Bull 1933, 15:273-289, 394.

5454. Riehl, H. Kunst. In Wörterbuch der
Soziologie. Stuttgart 1955.

5455. Robbins, A.B. The inheritance of de-
signing capacity. Eugenical News 1931,
16:192-193.

5456. Rodrígues Lafora, G. Don Juan, Los
Milagros, y otros ensayos. Madrid: Biblio-
teca Nueva 1927, 332 p.

5457. Roe, A. Alcohol and creative work;
painters. Quart J stud Alcohol 1946, 6:415-
467.

5458. ———. Artists and their work. J Per-
sonality 1946-47, 15:1-40.

5459. ———. Personality and vocation. Trans
NY Acad Sci 1947, 9:257-267.

5460. Rosen, F. Darstellende Kunst im Kinde-
salter der Völker. Z angew Psychol 1908,
1:93.

5461. Rostohar, M. L'évolution de la repré-

sentation visuelle à partir de l'impression initiale. Année Psychol 1930, 31:130-149.

5462. Roumeguère, P. Art et science (psychologie de l'art). Paris: Conférences inédites en Sorbonne 1952-53.

5463. Rowland, E.H. A study of vertical symmetry. Psychol Rev 1907, 14:391-394.

5464. Rudrauff, L. The morphology of art and the psychology of the artist. JAAC 1954, 13:18-36.

5465. Ruin, H. (In the Burning-Glass of Art.) Lund, Sweden: Gleerup 1949, 332 p.

5466. ———. Nutids Konst i Psykologisk Belysning. Hfors 1923.

5467. ———. La psychologie structurale et l'art moderne. Theoria (Lund) 1949, 15: 253-275.

5468. Rutz, O. Menschheitstypen und Kunst. Berlin 1921.

5469. Sagara, M., A. Tago, and Y. Shibuya. (The influence of subliminal stimuli upon the impressions of a line drawing of a face.) Jap Psychol Res 1962, 4(4).

5470. Sakurabayashi, H. (Visual creation by prolonged inspection—a research from a viewpoint of psychology of art.) Bigaku (Tokyo) 1952, 3(2).

5471. Salber, W. Bildgefüge und Erlebnisgefüge. Jahrbuch für Psychologie und Psychotherapie (Würtzburg) 1958, 5:72-81.

5472. Sander, F. Elementar-ästhetische Wirkungen zusammengesetzter geometrischer Figuren. Psychologische Studien 1913, 9:1-34.

5473. ———. Gestalt und Sinn. I Gestaltpsychologie und Kunsttheorie. Neue psychol Stud 1932, 4:319-414.

5474. Santangelo, P.E. Discorso sull'arte; appunti per una teoria psicologia dell'arte e per la critica della teoria dell'arte come intuizione. Reviewed in JAAC 1958, 17:280-281.

5475. Sarnoff, I. Some psychological problems of the incipient artist. Ment Hyg 1956, 40:375-383.

5476. Sartre, J-P. Psychology of the Imagination. NY: Philosophical Library 1948; NY: Citadel 1963, 282 p.

5477. Saxl, F. Die Ausdrucksgebärden der bildenden Kunst. Bericht Kongress dtsch ges Psychol Hamburg 1932, 12:13-25.

5478. Schaefer, R.F. Psychic and moral effects of painting. Adelphi Quart 1962, 5: 49-53.

5479. Scheerer, M., and J. Lyons. Line drawings and matching responses to words. J Personality 1957, 25:251-273.

5480. Scheffer, K. Künstlerstudien. Jahrbuch für Charakterologie 1924, 1:337-344.

5481. Scheidemann, N.V. A five pointed

5481. (cont.) starpattern for mirrordrawing. Amer J Psychol 1950, 63:441-444.

5482. Schenk, V.W.D. (Drawings of untrair and untalented adults.) Psychiatrische en neurologische bladen (Amsterdam) 1939, 43:591-612.

5483. Schertel, E. Der erotische Komplex: Untersuchung zum Problem der paranomal Erotik in Leben, Literatur und Bilderei. Berlin: Pergamon 1932.

5484. Schindlbeck, J. Über die Erscheinun wiesen des im Bilde dargestellten Raumes Arch ges Psychol 1924, 47:393-427.

5485. Schinnerer, A. Ein Beitrag zum Them Künstlerausbildung. Die Kunst 1934, 69: 245-246.

5486. Schmidt-Henrich, E. Zur Psychologie des Surrealismus. Wiener Arch für Nervenkrankheiten 1953, 3:1-13.

5487. Schneider, C. Entarte Kunst und Irre kunst. Arch für Psychiatrie u Nervenkrank heiten 1939, 110:135-164.

5488. Schneider, J.B. Die Erotik in der bild enden Kunst. Geschlecht und Gesellschaf 1914, 9(7).

5489. ———. Die Erotik im Kunstgewerbe. Geschlecht und Gesellschaft 1913, 8(1).

5490. Schnier, J. Dynamics of art expression. College Art J 1951, 10:377-385.

5491. Schoen, M. Psychology of art. In Encyclopedia of the Arts. NY: Philosophic Library 1945, 813-817.

5492. Scholz, H. Zur Erhellung der Kunst und des Genies. Berlin: Habel 1947.

5493. Schottländer, F. Über Perspektive. Psychoanal Bewegung 1931, 3:53-56.

5494. Schouten, J. (About the nature of art Ned Tijdschr Psychol 1951, 6:333-343.

5495. Schrecker, P. Phenomenological con siderations on style. Philos phenomenol Res 1948, 8:372-390.

5496. Schrickel, H.G. Psychology of art. In Roback, A.A. (ed.), Present-Day Psychc ogy. NY: Philosophical Library 1955, 931-947.

5497. Schultze, M. Emotional release, social adjustment through art. School Arts 1962, 62:5-8.

5498. Scott, C.A. Sex and art. Amer J Psyc] 1895-96, 7:153-223.

5499. Seashore, C.E. Psychology in the fir arts. In Pioneering in Psychology. Iowa C Univ Iowa Pr 1942, 212-218.

5500. Segal, A. The Development of the Visual Ability from the Earliest Childhood to the Adult Stage. A Psychological Analy. Based upon the Objective Laws of Paintin London: Author 1939, 15 p.

5501. Segy, L. Art appreciation and projec tion. ETC 1954, 12:23-32.

5502. Sendrail, M. (The monster and the art of today.) Concours Médical (Paris) 1960, 82:6173-6174.

5503. Shelly, M.W. Psychology of the scientist: VI. Scientist as artist. Perceptual & Motor Skills 1963, 16:635-636.

5504. Sherman, H.T. Drawings by Seeing: A New Development in the Teaching of Visual Arts through the Training of Perception. NY: Hinds, Hayden & Eldridge 1947, 77 p.

5505. ——. The eye in the arts. Educ res Bull 1944, 23:1-6.

5506. Shipley, W.C., P.E. Dattman, and B.A. Steele. The influence of size on preference for rectangular proportion in children and adults. J exp Psychol 1947, 37: 333-336.

5507. Sik, S. (Emotion and production.) Esztét Szle 1939, 5:440-450.

5508. Simat, Z. Sotto il velame; aspetti psicologici dell'arte. Rome: Tip Dorica 1959, 491 p.

5509. Simeček, F.L. Masque et visage, architecture de l'esprit. Paris: Les Éditiones Nouvelles 1957, 192 p.

5510. Sipprelle, C.N., and C.H. Swensen. Relationships of sexual adjustment to certain sexual characteristics of human figure drawings. J consult Psychol 1956, 20:197-198.

5511. Sisson, E.D., and B. Sisson. Introversion and the aesthetic attitude. J gen Psychol 1940, 22:203-208.

5512. Skinner, B.F. The psychology of design. In Boas, B. (ed.), Art Education Today. NY: Bureau of Publications, Teachers College 1941, 1-6.

5513. Skouras, F. Techné (art). Arthens: Karania 1951, 77 p.

5514. Smith, A.P., Jr., and B.A. Reed. Symbolic expression of emotional problems in spontaneous art. J Nat Med Ass 1960, 52:93-107.

5515. Sorge, S. Neue Versuche über die Wiedergabe abstraktes optischer Gebilde. Arch ges Psychol 1940, 106:1-89.

5516. Soueif, M.I. (The Psychological Basis of Artistic Creation.) Egypt: Al-Maaref Pr 1951, n.p.

5517. Souza Gomez, J.A. Las Bellas Artes en las prisiones. Arch de Crimonología, medicina legal e psiquiatria (Buenos Aires) 1902, 2.

5518. Spearman, C. The Creative Mind. London: Nisbet 1930, 153 p; NY: Appleton 1931.

5519. Spiaggia, M. An investigation of the personality traits of art students. Educ psychol Measmt 1950, 10:285-293.

5520. Springbett, B.M. The semantic differential and meaning in non-objective art. Perceptual & Motor Skills 1960, 10: 231-240.

5521. Stein, M.I. Creativity and culture. J Psychol 1953, 36:311-322.

5522. Stein, M.I., and S.J. Heinze. Creativity and the Individual: Summaries of Selected Literature in Psychology and Psychiatry. Glencoe, Ill.: Free Press 1960, 428 p.

5523. Stern, W. Über verlagerte Raumformen. Z angew Psychol 1909, 2:498-526.

5524. Sterzinger, O.H. Grundlinien der Kunstpsychologie. 2 Vols. Graz-Vienna-Leipzig: Leykam 1938, 279 p; 294 p.

5525. Stewart, L.H. The Expression of Personality in Drawings and Paintings. Doctoral dissertation. Univ California 1953; Genet psychol Monogr 1955, 51:45-103.

5526. Stickel, E.G. Painting Preferences and Personal Attitudes. Master's thesis. Western Reserve Univ 1953.

5527. Stuart, C.E. An ESP experiment with enclosed drawings. J Parapsychology 1945, 9:278-295.

5528. ——. GESP experiments with the free response method. J Parapsychology 1946, 10:21-35.

5529. Stuart, I.R., and W.G. Eliasberg. Personality structures which reject the human form in art: an exploratory study of cross-cultural perceptions of the nude. J soc Psychol 1962, 57:383-398.

5530. Sully, J. Art and psychology. Mind 1886, 1:479.

5531. ——. L'art et la psychologie. Rev philosophique de la France et de l'étranger 1876, 2.

5532. Sypher, W. The Loss of Self in Modern Literature and Art. NY: Random House 1962, 179 p.

5533. Taylor, F.H. Triumph of decomposition. Parnassus 1932, 4:4-9.

5534. Taylor, R.E., et al. Perception and production of complexity by creative art students. J Psychol 1964, 57:239-242.

5535. Taylor, W.S. A note on cultural determination of free drawings. Char Pers 1944, 13:30-36.

5536. Ten Doesschate, G. On imaginary space in paintings. Ophthalmologica 1951, 122:46-50.

5537. Te Peedrt, E. Das Problem der Darstellung des Moments der Zeit in den Werken der malenden und zeichnenden Kunst. Strassburg: Hirtz 1899.

5538. Terstenjak. A. (Psychology of Artistic Creation.) Ljubljana: Acad Sci Slovenica, Classis I: Historia et Sociologia, Opera 8, 1953, 150 p.

5539. Thoma, H. Zum Thema Traum und künstlerisches Schaffen. Der Kunstwart 1913(?), 26(5).

5540. Thompson, G.C. The effect of chronological age on aesthetic preference for rectangles of different proportions. J exp Psychol 1946, 36:50-58.

5541. Thorburn, J.M. Art and the unconscious. Monist 1921, 31:586-600.

5542. ———. Art and the Unconscious. London: Routledge & Kegan Paul 1925, 241 p.

5543. Thornton, A., and R. Gordon. The influence of certain psychological reactions in painting. Burlington Magazine 1920, 36:251-254.

5544. Thurstone, L.L. Creative talent. In Applications of Psychology. NY: Harper 1952, 18-37.

5545. Tietze, H. Zur Psychologie und Aesthetik der Kunstfälschung. Z Aesth 1933, 27:209-240.

5546. Tomasch, E.J., and L.G. Martsolf. A Thought Process in Drawing. Manhattan, Kans.: Kansas State College Agriculture & Applied Science 1950, 32 p.

5547. Triplett, M.L. Influences in the adolescent years of artists. School Rev 1943, 51:300-308.

5548. Tsanoff, R.A. The Ways of Genius. NY: Harper 1949, 310 p.

5549. Ulrich, P., and R.B. Ammons. Voluntary control over perceived dimensionality (perspective) of three-dimensional objects. Proc Montana Acad Sci 1960, 19:169-173.

5550. Umedzu, H. (Functional analysis of drawing.) Jap J Psychol 1931, 6:543-568.

5551. Urwick, L. Experimental psychology and creative impulse. Psyche 1922, 3:27-48.

5552. Utitz, E. Ammerkungen zur Kunstpsychologie. In Katz, D., and R. Katz (eds.), Handbuch der Psychologie. Basel: Schwabe 1960, 665 p.

5553. ———. Über die geistigen Grundlagen der jüngsten Kunstbewegung. Langensalza: Beyer 1929, 24 p.

5554. Valensi, H. L'allègement progressif de la matière à travers l'évolution de l'art. JPNP 1934, 31:159-170.

5555. Valentine, C.W. Mind and medium in art. Brit J Psychol 1920-21, 11:47-54.

5556. ———. Psychological theories of horizontal-vertical illusion. Brit J Psychol 1912, 5:1.

5557. Various. Politics, Psychology and Art. The Symposia Read at the Joint Session of the Aristotelian Society and the Mind Association at University College of North Wales, Bangor, July 8-10, 1949. London: Harrison 1949, 194 p.

5558. Vedel, V. Liv og Kunst. 2 Vols. Cophagen: Gyldendalske 1949, 244 p, 258 p.

5559. Vie, J., and P. Quéron. Productions artistiques des pensionnaires de la colon familiale l'Ainay-le-Château. Aesculape 1933, Nov.

5560. Vierkandt, A. Das Zeichnen der Naturvölker. Z angew Psychol 1912, 6:299.

5561. Vinchon, J. La tache et les dessins de Victor Hugo. Gazette des Beaux Arts 1961, 58:153-160.

5562. Vinson, D.B., Jr. Evaluation of psychological integration by mirror drawing. Dis Nerv System 1950, 11:212-214.

5563. Vogt, W. Zur Frage des Trainings. Int Z indiv-Psychol 1932, 10:146-151.

5564. Volavka, V. Die Handschrift des Malers. Prague 1953.

5565. Von Allesch, G.J. Psychologische Bemerkungen zu zwei Werken der neuren Kunstgeschichte. Psychol Forsch 1922, 2:368-381.

5566. Waehner, T.S. Interpretation of spontaneous drawings and paintings. Genet psychol Monogr 1946, 33:3-70.

5567. Wagner, J. Experimentalle psychologische Untersuchungen über den didaktischen Anschauungswert graphischer Darstellungen im Unterricht. Z pädag Psychol 1934, 35:217, 318, 352.

5568. Wallace, V.H., and N. Lindsay. Sex in art. Int J Sexology 1948, 2:20-26.

5569. Wallach, M.A., and R.C. Gahm. Personality functions of graphic constriction and expansiveness. J Personality 1960, 28:73-88.

5570. Wallach, M.A., and H.L. Thomas. Graphic constriction and expansiveness as a function of induced social isolation and social interaction: experimental manipulations and personaluty effects. J Personality 1963, 31:491-509.

5571. Washburn, M.F., C. Reagan, and E. Thurston. The comparative controllabili of the fluctuations of simple and complex ambiguous perspective figures. Amer J Psychol 1934, 46:636-638.

5572. Watkins, C.L. Emotional design in painting. Magazine of Art 1940, 33:280-287.

5573. Weber, C.O. The esthetics of rectangles and theories of affection. J appl Psychol 1931, 15:310-318.

5574. ———. Theories of affection and esthetics of visual forms. Psychol Rev 1927 34:206-219.

5575. Weber, J.P. La psychologie de l'art. Paris: PUF 1958, 136 p.

5576. Wechniakoff, T. Savants, penseurs et artistes. Biologie et pathologie com-

parées. Paris: Alcan 1899.

5577. Welch, L. Recombination of ideas in creative thinking. J appl Psychol 1946, 30:638-643.

5578. Werner, H. On physiognomic perception. In Kepes, G. (ed.), The New Landscape in Art and Science. Chicago: Theobald 1956, 280-283.

5579. White, R.K. The versatility of genius. J soc Psychol 1931, 2:460-489.

5580. Whittaker, W.G., W.O. Hutchinson, and R.W. Pickford. Symposium on the psychology of music and painting. Brit J Psychol 1942, 33:40-57.

5581. Wickes, F.G. The Inner World of Man. With Psychological Drawings and Paintings. NY: Farrar 1938, 313 p.

5582. Wilke, (?). Einfluss der Sexuallebens auf die Mythologie und Kunst der indoeuropäischen Völker. Mitt d anthrop G' schaft (Vienna) 1912(?), 42:1-48.

5583. Winkler, W. Psychologie der modernen Kunst. Tübingen: Alma Mater 1949, 303 p.

5584. Wisotsky, M., and L. Birner. Preference for human animal drawings among normal and addicted males. Perceptual & Motor Skills 1960, 10:43-45.

5585. Wittkower, R., and M. Wittkower. Born under Saturn. The Character and Conduct of Artists: a Documented History from Antiquity to the French Revolution. NY: Random House 1963, 344 p; London: Weidenfeld & Nicolson 1963.

5586. Witzig, H. Erlebnis und zeichnerische Gestalten. Zurich: Orell-Füssli 1930, 138 p; Doctoral dissertation. Zurich 1926.

5587. Wölfflin, H. Gedanken zur Kunstgeschichte. Gedrucktes und Ungedrucktes. Basel: Schwabe 1947.

5588. ———. Kleine Schriften (1886-1933). Basel: Schwabe 1946, 272 p.

5589. ———. The Sense of Form in Art: a Comparative Psychological Study. NY: Chelsea 1958, 230 p.

5590. Wolff, J. Zeitfragen des Stadtebaus.

Munich 1956.

5591. Wolzogen, von. Zur Psychologie der Künstlerehe. Sexualprobleme 1908, 4.

5592. Woodman, G.E. Imagination, immediacy, and human concerns. Art J 1963-64, 23(2):123-126.

5593. Woods, W.A. Visual Form-Space Manipulation and Its Relation to Art Participation. Dissertation Abstr 1953, 13:129.

5594. Woods, W.A., and J.C. Boudreau. Design complexity as a determiner of visual attention among artists and non-artists. J appl Psychol 1950, 34:355-362.

5595. Wrenn, C.G., and W.B. Dreffin. Spacial relations ability and other characteristics of art laboratory students. J appl Psychol 1948, 32:601-605.

5596. Wulffen, E. Sexualspiegel von Kunst und Verbrechen. Dresden: Aretz 1930(?).

5597. Wundt, W. Völkerpsychologie. Eine Untersuchung der Entwicklungsgesetz von Sprache, Mythen und Sitte. Vol. 3. Die Kunst. Leipzig: Englemann 1908, 564 p; NY: Macmillan 1916.

5598. Youngman, N. Painting and emotional development. New Era 1947, 28:169-171.

5599. Zachry, C.B. The role of mental hygiene in the arts. In Art Education Today: 1940. NY: Teachers College 1940, 31-36.

5600. Zajac, J.L. Studies in perspective. Brit J Psychol 1961, 52:333-340.

5601. Ziegenfluss, W. Bildende Kunst und Literatur. In Handwörterbuch der Soziologie. Stuttgart 1931.

5602. Ziehen, T. Die Beteiligung von Bewegungsempfindungen und Bewegungsvorstellungen bei Form-kombination. Z pädag Psychol 1914, 15:40.

5603. Zusne, L., and K.M. Michels. Geometricity of visual form. Perceptual & Motor Skills 1962, 14:147-154.

5604. ——— & ———. More on the geometricity of visual form. Perceptual & Motor Skills 1962, 15:55-58.

16 Psychopharmacology and Art

5605. Apfeldorf, M. Changes in the behavior and responses to psychological tests of psychotic patients during the administration of prochlorperazine. In Trans 6th Research Conference on Cooperative Chemotherapy Studies in Psychiatry and Broad Research Approaches to Mental Illness, March 1961. Washington, D.C.: Dept Med & Surgery, Veterans Administration 1961, 301–306.

5606. Bakker, C.B., and G.B. Amini. Observations on the psychotomimetic effect of Semyl. Comprehensive Psychiatry 1961, 2:269–280.

5607. Benda, C.E. Illness and artistic creativity. Atlantic 1961, 208:97–101; In Rolo, C. (ed.), Psychiatry in American Life. NY: Atlantic-Little, Brown 1963.

5608. Berdie, R.F. Effect of benzedrine sulphate on blocking in color naming. J exp Psychol 1940, 27:325–332.

5609. Berlin, L., T. Guthrie, A. Weider, H. Goodell, and H.G. Wolff. Studies in human cerebral function: the effects of mescaline and lysergic acid on cerebral processes pertinent to creative activity. JNMD 1955, 122:487–491.

5610. Böszörményi, Z. Creative urge as an after effect of model psychoses. Confin Psychiat 1960, 3:117–126.

5611. Bolton, W.B. Schizophrenia produced by LSD-25. Canadian J occupational Therapy 1961, 28:55–62.

5612. Cohen, B.D., R. Senf, and P.E. Huston. Perceptual accuracy in schizophrenia, depression, and neurosis, and effects of amytal. J abnorm soc Psychol 1956, 52: 363–367.

5613. Cramer-Azima, F.J. Personality changes and figure drawings: a case treated with ACTH. J proj Tech 1956, 20: 143–149.

5614. Davidson, G.M., and E. Ades. Perception and psycho-pharmacodynamics in schizophrenia (as reflected in patients' art). Dis Nerv System 1961, 22:273–278.

5615. Delay, J., H.P. Gérard, and D. Allaix. Illusions et hallucinations de la Mescalin Presse méd 1949, 81:1210–1211.

5616. Drobec, E., and H. Strotzka. Narko-diagnostische Untersuchungen bei Surrealisten. Z Psychother med Psychol 1951 1:64–71.

5617. Fingert, H.H., J.R. Kagan, and P. Schil der. The Goodenough Test in insulin and metrazol treatment of schizophrenia. J gen Psychol 1939, 21:349–365.

5618. Gamna, G. Modificazioni nello stile dei dipinti di uno schizofrenico trattato con tofranil. Minerva Med 1960, 51:4416–4437.

5619. Gratton, L., L. Houde, R. Lafontaine, and G. Fournier. Les syndromes hypermoteurs de l'enfant et ses réactions à la trifluopérazine. Union Médicale du Canad 1961, 91:23–31.

5620. Guttuso, R., and M. Russo. (Considerations on the prognostic value of drawings executed by a group of catatonic schizophrenics in the course of treatment with nialamide-Niamid Pfizer.) Minerva Med 1963, 54:1715–1717.

5621. Hartman, A.M., et al. Effect of mescaline, lysergic acid diethylamide and psilocybin on color perception. Psychopharmacologia (Berlin) 1963, 4:441–451.

5622. Helper, M.M., R.C. Wilcott, and S.L. Garfield. Effects of chlorpromazine on learning and related processes in emotionally disturbed children. J consult Psychol 1963, 27:1–9.

5623. Hetherington, R. The effects of E.C.T. on the drawings of depressed patients. J ment Sci 1952, 98:450–453.

5624. Hollister, L.E., and A.M. Hartman. Mescaline, lysergic acid diethylamide and psilocybin: comparison of clinical syndromes, effects on color, perception and biochemical measures. Comprehensive Psychiatry 1962, 3:235–241.

5625. Hyslop, T.B. Mental Handicaps in Art. London: Ballière, Tindall & Cox 1927, 98 p.

5626. Jakab, I. L'influence des produits

pharmaceutiques sur les dessins des
aliénés. Neuropsichiatria 1961, 17:405.

5627. Korngold, M. L.S.D. and the creative
experience. Psychoanal Rev 1963-64, 50
(4):152-155.

5628. Lehmann, H.E. New drugs in psychi-
atric therapy. Canadian med Ass J 1961,
85:1145-1151.

5629. Levine, A., H.A. Abramson, M.R. Kauf-
man, S. Markham, and C. Kornetsky. Ly-
sergic acid diethylamide (LSD-25): XIV.
Effect on personality as observed in psy-
chological tests. J Psychol 1955, 40:351-
366.

5630. Lienert, G.A. Die Farbwahl im Farb-
pyramidentest unter Lysergäurediätylamid
(LDS). Z exp angew Psychol 1961, 8:110-
121.

5631. Machover, K., and R. Liebert. Human
figure drawings of schizophrenic and nor-
mal adults. Arch gen Psychiat 1961, 3(2):
139-151.

5632. Maclay, W.S., and E. Guttmann. Mes-
calin hallucination in artists. Arch Neurol
Psychiat 1941, 45:130-137.

5633. Melikian, L. The effect of meproba-
mate on the performance of normal sub-
jects on selected psychological tasks.
J gen Psychol 1961, 65:33-38.

5634. Michaux, H. Light Through Darkness.
NY: Orion 1963, 240 p.

5635. Nickols, J. Tranquilizers and experi-
mental psychopathology. Amer Psychologist
1962, 17:263-264.

5636. Orsini, F., and P. Benda. L'épreuve
du dessin en miroir sous L.S.D.-25. Ann
méd-psychol 1960, 1:809-816.

5637. Pīsařovic, F., M. Harmsík, and J. Rou-
bal. Post-Comatose Graphic Reproduc-
tions of Schizophrenics. Durham: Univer-
sitas Carolina Medica 1955.

5638. Silverstein, A.B., and G.D. Klee. A
psychopharmacological test of the "body
image" hypothesis. JNMD 1958, 127:323-329.

5639. Sloane, R.B., R.P. Jones, and J. Inglis.
Clinical use of etryptamine. In Nodine,
J.H., and J.H. Moyer (eds.), Psychomatic
Medicine. Philadelphia: Lea & Febiger
1962, 656-670.

5640. Tonini, G., and C. Montanari. Effects
of experimentally induced psychoses on
artistic expression. Confinia Neurologica
1955, 15:225-239.

5641. Wittenborn, J.R., M. Plante, F. Burgess,
and N. Livermore. The efficacy of elec-
troconvulsive therapy, iproniazid and pla-
cebo in the treatment of young depressed
women. JNMD 1961, 133:316-332.

5642. Abel, T.M. Free designs of limited scope as a personality index. A comparison of schizophrenics and primitive culture groups. Char Pers 1938, 7:50-62.

5643. Abramov, V.V. (An Objective, Psychological Investigation of the Creative and Other Intellectual Functions of the Insane.) Thesis, Imperial Military Acad Med, St. Petersburg 1910-11, No. 27, 316 p.

5644. Aguiar Whitaker, E. de. (Artistic manifestations of a patient with manic-depressive psychosis.) Rev de Neurologia e Psychiatria de São Paulo 1936, 2:319-335.

5645. Ahnsjö. Peintures spontanées qui amenèrent à soupçonner la schizophrénie chez une fillette de 7 ans. Communication au Premier Congrès mondial de Psychiatrie, Paris 1950. Sauvegarde de l'Enfance, numéro spécial 1951, 203-206.

5646. Anastasi, A., and J.P. Foley, Jr. An analysis of spontaneous artistic production by the abnormal. J genet Psychol 1943, 28:297-313.

5647. —— & ——. An experimental study of adult psychotics in comparison with that of a normal control group. J exp Psychol 1944, 34:169-194.

5648. —— & ——. A survey of the literature on artistic behavior in the abnormal. II. Approaches and interrelationships. Ann NY Acad Sci 1941, 42:1-112.

5649. —— & ——. A survey of the literature on artistic behavior in the abnormal. IV. Experimental investigations. J gen Psychol 1941, 25:187-237.

5650. —— & ——. A survey of the literature on artistic behavior in the abnormal. I. Historical and theoretical background. J gen Psychol 1941, 25:111-142.

5651. —— & ——. A survey of the literature on artistic behavior in the abnormal. III. Spontaneous productions. Psychol Monogr 1940, 237, 52:1-71.

5652. Andrews, J.B. Asylum periodicals. Amer J Insanity 1876, 33:42-49.

5653. Anon. The art of insane patients.
Science 1928, 67, No. 1727, xlviii.

5654. Anon. Art of the insane at the Segy gallery. Art Digest 1954, 29:29.

5655. Anon. Art and insanity and pictures by lunatics. Current Opinion 1913, 55:340

5656. Anon. Art and psychopathology: an exhibition jointly sponsored by. the psychiatric division of Bellevue Hospital anc the Federal Art Project of the W.P.A. NY Federal Art Project, W.P.A., 1938, 9 p.

5657. Anon. Bildnerei der geisteskranken, Kunsthalle, Bern. Werk 1963, 50, Suppl 226.

5658. Anon. (Creative achievements in the terminal state of schizophrenia.) Confin Psychiat 1963, 6:102-160.

5659. Anon. The degree of sanity: art of th insane, the art of nature, and the art of the surrealist as art of this century. Art Digest 1943, 18:17.

5660. Anon. El Greco's madmen. Life 1955, 39:77-78.

5661. Anon. Experimental studies in psychiatric art. Nursing Times 1954, 50:185-186.

5662. Anon. Exposition internationale des oeuvres des malades mentaux, hôpital Ste Anne, Paris. Werk 1950, 37: sup 160-161.

5663. Anon. Insane asylum as the source of the coming craze in art. Current Lit 1911, 50:505-510.

5664. Anon. Insanity in art. Time 1938, 32: 48.

5665. Anon. Mad: aspects of schizophrenic art, exhibition at the Institute of Contemporary Art, London. Art News 1955, 54:58.

5666. Anon. Modem art as a form of dementia praecox. Current Opinion 1921, 71: 81-82.

5667. Anon. Proving painters insane. Lit Digest 1921, 69:26-27.

5668. Anon. Psychiatry and art; Netherne Hospital exhibition. Brit med J 1949, 2: 228.

5669. Anon. Sanity in art. Art Digest 1940, 15:18.

5670. Anon. U.S. Government and Bellevue

Hospital exhibit art of insane patients. Life 1938, 5(17):26-27.

5671. Anon. Who's loony now? Paintings of the insane compared with modern art. Lit Digest 1929, 102:21-22.

5672. Armas Pacheco, M. de. Pictographic characteristics of various mental disorders. Year Book Neurol Psychiat Neurosurgery 1947, 256-260; Bol Hosp Nac de Dementes (Cuba) 1947, 1-2; 4-14; Archivos de neurologia y psiquiatria de Mexico 1948, 3:62-66.

5673. Arnold, O.H. (Creative activity at the beginning of schizophrenic psychoses.) Zentralblatt für Nervenheilkunde 1953, 7: 188-206.

5674. Aschaffenburg, G. Allgemeine Symptomatologie der Psychosen. Handbuch Psychiatrie. Leipzig & Vienna: Deuticke 1915, 119-464.

5675. Audry, J. La folie dans l'art. Lyon Médical 1924.

5676. Bach, S.R. Spontanes Malen und Kneten in krankenhäusern. Schweiz ZPA 1952, 9:206-217.

5677. Bader-Bourasseau, A. Art moderne et schizophrénie. Contribution à une psychologie de la création artistique. Schweiz ZPA 1958, 17:48-54.

5678. ———. De la production artistique des aliénés. La Vie Médicale. Numéro Spécial. Art et psychopathologie. Dec. 1956, 21-23.

5679. Barbé, A. Les dessins stéréotypes d'un catatonique. Encéphale 1920, 15:49-50.

5680. Barison, F. Art et schizophrénie. Évolut Psychiat 1961, 26:70-92.

5681. Baruk, H., J. Launay, A. Meyer, and J. Roland. Action de la maladie mentale sur la création et la desorganisation artistique. Rôle de la personnalité profonde. Intérêt thérapeutique de la peinture et du dessin. Ann méd-psychol 1952, 110:695-698.

5682. Baynes, H.G. Mythology of the Soul; A Research into the Unconscious from Schizophrenic Dreams and Drawings. London: Ballière, Tindall & Cox 1939, 912 p; Baltimore: Williams & Wilkins 1940, 939 p; London: Methuen 1949.

5683. Becker, P.M. Das Zeichnen Schizophrener. ZNP 1934, 149:433-489.

5684. Bellak, L. Schizophrenia and the arts. In Schizophrenia: A Review of the Syndrome. NY: Logos 1958, 748-753.

5685. Bender, L. Gestalt function in visual motor patterns in organic disease of the brain, including dementia paralytica, alcoholic psychoses, traumatic psychoses and acute confusional states. Arch Neurol Psychiat 1935, 33:300-329.

5686. ———. Principles of Gestalt in copied form in mentally defective and schizophrenic persons. Arch Neurol Psychiat 1932, 27:661-686.

5687. Bennett, E.A. "Mythology of the Soul," review of H.G. Baynes' book. Brit J med Psychol 1941-43, 19:324-326.

5688. Benoiston, J.E., C. Mouzet, and M. Tanguy. (From mental disorder to plastic expression: semeiological content and developmental correlations.) Ann méd-psychol 1962, 120:193-230.

5689. Benson, G.R., and E. Schachtel. Portraits of psychotics by Dr. G. Jacob. Magazine of Art 1937, 30:485-489.

5690. Bertschinger, H. Illustrierte Halluzinationen. Jahrbuch für Psychoanalytische und Psychopathologische Forschungen 1911, 3: 69-100.

5691. Bessière, R. Aperçus sur l'art psychopathologique. Évolut Psychiat 1956, No. 1, 23-36.

5692. ———. L'art psychopathologiques. Arts (Paris) 1950, Sept. 22.

5693. Bettelheim, B. Joey: a "mechanical boy." Sci Amer 1959, 200:116-127.

5694. ———. Schizophrenic art: a case study. Sci Amer 1952, 186:30-34.

5695. Biermann, G. Die Bedeutung des Malens für die Diagnostik und Therapie der Enkopresis. Prax Kinderpsychol-Kinderpsychiat 1960, 19:33-47.

5696. Birnbaum, K. Psychopathologische Dokumente; Selbsterkenntnisse und Fremdzeugnisse aus dem seeligschen Grenzlande. Berlin: Springer 1920, 322 p.

5697. Bobon, J. (Psychopathology of plastic expression—gestures and drawings; preliminary note on "neomimisms" and "neomorphisms.") Acta neurol psychiat belg 1955, 55:923-929.

5698. ———. Symbolism et métamorphoses du poisson dans l'oeuvre picturale d'un schizophrène. La Vie Médicale. Numéro Spécial. Art et psychopathologie. Dec. 1956, 40-45.

5699. Bobon, J., and G. Maccagnani. L'expression plastique en psychopathologie. III. Les dessins-signes. Un cas de para-symbolie graphique délirante. La langue "idéologique." Acta neurol psychiat belg 1961, 61:849-865.

5700. ——— & ———. L'expression plastique en psychopathologie: I. Les "signes plastiques." Acta neurol psychiat belg 1961, 61:823-842.

5701. Bonheur, A. (Expressionism and insanity; unusual artistic work.) Rev de Psiquiatría y Criminàlia (Buenos Aires) 1938, 3:45-52.

5702. Borja, A.J. Iconografia esquifrenica. Rev de Neuro-Psiquiatría (Lima) 1938, 1: 551-569.

5703. Born, W. Art and mental disease. Ciba Symposia 1946, 7:202-207.

5704. ———. Artistic behavior of the mentally deranged. Ciba Symposia 1946, 7: 207-217.

5705. ———. The art of schizophrenics. Ciba Symposia 1946, 7:217-225.

5706. ———. Great artists who suffered from mental disorders. Ciba Symposia 1946, 7: 225-236.

5707. Bosch, G. Las ilusiones y las alucinaciones en la vida y en el arte. Anales de l'institut de Psychologia de l'Universite Buenos Aires 1941, 3:305-330.

5708. Brengelmann, J.C., and J.T. Marconi. Expressive movement in abnormals, with particular reference to extraversion and psychoticism. Acta psychol 1958, 14:200-214.

5709. Bürger-Prinz, H. Über die künstlerischen Arbeiten Schizophrener. In Bumke, O. (ed.), Handbuch Gesisteskrankheiten. Berlin: Springer 1932, 668-704.

5710. Burr, C.B. Art in the insane. Amer J Insanity 1916, 73:165-194; Psychoanal Rev 1916, 3:361-385.

5711. Capgras, J. Une persécutée démoniaque: présentation d'écrits et de dessins. Bull Soc clin méd ment 1911, 4:360-372.

5712. Carstairs, G.M. Psychotic illness and artistic production. Nature (London) 1962, 194:1012-1014.

5713. Carta, M. Alcuni aspetti del mondo esterno nella rappresentazione grafica degli schizofrenici; nota preliminare di psicopatholigia sperimentale. Riv di patologia nervosa e mentale (Florence) 1953, 74:221-223.

5714. Cascella, G. (Abstractism and schizophrenia.) Ospedale Psichiatrico (Naples) 1960, 28:85-104.

5715. Castelli, E. (ed.). L'Unmanesimo e il Demoniaco nell'Arte. In Atti del II Congresso Internazionali di Studi Umanistici. Rome 1952.

5716. Cazzamalli, F. Le allucinazioni creative. Giornale di Psichiatria di Neuropatologia 1937, 65:336-344; Riforma medica 1938, 54:71-72.

5717. César, O. (Art of the insane.) Arquivos do Departamento de assistência a psicopatas de estado de São Paulo 1951, 16:51-64.

5718. ———. A arte primitiva nos alienados. Memorias do Hospital Juquéri (São Paulo) 1925, 2:111.

5719. Chaix-Ruy, J. Le démoniaque dans l'art, la poésie et la littérature. Rev d'Esthétique 1956, 9:322-328.

5720. Chase, J.M. A study of the drawings of a male figure made by schizophrenic patients and normal subjects. Char Pers 1941, 9:208-217.

5721. Chatterji, N.N. Schizophrenic drawings. Sāmiksā 1951, 5:32-41.

5722. Christoffel, H., and E. Grossmann. Über die expressionistischen Komponente in Bildnereien geistig minderwertiger Knaben. ZNP 1923, 87:372-376.

5723. Clark, L.P. Mental and nervous diseases in classic pictorial art. Med Pickwick (Saranac Lake) 1916, 2:1-14.

5724. Crannell, C.W., and E. Plaut. Drawings of a three-dimensional object by mental patients: a preliminary report. J Psychol 1955, 39:351-354.

5725. Cautrecasas, J., and N.Z. Bula. El lenguaje gráfico en la esquizofrenia. Boletin del Instituto Psiquiatrie (Rosario, Argentina) 1939, 3:5-27.

5726. Dali, S. Aspects phénoménologiques de la méthode paranoïaque critique. La Vie Médicale. Numéro Spécial. Art et psychopathologie. Dec. 1956, 78-82.

5727. Dantas, J. Pintores e poetas de Rilhafolles. Medicina Contemporanea (Lisbo 1900, 3:220-221.

5728. Davidson, G.M., and B.V. Wise. Som observations on art and psychotherapy wi special reference to schizophrenia. Psych Quart Suppl 1957, 31:222-238.

5729. DeFursac, R. Les écrits et les dessi dans les maladies nerveuses et mentales. Paris: Masson 1905.

5730. Delanglade, F. L'art et la folie. Visages du monde 1935.

5731. ———. L'art à l'asile. Quadrige 1946, 7:48-50.

5732. Delay, J. Art psychopathologique et médecine. Sémaine des hôpitaux suppl 19 28:5-8.

5733. Delay, J., P. Desclaux, and R. Digo. Étude psychiatrique des peintures et dessins d'un schizophrène. Semaine des hôpitaux 1947, 23:1369-1376.

5734. Delay, J., and R. Volmat. Images de la folie. Médecin et Hygiène (Geneva) 1953, 11:431.

5735. Delgado, H. Les dessins des psychopathes. Informateur des aliénistes et des neurologistes 1923.

5736. ———. El dibujo de los psicopatos. Lima 1922, 26 p.

5737. ———. La pintura en la esquizofrenia. Centuro 1950, 3.

5738. ———. La producción artistica de los esquizofrenicos. Lima: Bellas Artes 1941, N

5739. Del Greco, F. Mentalita e psicopatie. Annali dell'Ospedale psichiatrico provinciale in Perugia 1935, 29:1-12.

5740. DeLuca, P., and E. Agresti. Originality and banality in the pictorial production of schizophrenics. Rass stud psichiat 1963, 52:77-80.

5741. Dequeker, J Monographie d'un psychopathe dessinateur: étude de son style. Toulouse: Subervie 1948, 124 p.

5742. Dolto, F. Introduction au dessin d'enfant. La Vie Médicale. Numéro Spécial. Art et psychopathologie. Dec. 1956, 27-39.

5743. Duca, L. L'art et les fous. Le monde illustré 1946, March 30.

5744. Ducoste, M. Deux aliénés inventeurs: présentation d'épures et de dessins. Bull Soc clin méd ment 1911, 4:372-382.

5745. ——. Outils, armes, pièce d'étoffe, tissé executés par des aliénés. Bull Soc clin méd ment 1920, 13:147-151.

5746. Due, F.O. Artistic productions in a case of schizophrenia. Arch Neurol Psychiat 1941, 46:376.

5747. Ellermann, M. (Genius and Insanity.) Holland: Hirschprungs 1940(?).

5748. Engerth, G., H. Hoff, and O. Pötzl. Zur Patho-Physiologie der hemianopischen Halluzinationen. ZNP 1935, 152:399-421.

5749. Ernst, M.G. A psychotherapeutic approach to schizophrenia. J ment Sci 1940, 86:668-674.

5750. Ernst, W. Plastische Arbeiten verbrecherischer Geisteskranker. Arch Psychiat Nervenkrankheiten 1925, 74:838-842.

5751. Escudero Valverde, J.A. El arte pictórico en la esquizofrenia. Anales de la Real Academia Nacional de Medicina (Madrid) 1957, 74:357-378.

5752. Eysenck, H.J., G.W. Granger, and J.C. Brengelman. Perceptual Processes and Mental Illness. London: Chapman & Hall 1957, 144 p.

5753. Fay, H.M. Réflexions sur l'art et les aliénés. Aesculape 1912, 2:200-204.

5754. Ferdière, G. L'aliénation créatice. Folia Psychiatrica, Neurologica, et Neurochirurgica Neerlandica 1948, 51:15-30.

5755. ——. Le dessinateur schizophrène. Évolut Psychiat 1951, 2:215-230.

5756. ——. Les dessins schizophréniques: leur stéréotypies vraies ou fausses. Ann méd-psychol 1947, 105:95-100.

5757. ——. Introduction à la recherche d'un style dans les dessins des schizophrènes. Ann méd-psychol 1947, 105:35-43.

5758. ——. La main du dessinateur schizophrène. J Premier Congrès mondial Psychiat (Paris) 1950, 3.

5759. ——. Le style des dessins schizophrénique: ils sont bourrés. Ann méd-psychol 1948, 106:430-434.

5760. ——. Le style des dessins schizophrénique: la symétrie et l'équilibre. Ann méd-psychol 1948, 106:434-437.

5761. Ferenczy, J. Parallele zwischen den Handarbeiten weiblicher Geisteskranken und der Volkskunst. In Benedek, L. (ed.), Hughlings Jackson Memorial Volume. Hungary: Clinic for Nervous & Mental Diseases Debricen 1935, 52:1-21.

5762. Fernandez, G. Surrealismo e esquizofrenia. Arch de assistencia a psicopatas de Pernambuco 1933, 3:140-150.

5763. Florisoone, M. Oeuvres de malades mentaux; exposition au centre psychiatrique de Sainte-Anne. Arts, Beaux-Arts, Littérature, Spectacles 1946, Feb 15, p. 1.

5764. Foltin, E.M. Paintings of psychotic patients. Amer Psychologist 1946, 1:445.

5765. ——. Personality traits of psychotic patients as revealed in their spontaneous paintings. J Psychol 1953, 36:251-259.

5766. Fontes, V. (Drawing and writing in psychiatric diagnosis.) Clinica, Higene e Hidrologia (Lisbon) 1938, May.

5767. ——. Interprétation psychologique du dessin anthropomorphique infantile, spécialement observé chez les oligophrènes. Sauvegarde 1950, 6:403-435.

5768. Forel, J. Aloyse ou la peinture magique d'une schizophrène. Thèse Méd. Lausanne, Henri Jaunin S.A. 1953, 72 p.

5769. Fortin, (?). La vision chez les peintres. Étude psychopathologique. Union-Méd Nord-Est 1908.

5770. Fraletti, P. Considerações sôbre a arte dos alienadoes e dos artistas modernos. Arquivos do Departamento de assistência a psicopatas de estado de São Paulo 1955, 20:139-173.

5771. Freyhan, F. Importance of art department for interpretation of psychic states. Delaware State Med J 1940, 12:111-118.

5772. Fromm-Reichmann, F. Remarks on the philosophy of mental disorder. Psychiatry 1946, 9:293-308.

5773. Gadelius, B. Psychiatrie und schaffende Kunst. Acta psychiat neurol 1936, 11:455-457.

5774. Garfinkle, L. Art teaching in Bellevue Psychiatric Hospital. Psychol League J 1939, 3:37-38.

5775. Gaupp, R. Das Pathologische in Kunst und Literatur. Deutsche Revue, eine monatsschrift (Berlin) 1911, Apr.

5776. Gilles, A., and J. Vinchon. Les visions du délire de rêve dans l'art japonais. France-Médicale. Rev d'études d'histoire de la médecine 1921.

5777. Glatter, A.N., and P. Hauck. Sexual symbolism in line qualities. J clin Psychol 1958, 14:168-169.

5778. Goldman, A.E. Symbol consensus and univocality in schizophrenia. J proj Tech 1962, 26:288-294.

5779. Gomirato, G., and G. Gamna. (Psychopathic significance of designs in drawings by schizophrenics.) Giornale di Psichiatrie di Neuropatologia 1954, 82:261-283.

5780. Gutiérrez-Noriega, C. Significado de los dibujos en la historia de un esquizofrénico. Rev de Neuro-Psiquiatría (Lima) 1940, 3:355-392.

5781. Guttmann, E., and W.S. Maclay. Clinical observations on schizophrenic drawings. Brit J med Psychol 1937, 16:184-204.

5782. Hamilton, A.M. Insane art. Scribner's Magazine 1918, 63:484-492.

5783. Haslam, J. Illustrations of Madness: Exhibiting a Singular Case of Insanity and a No Less Remarkable Difference in Medical Opinion. London: Hayden 1810, 81 p.

5784. Hassmann, O., and H. Zingerle. Untersuchung bildlicher Darstellung und sprachlicher Aüsserungen bei Dementia praecox. J für Psychologie und Neurologie 1913, 20: 24-61.

5785. Hauke, (?). Ein graphischer Exhibitionist. Kriminalistik 1939, 13:222-223.

5786. Havas, G. (Mental diseases in art.) Gyógyászat (Budapest) 1939, 79:188, 203, 218, 236, 250, 267, 283, 296, 313-314.

5787. Heitz, J. Les démoniaques et les malades dans l'art byzantin. Nouv iconographie 1901, 14.

5788. Hellpach, W. Psychopathologisches in Moderner Kunst und Literatur. Heidelberg: Winters 1911.

5789. Helweg, H. Künstlerische Produktion bei Schizophrenen. Acta psychiat neurol 1933, 8:445-446.

5790. Hickson, W.J. The mental finger print. Municipal Court Chicago, 8th & 9th Ann Rep 1913-15, 1-21, 42-48.

5791. Hildebrandt, K. Norm und Entartung des Menschen. Dresden: Sibyllen 1920, Ch 6.

5792. Hrdlicka, A. Art and literature in the mentally abnormal. Amer J Insanity 1899, 55:385-404.

5793. Huggler, M. Psychotische "Kunst" und Kunstgeschichte. Confin Psychiat 1960, 3:187-191.

5794. Huot, V.L. Note au sujet des peintures et dessins d'un schizophrène malgache. Ann méd-psychol 1936, 94:172-186.

5795. Hutter, A. (World view of schizophrenics as expressed in their art.) Ned Tijdschr Geneesk 1934, 78:1306-1323.

5796. Hyslop, T.B. Post-illusionism and art in the insane. 19th Cent & After, 1911, 69: 270-281; Art World 1916, 1:34-38.

5797. Ingegnieros, J. La psicopatologia en el arte; agitadores y multitudes en hacia la justica. Arch de psiquiatria y criminologia (Buenos Aires) 1903, 2:27.

5798. Jacobowsky, B. A pair of book-plates drawn by a manic-depressive patient. Acta psychiat neurol 1946, 21:399-408.

5799. Jacobsen, A.C. The pathologic in art. Med-Pharm Critic Guide 1909, 12:321-335

5800. Jakab, I. Dessins et Peintures des Aliénés. Analyse au point de vue psychiatrique et artistique. Budapest: Acad des Sciences de Hongrie 1956, 148 p.

5801. ——. Expression graphique des hallucinations schizophréniques. Ann médpsychol 1959, 117:1-24.

5802. ——. Zeichnungen und Gemälde der Geisteskranken; ihre psychiatrische und künstlerische Analyse. Budapest: Ungarischer Akad der Wissenschaften 1956, 168

5803. Janota, O. (Art in the insane.) Časop lék česk (Praha) 1924, 63:262-267, 308-318.

5804. Jaspers, K. Kunst und Zeichnungen. In Allgemeine Psychopathologie. Berlin: Springer 1923, 168-190; Paris: Alcan 1923.

5805. Jiménez Borja, A. (History and iconography of a schizophrenic patient.) Rev de Neuro-Psiquiatría (Lima) 1939, 2:228-245.

5806. ——. Iconographía esquizofrénica. Rev de Neuro-Psiquiatría (Lima) 1938, 1: 551-569.

5807. ——. Simbolismo en la iconografia esquizofrénica. Rev de Neuro-Psiquiatría (Lima) 1941, 4:239-249.

5808. Kamba, F. (The form of graphic creativity of schizophrenic subjects.) Ceskoslovenska Psychiatrie 1963, 59:265-273.

5809. Karpov, P.I. (The Creative Activity of the Insane and Its Influence on the Development of Science, Art and Technique.) Moscow: Sovereign Pub 1928, 199 p.

5810. Kellner, A.W. (Portrayals of mentally diseased persons up to 1100 A.D.) Medizinische Welt (Stuttgart) 1937, 11:1227-1230.

5811. Kempf, E.J. Psychopathology. St. Loui Mosby 1920, 762 p.

5812. Keraval, P. De l'art chez les aliénés. Informateur des aliénistes et des neurologistes 1909, 29-31.

5813. Kielholz, A. Die drei Delirien eines Malers. Bündner Lehrerverein 1931.

5814. Kihn, B., and H. Luxemburger. Die Schizophrenie. In Gütt, A., Handbuch für Erkrankheiten, Vol.2. Leipzig: Thieme 1940, 3

5815. Kirnan, J.G. Art in the insane. Alienist & Neurologist 1892, 13:244-275, 684-697.

5816. Kreyenberg, G. Das Junkerhaus zu Lemgo in Lausitz: ein Beitrag zur Bildnerei der Schizophrenen. ZNP 1928, 114:152-172.

5817. Kris, E. Art and regression. Trans NY Acad Sci 1944, 6:236-250.

5818. ———. Bemerkungen zur Bildnerei der Geisteskranken. Imago 1936, 22:339-370.

5819. ———. Review of Naumburg's "Schizo-phrenic Art." Psychoanal Quart 1953, 22: 98-101.

5820. Küngel, W. Kubismus und Geistes-krankheit. Arch Psychiat Nervenkrankheiten 1920, 62:395-407.

5821. Kürbitz, W. Die Zeichnungen geistes-kranker Personen in ihrer psychologische Bedeutung und differentialdiagnostischen Verwertbarkeit. ZNP 1912, 13:153-182.

5822. Kulcer, S. (Drawing of mentally dis-turbed.) Ofakim (Israel) 1957, 11:7-15, 37.

5823. Ladame, C. À propos des manifesta-tions artistiques chez les aliénés. Schweiz ANP 1920, 6:166-168.

5824. Laignel-Lavastine, M. La psychose périodique dans l'histoire, la littérature et l'art. Semaine des hôpitaux de Paris 1936, 12:314-325.

5825. Leconte, M., J. Chazaud, and R. Robert. Illustration de quelques aspects habituels de la peinture des schizophrènes. En-céphale 1961, 50:5-28.

5826. Ledgerwood, R. Patient as person: personality projection in paintings by psychotic patients. Proc Indiana Acad Sci 1948, 57:187-188.

5827. Legrün, A. Ein Fall von geringer Schriftbildkonstanz als Zeichen psycho-pathischer Veranlagung. Z Kinderforsch 1930, 38(4).

5828. Lehel, F. Notre art dément; quatre études sur l'art pathologique. Paris: Jon-quières 1926, 122 p.

5829. Leroy, M. Dessins d'un dément pré-coce avec état maniaque. Bull Soc clin méd ment 1911, 4:303-308.

5830. Levi Bianchini, M. La psicoanalisi della fantasia creatrice ed il pensiero autistico nell'arte e nelle psicosi. Arch Generale di Neurologie, Psichiatrie e Psicoanalisi 1922, 3:19-39, 73-76.

5831. Lewin, R. Das Psychopathische der Kunst. Pan 1911, 246 ff.

5832. Lewis, N.D.C. Graphic art produc-tions in schizophrenia (dementia praecox). Proc Ass Res Nerv Ment Dis for 1925, 1928, 5:344-368; NY: Hoeber 1928.

5833. Lombroso, C., and M. DuCamp. L'arte nei pazzi. Arch di psichiatria scientifico,
penali, antropologia e criminol 1880, 1: 333-342.

5834. Maccagnani, G. L'art psicopatologica. Rassegna critica, osservazioni generali e contributo casistico. Limiti dei rapporti tra arte moderna e arte psicopatologica. Considerazioni psicopatologische sul problema dello "stilwandel." Riv speri-mentale di Freniatria 1958, 82, suppl 2, 126 p.

5835. Maccagnani, G., and J. Bobon. L'ex-pression plastique en psychopathologie: II. Un exemple d'identité entre un néo-morphisme et le néographisme qui le nomme. Acta neurol psychiat belg 1961, 9:843-848.

5836. Maccagnani, G., et al. (Graphic ex-pression in psychopathology. IV. Further examples of correspondence between neo-graphism and neomorphism.) Riv sperimentale di Freniatria 1963, 87:803-813.

5837. MacCurdy, J.T. A psychological fea-ture of the precipitating causes in the psychoses and its relation to art. J abnorm Psychol 1914, 9.

5838. Maclay, W.S., E. Gutterman, and W. Mayer-Gross. Spontaneous drawings as an approach to some problems of psycho-pathology. Proc Royal Soc Med 1938, 31: 1337-1350.

5839. Madeiros, A. de. (Academic and mod-ern artists among insane patients of Tamarineira, mental institutions in Brazil.) Neurobiologia 1955, 18:114-121.

5840. Marcondes, D. A psicanálise dos desenhos dos psicopatas. Rev da Asso-ciação Paulista de Medicina 1933, 3:175-182.

5841. Marie, A. L'art et la folie. Rev Sci-entifique (Paris) 1929, 67:393-398.

5842. ———. Des dessins stéréotypés des aliénés. Bull Soc clin méd ment 1912, 5: 261-264.

5843. ———. L'expression artistique chez les aliénés. Arch Internationales de Neu-rologie (Paris) 1931, 50:211-212.

5844. Marie, A., and (?) Meunier. Note sur les dessins stéréotypés d'un dément pré-coce. JPNP 1907, 4:342-346.

5845. Marie, A., and B. Pailhas. Dessins curieux de déments précoces. Arch Inter-nationales de Neurologie (Paris) 1913, 35: 51.

5846. ——— & ———. Sur quelques dessins de déments précoces. Bull Soc clin méd ment 1912, 5:311-319.

5847. Marinow, A. Schöpferische Leistungen im Endzustand der Schizophrenie. Psychiatrie, Neurologie und medizinische Psychologie (Leipzig) 1960, 12:375-381.

5848. Maschmeyer, E. Ein Beitrag zur Kunst

der Schizophrenen. Arch Psychiat Nerven-
krankheiten 1926, 78:510-521.

5849. Meier-Mühler, H. Analyse du livre
de Morgenthaler: Ein Geisteskranker als
Kunstler. Schweiz ANP 1922, 11:309-314.

5850. Meige, H. Les fous dans l'art. Ico-
nograph Salpêtrière 1909, 97-107.

5851. Merzbach, A. Symbolische Selbst-
zeichnungen aus der Psychose eines
Jugendlichen und ihre Verwertbarkeit. ZNP
1930, 127:240-251.

5852. Messner, A.G. Artistic self-expres-
sion of psychotic patients. Amer J occup
Ther 1951, 5:235-240.

5853. Meyer, J-E. Stilwandel bildnerischer
Produktion unter dem Einfluss einer Psy-
chose. Nervenarzt 1954, 25:237-245.

5854. Miller, M. Géricault's paintings of
the insane. Warburg & Courtlauld Insti-
tutes J 1940-41, 4:151-163.

5855. Millier, A. Out of control. Art Digest
1932, 7:7.

5856. Modell, A.H. Changes in human fig-
ure drawings by patients who recover from
regressed states. Ops 1951, 21:584-596.

5857. Mohr, F. Das künstlerisches Schaffen
Geisteskranker und seine Beziehungen zum
Verlauf der Krankheit. Schweiz ANP 1940,
45:427-446.

5858. ———. Zeichnungen von Geisteskran-
ken. Z angew Psychol 1908-09, 2:291-300.

5859. ———. Uber Zeichnungen von Geistes-
kranken und ihre diagnostische Verwert-
barkeit. J für Psychologie und Neurologie
1906-07, 8:99-140.

5860. Monakow, P. Analyse du livre de H.
Prinzhorn: Bilderei der Geisteskranker.
Schweiz ANP 1922, 11:314-317.

5861. Montague, J.A. Spontaneous draw-
ings of the human form in childhood schiz-
ophrenia. In Anderson, H.H., and G.L.
Anderson (eds.), An Introduction to Pro-
jective Techniques. NY: Prentice-Hall
1951, 370-385.

5862. Morgenthaler, W. Ein Geisteskranker
als Künstler. Arbeiten aus dem angewandte
Psychiatrie 1921, 1:1-126; Bern: Bircher
1921, 126 p.

5863. ———. Einiges über Paralytikerzeich-
nungen. Schweiz ANP 1922, 10:321.

5864. ———. Das Kunstschaffen der Geistes-
kranken. Berichte zur Psychopathologie
u Psychologie 1931, 1:343.

5865. ———. Übergang zwischen Zeichnen
und Schreiben bei Geisteskranken. Schweiz
ANP 1918, 3:255-305.

5866. ———. Über Zeichnungen von Gesichts-
halluzinationen. ZNP 1919, 45:19-29.

5867. Morselli, E. Manuale di semejotica
delle malattie mentali. Guida alla diagnosi

della pazzia per i medici, i medici-legisti
e gli studenti. 2 Vols. Milan: Vollardi
1885, 438 p; 1894, 852 p.

5868. ———. Arte e schizofrenia nel pensier
di Karl Jaspers. Arch Psicol Neurol Psichia
1954, 15:177-187.

5869. Müller, M. Arta decadenta, arta pato
logica. Rev psicol (Madrid) 1948, 2:117-
132.

5870. Müller-Fahlbusch, H. (Limitations
of psychopathological evaluation of works
of art.) Medizinische Welt (Stuttgart) 196
45:2312-2316.

5871. Müller-Suur, H. Schizophrenic art.
Grenzgebiete der Medizin 1948, 1:150-
157.

5872. Näcke, P. Einige Bemerkungen be-
zwichen der Zeichnungen und anderer
künstlerischer Äusserungen von Geistes-
kranken. ZNP 1913, 17:453-473.

5873. Nagler, B. The art of the mentally ill
Digest of Neurology & Psychiatry 1950,
18:133-134.

5874. Nagler, B., and H.J. Tompkins. Psy-
chopathological Art. International Congres
of Psychiatry. Catalogue. Paris 1950, 90 p

5875. Nombela, J. y C. El arte en los alien-
dos. Arch de Criminología, medicina legal
e psiquiatria (Buenos Aires) 1909, 8.

5876. Norman, E. The play of a psychotic
child; illustrated with drawings by the
child. Brit J med Psychol 1948, 21:155-17C

5877. Offer, D., and D. Stine. The function
of music in spontaneous art productions.
Arch gen Psychiat 1960, 3:490-503.

5878. Osario, C. L'expression artistique
chez les aliénés. Arch Internationales
de Neurologie (Paris) 1931, 23.

5879. Osman, (?). Évolution visuelle d'une
démence précoce. Thèse Méd. Geneva 191

5880. Padovani, G. Limites de la validité
artistique des productions des malades
mentaux. Note e Rivista di Psichiatria
(Pesaro) 1957, 50:567-571.

5881. Pailhas, B. De l'art primitif chez
aliéné. Encéphale 1908, 2:196-198.

5882. ———. Dessins et manifestations d'art
chez deux aliénés circulaires. Iconograph
Salpêtrière 1908, Feb.

5883. Papertian, G. Langage ou technique.
Contribution a l'art psychopathologique.
Thèse Méd. Paris 1954, 163 p.

5884. Pappenheim, E., and E. Kris. The
function of drawings and meanings of the
"creative spell" in a schizophrenic artist.
Psychoanal Quart 1946, 15:6-31; In Kris,
E., Psychoanalytic Explorations in Art.
NY: IUP 1952, 151-172; London: Allen &
Unwin 1953, 151-172.

5885. Pariani, C. Nuove recerce sui rapport

dell'Arte e della Pazzia. Z Psychoanal
Psychother 1913, 3:620-622.

5886. Pasto, T.A. The schizoid bias in
visual art. Confin Psychiat 1958, 1:40-50.

5887. Pasturel, (?). Dessins anatomiques
et conceptions médicales d'un dément
précoce. Encéphale 1911, 6:358-360.

5888. Pérez, V. Valor semeiológico de las
manifestaciones gráficas en la locura.
Siglo Médico 1917, 64:546-549.

5889. Perry, J.W. The Self in Psychotic
Process; Its Symbolization in Schizophrenia.
Berkeley: Univ California Pr 1953, 184 p.

5890. Pfeifer, R.A. Über aussergewöhnliche
Kunstleistungen von Geisteskranken. ZNP
1923, 31:61.

5891. ———. Der Geisteskranke und sein
Werk: eine Studie über schizophrene Kunst.
Leipzig: Kröner 1923, 145 p.

5892. Pfister, O. Farbe und Bewegung in
der Zeichnung Geisteskranker. Schweiz
ANP 34:325-365.

5893. Pickford, R.W. Psychologic aspects
of schizophrenic art. Scottish Med J 1956,
1:193-200.

5894. Pinelli, T. (On a study of psycho-
pathological art.) Sistema Nervoso (Milan)
1960, 12:147-153.

5895. Pïsařovic, F., and M. Hamsík. (The
influence of schizophrenia with a course
of delirious confusion on artistic produc-
tion.) Neurologia, Psihiatria, Československa
venska 1954, 17:331-337.

5896. Podzemská, J., M. Hamsík, and F.
Pïsařovic. (Critical comments on artistic
productions by four psychotic patients.)
Neurologia, Psihiatria, Československa
1952, 15:109-137.

5897. Poritzky, J.E. Der pathologische
Künstler. Der Freihafen 1921, 4(1).

5898. Prince, (?). Curieuse fantasies
décoratives d'un hypomaniaque. Encéphale
1923, 18.

5899. Prinzhorn, H. Bildnerei der Gefang-
enen: Studie zur bildnerischen Gestaltung
ungeübter. Berlin: Juncker 1926, 57 p.

5900. ———. Bildnerei der Geisteskranken:
ein Beitrag zur Psychologie und Psycho-
pathologie der Gestaltung. Berlin: Springer
1923, 361 p.

5901. ———. Bildnerische Gestaltung, Ges-
undheit, Krankheit. ZNP 1923, 31:60-61.

5902. ———. Das Bildnerische Schaffen der
Geisteskranken. ZNP 1919, 52:307-326.

5903. ———. Gibt es schizophrene Gestal-
tungsmerkale in des Bildnerei der Geistes-
kranken? ANP 1922, 78:512-531; Abstract
in Psychol Bull 1924, 21:164-165.

5904. ———, et al. Der künstlerische Ge-
staltungsvorgang in psychiatrischer

Beleuchtung. Z Aesth 1925, 19:154-180.

5905. ———. Über Zeichnungen Geistes-
kranker und Primitiver. Wiener psycho-
analytischer Verlag 1921, Oct. 12.

5906. R., H. Analytische Bemerkungen über
das Gemälde eines Schizophrenen. Z Psy-
choanal Psychother 1913, 3:270-272.

5907. ———. Analyse einer schizophrenen
Zeichnung. Z Psychoanal Psychother 1913,
4:53-58.

5908. Régis, E. Les aliénés peints par eux-
mêmes. Encéphale 1883, 2:184-198, 373-
382, 547-564; 1883, 3:642-665.

5909. ———. Méthode graphique appliqué
à l'étude de la folie à double forme. En-
céphale 1884, 4:725.

5910. Regnard, P. Les maladies épidémiques
de l'esprit: sorcellerie, magnétisme, morph-
inisme, délire des grandeurs. Paris: Plon-
Nourrit 1887, 429 p.

5911. Reitman, F. Facial expression in schizo-
phrenic drawings. J ment Sci 1938, 85:264-
272.

5912. ———. Insanity, Art, and Culture. NY:
Philosophical Library 1954, 111 p; Bristol,
England: Wright 1954, 111 p.

5913. ———. Psychotic Art. London: Routledge
& Kegan Paul 1950, 180 p; NY: IUP 1951,
180 p.

5914. Réja, M. L'art chez les fous: le dessin,
la prose, la poésie. Paris: Sociéte du Mer-
cure de France 1908, 238 p.

5915. ———. L'art malade: dessins de fous.
Rev Universelle 1901, 1:913-915, 940-944.

5916. Rennert, H. Eigengesetze des bild-
nerischen Ausdrucks bei Schizophrene.
Psychiatrie, Neurologie und medizinische
Psychologie (Leipzig) 1963, 15(6-7):282-
288.

5917. Ries, J. von. Über das Dämonisch-
Sinnliche und Ursprung der ornamentalen
Kunst der Geisteskranker Adolf Wölfli.
Bern: Haupt 1946.

5918. Robertson, J.P.S. Mixture of writing
with drawing as a psychotic behavior. J
gen Psychol 1956, 54:127-131.

5919. ———. Creativity in a middle-aged
psychotic: a clinical case report and dis-
cussion. J clin exp Psychopath 1951, 12:
222-223.

5920. Rochowanski, L.W. Psychopathische
Künstler. Leipzig: Clauss 1923.

5921. Rodríguez Lafora, G. Estudio psico-
lógico del cubismo y expressionismo. Arch
de neurobiologia, psicologia, etc. (Madrid)
1922, 3:119-155.

5922. Rogues de Fursac, J. Les écrits et les
dessins dans les maladies,nerveuses et
mentales. Paris: Masson 1905, 306 p.

5923. Roi, G. Analisi fenomenologica dell'

assurdo schizofrenico nei rapporti col surreale dell'arte. Arch Psicol Neurol Psichiat 1953, 14:605-625.

5924. Rollin, H.R. Schizophrenia illustrated. Nursing Times 1962, 58:15-18.

5925. Romero Brest, J. El dolor en el arte. Rev de la Asociacion Medica Argentina 1953, 67:143-144.

5926. Rorschach, H. Analyse einer schizophrenen Zeichnung. Z Psychoanal Psychother 1913, 4:53-58.

5927. ———. Analytische Bemerkungen über das Gemälde eines Schizophrenen. Z Psychoanal Psychother 1913, 3:270-272.

5928. Rosenfeld, F. Oil paintings in Veterans Administration semi-disturbed ward. Ment Hospitals 1955, 6:1.

5929. Rosolato, G. Situation de l'art psychopathologique. Encéphale 1959, 48:428-443.

5930. Rouma, G. Un cas de mythomanie. Arch Psychol 1908, 7:258-282.

5931. Roumeguére, P. I. 1) La réalité perdue; 2) Vers la réalité: Salvador Dali et le manifeste mystique du surréalisme; 3) La réalité retrouvée: le réalisme dans l'oeuvre de Ferdinand Léger.—II. 1) Art et Psychiatrie: Images de la folie.—III. Le fantastique dans la peinture contemporaine: Brauner, Chagall, Coutaud, Ernst, Dali, Michaux, Miro.—IV. Salvador Dali et l'extase paranoïaque critique.—V. Max Ernst, fantastisme et surréalisme (investigation psychologique). VI. Folie et Art (II).—VII. Vers une psychanalyse de l'art moderne: Modigliani, Brauner, Dali, Cocteau, Picabia, Chirico.—VIII & IX. Le problème Picasso. Paris: Conférences inédites en Sorbonne 1951-52.

5932. Ruckstill, F.W. Great Works of Art and What Makes Them Great. NY: Garden City Publ 1925, 552 p.

5933. Ruhräh, J. Pediatrics in art; St. Nilus and St. Bartholomew curing an obsessed. Amer J Diseases Children 1933, 46:1102.

5934. Sandison, R.A. Psychological disturbance and artistic creation. JNMD 1953, 117:310-322.

5935. Sapas, E. Zeichnerische Reproduktionen einfacher Figuren durch Geisteskranke. Schweiz ANP 1918, 4:140-152.

5936. Satô, K. (Studies on the structure of perception in the insane. I. On the drawing of schizophrenics when reproducing an object and when copying from a pattern.) Jap J Psychol 1933, 8:91-107.

5937. Saurí, J.J. La estructura del espacio en las schizofrenias. Acta Neuropsiquiátrica (Argentina) 1959, 5:22-28.

5938. ———. La perspectiva en las esquizo-

frenias. Acta Neuropsiquiátrica (Argentina) 1957, 3:65-72.

5939. Schilder, P. Wahn und Erkenntnis; eine psychologische Studie. Berlin: Spring Monographien aus dem gesamtgebiete der Neurologie und Psychiatrie (Berlin) 1918, 15:1-115.

5940. Schilder, P., and (?) Weidner. Zur Kenntnis symbolähnlicher Bildungen im Rahmen der Schizophrenie. ZNP 1914, 26: 201-244.

5941. Schmidt, G., et al. Though This Be Madness; A Study in Psychotic Art. London: Thames & Hudson 1961, 114 p.

5942. Schneider, C. Entartete Kunst und Irrendkunst. Arch für Psychiatrie Nervenkrankheiten 1939, 110:135-164.

5943. Schönfeld, W. Zur Psychopathologie der Kinderkritzelein. Die Quelle 1933, 83: 254-257, 337-342.

5944. Schottky, J. Über einen künstlerisch Stilwandel in der Psychose. Nervenarzt 1936, 9:68-76.

5945. Schube, P.G., and J.G. Cowell. Art of psychotic persons. A restraint-activity index and its relation to diagnosis. Arch Neurol Psychiat 1939, 41:711-720.

5946. Schumacher, J. Die seelischen Volkskrankeiten im deutschen Mittelalter und ihre Darstellung in der bildenden Kunst. Berlin: Junker & Dunnhaupt 1940, 77 p.

5947. Scott, W.C.M. Discussion of Guttmann, E., & Maclay, W.S.: Clinical observations on schizophrenic drawings. Brit J med Psychol 1937, 16:204-205.

5948. Sechehaye, M. "Affects" et besoins frustrés vus à travers les dessin d'une schizophrène. Acta neurol psychiat belg 1957, 57:972-992.

5949. Sedlmayr, H. Art du démoniaque et démonie de l'art. Filosofia dell'Arte 1953, 1.

5950. Seward, G.H. An experimental study of schizophrenic interpretations of non-representational paintings. J Personality 1952, 21:205-216.

5951. Shapiro, M.B. The effects of mental disorder on the drawing of abstract design Bull Brit psychol Soc 1957, 33:31.

5952. Shear, H.J. The effect of a recorded voice on the drawing of a geometric desig as a predictor of social behavior. J clin Psychol 1958, 14:93-95.

5953. Sicard, J.A. À propos de dessins exécutés sous la suggestion hypnotique. Aesculape 1911, 1:129.

5954. Sigg, (?). Über das Zeichnen der Senilen. Schweiz ANP 1919, 5:184.

5955. Silverberg, W.V. The art of Dr. Gertrud Jacob 1893-1940: portraits of psy-

chotics. Psychiatry 1941, 4:157-160.

5956. ——. "Mythology of the Soul," review of H.G. Baynes' book. Psychoanal Quart 1942, 11:236-238.

5957. Simon, P.M. Les écrits et les dessins des aliénés. Arch di antropologia criminelle, psichiatria e medicina legale 1888, 3:318-355.

5958. ——. L'imagination dans la folie: Étude sur les dessins, plans, descriptions, et costumes des aliénés. Ann méd-psychol 1876, 16:358-390.

5959. Singer, R.H. Various Aspects of Human Figure Drawings As a Personality Measure with Hospitalized Psychiatric Patients. Dissertation Abstr 1958, 18:290.

5960. Smith, E. A study of sex differentiation in drawings and verbalizations of schizophrenics. J clin Psychol 1949, 5: 396-398; 1953, 9:183-185.

5961. Snyder, S. Perceptual closure in acute paranoid schizophrenia. Arch gen Psychiat 1961, 5:406-410.

5962. Snyder, S., D. Rosenthal, and I.R. Taylor. Perpetual closure in schizophrenia. J abnorm soc Psychol 1961, 63: 131-136.

5963. Speier, A. Characteristicas del dibujo del niño psicótico y su significado simbólico. Acta Neuropsiquiátrica (Argentina) 1961, 7:202-204.

5964. Stadelmann, H. Bildnerei der Geisteskranken. Psychiatrisch-neurologische Wochenschrift (Halle) 1927, 29:499-500.

5965. ——. Die Stellung der Psychopathologie zur Kunst. Ein Versuch. Münich 1908, 51 p.

5966. Stahly, F., and G. Oeri. L'art brut. Graphis 1950, 6(31):272-277.

5967. Stainbrook, E., and H. Lowenbach. Drawings of psychotic individuals after electrically induced convulsions. JNMD 1944, 99:382-388.

5968. Stavenitz, A.R. Art and psychopathology. Psychologists League J 1939, 3:36-37.

5969. Stertz, G. Beitrag zu dem Verhältnis von Kunstschaffen und Geisteskrankheit. Deutsch Z für Nervenheilkunde (Berlin) 1927, 100:40-62.

5970. Strnad, M., and E. Skula. Ein Fall von Kinderschizophrenie mit ausdrucksvoller Bildproduktion. Acta Paedopsychiatrica (Basel) 1960, 27:52-61.

5971. Szecsi, L. On works of art of the insane. Midtown Galleries, NY: Catalogue of the Exhibition of the Szecsi Collection, 1935.

5972. Takesaki, S. (Observations on the creations of the mentally ill.) Z für Psy-

choanalyse (Tokyo) 1939, 7, Nos. 9-10, 11-12.

5973. Taylor, I.A., D. Rosenthal, and S. Snyder. Variability in schizophrenia. Arch gen Psychiat 1963, 8(2):163-168.

5974. Telatin, L., and G. Maccagnani. La produzione artistica figurativa degli ammaloti di mente: alcune considerazioni sul cosiddetto stile del disegno degli schizofrenici; interesse diagnostico e vantaggi dell'arte-terapia. Riv sperimentale di Freniatria 1958, 82:31-54.

5975. Trepsat, L. Dessins d'un dément précoce. Encéphale 1913, 8:541-544.

5976. Trillot, (?), and (?) Ducoudray. Hallucinations visuelles projetées et dessinées chez une délirante chronique. Ann médpsychol 1936, 12:872-880.

5977. Trofimosa, A.J. (Une jeune schizophrène douée au point de vue artistique.) Vop Psikhonevrol Detei 1936, 3:133-142.

5978. Tsubina, M.I. (Schizophrénie et don artistique.) Klin Arckh genialn i ordaren 1929, 1:63-68.

5979. Utitz, E. (Insanity and art; art and mental disease.) Deutsche medizinische Wochenschrift (Stuttgart) 1925, 51:36-38.

5980. Van der Horst-Oosterhuis, C. Quelques idées relatives à la structure du monde des psychotiques. Évolut Psychiat 1961, 26:511-522.

5981. Various. Art et psychopathologie. Numéro Spécial. La Vie Médicale 1956, Dec.

5982. Vie, J., and P. Quéron. Productions artistiques des pensionnaires de la colonie familiale d'Ainay-le-Château. Aesculape 1933, 23:266-271.

5983. Vinchon, J. L'art dans l'examen et le traitement des malades psychiatriques. Paris: Conférences du Palais de la Découverte 1950, 28 p.

5984. ——. L'art dans le psychiatrie. Progrès médicale (Paris) 1956, 84:179-184.

5985. ——. L'art dément. Aesculape 1927, 17:163-167.

5986. ——. L'art et la folie. Aesculape 1924, 14:44-47, 64-67.

5987. ——. L'art et la folie. Paris: Boutelleau 1924, 127 p; Paris: Stock 1950, 270 p.

5988. ——. Le dessin des images intérieures en psychotherapie. Aesculape 1954, 35:1-20.

5989. ——. Essai d'analyse des tendances de l'art chez les fous. L'Amour et l'Art 1926, 7:246-248.

5990. ——. La folie et l'art. Bull de Acad de Médicin (Paris) 1924, 91:145-146.

5991. ——. Le IIIe congrès international d'art psychopathologique. Gazette Beaux Arts 1962, 60, Suppl 7.

5992. Volmat, R. L'art psychopathologique. Thèse Méd. Paris 1953, 725 p; Paris: PUF 1956, 325 p.

5993. ———. De l'évolution des idées sur "L'art et la folie." Histoire de la Médecine (Paris) 1955, 5:29-49.

5994. ———. L'exposition mondiale d'art psychopathologique. Comptes rendu du Congrès internat Psychiat. Paris: Hermann 1952, 8:165-168.

5995. ———. Expressions plastique de la folie. La Vie Médicale. Numéro Spécial. Art et psychopathologie. Dec. 1956, 9-20.

5996. ———. Expressions plastiques de la folie (introduction et dix planches commentées en offset huit couleurs). Médicine en France (Bombay) 1955, 61-70.

5997. ———. Présentation de la numéro spécial, "Art et psychopathologie." La Vie Médicale. Numéro Spécial. Art et psychopathologie. Dec. 1956, 7-8.

5998. ———. La schizophrénie par l'image. Paris: Roche-Chavanne 1958.

5999. Volmat, R., and C. Wiart. (Paintings contemporaneous with the clinical improvement of a maniacal attack treated by neuroleptics.) La Vie Médicale 1962, 43:31-37.

6000. Waal, N. A case of schizophrenia in early childhood, with examples of drawing. Acta psychiat neurol suppl 47, 1947, 323-339.

6001. Wallin, E.C. The History of Care for the Mentally Ill in Pennsylvania As Depicted by the Execution of a Mural. Dissertation Abstr 1957, 17:1056-1057.

6002. Warstat, W. H. Stadelman, die Stellung der Psychopathologie zur Kunst. Arch ges Psychol 1912, 24:163-167.

6003. Werner, H. Comparative Psychology of Mental Development. NY: Harper 1940, 510 p.

6004. Westman, H. The case of Joan. In The Springs of Creativity. NY: Atheneum 1961, 172-263.

6005. Weygandt, W. (Delineation of abnormal mental conditions in Japanese art.) ZNP 1934, 150:500-506.

6006. ———. Zur Frage der pathologischen Kunst. ZNP 1924, 37:338-339; 1925, 94: 421-429.

6007. ———. Kunst und Wahnsinn. Die Woc] 1921, 22:483-485.

6008. Whitaker, E. de A. (Syndrome of men) tal primitivism; delusion of mystical influences and visual hallucinations; partia expression in colored drawings and symbolic writing.) Rev Arch mun (São Paulo) 1943-44, 9(91):51-69.

6009. White, W.A. The language of the psychoses. Amer J Psychiat 1930, 27:697-718.

6010. Winslow, F. (ed.). Mad artists. J psychol Med & mental Pathology 1880, N.S. 6, 33-75.

6011. Wize, C. Culture et psychopatholog Ann méd-psychol 1936, 94:609-614.

6012. Wize, K. (The importance of artistic motives in the mentally diseased.) Nowin Psychiatryczne 1933, 10:185-199.

6013. Wizel, A. (Wit of the insane with a few words on their artistic ability.) Kryt lek (Warsaw) 1899, 3:33-41, 70-79.

6014. Wulff, M. Zur Arbeit von E. Kris, "Bemurkungen zur Bildnerei der Geisteskranken." Imago 1936, 22:471-475.

6015. Yahn, M. Exposição de Arte Psicopa tologica no. 1 Congress Internacional de Psiquiatria de Paris. Arquivos do Departa mento de assistência a psicopatas de estado de São Paulo 1951, 16:23-32.

6016. ———. Réflexions sur l'art psychopathologiques. J Brasileiro de Psiquiatria 1951, 1:460-466.

6017. ———. Sobre a criâcão de uma secçã(de arte no Hospital de Juquieri. Boletín d higiene mental (São Paulo) 1950.

6018. Zeldenrust, E.L.K. L'art et la folie. Étude ontologique et anthropologique. Évolut Psychiat 1951, No. 1, 73-86.

6019. Ziese, G. Die Bedeutung des affektiven Defektes in dem sprachlichen und bildnerischen Darstellungen der Schizophrenen. Psychiatrie, Neurologie und med zinische Psychologie (Leipzig) 1953, 5:5(65.

6020. Zimmerman, J., and L. Garfinkel. Pre liminary study of the art production of th(adult psychotic. Psychiatric Quart 1942, 16:313-318.

18 Sculpture, Coins, Frescoes, etc.

6021. Adriani, B. Problems of the Sculptor. NY: Nierendorf, 1943.

6022. Amiran, R. Myths of the creation of man and the Jericho statues. Amer School Oriental Res Bull 1962, 167:23-25.

6023. Anon. L'art chez les aliénés: curieuse sculpture sur bois, par un pensionnaire de l'asile d'aliénés de Montredon. Ann méd-psychol 1893, 18:250-255.

6024. Anon. Poul Bjerre's life—psychotherapy and sculpture. Ciba Symposia 1961, 9:128-137.

6025. Antoni, N. (Relief—possibly earliest picture of epileptic seizure in Lateran Museum at Rome.) Acta psychiat neurol (Copenhagen), suppl, 1956, 108:29-33.

6026. Arnheim, R. The holes of Henry Moore: on the function of space in sculpture. JAAC 1948, 7:29-38.

6027. Aru, C. La veduta unica e il problema del non finito in Michelangelo. L'Arte 1937, 8:46-52.

6028. Belluge, P. (Artistic anatomy in Khermian sculpture—Cambodia.) Aesculape 1926, 16:302-306.

6029. ——. (Morphologic considerations of the statue, the Doryphorus.) Presse méd 1937, 45:1431-1432.

6030. Bjornberg, A. ("Facies leontina" in a Scanian sculpture of about 1500.) Svensk Lakartidn 1959, 56:2880-2883.

6031. Bourdelle, A. Prophéties sur la sculpture. JPNP 1926, 23:303-305.

6032. Boyer, L.B. Sculpture and depression: a psychiatric study of the life and production of a depressed sculptress. Amer J Psychiat 1950, 106:606-615.

6033. Brachfeld, O. Über "Glyptophilie." Z für Sexualwissenschaft und Sexualpolitik 1931, 17:420-425.

6034. Brion, M. Aspect d'une esthétique nouvelle de la sculpture. Rev d'Esthétique 1954, 7(4).

6035. Brion-Guerry, L. Fresques romanes de France. Paris: Hachette 1958, 72 p.

6036. Brook, D., and L.R. Rogers. Sculptural thinking. Brit J Aesthetics 1963, 3(4).

6037. Chandler, A.R. Sculpture. In Beauty and Human Nature. Elements of Psychological Aesthetics. NY: Appleton-Century 1934, 136-149.

6038. Chowhan, J.S. "Caduceus"—or the significance of serpents as the emblem of the art of healing and snake worship. Indian Med Gazette 1949, 84:552-554.

6039. Cleaver, D. The concept of time in modern sculpture. Art J 1963, 22:232-236, 245.

6040. Courbon, M.P. (Bust of a stuporous person at Saint-Marc's Almshouse in Strasbourg.) Rev neurologique 1924, 1:56-61.

6041. ——. (Psychiatric import of a cathedral carving.) Rev neurologique 1922, 38:52-55.

6042. Cox, G.J. Sculpture today. Yrb nat Soc Stud Educ 1941, 40:212-215.

6042a. Danielou, A. An approach to Hindu erotic sculpture. Int J Sexology 1953, 6:144-148.

6043. Delcourt, M. Hermaphrodite. Myths and Rites of the Bisexual Figure in Classical Antiquity. London: Studio 1961, 109 p; Paris: PUF 1956.

6044. Deutsch, F. Creative passion of the artist and its synesthetic aspects. Int J Psycho-Anal 1959, 40:38-51.

6045. Dieke, W. (Hermaphroditism represented in old literature and sculpture; paramedical study. Zentralblatt für Gynäkologie 1956, 78:889-927.

6046. Dumas, P. Endocrinologic fresco by Marion Scott at McGill University. J Hôtel-Dieu Montréal 1943, 12:208-212.

6047. Elisofon, E., and W. Fagg. The Sculpture of Africa. NY: Praeger 1958, 256 p; London: Thames & Hudson 1958, 256 p.

6048. Ellis, J.B. The why and wherefore of sculpture. In Schoen, M. (ed.), The Enjoyment of Art. NY: Philosophical Library 1944, 65-106.

6049. Elsen, A.E. Rodin's "Gates of Hell." Dissertation Abstr 1955, 15:1222.

6050. Ernst, W. Plastiche Arbeiten verbrecherischer Geisteskranken. Arch Psychiat Nervenkrankheiten 1925, 74:838-842.

6051. Fagg, W. The Sibylline books of tribal art. Blackfriars (London) 1952, 33 (382).

6052. Fertig, H.H. Josiah Wedgwood, medallions and physicians. Bull Hist Med 1954, 28:127-139.

6053. Focillon, H. The Life of Forms in Art. New Haven: Yale Univ Pr 1942.

6054. França, J.A. La sculpture et le temps. Temps Modernes 1963, 203:1888-1904.

6055. Freud, S. The Moses of Michelangelo. Rev franç Psychanal 1927, 1:120-147; Collected Works 1949, 10:172-201; Collected Papers 1925, 1959, 4:257-287; Standard Edition 13:211-236; Imago 1914, 3:15-36; Gesammelte Schriften 1924, 10: 257-286; Gesammelte Werken 1946, 10: 172-201; Rivista italiani di psicoanalisi 1932, 1:353-380; Obras Completas (Madrid) Vol. 14; Obras Completas (Buenos Aires) 18:95-128.

6056. ——. Postscript to my paper on the Moses of Michelangelo. Rev franç Psychanal 1927, 1; Standard Edition 13:237-238; Gesammelte Schriften 1928, 11:409-410; Gesammelte Werken 1948, 14:321-322; Imago 1927, 13:552-553; Obras Completas (Buenos Aires) 18:129-130.

6057. Gangoly, O.C. Orissian sculpture. Aesthetics (Bombay) 1951, 1(1).

6058. Giedion, S. Construction and aesthetics. Transition 1936, 25:181-201.

6059. Giedion-Welcker, C. Constantin Brancusi. Basel: Schwabe 1958, 240 p.

6060. ——. Modern Plastic Art. Zurich: Girsberger 1937.

6061. Gill, E. Sculpture. NY: Chaucer Head 1924.

6062. Gocht, H. (Anatomic and pathologic studies of Greek sculpture.) Arch Orthopädische (Berlin) 1930, 28:30-42.

6063. Goldwater, R. Bambara Sculpture from the Western Sudan. NY: Museum of Primitive Art 1960, 64 p.

6064. Grassi, L. Storia e cultura dei monumenti. Milan: Societa ed. Libraria 1960.

6065. Gray, C. Sculpture and Ceramics of Paul Gauguin. Baltimore: Johns Hopkins Univ Pr 1963, 340 p.

6066. Griswold, A.B. Dated Buddha Images of Northern Siam. Ascona: Artibus Asiae 1957, 97 p.

6067. Güttich, A. (Muscular reflexes following shift in center of gravity as represented in Greek sculpture.) Arch für Ohren-Nasen- und Kehlkopfheilkunde (Berlin) 1942, 151:287-293.

6068. Guillaume, P., and T. Munro. Primitive Negro Sculpture. NY: Harcourt, Brace 1926.

6069. Herskovits, M. African art from an ivory tower. The Arts 1926, 10(4):241-243.

6070. ——. A arte de bronze e do panna em Dahome. Estudos Afro-Brasileeros, Vol. II. Rio de Janeiro: Ariel 1935, 227-235.

6071. ——. Bush Negro Calabash-carving. Man 1951, 51:163-164.

6072. ——. Review of The Sculpture of Negro Africa by Paul Wingert. Coll Art J 1951, 10(3):294-296.

6073. Herskovits, M., and F.S. Herskovits. The art of Dahomey: I. Brass-casting and applique clothes. Amer Magazine of Art 1934, 27(2):67-76.

6074. —— & ——. The art of Dahomey: II. Wood carving. Amer Magazine of Art 1934, 27(3):124-131.

6075. Hess, M.W. The universal particular situation in sculpture and poetry. Monist 1934, 44:255-261.

6076. Hildebrand, A. The Problem of Form. NY: Stechert, 1932; Strassburg 1913.

6077. Hitschmann, E. Ein geborner Bildhauer. Z für psychoanalytischer Pädagogie 1929, 3:474-475.

6078. Hodin, J.P. Barbara Hepworth. NY: McKay 1962.

6079. ——. Recent trends in contemporary English sculpture and their origins. Aesthetics (Bombay) 1953, 6:21-27.

6080. ——. Testimonianza sulla sculptura inglese attuale. Sele arte 1953, 2(9):57-64.

6081. Igna, N. (The cult of Aesculapius and Hygeia in Dacia as recorded in ancient sculptures and inscriptions.) Rev sanitară militară (Bukharest) 1935, 34:187-190.

6082. Kallus, I. (Medicohistorical study of wooden carved reliefs in cathedral of Gurk.) Wiener medizinische Wochenschrift 1939, 89:102-106.

6083. Kjersmeier, C. Centres de style de la sculpture nègre africaine. Copenhagen & Paris 1935-38, 4 Vols.

6084. Kohen, M. La Vénus de Willendorf. Rev franç Psychanal 1948, 12:125-138; Amer Imago 1946, 3:49-60.

6085. Kolscar, S. (Data on distortion of the face-body pattern.) Ofakim (Israel) 1959, 13:196-201.

6086. Kosice, G. Geocultura de la Europa de hoy. Buenos Aires: Losange 1959, 132 p

6087. Kris, E. Bemerkungen zur Bildnerei der Geisteskranken. Imago 1936, 22:339-370.

6088. ——. Über eine gotische Georgs-Statue und ihre nächsten Verwandten. Ein Beitrag zur Kenntnis der österreichischen Skulptur im frühen 15. Jahrhundert. Jahrbuch Kunsthistorischen Sammlungen

(Vienna) 1930, 4:121-154.

6089. ——. Die Madonna auf der Mond-
schiel im kunsthistorischen Museum. Ein
Beitrag zur schwäbischen Skulptur um
1500. Jahrbuch Kunsthistorischen Samm-
lungen (Vienna) 1928, 2:119-127.

6090. ——. Zur Psychologie alterer Bio-
grafik (dargestellt an der des bildenden
Künstlers). Imago 1935, 21:320-344; Amer
Imago 1937, 160-197.

6091. Laignel-Lavastine, M., and J. Vinchon.
Un cas de sculpture "automatique." Bull
de l'Academie de Médicin 1920, 83:317-
319.

6092. —— & ——. Délire mystique et
sculpture automatique. Rev neurologique
1920, 27:824-828.

6093. Lázár, B. Das Grundgesetz der monu-
mentalen Skulptur. Z Aesth 1915, 10:1-10.

6094. Lipps, T. Die ästhetische Betrach-
tung und das bildende Kunst. Hamburg-
Leipzig 1906.

6095. Luquet, G.H. Les Vénus paléolo-
thiques. JPNP 1934, 31:429-460.

6096. McElroy, W.A. Appreciation of sculp-
ture. Scottish Art Rev 1950, 3(2):11-15.

6097. ——. Responses to traditional and
modern sculpture, and factors influencing
its recall. Quart Bull Brit psychol Society
1950, 1:310-313.

6098. Maillard, R. Dictionary of Modern
Sculpture. NY: Tudor 1962, 310 p.

6099. Malraux, A. Le Musée Imaginaire de
la Sculpture Mondiale. 3 Vols. La Sta-
tuaire; Des Bas-Reliefs aux Grottes
Sacrée; Le Monde Crétien. Paris: Galli-
mard 1952, 1954, 1955.

6100. Martin, H. (Solutrian workshop in
the valley of Roc—Charente; its sculp-
tured frieze.) L'Anthropologie 1928, 38:
1-6.

6101. Matz, W. Eine Untersuchung über
das Modellieren sehender Kinder. Z angew
Psychol 1912, 6:1-20.

6102. Meyerson, I. Robert Jacobsen: Fig-
ures. Quand le fer parle. Paris: Éditions
de la Galerie de France 1957, 36 p.

6103. Michel, P.H. La fresque romane.
Paris: Tisné 1961, 175 p.

6104. Morgenstern, L. L'art plastique et
le problème de l'espace. JPNP 1931, 28
(5-6):473-480.

6105. Moriya, K. (The representation of
the human form in the Buddhist sculpture.)
Bigaku (Tokyo) 1952, 3(3).

6106. Muensterberger, W., and W.L.L. Muen-
sterberger. The Sculpture of Primitive
Man. London: Thames & Hudson 1955,
46 p; NY: Abrams 1955, 47 p.

6107. Murray, M.A. Female fertility figures.

J Royal Anthrop Inst Great Britain & Ire-
land 1934, 64:93-100.

6108. Myron, R.E. Hopewellian Figurative
Sculpture. Dissertation Abstr 1959, 20:
263-266.

6109. Neumann, E. The Archetypal World
of Henry Moore. NY: Pantheon 1959, 138 p;
London: Routledge & Kegan Paul 1959,
138 p.

6110. Nissen, I. A psychologic interpreta-
tion of Gustav Vigeland's group sculptures.
Int Record of Med (NY) 1953, 166:319-323.

6111. ——. Psychological motifs in the
work of the Norwegian sculpture, Gustav
Vigeland. Int Record of Med (NY) 1952,
165:177-183.

6112. Ocaranza, F. (The work of Martín
del Campo as sculptor.) Rev Escuela de
médicina militar 1943, 2:19-22.

6113. Osario, C., and J.P. Monteiro. Con-
tribuiçao ao estudo do symbolismo mystico
nos aliendos ("Un caso de demencia pre-
coce paranoide, n'um antigo esculptor.")
Sao Paolo: Officinas da Editorial Helios
Limitada 1927, 82 p.

6114. Palmer, E.G. The Secret of Ancient
Egypt. Philadelphia: McKay 1928, 103 p.

6115. Panofsky, E. Die deutsche Plastik
des elften bis dreizehten Jahrhunderts.
Münich 1924, 2 Vols.

6116. ——. Tomb Sculpture. NY: Abrams
1963.

6117. Pareja Yévenes, J. (Sculpture of joy
and statue of despair; biotypes, charac-
terology and art.) Boletín Cultural e In-
formativo; Consejo General de Colegios
Médicos de España (Madrid) 1948, 4:37
39.

6118. Payant, F. Sculptors and their work.
Yrb nat Soc Stud Educ 1941, 40:207-211.

6119. Plachte, K. Symbol und Idol. Berlin
1931, 145 p.

6120. Pöch, H., and P.E. Becker. (Muscular
dystrophy on ancient Egyptian relief.)
Nervenarzt 1955, 26:528-530.

6121. Porter, A.M. Cats, carvings and coins.
A comparison of schizophrenic and arachaic
art. Practitioner 1960, 185:100-101.

6122. Radin, P., and J.J. Sweeney (eds.).
African Folktales and Sculpture. NY: Pan-
theon 1952, 1964.

6123. Read, H. The Art of Sculpture. The
A.W. Mellon Lectures in the Fine Arts
1954, National Gallery of Art. Washington.
NY: Pantheon 1956, 125 p.

6124. Reddy, D.V.S. Fainting and collapse
as illustrated in ancient Indian sculpture.
Bull Hist Med 1940, 8:277-284.

6125. Reik, T. The Moses of Michelangelo
and the events on Sinai. In Ritual: Psycho-

analytic Studies. NY: IUP 1958, 305–361.

6126. Renaud, E.B. Prehistoric female figurines from America and the Old World. Sci Monthly 1929, 28:507–512.

6127. Rindge, A.M. The Art of Sculpture: An Analysis of the Aesthetics of Sculpture. Doctoral dissertation. Radcliffe College 1928.

6128. Rogers, L.R. Sculptural thinking. Brit J Aesthetics 1962, 2(4).

6129. Rosenfeld, E.M. The pan-headed Moses—a parallel. Int J Psycho-Anal 1951, 32:83–93; Rev franç Psychanal 1951, 15:425–444.

6130. Rossetto, E. (The child in sculpture.) Minerva med 1952, 43:940–948.

6131. Rubin, E. Visuell Wahrgenommene Figuren. Copenhagen: Gyldendal 1921.

6132. Sartre, J-P. Existentialist or mobilist. Art News 1947, 46(10):22–23, 55–56.

6133. Saunders, E.D. Mudra: A Study of Symbolic Gestures in Japanese Buddhist Sculpture. NY: Pantheon 1960, 296 p.

6134. Schnier, J. Sculpture in Modern America. Berkeley: Univ California Pr 1948, 224 p.

6135. Segy, L. African names and sculpture. Acta Tropica (Basel) 1953, 10(4).

6136. ———. African sculpture and animism. J Human Relations 1954, 2(1); Psyché-Paris 1953, 8:108–118.

6137. ———. African Sculpture Speaks. NY: Wyn 1952, 254 p; NY: Dover 1962, 244 p.

6138. ———. African sculpture and writing. J Human Relations 1953, 1(3).

6139. ———. Bakota funerary figures. Zaire (Louvain) 1952, 6(5).

6140. ———. Cérémonies d'initiation et sculptures africaines. Psyché-Paris 1954, 9:128–138; Amer Imago 1953, 10(1):57–82.

6141. ———. Circle-dot symbolic sign on African ivory carvings. Zaire (Louvain) 1953, 7(1).

6142. ———. The mask in African dance. Bull Negro History 1953, 14(5).

6143. ———. Plastic aspects of African sculpture: the theory of tension. ETC 1957, 14:185–202.

6144. Servadio, E. An unknown statuette of Moses. Int J Psycho-Anal 1951, 32:95–96.

6145. Shun-sheng, L. Ancestral tablet and genital symbolism in ancient China. Bull Inst Ethnology, Academica Sinica (Formosa) 1959, 8:1–46.

6146. Sieber, R. African Tribal Sculpture. Ann Arbor: Univ Microfilms 1957, Publ No. 23768; Dissertation Abstr 1957, 17(12): 2970–2971.

6147. Stärcke, A. (An artistic production.) Ned Tijdschr Geneesk 1920, 65:220–223.

6148. ———. (Demonstration of forty drawings and plastic works produced by a slightly hebephrenic sculptor during his stay in an institution.) Ned Tijdschr Geneesk 1920, 64:103–104.

6149. ———. (Supplementary remarks on the demonstration of an artistic production.) Ned Tijdschr Geneesk 1921, 65:897–898.

6149a. Stokes, A. Stones of Rimini. London Faber & Faber 1934.

6150. Suhr, E.G. Venus de Milo the Spinne: the Link between a Famous Art Mystery ar Ancient Fertility Symbols. NY: Exposition 1958, 94 p.

6151. Trier, E. Form and Space. NY: Praege 1962.

6152. Trowell, M. Classical African Sculpture. London: Faber & Faber 1954, 103 p; NY: Praeger 1955, 103 p.

6153. Tyler, P. Rodin and Freud: masters o' ambivalence. Art News 1955, 54:38–41.

6154. Underwood, L. Bronzes of West Afric London: Tiranti 1949, 32 p; Hollywood, Fl Transatlantic 1949, 32 p.

6155. ———. Figures in Wood of West Afric London: Tiranti 1947, 49 p; Hollywood, Fl Transatlantic 1948, 49 p.

6156. Vafeas, W.P. The Effect of Barriers on the Creative Development and Aestheti Quality of Three-Dimensional Art Forms. Dissertation Abstr 1962, 22:3930.

6157. Valentiner, W.R. Origins of Modern Sculpture. NY: Wittenborn 1946.

6158. ———. The simile in sculptural composition. Art Quart 1947, 10(4):262–277.

6159. Vallery-Radot, P. (Physicians and statues.) Présse med 1953, 61:398.

6160. Victorius, K. Der "Moses des Miche. angelo" von Sigmund Freud. Eine Studie. Psyche (Stuttgart) 1956–57, 10:1–10.

6161. Villamil. Matiz inenso de religiosida inconsciente del psiquismo humano. Progressos de terapeutica Clinica (Madrid) 1933, No. 254.

6162. Ward, T.H.G. An experiment on seria reproduction with special reference to the changes in the design of early coin types. Brit J Psychol 1949, 39:142–147.

6163. Watkins, J.G. Concerning Freud's paper on "The Moses of Michelangelo." Amer Imago 1951, 8:61–63.

6164. Watts, P. The sculptor. In Todd, J.M. (ed.), The Arts, Artists and Thinkers. NY: Macmillan 1958.

6165. Weismann, E.W. Mexico in Sculpture 1521–1821. Cambridge: Harvard Univ Pr 1950, 224 p.

6166. Werner, A. The universal humanism of Ernst Barlach. Amer Artist 1961, 25:22–26.

6167. West, S.S. The hypothesis of slow cyclical variation of creativity. Amer J Sociology 1957, 63:143–151.

6168. Weygandt, W. Über pathologische Plastik. ZNP 1926, 42:347.

6169. ———. Die pathologische Plastik des Fürsten Palagonia. ZNP 1926, 101:857–874.

6170. Wight, F.S. Henry Moore: the reclining figure. JAAC 1947, 6:95–105.

6171. ———. Masks and symbols in Ensor. Magazine of Art 1951, 44:255–260.

6172. Wilenski, R.H. The Meaning of Modern Sculpture. NY: Stokes 1932.

6173. Wingert, P.S. American Indian Sculpture. NY: Augustin 1949, 144 p.

6174. ———. Tsimshian sculpture. In Garfield, V. (ed.), The Tsimshian: Their Arts and Music. NY: Augustin 1951.

6175. Wolbarsht, M.L., and J.D. Lichtenberg. Freud and the Moses of Michelangelo. Amer Imago 1961, 18(3):263–268.

6176. Wolff, W. Island of Death; A New Key to Easter Island's Culture through an Ethno-Psychological Study. NY: Augustin 1948, 228 p.

6177. Zimmer, H. Myths and Symbols in Indian Art and Civilization. Edited by Joseph Campbell. NY: Pantheon 1946, 248 p.

19 Tests: Aesthetics

6178. Alexander, C. A result in visual aesthetics. Brit J Psychol 1960, 51:357-371.

6179. Anderson, W.H. Social Reality As a Possible Prepotent Influence in Establishing Preferences for Painting. Dissertation Abstr 1962, 22:3597.

6180. Asthana, B.C. Individual differences in aesthetic appreciation. Educ & Psychol (Delhi) 1956, 3(1):22-26.

6181. Aust, F. Some experimental work in art appreciation and art analysis. Report to Conference on Art Tests. Carnegie Corp. Cambridge, Mass. 1929.

6182. Barnes, M.W. A technique for testing understanding of the visual arts. Educ psychol Measmt 1942, 2:349-352.

6183. Barnhart, E.N. The criteria used in preferential judgments of geometrical forms. Amer J Psychol 1940, 53:354-370.

6184. ———. A special order of merit for preference judgments. J exp Psychol 1939, 25:506-518.

6185. Barron, F. Personality style and perceptual choice. J Personality 1952, 20: 385-401.

6186. Barron, F., and G.S. Welsh. Artistic perception as a possible factor in personality style: its measurement by a figure preference test. J Psychol 1952, 33: 199-203.

6187. Beebe-Center, J.G., and C.C. Pratt. A test of Birkhoff's aesthetic measure. J gen Psychol 1937, 17:339-353.

6188. Beier, E., et al. Response to the human face as a standard stimulus. J consult Psychol 1953, 17:126-131.

6189. Beittel, K.R. Some Experimental Approaches to the Aesthetic Attitudes of College Students. Doctoral dissertation. Pennsylvania State Univ 1953; In Research in Art Education. 7th Yearbook. Kutztown, Pa.: National Art Educ Ass 1956, 47-61.

6190. Bevan, W., Jr., and G. Seeland. An exploration of the influence of personal relevance upon statements of aesthetic preference. Acta psychol 1953, 9:254-287.

6191. Birkhoff, G.D. Aesthetic Measure. Cambridge: Harvard Univ Pr 1934, 226 p.

6192. ———. The present status of aesthetic measure. Sci Monthly 1938, 46:351-357.

6193. Bolton, E.B. Brief evaluation of two tests of aesthetic judgment. Peabody J Educ 1955, 32:211-222.

6194. Bottorf, E.A. A study comparing two methods of developing art appreciation with college students. J educ Psychol 1947 38:17-44.

6195. Bouffleur, E.J. An Analytical Study of Methods of Testing Art Appreciation. Doctoral dissertation. Univ Chicago 1925.

6196. Brighouse, G. The effects of protracted observation of a painting. Psychol Bull 1939, 36:552.

6197. ———. A study of aesthetic appreciation. Psychol Monogr 1939, 51, No. 231, 1-22.

6198. ———. Variability in preference for simple forms. Psychol Monogr 1939, 51, No. 231, 68-74.

6199. Brittain, W.L., and K.R. Beittel. Analyses of levels of creative performance in the visual arts. JAAC 1960, 19:82-90.

6200. Bulley, M.H. An enquiry as to aesthetic judgments of children. Brit J educ Psychol 1934, 4:162-182.

6201. Cahalan, E.J. The consistency of aesthetic judgments. Psychol Monogr 1939, 51, No. 231, 75-87.

6202. Carroll, H.A. A preliminary report on a study of the interrelationships of certain appreciations. J educ Psychol 1932, 23: 505-510.

6203. Carroll, H.A., and A.C. Eurich. Abstract intelligence and art appreciation. J educ Psychol 1932, 23:214-220.

6204. Cerbus, G. Personality Correlates of Picture Preferences. Dissertation Abstr 1961, 22(1):319-320.

6205. Cerbus, G., and R.C. Nichols. Personality correlates of picture preferences. J abnorm soc Psychol 1962, 64:75-78.

6206. Child, I.L. Observations on the meaning of some measures of esthetic sensi-

tivity. J Psychol 1964, 57:49–64.

6207. ———. Personal preferences as an expression of aesthetic sensivity. J Personality 1962, 30:496–512.

6208. Christensen, C.M. Use of design, texture, and color preferences in assessment of personality characteristics. Perceptual & Motor Skills 1961, 12:143–150.

6209. Christensen, E.O. Discrimination of Varying Degrees of Organization in Simple Examples of Artistic Expression as a Measure of Sensitiveness in Aesthetic Reactions. Cambridge: Harvard Univ Pr 1927.

6210. Christensen, E.O., and T.F. Karwoski. A test in art appreciation. Preliminary report. Univ North Dakota Bull 1925, 9, No. 1; Art Psychol Bull No. 3, 77 p.

6211. ——— & ———. A test in art appreciation. Second report. Univ North Dakota Bull 1926, 10, No. 7; Art Psychol Bull No. 4, 76 p.

6212. Clair, M.B. Variation in the perception of aesthetic qualities in paintings. Psychol Monogr 1939, 51, No. 5, 52–67.

6213. Cowles, J.T. An experimental study of the pairing of certain auditory and visual stimuli. J exp Psychol 1935, 18: 461–469.

6214. Crannell, C.W. The validity of certain measures of art appreciation in relation to a drawing task. J Psychol 1953, 35:131–142.

6215. Crosby, R.M. Measurement of Art Appreciation in the Boulder Public Schools by Means of the McAdory Art Test. Master's thesis. Univ Colorado 1932.

6216. Dantzig, M.M. van. (Study of the possibility of objectivation of art judgment.) Ned Tijdschr Psychol 1959, 14: 399–417.

6217. Dashiell, J.F. Affective value-distance as a determinant of esthetic judgment-time. Amer J Psychol 1937, 50:57–67.

6218. Davis, R.C. An evaluation and test of Birkhoff's aesthetic measure formula. J gen Psychol 1936, 15:231–240.

6219. Dewars, H. A comparison of tests of artistic appreciation. Brit J educ Psychol 1938, 8:29–49.

6220. Drought, R.A. Survey of studies in experimental esthetics. J educ Res 1929, 20:97–102.

6221. Ekman, G., and T. Künnapas. Measurement of aesthetic value by "direct" and "indirect" methods. Scandinavian J Psychol 1962, 3(1):33–39.

6222. ——— & ———. Scales of aesthetic value. Perceptual & Motor Skills 1962, 14(1):19–26.

6223. Eurich, A.C., and H. Carroll. Abstract intelligence and art appreciation. J educ Psychol 1932, 23:214–220.

6224. ——— & ———. Group differences in art judgment. School & Soc 1931, 34:204–206.

6225. Eysenck, H.J. The general factor in aesthetic judgments. Brit J Psychol 1940, 31:94–102.

6226. ———. "Type"-factors in aesthetic judgments. Brit J Psychol 1941, 31:262–270.

6227. Fairbairn, W.R.D. The ultimate basis of aesthetic experience. Brit J Psychol 1938, 29:167–181.

6228. Farnsworth, P.R. Concerning art standards. Psychol Rev 1926, 33:324–328.

6229. ———. Meier-Seashore art judgment test. In Buros, O.K. (ed.), 1940 Mental Measurements Yearbook. Highland Park, N.J.: Oscar K. Buros 1941, 147–148.

6230. ———. The preference for rectangles. J gen Psychol 1932, 7:479–481.

6231. Farnsworth, P.R., and H. Beaumont. Suggestion in pictures. J gen Psychol 1929, 2:362–366.

6232. Farnsworth, P.R., and I. Misumi. Further data on suggestion in pictures. Amer J Psychol 1931, 43:632.

6233. ——— & ———. Notes on the Meier-Seashore Art Judgment Test. J appl Psychol 1931, 15:418–420.

6234. Faulkner, R. Educational research and effective art teaching. J exp Educ 1940, 9: 9–22.

6235. ———. Evaluation in art. J educ Res 1942, 35:544–554.

6236. ———. Evaluation in a general art course. J educ Psychol 1940, 31:481–506.

6237. ———. An Experimental Investigation Designed to Develop Tests of Art Understanding and Appreciation. Doctoral dissertation. Univ Minnesota 1937, 246 p.

6238. ———. A research program in art appreciation. J educ Res 1939, 33:36–43.

6239. Feasey, L. Some experiments on esthetics. Brit J Psychol 1921, 12:253–272.

6240. Fehl, P.P. Tests of taste: Meier Seashore art judgment test, McAdory art test, Horn aptitude scale, and others. College Art J 1953, 12(3):232–248.

6241. Frumkin, R.M. Preference for Traditional and Modern Painting: an Empirical Study. Dissertation Abstr 1962, 22(11): 4106–4107.

6242. ———. Some factors in painting preferences among college students: An empirical study in the sociology of art. J human Relations 1960, 9:107–120.

6243. Frumkin, R.M., and A. Wulff. Pref-

erences for abstract and representational art. J soc Psychol 1963, 60:255-262.

6244. Glascock, J., J. Cattell, and M.F. Washburn. Experiments on a possible test of aesthetic judgment of pictures. Amer J Psychol 1918, 29.

6245. Gordon, D.A. The artistic excellence of oil paintings, as judged by experts and laymen. J educ Res 1955, 48:579-588.

6246. ———. Individual differences in the evaluation of art and the nature of art standards. J educ Res 1956, 50:17-30.

6247. Gordon, K. A study of esthetic judgments. J exp Psychol 1923, 6:36-43.

6248. Graves, M. Analysis of the Graves Visual Design Test. Art Instruction 1939, 3:23-25.

6249. ———. Design Judgment Test. NY: Psychological Corp 1946.

6250. Green, H.B., and R.H. Knapp. Time judgment, aesthetic preference, and need for achievement. J abnorm soc Psychol 1959, 58:140-142.

6251. Guilford, J.P., and J.W. Holley. A factorial approach to the analysis of variances in esthetic judgments. J exp Psychol 39:208-218.

6252. Haines, T.H., and A.E. Davies. Psychology of esthetic reaction to rectangular forms. Psychol Rev 1904, 11:249-281.

6253. Haller, A.J. An Experimental Study in Aesthetic Appreciation. Master's thesis. Univ Pittsburgh 1930.

6254. Hanawalt, N.G. The role of the upper and lower parts of the face as a basis for judging facial expressions: I. In painting and sculpture. J gen Psychol 1942, 27: 331-346.

6255. Harsh, C.M., J.G. Beebe-Center, and R. Beebe-Center. Further evidence regarding preferential judgment of polygonal forms. J Psychol 1939, 7:343-350.

6256. Hattori, F.S. Esthetic Judgment; Experimental Study of Differences between Japanese and Occidental People in Respect to Japanese and Occidental Pictures. Doctoral dissertation. Columbia Univ 1927.

6257. Haubold, M. Bildbetrachtung durch Kinder und Jugendliche. (Versuche über das Unterscheiden von Bildern verschiedenen Stiles. Mit 36 abb.) Neue psychol Stud 1933, 7(2).

6258. Henderson, R., W. Kates, and W. Rohwer. Painting and perception; a cognitive approach to differential perception and preference for conventional and art objects. Unpublished honors thesis. Harvard Univ 1959.

6259. Hevner, K., and J.H. Mueller. Effec-

tiveness of various types of art appreciation aid. J abnorm soc Psychol 1939, 34: 63-72.

6260. Hornberger, R.H. The Projective Effects of Experimentally Aroused Response Tendencies on the Rating of Pictures. Dissertation Abstr 1957, 17:3091-3092.

6261. Iliffe, A.H. A study of preferences in feminine beauty. Brit J Psychol 1960, 51:267-273.

6262. Israeli, N. Affective reactions to painting reproductions; a study in the psychology of aesthetics. J appl Psychol 1928, 12:125-140.

6263. ———. Variability and central tendency in aesthetic judgments. J appl Psychol 1930, 14:137-149.

6264. Jahoda, G. Sex differences in preferences for shapes: a cross-cultural replication. Brit J Psychol 1956, 47:126-132.

6265. Johnson, O., et al. Sex differences in aesthetic preferences. J soc Psychol 1963, 61:279-301.

6266. Käräng, G., and C.I. Sandström. (The applicability of aesthetic judgment of tests.) Pedagogisk Forskning (Oslo) 1959, No. 1, 44-56.

6267. Karwoski, T.F., and E.O. Christensen. A test for art appreciation. J educ Psychol 1926, 17:187-194.

6268. Katz, E. A test for preferences for traditional and modern paintings. J educ Psychol 1942, 33:668-677.

6269. ———. Testing preferences with 2" by 2" slides. Educational Screen 1942, 21: 301.

6270. Kellett, K.R. A gestalt study of the function of unity in aesthetic perception. Psychol Monogr 1939, 51, No. 5, 23-51.

6271. Kennedy, J.E. The paired-comparison method and central tendency effect in esthetic judgments. J appl Psychol 1961, 45: 128-129.

6272. Kieselbach, A.G. An Experimental Study in the Development of an Instrument to Measure Aesthetic Perception. Ann Arbo Univ Microfilms 1956, Publ No. 14852; In Research in Art Education. Kutztown, Pa.: National Art Educ Ass 1956, 62-73.

6273. Knapp, R.H., and H. Ehlinger. Stylist consistency among aesthetic preferences. J proj Tech 1962, 26:61-65.

6274. Knapp. R.H., and S. Green. Preferenc for styles of abstract art and their personality correlates. J proj Tech 1960, 24: 396-402.

6275. Knapp, R.H., L.R. McElroy, and J. Vaug On blithe and melancholic aestheticism. J gen Psychol 1962, 67:3-10.

6276. Kolb, H. Dimensionen der Beurteilun

von Illustrierten-Titelbildern. Psychol Praxis 1962, 6(3):97-107.

6277. Kuhns, R.F. Perception, Understanding, and Style; A Study in the Foundations of Criticism Developed from an Examination of Artistic Creativity and Appreciation. Ann Arbor: Univ Microfilms 1956, Publ No. 15743.

6278. Langford, R.C. Ocular behavior and the principle of pictorial balance. Psychol Bull 1933, 30:679.

6279. Lark-Horovitz, B. On art appreciation of children: I. Preference of picture subjects in general. J educ Res 1937, 31:118-137.

6280. Lawlor, M. Cultural influences on preferences for designs. J abnorm soc Psychol 1955, 61:690-692.

6281. ———. An investigation concerned with changes of preference which are observed after group discussion. J soc Psychol 1955, 42:323-332.

6282. Legowski, L.W. Beiträge zur experimentellen Ästhetik. Arch ges Psychol 1908, 12:236-311.

6283. Lepore, G. Lamisura del guidizio estetico mediante il test di Graves. Bollettino de Psicologia applicata 1960, 37/39:145-154.

6284. ———. Ulteriori richerche sul Test del Graves. Bollettino de Psicologia applicata 1962, 51/52:15-18.

6285. Lewis, F.H. The development of artistic appreciation. Psychol Bull 1934, 31:679.

6286. Littlejohn, J., and A. Needham. Training of Taste in the Arts and Crafts. London: Pitman 1933, 152 p.

6287. Lund, F.H., and A. Anastasi. An interpretation of esthetic experience. Amer J Psychol 1928, 40:434-448.

6288. Lundholm, H. The affective tone of lines; experimental researches. Psychol Rev 1921, 28:43-60.

6289. McElroy, W.A. Aesthetic ranking tests with Arnhem Land aborigines. Bull Brit psychol Soc 1955, 26:44.

6290. Maslow, A.H., and N.L. Mintz. Effects of esthetic surroundings. I. Initial effects of three esthetic conditions upon perceiving "energy" and "well-being" in faces. J Psychol 1956, 41:247-254.

6291. Meier, N.C. Aesthetic judgment as a measure of art talent. Univ Iowa Studies: Series on Aims & Progress of Research 1926, 1, No. 19, 30 p.

6292. ———. Aesthetic Perception. Test II—The Meier Art Tests. Iowa City: Bur Educ Res & Service, State Univ Iowa 1963.

6293. ———. A device for the measurement of aesthetic sensitivity. Proc Iowa Acad Sci 1926, 33:288-289.

6294. ———. A genetic approach to the problem of artistic genius. Psychol Bull 1933, 30:678.

6295. ———. The Meier Art Tests. I. Art Judgment. Iowa City: Bureau Educ Res, Univ Iowa 1940, 100 p.

6296. ———. The Meier Art Tests. I. Art Judgment; Examiner's Manual. Iowa City: Bureau Educ Res, Univ Iowa 1942, 24 p.

6297. ———. Reconstructive imagination. Psychol Monogr 1939, 51, No. 5, 117-126.

6298. Meier, N.C., and C.E. Seashore. Manual for the Meier-Seashore Art Judgment Test. Univ Iowa Bureau Educ Res & Service 1930, 24 p.

6299. ——— & ———. The Meier-Seashore Art Judgment Test. Iowa City: Bureau Educ Res & Service, Univ Iowa 1929, 125 p.

6300. Mendenhall, J.E., and M.E. Mendenhall. The Influence of Familiarity upon Children's Preferences for Pictures and Poems. Lincoln School Research Studies. NY: Teachers College 1933, 74 p.

6301. Miller, G.T. Reactions of Junior High School Students to the Architectonics of Pictures. Master's thesis. Univ Pittsburgh 1931.

6302. Mintz, N.L. Effects of esthetic surroundings. II. Prolonged and repeated experience in a "beautiful" and an "ugly" room. J Psychol 1956, 41:459-466.

6303. Mitra, S.C., and R. Ghosh. Studies in aesthetic perception. Indian J Psychol 1936, 11:115-122.

6304. Mitzel, H.E., L.M. Ostreicher, and S.R. Reiter. Development of Attitudinal Dimensions from Teachers' Drawings. NY: College of the City of New York, Division of Teacher Education, Office of Research & Evaluation 1954, 49 p.

6305. Munro, T. Powers of art appreciation and evaluation. In Art in American Life and Education. 40th Yearbook. National Soc Stud Educ. Bloomington, Ill.: Public School Publ Co. 1941, 323-348.

6306. ———. Tests in art appreciation. Art News 1934, 33:17.

6307. Mursell, J.L., et al. The measurement of understanding in the fine arts. In The Measurement of Understanding. 45th Yearbook, Part I. National Soc Stud Educ. Chicago: Univ Chicago Pr 1946, 201-212.

6308. Pan, S. (A study in esthetic judgment: the influence of familiarity.) N C J Psychol nat cent Univ 1934, 1(2), 10 p.

6309. Patrick, C. Different responses produced by good and poor art. Proc Amer Soc Aesthetics 1944, 1:28-29; J gen Psychol 1946, 34:79-96.

6310. Peel, E.A. A new method for analyzing aesthetic preferences: some theoretical considerations. Psychometrika 1946, 11: 129-137.

6311. Peters, H.N. Experimental studies of the judgmental theory of feeling. VI. Concrete versus abstract sets in the preference judgments of pictures. J exp Psychol 1943, 33:487-499.

6312. ———. The experimental study of aesthetic judgments. Psychol Bull 1942, 39: 273-305.

6313. Pickford, R.W. Experiments with pictures. Advancement of Science 1948, 5: 140.

6314. ———. Factorial studies of aesthetic judgments. In Roback, A.A. (ed.), Present-Day Psychology. NY: Philosophical Library 1955, 913-929.

6315. Pinter, R. Aesthetic appreciation of pictures by children. Ped Sem 1918, 25: 216-218.

6316. Puffer, E.D. Studies in symmetry. Psychol Rev Monogr Suppl No. 17, 1903, 467-539.

6317. Reynolds, G.L. An experiment in the development of art judgment. Yrb nat Soc Stud Educ 1941, 40:592-595.

6318. Roos, F.J., and L.M. Heil. Measuring the listener's attitude toward a radio art appreciation course. J appl Psychol 1939, 23:75-85.

6319. Ross, M. Investigation into the esthetic judgment of second-year pupils as applied to picture appreciation. High Points 1936, 18:41-44.

6320. Saunders, A.W. Meier-Seashore Art Judgment Test. In Buros, O.K. (ed.), 1940 Mental Measurements Yearbook. Highland Park, N.J.: Oscar K. Buros 1941, 148.

6321. Scott, H.N. An Evaluation of Two Types of Teaching for Appreciation of Art. Master's thesis. Indiana Univ 1932.

6322. Seashore, C.E. The Seashore-Meier Art Judgment Test. Science 1929, 69:380.

6323. Shively, J.M. The Building of an Objective Examination in Art Appreciation for College Freshmen. Master's thesis. Colorado State Teachers College 1932.

6324. Sisson, E.D. Suggestion in art judgment. J gen Psychol 1938, 18:433-435.

6325. Sisson, E.D., and B. Sisson. Introversion and the aesthetic attitude. J gen Psychol 1940, 22:203-208.

6326. Slate, J., and I.L. Child. Preconceptual eye, a study of preferences in art among college men. Art J 1963, 23(1):27-32.

6327. Speer, R.K. Measurement of Appreciation in Poetry, Prose, and Arts, and Studies in Appreciation. NY: Teachers College Contribution to Education 1929, 77 p.

6328. Stewart, W.R. The Interaction of Certain Variables in the Appreciation of Painting. Dissertation Abstr 1962, 22:2295.

6329. Sutherland, E.W. A Determination of the Art Appreciation of Eighth Grade Girls in Story County, Iowa, as a Basis for Courses in Art Related to Homemaking. Master's thesis. Iowa State College 1931.

6330. Thompson, G.G. The effect of chronological age on aesthetic preferences for rectangles of different proportions. J exp Psychol 1946, 36:50-58.

6331. Thorndike, E.L. Individual difference in judgment of the beauty of simple forms. Psychol Rev 1917, 24:147-153.

6332. ———. Tests of aesthetic appreciation. J educ Psychol 1916, 7:509-523.

6333. Traill, M.J., and H. Harap. Art preferences in junior high school. A guide to art objectives. J exp Educ 1934, 2:355-365

6334. Tucker, W.T. Experiments in Aesthetic Communications. Doctoral dissertation. Univ Illinois 1955.

6335. Vernon, P.E. Tests in aesthetics. In Yearbook of Education, 1935. London: Evans 1935, 528-536.

6336. Voss, M.D. An experimental study of the developmental processes in art appreciation. Proc Iowa Acad Sci 1935, 42:173.

6337. ———. A study of conditions affecting the functioning of the art appreciation process at the child-level. Psychol Monogr 1936, 48, No. 2, 1-39.

6338. Washburn, M.F., J. Cattell, and J. Glacock. Experiments on a possible test of aesthetic judgment of pictures. Amer J Psychol 1918, 29:333-336.

6339. Waymack, E.H. Child reactions as a Basis for Teaching Picture Appreciation. Master's thesis. Univ Cincinnati 1931.

6340. Waymack, E.H., and G. Hendrickson. Children's reactions as a basis for teaching picture appreciation. Elem School J 1930, 33:268-276.

6341. Welsh, G.S. Welsh Figure Preference Test: Preliminary Manual. Palo Alto, Calif: Consulting Psychologists Pr 1959.

6342. White, R.K., and C. Landis. Perception of silhouettes. Amer J Psychol 1930, 42:431-435.

6343. Wiley, L.N. A résumé of major experiments in abstract design ending with the year 1941. Psychol Bull 1941, 38:976-990

6344. ———. The Validity of Certain Accepted Criteria of Design. Doctoral dissertation. Univ Illinois 1940.

6345. ———. The validity of four accepted criteria of design. Psychol Bull 1939, 36:551

6346. Williams, F. An investigation of children's preferences for pictures. Elem School J 1924, 25:119-126.

6347. Wilson, D.J. An experimental investigation of Birkhoff's aesthetic measure.

J abnorm soc Psychol 1939, 34:390-394.

6348. Zane, N.B. Appreciation of the space arts. In Various, Studies in College Teaching. Eugene, Oregon: Univ Oregon Pr 1934, 4, No. 6, 53-82.

20 Tests: Art Ability

6349. Andersen, I., and R. Munroe. Personality factors involved in student concentration on creative painting and commercial art. Rorschach Res Exch 1948, 12: 141-154.

6350. Anderson, R.G. A modification of the McAdory Art Test. J consult Psychol 1948, 12:280-281.

6351. Anon. Can art talent be discovered by test devices? 23rd Ann Rep Western Arts Ass 1927, 74-79.

6352. Archer, B.C. The Measurement of Change in Certain Aspects of Art Ability. Dissertation Abstr 1956, 16:2345.

6353. Ayer, F.C. The present status of instruction in drawing with respect to scientific investigation. Yrb nat Soc Stud Educ 1919, 18(2):96-110.

6354. Badger, A.J. A Standard Test in Fundamental Mechanical Drawing. Bloomington, Ill.: Public School Publ 1929.

6355. Barrett, D.M. Aptitude and interest patterns of art majors in a liberal arts college. J appl Psychol 1945, 29:483-492.

6356. Barrett, H.O. An examination of certain standardized art tests to determine their relation to classroom achievement and to intelligence. J educ Res 1949, 42: 398-400.

6357. ———. Sex differences in art ability. J educ Res 1950, 43:391-393.

6358. Begbie, G.H. Accuracy of aiming in linear hand-movements. Quart J experimental Psychol 1959, 11:65-75.

6359. Beley, (?). Mesure des facultés originales de raisonnement logique par les tests non-verbaux de Penrose. Groupement franç Étud Neuro-psychopath infant 1938, 1(3):62-73.

6360. Borg, W.R. Does a perceptual factor exist in artistic ability? J educ Res 1950, 44:47-53.

6361. ———. The interests of art students. Educ psychol Measmt 1950, 10:100-106.

6362. ———. Some factors relating to art school success. J educ Res 1950, 43:376-384.

6363. ———. A study of the relationship between general intelligence and succes in an art college. J educ Psychol 1949, 4 434-440.

6364. Bottorf, E.A. A study comparing art abilities and general intelligence of college students. J educ Psychol 1946, 37: 398-426.

6365. Brengelmann, J.C. Expressive movement and learning: a study of score complexity. J ment Sci 1959, 105:81-92.

6366. Brittain, W.L. Can creativity be measured? Res Bull, Eastern Arts Ass 1954, 5: 12-14.

6367. ———. An experiment toward measuri creativity. In Research in Art Education. 7th Yearbook. Kutztown, Pa.: National Art Educ Ass 1956, 39-46.

6368. ———. Experiments for a Possible Te to Determine Some Aspects of Creativity in the Visual Arts. Dissertation Abstr 195 53, 15:277-279.

6369. Brooks, F.D. The relative accuracy of ratings assigned with and without use of drawing scales. School & Soc 1928, 2 518-520.

6370. Brown, R.L. A Study of the Relationship between Ability Ratings of Art and Architecture Students, Intelligence, and Scores on Two Art Aptitude Tests. Dissertation Abstr 1962, 23:528.

6371. Bryan, A.I. Grades, intelligence and personality of art school freshmen. J edu Psychol 1942, 33:50-64.

6372. Burkhart, R. The relation of intelligence to art ability. JAAC 1958, 17:230-241.

6373. Burt, C. Mental and scholastic test Report of the London County Council. Lo don 1921.

6374. Cain, T.J. The objective measureme of accuracy in drawings. Amer J Psychol 1943, 56:32-53.

6375. Cameron, N. Functional immaturity on the symbolization of scientifically trained adults. J Psychol 1938, 6:161.

6376. Carroll, H.A. A preliminary report o

a study of the relationship between abil-
ity in art and certain personality traits.
School & Soc 1932, 36:285-288.

6377. ———. What do the Meier-Seashore
and McAdory Arts Tests measure? J educ
Res 1933, 26:668-673.

6378. Cattell, R.B. Personality traits asso-
ciated with abilities. I. With intelligence
and drawing ability. Educ psychol Measmt
1945, 5:131-146.

6379. Childs, H.G. Measurement of the
drawing ability of 2177 children in Indiana
city school systems by a supplemental
Thorndike Scale. J educ Psychol 1915, 6:
391-408.

6380. Christensen, E.O. Discrimination of
Varying Degrees of Organization in Simple
Examples of Artistic Expression, As a
Measure of Sensitiveness in Aesthetic
Reactions. Doctoral dissertation. Harvard
Univ 1927.

6381. Cohen, J. The use of objective cri-
teria in the measurement of drawing abil-
ity. Ped Sem 1920, 27:137-151.

6382. Connelley, R.L. Test on famous
painters and their works. Instructor 1939,
48:21.

6383. Daniels, P.C. Discrimination of com-
positional balance at the pre-school age.
Psychol Monogr 1933.

6384. Dannenberg, O. Auslese und Berufs-
beratung der kunstlerisch Begabten. Prak-
tische Psychologie (Leipzig) 1920, 1:150.

6385. Decroly, O.J. Le dessin. Les tests
d'aptitude graphique et leur application
à l'orientation professionelle. Rapport à
la Conf Int de Psychotechnique appl
l'Orientation Professionelle. Barcelona
1921.

6386. ———. Le développement de l'aptitude
graphique. J de Neurologie et Psychiatria
1912, 17:441-453.

6387. Dembo, (?), and E. Hanfmann. (Intui-
tive halving and doubling of figures.)
Psychol Forsch 1933, 17:306.

6388. DeWit, F. The Block Design Test and
Drawing Ability. Master's thesis. Penn-
sylvania State College 1951.

6389. Doucette, A.H. Minutes. Conference
on Arts Tests, Carnegie Corp of New York.
Cambridge, Mass. 1929.

6390. ———. Research problems in art edu-
cation. Everyday Art 1931, April.

6391. Dreffin, W.B., and C.G. Wrenn. Spa-
tial relations ability and other characteris-
tics of art laboratory students. J appl
Psychol 1948, 32:601-605.

6392. Dreps, H.F. The psychophysical capa-
cities and abilities of college art students
of high and low standing. Univ Iowa Stud

1933, 18:134-146; Psychol Monogr 1933,
45, No. 200, 134-146.

6393. Elderton, E. On the association of
drawing with other capacities in school
children. Biometrika 1910, 222 ff.

6394. Farnum, R.B. Art Education in the
United States. Biennial Bulletins—1922,
1924, 1930. Washington, D.C.: Office of
Education, Dept Health & Welfare.

6395. Ferguson, E.B. A method for getting
to know your pupils quickly. Elem School
J 1950, 50:341-345.

6396. Findley, W.G. Factor analysis of a
short-item drawing test. Psychol Bull 1936,
33:605.

6397. Fischlovitz, A. An Inductive Study of
Abilities Involved in Drawing. NY: Columbia
Univ Pr 1903.

6398. Flory, C.D. The effect of art training
on mirror drawing. J exp Psychol 1936, 19:
99-105.

6399. Furfey, P.H. Tests for the measure-
ment of non-intellectual traits. Educ Res
Bull 1928, 3(8), 35 p.

6400. Galli, E., and W. Hochheimer. Beo-
bachtungen an Nachzeichnungen mehr-
deutiger Feldkonturen. Z Psychol 1934,
132, 304 p.

6401. Gowan, J.C., and M. Seagoe. The re-
lation between interest and aptitude tests
in art and music. Calif J educ Res 1957,
8:43-45.

6402. Guilford, J.P. A Factor Analytic Study
of Creative Thinking. Univ Southern Cali-
fornia Pr 1952.

6403. Guilford, J.P., and R.B. Guilford. A
prognostic test for students in design. J
appl Psychol 1931, 15:335-345.

6404. Gutekunst, J.G. The Prediction of Art
Achievement of Art Education Students by
Means of Standardized Tests. Dissertation
Abstr 1960, 20:3202-3203.

6405. Hall, C.E. Factors Involved in Tests
of Spatial Relations Abilities. Dissertation
Abstr 1960, 21:124.

6406. Harris, R.H. The Development and
Validation of a Test of Creative Ability.
Dissertation Abstr 1955, 15:1891.

6407. Horn, C.A. Horn Art Aptitude Inventory.
Preliminary Form, 1944 Revision. Rochester,
NY: Rochester Institute of Technology 1944.

6408. Horn, C.A., and L.F. Smith. The Horn
art aptitude inventory. J appl Psychol 1945,
29:350-355.

6409. Ivanoff, E. Recherches expérimentales
sur le dessin des écoliers de la Suisse
romande. Corrélation entre l'aptitude au
dessin et les autre aptitudes. Arch Psychol
1908, 7; 1909, 8:97-156.

6410. Jones, E.E. Correlations of visual

memory and perception of perspective with drawing ability. School & Soc 1922, 16:174-176.

6411. Kimber, J. Scales for measuring results in drawing. School Arts 1915, 14: 334.

6412. Kinter, M. The Measurement of Artistic Abilities: A Survey of Scientific Studies in the Field of Graphic Arts. NY: Psychological Corp 1933, 90 p.

6413. Kireenko, V.I. (The Psychology of Abilities for Artistic Activity.) Moscow: RSFSR Acad Pedag Sci 1959, 304 p.

6414. Kline, L.W., and G.L. Carey. A Measuring Scale for Freehand Drawing. Part I. Representation. Part II. Design and Composition. Baltimore: Johns Hopkins Univ Studies in Education No. 5, 1922-23, 119 p, 58 p.

6415. Knauber, A.J. The construction and standardization of the Knauber Art Tests. Education 1935, 56:165-170.

6416. ———. The Knauber Art Ability Test. Cincinnati: Author 1932.

6417. ———. The Knauber Art Vocabulary Test. Cincinnati: Author 1935.

6418. ———. A study of the art ability found in very young children. Child Develpm 1931, 2:66-71.

6419. ———. Testing for art ability. Education 1934, 55:219-223.

6420. Knauber, A.J., and S.L. Pressey. A report on the development of the Knauber-Pressey Tests of Art Ability. Conference on Art Tests, Carnegie Corp. Cambridge, Mass. 1929.

6421. Koester, H.L. Über das Verhaltnis der intellectuellen Begabung zur musikalischen, zeichnerischen und technischen Begabung. Z pädag Psychol 1930, 31:399-403.

6422. Lark-Horovitz, B., E.N. Barnhart, and E.M. Sills. Graphic Work-Sample Diagnosis: an Analytic Method of Estimating Children's Drawing Ability. Cleveland: Cleveland Museum of Art 1939, 110 p (mimeographed).

6423. Lewerenz, A.S. I.Q. and ability in art. School & Soc 1928, 27:489-490.

6424. ———. Measurement in art from the vocational guidance approach. Education 1946, 66:454-460.

6425. ———. Predicting ability in art. J educ Psychol 1929, 20:702-704.

6426. ———. Relation of I.Q. and Mental Age to Certain Abilities Conditioning Success in Visual Art. Los Angeles School District, Dept Psychol & Educ Res 1928.

6427. ———. Sex differences on ability tests in art. J educ Psychol 19:629-635.

6428. ———. A test in graphic art. Psychol Bull 1928, 25:455-456.

6429. ———. Tests in Fundamental Abilities of Visual Arts. Los Angeles: California Test Bureau 1927.

6430. Lowenfeld, V. Tests for visual and haptical aptitudes. Amer J Psychol 1945, 58:100-111.

6431. McAdory, M. The Construction and Validation of an Art Test. NY: Teachers College Contributions to Education, No. 383, 1929, 40 p.

6432. ———. McAdory Art Test. NY: Bureau of Publications, Teachers College 1929.

6433. McCarty, S.A. Drawing Scale for Young Children. Baltimore: Williams and Wilkins 1924.

6434. Manuel, H.T. A Study of Talent in Drawing. School & Home Educ Monogr, No 3. Bloomington, Ill.: Public School Publ 1919, 152 p.

6435. Mathieu, J. Erziehung zum exacten optischen Auffassen und Einpragen nach der Poppelreuterschen psychokritischen Methodik. Z angew Psychol 1932, 42:362.

6436. Meier, N.C. Can art talent be discovered by test devices? 33rd Ann Report Western Arts Ass 1927, 74-79.

6437. ———. Creative Imagination. Test III—The Meier Art Tests. Iowa City: Bureau Ed Res & Service, State Univ Iowa 1964.

6438. ———. Diagnosis in art. Ann Bull Western Arts Ass 1928, 24-25.

6439. ———. Diagnosis in art. Yrb nat Soc Stud Educ 1935, 34:463-476.

6440. ———. Les éléments constitutifs de l'aptitude à l'art. Rev d'Esthétique 1957, 10:225-235.

6441. ———. Esthetic judgment as a measure of art talent. Univ Iowa Stud Ser Aims & Prog of Res 1926, 1, No. 19, 30 p.

6442. ———. Factors in artistic aptitude: final summary of a ten-year study of a special ability. Psychol Monogr 1939, 51, No. 5, 140-158.

6443. ———. Further studies in creative artistic intelligence. Psychol Bull 1935, 32:73-738.

6444. ———. Knauber Art Ability Test. In Buros, O.K. (ed.), 1940 Mental Measurements Yearbook. Highland Park, N.J.: Oscar K. Buros 1941, 143-144.

6445. ———. McAdory Art Test. In Buros, O. (ed.), 1940 Mental Measurements Yearbook. Highland Park, N.J.: Oscar K. Buros 1941, 145-146.

6446. ———. A measure of art talent. Psychol Monogr 1928, 39:184-199.

6447. ———. A preliminary report on the measurement of talent in graphic art. Proc Iowa Acad Sci 1925, 32:397.

6448. ———. Special artistic talent. Psychol Bull 1928, 25:265-271.

6449. ———. Studies in the foundations of artistic aptitudes. Proc Iowa Acad Sci 1933, 40:195-196.

6450. ———. What we know about talent in children. Ann Bull Western Arts Ass 1943, 143-163.

6451. Meier, N.C., and W. McCloy. An instrument for the study of creative artistic intelligence. Psychol Monogr 1936, 48, No. 213, 164-172.

6452. Meloun, J. Does drawing skill show in handwriting? Char Pers 1935, 3:194-213.

6453. Mitchell, W.W. Drawing Aptitude Test. Bloomington, Ill.: McKnight & McKnight 1940, 22 p.

6454. Moore, J.E. A note on the reliability of the Knauber art vocabulary test. J educ Psychol 1938, 29:631-635.

6455. Morrow, R.S. An analysis of the relations among tests of musical, artistic, and mechanical abilities. J Psychol 1938, 5:253-263.

6456. Munro, T. Art tests and research in art education. Ann Bull Western Arts Ass 1933, 17:1-6, 69-85.

6457. ———. Some proposed tests and their fallacies. Art News 1934, 33:17.

6458. Obonai, T., and T. Matsuoka. The color symbolism personality test. J gen Psychol 1956, 55:229-239.

6459. Oltman, R.M. A Study of the Difference between Art and Non-Art Students as Measured by the Guilford-Zimmerman Temperament Survey and a Biographical Questionnaire. Master's thesis. Western Reserve Univ 1951.

6460. O'Shea, M.V. Mental Development and Education. NY: Macmillan 1921, Ch. 6.

6461. Patzig, E. Ways of evaluating students' art work. In Art in American Life and Education. 40th Yearbook. National Soc Study Educ. Bloomington, Ill.: Public School Publ 1941, 599-603.

6462. Paulsson, G. Tests of Artistic Ability. Stockholm, n.d., 17 p.

6463. Peck, L. An experiment with drawing in relation to the prediction of school success. J appl Psychol 1936, 20:16-43; Doctoral dissertation. Univ Texas 1934.

6464. Peter, R. Beiträge zur Analyse der zeichnerischen Begabung. Z pägad Psychol 1914, 15:96-104.

6465. Pétin, M. La psychologie appliquée au domaine des beaux-arts. Année Psychol 1954, 54:157-164.

6466. Pitts, R. The relation between entrance examination results and subsequent achievement in a junior art school, with an analysis of the abilities involved. Brit J educ Psychol 1953, 23:135-138.

6467. Progressive Education Association. The Visual Arts in General Education. NY: Appleton-Century 1940.

6468. Prothro, E.T., and H.T. Perry. Group differences in performance on the Meier Art Test. J appl Psychol 1950, 34:96-97.

6469. Rahm, J. Die Bildbetrachtung im Zusammenhange einer Eignungsuntersuchung. Z angew Psychol 1937, 53:334-366.

6470. Rosen, F. Darstellande Kunst im kindesalter der volker. Z angew Psychiat 1907, 1:93-118.

6471. Rosen, J.C. The Barron-Welsh Art Scale as a predictor of originality and level of ability among artists. J appl Psychol 1955, 39:366-367.

6472. Saunders, A.W. An Objective Psychological Analysis of Fundamental Art Ability. Doctoral dissertation. St. Louis, Mo.: Washington Univ 1930.

6473. ———. The stability of artistic aptitude at the childhood level. In Studies in the Psychology of Art. Psychol Monogr 1936, 48, No. 1, 126-153.

6474. Schierack, G. Über den psychologischen Wert unserer Tests. Das Zeichnen nach Diktat. Pädagogisch-psychologische Arbeiten (Leipzig) 1919, 9.

6475. ———. Selbstbeobachtung als Prüfungsmittel für Begabungstests. Pädagogisch-psychologische Arbeiten (Leipzig) 1920, 10:24.

6476. Schlotte, F. Zeichnen nach Diktat. Pädagogisch-psychologische Arbeiten (Leipzig) 1919, 9.

6477. Sharp, A.A. The diagnostic significance of a visual memory drawing test. J abnorm soc Psychol 1949, 44:517-527.

6478. Sherman, L.J. Sexual differentiation or artistic ability? J clin Psychol 1958, 14:170-171.

6479. Siceloff, M.M., E. Woodyard, et al. Validity and Standardization of the McAdory Art Test. NY: Teachers College 1933, 32 p.

6480. Steggerda, M. The McAdory art tests applied to Navajo Indian children. J comp Psychol 1936, 22:283-285.

6481. Steggerda, M., and E. Macomber. A revision of the McAdory art test applied to American Indians, Dutch whites and college graduates. J comp Psychol 1938, 26:349-353.

6482. Sterzinger, O. Zur Prüfung und Untersuchung der künstlerischen Veranlangung. Psychotechnische Z 1931, 6:1-10.

6483. Tamburri, T. (The use of mental tests in the orientation and selection of persons desiring to devote themselves to the figurative arts.) Annali dell'Ospedale psychiatrico provinciale in Perugia 1932, 26: 41-70.

6484. Thorndike, E.L. The measurement of achievement in drawing. Teachers College Record 1913, 14:345-382.

6485. ———. A scale of general merit of children's drawings. Teachers College Bull 1912, No. 6.

6486. ———. Thorndike's Scale for General Merit of Children's Drawings. NY: Bureau of Publications, Teachers College 1913, 1923.

6487. Tiebout, C. The measurement of quality in children's paintings by the scale method. Psychol Monogr 1936, 48, No. 213, 85-94.

6488. ———. The measurement of psychophysical functions characteristic of extreme degrees of artistic capacity. Proc Iowa Acad Sci 1933, 40:197.

6489. ———. The psychophysical functions differentiating artistically superior from artistically inferior children. Univ.Iowa Stud 1933, 18:103-133; Psychol Monogr 1933, 45, No. 200, 108-133.

6490. Tiebout, C., and N.C. Meier. Artistic ability and general intelligence. Psychol Monogr 1936, 48, No. 213, 95-125.

6491. Todd, J.M. A test in art for grade children. School Arts 1931, 30:365-368.

6492. Vamum, W.H. Opportunities in the art field and a selective art aptitude test. In Record of the Conventions at St. Louis & Milwaukee, 1940. Bull. Vol. 6. Washington, D.C.: National Educ Ass 1940, 182-185.

6493. ———. Selective Art Aptitude Test. Scranton, Pa.: International Textbook Co 1939, 52 p.

6494. ———. Selective Art Aptitude Test: Validation, Reliability and Rating Manual. Scranton, Pa.: International Textbook Co 1940.

6495. Vaughan, D. Systems of grading. In Art in American Life and Education. 40th Yearbook. National Soc Study Educ. Bloom-ington, Ill.: Public School Publ 1941, 601

6496. Voss, M.D. The validity and reliability of a modified form of the McAdory Art Test for use at lower grade levels. Psychol Monogr 1936, 48, No. 213, 68-8

6497. Waggoner, J.T. The Evaluation of Some New Three-Dimensional Spatial Visualization Test Items as Predictors o Success in Art, Architecture, and Engine ing Drawing. Dissertation Abstr 1959, 2 1072.

6498. Wallis, N. A Study of Tests Design to Measure Art Capacities. Master's the Florida State College for Women 1930.

6499. Washbum, M.F., and M.A. Walker. The Healy-Femald picture completion te as a test of perception of the comic. Am J Psychol 1919, 30:304-307.

6500. Whitford, W.G. An empirical study pupil ability in public school art course Elem School J 1919, 20:33-46, 95-105.

6501. Wiggen, R.G. Viktor Lowenfeld's Visual-Haptic Tests. A Critique of One Approximation and One Original Version. College Park, Md.: Univ Maryland 1951, 114 p.

6502. Winslow, L.L. Integrated School Ar Program. NY: McGraw-Hill 1939, 391 p.

6503. Wold, S.G. A Comparison of Colleg Students' Performance on Selected Art Tasks and on the Graves Design Judgme Test. Doctoral dissertation. Univ Minne sota 1960, 188 p.

6504. Wood, J., and E. Schulmann. The El Visual Designs Test. J educ Psychol 194 31:591-602.

6505. Ziegfeld, E. Art. In Buros, O.K. (ed. The Third Mental Measurements Yearboo New Brunswick, N.J.: Rutgers Univ Pr 19 257-259.

6506. ———. McAdory Art Test. In Buros, C K. (ed.), 1940 Mental Measurements Yea book. Highland Park, N.J.: Oscar K. Buro 1941, 146.

6507. Ziehen, T., and V. Häcker. Beitrag zur Lehre von der Vererbung und Analyse der zeichnerischen und mathematischen Begabung inbesondere mit Bezug auf die Korrelation zur musikalischen Begabung. Z Psychol 1931, 121:1.

6508. Abel, T.M. Figure drawings and fa-
cial disfigurement. Ops 1953, 23:253-264.
6509. Abel, T.M., and J.B. Sill. The per-
ceiving and thinking of normal and sub-
normal adolescents and children on a
simple drawing scale. J genet Psychol
1939, 54:391-403.
6510. Abraham, E. Zum Vorgang der Projek-
tion. Schweiz ZPA 1951, 10:225-242.
6511. Albee, G.W., and R.M. Hamlin. An
investigation of the reliability and valid-
ity of judgments of adjustment inferred
from drawings. J clin Psychol 1949, 5:
389-392.
6512. ——— & ———. Judgment of adjustment
from drawings: the applicability of rating
scale method. J clin Psychol 1950, 6:363-
365.
6513. Alexander, H. An investigation on
the effects of music in personality by
way of figure drawings. Amer J Psychother
1954, 8:687-702.
6514. Alschuler, R.M., and L.W. Hattwick.
Easel painting as an index of personality
in pre-school children. Ops 1943, 13:616-
626.
6515. Ames, L.B. Free drawing and com-
pletion of drawing; a comparative study
of preschool children. J genet Psychol
1945, 66:161-165.
6516. ———. The Gesell incomplete man
test as a differential indication of average
and superior behavior in preschool chil-
dren. J genet Psychol 1943, 62:217-274.
6517. Ames, L.B., and A. Gesell. The de-
velopment of directionality in drawing. J
genet Psychol 1946, 68:45-61.
6518. Anastasi, A. Differential Psychology.
NY: Macmillan 1958.
6519. Anastasi, A., and R.Y. D'Angelo. A
comparison of Negro and white preschool
children in language development and
Goodenough Draw a Man I.Q. J gen Psy-
chol 1952, 81:147-165.
6520. Anderson, H.H., and G.L. Anderson
(eds.). An Introduction to Projective
Techniques. NY: Prentice-Hall 1951.

6521. Ansbacher, H.L. The Goodenough
draw-a-man test and primary mental abil-
ities. J consult Psychol 1952, 16:176-180.
6522. Anzieu, D. Les méthodes projectives.
Paris: PUF 1960, 286 p.
6523. Appia, B. La réprésentation humaine
dans les dessins d'enfants noires. Bull de
l'Institute françois d'Afrique noir 1939, 1.
6524. Armstrong, R.B. The consistency of
longitudinal performance on the Graham-
Kendall Memory-for-Designs test. J clin
Psychol 1952, 8:411-412.
6525. Armstrong, R.B., and P.A. Hauck. Sex-
ual identification and the first figure drawn.
J consult Psychol 1961, 25:51-54.
6526. Arnstein, E. A Drawing Test As a Rough
Measure of Occupational Fitness of Young
Immigrants. Jerusalem: Hadassah Vocational
Education Services 1954, 13 p (mimeo-
graphed).
6527. Asmus, K. Ein Beitrag zur Lehre von
der Entwicklung der optischen Raumauffass-
ung und des optischen Raumgedachtnisses
bei Schulkindern. Philosophie Psychol Arb,
Langensalza 1922.
6528. Aupècle, M. Dessins-robots. Enfance
1958, No. 2, 145-150.
6529. ———. Détermination du niveau mental
par un dessin. Beyrouth 1957, 43 p.
6530. Baltrusch, H.J. Klinisch-psychologische
Erfahrungen mit dem Figure-Drawing-Test.
Z psycho-som Med 1956, 3:29-40.
6531. Bappert, J. Zur qualitativen Bewertung
des Zeichentests von Binet-Simon. Z angew
Psychol 1923, 21:259.
6532. Barcellos, F.A.V.F. Psico-diagnóstico
Atraves do Desenho Infantil. Araruama:
(Author) 1952-53, 132 p.
6533. ———. O Sociodiagnóstico; Nova Tech-
nica Sociométrica Baseada Num Métoda
Projectivo Através do Desenho. Araruama:
(Author) 1953, 31 p.
6534. ———. Sociodiagnóstico Através do
Desenbo Infantil. Araruama: (Author) 1953,
127 p.
6535. ———. O Téste do Desenho e o Estudo
da Personalidade Infantil. Niterói: Livraria

Universitária 1952, 60 p.

6536. Bardet, C., F. Moreigne, and J. Sene-
cal. Application du test de Goodenough
a des écoliers africains de 7 a 14 ans.
Enfance 1960, No. 2, 199-208.

6537. Barker, A.J., J.K. Mathis, and C.A.
Powers. Drawings characteristic of male
homosexuals. J clin Psychol 1953, 9:185-
188.

6538. Basaglia, F. (Design tests in lan-
guage disorders of developmental age.)
Lavoaro di Neuropsichiatrie 1952, 10:551-
563.

6539. Bash, K.W., and E. Lampl. Intelli-
genz- und Ausdrucksmerkmale in Ror-
schach-Test und in Kinderzeichnungen. Z
Kinderpsychiat 1951, 17:174-184.

6540. Battista, E., and B. Pagano. (Drawing
in mental tests. Research on children with
pathological personalities by means of
the tree test.) Rassegna di Neuropsichia-
tria 1962, 16:193-211.

6541. Bauer, L. Erfahrungen mit dem War-
teggtest auf unserer Kinderstation. Ner-
venarzt 1952, 23:52-55.

6542. Bauermeister, H. Die Begabungsfrage
in der bildenden Kunst. Int Z indiv-Psychol
1929, 7:108-111.

6543. Baumgarten, F. (ed.). La psycho-
technique dans le monde moderne. Paris:
PUF 1952, 630 p.

6544. Beck, H.S. A study of the applicabil-
ity of the H-T-P to children with respect
to the drawn house. J clin Psychol 1955,
11:60-63.

6545. Bell, J.E. The case of Gregor: inter-
pretation of test data. Rorschach Res Exch
1949, 13:433-468.

6546. ———. Projective Techniques; A Dy-
namic Approach to the Study of Personality.
NY: Longmans, Green 1948, 350-398.

6547. Bemelmans, F. Le test de dessin
d'A. Rey. Bull d'Orientation Scholaire
et Professionnelle (Brussels) 1958, 7:11-
30.

6548. Bender, L. Child Psychiatric Tech-
niques. Springfield, Ill.: Thomas 1952.

6549. ———. The drawing of a man (Good-
enough test) in chronic encephalitis in
children. JNMD 1940, 41:277-286.

6550. ———. The Goodenough test and its
clinical use. Res Monogr Amer Orthopsy-
chiat Ass 1935, 3:277-286.

6551. ———. A visual motor Gestalt test and
its clinical use. Res Monogr Amer Ortho-
psychiat Ass 1938, No. 3, 176 p.

6552. Bender, L., and P. Schilder. Simpli-
fication of the world and its problems in
the art of asocial delinquent boys. In
Hammer, E.F. (ed.), The Clinical Applica-

tion of Projective Drawings. Springfield,
Ill.: Thomas 1958, 562-595.

6553. Berdie, R.F. Measurement of adult
intelligence by drawings. J clin Psychol
1945, 1:288-295.

6554. Berges, J., and I. Lezine. Test d'imi
tation de gests. Paris: Masson 1963, 128

6555. Berman, A.B., A. Klein, and A. Lippma♦
Human figure drawings as a projective
technique. J gen Psychol 1951, 45:57-70.

6556. Berman, S., and J. Laffel. Body type
and figure drawing. J clin Psychol 1953,
9:368-370.

6557. Biedma, C.J., and P.G. D'Alfonso. D
Sprache der Zeichnung: Der Wartegg-Bied
Test. Eine Abwandlung des Wartegg-Test♦
Bern-Stuttgart: Huber 1959, 110 p.

6558. Bieliauskas, V.J. The House-Tree-
Person (H-T-P) Research Review: 1963
Edition. Los Angeles: Western Psycholog♦
cal Services 1964.

6559. ———. The H-T-P Bibliography. West
Los Angeles, Calif.: Western Psychologic
Services 1957, 10 p.

6560. ———. Scorer's reliability in the quan
titative scoring of the H-T-P technique. ♦
clin Psychol 1956, 12:366-369.

6561. ———. Sexual identification in chil-
dren's drawings of human figure. J clin
Psychol 1960, 16:42-44.

6562. Bieliauskas, V.J., and R.B. Bristow.
The effect of formal art training upon the
quantitative scores of the H-T-P. J clin
Psychol 1959, 15:57-59.

6563. Bieliauskas, V.J., and A.B. Heffron.
Differences in performance on the chro-
matic vs. achromatic H-T-P drawings. J
clin Psychol 1960, 16:334-335.

6564. Bieliauskas, V.J., and S.L. Kirkham.
An evaluation of the "organic signs" in
the H-T-P drawings. J clin Psychol 1958,
14:50-54.

6565. Biersdorf, K.R., and F.L. Marcuse. R♦
sponses of children to human and to ani-
mal pictures. J proj Tech 1953, 17:455-45

6566. Bingham, J.L. Personality Projection
through Picture Interpretation As a Functi♦
of Physical and Situational Ambiguity. Di♦
sertation Abstr 1957, 17:1379.

6567. Blum, R.H. The validity of the Mach♦
over DAP technique. J clin Psychol 1954,
10:120-125.

6568. Bobertag, O. Über Intelligenzprüfung
nach der Methode von Binet und Simon. Z
angew Psychol 1911, 5:105.

6569. Bodwin, R.F., and M. Bruch. The ada♦
tation and validation of the draw-a-perso
test as a measure of self concept. J clin
Psychol 1960, 16:414-416.

6570. Bönisch, R. Über den Zusammenhang

seelischer Teilstrukturen. Neue psychol Stud 1939, 15:1.

6571. Boernstein, W.S. The verbal self-portrait test. Part I. Psychiat Quart Suppl 1954, 28:15-25.

6572. Bolin, B.J., A. Schneps, and W.E. Thorne. Further examination of the tree-scar-trauma hypothesis. J clin Psychol 1956, 12:395-397.

6573. Brill, M. A study of instability using the Goodenough Drawing Scale. J abnorm soc Psychol 1937, 32:288-302.

6574. Britton, J.H. Influence of social class upon performance on the Draw-A-Man Test. J educ Psychol 1954, 45:44-51.

6575. Brower, D., and L.E. Abt (eds.). Progress in Clinical Psychology. NY: Grune & Stratton 1956.

6576. Brown, D.G., and A. Tolor. Human figure drawings as indicators of sexual identification and inversion. Perceptual & Motor Skills 1957, 7:199-211.

6577. Brown, F. Adult case study: clinical validation of the House-Tree-Person drawings of an adult (chronic ulcerative colitis with ileostomy). In Hammer, E.F. (ed.), The Clinical Application of Projective Drawings. Springfield, Ill.: Thomas 1958, 261-275.

6578. ———. House-Tree-Person and human figure drawings. In Brower, D., and L.E. Abt (eds.), Progress in Clinical Psychology. NY: Grune & Stratton 1952, 173-184.

6579. Bruck, M., and R.F. Bodwin. Age differences between SCS-DAP test results and GPA. J clin Psychol 1963, 19:315-316.

6580. Buck, J.N. The Case of R: before and after therapy. In Hammer, E.F. (ed.), The Clinical Application of Projective Drawings. Springfield, Ill.: Thomas 1958, 276-308.

6581. ———. Une descripcion breve de la tecnica C-A-P. Rev psicol (Madrid) 1952, 7:11-28.

6582. ———. Direction for administration of the achromatic-chromatic H-T-P. J clin Psychol 1951, 7:274-276.

6583. ———. The H-T-P, a measure of adult intelligence and a projective device. Amer Psychologist 1946, 1:285-286.

6584. ———. The H-T-P, a projective device. Amer J ment Deficiency 1947, 51:606-610.

6585. ———. The H-T-P technique. J clin Psychol 1949, 5:37-74.

6586. ———. The H-T-P technique; a qualitative and quantitative scoring manual. J clin Psychol 1948, 4:317-396.

6587. ———. The H-T-P technique; a qualitative and quantitative scoring manual. J clin Psychol, Monogr Suppl 5, 1948, 120 p.

6588. ———. The H-T-P test. J clin Psychol 1948, 4:151-159.

6589. ———. JNB drawing test. Virginia Mental Hygiene Survey 1940, 2(12).

6590. ———. The quality of the quantity of the H-T-P. J clin Psychol 1951, 7:352-356.

6591. ———. Tests of personality: picture and drawing techniques. D. House-Tree-Person drawing technique. In Weider, A. (ed.), Contributions Toward Medical Psychology; Theory and Psycho-diagnostic Methods. NY: Ronald 1953, 688-701.

6592. ———. The use of the H-T-P test in a case of marital discord. J proj Tech 1950, 14:405-434.

6593. Bührer, L., R. de San Martin, and de Ny E.S. Velasco. Ensayo de tipificación de la prueba mental "Dibujo de un hombre" de Fl. Goodenough. Publ Inst Biotipol Exper Univ Cuyo 1951, 2(2):133 p.

6594. Burbury, W.M. The use of children's drawings in clinical diagnosis. J ment Sci 1957, 103:487-506.

6595. Burchard, E.M.L. The use of projective techniques in the analysis of creativity. J proj Tech 1952, 16:412-427.

6596. Burton, A., and B. Sjoberg, Jr. The diagnostic validity of human figure drawings in schizophrenia. J Psychol 1964, 57: 3-18.

6597. Caligor, L. The detection of paranoid trends by the Eight Card Redrawing Test. J clin Psychol 1952, 8:397-401.

6598. ———. Determination of an individual's unconscious conception of his own masculinity-feminity identification. J proj Tech 1951, 15:495-509.

6599. ———. A New Approach to Figure Drawing Based Upon an Interrelated Series of Drawings. Springfield, Ill.: Thomas 1957, 160 p; 1958, 148 p.

6600. ———. Quantification of the Eight Card Redrawing Test (8CRT). J clin Psychol 1953, 9:356-361.

6601. Cassel, R.H., A.P. Johnson, and W.H. Burns. Examiner, ego defense, and the H-T-P test. J clin Psychol 1958, 14:157-160.

6602. Cesa-Bianchi, M., G. Jacono, and A. Perugia. Il disegno come mezzo diagnostico dell personalita. Arch Psicol Neurol Psichiat 1953, 14:207-208.

6603. Chang, K. (Application of Goodenough's intelligence test by drawing in China.) Chung Hwa educ Rev 1935, 23(5):49-55.

6604. Clostermann, G. Studien zur Testwissenschaft. Der Mann-Zeichen-Test in formtypischer Auswertung (MZT/ft). Münster: Aschendorf 1959, 363 p.

6605. Cohen, D.N. The Goodenough Drawing Scale applied to thirteen-year-old children. Master's thesis. Columbia Univ 1933.

6606. Cohen, R. Eine Untersuchung des Wartegg-Zeichentestes, Rorschachtestes und Z-Testes mit dem Polaritätsprofil. Diagnostica 1959, 5:155-172.

6607. Cohn, R. The Person Symbol in Clinical Medicine: A Correlation of Picture Drawing with Structural Lesions of the Brain. Springfield, Ill.: Thomas 1960, 196 p.

6608. Cook, M. A preliminary study of the relationship of differential treatment of male and female head size in figure drawing to the degree of attribution of the social function of the female. Psychol Newsletter 1951, 34:1-5.

6609. Cotte, S. Le bonhomme "aux mains coupées"; dessins d'enfant delinquents: à propos de quelques omissions inconscientes dan le test de Goodenough. Z Kinderpsychiat 1946, 13:156-164.

6610. ——. A propos d'omissions ou de dissimulations dans le test de Goodenough. Confrontation avec le psychodiagnostiç de Rorschach. Criança portug 1949-50, 9: 41-68.

6611. Cotte, S., G. Roux, and M.A. Aureille. Utilisation du dessin comme test psychologique chez les enfants. Comité pour de l'etudier les enfants deficiente 1951, 82 p.

6612. Cowden, R.C. The Draw-A-Person Test. Med Sci 1958, 649-653.

6613. Cowden, R.C., H.L. Deabler, and J.H. Feamster. The prognostic value of the Bender-Gestalt, H-T-P, TAT, and Sentence Completion Test. J clin Psychol 1955, 11: 271-275.

6614. Craddick, R.A. Draw-a-person characteristics of psychopathic prisoners and college students. Perceptual & Motor Skills 1962, 15:11-13.

6615. ——. The self-image in draw-a-person test and self-portrait drawings. J proj Tech 1963, 27:288-291.

6616. Crovitz, H.F. On direction in drawing a person. J consult Psychol 1962, 26(2): 196.

6617. Curci, F., and O. Sepe. (Goodenough's test in childhood.) Rassegna di Neuropsychiatria 1962, 16:119-132.

6618. Cureton, E.E. Validity. In Lindquist, E.F. (ed.), Educational Measurement. Menasha, Wis.: Banta 1955, 621-694.

6619. Cummings, J.D. Family pictures: a projection test for children. Brit J Psychol 1952, 43:53-61.

6620. Cutter, F. Sexual differentiation in figure drawings and overt deviation. J clin Psychol 1956, 12:369-372.

6621. DaCosta, R.C. Un "test" del Dr. Decroly en las escuelas de Portugal. Rev Psicol gen apl (Madrid) 1951, 6:101-113; In Baumgarten, F. (ed.), La psychotechnic dans le monde moderne. Paris: PUF 1952, 193-198.

6622. ——. (Drawing and the Decroly test of mental representation, applied in Portugese schools.) Criança portug 1944, 3: 119-176.

6623. Daiber, W. Das Eigengestalten des Kindes im Zeichnen. Münich: Kaiser 1952 64 p.

6624. Dalla-Volta, A. Il disegno come complemento della prova di Rorschach. Arch Psicol Neurol Psichiat 1949, 10:174-180.

6625. ——. La reppresentazione grafica di alcuni aspetti del mondo esterno come te del grado di suiluppo mentale del bambin Arch Psicol Neurol Psichiat 1951, 12:325-332.

6626. Dall'Oglio, G.N. Il test dell' albero (Baumtest) di Kock e dell' "omino" di F.L Goodenough in un gruppo di bambini ricoverati presso un orfanotrofio. Neurone 1955, 3:229-237.

6627. Davidson, A.J. Cultural Differences in Personality Structure as Expressed in Drawings of the Human Figure. Doctoral dissertation. New York Univ 1953.

6628. Defayolle, M., M. Matthieu, and P. Fustier. Essai d'une approche psychométrique du test de l'arbre. Psychologie Française 1962, 7(3):223-229.

6629. Delclós, V. (Modern projection tests in psychiatry of children, including drawing of family members.) Arch de Pediatria (Barcelona) 1956, 7:91-110.

6630. Dennis, W. The human figure drawings of Bedouins. J soc Psychol 1960, 52: 209-219.

6631. ——. The performance of Hopi children on the Goodenough Draw-a-Man Tes J comp Psychol 1942, 34:341-348.

6632. ——. Performance of Near Eastem children on the Draw-A-Man Test. Child Develpm 1957, 28:427-430.

6633. De Vries, W.H.M. (Tree-drawings by dementia patients.) Gawein 1953-54, 2: 26-34.

6634. Diamond, S. The house and tree in verbal phantasy. I. Age and sex difference in themes and content. J proj Tech 1954, 18:316-325.

6635. ——. The house and tree in verbal fantasy. II. Their different roles. J proj Tech 1954, 18:414-417.

6636. Digiammo, J.J., and R.D. Ebinger. Th

net-weighted H-T-P score as a measure of abstraction. J clin Psychol 1961, 17:55.

6637. DuBois, C. The People of Alor; A Social-Psychological Study of an East Indian Island. Minneapolis: Univ Minnesota Pr 1944, 566-587.

6638. Duhm, E. Die Bedeutung der Anfangszeichen im Wartegg-Zeichentest. Psychologische Rundschau 1952, 3:242-248; 1953, 4:11-32.

6639. Dyett, E.G. The Goodenough Drawing Scale Applied to College Students. Master's thesis. Columbia Univ 1931.

6640. Eells, W.C. Mental ability of the native races of Alaska. J appl Psychol 1933, 17:417-438.

6641. Eggers, M.M. Comparison of Army Alpha and Goodenough Drawings in Delinquent Women. Master's thesis. Columbia Univ 1931.

6642. Eiduson, B.T. Artist and nonartist: a comparative study. J Personality 1958, 26:13-28.

6643. Elkisch, P. Certain Projective Techniques As a Means of Investigating the Psychodynamic Status of Children. Doctoral dissertation. Univ Michigan 1943.

6644. ———. Children's drawings in a projective technique. Psychol Monogr 1945, 58(1), Whole No. 266, 31 p.

6645. ———. Comment to a reply by Drs. Gehl and Kutash. J proj Tech 1951, 15: 514-515.

6646. ———. Free art expression. In Rabin, A.I., and M.R. Haworth (eds.), Projective Techniques with Children. NY: Grune & Stratton 1960, 273-289.

6647. ———. Further experiments with the Scribbling Game-Projection Method. J proj Tech 1951, 15:376-379.

6648. ———. The scribbling game, a projective method. Nervous Child 1948, 7:247-256.

6649. ———. Significant relationship between the human figure and the machine in the drawings of boys. Ops 1952, 22: 379-385.

6650. Ellis, A., and E. Rosen. H-T-P: a projective device and a measure of adult intelligence. In Buros, O.K. (ed.), The Fourth Mental Measurements Yearbook. NY: Gryphon 1953, 178-181.

6651. Epstein, L., and H. Hartford. Some relationships of beginning strokes in handwriting to the human figure-drawing test. Perceptual & Motor Skills 1959, 9: 55-62.

6652. Exner, J.E., Jr. A comparison of the human figure drawings of psychoneurotics, character disturbances, normals and sub-

jects experiencing experimentally-induced fear. J proj Tech 1962, 26:392-397.

6653. Faterson, H. The Figure Drawing Test as an adjunct in the selection of medical students. J med Educ 1956, 31:323-327.

6654. Feather, D.B. An exploratory study in the use of figure drawings in a group situation. J soc Psychol 1953, 37:163-170.

6655. Fedorovich, L.V., and M.K.H. Kekcheeva. (From an experimental conduction of exercises and problem solving in projective drawing.) Izvetsiia Akademii Pedagogischeskikn Nauk RSFSR 1949, No. 21, 151-177.

6656. Feldman, M.J., and R.G. Hunt. The relation of difficulty in drawing to ratings of adjustment based on human figure drawings. J consult Psychol 1958, 22:217-219.

6657. Feshbach, S., R.D. Singer, and N. Feshbach. Effects of anger arousal and similarity upon the attribution of hostility to pictorial stimuli. J consult Psychol 1963, 27:248-252.

6658. Fiedler, F.E., and S.M. Siegel. The free drawing test as a predictor of non-improvement in psychotherapy. J clin Psychol 1949, 5:386-389.

6659. Figueras, A. El "test" del interior del cuerpo de C. Downing Tait and R.C. Asher. Acta Neuropsiquiátrica (Argentina) 1956, 2:251-259.

6660. Fine, R. Interpretation of Jay's make-a-picture-story method. J proj Tech 1952, 16:449-453.

6661. Fisher, G.M. Comment on Starr and Marcuse's "Reliability in the Draw a Person Test." Perceptual & Motor Skills 1959, 9:302.

6662. ———. A preliminary investigation of schizophrenia indicators in the Machover Test. Bull Maritime Psychol Ass 1952 (Spring), 11-14.

6663. ———. Relationship between diagnosis of neuropsychiatric disorder, sexual deviation, and the sex of the first-drawn figure. Perceptual & Motor Skills 1959, 9:47-50.

6664. Fisher, L.J. An Investigation of the Effectiveness of Human Figure Drawings as a Clinical Instrument for Evaluating Personality. Doctoral dissertation. NY Univ 1952.

6665. Fisher, R. The effect of a disturbing situation upon the stability of various projective tests. Psychol Monogr 1958, 72, 14, Whole No. 467, 23 p.

6666. Fisher, S., and S.E. Cleveland. Body Image and Personality. NY: Van Nostrand 1958.

6667. Fisher, S., and R.L. Fisher. Style of sexual adjustment in disturbed women and its expression in figure drawings. J

Psychol 1952, 34:169-179.

6668. —— & ——. Test of certain assumptions regarding figure drawing analysis. J abnorm Soc Psychol 1950, 45:727-732.

6669. Flakowski, H. Entwicklungsbedingte Stilformen von Kinderaufsatz und Kinderzeichnung. Psychol Beiträge 1957, 3:446-467.

6670. Flury, M. Zeichne Deine Familie. Prax Kinderpsychol Kinderpsychiat 1954, 3:117-125.

6671. Fontes, V., M.I. Leite da Costa, and A. Fereira. Contribuição para o estudo do teste de Fay aplicado em crianças portugeses. Criança portug 1944, 3:13-34.

6672. Forno, L. La technique des dessins de la maison, de l'arbe et du bonhomme, comme moyen d'exploration de la personnalité. Rev de Neuropsychiatrie Infantile 1960, 1-2:52-63.

6673. Forteza, M. El dibujo como test imaginativo en la selección de aprendices. Rev di Psicologia i Pedagogia aplicata (Valencia) 1952, 3:251-261.

6674. Frank, G.H. A test of the use of a figure drawing test as an indicator of sexual inversion. Psychol Reports 1955, 1:137-138.

6675. Frank, L.K. Projective Methods. Springfield, Ill.: Thomas 1948.

6676. ——. Projective methods for the study of personality. J Psychol 1939, 8:339-418.

6677. Freed, G.O. A Projective Test Study of Creativity in College Students in Visual Arts. Dissertation Abstr 1961, 22:640-641.

6678. Freed, H., and J.T. Pastor. Evaluation of the Draw-a-Person Test (modified) in thalamotony with particular reference to the body image. JNMD 1951, 114:106-120.

6679. —— & ——. Psychodiagnostic drawing test. Arch Neurol Psychiat 1951, 65: 125-126.

6680. Gallese, A.J., Jr., and D.T. Spoerl. A comparison of Machover and TAT interpretation. J soc Psychol 1954, 40:73-77.

6681. Garret, E.S., A.C. Price, and H.L. Deabler. Diagnostic testing for cortical brain impairment. Arch Neurol Psychiat 1957, 77:223-225.

6682. Gayral, L., and H. Stern. Machover drawing test. In Stern, E. (ed.), Handbuch der klinischen Psychologie. Zürich: Rascher 1955.

6683. Gehl, R.H., and S.B. Kutash. Psychiatric aspect of a graphomotor projection technique. Psychiat Quart 1949, 23:539-547.

6684. —— & ——. A reply to Elkisch's critique of the Graphomotor Projection Technique. J proj Tech 1951,15:510-513.

6685. Geil, G.A. The use of the Goodenou test for revealing male homosexuality. J clinical Psychotherapy 1944, 6:307-321.

6686. Gesell, A. The Mental Growth of the Preschool Child. NY: Macmillan 1925, 447 p.

6687. Giedt, F.H., and G.F.J. Lehner. Assi ment of ages on draw-a-person test by male neuropsychiatric patients. J Personality 1951, 19:440-448.

6688. Gilbert, J.G., and M.R. Hall. Chang with age in human figure drawing. J Gero tology 1962, 17:397-404.

6689. Gitlitz, H.B. The Goodenough Drawing Scale Applied to Fourteen-Year-Old Children. Master's thesis. Columbia Uni 1933.

6690. Göllnitz, (?), (?) Lenz, and (?) Wint ling. Beiträge zur Psychodiagnostik des Sonderschulkinders. Münich-Basel: Reinhardt 1957, 76 p.

6691. Goldstein, A.P., and M.L. Rawn. The validity of interpretive signs of aggressi in the drawing of the human figure. J clin Psychol 1957, 13:169-171.

6692. Goldworth, S. A Comparative Study of the Drawings of a Man and a Woman Done by Normal, Neurotic, Schizophrenic and Brain-Damaged Individuals. Doctoral dissertation. Univ Pittsburgh 1950.

6693. Gomez del Cerro, J. El test del árbo en clínica psiquiátrica; Baum-test. Acta médica hispanica 1950, 8:53-58.

6694. Goodenough, F.L. The Intellectual Factor in Children's Drawing. Dissertatic Abstr. Stanford Univ 1924-26, 26-32.

6695. ——. L'intelligence d'après le dess Paris: PUF 1957, 133 p.

6696. ——. Measurement of Intelligence Drawings. Yonkers: World 1926, 177 p.

6697. ——. A new approach to the measur ment of the intelligence of young childre Ped Sem 1926, 33:185-211.

6698. ——. Racial differences in the intel gence of school children. J exp Psychol 1926, 9:388-397.

6699. Gräser, L. Familie in Tieren. Die Familiensituation im Spiegel der Kinderzeichnung. Entwicklung eines Testverfahrens. Münich: Reinhardt 1957, 119 p.

6700. Graham, F.K., and B.S. Kendall. Mem ory-for-Designs Test. Missoula, Mont.: Psychological Test Specialists 1946, 1963.

6701. —— & ——. Memory-for-Designs Test: revised general manual. Perceptual & Motor Skills 1960, 11:147-188.

6702. —— & ——. Performance of brain-damaged cases on a memory-for-design t J abnorm soc Psychol 1946, 41:303-314.

6703. Graham, S.R. Relation between his-
tamine tolerance, visual autokinesis,
Rorschach human movement and figure
drawing. J clin Psychol 1955, 11:370-373.

6704. ———. A study of reliability in human
figure drawings. J proj Tech 1956, 20:385-
386.

6705. Grams, A., and L. Rinder. Signs of
homosexuality in human-figure drawings.
J consult Psychol 1958, 22:394.

6706. Granick, S. Comparative performance
of normal and psychoneurotic children on
the draw-a-person test. J Germantown
Hospital 1963, 4:17-22.

6707. Granick, S., and L.J. Smith. Sex
sequence in the Draw-A-Person Test and
its relation to the MMPI Masculinity-
Feminity Scale. J consult Psychol 1953,
17:71-73.

6707a. Green, M., and E.E. Levitt. Con-
striction of body image in children with
congenital heart disease. Pediatrics 1962,
29:438-441.

6708. Greenberg, P. The use of the grapho-
motor projection test in describing the
personality of a group of normal girls.
Psychol Rev 1952, 1:469-494.

6709. Gridley, P.F. Graphic representation
of a man by four-year-old children in nine
prescribed drawing situations. Genet psy-
chol Monogr 1938, 20:183-350.

6710. Griffith, A.V., and D.A.R. Peyman.
Eye-ear emphasis in the DAP as indicating
ideas of reference. J consult Psychol 1955,
23:560.

6711. Grill, I. Entwicklung eines unstruk-
turierten Intelligenztests. Z exp angew
Psychol 1960, 7:211-225.

6712. Groth, G. Beziehungen zwischen
intellektueller und künstlerisch-technischen
Begabung an einem Mädchenlyceum. Z
pädag Psychol 1932, 33:199.

6713. Guertin, W.H., and W. Sloan. A com-
parison of H-T-P and Wechsler-Bellevue
IQ's in mental defectives. J clin Psychol
1948, 4:424-426.

6714. Gunderson, E.K., and G.F.J. Lehner.
Height of figure as a diagnostic variable
in the Draw-a-Person test. Amer Psycholo-
gist 1950, 5:472.

6715. ——— & ———. Reliability in a projec-
tive test (the Draw-A-Person). Amer Psy-
chologist 1949, 4:387.

6716. Haggard, E.A. A projective technique
using comic strip characters. Char Pers
1942, 10:289-295.

6717. Halpern, F. Child case study: a
troubled eight year-old. In Hammer, E.F.
(ed.), The Clinical Application of Projec-
tive Drawings. Springfield, Ill.: Thomas

1958, 113-129.

6718. Hammer, E.F. (ed.). The Clinical
Application of Projective Drawings. Spring-
field, Ill.: Thomas 1958, 663 p.

6719. ———. A comparison of H-T-P's of
rapists and pedophiles. J proj Tech 1954,
18:346-354.

6720. ———. A comparison of the H-T-P's
of rapists and pedophiles: III. The "dead"
tree as an index of psychopathology. J
clin Psychol 1955, 11:67-69.

6721. ———. Comparison of the performances
of Negro children and adolescents on two
tests of intelligence, one an emergency
scale. J genet Psychol 1954, 84:85-93.

6722. ———. Creativity; An Exploratory In-
vestigation of the Personalities of Gifted
Adolescent Artists. NY: Random 1961, 150 p.

6723. ———. Critique of Swensen's "Empiri-
cal evaluations of human figure drawings."
J proj Tech 1959, 23:30-32.

6724. ———. Emotional instability and crea-
tivity. Perceptual & Motor Skills 1961, 12:
102.

6725. ———. An experimental study of sym-
bolism on the Bender Gestalt. J proj Tech
1954, 18:335-345.

6726. ———. Frustration-aggression hypoth-
esis extended to socio-racial areas: com-
parison of Negro and white children's H-
T-P's. Psychiat Quart 1953, 27:597-607.

6727. ———. Guide for qualitative research
with the H-T-P. J genet Psychol 1954, 51:
41-60.

6728. ———. Hierarchal organization of per-
sonality and projective techniques. NY
Soc clin Psychologists Newsletter 1964,
12(2):1,4-5, 7.

6729. ———. The house-tree-person (H-T-P)
drawings as a projective technique with
children. In Rabin, A.I., and M.R. Haworth
(eds.), Projective Techniques with Children.
NY: Grune & Stratton 1960, 258-272.

6730. ———. The H-T-P Clinical Research
Manual. Beverly Hills, Calif.: Western
Psychol Services 1955, 58 p.

6731. ———. An investigation of sexual sym-
bolism—a study of H-T-P's of eugenically
sterilized subjects. J proj Tech 1953, 17:
401-413.

6732. ———. Negro and white children's per-
sonality adjustment as revealed by a com-
parison of their drawings (H-T-P). J clin
Psychol 1953, 9:7-10.

6733. ———. The possible effects of projec-
tive testing upon overt behavior. J Psychol
1953, 36:357-362.

6734. ———. Projective Drawing Interpretation.
Springfield, Ill.: Thomas 1957.

6735. ———, et al. The reliability of size of

children's drawings. J clin Psychol 1964, 20:121.

6736. ———. Relationship between diagnosis of psychosexual pathology and the sex of the first drawn person. J clin Psychol 1954, 10:168-170.

6737. ———. The role of the H-T-P in the prognostic battery. J clin Psychol 1953, 9:371-374.

6738. Hammer, E.F., and Z.A. Piotrowski. Hostility as a factor in the clinician's personality as it affects his interpretation of projective drawings (H-T-P). J proj Tech 1953, 17:210-216.

6739. Hanfmann, E. Picture completion in schizophrenic and in organic disorders. Psychol Bull 1938, 35:647-648.

6740. ———. A qualitative analysis of the Healy pictorial completion test: II. Ops 1939, 9:325-330.

6741. ———. Thought disturbances in schizophrenia as revealed by performance in a picture completion test. J abnorm soc Psychol 1939, 34:249-264.

6742. Hanselmann, H. Über einen Sozialtest. Gesundheit u Wohlfart 1946, 237.

6743. Hanvik, L.J. The Goodenough test as a measure of intelligence in child psychiatric patients. J clin Psychol 1953, 6: 213-233.

6744. Hardy, M.W. The Interaction of Patients' Intelligence and Other Factors with Clinicians' Skill in the Diagnostic Use of Human Figure Drawings. Dissertation Abstr 1960, 20:4438.

6745. Hare, A.P., and R.T. Hare. The Draw-A-Group Test. J genet Psychol 1956, 89: 51-59.

6746. Harris, D.B. Children's Drawings As Measures of Intellectual Maturity: A Revision and Extension of the Goodenough Draw-a-Man Test. NY: Harcourt, Brace & World 1964, 400 p.

6747. Harrower, M.R. The Most Unpleasant Concept Test. In Hammer, E.F. (ed.), The Clinical Application of Projective Drawings. Springfield, Ill.: Thomas 1958, 365-390.

6748. ———. The Most Unpleasant Concept Test; a graphic projection technique. J clin Psychol 1950, 6:213-233.

6749. Havighurst, R.T., M.K. Gunther, and I.E. Pratt. Environment and the Draw-a-Man test: the performance of Indian children. J abnorm soc Psychol 1946, 41:50-63.

6750. Head, H. Aphasia and Kindred Disorders of Speech. 2 Vols. Cambridge: Cambridge Univ Pr 1926, 549 p, 430 p.

6751. Heidgerd, E. Research in drawing techniques. In Hammer, E.F. (ed.), The Clinical Application of Projective Drawings. Springfield, Ill.: Thomas 1958, 483-507.

6752. Hellersberg, E.F. The Horn-Hellersberg Test and adjustment to reality. Ops 1945, 15:690-710.

6753. Herrtwich, W. Das Tiermaskenverfahren. Psychol Beiträge 1960, 4:356-361.

6754. Hertz, M.R., A. Ellis, and P.M. Symonds. Rorschach methods and other projective technics. Rev educ Res 1947, 17:78-100.

6755. Hessel, M.G., and R.M.W. Travers. Use of drawings as a screening device in education. J educ Res 1954, 48:145-147.

6756. Heuyer, G., S. Lebovici, and N. Angoulvent. Le test de Lauretta Bender. Enfance 1949, 4:289-305.

6757. Heyer, G.R. Analyse von Handzeichnungen Analysierter. Zentralblatt für die gesamte Neurologie und Psychiatrie (Berlin) 1929, 53:398-399.

6758. Hinrichs, W.E. The Goodenough drawing test in relation to delinquency and problem behavior. Arch Psychol 1935, 175: 1-82.

6759. Höhn, E. Theoretische Grundlagen der Inhaltsanalyse projektiver Tests. Psychol Forsch 1959, 26:13-74.

6760. Holtzman, W.H. The examiner as a variable in the Draw-A-Person Test. J consult Psychol 1952, 16:145-148.

6761. Holzberg, J.D., and M. Wexler. The validity of human form drawings of personality deviation. J proj Tech 1950, 14: 343-361.

6762. Homma, M. Studies on the H-T-P (Buck). Folia Psychiatrica et Neurologica Japonica 1957, 11:1-26.

6763. Horowitz, R., and L. Murphy. Projective methods in psychological study of children. J exp Educ 1938, 7:133-140.

6764. Howard, A., and D.J. Shoemaker. An evaluation of the Memory-for-Designs Test. J consult Psychol 1954, 18:266.

6765. Hoyt, T.E., and M.R. Baron. Anxiety indices in same-sex drawings of psychiatric patients with high and low MAS scores. J consult Psychol 1959, 23:448-452.

6766. Hsiao, H.H. (Hsiao's revision of Goodenough's test of intelligence for children.) Monogr Psychol Educ Nat cent Univ 1939, 4, No. 1, 51 p.

6767. ———. (A revision of Goodenough's "Draw-a-Man" test.) Chinese J educ Psychol 1940, 1.

6768. Hulse, W.C. Childhood conflict expressed through family drawings. J proj Tech 1952, 16:66-79.

6769. ——. The emotionally disturbed child draws his family. Quart J Child Behavior 1951, 3:152–174.

6770. Hunkin, V. Validation of the Goodenough Draw-a-Man Test for African children. J Social Research (Pretoria) 1950, 1(1):52–63.

6771. Hunt, H.F. Testing for psychological deficit. In Brower, D., and L.E. Abt (eds.) Progress in Clinical Psychology, Vol. 1. NY: Grune & Stratton 1952, 91–107.

6772. Hunt, R.G., and M.J. Feldman. Body image and ratings of adjustment of human figure drawings. J clin Psychol 1960, 16: 35–38.

6773. Huntley, W. Judgments of Self Based upon Records of Expressive Behavior. Doctoral dissertation. Howard Univ 1938, 265 p.

6774. Hutt, M.L. Assessment of individual personality by projectives: current problems. J proj Tech 1951, 15:388–393.

6775. Instituto de Neuro-Psiquiatria. A prova de reprodução de figuras do INP. Bollettino di Psicologia applicata 1958, 3:27–33.

6776. Jacobi, J. Pictures from the unconscious. J proj Tech 1955, 19:264–270.

6777. Jakab, I. (Conscious and unconscious self-portraits in human figure drawings.) Confin Psychiat 1962, 5:112–129.

6778. Jampolsky, P. (Drawing tests in clinical psychology.) Année Psychol 1955, 55:119–127.

6779. Jolles, I. A Catalogue for the Qualitative Interpretation of the H-T-P. Beverley Hills, Calif.: Western Psychological Services 1952.

6780. ——. Child case study: the projection of a child's personality in drawings. In Hammer, E.F. (ed.), The Clinical Application of Projective Drawings. Springfield, Ill.: Thomas 1958, 236–248.

6781. ——. Children's Revision H-T-P Post Drawing Interrogation Folder. West Los Angeles: Western Psychological Services.

6782. ——. Some advances in interpretation of the chromatic phase of the H-T-P. J clin Psychol 1957, 13:81–83.

6783. ——. A study of the validity of some hypotheses for the qualitative interpretation of the H-T-P for children of elementary school age. II. The "phallic" tree as an indicator of psychosexual conflict. J clin Psychol 1952, 8:245–255.

6784. ——. A study of the validity of some hypotheses for the qualitative interpretation of the H-T-P for children of elementary school age. I. Sexual identification.

J clin Psychol 1952, 8:113–118.

6785. Jolles, I., and H.S. Beck. A study of the validity of some hypotheses for the qualitative interpretation of the H-T-P for children of elementary school age. III. Horizontal placement. J clin Psychol 1953, 9:161–164.

6786. —— & ——. A study of the validity of some hypotheses for the qualitative interpretation of the H-T-P for children of elementary school age. IV. Vertical placement. J clin Psychol 1953, 9:164–167.

6787. Johnson, A.P., A.A. Ellerd, and T.H. Lahey. The Goodenough Test as an aid to interpretation of children's school behavior. Amer J ment Deficiency 1950, 54: 516–520.

6788. Jones, L.W., and C.B. Thomas. Studies on figure drawings. Psychiat Quart Suppl 1961, 35:212–261.

6789. Judson, A.J., and B.W. MacCasland. A note on the influence of the season on tree drawings. J clin Psychol 1960, 16: 171–173.

6790. Kaartinen, A. Drawings of girls and boys as indicators of the differentiation of sex roles in school age. Acta Acad Paedag Jyvaskylaensis 1960, No. 20, 25–33.

6791. ——. Relations between drawing variables dependent on sex and personality traits. Acta Acad Paedag Jyvaskylaensis 1960, No. 20, 34–43.

6792. Kahn, T. An original test of symbol arrangement validated on organic psychotics. J consult Psychol 1951, 15:439–444.

6793. Kamano, D.K. An investigation on the meaning of human figure drawing. J clin Psychol 1960, 16:429–430.

6794. Kato, M. A genetic study of children's drawings of a man. J exp Psychol 1936, 3:175–185.

6795. Katz, J. A new figure drawing technique for diagnosis and evaluation. Psychoanal Rev 1960, 47(2):103–105.

6796. Kendall, B.S., and F.R. Graham. Further standardization of the Memory-for-Designs Test on children and adults. J consult Psychol 1948, 12:349–354.

6797. Kendig, I.V. The draw-a-person test. In Rosenthal, D. (ed.), The Genain Quadruplets, A Case Study and Theoretical Analysis of Heredity and Environment in Schizophrenia. NY: Basic Books 1963, 257–268.

6798. Keyes, E.J., and J. Laffal. The use of a graphomotor projective technique to discriminate between failure and success reactions in a level of aspiration situation.

J clin Psychol 1953, 9:69-77.

6799. Kienzle, R. Die Schülerzeichnung als Ausdruck des Charakters. Esslingen: Schneider 1951, 100 p.

6800. Kinget, G.M. The drawing completion test. In Hammer, E.F. (ed.), The Clinical Application of Projective Drawings. Springfield, Ill.: Thomas 1958, 344-364.

6801. ———. The Drawing Completion Test —A Projective Technique for the Investigation of Personality. NY: Grune & Stratton 1952, 238 p.

6802. ———. Personality assessment. Int House Quart 1953, 17(2):69-76.

6803. Klages, L., et al. Le diagnostic du caractère. Paris: PUF 1949, 266 p.

6804. Knapp, R.H., and S. Green. Preferences for styles of abstract art and their personality correlates. J proj Tech 1960, 24: 396-402.

6805. Knight, W.R., and J.F. Hall. Use of a cartoon-type projective technique in measuring attitudes toward psychology. Perceptual & Motor Skills 1957, 7:25-28.

6806. Knopf, I.J., and T.W. Richards. The child's differentiation of sex as reflected in drawings of the human figure. J genet Psychol 1952, 81:99-112.

6807. Koch, K. Der Baum-Test, das Baum zeichenversuch als psychodiagnostische Hilfsmittel. Bern: Huber 1949, 1952, 1957, 88 p.

6808. ———. Le test de l'arbre. In Baumgarten, F. (ed.), La psychotechnique dans le monde moderne. Paris: PUF 1952, 221-222.

6809. Koh, S.D. On the relationship between the Goodenough scale and the Thorndike scale in drawing of a man. Stud Psychol Ewha Woman's Univ 1954, 1:54-61.

6810. Koppitz, E.M. Teacher's attitude and children's performance on the Bender Gestalt test and human figure drawings. J clin Psychol 1960, 16:204-208.

6811. Kornmann, E. Über die Gesetzmässigkeiten und den Wert der Kinderziechnung. Ratingen: Henn 1953, 24 p.

6812. Koseff, J.W. A Study of Changes in Body Image during Psychotherapy. Doctoral dissertation. New York Univ 1952.

6813. Kotkov, B., and M. Goodman. The Draw-A-Person tests of obese women. J clin Psychol 1953, 9:362-364.

6814. ——— & ———. Prediction of trait rank from Draw-A-Person measurements of obese and nonobese women. J clin Psychol 1953, 9:365-367.

6815. Krugman, M., and K.W. Wilcox. H-T-P house, tree, and person: a measure of adult intelligence and a projective device: preliminary edition. In Buros, O.K. (ed.),

The Third Mental Measurements Yearbook. New Brunswick, N.J.: Rutgers Univ Pr 1949, 84-86.

6816. Kutash, S.B. A new personality test: the graphomotor projection technique. Trans NY Acad Sci 1952, 15:44-46.

6817. ———. Recent developments in the field of projective techniques. Rorschach Res Exchange & J proj Tech 1949, 13(1): 14-86.

6818. Kutash, S.B., and R.H. Gehl. A simple scoring device for quantifying graphic productions. J clin Psychol 1949, 5:424-425.

6819. Laane, C.L. Clinical experience with the figure drawing test. J clin exp Psychopath 1960, 21:129-141.

6820. Lakin, M. Affective tone in human figure drawings by institutionalized aged and by normal children. J Amer Geriatrics Soc 1958, 6:495-500.

6821. ———. Certain formal characteristics of human figure drawings by institutionalized aged and by normal children. J consult Psychol 1956, 20:471-474.

6822. Landisberg, S. A personality study of institutionalized epileptics. Amer J ment Deficiency 1947, 52:16-22.

6823. ———. Relationship of the Rorschach to the H-T-P. J clin Psychol 1953, 9:179-183.

6824. ———. A study of the H-T-P test. Training School Bull 1947, 44:140-152.

6825. Lantz, B. Easel Age Scale. Ages 4 to 85. Manual. Los Angeles: California Test Bureau 1955, 20 p.

6826. Lark-Horovitz, B. Interlinkage of sensory memories in relation to training in drawing. J genet Psychol 1936, 49:69-89.

6827. Lauriers, A. des., and F. Halpern. Psychological tests in childhood schizophrenia. Ops 1947, 17:57.

6828. Lee, H.B. Projective features of contemplative artistic experience. Ops 1949, 16:101-111.

6829. Lehman, E. The Monster Test. Arch gen Psychiat 1960, 3:535-543.

6830. Lehner, G.F.J., and E.K. Gunderson. Height relationships on the Draw-a-Person test. J Personality 1953, 21:392-399.

6831. ——— & ———. Reliability of graphic indices in a projective test (DAP). J clin Psychol 1952, 8:125-128.

6832. Lehner, G.F.J., and H. Silver. Age relationships on the Draw-a-Person Test. J Personality 1948, 17:199-209.

6833. Leider, K. Der Wartegg-Zeichentest und seine grippendiagnostische Auswertung. In Hippius, R. (ed.), Volkstum, Gesinnung und Charakter. Stuttgart-Prague 1943.

6834. Leite da Costa, M.I. O teste de desenho de Prudhommeau. Criança portug 1949-50, 9:229-308.

6835. LeMen, J. Presentation d'une épreuve de dessin. Rev de Psychologie Appliquée 1953, 3:97-101.

6836. Levine, M., and E. Galanter. A note on the "tree and trauma" interpretation in the H-T-P. J consult Psychol 1953, 17: 74-75.

6837. Levitt, E.E., and H.J. Grosz. A note on sex sequence in the Draw-a-Person Test. Psychol Newsletter 1959, 10:213-214.

6838. Levy, L.R. The function of the Good-enough Drawing Scale in the study of high school freshmen. Master's thesis. Columbia Univ 1931.

6839. Levy, S. Case study of an adult: the case of Mr. P. In Hammer, E.F. (ed.), The Clinical Application of Projective Draw-ings. Springfield, Ill.: Thomas 1958, 135-161.

6840. ———. Figure drawings as a projec-tive test. In Abt, L.E., and L. Bellak (eds.), Projective Psychology. NY: Knopf 1950, 257-297.

6841. ———. Projective figure drawings. In Hammer, E.F. (ed.), The Clinical Applica-tion of Projective Drawings. Springfield, Ill.: Thomas 1958, 83-112.

6842. Levy, S., and R.A. Levy. Symbolism in animal drawings. In Hammer, E.F. (ed.), The Clinical Application of Projective Drawings. Springfield, Ill.: Thomas 1958, 311-343.

6843. Lewinsohn, P.M., and J.G. May, Jr. A technique for the judgment of emotion from figure drawings. J proj Tech 1963, 27:79-85.

6844. Lieberman, M.G. Childhood memories as a projective technique. J proj Tech 1957, 21:32-36.

6845. Lindner, R.S. The Goodenough Draw-a-Man Test: Its Relationship to Intelli-gence, Achievement, and Cultural Vari-ables of Negro Elementary School Children in the Southeast United States. Disserta-tion Abstr 1962, 23(2):703-704.

6846. Linton, H., and E. Graham. Person-ality correlates of persuasibility. In Hov-land, C.I., and I.L. Janis (eds.), Person-ality and Persuasibility. New Haven, Conn.: Yale Univ Pr 1959, 69-101.

6847. Lorand, R.L. Family Drawings and Adjustment. Dissertation Abstr 1957, 17: 1596.

6848. Lord, E., and L. Wood. Diagnostic values in a visuo-motor test. Ops 1942, 12:414-428.

6849. Lorge, I., J. Tuckman, and M.B. Dunn. Human figure drawings by younger and older adults. J clin Psychol 1958, 14:54-56.

6850. Lossen, H. Die Bedeutung des Ver-laufsanalyse für den Wartegg-Zeichentest. Z diagnost Psychol 1955, 3:142-154.

6851. Lossen, H., and G. Schott. Wartegg-Zeichentest. Gestaltung und Verlaufsdynamik. Biel 1952.

6852. Lowenfeld, M. The world pictures of children. A method of recording and study-ing them. Brit J med Psychol 1939, 18:65-101.

6853. Lubin, B. Differentiation of overtly stable and unstable psychiatric aides by means of the DAP Test. Psychol Reports 1959, 5:26.

6854. Luza, S.M. La Prueba de Wartegg en la esquizofrenia. Rev de Neuro-Psiquiatría (Lima) 1954, 17:162-194.

6855. Lyons, J. The scar on the H-T-P tree. J clin Psychol 1955, 11:267-270.

6856. McCarthy, D. A study of the reliability of the Goodenough Test of intelligence. J Psychol 1944, 18:201-216; Psychol Bull 1937, 34:759-760.

6857. McCurdy, H.G. Group and individual variability on the Goodenough Draw-A-Man Test. J educ Psychol 1947, 38:428-436.

6858. Macfarlane, J.W., and R.D. Tuddenham. Problems in the validation of projective techniques. In Anderson, H.H., and G.L. Anderson (eds.), An Introduction to Projec-tive Techniques. NY: Prentice-Hall 1951.

6859. Machover, K. Adolescent case study: a disturbed adolescent girl. In Hammer, E.F. (ed.), The Clinical Application of Pro-jective Drawings. Springfield, Ill.: Thomas 1958, 130-134.

6860. ———. The body image in art communi-cation as seen in William Steig's draw-ings. J proj Tech 1956, 19:453-460.

6861. ———. Drawings of a human figure. In Frank, L.K., et al. (eds.), Personality De-velopment in the Adolescent Girl. Yellow Springs, Ohio: Antioch Pr 1953.

6862. ———. Drawings of the human figure: a method of personality investigation. In Anderson, H.H., and G.L. Anderson (eds.), An Introduction to Projective Techniques. NY: Prentice-Hall 1951.

6863. ———. Human figure drawings of chil-dren. J proj Tech 1953, 17:85-91.

6864. ———. Personality Projection in the Drawings of the Human Figure. A Method of Personality Investigation. Springfield, Ill.: Thomas 1949, 181 p; 1961, 192 p.

6865. ———. Sex differences in the develop-

mental pattern of children as seen in
human figure drawings. In Rabin, A.I.,
and M.R. Haworth (eds.), Projective Tech-
niques with Children. NY: Grune & Strat-
ton 1960, 238-257.

6866. Machover, K., and M. Zadek. Human
figure drawings of hospitalized involu-
tionals. Psychiat Quart Suppl 1956, 30:
222-240.

6867. McHugh, A.F. Children's figure
drawings and school achievement. Psychol
in the Schools 1964, 1(1).

6868. ———. H-T-P proportion and perspec-
tive in Negro, Puerto Rican, and white
children. J clin Psychol 1963, 19:312-313.

6869. ———. Sexual identification, size, and
associations in children's figure drawings.
J clin Psychol 1963, 19:381-382.

6870. McHugh, G. Changes in Goodenough
IQ at the public school kindergarten level.
J educ Psychol 1945, 36:17-30.

6871. ———. Relationship between the Good-
enough Drawing of a Man Test and the
1937 Revision of the Stanford-Binet Test.
J educ Psychol 1945, 36:119-124.

6872. Mainord, F.B. A note on the use of
figure drawings in the diagnosis of sexual
inversion. J clin Psychol 1953, 9:188-189.

6873. Mallet, C.H. Eine Bilderserie als
Hilfsmittel zum Verständnis der Familien-
situation des Kindes. Prax Kinderpsychol
Kinderpsychiat 1955, 4(5-6):120-126.

6874. Manuel, H.T., and L.S. Hughes. The
intelligence and drawing ability of young
Mexican children. J appl Psychol 1932,
16:382-387.

6875. Margolis, M.F. A comparative study
of figure-drawings at three points in ther-
apy. Rorschach Res Exch 1948, 12:94-105.

6876. Markham, S. An item analysis of
children's drawings of a house. J clin
Psychol 1954, 10:185-187.

6877. Martin, A.W., and A.J. Weir. A com-
parative study of the drawings made by
various clinical groups. J ment Sci 1951,
97:532-544.

6878. Matheis, H. Der Wartegg-Zeichen-
test in der psychologischen und psycho-
pathologischen Diagnostik. Doctoral dis-
sertation. Mainz 1930.

6879. Mathieu, M. Le Test de l'Arbre en
psycho-pathologie. Lyon, France: BOSC
1961, 83 p.

6880. Meili-Dworetzky, G. Das Bild des
Menschen in der Vorstellung und Dar-
stellung den Kleinkindes. Bern-Stuttgart:
Huber 1957, 136 p.

6881. Mellone, M.A. A factorial study of
picture tests for young children. Brit J
Psychol 1944, 35:9-16.

6882. Memory-for-Designs Tests (MFD).
Missoula, Montana: Psychological Test
Specialists 1962.

6883. Menzel, E.W. The Goodenough In-
telligence Test in India. J appl Psychol
1935, 19:615-624.

6884. Meurisse, R. Le test du gribouillage.
Psyché-Paris 1948, 3:1372-1378.

6885. Meyer, B., F. Brown, and A. Levine.
Observations on the House-Tree-Person
drawing test before and after surgery.
Psychosom Med 1955, 17:428-454.

6886. Michael-Smith, H. The identification
of pathological cerebral function through
the H-T-P technique. J clin Psychol 1953,
9:293-295.

6887. Miller, J. Intelligence testing by
drawings. J educ Psychol 1938, 29:390-
394.

6888. Mira y López, E. (A new technic for
determining the dangerousness of criminals
and mental patients.) Rev de medicina lega
y jurisprudencia médica (Argentina) 1940,
4:3-25.

6889. Modell, A.H., and H.W. Potter. Human
figure drawings of patients with arterial
hypertension, peptic ulcer and bronchial
asthma. Psychosom Med 1949, 11:282-292.

6890. Mogar, R.E. Anxiety indices in human
figure drawings: a replication and exten-
sion. J consult Psychol 1962, 26:108.

6891. Morin, J. G 52: Test d'intelligence
pour Nord-Africains illettrés. Travail hum
1962, 25:353-364.

6892. Morris, W.W. Methodological and
normative considerations in the use of
drawings of the human figure as a projec-
tive method. Amer Psychologist 1949, 4:
267.

6893. ———. Ontogenetic changes in adoles-
cence reflected by drawing human-figures
technic. Ops 1955, 25:720-728.

6894. ———. Other projective methods. In
Anderson, H.H., and G.L. Anderson (eds.),
An Introduction to Projective Techniques.
NY: Prentice-Hall 1951, 513-538.

6895. Mott, S.M. The development of con-
cepts. A study of children's drawings.
Child Develpm 1936, 7:144-148.

6896. ———. The growth of an abstract con-
cept. Child Develpm 1939, 10:21-25.

6897. ———. Muscular activity as an aid
in concept formation. Child Develpm 1945,
16:97-109.

6898. Müller, P.H. Un test collectif de
dessin pour le diagnostic rapide des in-
suffisances psychique. Schweizerische
Z für Psychologie und ihre Andwendungen
(Bern) 1950, 9:462-466.

6899. Müller-Suur, H. Psychiatric experien

with Wartegg drawing test. Nervenarzt 1952, 23:446-450.

6900. Munroe, R., T.S. Lewinson, and T.S. Waehner. A comparison of three projective methods. Char Pers 1944, 13:1-21.

6901. Murphy, L.B. Interiorization of family experiences by normal preschool children as revealed by some projective methods. Psychol League J 1940, 4:3-5.

6902. ——. Patterns of spontaneity and constraint in the use of projective materials by preschool children. Trans NY Acad Sci 1942, 4:124-138.

6903. Murphy, M.M. A Goodenough Scale evaluation of human figure drawings of three non-psychotic groups of adults. J clin Psychol 1956, 12:397-399.

6904. ——. Sexual differentiation of male and female job applicants on the Draw-a-Person. J clin Psychol 1957, 13:87-88.

6905. Murray, D.C., and H.L. Deabler. Drawings, diagnoses, and the children's learning curve. J proj Tech 1958, 22:415-420.

6906. Navartil, L. Der Figur-Zeichnen-Test beim chronischen Alkoholismus. Z psychosom Med 1958, 4:97-103.

6907. Naville, P. Caractéristiques du développement du dessin par groupes d'ages, selon divers auteurs. Enfance 1950, 3:35-40.

6908. ——. Correction d'un test de dessin par trois correcteurs différents. JPNP 1948.

6909. Nel, B.F., and C.H. Esterhuysen. The Drawing of the Human Figure As a "Projective" Technique. Pretoria, South Africa: Univ Pretoria 1958, 98 p.

6910. Nichols, R.C., and D.J.W. Strumpfer. A factor analysis of Draw-a-Person Test scores. J consult Psychol 1962, 26:156-161.

6911. Nielsen, R.F. Le développement de la sociabilité chez l'enfant. Étude experimentale. Neuchâtel: Delachaux & Niestlé 1951, 166 p.

6912. Nira, E. Myokinetic psychodiagnosis: a new technique for exploring the conative trends of personality. Proc Royal Soc Med 1940, 33:9-30.

6913. Noller, P.A., and A. Weider. A normative study of human figure drawings for children. Amer Psychologist 1950, 5:319-320.

6914. Oakley, C.A. Drawings of a man by adolescents. Brit J Psychol 1940, 31:37-60.

6915. ——. The interpretation of children's drawings. Brit J Psychol 1931, 21:256-270.

6916. Ochs, E. Change in Goodenough drawing associations with changes in social adjustment. J clin Psychol 1950, 6:282-284.

6917. Osterrieth, P.A. Le dessin le diagnostic de la personnalité en psychologie clinique. Bull de l'Association Internationale de Psychologie Appliquée 1957, 6:4-27.

6918. ——. Remarque sur l'interpretation des tests de dessin en psychologie clinique. Rev de Psychologie Appliquée 1953, 3:338-343.

6919. ——. Le test de copie d'une figure complexe: contribution à l'étude de la perception et la mémoire. Arch Psychol 1944, 30:206-356.

6920. Papavassiliou, I.T. Le dessin du "Bonhomme" comme test d'intelligence chez les enfants arriérés. Rev de Neuro-psychiatrie Infantile 1952, 58:4.

6921. ——. Notes sur l'application du Test du Bonhomme en Grèce. Z Kinderpsychiat 1950, 16:129-133.

6922. ——. The validity of the Goodenough Draw-A-Man Test in Greece. J educ Psychol 1953, 44:244-248.

6923. Pariog, C. (The Psychology of Drawing.) Cluj, Roumania: Inst de Psychologie de l'Univ de Cluj 1932.

6924. Park, S.I. (Goodenough's Draw-a-Man Test standardized for Seoul city children.) Ewha Women's Univ Commemorative Essays 1956, 153-182.

6925. Pauker, J.D. An easily constructed scale for rating line darkness of drawings. J clin Psychol 1964, 20:122.

6926. ——. A simple method of measuring the area of figure drawings. J proj Tech 1962, 26:237-238.

6927. Payne, J.T. Comments on the analysis of chromatic drawings. J clin Psychol 1949, 5:75-76.

6928. ——. Observations on the Use of Color with the H-T-P. Morgantown, N.C.: North Carolina State Hospital 1950 (mimeographed).

6929. Pechoux, R., M. Kohler, and V. Girard. Reflexions sur l'evaluation de l'intelligence chez les enfants irréguliers. J de Médecine de Lyon 1947, 28:337-342.

6930. Pertejo, J. La interpretación del psicodiagnóstico de Rorschach y los dibujos infantiles segun F. Minkowska: su obra. Rev Psicol (Madrid) 1955, 10:25-47.

6931. Peters, G.A., and P.R. Merrifield. Graphic representation of emotional feelings. J clin Psychol 1958, 14:375-378.

6932. Pflaum, J.H. Restricted figure drawing as a projective measure of personality. J soc Psychol 1962, 58(2):283-287.

6933. Phatak, P. Calculations of norms on Phatak's Draw-a-Man Scale for Indian

children in Gujarat. J Maharajah Saya-
jirao Univ Baroda 1962, 11(1-2):131-138.

6934. ——. Comparative study of revised
Draw-a-Man Scale (Harris) and Phatak
Draw-a-Man Scale for Indian children.
Psychol Studies (Mysore) 1961, 6(2):12-
17.

6935. ——. Draw-a-Man Test: survey of
investigations. Indian J Psychol 1956, 31:
31-40.

6936. ——. A study of the revised Good-
enough scale with reference to artistic
and non-artistic drawings. J vocational
& educ Guidance (Baroda) 1960, 7:35-40.

6937. Pichon Rivière, A.A. El juega de con-
struir casas: su interpretacion y su valor
diagnostico. Rev de Psicoanálisis (Buenos
Aires) 1950, 7:347-388.

6938. Pickford, R.W. Personality and the
interpretation of pictures: a new projec-
tion technique. J Personality 1948, 17:
210-220.

6939. Pine, F., and R.R. Holt. Creativity
and primary process: a study of adaptive
regression. J abnorm soc Psychol 1960,
61:370-379.

6940. Pinillos, J.L. Configuracion y carac-
ter: notas sobre el test dibujo de Ehrig
Wartegg. Rev Psicol (Madrid) 1951, 6:
307-333.

6941. Pinillos, J.L., and J.C. Brengelmann.
Bilderkennung als Personlichkeitstest. Z
exp angew Psychol 1953, 1:480-500.

6942. Pinter, R., and H.A. Toops. A draw-
ing completion test. J appl Psychol 1918,
2:164-173.

6942a. Pollitt, E., S. Hirsch, and J. Money.
Priapism, impotence and human figure
drawings. JNMD 1964, 139(2):161-168.

6943. Ponzo, E. An experimental variation
of the draw-a-person technique. J proj
Tech 1957, 21:278-285.

6944. Prados, M. Rorschach studies on
artists-painters. I. Quantitative analysis.
Rorschach Res Exch 1944, 8:178-183.

6945. Precker, J.A. Painting and drawing in
personality assessment. J proj Tech 1950,
14:262-286.

6946. Prudhommeau, M. Le dessin de l'en-
fant. Paris: PUF 1947, 151 p.

6947. Rabin, A.I., and M.R. Haworth (eds.).
Projective Techniques with Children. NY:
Grune & Stratton 1960, 392 p.

6948. Rannells, E.W. Psychological tests
in art. Art Educ Bull 1948, 5(6):1-2; 5(7):
1-3.

6949. Rapaport, D. Diagnostic Psychologi-
cal Testing. Vol. II. Chicago: Yearbook
Publ 1946, 13-85.

6950. Raven, J.C. Controlled Projection for
Children. London: Lewis 1951, 176 p.

6951. Reichenberg-Hackett, W. Changes
in Goodenough drawings after a gratifyin
experience. Ops 1953, 23:501-517.

6952. Reiman, M.G. The mosaic test: its
applicability and validity. Amer J Psychi
1947, 26:413-430.

6953. Renner, M. Der Wartegg-Zeichnen-
test im Dienste der Erziehungsberatung.
Münich-Basel: Reinhardt 1953, 60 p.

6954. Rey, A. Épreuves de dessin; témoin
du développement mental. Arch Psychol
1946, 31:369-380.

6955. ——. Épreuves de dessin; témoins
du développement mental: II. Reproductio
d'objets simples selon différents points
de vue. Arch Psychol 1947, 32:145-160.

6956. Reznikoff, M., and A.L. Nicholas. A
evaluation of human-figure drawing indi-
cators of paranoid pathology. J consult
Psychol 1958, 22:395-397.

6957. Reznikoff, M., and H.R. Reznikoff.
The family drawing test: a comparative
study of children's drawings. J clin Psy-
chol 1956, 12:167-169.

6958. Reznikoff, M., and D. Tomblen. The
use of human figure drawings in the diag
nosis of organic pathology. J consult
Psychol 1956, 20:467-470.

6959. Ribler, R.I. Diagnostic prediction
from emphasis on the eye and the ear in
human figure drawing. J consult Psychol
1957, 21:223-225.

6960. Richey, M.H., and J.V. Spotts. The
relationship of popularity to performance
on the Goodenough Draw-A-Man test. J
consult Psychol 1959, 23:147-150.

6961. Rieger, R.E. Differences in Projectiv
Drawing Test Results between Patients
Diagnosed As Schizophrenic and As Or-
ganic. Master's thesis. Catholic Univ
1952.

6962. Roe, A. Painting and personality.
Rorschach Res Exch 1946, 10:86-100.

6963. ——. The personality of artists. Edu
psychol Measmts 1946, 6:401-408.

6964. Rosolato, G., C. Wiart, and R. Volmat.
Technique d'analyse picturale. Méthode,
catégorisation et première étude statistiq
Ann méd-psychol 1960, 2:27-56.

6965. Ross, B.M., et al. On making a rand
pattern. Perceptual & Motor Skills 1963,
17:587-600.

6966. Rothe, R. Kindertümliches Zeichnen,
gesetzhafte Form. Vienna: Jugend & Volk
1952, 132 p.

6967. Royal, R.E. Drawing characteristics
of neurotic patients using a drawing of a
man and a woman technique. J clin Psych
1949, 5:392-395.

6968. Rubin, H. A quantitative study of the H-T-P and its relationship to the Wechsler-Bellevue Scale. J clin Psychol 1954, 10:35-38.

6969. Rudolph, R. The silhouette test. Nordisk Psykologi 1959, 11:25-43; Acta psychol 1959, 16:25-44.

6970. Russell, R.W. The spontaneous and instructed drawings of Zuni children. J comp Psychol 1943, 35:11-15.

6971. Sacher, H. Der charakterologische Intelligenztest (CIT). Göttingen 1953.

6972. Samson, H. Drawing As a Technique of Investigation and Therapy with Children. Doctoral dissertation. Catholic Univ 1952.

6973. Santorum, A. A cross-validation of the House-Tree-Person drawing indices predicting hospital discharge of tuberculosis patients. J consult Psychol 1960, 24:400-402.

6974. Santos, J.F., and J.R. Montgomery. Stability of performance on the Color-Word Test. Perception & Motor Skills 1962, 15:397-398.

6975. Sarason, S.B. Psychological Problems in Mental Deficiency. NY: Harper 1953, 260-261.

6976. Sargent, H. Projective methods: their origins, theory and applications in personality research. Psychol Bull 1945, 42:257-293.

6977. Schachter, M., and S. Cotte. The diagnostic value of drawings in clinical psychology. In Stem, E. (ed.), Handbuch der klinischen Psychologie. Zürich: Rascher 1955.

6978. Schactel, E.G. Projection and its relation to character attitudes and creativity in the kinesthetic responses. Psychiatry 1950, 13:69-100.

6979. Schilder, P. The Image and Appearance of the Human Body. NY: IUP 1950; London: Kegan Paul, Trench, Trubner 1935.

6980. Schmidt, L.D., and J.F. McGowan. The differentiation of human figure drawings. J consult Psychol 1959, 23:129-133.

6981. Schneck, J.M., and M.V. Kline. Clinical psychiatric status and psychological test alterations following hypnotherapy. Brit J med Hypnotism 1950, 2:30-41.

6982. Schneidman, E.S. The case of Jay: psychological test and anamnestic data. J proj Tech 1952, 16:297-345.

6983. ———. Some relationships between thematic and drawing materials. In Hammer, E.F. (ed.), The Clinical Application of Projective Drawings. Springfield, Ill.: Thomas 1958, 620-626.

6984. Schneidman, E.S., J.E. Bell, R. Fine, R. R. Holt, S.B. Kutash, and P.G. Vorhaus. The case of Jay: interpretations and discussion. J proj Tech 1952, 16:444-475.

6985. Schube, P.G., and J.G. Cowell. Art of psychotic persons: a restraint-activity index and its relation to diagnosis. Arch Neurol Psychiat 1939, 41:711-720.

6986. Schwartz, A.A. Some interrelationships among four tests comprising a test battery: a comparative study. J proj Tech 1950, 14: 153-172.

6987. Schwartz, A.A., and I.H. Rosenberg. Observations on the significance of animal drawings. Ops 1955, 25:729-746.

6988. Sechrest, L., and J. Wallace. Figure drawings and naturally occurring events: elimination of the expansive euphoria hypothesis. J educ Psychol 1964, 55(1): 42-44.

6989. Sehringer, W. Die Entwicklung der Diagnostik der Kinderzeichnung im Überblick. Diagnostica 1960, 6:18-30.

6990. ———. Der Goodenough-Test Probleme der Diagnostik bei der kindlichen Zeichnung eines Menschen. Psychol Forsch 1957, 25: 155-237.

6991. Shanan, J. Intraindividual response variability in figure drawing tasks. J proj Tech 1962, 26:105-111.

6992. Shapiro, M.B. The rotation of drawings by illiterate Africans. J soc Psychol 1960, 52:17-30.

6993. Sherman, L.J. The influence of artistic quality on judgments of patient and nonpatient status from human figure drawings. J proj Tech 1958, 22:338-340.

6994. ———. Sexual differentiation or artistic ability? J clin Psychol 1958, 14:170-171.

6995. Silver, A.A. Diagnostic value of three drawing tests for children. J Pediatrics 1950, 37:129-143.

6996. Singer, H. Validity of the Projection of Sexuality in Drawing of the Human Figure. Master's thesis. Western Reserve Univ 1952.

6997. Singer, R.H. A Study of Drawings Produced by a Group of College Students and a Group of Hospitalized Schizophrenics. Master's thesis. Pennsylvania State College 1950.

6998. Sipprelle, C.N., and C.H. Swensen. Relationship of sexual adjustment to certain sexual characteristics of human figure drawings. J consult Psychol 1956, 20:197-198.

6999. Sloan, W. A critical review of H-T-P validation studies. J clin Psychol 1954, 10:143-148.

7000. Smith, F.O. What the Goodenough intelligence test measures. Psychol Bull

1937, 34:760-761.

7001. Smith, G. The serial mirror-drawing test. Nordisk Psykologi 1957, 9:230-240.

7002. Smits, W.C.M. (Space-adaptability in the Tree Test.) Gawein 1960, 8:234-238.

7003. Smykal, A., and F.C. Thorne. Etiological studies of psychopathic personality: II. Asocial type. J clin Psychol 1951, 7:299-316.

7004. Sohler, D.T., et al. The prediction of family interaction from a battery of projective techniques. J proj Tech 1957, 21:199-208.

7005. Starr, S., and F.L. Marcuse. Reliability in the Draw-A-Person Test. J proj Tech 1959, 23:83-86.

7006. Stavsky, W.H. A short note on a child's drawing. Ops 1938, 8:560-561.

7007. Steggerda, M. Maya Indians of Yucatan. Washington, D.C.: Carnegie Inst 1941.

7008. Steinman, K. The Validity of a Projective Technique in the Determination of Relative Intensity in Psychosis. Doctoral dissertation. New York Univ 1953.

7009. Stern, E. (ed.). Handbuch der klinischen Psychologie. Band 1. Die Tests in der klinischen Psychologie. 2. Halbband. Zürich: Rascher 1955, 418 p.

7010. Stern, M.M. Trauma projective technique and analytic profile (free painting of patients). Psychoanal Quart 1953, 22:221-252.

7011. Stern, W. Cloud pictures: a new method for testing imagination. Char Pers 1938, 6:132-146.

7012. Stoltz, R.E., and F.C. Coltharp. Clinical judgments and the draw-a-person test. J consult Psychol 1961, 25:43-45.

7013. Stonesifer, F.A. A Goodenough scale evaluation of human figures drawn by schizophrenic and non-psychotic adults. J clin Psychol 1949, 5:396-398.

7014. Stora, R. L'art de Koch. Test original et test modifié. Enfance 1948, 1:327-344.

7015. ———. L'influence du milieu sur les individus décelée par le test d'arbres. Enfance 1952, 5:357-372.

7016. Strumpfer, D.J.W. The relationship of Draw-A-Person Test variables to age and chronicity in psychotic groups. J clin Psychol 1963, 19:208-211.

7017. ———. A Study of Some Communicable Measures for the Evaluation of Human Figure Drawings. Dissertation Abstr 1960, 20:2910-2911.

7018. Suarès, N., and C. Desouches. Étude psychologique des enfants français et anglosaxons, de 4 à 7 ans. Enfance 1961,

3:255-363.

7019. Subes, J., and C. Mousseau. Étude sur le test du village. Schweiz ZPA 1954, 13:211-231.

7020. Suchenwirth, R. (Experiences in the use and evaluation of drawing test methods in medical psychology.) Medizinische Welt (Stuttgart) 1962, 51:2709-2715.

7021. Swenson, C.H. Empirical evaluations of human figure drawings. Psychol Bull 1957, 54:431-466.

7022. ———. Sexual differentiation in the Draw-A-Person test. J clin Psychol 1955, 11:37-41.

7023. Swenson, C.H., and K.R. Newton. The development of sexual differentiation on the Draw-A-Person test. J clin Psychol 1953, 11:417-419.

7024. Swenson, C.H., and C.N. Sipprelle. Some relationships among sexual characteristics of human figure drawings. J proj Tech 1956, 20:224-226.

7025. Symonds, P.M. Adolescent Fantasy. An Investigation of the Picture-Story Method of Personality Study. NY: Columbia Univ Pr 1949.

7026. ———. Projective techniques. In Harriman, P.L. (ed.), Encyclopedia of Psychology NY: Philosophical Library 1946, 583-590.

7027. Tait, C.D., Jr., and R.C. Ascher. Inside-of-the-body test. A preliminary report. Psychosom Med 1955, 17:139-148.

7028. Takala, M., and M. Hakkarainen. Über Faktorenstruktur und Validität des Wartegg-Zeichentests. Ann Acad Sci (Finland) 1953, 81(1), Ser. B., 95 p.

7029. Taylor, R.E. Figure location in student and patient samples. J clin Psychol 1960, 16:169-171.

7030. Telford, C.W. Test performance of full and mixed-blood North Dakota Indians. J comp Psychol 1932, 14:123-145.

7031. Thomas, R.M., and A. Sjah. The Draw-A-Man test in Indonesia. J educ Psychol 1961, 52:232-235.

7032. Thurner, F.K. Suizid und Testzeichnung. Z exp angew Psychol 1956, 3:439-457.

7033. Tolor, A. A preliminary report on a technique designed to differentiate patients with cerebral pathology and psychoneurosis. J clin Psychol 1954, 10:43-47.

7034. ———. The stability of tree drawings as related to several Rorschach signs of rigidity. J clin Psychol 1957, 13:162-164.

7035. ———. Teachers' judgments of the popularity of children from their human figure drawings. J clin Psychol 1955, 11:158-162.

7036. Tolor, A., and J. Colbert. Relationship

of body image to social desirability. J ment Sci 1961, 107:1060-1061.

7037. Tolor, A., and B. Toler. Judgment of children's popularity from human figure drawings. J proj Tech 1955, 19:170-175.

7038. Tramer, M. Manoggel mit abgehauen Händen. Z Kinderpsychiat 1946, 13:169-170.

7039. Traube, T. La valeur diagnostique des dessins des enfants difficiles. Arch Psychol 1937, 26:285-309.

7040. Truumaa, A. The Effect of Masculinity on Projection As Elicited by Male and Female Figures and Situations. Dissertation Abstr 1957, 17:1601.

7041. Tuompo, A. (The S-test. Drawing of the human figure as a diagnostic method.) Nordisk Psykologi 1953, 5:194-195.

7042. Urban, W.A. The Draw-A-Person Catalogue for Interpretative Analysis. Los Angeles: Western Psychological Services 1964.

7043. Utsugi, E., and K. Ohtsuki. A study on the human figure drawing of children. Tohoku Psychologica Folia 1955, 14:131-146.

7044. Van de Loo, K.J.M. (The basic situation of the Wartegg Drawing Test.) Ned Tijdschr Psychol 1956, 11:134-157.

7045. ——. Problemen van de Wartegg-Teken-Test. Ned Tijdschr Psychol 1958, 13:303-326.

7046. Van Krevelen, D.A. (Drawing.) Leiden: Stenfert Kroese 1953, 198 p.

7047. Vernier, C.M. Current avenue of psychological research in projective techniques. Quart Rev Psychiatry & Neurology 1952, 7:1-4.

7048. ——. Projective Test Productions. I. Projective Drawings. NY: Grune & Stratton 1952, 168 p.

7049. Vernier, C.M., J.F. Whiting, and M.L. Meltzer. Differential prediction of a specific behavior from three projective techniques. J consult Psychol 1955, 19: 175-182.

7050. Wagner, E.E. The use of drawings of hands as a projective medium for differentiating neurotics and schizophrenics. J clin Psychol 1962, 208-209.

7051. Wagner, M.E., and H.J.P. Schubert. D.A.P. Quality Scale for Late Adolescents and Young Adults. Kenmore, N.J.: Delaware Letter Shop 1955.

7052. —— & ——. Draw-a-Person Quality Scale. Buffalo, N.Y.: Wagner 1957, 195 p.

7053. Wallon, E.J. A Study of Criteria Used to Differentiate the Human-Figure Drawings of Normals, Neurotics, and Psychotics. Dissertation Abstr 1959, 20:1873.

7054. Wartegg, E. Archetypical qualities in the Wartegg test. In Wellek, A. (ed.), Bericht über den 20. Kongress der Deutschen Gesellschaft für Psychologie in Berlin 1955. Göttingen: Hogrefe 1956.

7055. ——. Gefühl. Neue psychol Stud 1934, 12.

7056. ——. Gestaltung und Charakter. Ausdrucksdeutung zeichnerischer Gestaltung und Entwurf einer charakterologischen Typologie. Leipzig: Barth 1939, 261 p.

7057. ——. Schichtdiagnostik. Der Zeichentest (WZT). Einführing in die experimentelle Graphoskopie. Göttingen: Verlag für Psychologie 1953, 107 p.

7058. ——. Wartegg drawing test. In Stern, E. (ed.), Handbuch der klinischen Psychologie. Zürich: Rascher 1955.

7059. Waxenberg, S.E. Psychosomatic patients and other physically ill persons: a comparative study. J consult Psychol 1955, 3:163-169.

7060. Weider, A., and P.A. Noller. Objective studies of children's drawings of human figures. II. Sex, age, intelligence. J clin Psychol 1953, 9:20-23.

7061. —— & ——. Objective studies of children's drawings of human figures. I. Sex awareness and socio-economic level. J clin Psychol 1950, 6:319-325.

7062. Weil, P.G. Étude factorielle de courbes de croissance mentale. Contribution expérimentale a l'étude de la loi de régression de ribot. Enfance 1950, 3:59-75.

7063. ——. Le test du dessin d'un bonhomme comme contrôle periodique simple et rapide de la croissance mentale. Enfance 1950, 3: 41-57.

7064. Wellisch, E. The use of projective paintings in the Rorschach method. Brit J med Psychol 1949, 22:66-71.

7065. West, J.H. Correlates of the Draw-A-Scene test. J clin Psychol 1960, 16:44-45.

7066. West, J.V., V.S. Baugh, and A.P. Baugh. Rorschach and Draw-A-Person responses of hypnotized and nonhypnotized subjects. Psychiat Quart 1963, 37:123-127.

7067. Wexler, M., and J.D. Holzberg. A further study of the validity of human figure drawings in personality evaluation. J proj Tech 1952, 16:249-251.

7068. Whitaker, L. The use of an extended draw-a-person test to identify homosexual and effeminate men. J consult Psychol 1961, 25:482-485.

7069. White, R.W. The interpretation of imaginative productions. In Hunt, J. McV. (ed.), Personality and the Behavior Disorders, Vol. I. NY: Ronald 1944, 214-254.

7070. Whitmyre, J.W. The significance of

artistic excellence in the judgment of adjustment inferred from human figure drawings. J consult Psychol 1953, 17:421-424.

7071. Williams, J.H. Validity and reliability of the Goodenough Intelligence Test. School & Soc 1935, 41:653-656.

7072. Williams, J.N. Interpretation of drawings made by maladjusted children. Virginia Med Monthly 1940, 67:533-538.

7073. Williams, M.L. The growth of intelligence as measured by the Goodenough Drawing Test. J appl Psychol 1930, 14: 239-256.

7074. Windsor, R.S. An experimental study of easel painting as a projective technique with nursery school children. J genet Psychol 1949, 75:73-83.

7075. Wintsch, J. Le dessin comme témoin du développement mental. Z Kinderpsychiat 1935, 2:33-44, 69-83.

7076. Wirths, C.G. A simple quantitative measure of pressure for use in the projective techniques. J clin Psychol 1952, 8: 208-209.

7077. Wisotsky, M. A note on the order of figure drawing among incarcerated alcoholics. J clin Psychol 1959, 15:65.

7078. Witkin, H.A., H.B. Lewis, M. Hertzman, K. Machover, P.B. Meissner, and S. Wapner (eds.). Personality Through Perception. NY: Harper 1954, 511 p.

7079. Wolff, W. "Graphometry": a new diagnostic method. Psychol Bull 1942, 39: 465.

7080. ———. Projective methods for personality analysis of expressive behavior in preschool children. Char Pers 1942, 4: 309-330.

7081. Wolff, W., and J.A. Precker. Expressive movement and the methods of experimental depth psychology. In Anderson, H. H., and G.L. Anderson (eds.), An Introduction to Projective Techniques. NY: Prentice-Hall 1951, 457-497.

7082. Woltman, A.G. Mud and clay—their function as developmental aids and as media of projection. Personality 1950, Symposium No. 2, 35-50.

7083. Woods, W.A., and W.E. Cook. Proficiency in drawing and placement of

hands in drawings of the human figure. J consult Psychol 1954, 18:119-121.

7084. Yakir, M. (Children's drawings as mental tests.) Ofakim (Israel) 1953, 7: 133-142.

7085. Zaragozá, J. Psicograma. Rev de Psicologia i Pedagogia aplicata (Valencia) 1954, 5:123-151.

7086. Zarncke, L. Bildgestaltung und Bilddeutung in der praktischen Erziehungsberatung. I. Teil: Plastische Bildestaltung als Ausdruck der Situation und der Charakterentwicklung jungen Menschen. Freiburg: Lambertus 1954, 156 p.

7087. ———. (Psychodiagnostic evaluation of pictures.) In Wellek, A. (ed.), Bericht über den 20. Kongress der Deutschen Gesellschaft für Psychologie in Berlin 1955. Göttingen: Hogrefe 1956.

7088. Zazzo, R. Le geste graphique et la structuration de l'espace. Enfance 1950, 3:17-33.

7089. ———. Manuel pour l'examen psychologique de l'enfant. Neuchâtel: Delachaux & Niestlé 1960, 435 p.

7090. ———. Première contribution des psychologues scolaires à la psychologie différentielle des sexes. Enfance 1948, 1: 168-175.

7091. Zesbaugh, H.A. Children's Drawings of the Human Figure. Chicago: Univ Chicago Pr 1934.

7092. Zierer, E. Dynamics and diagnostic value of creative therapy; the body-space test. Acta Medica Orientalia; The Israel Med J 1950, 9:35-42.

7093. Ziler, H. Der Mann-Zeichentest. Heilpädagogische Blätter 1950, Oct.

7094. ———. Der Mann-Zeichen-Test in detail-statisticher Auswertung. Münster: Aschendorff 1958, 51 p.

7095. Zimmer, H. Predictions by means of two projective tests of personality evaluations made by peers. J clin Psychol 1955, 11:352-354.

7096. ———. Validity of sentence completion tests and human figure drawings. In Brower D., and L.E. Abt (eds.), Progress in Clinical Psychology, Vol. 2. NY: Grune & Stratton 1956, 58-75.

22 Miscellaneous

7097. Anon. Modern Museum a psycho-
pathic ward as surrealism has its day.
Art Digest 1936, 11:5-6.

7098. Anon. Psychology museum opens
offices in Chicago. Museum News 1938,
15:1.

7099. Anon. Sociology of art. Time Lit
Suppl (London) 1961, 3091:325.

7100. Arnheim, R. Form and the consumer.
College Art J 1959, 19(1):2-9.

7101. Barnett, J.H. The sociology of art.
In Merton, R.K., L. Broom, and L.S. Cottrell,
Jr. (eds.), Sociology Today. NY: Basic
Books 1959.

7102. Benjamin, W. Das Kunstwerk im zeit-
alter seiner technischen reproduzierbar-
keit. Drei Studien zur Kunstsoziologie.
Frankfurt a.M.: Suhrkamp 1963, 157 p.

7103. Benson, G. Art and social theories.
Creative Art 1933, 12:216-218.

7104. Berger, J. The artist and modern so-
ciety. Twentieth Century 1955, 158:148-
154, 290-297, 484-487.

7105. Bergeron, M., and R. Volmat. Sur la
nécessité et l'urgence de la création d'un
Musee d'art psychopathologique. Ann méd-
psychol 1952, 110:705-710.

7106. Bloch, H.A. Towards the development
of a sociology of literary and art-forms.
Amer Sociological Rev 1943, 8:313-320.

7107. Bower, R.T., and L.M. Sharp. The use
of art in international communication: a
case study. Public Opinion Quart 1956,
20:221-229.

7108. Brinkmann, G. Kunstsoziologie. In
Handwörterbuch der Sozialwissenschaften.
Göttingen 1957.

7109. Brown, M.W. Twentieth-century
nostrums: pseudo-scientific theory in
American painting. Magazine of Art 1948,
41:98-101.

7110. Calhoun, C.B. The contribution of
art to social understanding. Educational
Method 1934, 14:71-75.

7111. Campbell, N.R. Science, imagination,
and art. Science 1957, 125:803-806.

7112. Cirlot, J.E. A Dictionary of Symbols.
NY: Philosophical Library 1963.

7113. Comfort, A. Darwin and the Naked
Lady. Discursive Essays on Biology and
Art. NY: Braziller 1962, 174 p; London:
Routledge 1962, 174 p.

7114. Cooley, C.H. Art, science, and soc-
iology. In Calverton, V.F. (ed.), The Making
of Society. NY: Modern Library 1937.

7115. De Pina, L. (Tattoo marks.) Arch De-
part Antrop crim Psicol exp Ident civ Pôrto
1931, 1:147-156.

7116. Dugan, J.T. The license of liberty:
art, censorship, and American freedom.
JAAC 1954, 12:366-372.

7117. Duncan, H.D. Sociology of art, litera-
ture and music: social contexts of sym-
bolic experience. In Becker, H., and A.
Boskoff (eds.), Modern Sociological Theory
in Continuity and Change. NY: Dryden
1957.

7118. Evarts, A.B. A lace creation revealing
an incest fantasy. Psychoanal Rev 1918,
5:364-380.

7119. Farnsworth, P.R. Aesthetic behavior
and astrology. Char Pers 1938, 6:335-340.

7120. Fischer, J.L. Art styles as cultural
cognitive maps. Amer Anthropologist 1961,
63:79-93.

7121. Foster, M. The mental health of the
artist as an educator in the community.
Ment Hyg 1956, 40:96-106.

7122. Gehlen, A. Zeit-Bilder. Zur Soziologie
und Aesthetik der modernen Malerei. Frank-
furt: Athenäum 1960.

7123. Gillet, P.M.S. Kunst und Religion.
Schönere Zukunft 1929, 5:715-716.

7124. Goodman, P. Art and Social Nature.
NY: Vinco 1946.

7125. Gottlieb, A. Artist and society, a brief
case history. College Art J 1955, 14(2):96-
101.

7126. Guyen, J-M. L'art du point de vue
sociologique. Paris 1887.

7127. Hausenstein, W. Bild und Gemein-
schaft. Entwurf einer Soziologie der Kunst.
Munich 1920.

7128. ———. Die Kunst und die Gesellschaft.

Munich 1916.

7129. ——. Der nakte Mensch in der Kunst aller Zeiten und Völker. Munich 1911.

7130. ——. Versuch einer Soziologie der bildenden Kunst. Arch für Sozialwissenschaft u Sozialpolitik 1912.

7131. Henkes, R. Art and the professional guidance counselor. School Arts 1961, 60: 7-8.

7132. Henry, W.E. Art and cultural symbolism, a psychological study of greeting cards. JAAC 1947, 6:36-44.

7133. Hepler, E.R. Order of Presenting Orthographic Projection and Pictorial Representation and Its Effect on Achievement in Engineering Drawing. Dissertation Abstr 1957, 17:2222-2223.

7134. Hiss, P., and R. Fansler. Research in Fine Arts in the Colleges and Universities of the United States. NY: Carnegie Corp 1934, 223 p.

7135. Hogisheim, P. Soziologie der Kunst, Musik und Literatur. In Eisermann, G. (ed.), Die Lehre von der Gesellschaft. Stuttgart: Enke 1958.

7136. Jablonski, W. Richerche sulla percezione delle forme nei miopi. Arch ital di psicol 1937, 15:70-81.

7137. Jacobsen, E.A. A Comparison of Competitive and Cooperative Learning Experiences in Technical Drawing on the College Level. Dissertation Abstr 1957, 17:2223-2224.

7138. Kallir, A. Sign and Design: The Psychogenic Source of the Alphabet. London: Clarke 1961, 348 p.

7139. Kaufman, O.P. (Problems of rationalization of the teaching of graphics.) Sovetsk Psikhotekhn 1934, 7:199-220.

7140. Kavolis, V. Art style as projection in community structure. Sociology & Social Research 1964, 48(2):166-175.

7141. Klanfer, J. Theorie der heraldischen Zeichen. Arch ges Psychol 1935, 94:413-445.

7142. Klatt, F. Erwachsenbildung und künstlerische Gestaltung. Abendgymnasium 1929, 4:1-7.

7143. Kroeber, A.L. Style and Civilizations. Ithaca: Cornell Univ Pr 1957, 191 p.

7144. Krüger, G. Analyse der Denkvorgänge beim Lesen von Werkzeichnungen. Psychotechnische Z 1933, 8:24-33.

7145. Kurzband, T.K. Originality in the search for symbols. School Arts 1953, 53: 19-22.

7146. Jacobsen, W.F. An experimental investigation of the basic aesthetic factors in costume design. Psychol Monogr 1933, 45, No. 1, 147-184.

7147. Lehmann-Haupt, H. Art Under a Dictatorship. NY: Oxford Univ Pr 1954, 277 p.

7148. Lenk, K. Zur Methodik der Kunstsoziologie. Kölner Z für Soziologie u Sozialpsychologie 1961, 13(3):413-425.

7149. Lepper, R.L. The visual arts and post war society. JAAC 1944, 3(9):5-7.

7150. Levy, F.N. A special counselor on education for the arts. Occupations 1940, 19:114-116.

7151. Lotspeich, W.D. The place of form in the study of life. Perspectives in Biolog & Med 1963, 7:107-117.

7152. Marvin, F.S., and A.F. Clutton-Brock (eds.). Art and Civilization. London: Oxford Univ Pr 1928, 263 p.

7153. Maude, J. Optical convergence and stereopsis in relation to perspective. Med J Australia 1940, 2:281.

7154. Meige, H. (Sleep in art.) Aesculape 1927, 17:269-282.

7155. Mendieta y Núñez, L. Sociología del arte. Rev Mexicana de Sociologia 1956, 18:9-18; 1947, 9:368-383.

7156. Meyer, L.B. Forgery and the anthropology of art. Yale Rev 1963, 52:220-233.

7157. Mierendorff, M. Aufgaben einer Kunstsoziologie. Sozialistische Welt 1957 8:42-44.

7158. ——. Uber den gegenwärtigen Stand der Kunstsoziologie in Deutschland. Kölner Z für Soziologie u Sozialpsychologie 1957, 9:397-412.

7159. Mierendorff, M., and H. Tost. Grundlegung einer Kunstsoziologie. Kölner Z für Soziologie u Sozialpsychologie 1953-4, 6:1.

7160. Mills, G. Art: an introduction to qualtative anthropology. JAAC 1957, 16:1-17.

7161. Mills, L. Peripheral vision in art. Arch Ophthalmology (Chicago) 1936, 16: 208-219.

7162. Moore, B. Art As a Social Agency. Master's thesis. Univ Washington 1927.

7163. Morris, D. An analysis of paintings and drawings by chimpanzees. Bull Brit psychol Soc 1958, 36:29-30.

7164. ——. The Biology of Art; A Study of the Picture-Making Behavior of the Great Apes and Its Relationship to Human Art. NY: Knopf 1962, 176 p; London: Methuen 1962, 176 p.

7165. Moulin, R. Le marchand de tableaux. JPNP 1961, 58:309-330.

7166. Mukerjee, R. The meaning and evolution of art in society. Amer Sociological Rev 1945, 10:496-503.

7167. Mumford, L. Irrational elements in art and politics. New Republic 1954, 130:

16-18 (April 5), 17-19 (April 5), 17-19 (April 12).

7168. Niederland, W.G. River symbolism: Part II. Psychoanal Quart 1957, 26:50-75.

7169. Nielsen, L.C. A technique for studying the behavior of museum visitors. J educ Psychol 1946, 37:103-110.

7170. O'Doherty, B. "The Method." Overdocumentation of modern art by misapplied scholarship. New York Times 1963, Nov. 24, Section 2, p. X21.

7171. O'neil, F.R. Social Value in Art. London: Routledge 1939.

7172. Ossowski, S. (Sociology of art. A survey of problems.) Przegląd Socjologiczny 1936.

7173. Pailhas, B. Projet de création d'un Musée réservé aux manifestations artistiques des aliénés. Encéphale 1908, 2: 426-427.

7174. Palm, R. On the symbolic significance of the Star of David. Amer Imago 1958, 15: 227-231.

7175. Parry, A. Tattooing among prostitutes and perverts. Psychoanal Quart 1934, 3: 476-482.

7176. ———. Tattoo; Secrets of a Strange Art As Practiced among the Natives of the United States. NY: Scribner's 1933, 171 p.

7177. Peter, (?). (The work of the police in suppressing obscene writings and pictures.) Arch für Kriminologie (Leipzig) 1928, 83:66-71.

7178. Raphael, M. Proudhon, Marx, Picasso; trois études sur la sociologie de l'art. Paris 1933, 237 p.

7179. Reis, W. (How the eye is represented in expressionistic art.) Z für Augenheilkunde (Berlin) 1937, 92:158-167.

7180. Reĭtÿnbarg, D.I. (On the perception of posters.) Vop Psikhol 1961, No. 1, 141-148.

7181. Robinson, E.S. Psychological problems of the science museum. Museum News 1930, 8:9-11.

7182. Saint-Saëns, M. Le carton et la liberté de création dans la tapisserie. JPNP 1951, 44:176-184.

7183. Sauermann, H. Soziologie der Kunst. In Dunkmann, K. (ed.), Lehrbuch d. Soziologie und Sozialphilosophie. Berlin 1931.

7184. Seltman, C. Art and society. Studio 1953, 145:98-114.

7185. Sewter, A.C. The possibilities of a sociology of art. Sociol Rev (London) 1935, 27(4):441-453.

7186. Shinn, M. (ed.). Obscenity and the arts. Law & Contemporary Problems 1955, 20:531-688.

7187. Smith, W. Schools, pots, and potters.

Amer Anthropologist 1962, 64:1165-1178.

7188. Sorokin, P.A. Growth, fluctuation, and decline of main forms of fine arts. In Society, Culture and Personality: Their Structure and Dynamics. NY: Harper 1947, 593-606.

7189. ———. Social and Cultural Dynamics. Fluctuations of Forms of Art. Vol. I. London: Allen 1938, 745 p.

7190. ———. Studien zur Sociologie der Kunst. I. Reihenfolge der Künste im kulturellen Lebensprogress. Sociologus 1933, 9:45-65.

7191. Spink, W. Indian art in the teaching of Indian civilization. In Singer, M. (ed.), Introducing India in Liberal Education. Chicago: University of Chicago 1957, 165-178.

7192. Spirito, U. Funzione sociale dell' arte. Riv di Estetica 1956, 1(1).

7193. Steinhof, E.G. Art and society. Parnassus 1937, 9:15-19.

7194. Tanyol, C. Örf ve âdetler sosyolojisi bakimindan san'at ve ahlâk. Istanbul: Matbaasi 1953, 294 p.

7195. Tietze, H. Fine art as a sociological problem. Art Digest 1932, 6:26; Jahrbuch für Sozialwissenschaft 1925, 1:280.

7196. Tomasini, W.J. The Social and Economic Position of the Florentine Artist in the Fifteenth Century. Ann Arbor: Univ Microfilms 1953, Publ No. 5750.

7197. Ülken, H.Z. (Art, thought and social structure.) Sosyoloji Dergisi (Istambul) 1958-59, 13/14:1-34.

7198. Vallis, V. Artist and environment: an Australian study. Brit J Aesthetics 1962, 2:328-336.

7199. Van Martin, A. Art of the full Renaissance. In Sociology of the Renaissance. NY: Harper Torchbook 1962.

7200. Venzmer, G. (The relation of constitution to artistic production.) Fortschr Med 1932, 50:354-355.

7201. Verweyn, J.M. Soziologie der Kunst. Z Aesth 1924-25, 18:223-230.

7202. Vié, J., and G. Ferdière. Appel en faveur d'un Musée d'art psycho-pathologique. Ann méd-psychol 1939, 1:130-131.

7203. Watson, B. Kunst, Künstler und soziale Kontrolle. Cologne: Westdeutscher Verlag 1961, 108 p.

7204. Wayne, I. American and Soviet themes and values: a content analysis of pictures in popular magazines. Public Opinion Quart 1956, 20:314-320.

7205. Wiese, L. von. Die bildende Kunst der Gegenwart-soziologisch Behandelt. Kölner Z für Soziologie u Sozialpsychologie 1952-53, 5:439-445.

7206. Wilke, (?). Geburt und Missgeburt
 in Mythus and Kunst. Leipzig: Kröner 1914.
7207. Wollheim, R. Sociological explana-
 tion of the arts: some distinctions. In Proc
 3d Int Congress on Aesthetics. Turin 1957.

7208. Zsakó, S., and J. Jó. Das Museum
 der Budapest-Angyalfölder Irren- und Ner-
 venheilanstalt. Psychiatrisch-neurologisch
 Wochenschrift (Halle) 1931, 33:587-590,
 597-600.

Index

Moulin, R., 7165
Mountford, C.P., 4556
Mousseau, C., 7019
Moutsopoulos, E., 0978
Mouzet, C., 5688
Moyer, J.H., 5639
Mühle, G., 2831, 5360
Müller, F., 2832
Müller, G.E., 1830, 3536, 3537
Mueller, J.H., 0979, 6259
Müller, M., 0980, 5869
Müller, P.H., 6898
Müller, W., 0981
Müller-Fahlbusch, H., 5870
Müller-Freienfels, R., 0982, 0983, 3535,
 5361, 5362, 5363, 5364, 5365, 5366,
 5367, 5368, 5369, 5370, 5371
Müller-Suur, H., 5871, 6899
Muensterberger, W., 4557, 4677, 4766,
 4776, 6106
Muensterberger, W.L.L., 6106
Münz, L., 4349
Mukerjee, R., 0984, 0985, 7166
Mullen, F.A., 3912
Muller, A., 4865
Muller, H., 1831
Multari, G., 4246
Mumford, L., 0986, 0987, 0988, 1832, 1833,
 1834, 1835, 1836, 1837, 1838, 1839,
 1840, 1841, 1842, 1843, 1844, 7167
Munari, I., 2038
Mundell, L.R., 2833
Mundt, E., 0989
Mundy, L., 2093
Munitz, M.K., 0990
Munro, L., 2202
Munro, T., 0991, 0992, 0993, 0994, 0995,
 0996, 0997, 0998, 0999, 1000, 1001,
 1002, 1003, 1004, 1005, 1006, 1007,
 1008, 1009, 1010, 1011, 1012, 1013,
 1014, 1015, 2834, 2835, 2836, 2837,
 2838, 2839, 4558, 4866, 5372, 5373,
 5373a, 5373b, 5374, 5375, 5375a, 5376,
 5377, 5378, 5378a, 6068, 6305, 6306,
 6456, 6457
Munroe, R., 4983, 6349, 6900
Munson, G., 5379
Munsterberg, E., 5380
Munsterberg, H., 5381
Murchison, C., 2490
Murphey, B.J., 4867
Murphy, A.E., 1016
Murphy, J., 4559
Murphy, L.B., 2709, 6763, 6901, 6902
Murphy, M.M., 6903, 6904
Murray, D.C., 3538, 6905
Murray, E., 1017, 3539, 3540
Murray, H.A., 5382
Murray, M.A., 6107
Murray, P., 2203

Mursell, J.L., 2840, 2841, 5383, 6307
Mussen, P.H., 5380
Muth, G.F., 2842, 2843, 2844, 2845
Muybridge, E., 4277, 4278
M'Uzan, M. de, 4637a
Myers, B.S., 1018, 1019
Myers, E., 0401
Myers, L., 2204
Myron, R.E., 6108

Naber, L., 2846
Nachmansohn, M., 1020
Nadel, S.F., 4560
Näcke, P., 5872
Nagai, M., 4350
Nagler, B., 5873, 5874
Naguib, A., 2847
Nagy, L., 2848
Nahm, M.C., 0134, 0204, 1021, 1022, 1023,
 1024, 1025, 1026, 1027
Naka, Y., 2647
Nakae, J., 2849
Nakashima, T., 5384
Nakian, R., 1028
Napoli, P.J., 3791, 3792, 3793, 3794, 3795,
 3796, 3797, 3798
Narazaki, M., 1029
Nathan, H., 2205
National Education Association, 2850
National Society for the Study of Education,
 2851
Natorp, F., 2852
Naumann, F., 3541
Naumberg, M., 2066, 2067, 2068, 2069,
 2070, 2071, 2072, 2073, 2074, 2853,
 2854, 2855, 2856, 2857, 2858, 5385,
 5386, 5819
Navartil, L., 6906
Naville, A., 1030
Naville, P., 2859, 2860, 2861, 6907, 6908
Needham, A., 6286
Negri, N.C., 1031
Neihardt, C.R., 1032
Neilsen, H.H., 4351
Nekeljković, D., 5387
Nel, B.F., 6909
Nelson, B.N., 4758
Nelson, H., 5388
Nemitz, F., 4868, 5389
Nervi, P.L., 1845
Netschajeff, A., 5390
Nettleship, A., 4561
Neubauer, V.E., 2862, 2863
Neugebauer, E., 2653
Neuhaus, W., 2864
Neumann, E., 4869, 6109
Neumann, J., 4870
Neumeyer, A., 1033, 1034, 1035
Neuschutz, L.M., 3799, 3800